CREATION
ART SINCE THE BEGINNING

JOHN-PAUL STONARD

BLOOMSBURY CIRCUS

LONDON · OXFORD · NEW YORK · NEW DELHI · SYDNEY

Why do humans make images? Why do we create works of art? Throughout history there have been many different answers to these questions – as many answers as there have been works of art. And yet there is one aspect of the images of art that runs like a golden thread connecting them over space and time: works of art have always been a record of the human encounter with nature. They show how we think and relate to the world, our curiosity and fear, our boldness and our sense of where we stand in relationship to other animals.

The encounter is also with ourselves, with human nature. We record what we see and experience around us, but also what we remember, and imagine, ghosts and gods, and creatures of our fantasy. With the images of art we also confront that part of human nature that is most mysterious, and most inevitable – the nature we encounter in a lightless cave, or a darkened room: mortality and death, of others and ourselves.

One night the Japanese artist Katsushika Hokusai dreamed of walking in a wide and varied landscape laced together with one hundred bridges. Such was his happiness at wandering in this interconnected world that when he awoke he immediately picked up his brush and ink and made a drawing of it.

Hokusai's drawing appears like a map for the story told in this book, a world of bridges in space and time, joining ideas, images and objects, so that, however distant they might seem, however far across oceans, or lodged in the inaccessible reaches of deep time, we might always somehow find our way to them. In the final count nothing – not even the art made in Japan in Hokusai's era, when the Japanese islands were cut off from any dealings with the outside world – exists in total isolation. We only have to voyage with our minds, and our eyes, open, and in a spirit of bold curiosity.

The first human images were carved and drawn in rock shelters, but also marked on our own skin, in the form of tattoos and bodily adornments. Gradually we learned to live in the world, to use it and to show it. We learned to dominate space by rationalising it – most famously through perspectival drawing based on mathematical rules. We can imagine the story of art as gradually expanding from our immediate space until it encompasses the whole world.

Nowadays works of art can be 'installations' in which we immerse ourselves – real spaces. Has the whole world become a work of art? It has become a human work, such that we live in an entirely human-made environment. This is the transformation preserved in the past of human images, and one of the stories traced in this book. As the human relationship with nature enters a period of profound reckoning, the history of our encounter with our world, recorded in the images of art, is more important than ever to comprehend.

1

Signs of Life

Wandering through the landscape in small bands, sheltering beneath rocks, drinking from rivers, the earliest humans lived close to the nature that surrounded them. They carried out their lives not as if above animals, but one creature among many.

And yet there was a difference. With their hands they shaped stones into tools, chipping them with an eye to symmetry. From old fires they took lumps of charcoal to make marks on rough cave walls, and on flat stones held in their hands. Their bodies they decorated with shells from the shore, drawing patterns on their skin with reddish pigments, mixed in empty shells. They left signs of life in the shelters they returned to, season after season, generation after generation.

Around fifty thousand years ago a small band of humans left their ancestral home, the African continent, to wander through the world. From this moment the earliest known signs of a new human ability survive, perhaps already tens of thousands of years old, but only now making its mark on the world – the ability to create images. With a few strokes of charcoal a deer could appear running across a cave wall. Whittling and carving a length of wood or ivory, a lion could be held captive in the hand.

It was like a light turning on in the human mind.

Remarkably, these earliest known images appeared around the same time at opposite ends of the world.

On a limestone wall in a cave on an island in the eastern oceans (modern Sulawesi), a human used red ochre pigment to draw a species of pig, probably the Sulawesi warty pig, native to the island. Perhaps using the end of a stick, chewed to soften it to hold the red ochre, they drew four of these hairy creatures alongside two stencilled images of hands, made by blowing pigment around outstretched fingers – like the hand of a hunter, reaching for their quarry.[1] Similar paintings of the warty pig, alongside the anoa (a small, shy water buffalo), and in at least one case diminutive stick figures, probably representing humans

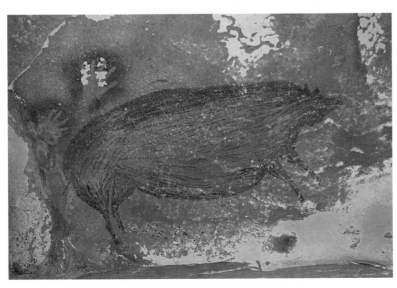

Hand stencil and wild pig, Leang Tedongnge, Sulawesi. c.45,500 years ago.

hunting, were made on a number of limestone caves on the south-western shores of Sulawesi over a long period, perhaps as much as ten thousand years.

A few thousand years later, on the other side of the world, another human set to work, taking a tusk from a dead woolly mammoth and, using a stone tool, carving from it the figure of a lion standing on its hind legs.[2] The hollow part inside the mammoth's tusk cleverly creates the gap between the lion's legs, while the curve of the tusk gives the lion a standing, leaning pose, as if listening, or speaking, like a human.

The finished carving may have had magical properties, or may even have been worshipped as a god – or perhaps it was carved simply to be admired as an image. We have no way of knowing for sure. There is, however, no mistaking the carver's skill, their ability to see the form of the lion in the tusk before they set to work. They had doubtless shaped such standing lions before, practising their craft and thinking about the way the shape could be created from the tusk and perhaps from other materials – a length of wood or a soft carvable stone. Like the warty pig of Sulawesi, the standing lion, made in the region of modern southern Germany, might be the earliest surviving image carved by human hands, but it was made with skills honed over countless years by humans and their ancestors through the fabrication of stone tools.

For tens of thousands of years, perhaps since the first modern humans (known today as *Homo sapiens*) emerged in Africa around three hundred thousand years ago, people had been scratching marks on stones and shells, drawing lines with sticks of ochre: cross-hatched and lattice shapes whose meaning remains obscure. They may have conveyed a shared understanding about some important aspect of life, or have simply been signs of human presence.

A few thousand years after the standing lion was carved, another human image-maker took a lump of charcoal from an old fire and set to work

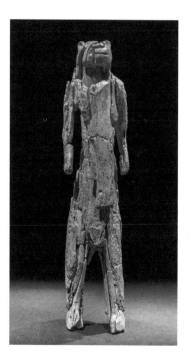

Standing figure, possibly a lion. c.40,000 years ago. Carved mammoth tusk, h. 31.1 cm. Museum Ulm.

marking lines on a cave wall. The images appear to dance and move in the flickering illumination of an oil lamp or a wooden torch: four horses galloping across a cave wall.

Their creator had seen such a herd of horses, and may have practised drawing their outline in the earth, or scratching it in a rock held in their hand, before making the living image on the wall. They had learned to differentiate the horse from other creatures with a sound that became its name, perhaps whispering it under their breath as they drew. Sensitive lines suggest the volume of the horses' heads and the softness of their manes, giving them a tender, thoughtful expression. They joined the bestiary that had been gathering in the cave, in southern France (known as the Chauvet Cave), taking their place among fighting rhinoceroses, stags and woolly mammoths.

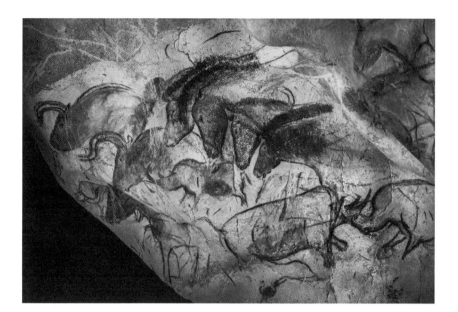

Horses, mammoths, rhinoceroses, Chauvet cave, Vallon Pont d'Arc. c.32,000–30,000 BCE.

Quite why these carved and drawn images appeared simultaneously on different sides of the world remains a mystery. It cannot be explained by contact over continents between those who made them. Was there a time trigger in the long process of human evolution that, at this moment, in response to new surroundings, unlocked the image-making instinct? Or had it emerged much earlier in images that were later lost? Although many of the earliest images survive outside Africa, the image instinct may well have emerged in the human homeland, in the form of creations that were not to stand the test of time. [3]

The long journey itself, the migration east and west across Eurasia, travelling over most of the Earth and its oceans, must also have spurred the evolution of the image-making capability. Adapting to terrain along the coastal migratory routes meant new ways of communicating, signalling danger or opportunity. Wandering hunters encountered a new world of nature, birds, animals, plants, forests, rivers and mountains, as well as changing climates, from searingly hot deserts to cold mountain passes and endless expanses of tundra. It was a physical challenge and threat, so that hunters admired nature but also waged war on it, killing entire species as they went.

Drawing the shapes of animals was part of this struggle, gaining knowledge of the world as it appeared in its great variety. Image-making was also, perhaps, an act of memorialisation. When they reached a rocky peninsula stretching into the ocean, far from their ancestral home, the hunters began engraving the outlines of countless animals on large boulders littering the coast. One shows a wolf with a striped back, known as the Tasmanian tiger, which soon became extinct in the region, now known as the Burrup Peninsula, in northern Australia.

Humans began to remember and imagine, anticipating what might be beyond the mountain, down the river on the plains. Evolving a capacity to think in terms of images was inseparable from the long story of migration and the encounter with nature in its spectacular variety and abundance, an encounter that had begun long before, in Africa.

These early human images excite our imaginations, although there is little about them that we can say with certainty. One thing, however, can be said. The first thirty thousand or so years of human image-making were devoted to a single subject: animals. Not all animal species were shown, and the majority depicted, at least on cave walls, were either bison or horses. Other animals also appeared – the Chauvet Cave is crowded with mammoths, lions, horses, reindeer and bears, as well as rhinoceroses and unusual beasts such as the long-eared owl and a panther.

This obsession with animals occurs everywhere humans went, from the caves of southern France to the sandy shores of Australia. Nowhere, for thirty thousand years, are there any images of landscapes, plants, trees, rivers, the sea, the sun or the moon – all things that surrounded early humans and were just as important for survival.

Perhaps the changing appearance of animals made them special. Early humans survived by hunting and foraging, and the need quickly to recognise their prey. Their deep knowledge of the habits and appearance of animals was reflected in the images they made – showing their winter coats or distinguishing different ages of deer by the type of antler.[4]

Thousands of years after the lion man was carved, another craftsman took the tusk of a woolly mammoth and created the image of two reindeer, their streamlined forms and raised heads indicating that they are swimming. Markings on their sides show that a male stag is following a female hind. The details are minutely observed so that not only their sex but also their species, the tundra reindeer, is preserved, as well as the time of year: full antlers and long hair show they are crossing a river in autumn, their eyes bulging with the effort and fear of their task.[5] Such observations were derived from daily co-existence with animals, creating a companionship and also a spiritual connection. It was also a source of dominance. Images were stores of hunting knowledge gathered over generations. Images gave humans their advantage in a world.

One animal was notably absent in this new world of images – humans themselves. Signs of human presence were scattered far and wide, from the earliest chipped stone tools to the lines of ochre on stones and shells reaching back over a hundred thousand years. Stencilled images of hands, made by blowing pigment around an outstretched hand on a wall, can be found wherever humans reached on their long voyage of migration, from modern-day Indonesia to Argentina, Borneo, Mexico and many sites in Europe and Asia. Judging by the difference of length between ring and index finger, many of these show women's hands.[6] But virtually no images of that vulnerable upright form, with a forked lower half and spindly-limbed top, survive from the first twenty millennia of human image-making. It seems simply that none was made – there was no need.

The earliest images of humans to have survived are carvings of female figures, emphasising the childbearing parts of the body. The face of one of these, made around twenty-six thousand years ago, and found at the site of Dolní Věstonice (in the modern Czech Republic), is featureless apart from two diagonal slits for eyes, so that she appears to be wearing a hood. She is the oldest known object made by firing clay in a kiln. It was at least another ten thousand years before clay was fired to make useful things like pots.[7] The Dolní Věstonice figure may have served as a lucky charm, an object with magical properties, but

Female figure from Dolní
Věstonice. 29,000–25,000 BCE.
Fired clay, h. 10.1 cm. Moravské
Zemské Muzeum, Brno.

is by no means more powerful or elegant than the standing lion or swimming reindeer. Humans saw themselves as just one animal among many, and by no means the most beautiful or well adapted for survival in an inhospitable world.[8]

The warty pig in Sulawesi, just as much as stencilled images of human hands in Argentina and the animals on the walls of the caves at Chauvet, Lascaux, Altamira and other sites, show that the image instinct could manifest itself wherever humans wandered. In some places it was a mere flash of illumination before the wandering hunters were cast back into a long imageless time. In many other places it did not appear at all, at least in ways that survived.[9] Creativity was undoubtedly manifest in other ways, in dance and song, and in the earliest forms of music, or in elaborate decoration of the human body.

And yet, as millennia passed, the instinct to create and recognise images became indispensable to human life, part of what it meant to be human. Images were a sign of being set apart from other animals and from the natural world – and capable of their domination.

Through images we also encountered ourselves, linking our minds over time and space with memories of hunting encounters, of the changing appearance of animals through the seasons and even of the strange and fanciful beasts that appear in our dreams. To enter the dark cave where our ancestors sheltered, and which they adorned with animal images, is like entering the human mind itself – an extraordinary, moving and very, very long prologue to the story of creativity to come.

The image instinct probably appeared fifty or sixty thousand years ago. Around twelve thousand years ago a second instinct emerged. Rather than wandering, this time it was propelled by new settled patterns of human life, by agriculture, a life of planting crops and grazing animals.[10]

Large standing stones began to appear in the landscape, quite unlike any natural rock formation. Places to congregate and return to as the seasons changed, they were homes for spirit beings and for the memory of powerful ancestors, darkened by rain and warmed by the sun. They were signs of a more established way of life. Farming meant that a surplus of food could be produced and traded, and wealth accumulated. Powerful leaders built up their domains, and humans began to see themselves in terms of larger groups, co-operating towards a common aim. Together these groups, the earliest societies, could create things far beyond the reach of the individual. All these changes were reflected in the new impressive stone shapes in the landscape, the first permanent signs of human dominance.

More ambitious stone structures soon appeared. One common form was made by laying a large rock across the top of two standing stones, forming a narrow shelter, or a gateway.

Like the earliest hunter–gatherer images, these rock forms appeared in many places where humans settled, far from Africa. A peninsula in the eastern ocean (modern Korea)

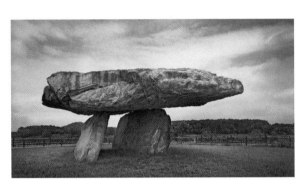

is home to the largest number of these standing stones, some weighing up to three hundred tonnes, and known as 'dolmen' (or *koindol* and *chisokmyo* in modern Korean).[11] They were burial sites – the ritual of burial was an important part of settled life – but also a way of marking territory, an anchor in the landscape for families and dynasties. Coming across the rough, weatherworn standing stones in the landscape, a wanderer might have seen them as if formed by natural magic. They were also the expression of a deeper sense of human structure, of the uprightness, the two-leggedness, the top-heaviness of the human body itself.

Increasingly they were not only hauled and stacked, but also formed, showing the work of clever human hands. Humans learned how to smooth and flatten the stones. At the ancient site known as Göbekli Tepe (in modern Turkey), one of the earliest known gatherings of standing stones, images have been carved into the flattened sides of upright monoliths, including snakes, wild boar, foxes, ducks and aurochs (a species of wild cattle), as well as vultures and scorpions.[12] The standing stones are arranged in circles, surrounding two larger T-shaped stones. Some of the monoliths at Göbekli Tepe are also carved with arms and hands, transforming them into human figures – ancestors, perhaps, or images of tribal chiefs. Small images of animals are carved onto their sides. The old methods of survival, the violence of hunting and killing animals, were being replaced by the new life of settled farming and the domestication of animals. The stones at Göbekli Tepe signal a new sense of human presence and the domination of animals and nature.

By flattening surfaces, preparing stone blocks with regular sides, larger, more elaborate enclosed structures could be built, solid walls against inclement weather and colder seasons. These were the first alternatives to the temporary shelters and caves in which humans had dwelt for hundreds of thousands of years. These enclosures, like those found on the modern-day islands of Malta and Gozo, were welcome refuges from wild nature, yet the images that adorn them are often simple, lacking the elegance and lifelikeness of the earlier cave images and carvings. Settled farmers and traders used their stone structures to embody a wider awareness of the natural world, one more attuned to the shape of the landscape, the rhythms of the sun and the patterns of the stars, and to the human form itself, and yet they seem to lose much of the energy of the closely

Signs of Life

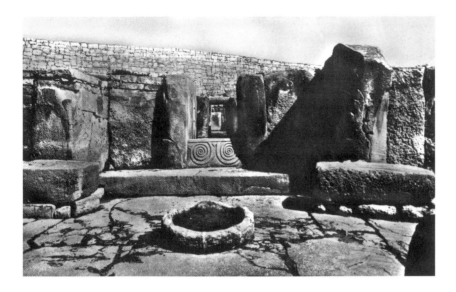

Tarxien Temple, Malta.
c.3000–1400 BCE.

observed drawings and carvings of animals made by hunters. After all, they no longer needed such knowledge to survive.

What mattered now was the rhythm of the seasons, and knowledge of the celestial sphere. Many of the temples on Malta are positioned to give the clearest view of the night sky. In the absence of calendars or a record of passing time, the movement and position of celestial constellations was the only way to chart the changing times of year – when to sow, when to expect rain, when to harvest. Buildings were themselves time-keepers, clocks and calendars in one. It was a way of orienting human life and survival towards the future, a form of prediction, but also a way of remembering the past. Passage tombs, formed of a corridor descending to a lower, submerged burial chamber, were oriented towards the rising sun. One passage tomb in Newgrange, modern-day Ireland, is aligned with the midwinter sunrise, so that once a year sunlight streams down the passage and illuminates the tomb.

Building such precisely positioned stone structures could take many years, centuries even, becoming the work of generations. Memories were folded into landscapes where signs of human life had taken deep root. On the southern hills of a cold, wet island (modern Britain), one such working settlement began as a simple earthwork circle, around which timber posts were arranged.[13] Hundreds of years later enormous boulders, known as bluestones, were chipped into shape and hauled over one hundred and fifty miles from mountains in the west, and positioned standing in a circle.

Thousands of people lived in settlements around the site where they worked, later known as Stonehenge ('henge' may have originally meant in Anglo-Saxon 'hanging', as in 'hanging stones', suggested by their upright forms). Many generations later, even larger blocks of sandstone were transported from hills twenty miles away, becoming supports for the towering post-and-lintel structures, like giant doorways. Such an operation, including the smoothing of the blocks and fitting them with joints so that they would fit together when erected, was an impressive feat of planning and co-operation by a large group of people.

Their imagination grew ever bolder, each generation rivalling the achievements of their ancestors. Perhaps some generations despaired of the task, turning their attention elsewhere. The upright stones are slightly wider at the top so that they appear straight when viewed from the ground, an astonishing coup of intelligent design. The lintel stones, resting on top of the upright stones, curve slightly, to preserve the idea of a circular enclosure. Like the passage tombs, the circle of stones was aligned to frame the furthest limits of solar movement: the rising sun at the summer solstice and, on the opposite side, the midwinter sunset to the south-west. A master builder would have made detailed calculations, passed down by word of mouth to his successors over generations. The sound of stone tools chinking against quarried blocks would have echoed around the surrounding downlands and valleys for hundreds, even thousands, of years.

Bones and cremated remains indicate that Stonehenge was a burial site, although this gives no explanation as to the elaborate construction and the changes to the site over the centuries. Who planned it, how the builders lived, what people felt encountering it travelling from far afield, perhaps over oceans, we will never entirely know. Something of the experience of those first encounters seems preserved still in the standing stones, obdurate presences that seem to slow down time, unshakeable evidence of a new relationship between humans and nature, a feeling of being at home in the world as part of a greater community.

As a symbol of this new feeling of life, Stonehenge was hardly the most advanced structure in the world, certainly in the final stages of its construction, around four thousand years ago. Civilisations were appearing elsewhere, founded on the new and revolutionary materials of iron and bronze. Around the world, wherever the descendants of the first modern humans had settled, different ways of making images were unfolding with increasing speed, bewilderingly, excitingly fast, compared to the previous thirty thousand years of creativity.

On the islands of Japan, humans had been making ceramic pots for several thousands of years, decorated by patterns of line made by pressing rope into the unfired wet clay surface. Across on the mainland, in China, sophisticated painted pottery and elaborated jade objects had been produced since the beginnings of settled life. The earliest known burnt clay vessels appeared in Japan, China and to the north in Siberia, apparently simultaneously, around 11,500 BCE, as the glaciers were receding at the end of the last Ice Age.[14] On the Yangtze River delta in China a civilisation was evolving in the fourth millennium BCE, supported by rice cultivation and impressive systems of irrigation, centred on a great walled city now known as Liangzhu (near modern Hangzhou, in Zhejiang Province), where craftsmen used diamond tools to work stone objects and incised elaborate images with great precision on symbolic objects made from jade.

Closer to the origins of human life, in the hot region stretching from Egypt in North Africa, where the first pyramids were being built, through to the fertile river deltas of Mesopotamia (now Iraq) and further east to the Indus Valley (now Pakistan), other civilisations were evolving. To a dweller of Stone Age Britain,

a farmer from Göbekli Tepe or a nomadic hunter from the deep past in southern France, Sulawesi or Africa itself, these new human societies would have seemed shocking in the density of their populations, the ambition of their built structures and the detail and lifelikeness of their images.

We are leaving the older, magical world of animals and nature, and entering a new historical era of sprawling cities and monumental buildings, adorned with sophisticated symbols and images, inhabited by powerful rulers, and watched over by the awesome spirits of their gods.

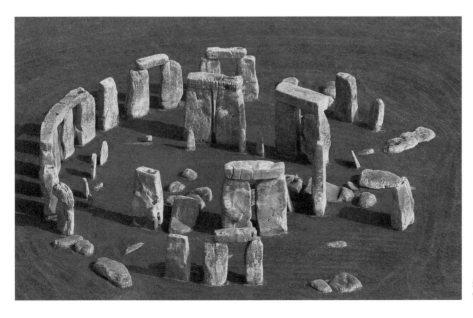

Stonehenge, Salisbury Plain, Wiltshire. c.3200–1600 BCE.

2

Eyes Wide Open

In a temple in a river valley in Mesopotamia stands a small upright figure. His hands are clasped by his chest, and his eyes are open wide. Thick hair, broad shoulders and a braided beard give him an air of importance. Other upright statues stand alongside, all with the same imploring gestures and wide-open eyes. They were placed here, in a temple at the town of Eshnunna (modern Tell Asmar, in Iraq) by local worshippers, to intercede on their behalf with the local city god, Abu.

Clay figures of the human form had been shaped for thousands of years, from the earliest female figures fired at Dolní Věstonice. In the eastern Mediterranean, on the island of Cyprus and in the Levant, figures were roughly modelled in clay, as early as 7000 BCE. Yet none of these earlier figures seems remotely aware of the surrounding world – they are closed, blind forms. The spellbinding gaze and open eyes of the Eshnunna worshipper radiate a new sense of human confidence, self-consciousness and purpose.

It was one of the great leaps in human history: the appearance, around 3500 BCE, of the first city-states, on the southern plains of Mesopotamia between two rivers, the Tigris and the Euphrates. The people who lived in these first cities are known as the Sumerians, their land as Sumer. One of these early cities, known as Uruk (modern Warka, in Iraq), grew to become the largest settlement on the river plain, and probably the largest city in the world at that time. Nourished by bounty from surrounding farming communities, human life multiplied, so that within a few hundred years there were tens of thousands of inhabitants. At the

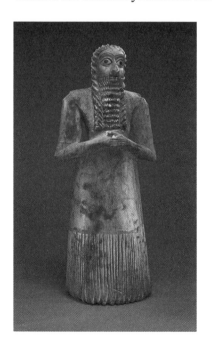

heart of the city two mud-brick temples were devoted to the goddess Inana and the god An. Palaces and houses for officials were built from mud bricks, and storage halls for the produce that was flowing in larger and larger quantities along trade routes to the east and west. The first writing system was invented, at first as a way of counting and recording trade transactions but also, increasingly, as a way of recording events in the wider world. The Sumerian language was recorded on clay tablets with a script known as cuneiform ('wedge-shaped' script). In time the world's first great work of literature appeared, the story of a legendary king of Uruk known as Gilgamesh, versions of which were first recorded on clay around 2000 BCE.

Burgeoning mud-brick cities linked by trade routes, vibrating with the

Standing male worshipper, from Eshnunna (modern Tell Asmar). c.2900–2550 BCE. Gypsum, shell, black limestone, and bitumen, h. 29.5 cm. The Metropolitan Museum of Art, New York.

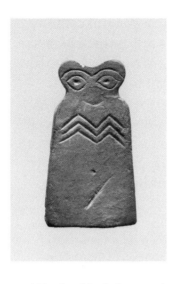

Eye Idol, from Tell Brak.
c.3700–3500 BCE. Gypsum
alabaster, h. 7.6 cm.
Metropolitan Museum of Art,
New York.

energy of urban life, the confidence that writing gave as a record of spoken language and the sheer delight of the literary imagination, combined to give a new sense of life and history, a new awareness of being in the world. City-dwellers abided by regulations, adopted new ways of co-operating and behaving in daily life – for instance, ways of behaving towards strangers – and enjoyed ever greater concentrations of wealth. Older feelings of fear and desire were being overwritten by a more complex consciousness of being in the world, and of the role of the human mind within it. Through writing the past was remembered, the future imagined and supernatural realms evoked. Through images and writing awareness of the world had suddenly become larger.

This awareness is crystallised in the image of a wide open eye. As a symbol it had first appeared in Mesopotamia over a thousand years earlier, in the form of carved plaques, often small enough to be held in the palm of the hand. They show the human form reduced to a limbless body topped by two blankly staring eyes.

Some of these eye idols, as they are known, are incised with decorative lines; others incorporate a smaller figure, perhaps showing a child. Like the Eshnunna worshipper, they were placed in temples, such as the one at Tell Brak, on the northern plains of Mesopotamia, where many were later discovered, to pray with their imploring eyes to the city gods for a return to health, a successful childbirth, for plentiful rain and a good harvest.[1]

The world was also getting larger, or so it seemed, through rising trade between cities and regions. The plains of Mesopotamia were good for crops but lacked materials such as timber, copper and the bright, hard, blue stone known as lapis lazuli, which came from the mountains to the east, in modern Afghanistan.

Cylinder seal with ram handle,
Uruk. c.3000 BCE. Ashmolean
Museum, Oxford.

Trade in these materials led to the richest and most unexpected source of imagery in the Mesopotamian world. Small cylinders of stone, compact enough to fit in the palm of a hand, were engraved so as to leave an image when rolled over clay. Tradesmen and officials used them to seal goods transported in jars, to secure them and mark ownership.[2] Seal designs show not, as you might expect, the goods being stored but rather vivid scenes of humans and animals, often involved in some sort of ritual struggle. A popular type of image, used by many merchants, shows a naked hero or heroine grasping two wild animals on either side. The 'Master of Animals' scene was a symbol of equilibrium in the natural world, with humans dominating the struggle for survival.

Other cylinders show scenes of agricultural life. One from early Sumerian times has a continuous band of cattle processing to a watering hole, or perhaps to market, and beneath them a row of huts made from marsh reeds and mud, for keeping storage jars. Between each hut – the carving is impressively fine – calves emerge to drink from a water trough. Poles, or standards, sprout from the huts, hung with rings that perhaps indicate the status of the hut owner, like shop signs. The unusually large seal is mounted on a spindle, topped by the form of a kneeling ram cast in silver, used as a handle by the merchant, probably a successful and wealthy trader able to afford such a weighty, finely carved seal.[3]

The cylinder seal animals, most of them bovine, were part of the oldest tradition of image-making, stretching back to the earliest drawn and carved images. Fantastical beasts also played their part. The Sumerians imagined a four-legged creature with an elongated, snake-like neck, a 'serpopard', or combination of a serpent and a leopard, a compact of strength and cunning.

One of the most terrifying animal images, however, came from the kingdom of Elam, on the mountains and plains of modern-day south-west Iran. A lion, or lioness, turns its majestic head and clasps its forepaws together, the tense muscular forms like a compressed knot of power. It was carved from a whitish stone, magnesite, with legs of precious metal and a tail and mane attached to holes in the back of the figure, all later lost. The eyes, made perhaps of polished shells, sparkled with menace. Whoever made the figure understood the anatomy of the lion – the muscular tension in the legs, back and shoulders – but also how these could be miniaturised while preserving a feeling of the monumental presence of the feline god.[4] It may have been a mountain demon, or a representation of the Mesopotamian war god Ishtar. Here was the darker side of the first age of cities – the knowledge and fear of rival kingdoms, the need to protect trade routes and defend wealth accumulated in city palaces, temples and strongholds.

Fifty miles south of Uruk, across the River Euphrates, the city of Ur was the second great Sumerian dynastic stronghold. Here the wealth of Sumer, accumulated through regional trade, left its most lasting impression; not in the forms of temples or palaces but sealed up in royal tombs.[5]

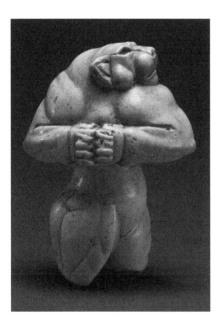

Standing lioness. c.3000–2800 BCE. Magnesite or crystalline limestone, h. 8.8 cm. Private collection.

Around the middle of the third millennium BCE the custom arose of burying rulers and their officials in pits with a treasure trove of gold, silver, lapis lazuli, copper and carnelian crafted into masterly and magnificent objects. Such an accumulation of wealth, of bright, richly coloured, finely wrought objects, had never been seen before.

In one tomb was placed a pair of lyres (types of harp), along with cymbals and sistrum (a rattling instrument), to entertain the dead in the afterlife. The sound box of the lyre is topped with the head of a bull, his eyes

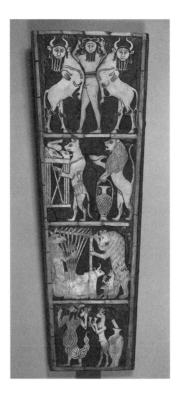

inlaid with bright shell with lapis lazuli pupils, his flowing beard and horn tips also crafted with the same precious blue mineral. Below are four mysterious scenes of animals and men. At the top a naked bearded hero embraces two human-headed bison, although their cheerful appearance makes it less a 'Master of Animals' struggle than a scene from a rowdy fancy-dress banquet. Animals pose on hind legs beneath, preparing food for such a feast – a dog brings a plate of meat on a stand, followed by a lion with a pitcher of wine. The musicians are also animals, or dressed as such: an ass plays an enormous lyre decorated with a sculpture of a bull, supported by a bear, against whose legs another creature, perhaps a fox, rattles a sistrum and sings from music inscribed on a clay tablet. To the music of lyre, sistrum and song, a scorpion man dances, kept in drink by an attendant gazelle.

The jollity of the scenes, like a carnival procession, inlaid on the lyre is at odds with the events surrounding royal burials at Ur. The lyre was placed on the bodies of three women, musicians perhaps, and part of a large retinue of servants and guards who were sealed alive in the tomb or drugged and bludgeoned to death shortly before. Their sad promise was that they too might journey to the afterlife, forever playing, serving, guarding. The journey would take them over the mountains to the east, towards the rising sun, a land where animals and humans were the same, which for the Sumerians was the destination of the soul after death. 'When may the dead see the rays of the sun?' laments Gilgamesh after the death of his friend and ally Enkidu, in *The Epic of Gilgamesh*. Their journey to the afterlife was illuminated rather by the glint of gold and carnelian in the darkness of the tomb.

These piles of gold and precious objects, and the temples and cities that grew around them, led to the most brutal aspect of the new human civilisations (apart from being buried alive) – warfare. Struggle and dominion, boundaries and defence, became routine as cities became citadels during the third millennium. Around 2300 BCE the first great empire of the ancient world began its dogged rise from its capital at Agade on the banks of the River Tigris (the precise location remains unknown). The Akkadians conquered in the mountains and the plains, putting an end to the first Sumerian city-states. For the greatest of their rulers, Naram-Sin, the grandson of the founder of the imperial dynasty, Sargon of Akkad, it must have seemed as though the whole world had been brought within his power. Naram-Sin ruled, according to the Sumerian King List (a long inscription that survives in various forms on clay tablets), from 2254 to 2218 BCE.

The energy of their conquests was poured into images of victory. Portrait busts of their rulers, cast in copper alloy, were placed in conquered cities and worshipped as though they were gods. Detailed relief carvings told the story

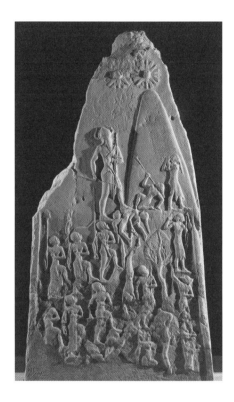

Victory Stele of Naram-Sin. c.2250 BCE. Limestone, h. 200 cm. Musée du Louvre, Paris.

of their battles – at least, those they won – and their skilfully carved cylinder seals show some of the first landscape scenes ever made: lands that they conquered and owned, and which were surely also shown in wall paintings, which like the vast majority of Akkadian images were not to survive. One seal shows a scene in the mountains of men and lions hunting goats beneath a radiant disc, the sun god Shamash. One mountain is a steep outline, the other a patterned pyramid, a sign of the sacred Zagros mountains to the east. It is hardly lifelike – the goats seem to fly in the air, the scene is sketched in a few lines – and yet there is a new feeling of the natural world, a unifying sense of creatures shown within nature.[6]

On a tall standing stone (known as a stele) Naram-Sin proudly poses with bow, axe and javelin, wearing a horned helmet, a symbol of his god-like presence. The stone was carved from limestone and erected in a conquered town called Sippar. Naram-Sin tramples the broken bodies of his enemies, the Lullubi people from the Zagros mountains, who tumble down the mountain as the Akkadian troops march up. Naram-Sin is twice the size of the other figures and is bathed in divine radiance from two solar discs at the summit of the mountain he ascends. Like the Akkadian seal, it is both a symbolic image and a unified scene, a glimpse of the real world. The carver has gone to the trouble of showing a tree native to the scene of battle – it has been identified as a type of oak tree that grows in the mountains.[7]

Rulers in this new world of political dominion were quick to learn the power of images. In the southern Mesopotamian city of Girsu (modern Tello), a town within the kingdom of Lagash, the ruler Gudea, who came to power a hundred years or so after Naram-Sin, had numerous images of himself carved in the extremely hard stone diorite. In one surviving statue he is shown with the plan of a temple which he claimed was revealed to him in a dream. An inscription covering

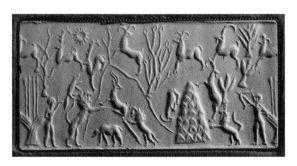

the statue describes the temple, known as E-ninnu, as devoted to Ningirsu, the god of war and patron deity of Lagash. The plan shows a thick defensive wall surrounding an L-shaped courtyard with six entrances flanked by buttresses and guardrooms.

Modern impression of cylinder seal. c.2334–2154 BCE. Diorite, h. 3.6 cm. Museum of Fine Arts, Boston.

Lagash was one of the largest cities in Mesopotamia, probably in the world, at the time of Gudea's rule, and the E-ninnu, with its thick beams of cedar and boxwood, vast doors adorned with carvings of 'shining flowers' and votive statues of copper and gold, would also have been stocked with weapons, and perhaps also housed Gudea's army. The long inscriptions on Gudea's statue of dark green diorite glorify the building, and also warn of the fate to befall Gudea's enemies, or those who disregard his judgement or deface his statues – they will be 'slaughtered like a bull [...] seized like an auroch by his fierce horn'.[8]

Of all the symbols of dominance and rule in this first era of human civilisation, the most impressive and imposing were the colossal mountains of mud-bricks known as ziggurats (from the Akkadian word ziqquratu, meaning pinnacle or mountain summit). The earliest of these stepped structures, which appeared around the same time as the first of the Egyptian pyramids, was built in the city of Kish in the middle of the third millennium BCE. Many more were constructed a few hundred years later, at a time when Ur had regained its primacy after the fall of the Akkadian Dynasty, and was the centre of a new kingdom, the so-called Third Dynasty of Ur.

One of the grandest of all was built at the centre of Ur, and dedicated to the moon god Nanna, the patron deity of the city-state. Priests and officials ascended a monumental staircase to conduct their rites on a platform at the top, seen as the symbolic peak of a sacred mountain, a presence visible throughout the city and the land beyond. While the Egyptian stone mountains are tombs that hold their secrets within, the ziggurats were solid structures, temple platforms giving physical access to the airy domain of the gods: the same realm that the Eshnunna worshipper had sought to bridge with his wide-eyed imploring gaze over a thousand years earlier.

Despite their grandiosity, such buildings were a symbol not of continuity but of the instability of life, and the problems of dominion. Life was

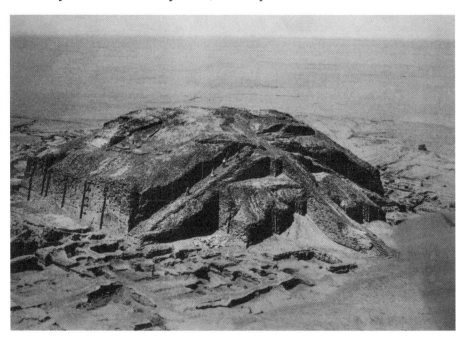

Ziggurat of Ur. c.2100 BCE. Photograph from Leonard Woolley, *Ur Excavations vol. V: The Ziggurat and its Surroundings*, London 1939, plate 41.

beset with the anxiety of impermanence. The old sureties of the village life that had continued for thousands of years seemed to have been overwritten in the new world of wealth and dominion. It was a feeling known to the Gilgamesh author:

> Ever the river has risen and brought us the flood
> The mayfly floating on the water
> On the face of the sun its countenance gazes
> Then all of a sudden nothing is there![9]

The Akkadian empire lasted barely two hundred years before falling to invading tribes known as Gutians from the Zagros mountains. Ur resurgent, after the Akkadian defeat, captured some of the glory of the first Sumerian cities, and was the stage on which Sumerian literature reached new peaks – it was at this time that the standard version of the Gilgamesh epic was set down in cuneiform. A sadder literary genre were the city laments, poems mourning Sumerian cities that had been destroyed. The *Lament for Ur* was composed around 1900 BCE and written in cuneiform on a clay tablet. The goddess Ningal, wife of the moon god Nanna, petitions the gods that the city will be saved: 'May my city not be ravaged, I said to them, may Ur not be ravaged.' But Ningal's words were in vain, the poet records – the temple shrine is now haunted by breezes, the city in ruin. By the time the poem was written, Ur and the Third Dynasty, the last breath of the first civilisation of Sumeria, had fallen to another wave of invaders from the highlands and plateaux to the east, this time from the kingdom of Elam.

The story of images in ancient Mesopotamia is shaped by the rise and fall of Sumer, the Akkadians and the Sumerians once again, with their great city of Ur. It is with the fourth great regional power, that of Assyria, that the stories told by these images take on a new and vivid life.

Towards the end of the second millennium BCE the Assyrians, who had long ruled a peaceful kingdom from the trading city of Assur, on the banks of the River Tigris, began a series of military conquests with remarkable success. In the following centuries they ruled a vast stretch of land from Egypt to Persia – an empire far larger than that of the Akkadians. The Assyrian kings were warriors and hunters known for their brutality, but also built large palaces which they decorated with sculptures, mosaics and carved images. Alongside temples, and bound by great city walls, these palaces occupied the three great citadels established over four centuries by Assyrian rulers, north of modern-day Baghdad: first Nimrud, then Khorsabad and, finally, the great city of Nineveh.[10]

Nimrud was established as the capital of the Assyrian empire by King Ashurnasirpal II, around 878 BCE. Quite why he moved his court from the old town of Assur nobody knows, but he did it in style, erecting a monumental city wall some twelve metres thick, a new palace and nine new temples. Like Gudea of Lagash, and Naram-Sin before him, he knew how images could project power,

and outdid them both with the fearsome human-headed winged bulls, known as *lamassu*, which guarded the entrances to his palaces and temples. These imposing creatures were carved with five legs, so that from the side they seem menacingly to advance, while from the front they firmly stand guard.

When Ashurnasirpal unveiled his new palace and citadel, complete with botanical garden and zoo, visitors admitted to the inner courtyard and throne room would have gazed with astonishment at the images on the walls. Nothing like them had been seen before. It was not only the clarity and elegance of the carvings, made on large slabs of limestone, but also the way in which they vividly told the story of Ashurnasirpal's military campaigns – events that had actually happened. On one panel soldiers are shown swimming across a river, possibly the Euphrates, using the inflated bladders of animals to keep themselves afloat. Never before had the human body been shown with such care for its anatomical structure: the muscles in the legs, the impression of the ribs on the outstretched torso as the soldiers struggle through the current to the opposite shore. Where Naram-Sin's stone stele was a symbolic record, the carved reliefs in Ashurnasirpal's palace were records of the events themselves, images shown in sequence as though time were unfolding across the wall. Life-size figures, painted bright colours, were living presences, mirroring the events of life outside the palace building.

For over two hundred years Assyrian kings took their cue from Ashurnasirpal, building palaces and decorating them with stories of their military and hunting prowess. They were restless. Sargon II moved the capital north to Khorsabad, building a palace guarded by some of the largest and most terrifying guardian *lamassu* ever carved. The dazzle was continued outside in the form of a four-storey ziggurat, each level painted a different colour, white, black, red and blue rising to the summit.

Sargon's son Sennacherib moved the capital back to the old city of Nineveh, which he converted into a far larger citadel to contain his vast new residence, called the 'Palace without Rival'. Nineveh remained the stronghold of Assyrian power until the time of Sennacherib's grandson Ashurbanipal. By this time the empire was at its height, and the skill of the Assyrian designers and carvers unrivalled. Their greatest work was the frieze carved on gypsum panels for Ashurbanipal's North Palace at Nineveh, which tells the story of a lion hunt.

Standing on a wooden cage, a boy lifts the gate to release a lion into an enclosure. Guards with spears and vicious mastiffs are posted for protection. The king, in full royal regalia, his bow decorated with the head of a lion, looses arrows at the lion from the relative safety of his chariot. Guards with spears weaken the lion further, until its leg gives way and it stumbles in the dust. The animal's suffering is captured in a sequence of moving images – his body slackens, his eyes narrow and his tongue extrudes as he chokes blood, which flows from his mouth, and from the wounds made by the arrows that pierce his body. The lions that were once feared and worshipped as gods, their images kept and handled as a form of protection, are now slaughtered as a game. No longer the equilibrium of the 'Master of Animals' contest shown on cylinder seals, the lion-hunt reliefs at Ashurbanipal's North Palace are a statement of human supremacy over the animal world.

The carved reliefs at Nineveh, Khorsabad and Nimrud open a window onto the Assyrian world, embellished, no doubt, by the artists of the royal workshop, yet still giving a glimpse of life as it was lived. They complemented the

histories and stories that had been recorded in writing for thousands of years, and which were brought together by Ashurbanipal at Nineveh to form one of the first libraries, an archive of pillow-shaped clay tablets and wax-coated writing boards with texts collected and commissioned by Ashurbanipal. The subjects covered were diverse – from divination derived from astrological observations to medical texts and guides to rituals of kingship, as well as poetry and stories. One of the greatest surviving sets of tablets carried a complete version of the Gilgamesh epic, written down by a Babylonian scribe, Sîn-lēqi-unninni, some time around the end of the second millennium BCE, and known by its first line, *He who saw the Deep*.

Without these writings, many of them by Babylonians living in the south, where the centres of scholarship and writing were found, much of the history of ancient Mesopotamia would be lost, and the meaning of the images that have survived would be all the more obscure. In 612 BCE, Nineveh was stormed by the Babylonians, in consort with a tribe from the east known as the Medes. 'Nineveh is laid to waste, who will bemoan her?', wrote a Hebrew living in Jerusalem, whose own city had been invaded by Sennacherib decades earlier.[11] The Assyrians were slaughtered in their citadel, dying in front of their winged-bull guardian statues and royal hunting reliefs. Fire tore through their palaces, burning timber and cracking bricks and charring stone, the upper storeys, where the library and archives were kept, crashing down through the ceiling and shattering on the floors beneath. The act of destruction was also, miraculously, one of preservation: the clay tablets were baked in the fire, preserving them in the ruins to be rediscovered over two thousand years later.

Babylon has gone down in history as the archetypal city of sin – not the last great metropolis to gain such a reputation. Over a thousand years before the fall of Nineveh it had risen to power under the rule of King Hammurabi, who created Babylon as the heart of a powerful and efficiently organised state – the heir in every way to the Akkadians and the Sumerians. This 'Old Babylonian' period was followed by a period of invasion and occupation, by the Assyrians as well as the Hittites, a people from the north-west, in Anatolia. And yet, unlike other Mesopotamian cities, Babylon retained its great aura and allure as a city on the southern plains.

After the fall of Assyria, the old city of Babylon rose once again as a power under King Nebuchadnezzar, who only added to the poor reputation of the city by deporting there a large number of people from the eastern Mediterranean kingdoms of Israel and Judah, after conquering the holy city of Jerusalem in 587 BCE – the Babylonian captivity of the Israelites described in the Old Testament Book of Psalms.[12]

Nebuchadnezzar's most reviled act was the destruction of the most sacred building in Jerusalem, the Temple built by King Solomon to house the Ark of the Covenant, a stave-borne box of acacia wood with a golden lid containing the stone tablets inscribed with the sacred commandments revealed by God to Moses on Mount Sinai.[13] Built on a hill in Jerusalem later known as the Temple Mount, Solomon's temple was a magnificent structure, constructed of stone and

olive and cedar wood, clad in gold and containing a sequence of panelled chambers decorated with carvings of 'cherubim and palm trees and open flowers'. These led to the Holy of Holies, the cubic sanctuary where the Ark was kept, a room forbidden to all but the High Priest, who entered once a year to intone the sacred name of the one invisible God, creator of all things.[14]

Having destroyed the Temple, Nebuchadnezzar may have taken the Ark to Babylon as a symbol of his victory over the Jewish people. Like Solomon's Temple itself, no trace of the Ark remains. Whether present or not in Nebuchadnezzar's city, removing it from Solomon's Temple was hardly a good omen. Less than fifty years later, Babylon itself was destroyed. Nothing but the barest outline in the earth remains of the great temple-tower known as the Etemenanki, the ziggurat dedicated to the city god Marduk, which may have inspired the story of the Tower of Babel told in the Old Testament book of Genesis, whose destruction was a punishment for Babylonian pride and the origin of the world's many languages.[15] Of the so-called Hanging Gardens of Babylon, a set of rising terraced gardens that brought resplendent greenery to the city, built, it is said, to remind Nebuchadnezzar's wife of her homeland in Media, nothing was to remain. They are preserved only in brief descriptions by ancient authors, leading to doubts that they ever existed at all.[16]

Babylon would be a city entirely of the imagination, were it not for the survival of one its most spectacular parts, a walled processional way and decorated gateway, the entrance to the inner part of the city. Across the façade of the gateway stride glaring-eyed aurochs and fantastical snake-headed dragons, known as *mushhushshu*, set against a rich blue surface of glazed terracotta bricks. Roaring lions march down the processional way leading to the gate, proclaiming the power of the Babylonian empire and its gods, of the city god Marduk and the war goddess Ishtar, after whom the gateway is known. The Ishtar gate gives a sense of what it would be like to be a visiting envoy, merchant or traveller arriving in a

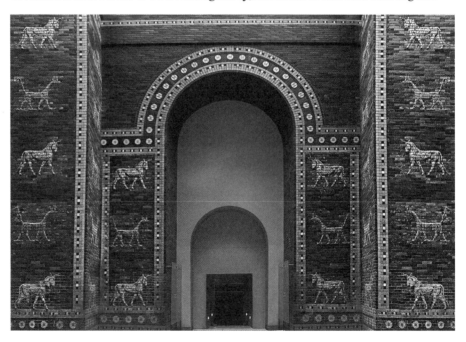

Ishtar Gate (reconstruction), Babylon. *c.*575 BCE. Staatliche Museen, Berlin.

EYES WIDE OPEN

Mesopotamian city during Akkadian or Assyrian times, a prospect both fearful and exciting.

Not even Ishtar and her *mushhushshu* could save Babylon from the inevitable cycle of destruction. In 539 BCE the great city on the southern plains of Mesopotamia and the empire it commanded – the Neo-Babylonian Empire – were conquered by a tribe of horsemen from the east, led by a ruler who termed himself 'King of the Four Corners of the World'. He was Kurush II, more commonly known as Cyrus the Great, king of Persia. Cyrus' triumphant arrival in Babylon along the processional way was celebrated in cuneiform on a large clay cylinder, like a giant nut, presenting Cyrus as a liberator of the Babylonian people from the tyranny of the last king, Nabonidus, at the behest of the city god Marduk. 'I am Cyrus, king of the universe, the great king, the powerful king, king of Babylon, king of Sumer and Akkad, king of the four quarters of the world!'[17] So boasts the Cyrus cylinder, before recounting the peaceful intentions of his rule, a matter of religious tolerance and a spirit of co-operation. Cyrus repaired the temples neglected by the Babylonian rulers, and restored images of the gods to the city sanctuaries, including those at Assur, Akkad and Eshnunna. He restored the city wall, probably damaged when he laid siege to the city. Although it is not made clear on the cylinder inscription, the Bible lauds Cyrus for having returned the Judaean people to Israel, putting an end to the Babylonian exile after some fifty years. There were probably only a few who were old enough to remember departing from Jerusalem when they finally returned home.

The Persian empire founded by Cyrus was the last great power of western Asia that truly kept alive the ancient forms of Mesopotamia – of Sumer, Akkad, Assyria and Babylon. It was far larger than any of them, reaching its height around the turn of the fifth century BCE under the rule of Darius the Great, a noble who usurped the throne and brought together lands reaching from Libya in the west to the Indus in the east, including the other great power to the west, Egypt, whose capital city, Memphis, fell to the Persians in 525 BCE. Images created by the Achaemenids ('Achaemenid' comes from Achaemenes, the name of a royal ancestor of Darius,

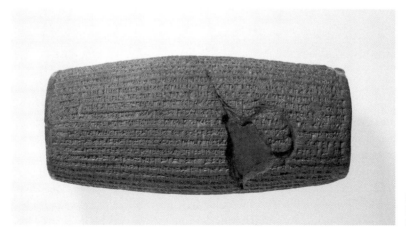

Cyrus Cylinder. After 539 BCE. Fired clay, l. 22.8 cm. British Museum, London.

which he used to legitimise his rule) mirror their broad reach over many lands, as well as the ancient Mesopotamian traditions on which they drew.

The art of the Achaemenids, like that of the Babylonians and Assyrians, and of the Akkadians before them, was a reflection of royal power. It was a court art. Craftsmen from throughout the empire travelled to build and embellish the great Achaemenid royal capital on the plain of Marvdasht, in south-west Iran, founded in the reign of Darius. Raised on a sprawling stone terrace entered by a monumental staircase, the buildings of Parsa (the Greeks called it Persepolis) were outsize halls filled with columns, seemingly endless carved reliefs painted bright colours and guardian winged-bull statues echoing the *lamassu* of Nimrud, Nineveh and Khorsabad. The Apadana, or audience hall, of Darius, completed by his son and successor Xerxes, was the most breathtaking structure by its sheer size, designed to overwhelm even the grandest of visiting potentates. Columns soaring twenty metres were capped with painted capitals in the shape of twinned bulls and lions, cradling enormous roof beams. The hall stood in the middle of a complex of buildings where representatives of the whole empire were summoned to pay tribute, as carvings around the base of the entrance stairway record: Indians arrive with spices and gold dust; Arabs, Armenians and Egyptians bring clothing and vessels; Elamites carry bows and daggers, while Bactrians lead a two-humped camel; Ionian Greeks bring balls of wool and bales of cloth; Arochisians bear gifts including the skin of a wild cat; Ethiopians bring elephant tusks and a giraffe, while Libyans bring a mountain goat; and six Babylonians present the Persian king with a buffalo.[18] All the world came to Persepolis to pay tribute and marvel at the splendid palace on the plains, against the backdrop of rocky ridges and mountains.

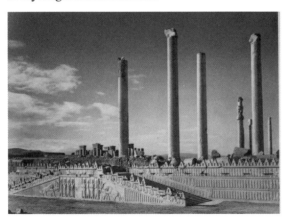

Persepolis, Iran. Apadana. General view of part of East Stairway, with Darius' palace in the background. Oriental Institute of the University of Chicago.

Persepolis, along with the other great Achaemenid cities of Susa and Pasargadae, witnessed the gathering together of three thousand years of image-making in ancient Mesopotamia. It lasted almost two hundred years – not a bad stretch compared with the cities of Mesopotamia. And yet in 330 BCE, when the Greek warrior-king Alexander of Macedon arrived to conquer and destroy Persepolis, the heritage of ancient Iran and Mesopotamia may well have appeared archaic, old-fashioned. Cities in the Greek world had been transformed by a new vision of human life, of architecture and, above all, of the human body. This new vision had spread around the Mediterranean, and was being carried by Alexander

of Macedon far from its place of origin, the city of Athens, out into what became known as the Hellenistic world (from the Greek word for their land, Hellas). Just as Stonehenge would have looked quite outdated to the earliest Sumerians (had they ever seen it), so the Achaemenid palaces would have appeared old-fashioned to Alexander's warriors: they were remnants of an older world, antiques in their own time. In the Greek world astonishingly lifelike sculptures had been made for over a century. Portraits of Alexander looked like living things compared with the rigid relief portraits of Darius, carved on the side of his palace – although this did not, of course, mean that the images of Darius were any less powerful. But seen as a matter of refinement, Achaemenid carving was a mortification of older forms compared with the warm, vital spirit of Greek sculpture.

And yet, looking back, from the wide-open gaze of the Eshnunna worshipper to the drama of the Assyrian royal reliefs, the world of ancient Mesopotamia appears filled with the awakening of new vision, with flashes of fresh emotion and life. Not all Assyrian carving was created with the formulas of court art. For the first time an image was made that appears to capture time itself, an arrow carved in Ashurbanipal's royal relief, hanging suspended in the air between the king's bow and the lion whose flesh it is about to pierce.

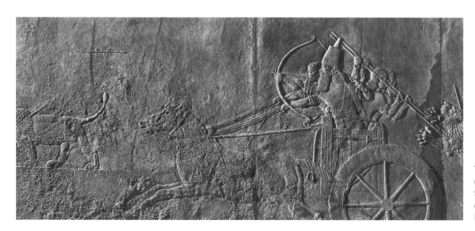

The Royal Lion Hunt, detail of carved wall panel from the North Palace, Nineveh. c.645–635 BCE. Gypsum. British Museum, London.

3

Ages of Elegance

As the first cities were springing up in Mesopotamia, to the west, on a narrow strip of verdant land in the Sahara desert, another civilisation was emerging. It happened in parallel, in the late years of the fourth millennium – the emergence of cities, of writing, of the first human civilisations. But where the cities of ancient Mesopotamia, from Uruk to Babylon, were constantly being destroyed and rebuilt, the civilisation of ancient Egypt along the River Nile projected an aura of changeless continuity for over three thousand years.

Human life had existed on the African continent for millennia before the first cities were settled along the Nile. The animals that had wandered through the human imagination for aeons, and which for thousands of years were carved into savannah rocks by Saharan cattle herders, became cult figures in dynastic Egypt. Climate change and the desertification of the savannah, which occurred around 5000 BCE, had forced the herders to migrate to the Nile Valley, the only verdant strip of land left in the region. They took the images of their animals with them, transforming them into gods, perhaps as a deep memory of their former nomadic lives.[1]

Herders became farmers, dependent on the annual flooding of the Nile for their crop grown in the black soil which gave them the name of their land, Kemet, or 'Black Land'. As in Mesopotamia, cities and strongholds of power grew, but around 3000 BCE a revolutionary event occurred – the creation of the first political state, a power larger than a region, as in the Mesopotamian city-states, but unifying instead an entire land.

This act of unification is symbolised on an object from the beginning of

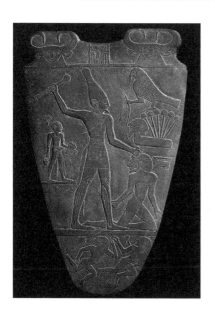

dynastic Egypt, a shield-shaped object made of dark grey slate. The images it carries of animals and men, and of the picture-writing known as hieroglyphics, are hardly rudimentary but rather fully established forms that were to survive for over three thousand years. A falcon representing the god Horus perches above an image of a pharaoh smiting an enemy with a mace. Pictures at the top of the slate reveal the name of the pharaoh between two horned heads: a catfish ('nar') and chisel ('mer') spell the name of King Narmer, probably the first ruler of the First Dynasty. Narmer wears the twin crowns of upper and lower Egypt (crowns were also, it seems, an Egyptian invention), proclaiming him the unifier, king of all Egypt. On the reverse

Slate palette of King Narmer (front). c.3200 BCE. Siltstone, h. 64 cm. Egyptian Museum, Cairo.

of the palette, Narmer is shown as a horned bull beneath two feline creatures, serpopards who entwine their long necks to form a circle, the shallow disc in which a cosmetic, the black eye make-up kohl, was supposed to be ground. This strange creature may have travelled from ancient Mesopotamia, where it had been imagined by the Sumerians around the same moment; it may equally have been born in the imagination of Saharan herders, although no trace of such a creature can be found on the fragmented remains of their painted pottery or engraved into the desert rocks.

The riddling symbols on the Narmer Palette were created according to a handful of loosely defined conventions, giving the indestructible and instantly recognisable 'look' of ancient Egyptian images. Figures were drawn in profile, at their most legible, with no tricks of depth illusion or other visual refinements. Grids and guidelines gave regularity to figures, like the lines on a page of writing, although it is not clear that the Egyptians used any fixed set of proportions for drawing the human figure.[2] The purpose of these grids was, rather, to locate the image on the flat surface, integrating it with hieroglyphic writing.

The clear ordering of words and pictures was another convention – it is rare to find images without writing on ancient Egyptian monuments. Hieroglyphics were a form of drawing, just as carved and painted images have the clarity of writing; Egyptian sculpture was similarly closely allied to architecture, solid and cubic, and buildings often have the appearance of sculpture. Writing and architecture were in this way the twin ideals of Egyptian shapes and forms, ideals of stability and clarity. The space of nature itself, imprinted on human consciousness, seemed shaped by such a regulating ideal – the River Nile, with its ineluctable flow from south to north, bisected by the path of the sun drawing a line from eastern desert horizon to western desert horizon each day. These co-ordinates were animated by the annual flood of the Nile, irrigating the plains either side with divinely ordained regularity. Geometry in ancient Egypt was a life-giving force.

Although the sculptural-architectural ideal was reached in the perfect form of the pyramid, the first of these structures, built around four hundred years after Narmer's time, was more like the stepped structure of the ziggurat. It was built at Saqqara, near the newly founded capital city of Memphis, as a tomb for the pharaoh Djoser, part of a burial complex surrounded by a wall, and including false buildings, backdrops for funerary ceremonies conducted long after the pharaoh's death. Unlike the Sumerian mud-brick ziggurats, which began appearing around the same time, Djoser's pyramid was built of stone – the first known monumental building to be built of carved chunks of rock. And where the ziggurats were solid structures, temple staircases to the sky, the pyramids were hollow tombs, more like gateways to the afterlife. Djoser's pyramid and the burial complex in which it stands were designed by the priest–architect Imhotep, a statue of whom once stood at the entrance to Djoser's burial complex. That Imhotep's name was to survive through the ages (none of the architects of ancient Mesopotamia is known by name) is testament to the power of his designs – he was eventually taken for a god, thanks to the magical structures he created, rising from the desert sands.

The division of the history of ancient Egypt into thirty dynasties, beginning in the time of Narmer, was first conceived by a Greek-speaking Egyptian priest named Manetho, in the third century BCE. Manetho's divisions were simplified even further much later by the ordering of the high moments of Egyptian creativity into the Old Kingdom (dynasties four to six), the Middle Kingdom (dynasties eleven to thirteen) and the New Kingdom (eighteenth to twentieth dynasties).

The Fourth Dynasty of the Old Kingdom and the Eighteenth Dynasty of the New Kingdom were the true golden ages of Egyptian art – the trick of appearing never to change runs alongside these moments of great invention and refinement.

During the Fourth Dynasty of the Old Kingdom, Imhotep's legacy came into its own, and the great age of pyramid-building began – although it was not exactly a smooth start. The first ruler of the Fourth Dynasty, Sneferu, had his pure vision of pyramid architecture built at Memphis, a perfectly geometric pyramid whose sides symbolised the beams of the African sun, making Djoser's stone pile, visible near by, look archaic by comparison. Sneferu called his pyramid simply 'Appearance', referring to the rising sun, although it ended by appearing far from perfect, subsidence forcing the workers to flatten the top off, so that it became known less grandly as the 'bent' pyramid. Sneferu set his engineers to work once more, and they produced a more perfect version, known as the Red Pyramid, in which he finally began his journey to the afterlife.

The projection of power through creating a vast, utterly geometric shape in the landscape, alien to all natural forms, was perfected on firmer foundations (limestone) at Giza, where Sneferu's grandson Khufu and his son Khafre built their own death-conquering machines. Along with those of Khafre's own son Menkaure they were a dazzling spectacle when first complete, clad in bright white Tura limestone – impossible to gaze at directly in the pulsing midday sun, whose spreading rays they symbolised, glowing in the evening and mystically dissolving in the haze of dawn. At the edge of the desert, where the dunes blend imperceptibly with the sky, the noise of the city, carried on the wind, rises from the valley below. As with the monoliths of Stonehenge, time itself seems to dissolve in their presence, and with it, so hoped the pharaohs, the finality of death.

Khufu's pyramid was the grandest, built with over two million stones, each weighing at least a ton. Reaching almost five hundred feet, it was taller than the ziggurat at Ur, and the tallest building in the world for thousands of years to come. Despite its colossal size, it was built with utter precision, so that three hollow air shafts reaching from the centre of the tomb, opening in the upper part of its sides, point directly at three stars: to the south, Sirius, the dog star, which was associated with the goddess Isis, and to the north the stars now known as Beta Ursae Minoris, in the constellation of Ursa Minor, containing the pole star. In the time of ancient Egypt the star of Thuban, in the constellation of Draco, was closer to the celestial north pole and was visible through another air shaft rising from the tombs within. Such cosmic expression of human life at the centre of an unfathomably vast universe was never to be rivalled.

As at Djoser's tomb, each pyramid at Giza stood as part of a complex of buildings, including the mastaba, smaller tombs for the pharaoh's family and high court officials (the word comes from the Arabic for 'mud bench', the shape of the

mastaba tomb seen from the outside). Daily rituals for the dead were conducted in a funerary temple built on the eastern side of the pyramid. A walkway led down to another structure, a valley temple serving as a gateway to the mortuary. Gleaming with polished red granite and white calcite, Khafre's valley temple was filled with twenty-three statues of the pharaoh carved in the hard dark stone diorite, each

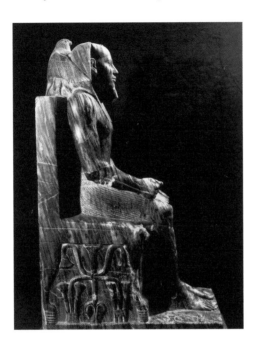

slightly different in pose and shape. He is shown seated, wearing the *nemes* head cloth, the symbol of kingship, Horus hovering behind his head, his wings outstretched in a gesture of protection. Khafre stares impassively out, utterly immobile.

The hardened look was a convention of royal portraiture, made in the royal workshops. It may have borne little relation to reality, particularly to the pampered lifestyle of a pharaoh. Even if Khafre had been a benign ruler, known for his compassion and wit (which seems in any case unlikely), he still would have been shown as an unyielding tyrant.

The statue was made by skilled craftsmen to a high level of refinement, but it also had a practical task – to contain Khafre's life force, his *ka*, once it had left his body after death. For this to happen, the statues in the valley temple had to be animated by a ritual known as 'Opening the Mouth', where magic implements, including amulets, ritual blades and animal parts, were used to touch and symbolically to open the eyes, ears, nose and mouth so that the *ka* might enter. Almighty power was shored up in the close-grained, heavy stone, bent on eternity at any expense, of money or life. And it was not simply a matter of unveiling the statues and pyramid tomb after death – as at all the great mortuary complexes of the dynastic kings, the engineers, builders and sculptors were hard at work throughout the pharaoh's reign. Temple- and tomb-building were a continual reflection of kingly power and might.

Egyptian craftsmen were also capable of images that captured life in a different way. Rahotep, Khufu's brother (and therefore Khafre's uncle), served as high priest at Heliopolis and the temple of the sun god Ra. His tomb at Meidum was decorated with carved and painted scenes of hunting, fishing, ploughing and boat-building – scenes of the sorts of activity that would lead to continual wealth and power in the afterlife, and shown according to Egyptian conventions.[3] Like the pyramids of their sovereign, the tombs of high officials were designed with imagery that was believed to sustain the occupant after the death. On a limestone panel, set into a false door, a blind framed entrance through which the soul of the dead was supposed to enter the afterlife, Rahotep is shown in profile, sitting next to an offering table laden with half-loaves of bread. Above, hieroglyphs indicate

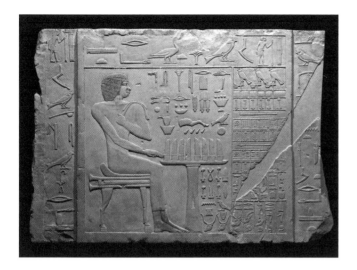

Panel from tomb of Prince Rahotep. Fourth dynasty, c.2613–2494 BCE. Limestone, 114.3 cm by 83.8 cm. British Museum, London.

a variety of useful objects that he might pack with him for his journey to the next world – incense, green eye paint, wine and figs. The panel was originally painted showing Rahotep wearing a leopard skin stretching down to his ankles. It was a matter not only of survival but of perpetuating the pleasures of daily life. With pharaonic wealth at one's disposal, what could be more irksome than having life cut short by bothersome death? What better prospect than a continued life with all the bad bits taken out?

Using the old conventions of drawing, and the rigid code of hieroglyphs, the tomb images reveal little, if anything, of who Rahotep actually was, other than through his family relations – son of King Sneferu, and therefore brother to Khufu. Two other images in his tomb tell a different story. Painted and plastered limestone statues show Rahotep and his wife, Nofret, sitting

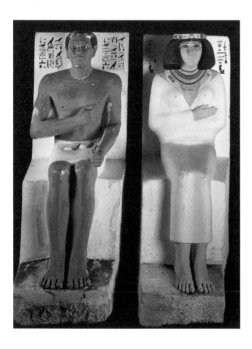

alongside each other (at least when the statues are placed together – Nofret's may have originally stood in her own tomb, next door). Rahotep has abandoned his leopard skin and wears a sober white kilt, his skin painted a darker colour than Nofret, according to convention. He wears eye make-up and a necklace carrying an amulet. Nofret wears a thick wig, under which her natural hair colour shows. Straps of the tight white overgarment she wears are seen beneath her striped collar, with silver pendants. Through all these small details and observations we seem to glimpse into their lives, past the conventions and symbols of the carved reliefs. Nofret appears

Prince Rahotep and his wife Nofret. Fourth dynasty, c.2613–2494 BCE. Painted limestone. Egyptian Museum, Cairo.

with a more resolute and intelligent expression than her husband. Perhaps she held the greater share of power in their marriage, organising their lives as Rahotep went about his daily duties worshipping the sun at Heliopolis.

Khufu had a half-brother, Ankhhaf, whom he employed as an adviser on the building site of his pyramid and mortuary temples. It can hardly have been

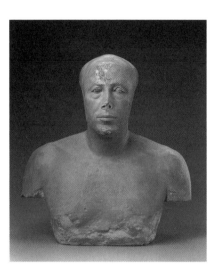

an easy job to organise the construction of such a vast and complicated structure, despite the highly efficient organisation of the Egyptian labour force into crews of around two thousand men, subdivided into smaller groups, the smallest teams competing against each other, as if pyramid-building was a sport. Working conditions, however, were hardly enjoyable, and the spirit of competition must frequently have turned sour, only adding to Ankhhaf's burden. As if that wasn't enough, Ankhhaf later became adviser to his nephew, the reportedly tyrannical Khafre. Ankhhaf's portrait bust in plaster, modelled over limestone, is an image not of divine majesty but of practical power, seen in his heavy expression, baggy eyes and stern mouth. This lifelikeness is in part due to the medium the sculptor used – plaster is much easier to model, and limestone to carve, than diorite. It may well have been a different class of artisan who made such images.[4] It is unlikely to have been an entirely accurate image, in the sense of an instantly recognisable portrait – the ancient Egyptians probably had little use for such images. And yet here, it seems, is a real person, with real dilemmas. We might imagine him setting his mind not on banqueting in the land of the dead but on the limestone quarries at Tura, a short way down the Nile from Giza, thinking about the next shipment of limestone cladding for the pyramid. It is an image of lived reality, rather than cold pharaonic power.[5]

The bust was placed in Ankhhaf's mastaba tomb at Giza. In commissioning it, Ankhhaf may have wished to create something quite different from the pharaonic style. Perhaps he had just heard of Khafre's latest grandiose project and thought that he had finally gone too far. His nephew had commissioned the carving of a monumental figure of a lion from a rocky outcrop on the Giza plateau, a short way from his pyramid tomb. The oversized lion was to be given Khafre's own features, and became known as the Great Sphinx of Giza: an enigmatically mute witness to the will of a tyrant.

The Old Kingdom, despite its appearance of eternity, disappeared as if in a swirl of sand at the end of the Sixth Dynasty, around 2180 BCE. Droughts, every pharaoh's worst nightmare, were undoubtedly the cause. Dynastic fortunes

depended on the annual flood of the Nile, irrigating the land either side and ensuring a good harvest. No rain meant no food, and the pharaoh was to blame.

Where the Old Kingdom rulers were revered as gods, those of the period known as the Middle Kingdom held onto power through military might, during a time of political unrest and then civil war. It was also a time of great literature and for this reason seems, to posterity, more alive than any other period of dynastic times. Stories appeared that offered a more profound reflection on human life and fate than anything that had come before, both in philosophical texts (*Dispute between a Man and His Soul*) and ripping yarns (*The Shipwrecked Sailor*), as well as the great narrative work *The Tale of Sinuhe*, a story of a courtier exiled in Palestine, longing for return to his homeland. They could also be unpharaonically funny: the *Satire of the Trades* tells of a man who advised his son to become a scribe, rather than any of the other professions, all of which he casts in a terrible light. What after all could be grander than not leaving your house all day, making a living by writing? Surely better than having to build a pyramid.

Sculptors of the Middle Kingdom, however, hardly improved on the work of their predecessors. Little emerged from the royal workshops to match the austere Old Kingdom statue of Khafre, the lifelike portraits of Ankhhaf, Rahotep or Nofret, and certainly no pyramid grander than Khufu's and no monument crazier than Khafre as an oversized sphinx.

Yet there was something new, a type of royal portraiture that showed the pharaoh with a far higher degree of individuality, often with a careworn face and keenly observed features, although whether the portraits actually looked like the pharaoh is, of course, impossible to know.[6] Some of the greatest of these were of Senuseret III, a king of the Twelfth Dynasty who, building on the work of his predecessors, returned absolute power to the pharaohs, after a period of feudalism and power in the hands of local princes, or nomarchs, and the reunification of Egypt under the first of the Middle Kingdom kings, Mentuhotep. Senuseret established a system of fortifications reaching down into Nubia, the source of gold, elephants and slave labour, and established a new capital near

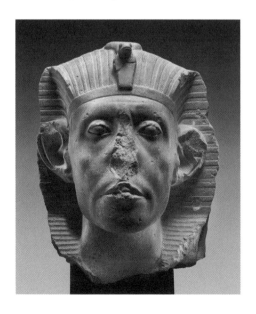

Memphis.[7] He also introduced a new type of pharaoh image. His portrait bust, carved from yellowish quartzite, shows a face riven with experience, framed by the nemes head-dress. His eyes bulge in sunken sockets, as if darkened by fatigue; furrows cross his brow, and two swelling cheekbones push through wizened skin. Enlarged ears show the tyrannical pharaoh listening through his extensive network of surveillance. The sculptor who originally carved Senuseret's portrait, creating a model for others to copy, had painstakingly shaped the bone structure beneath the skin, capturing the subtle changes

Head of Sen-useret III. Twelfth dynasty, c.1874–1855 BCE. Yellow quartzite, h. 45.1 cm. The Nelson-Atkins Museum of Fine Art, Kansas City.

of shape across the face and skull, transforming quartzite into careworn, power-hardened pharaoh-flesh.

Stability had returned to the Nile under the Twelfth Dynasty, and continued for another fifty or so years after the death of Senuseret III, until the accession of the first queen of Egypt, Sobekneferu. But it was to be over three hundred years before the next high moment of pharaonic civilisation along the Nile, during the two and a half centuries of rule by the kings and one queen of the Eighteenth Dynasty, in the time of the New Kingdom.

The southern city of Thebes was transformed into the glittering capital of the Egyptian empire. Under the second king of the Eighteenth Dynasty, Amenhotep I, temples were built as well as a vast gateway in a form known (by the Greeks) as a pylon, comprising two flattened towers either side of a small entrance, in a shape resembling the hieroglyph *akhet* (meaning 'horizon'), so that the whole temple–gateway was a symbol of the rising and setting sun. On the west bank of the Nile, a dry river valley, or wadi, was the traditional site for the Theban necropolis, such as the famous Valley of the Kings. Here Amenhotep built his own temple, and initiated a new form of burial, in which the body was buried in a separate underground tomb, reached by a long sloping passage, its location a secret to deter tomb robbers (Amenhotep's own tomb has never been found).

Of all these Eighteenth Dynasty structures, new in their forms, but covered with hieroglyphs and images in a style identical to that of the Narmer Palette, the most unexpected structure is a temple built at Deir el-Bahari, a sheer cliff where dwelt, it was believed, the mother goddess Hathor. It was a temple built for a queen, the fifth pharaoh of the Eighteenth Dynasty, known as Hatshepsut – one of the greatest of all pharaohs, and one of the first truly powerful women in recorded history (although not the first female pharaoh – Sobekneferu had taken that mantle three hundred years earlier).

Hatshepsut's mortuary temple at Deir el-Bahari seems, like Khufu's Great Pyramid, to emerge from the landscape itself, a work of nature rather than of human hands. An avenue, originally lined with some two hundred sphinxes featuring Hatshepsut's head, leads from the green plains, rising up two vast ramps

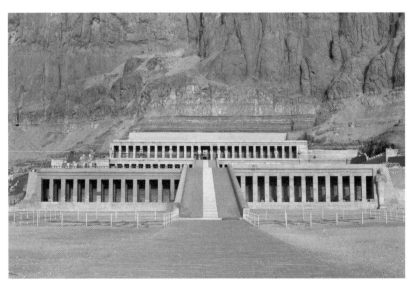

Mortuary temple of Queen Hatshepsut, Deir-el Bahari. Eighteenth dynasty, c.1507–1458 BCE.

AGES OF ELEGANCE

to the colonnaded court of Hatshepsut's temple, surrounded by smaller sanctuaries. With its almost perfect symmetry it appears not as a heavy solar-inspired mountain of stone but, rather, as a forest-like façade of columns, which, in retrospect, has more in common with the architecture of ancient Persia and Greece than any building along the Nile, although it was built over a thousand years earlier.

At the very back, cut into the rock, is a sanctuary to Amun-Ra, by this time the chief deity of the Egyptian state. Scattered around were statues of Hatshepsut, although not all show her as a woman. In most she appears as a nemes-wearing male pharaoh, according to age-old conventions – having a female king posed a problem for the age-old iconography of royal power. Only in a number of seated statues is she obviously female, posed with her hands on her knees, the sign of an image intended for offerings, so placed in a chapel, or less public part of the temple. On statues of her ancestors Hatshepsut had inscribed female epithets, feminising her male predecessors – an upending of tradition but at the same time a continuation of age-old pharaonic power, bending the world to the royal will.

Hatshepsut was a formidable leader, who built up trading routes and contributed greatly to the wealth and power of the dynasty. Her temple at Deir el-Bahari is just one of her vast Theban building projects, buoyed by the riches of the New Kingdom pharaohs, flowing in from provinces won by military might, stretching all the way to Mesopotamia and Syria, and down into sub-Saharan Africa.

Just over a hundred years later, with the reign of Amenhotep III, the ninth monarch of the Eighteenth Dynasty, the imperial splendour of the empire was at its height – quite literally, in towering stone effigies of the ruler. There are more surviving statues of Amenhotep III than of any other pharaoh, and no pharaoh built quite so frenetically or laid his mark on existing temples in Egypt and Nubia, transforming them wherever possible into cult centres for the sun god Ra, the creator of all things. He rebuilt and multiplied the temples and pylons at Thebes, decorating them with hundreds of statues of the lion goddess Sekhmet, and constructed his own sprawling mortuary complex, the largest in all of ancient Egypt; it was too near the river, though, so that within a few hundred years of his death all that remained were two giant seated figures of Amenhotep III guarding the entrance, known since Roman times as the Colossi of Memnon. Amenhotep's statues were the glory of Egypt at the zenith of its power. He saw himself as the embodiment of the sun itself, the centre of a solar cult ensuring the rise and passage of Ra through the heavens every day.[8]

It may have seemed like eternity, but it was not to last for long. In a thoroughly bold gesture Amenhotep III's second son, also called Amenhotep, banished Amun, the chief deity since ancient times, along with the falcon god Horus and all other gods and cults worshipped from the Nile delta in the north to Nubia in the south. They were replaced with a single, all-powerful god, Aten, the visible sun, embodied in the image of a solar orb whose emanating rays ended in reaching hands.

To seal this momentous shift he changed his name to Akhenaten, and moved the royal capital to a new city, Akhetaten (now known as Amarna), built alongside limestone cliffs halfway down the Nile from Thebes to Memphis. Here they devoted themselves to the worship of Aten, the sun-disc, and to the reverence of sun and light in open-air temples; Akhenaten commuted daily through the city in his gold-plated chariot, surrounded by bodyguards, symbolising the apparent movement of the sun itself.[9] Singing hymns to gods in the form of crocodiles and

birds, the traditional Egyptian form of worship, seemed naive by comparison. Akhenaten composed his rapturous poem the *Great Hymn to the Aten*, known from inscriptions on the tombs of high officials, in which he praised the 'sole god' Aten for having created all things:

> You shine forth in beauty on the horizon of heaven,
> O living Aten, the creator of life!
> When you rise on the eastern horizon,
> You fill every land with your beauty
> Beautiful, great, dazzling,
> High over every land,
> Your rays encompass the lands
> To the limit of all that you have made.

Relief of royal couple, possibly Nefertiti and Akhenaten. Eighteenth dynasty, c.1353–1336 BCE. Limestone, 24.8 cm by 20 cm. Staatliche Museen, Berlin.

It was a revolution in style but also in belief. Never before, anywhere in the world, had a sole god been worshipped in this way – not even Ptah, the Egyptian creator-god who had thought the world into existence.

It is said that Akhenaten's father had married for love. His wife, Tiye, was a commoner, a beautiful woman who came to wield considerable influence at the court. Many statues show her side-by-side with her husband and on the same scale – unusual for a pharaoh's wife.

It was perhaps with his mother in mind, or even at her suggestion, that Akhenaten also made a love match, in his case with a woman whose images was to become a touchstone of beauty – Nefertiti. Their seventeen-year rule, later known as the Amarna period, ushered in a subtle new spirit in Egyptian image-making. Older divine values and rigid formulas give way to a new feeling of emotional openness and a transparent enjoyment of life. The human figure grew more rounded, feminised, with swelling belly and thighs, heads elongated and loping forward, as if stretched by new spiritual awareness. Power seems to ebb from these bodies, given over to a principle of pleasure and fecundity: where Hatshepsut was shown as a man, Akhenaten appears fleshy and feminised. A hand waves a blue olive branch; ducks take flight in broad strokes on a painted palace floor. Akhenaten and his bride, Nefertiti, pose in a garden, stylish and in love, or scramble enthusiastically into bed. Their robes are flowing. Nefertiti offers her husband a flower, bathing in the sunshine of an Egyptian spring.

This new awareness inspired a great sculptural hymn to beauty, a portrait bust of Nefertiti made by the court sculptor Thutmose. The elegance is a matter not simply of her serene, serious expression, the delicate poise of her long neck, framed with an elaborate collar, her finely modelled features and stylish blue crown, wrapped in a gold diadem, nor just of her unusually shaped eyes, dipping towards the nose, narrowing gracefully towards the temple. It is also visible in the fine, subtle detailing of wrinkles on Nefertiti's neck, and the almost imperceptible creases beneath her eyes, subtle signs of ageing. Even in springtime true beauty is also a matter of experience.

Nefertiti's bust was created in the workshop of the court sculptor Thutmose – at least, this is where it was found, among ruins, over two thousand years later. Thutmose himself is identified by a small inscription on an ivory horse's blinker. Portrait images in plaster also kept in his studio, probably direct casts, are lifelike images of individuals, perhaps members of Akhenaten's family. Thutmose's own tomb, at the old necropolis at Saqqara (perhaps close to that of Imhotep, the deified architect), is inscribed 'Head of Painters in the Place of Truth'. Although we can only imagine how Thutmose's paintings appeared, this truth can be read from the plaster casts as an intense lifelikeness derived from direct observation of appearances, of a sort that led to the captivating detail of Nefertiti's bust. 'Truth' in ancient Egypt was conveyed by the word *maat*, giving the sense both of verity and of cosmic order, embodied in a goddess of that name, a slender woman wearing an ostrich feather in her hair. Maat, with her feather, flows through the images of the Amarna period, joyfully disrupting official conventions. Nature is no longer a stylised backdrop but awakened and warmed by the rays of the sun.

Akhenaten's vision of a new Egypt passed swiftly into obscurity following his demise. The old gods were restored, and with them the age-old rules that governed the representation of gods and kings. The court returned to the traditional spiritual centre of Thebes. Akhenaten's successor (and son-in-law) was known as Tutankhamun (originally 'Tutankhaten', the latter part of his new name indicating the restoration of Amun, the old king of the gods). Tutankhamun was a minor pharaoh who spent his life undoing his father's works, before dying

young and being buried in a small tomb crammed full of luxurious objects. His gilded death mask is a skilled piece of craftsmanship, but shows a craft given over entirely to the ostentatious demonstration of the wealth accumulated by his ancestor, much of it from the trade built up by the hard-working Hatshepsut. Tutankhamun's mask looks back over a thousand years to the Great Sphinx at Giza as an expression of cold dominion.

When the Greek historian Herodotus travelled to Egypt in 450 BCE, the rulers were Persians.[10] Foreign rulers had been present in ancient Egypt for hundreds of years, and the ancient heritage had been gradually unravelling,

Head of a priest ('The Boston Green Head'). Thirtieth dynasty, c.380–322 BCE. Greywacke, h. 10.5 cm. Museum of Fine Arts, Boston.

the glories of the Old Kingdom attractive as antiquities but the spirit of the pyramid age far harder to capture. It was only when the Persians were forced out of Egypt, during the rule of the Greek dynasty of the Ptolemys, after the conquest by Alexander of Macedon some seventy years later, that we can detect, at least in the images that survive, some flicker of the glories of the royal Egyptian workshops of the past. Portrait sculptures appear in this period recalling the lifelikeness of Thutmose and his workshop and the earlier portraits of Rahotep and Ankhhaf. The image of an unknown priest is made with captivating observed detail, showing the smooth, uneven shape of his skull and his pinched, fleshy features. Such a vivid image seems more like the portraiture of the Roman republic being made at the same moment on the Italian peninsula, although it has a calm, self-contained aura, so that we can be sure that this is an Egyptian priest, however Roman-leaning he may appear. Rather than the soft marble used in the Roman world, he is carved in a hard stone known as greywacke, rigid and unpliable like the formulas themselves, and yet the skill of the sculptor, whose name, like those of almost all Egyptian artists, has not survived, makes the material as soft and yielding as flesh itself.

Under the Ptolemys, the Greek dynasty that ruled Egypt for some three hundred years after Alexander's invasion, many new temples were built, and older forms revived – an 'archaism' that signalled, on the surface at least, business as usual along the Nile. The new capital, Alexandria, personally founded by Alexander of Macedon on the Mediterranean coast, was a Greek-speaking metropolis and set the tone for the Ptolemaic period, in which Greek and Egyptian sculptural and architectural styles appeared alongside one another. Ptolemy I established a library at Alexandria, part of an academy known as the Mouseion, or Museum, to which scholars were lured by attractive stipends, food and lodging, including some learned Egyptians, such as Manetho, the priest who had divided pharaonic history into convenient dynasties, but for the most part Greeks – among them, it is said, the mathematician Euclid and the engineer Archimedes of Syracuse. As with the other great monument in Alexandria, the Pharos, or lighthouse, built from enormous blocks of stone and towering hundreds of feet over the harbour, only the barest sense of the appearance of the Great Library was to survive, although the great statue of Zeus atop the Pharos was a lasting reminder of Greek power over Egypt.

For all this, Egypt's fate was ultimately Roman – as was that of its great foe, the Persian Seleucid empire, defeated by the Roman general Pompey in 63 BCE. When, in 30 BCE, the last great ruler of pharaonic Egypt, Cleopatra, the daughter of Ptolemy XII, held her dying lover, the Roman general Mark Antony, in her arms, she must have realised her own fate and, with it, that of Egypt itself. Her suicide, however it happened, was a subject that could never be represented by the strict formulas of Egyptian kingship imagery, which could hardly show the defeat of a pharaoh. The cult of her own allure and splendour, like a goddess in her own life, was worshipped long after her death, but by this time the great wealth of Egypt had been plundered by the first of a long series of foreign powers, Rome.

The image-makers of ancient Egypt may have felt themselves unrivalled on the African continent, but they were far from alone. The Nile Valley, a long, thin strip of civilisation surrounded by dry desert sand, is physically isolated but hardly cut off from the lands to the east, across Sinai, or from the continental landmass to the south and west. Desert sands were easier to traverse than mountain passes. Trade routes reached south of the Sahara desert, as far west as the River Niger. It was here, in villages scattered on the grassland plains and in the forests, in modern-day Nigeria, that the largest surviving group of images in ancient Africa, outside of Egypt, was created.[11] Vividly expressive terracotta figures, with striking heads, were made to be placed on and near burial sites. They were hollow vessels made with thin walls, built up using coils of clay and then smoothed off and modelled with features.[12]

 The figures, known as 'Nok' after the village near which they were later found, are often life-size, and carved with a strong sense of balance and pattern, transforming body parts into living shapes. Deeply carved and pierced eyes, elaborate hairstyles of buns and braids and wide open mouths, so that the figures seem to be speaking or perhaps singing, shape the 'Nok' style. Perhaps they were intended to sing the dead into the afterlife – a far less gruesome ceremony than that practised by the Sumerians, and certainly a more joyful prospect than spending eternity shut in a silent stone pyramid.

 The earliest known Nok figures date to around 900 BCE, but, like so many 'first' appearances, they belong to a tradition that stretches back much further, perhaps around four hundred years, to the time of Tutankhamun and the dying days of the Eighteenth Dynasty. Some are decorated with the pharaoh's crook and flail, or sport the long-braided beard familiar now from Tutankhamun's death mask. How the Nok people were aware of the great civilisation to the east, across thousands of miles of desert, is not known for sure. Perhaps traders arrived with images and objects in their baggage, as they plied the routes linking the north African coast and the rich copper and tin mines of western Africa.[13] Like the pharaonic carvings of Egypt, the style of the Nok heads appears to have remained unchanged for around a thousand years, although there are endless variations on the same basic patterns of features. And yet their character is quite unlike Egyptian sculpture, evidence of a different kind of intelligence, one that could transform and invent, move beyond visible appearances and create images not just of power but also of empathy. After thousands of years of the rigid, unspeaking monoliths along the Nile, these singing heads signal the presence of a very different idea of civilisation on the African continent.

Head, Nok culture, from Rafin Kura. After 900 BCE. Terracotta, h. 36 cm. National Museum, Lagos.

4

Jade and Bronze

The first civilisations grew up along great rivers, along the Tigris and the Euphrates in Mesopotamia, the Nile in Egypt, the Yellow and Yangtze rivers in China and, in western Africa, the River Niger. Larger than all of these settlements was the civilisation that appeared along the River Indus and its tributaries, in modern-day Pakistan.

The people who lived in the cities of the Indus Valley are among the most mysterious inhabitants of the first civilisations. Few traces remain of their lives. They developed a written language, but the sense of it was forgotten, and it remains undeciphered. They built sprawling cities but left no temples or other large buildings that could have revealed something of their beliefs, what they strove for, how they feared and loved.

The greatest number of surviving images are tiny carvings on seals used in trade. Rather than the cylindrical 'rollers' of Mesopotamia and ancient Persia, these are flat, square stamps. Many show a creature, an ox-like animal with a single horn, like that of an antelope. The one-horned ox stands in front of a pillar onto which is fixed a bowl, perhaps to hold ritual incense or sacrificial blood. The riddling image is accompanied by a set of symbols, perhaps giving the name of a god.[1]

The horned ox is one of those cobbled-together creatures that humans had been concocting for thousands of years. It was a way of creating a kinship with the animal world, but a means also of harnessing the various strengths of animals, their speed, strength or flight. Like the serpopard, which seems to have travelled from Mesopotamia to Egypt, so too the horned ox journeyed westward via Persia, where it appeared as a single-horned bull being killed by a lion on the walls of Persepolis. By the time it reached Europe it had been transformed again, this time into a horned horse known as a unicorn.

Another image common on Indus seals is the 'Master of Animals' image – a human holding two beasts in their command. And yet from the meagre evidence of their settlements, dominance is not what drove the Indus people. Unlike the cities of the Nile and the Euphrates, they built up their towns and cities

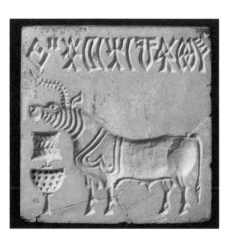

with baked mud-brick houses. The largest buildings were probably used for agricultural storage – they erected no temples, no palaces, certainly no pyramids or ziggurats. A cast-metal figure of a standing woman from the Indus Valley city of Mohenjo-Daro is a remarkable survivor from this early period of settlement. She might be a dancer at rest, or simply enjoying herself with an ease and confidence hardly evident in any other early civilisation. The Indus people may have felt that the gods were among them

Stamp seal with one-horned ox and ritual offering, Indus Valley. c.2500–1500 BCE. Clay. National Museum of India, New Delhi.

already, accompanying their journeys along the rivers, in the open spaces inhabited by sacred trees where they gathered.

To the north of the Indus, in the central Asian lands between the Caspian Sea and the Tian Shan mountains, smaller cities were emerging in the second millennium BCE that looked more like those of Mesopotamia, built up with palaces and temples and forbidding fortifications. The kingdom of Margiana was part of a greater area known as the Oxus civilisation, after the river at its heart. Power was a different matter in the walled city of Gonur Depe, the capital of Margiana (in modern-day Turkmenistan), as figures included in burials suggest. They show a seated woman wearing a bulky sheepskin robe, woven in tufts similar to smaller mantles known as kaunakes worn in ancient Persia and Mesopotamia. They were a sign of status, and are exaggerated in the stone carvings of Gonur Depe by the small arms and finely carved head that emerge from the blanketed body. These might well be Margian queens, giving audience in their well-wrapped majesty.

Settlements on rivers and around the oases of central Asia, surrounded by mountains and rugged highlands, were increasingly on the criss-crossing paths of trade between the far reaches of Egypt in the west and China in the east. Silk from China was sent west, while the hard green stone nephrite, known as jade, made its way in the opposite direction along the path later known as the Silk Route.

For the inhabitants of Gonur Depe, as for the temple-less cities of the Indus Valley, these objects were the first signs of a civilisation growing in the east. They were evidence of an advanced technology using silk and jade, crafted with skills that had been honed already for some two thousand years. In the ancient city of Liangzhu, on the Yangtze near Lake Tai, surrounded by moats and immense fortified walls, craftsmen had been making objects of a magical and decidedly unnatural appearance since the middle of the fourth millennium, some time before the first cities were rising in the Western world.[2] Using techniques of drilling

and abrading or rubbing (jade is too hard to be carved), the green stone was shaped into the form of animals, among them stags, dragons, birds and frogs, but also into fine ritual objects, axes and blades with a remarkable flatness and regularity of shape. They seem to emerge from a world quite different from that defined by the roughly chipped stone tools held by human hands since time immemorial. The cool, smooth hardness of jade was something else entirely.

JADE AND BRONZE

The most mysterious jades were flat, rounded discs with a central hole, painstakingly measured and cut. Known as *bi*, they are handmade objects that mirror the perfection of nature, rings made in water by a dropped stone or a round full moon. *Bi* were protective, watchful forms, placed in tombs to guard the dead, deposited alongside vase-like objects, long square forms with cylindrical interiors, often decorated with the image of an eye, and known as *cong*. These were living, watching charms created to protect the dead.

Such perfect objects are testament to the great advances in technology made by the settlers of ancient China. To the north of Liangzhu, in the coastal region of modern Shandong, along the Yellow River, ceramicists used a fine black clay to make thin-walled, highly polished vessels with the lightness and delicacy of a bird's egg (and so known as eggshell pottery). Like the *bi* and *cong*, these vessels are astonishing in their precision, and could not have been made without the invention of the fast-spinning pottery wheel. Like many very good ideas, this technology appeared in different places at the same time, in a number of cities across Asia and also in Egypt during the fourth millennium. Silk was a different matter. The ancient inhabitants of China fiercely guarded the secret of how to farm silkworms and weave textiles on looms that gave a new feeling of luxury to life – certainly smoother and lighter than the tufted wool robes worn by the Margian queens.

The new textures of life, heaviness, lightness, smoothness, intricacy, brilliance and range of colour were the result of powerful new methods of making, combined with the evolution of long-distance trade.

Bronze was first discovered in western Asia, some time in the late fourth millennium BCE. Craftsmen gradually realised how to strengthen objects forged and hammered in copper by adding small amounts of arsenic or tin, forming an alloy, or mix, later known as bronze.[3]

Where in the Western world bronze was used primarily for weapons and tools, as well as for ornaments to be worn on the body, ancient Chinese craftsmen, who may well have discovered the material independently, created ever more elaborate ritual vessels in the new medium. Their striking shapes give some clue to their purpose: stocky cooking pots known as *ding* are sturdy and unfussy – just right for steadily boiling a stew. The elongated shapes of *jue*, or wine carafes, seem like embodiments of the act of pouring. These distinctive forms were memories of older types of ceramic, shapes that had developed over long periods in answer to a particular need.[4] At the walled city of Erlitou, in central China, one of the earliest places where metal-casting workshops were established, artisans cast bronze vessels modelled on the forms of ceramic pots made over a thousand years earlier.[5] They were ritual vessels, for use in tombs honouring the dead, their shapes themselves a form of esteem. Their makers were accorded high social status: bronze-casters were considered nobles.[6] At the city of Anyang, the capital of the Shang dynasty, the first great era of ancient

Bi. Liangzhu culture. c.3000–2000 BCE. Nephrite, diameter 18.9 cm. Fitzwilliam Museum, Cambridge.

China, craftsmen forged a zun, or jar-like vessel for holding wine, with two rams either side, their forms cleverly combined so that their legs act as supports, their swelling bodies indicating the fullness of the container, their cheerful expressions seeming to bring the otherwise mute, heavy pot to life.

This living, 'speaking' quality of Shang-dynasty bronzes was also a matter of the decoration cast and incised on their surfaces. Most typical is a fantastical creature, emerging from a swirling, linear pattern. Around two eyes, glaring from the vessel, body parts accrue – claws, fangs, muzzles, horns and tails, puzzles half-lost in pattern. The figures are symmetrical, but it is impossible to tell whether there are two dragon monsters confronting each other or two profiles of the same creature. It was doubtless a pattern copied and recopied until it was barely recognisable – the double dragon appears on some of the earliest jade cong.

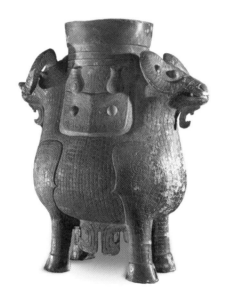

The dragons were later called *taotie*, the name of a mythical monster. Quite what they meant for those who used them is unclear. They seem to offer some sort of warning. Threats to life were numerous for the people living on the Central Plains, where the *taotie* was most in evidence.[7] The double dragons may have indicated the source of the threat, in the mountains to the north, where herdsmen warriors on horseback wore bronze belt buckles with similar confrontations of monstrous faces and wild beasts. These fantastical creatures belong to a tradition of 'Animal-Style' imagery made by people occupying the northern steppes stretching across central Asia from modern-day Mongolia and Siberia, the Mongols and Magyars, the Cimmerians and Sarmatians, to the people who inhabited the area north of the Black Sea, later known as the Scythians.[8]

The city of Liangzhu, along the banks of the Yangtze, was probably the largest early settlement in ancient China. It appeared around the same time as Uruk in Mesopotamia, around 3500 BCE, although surviving evidence showed that it was on a much larger scale. It was the first great city of a civilisation that was drawn together by technologies of production, of building, of the working of jade and the weaving of silk, and later the forging of bronze. It bears much in common with the Shang capital of Anyang that arose a thousand years later. There was a common feeling of life that connected these ancient Chinese cities, just as there was in the Indus Valley, and along the Tigris and Euphrates.

In a walled city in the mountains two thousand miles west of Anyang, in modern Sichuan, another civilisation was thriving.[9] Unlike the dwellers of the

Double-ram zun. Shang dynasty, c.1200–1050 BCE. Bronze, h. 45.1 cm. British Museum, London

JADE AND BRONZE

Shang capital, the dwellers of Sanxingdui, as it is known, appear to have had no written language – all that remains of their pocket of civilisation are remarkable bronze sculptures which they buried in large sacrificial pits. The Sanxingdui bronzes are unique: figures, masks and heads with powerfully carved features, large, angular eyes and unnaturally wide mouths. Elaborate bronze trees complete with bird ornaments form a strangely charming counterpoint to the terrifying masks. The most disturbing features are thick protruding eyes, as if the beams of vision had solidified. Perhaps they symbolised some special belief in the power of vision, of the eye emitting light to illuminate the world: vision as a means of penetration and command. Also deposited in the sacrificial pit were numerous bronze eyes, pupils and eyeballs, perhaps intended to be mounted on masks. They bring to mind more the stylised features of west African Nok sculpture than anything being made elsewhere in ancient China or south-east Asia.

The city of Sanxingdui and the surrounding settlements – the civilisation of the protruding eyes – disappears from history around 800 BCE. Perhaps it was the absence of a writing system that meant they were unable to create a sense of memory and continuity – their world appears to have simply fizzled out. The same was true for the great city of Liangzhu, where forms of symbolic communication were developed that did not evolve into a written language. It was the great and lasting achievement of the Shang dynasty to create a written form of communication that, unlike the cuneiform of Mesopotamia and the hieroglyphs of Egypt, was not to be erased as a living language. It began with small characters incised on animal bones and tortoise shells, as a form of divination – a quite different origin from cuneiform and hieroglyphs, at first used for accounting. Unlike the writing systems of Egypt and Mesopotamia, those of ancient China developed into a writing system that was to flow through eastern Asia for millennia to come – a survival that might well be ascribed to the origins of the language in poetry and magic.

Ancient Chinese was the script used for one of the earliest recorded historical accounts of China, the *Shiji*, or *Records of the Grand Historian*, written by the court historian Sima Qian around 94 BCE. It was the first official history of China, covering over two thousand years, and completed by Sima after he had been dismissed from his official position, castrated and imprisoned.

Sima was writing from the time of the Han dynasty, who, a hundred years earlier, had vanquished the first emperor of China, Shihuangdi of the Qin dynasty. For Sima, the Qin emperor was a brutal tyrant, and his reign from the Qin state in western China mercifully brief. It was nevertheless his achievement to bring political unity to China in 221 BCE, a matter for the most part of military conquest: 'The king of Qin [...] waved his long whip and drove the contents of the cosmos before him', wrote the Han poet Jia Yi.[10]

Mask with protruding pupils, Sanxingdui culture. c.1100 BCE. Bronze, h. 66 cm. Sanxingdui Museum.

The Qin emperor imposed uniform laws and set standards for measurements, as well as currency, and had them inscribed on stele which he placed on mountainsides. In so doing, he not only founded an empire but also created one of the first bureaucratic states. As befitted such a great ruler, his empire was reflected in magnificent images. Twelve colossal bronze statues, images of giants, were forged from melted-down weapons for his palace at Xianyang (near modern Xi'an), the Qin capital in central China, along with a set of bronze bells that rang out Qin's great victory. (They were all later melted down for more weapons.)

The bronze statues were, however, only a hint of what was to come. From the moment he ascended the imperial throne Qin began work on his burial site, which was to outdo any other bid for eternity in the ancient world, rivalling only those of the Egyptian pharaohs. Sima describes the completed tomb as a detailed reconstruction of the universe which the emperor expected to rule after his death. Over 700,000 convicts were sent from all over the empire to work on the tomb, which was filled with 'replicas of palaces, pavilions, all the various officials, and wonderful vessels', so that it formed a complete underground city. Waterways of mercury, representing the Yellow and Yangtze rivers, and a great ocean were created and made to flow, Sima writes, by use of ingenious mechanical devices. Whale-oil lamps were installed to burn for eternity,

illuminating a vast vault decorated to represent the heavenly constellations. The craftsmen who had created the whole were shut in the tomb, it is said, along with all the emperor's concubines. None ever saw the light of day again. The whole was encased in a vast earthen mound, planted with grass and trees to resemble a mountain.[11]

The emperor's tomb was guarded by seven thousand baked clay (terracotta) figures, soldiers armed with bronze weapons, and over a hundred wooden war chariots, the whole paraphernalia of an army, standing in underground chambers a short way from the burial mound. Craftsmen worked with age-old knowledge of clay ceramics, but there was no precedent in the Shang or succeeding Zhou dynasties, or in any of the cultures that came before, of human figures on this scale or this degree of lifelikeness. Each of the soldiers appears distinct, adapted by a craftsman from a standardised mould so that they appeared alive, worthy replacements for the human sacrifices that might otherwise accompany an emperor to his grave, depriving him of a standing army.[12]

It was extraordinary that such a great creative endeavour, involving the effort of tens of thousands of people, was destined to be buried as soon as it was complete, especially as such skilfully made sculptures of the human form had never

JADE AND BRONZE

before been seen in China. Only far away to the west, in Greece, was there the same knowledge and inspiration to produce such lifelike figures. Had some craftsman from the Greek colony of Bactria made the long journey across central Asia with the tricks of his trade? Or had a very observant Chinese trader brought back the secrets, along the route that was to become the Silk Route? To anyone travelling to the lands of western and central Asia in the wake of Alexander of Macedon's conquests, the most striking memory would have been of the living men in stone, the startlingly believable appearance of Greek sculpture. Among the Qin army figures are a number of acrobats, stretching and flexing, whose unclothed bodies show a knowledge of musculature and an ability to sculpt flesh that mirror Greek sculpture from two hundred years earlier. [13]

If Qin Shihuangdi had intended his army to sustain his empire after his death, then it was a spectacular failure: his dynasty lasted only four more years. And with him died the creation of life-size figurative sculpture that he had inaugurated. It was to be at least another five hundred years before Chinese craftsmen made sculptures with the same level of lifelike detail.

At the time Sima Qian was writing his grand history, China was controlled by the Han dynasty. The capital was at Xi'an, near the old Qin capital of Xianyang, in the interior of the country (present-day Shaanxi province). Xi'an was one of the largest cities in the world, equalled only by Rome, rising in the west. Under the Han trade continued to expand over the seas, to the Persian Gulf and Indian Ocean, and along land routes over the Taklamakan desert to the west, gold and silk travelling to distant lands, giving the route its name. Compared with the heaviness of the Shang bronzes, or the monumental undertaking of Qin Shihuangdi, the images of the Han dynasty are lighter in feel, more flexible in spirit, conveying a sense of openness to the natural world. Moulded earthenware bricks were decorated with scenes of hunting and harvesting, and baked clay figures of graceful dancers with long flowing sleeves became something of a speciality for Han sculptors. One of the greatest inventions of the Han dynasty, around 100 CE, was something as simple as a new type of flat surface on which to write and draw, one that endures to the here and now – paper.

As the Shang dynasty was establishing its capital at Anyang, the first glimmers of another civilisation were appearing far away to the east, thousands of miles over the Pacific Ocean. On the Gulf Coast and tropical lowlands of Mexico and Central America, in modern-day Veracruz and Tabasco, colossal stone heads were being carved from volcanic basalt boulders, quarried for the purpose in the Sierra

Brick with scene of hunting and harvesting. Eastern Han dynasty, c.25–220 CE. Earthenware, 39.6 cm by 45.6 cm. Sichuan Provincial Museum, Chengdu.

de los Tuxtlas mountains. Using stone tools, carvers created heads with forceful, flattened features and glaring eyes, wearing closely fitting caps, like some sort of protective headgear. These solemn boulder heads were powerful presences: for children, likely a source of fear and wonder; for adults a marker of territory, symbols of memory and power – anchors in the world.[14]

They were made by the earliest known civilisation on the American continent. These people were later called Olmecs on account of their ability to tap rubber from trees and trade it around the region ('Olmec' was the Aztec word for rubber). The protective caps suggest that they might be images of players in a ball game, in which a hard rubber ball was bounced off the leg and upper bodies of players in a stone court with sloping sides. The aim was to keep the ball in the air, and in some versions of the game to pass it through an impossibly small-looking stone hoop mounted at the side of the ball court. The grave expression of the boulder heads show that this was no mere pastime but a serious part of Olmec life, a matter of social prestige and power, perhaps even of life and death. Like the quarried rocks of Stonehenge, the basalt boulders were a great labour to transport from the mountains, making their presence in the lowland jungles all the more striking and powerful. They stood at the centre of ritual centres built by the Olmecs, the two largest of which are known as San Lorenzo and La Venta. Here they built flat-topped stone pyramid structures and other ritual structures, including the ball courts. These ritual precincts were not intended for habitation – most people lived in surrounding villages, farming and surviving.

Olmec boulder heads are the earliest monumental carvings of human heads. Only in Egypt, with the oversized heads of Amenhotep in the Eighteenth

Colossal head. Olmec, c.900–400 BCE. Basalt, h. 2.41 m, Museo La Venta, Villahermosa, Tabasco.

JADE AND BRONZE

Dynasty, was there some precedent. Olmec stone architecture also brings to mind the structures of ancient Egypt, the mortuary complexes of temples and pyramids at Giza, although there is no evidence that the Egyptians were interested in competitive sports, apart from pyramid-building.

The Olmecs were inspired by their own natural surroundings, the thick tropical forest of the Gulf Coast and the rugged inland highlands, the mountains and rivers that they held sacred. From obsidian, jade and other stones they created remarkable stylised images of animals, jaguars, armadillos, snakes, monkeys, rabbits, fish and toads, with a freedom of imagination that came from direct observation rather than subservience to any tradition, local or otherwise. They were true originals.

And yet the Olmec jade carvings do bear a remarkable resemblance to the images of another culture: those of ancient China. The blocky form of an Olmec jade mask representing a snarling face, half-human, half-jaguar, or 'were-jaguar', strongly brings to mind the Shang-dynasty *taotie* images of patterned dragons, with their fearsome visages. The comparison is so close that, knowing no better, we might imagine the 'were-jaguar' mask as the production of some provincial Chinese jade worker in the north or the *taotie* pattern incised on a jade slab as the work of an Olmec craftsman from La Venta.

It was a matter not just of style but also of symbolic meaning. Both ancient Chinese and Olmec people considered jade to have an other-worldly energy which could be used to preserve the spirit after death. At La Venta, the most important Olmec ritual site, a burial was created containing hundreds of smoothed slabs of green stone, carrying no inscriptions and packed neatly into a pit. In Han-dynasty China a similar power was expected of jade burial suits, made from panels of jade meticulously stitched together with gold wire to cover the body completely. Bodily orifices were sealed with jade plugs, over which *bi* might be placed.[15]

Why these similarities? Was there some connection between the two cultures, otherwise separated by thousands of miles of open ocean? Since the disappearance around 10,000 BCE of the Bering Land Bridge, the northern passage

by which, at low tide, humans crossed from Siberia to Alaska, the only way that knowledge of such images could have been transmitted was by sea, over the vast stretch of the Pacific Ocean. Yet there is no evidence that such an epic and hazardous journey was made, in either direction.

Comparisons between Shang and Olmec images point, rather, to a parallel leap in human creativity. Similar ways of imagining the world and of making images were

Mask. Olmec, c.900–400 BCE. Jadeite, h. 14.6 cm. The Metropolitan Museum of Art, New York.

triggered as humans evolved alongside nature, just as the earliest image of animals appeared on opposite sides of the planet. Such parallelism of image-making is a sign of the evolving intelligence of human life, of adapting to the environment and discovering how materials encountered in the world could be worked, imprinted with a human sense of design.

The Olmecs never attained the geometric perfection of Shang carving, nor that of the Zhou dynasty which followed. And yet in their images of the human figure they achieved a greater sense of human warmth. One remarkable stone sculpture made, it is thought, by an Olmec craftsman, shows a seated figure, wearing a loincloth, caught suspended in a twisting movement, as if limbering up. His limbs are not anatomically correct (the upper arms are very short), and yet they are full of tense life. His beard, moustache and pierced ears may signify adherence to a particular cult, perhaps one associated with the rubber ball game.[16]

The twisting figure was not carved with the same knowledge used for the acrobats in the Qin emperor's retinue, and there are no other even remotely similar figures known from Olmec times, making him something of a perplexing anomaly. Anomalies, however, were an Olmec speciality, a mark of their originality. They made many sculptures of unusual bodies, marked by deformation, as well as startling images of old age, whose likeness to the effects of time on real human bodies is without compare in the ancient world.

Among their strangest sculpted images are those showing children or babies sitting and staring impassively. They might well have been showing special mental and physical conditions, perhaps those that were common to Olmec people. They are carved with a great sense of openness to the world of appearances – images were not only the province of idealised gods and rulers, or successful ball game players, but could take in the plight of any human life.

Over thousands of years the human form emerged from the earth, shaped by human instinct into the form of clay figurines. Each was a projection of some feeling – of fear, of desire, or simply of curiosity. From the earliest figures fired in clay, at Dolní Věstonice, they appear all over the settled world, from the Xinglongwa culture in north-east China to the Badari herders on the Sahara plains of pre-dynastic Egypt and the Hamangia culture (modern Romania), which created some of the clearest early models of the human form.

The earliest known clay people in South America come from the coast of modern Ecuador, small figurines mostly showing women. Known as Valdivia, from the place where they were later discovered, they have elaborate hairstyles, piled up to frame the simple features of the face. They have an individuality and charm that must have been part of their original purpose, perhaps as charms carried by women or as a form of solace and protection in a harsh, often violent world.[17]

This world of little clay people, evolving over thousands of years, shows the image instinct at its most fundamental – the urge to create by hand a living thing from a lump of clay. The diversity of ways in which the human form could be interpreted is remarkable.

One of the oldest and longest traditions of clay figure-making, reaching back to fourteen thousand years ago, was maintained by the ancient dwellers on the islands of modern Japan.[18] Their ceramic pots and figurines, known as Dogū, fired in open pits (kilns had not yet been introduced to Japan), are endlessly inventive in shape and form. Heads are made from triangles, flattened ovals, mask-like configurations of abstract shapes, far from lifelike yet still recognisably human – just. Markings on the bodies, perhaps indicating tattooing, seem the result of vital creative forces surging around within. One of the most remarkable of these was made in the final phase of the Jōmon culture, as it was later known, around the same time as the Olmecs were carving their boulder heads and jade animals across the ocean. It is a hollow-bodied clay figure with bulging, goggle-like eyes, seeming to wear a tasselled costume with punctuated patterning, rising up to a plume-like headdress. Is it even human? Perhaps it was a lucky charm, or a form of solace, like the Valdivia figures, or an expression of joy-taking in life, like the confident young woman from Mohenjo-Daro. Whatever their purpose, these clay figures show humans getting to know themselves in their new settled lives, taking pleasure in their bodies, expressing their fears, discovering and gaining knowledge of life, but also realising the strange uniqueness of being human, the loneliness, even, of being the only image-creating animal.

Figure. Valdivia culture, 2200-2000 BCE. Clay, h. 10.2 cm. Metropolitan Museum of Art, New York.

5

The Human Measure

The fame of the ancient city-state of Athens rests not only on the first stirrings of political democracy but also on some of the most impressive sculpture and architecture ever created. Greek sculptors cast and carved images of the human figure of unparalleled physical splendour and psychological depth. In their architecture the Greeks created the most influential building style of all time, known later simply as 'classical'. They were structures as expressive and moving as the sculptures they housed. These temples and sculptures were dedicated to the gods on Mount Olympus, but for the first time the achievements of artists seem to justify the claim that humans really could take on the creative power of divine beings.

It began with a memory. In his epic poem the *Odyssey*, composed around the eighth century BCE, the Greek poet Homer recalls the splendid palaces and mighty god-like beings of an earlier age. The young prince Telemachus is searching for his father, Odysseus, and visits the palaces of King Nestor at Pylos and King Menelaus at Sparta. Both are magnificent structures, filled with golden cups and bronze weaponry – 'The lofty halls of Menelaus / Shone like the dazzling light of sun and moon'. Odysseus, however, was not there. He had embarked on a series of adventures after being blown off course returning from the Trojan Wars, which had been sparked by the abduction of Helen, the wife of King Menelaus (according to some ancient sources, she in fact spent the wars enjoying herself in Egypt).

Homer writes of an age, some five hundred years before his own, when humans were filled with the power of gods, and sometimes born of them. Helen's mother was Leda, who had been raped by Zeus, the king of the Gods. Achilles, the Greek hero, achieved divine status by slaying the Trojan prince Hector in battle, and was worshipped as a god. Where the Egyptians venerated animals and the Persian gods had no recognisable form to speak of, the Greeks were unique in seeing their deities as living, breathing men and women.

Homer was remembering an older, vanished Greek world, that of the Mycenaeans, who launched the war against Troy, and the ruins of whose palaces could still be seen in his day. He immortalised the long conflict between the Trojans and the Greeks in his two great poems, the *Odyssey* and the *Iliad*. The heroes that he imagined became the origin story of the Greek world to come.

The age of heroes that Homer describes had its origins in a Mediterranean civilisation that stretched back thousands of years before his own time. The first glimmerings appear in the middle of the third millennium BCE on the largest of the islands in the Aegean Sea, Crete. For the inhabitants, the Minoans, as

they were much later known (after their mythical leader, King Minos), nature was the greatest source of inspiration. The sea that surrounded them was full of marvels that they reproduced on the objects they crafted. For inscriptions on clay cups they used black ink derived from cuttlefish. The mythical form of the sea god Triton cavorts among starfish, corals and rocks on their painted pottery. An octopus, painted on a round clay vase, his tentacles sprawling around weed and rocks and sea urchins, was drawn by an artist intuitively able to translate their vision of the sea creature into a decorative design. In its writhing tentacles is the beginning of the energy and delight in the natural world that go headlong through the next thousand or so years in the Mediterranean, such as the scenes the Minoans sculpted and painted of the energetic sport of bull-leaping which they so loved, creating some of the first images of bodies in space, or the running spiral that the Minoans painted hurtling around the chambers of their palaces. The walls of their palaces were decorated with images of young men wearing peacock feathers and their women dancing topless, surrounded by lilies and orchids. Their images give an impression of the happy, pleasure-loving lives of an island people.[1]

A volcanic eruption on the island of Thera (modern-day Santorini) in the middle of the second millennium BCE brought this first civilisation on Crete to an end. Weakened by the destruction, Cretan palaces were eventually overrun by Mycenaean invaders from the mainland. The fortified hilltop citadel of Mycenae itself was the stronghold of Agamemnon, who led the coalition of Greek forces against the city of Troy.[2]

When not fighting, the Mycenaeans devoted much of their energy to forging weapons from bronze and hoarding gold. Death on the battlefield was the summit of glory, recorded in images that recall the heroic battles and fighting

Octopus vase from Palaikastro. c.1500 BCE. Ceramic, h. 27 cm. Archaeological Museum, Heraklion.

described in the *Iliad*. Buried with a Mycenaean warrior on a hilltop at Pylos, near Nestor's palace, a carved piece of coloured agate showing a sword-wielding warrior slaying another man armed with a spear, a dead soldier lying beneath, is a technically astonishing work of miniature carving.[3] The warrior's limbs and muscles are drawn with such elegance and accuracy, and with such clearly defined features, that contemporaries must have looked on the object – squinted rather, so minute is it – to take in what they could, and marvelled at something so unique. It may well have been carved in the

THE HUMAN MEASURE

workshop of a Minoan, people who were known for their gem carving; and yet it seems also to come directly from a Homeric world in which myth and history were effortlessly combined.

Homer describes the unremitting action of the Trojan Wars as being like an unstoppable fire. The same burning energy was to grip sculpture and architecture over the next four hundred years. Minoan and Aegean delight in nature, and the violent energy of Mycenae, as well as the revelation of the human body – the heroic, muscular, victorious body – as a subject for image-makers, stands at the beginning of this period of revolution, which was to culminate around a thousand years later in the city-state of Athens.

Following the collapse of Mycenaean civilisation there followed a period of darkness, at least in the eyes of history. It was in the images and rhythms of poetry, the oral compositions of Homer and other wandering bards, that the memories of this earlier age were preserved. In the middle of the eighth century BCE the mists of history seem to clear, with the introduction in Greece of a writing system – the alphabet devised by the Phoenicians, traders on the eastern Mediterranean. Homer's poetry was written down, and images from his stories begin to appear, most of which survive in the form of painted vases. They record the evolution of the early Greek world, particularly in the city-states, or poleis, of Athens and Corinth.[4]

The decoration is at first abstract and geometric, space-filling designs of shapes and patterns, a buzz of life from which human figures slowly emerge. They are at first no more than stick men, but soon enough versatile, lively characters appear, fighting, competing, drinking, fornicating, acting out the stories told in market squares by wandering bards with their weatherworn faces. A shallow drinking bowl shows the struggle between the mythical figure of Herakles (Hercules), identified by his lionskin, and a sea monster known as Triton. Dolphins swim around them as they fight, Herakles having the upper hand. Nereids, or sea-nymphs, dance rings around the exterior. The figures are drawn with simple outlines, painted in black and incised into the surface. This so-called black-figure pottery appeared first around 700 BCE in the city of Corinth, the leading city, at least for ceramics, of the time. The spinning Nereids bring back the Minoan image world, their forms radiating out with a pulsating rhythm.

Delight in the discovery of this style soon led to a new technique of vase painting, which first appeared in the pottery workshops of Athens about a hundred years later. It was a simple reversal, red figures on a black background, rather than black figures on red. The result was figures more naturalistic, fuller, weightier – it was as if a back light had suddenly been swung around to the front, turning silhouettes into rounded beings. Drawing

Internal medallion of a lip cup, showing Herakles and Triton, and dance of Nereids. c.550–530 BCE. Ceramic, 32 cm in diameter.

Calyx krater, painted with
unidentified subject including
Herakles and Athena, by the
Niobid Painter. c.460–450 BCE.
Ceramic, h. 54 cm. Musée du
Louvre, Paris.

becomes more sophisticated and lifelike thanks to the fluidity of brushstrokes. On one red-figure *krater* (a vessel for mixing wine with water) two naked warriors are shown in three-quarter view, lounging beneath the figure of Herakles with his lionskin, club and bow. Faint lines indicate an undulating landscape on which the figures stand. The artist – anonymous, like so many Greek vase painters – is known as the 'Niobid Painter', after the scene on the other side of the *krater*: the slaughter of the fourteen children of Niobe, who foolishly bragged to the gods of her offspring.[5]

Calyx krater, painted with unidentified subject including Herakles and Athena, by the Niobid Painter. c.460–450 BCE. Ceramic, h. 54 cm. Musée du Louvre, Paris.

The skill of these painted vase figures hints at how painting may have looked elsewhere in the Greek world (none of it has survived).[6] Paintings on walls and wooden panels were staging a revolution in the way that images were read: figures seemed more rounded, arranged in dramatic settings underlining their character and ethos – the moral message they conveyed.

According to the Greek traveller Pausanias (although writing some five hundred years later), the famed artist Polygnotus painted scenes of the destruction of Troy and of Odysseus in the Underworld, distributing his many figures at different levels to give a sense of their presence in real space, rather than just as designs on a flat surface – 'so great is the number of figures and so many are their beauties', Pausanias concludes.[7] Polygnotus was also, according to the Roman writer Pliny the Elder, the first to depict women in transparent dress and to give his figures expression by painting open mouths and even teeth – not an easy thing to do convincingly.[8] A spirit of competition drove Greek painters, pushing them to ever more cunning and artful illusions. Pliny also wrote of the painter Zeuxis, who acquired such wealth through his painting that he embroidered his name in gold on his robes. Zeuxis painted grapes so well that birds flew up to eat them, Pliny writes, although he was outdone by his rival Parrhasius, who painted a curtain so well that Zeuxis was fooled into asking him to pull it aside to reveal the painting behind.

Such were the games of illusion that Greek painters played to outdo each other, attaining ever more likelike images. Pots such as the Niobid vase may only be a faint echo of these celebrated works, but without them the surviving vision of the early Greek world would be so much the dimmer. Greek pots contained their memories, as it were, on the outside.

The origin of painting was itself, according to Greek myth, an act of memory creation. Pliny records the story in his *Natural History* of the young woman from Corinth who traced the outline of her lover's shadow, before he went away – the story is remarkably close to the truth of the first figurative

THE HUMAN MEASURE

images, stencilled images of human hands on cave walls, preserving the presence of a human body. *Mnemosyne*, or memory, was the mother of the Muses in Greek mythology.

Greek sculpture also had its origins in myth. The first monumental carvings were cult images made of wood and, in time, of limestone and marble. According to legend, their origins were in a style of sculpture first seen on Crete, made by the hands of an artist known as Daedalus. It was Daedalus who is said to have designed the labyrinth at the Cretan palace of Knossos on the command of King Minos, at the centre of which was another of those cobbled-together creatures, the minotaur: half-man, half-bull. Daedalus was the archetypal designer–creator. His mythical feats included engineering the flying apparatus with which he escaped from King Minos, flying from Crete to Sicily – his son Icarus famously flying too close to the sun and crashing into the sea. Daedalus was *protos heuretes* in the Greek tradition, a 'first finder' of new techniques and forms, whose name became synonymous with invention. He was a model of creativity, craft and cunning.[9] Like Imhotep in ancient Egypt, Daedalus was worshipped as an artist with divine powers, although, unlike Imhotep, there is not a shred of evidence that he ever actually existed.

The 'daedalic' sculptures, however, did exist, from around the seventh century BCE. Standing figures carved with mask-like faces, they were

like enlarged upright versions of the smooth forms of marble sculpture made on the Cycladic islands, including Naxos and Santorini, between Crete and mainland Greece for over a thousand years before – virtually featureless female figures with folded arms and subtly carved eyes and noses. Like so much antique sculpture, the Cycladic figures were painted bright colours, perhaps including wide-open eyes, like the Eshnunna worshipper.

To this idea of sculpture – Cycladic, daedalic – came a new inspiration from the south, from Africa. By the middle of the seventh century BCE the Greeks had established a trading post, Naucratis, on the Nile, south of Alexandria (it was here that Herodotus landed when he made his survey of pharaonic Egypt). The revelation of the monumental stone-carving of Egypt had a powerful effect on the Greek world, setting a standard and spurring a spirit of competition.[10]

In time a new type of carving emerged from Greek sculpture workshops, images of young males,

Kouros, known as the 'Apollo of Tenea'. c.560–550 BCE. Marble, h. 1.53 m. Glyptothek, Munich.

known as *kouros*, and their female counterparts, known as *kore* – and together (by the masculine plural) as *kouroi*. It was the first properly Greek sculpture – Crete and the Aegean islands were really too far off to be considered part of the Greek world. The *kouroi* were memories of the heroism of youth, of those who had died young – or alternatively those who had died old but wanted to be memorialised with the bodies of their heyday. Placed in sanctuaries, they were tokens of gratitude for victory in battle (over the Persians), or for victory in a chariot race or boxing match. The *kouros* were always proudly naked, like competitors in the games at Olympia, by then over a century old. The *kore*, however, were at least lightly robed – it was almost two hundred years before the first naked female statue was made by a Greek artist (although they did exist on a smaller scale, as figurines). The rigid poses of the *kouroi* were inspired to a greater or lesser degree by Egyptian sculpture. But with fists held tight, heads raised looking intently ahead and one leg moved slightly forward, they break the spell of the Egyptian formulas, weaving their own magic. The intentness of their vision appears to have the power to open up the space before them.

The body of one *kouros*, known as the Apollo of Tenea, made in Corinth in the middle of the sixth century BCE, seems to rise, springing on agile muscle. The eyes bulge with pleasure and delight, the smile such that you could imagine rosy cheeks flanking the inquisitively pointed nose. The unnaturally flat neck, like a supporting stone, reminds us that these heroic figures had still fully to escape from the daedalic world of myth. And yet, unlike their Egyptian cousins, they appear to stare not into eternity but to the next island, the next coastline. Their smile is one of Greek curiosity rather than Egyptian salvation – of delight in the discovery and knowledge of the world, and of themselves.

The Greeks continued their dominance of the surrounding seas, in Sicily and southern Italy, the north coast of Africa and around the Black Sea, establishing trading posts and colonies, creating prosperity in their city-states back home. A sense of shared identity arose among the dwellers of these cities, who called themselves the Hellenes and used a common language (the later word 'Greek' comes from Graecia, the Roman name for the country). It was also a time of almost continuous warfare on the Greek mainland and to the east. The sound of bronze swords and spear-tips clashing was as familiar as the chink of chisel on stone. In the early years the foe was the great civilisation to the east, Achaemenid Persia.

The unlikely and heroic Athenian victory over the Persians at the Battle of Marathon in 490 BCE unleashed a swell of confidence and was a foundational moment of self-belief for the Greek world. Athenian glory was secured a decade later at the sea battle of Salamis, after which the city-state entered into a golden age under the leadership of the statesman and orator Pericles, from the middle years of the century. It was a high moment, but short-lived (as high moments generally are). Athens was soon mired in a disastrous war with the rival state of Sparta, making it all the more remarkable that sculptors and architects could, in such a short space of time, bring their work to such a peak of perfection that their ideas held sway for thousands of years to come.

Bronze was the first medium for this perfection, at least in sculpture. In Homer's age of heroes, bronze had been forged and hammered into weapons but also into tightly fitting body armour, mapping the surface of the muscular human body. The first bronze sculptures of the human figure were made in a similar way,

hammering sheets of the malleable metal into shape.[11]

The inspiration for the first cast-bronze sculpture, made by pouring molten metal into a mould, first attempted, it seems, on the island of Samos, came again from Egypt, and also from western Asia. Samos was rich in cast-bronze objects imported from both places.

The bronze figures made in Greek workshops, however, were on a scale and level of detail that went far beyond all older forms, including the *kouroi*. Before long, sculptors were forging statues that could embody the gods themselves. Zeus, father of all Olympus, stands measuring the air with outstretched hands, a creative titan ready to launch a thunderbolt into the world. His body is that of a winning athlete, modelled and cast with deep knowledge of the structure and measure of the human body, and yet is not just an exercise in anatomy but also the embodiment of a world view – he is also a philosopher, an ideal combination of youthful physique and the wisdom of maturity. For the Greeks the human measure had a philosophical and moral meaning – noble proportions were the realisation of a virtuous life. Where the Egyptians had developed rough drawing systems so that their figures appeared consistent over time, the Greeks measured the human body so as to reveal the soul within.

Most of the bronze sculptures created by Greek artists were later melted down (many of them, inevitably, to make weapons). The lucky ones were lost in shipwrecks – at least they might later be recovered. For the most part these early bronzes survive only through marble copies of varying quality – some almost improvements on the original, others garden ornaments by comparison.[12]

One such marble copy reveals better than most the nature of Greek sculpture in the fifth century BCE. The original of the Doryphoros, or 'spear bearer' (the *doru* was the spear of the ancient Greek infantry soldier), was created by the Athenian Polykleitos, one of the greatest sculptors of the ancient world. Copies of the Doryphoros show a complete transformation from the rooted, static world of the *kouroi*. Body parts become more distinct, muscles expand, arms lift to gesture into the space around them. The spear-bearer seems both to be both walking forward and standing still – not, however, by the five-leg trick of the Assyrian *lamassu*, but rather by the subtlety of pose and balance. The body turns

Doryphoros ('Spear-bearer'), by Polykleitos. Original c.440 BCE. Marble copy from 150–120 BCE, h. 2.12 m. National Archaeological Museum, Naples.

to the left, the head to the right, catching movement in perfect balance. Life flows into the forged forms of bronze, at least in their marble echo, radiating self-confidence and self-knowledge.

Polykleitos wrote a treatise, later lost, known as the 'Canon'. With it he laid out his theory of proportion and symmetry, determining every part of the human body, giving a feeling of wholeness and unity. There were many attempts in later times to recover Polykleitos' formula for representing the human body, known only from parts copied in other ancient texts, but it seems unlikely that knowing the numbers would add much to an appreciation of his sculpture. Proportions and other rational, philosophical or even moral ideas, such as personal ethos, were embodied directly in cast bronze or carved marble.

Conveying life also meant giving a sense of movement. One of the most celebrated bronze sculptures of the fifth century BCE took the idea of suspended moment captured by the Doryphoros to an extreme. The image of a discus thrower created by the Athenian sculptor Myron shows movement by depicting an athlete at the highest point of his upswing, the moment of pause before the body rotates back, releasing tense elastic energy to fling the metal disc.

The Greek revolution in sculpture was like this: a discus flung against a blue sky, sudden and far-reaching. Quite how sculptors were able to depict bodies with such lifelikeness, with such philosophical underpinning, cannot be reduced to a single explanation. Artists stepped well beyond the bounds of instinctive creativity, summoning their intelligence as much as their emotional response to the world.

In hindsight, it seems natural to link this freedom of creativity with political freedom. The new idea of democracy in Athens, although limited compared with much later variants of the democratic political ideal, accorded more powers to the individual and a new sense of human worth. The connection is far from straightforward – Egyptian sculptors made impressive lifelike sculpture under a thoroughly authoritarian system. And yet the focus on the human body as a free agent, part of a tradition running back to the bull-leapers shown by the non-Greek, Minoan artists of Crete, has a strong political meaning. Free bodies were the prime subject: one of the most telling elements of the Greek revolution was a turn away from the animals that had dominated image-making for millennia. Animals do appear on the many grave reliefs carved in Greek workshops, showing lions, panthers and slim hunting dogs favoured by aristocratic youths, but they are domesticated creatures, at best only caricatures of wildness. Greeks were not interested in the souls of non-human animals. Nature was now a matter of human nature, of the world seen through human eyes.

Another source for the innovations of Greek sculptors and architects was more immediate – the energy and competition of war, with the Battle of Marathon as a turning point. If such a small number of Greeks could defeat a vast Persian army, should not Greece have buildings to match those of Persepolis and Pasargadae? Ten years after Marathon the Persians had returned, under the Achaemenid commander Xerxes, winning victory at Thermopylae and going on to sack Athens, destroying temples and toppling statues on the Acropolis, including those celebrating the Athenian victory at Marathon.

The Persians were finally driven out following the Greek victory at Mycale the following year, clearing the way for the rebuilding of the Acropolis

a few decades later, when Athens was under the command of the statesman and orator Pericles. A temple was built to house the cult image of the goddess Athena, the patron and protectress of the city, to replace an older temple and olivewood cult image, known as the Athena Polias. The statue was to be made by the sculptor Pheidias, whose towering image of Athena, later destroyed, was covered in ivory and gold ('chryselephantine'). Armed with helmet, spear and shield, she appeared ready to finish off any descendant of Xerxes who would dare return to Athens. Her military victory was symbolised by the small figure of Nike that she held, resting it on a column. Pheidias' colossal statue of Athena was rivalled only by the other great temple god he created, a figure of Zeus for the temple at Olympia. Even when seated, the head of this Zeus almost touched the ceiling, fourteen metres above, the impression doubled in size by the reflection in a shallow pool of black limestone filled with olive oil surrounding the seated god.

Pheidias' new cult statue of Athena was housed in a temple on the Acropolis called the Parthenon. It is a structure experienced as much in the imagination as in reality. The stepped base on which it stands curves gently upwards towards the centre on each side, giving a cushioned, weightless feel, as though the whole building were breathing in and rising slightly. The surrounding columns swell and taper, leaning in very slightly towards the centre, so that they continue rising in the imagination, converging in the sky among the gods (one and a half miles above the temple roof, if calculated). It is an expression of grandeur and self-confidence, certainly, but also of freedom, of weightlessness in stone.

Along the top of the outer columns, running around the four sides, ninety-two relief carvings, known as 'metopes', show scenes of struggle: gods fighting giants, Greeks fighting Trojans and Amazons, Lapiths (a legendary tribe from the mountains of Thessaly) fighting centaurs, each of these a symbol for the Greek victory over the Persians. The pediments, shallow triangles atop the columns at either end, are given over to myths of Athena: at the temple front, Athena is born from the head of her father, Zeus, with the help of a blow from the axe of her brother Hephaestus. The day of her birth is marked by the rising of the sun god Helios and the setting of the moon god Selene. The other pediment shows

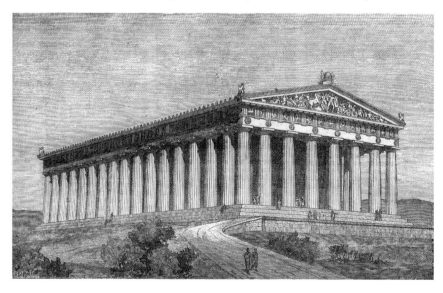

The Parthenon, Athens, designed by Pheidias. 447–432 BCE (engraving from the 19th century).

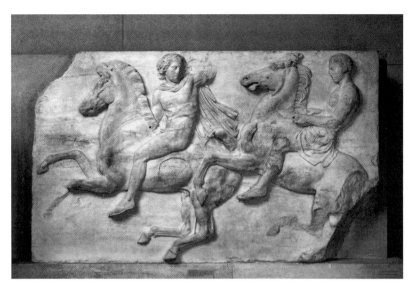

Two horsemen, from the west frieze of the Parthenon, by Pheidias. 438–432 BCE. Marble. British Museum, London.

the dispute between Athena and Poseidon over who best could protect Attica, the region of Athens – Athena won, giving her name to the city.

The greatest adornment, however, was the frieze running around the top of the inner temple. Nobody is sure precisely what it represents, except that it refers to the procession at an annual, city-wide festival, known as the Panathenaic festival, in which a newly woven wool robe, or *peplos*, was presented to the old olivewood statue of Athena Polias.

A mounting excitement and energy ripples through the figures. First, cavalrymen prepare to leave, tying their sandals, mounting horses that bridle with excitement. Ranks of horsemen, skilfully carved in perspective, form two streams down the sides of the temple, a steady rhythm of hoofs thudding the dry earth, the horsemen concentrating, mindful of the seriousness of the occasion. The marble slabs punctuate the flow of movement like bars in a musical score. From the dust and clamour sometimes emerges only a face, a hoof, a bristling mane; the texture of the stone itself suggests the gathering of resolve, the increase of momentum as the procession builds. And then a halt, as if a narrow torrent poured into a larger, slower pool, billowing-robed charioteers introducing a more stately rhythm, the eyes of their horses bulging still with effort and nervous excitement. Then, graver still, statesmen and elders, conversing and looking ahead to musicians and boys bearing trays and water pitchers for the ritual feast. Ahead of them youths lead heifers, their bulking forms slowing the rhythm all the more. Animals become alert and agitated as they intuit their sacrificial fate. One rears its head and is caught lowing to the heavens, a plaintive sound that echoes through time. Then come girls with heavy robes, processing in single file, carrying jugs and bowls, and more elder statesmen, and now the images of the seated gods themselves, insouciantly chatting, like royalty at the theatre. Athena, the star of the show, sits next to her axe-wielding brother Hephaestus. A child hands the ceremonial robe to the high priest of Athens, who inspects it, ready to lay it on the lap of the olivewood statue. In time their faces became worn of all features, as smooth and old as the robe itself.

It should not be forgotten that, as the cloak is examined, elsewhere on the frieze the horsemen are still setting out. This is the remarkably moving truth

THE HUMAN MEASURE

of the Parthenon frieze – the Athenians are shown as one, each understanding his or her position and role, proud of belonging to a city at the height of its power, victorious in the Persian Wars. As the great statesman Pericles exhorted them in his famous funeral oration, part of winter rites for the war dead: 'What I would prefer is that you should fix your eyes every day on the greatness of Athens as she really is, and should fall in love with her.'[13] The Parthenon frieze radiates the energy of belonging, of confidence and trust in victory, the vivid joy of shared purpose.

It was all the more glorious for being so short-lived. The last few decades of the fifth century BCE were as damned as the previous fifty years were gilded. A terrible plague struck Athens, killing some hundred thousand people, described in vivid detail by the historian Thucydides in his eyewitness account of the Peloponnesian War, which resulted in defeat for Athens and its allies against a league led by Sparta, with some help from the Achaemenid Persians. The self-confidence and stability of the Greek world under Pericles were coming to an end.

The tenor of the times was determined not by the sureness and ease of Polykleitos and his spear-bearer, but rather by the irruption of an irrational, unstable world, given expression by Euripides in his play *The Bacchae*, written in exile in Macedon. It tells the story of the god Dionysus' return to his home city of Thebes to prove his divinity, accompanied by a retinue of Bacchae, women devoted to his cult whom he gathered on his travels in Asia. The women are dressed in fawn skins and waving the thyrsus, a wand of giant fennel and ivy, to produce

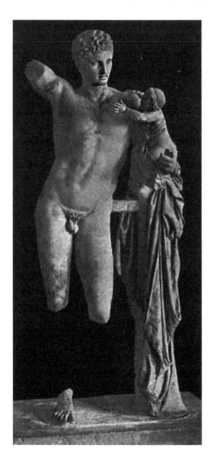

wine from the ground, in the mountains of Cithaeron, where they conduct their Bacchic rites. The king of Thebes, his cousin Pentheus, refuses to recognise the mystery cult Dionysus brings from the east. 'Let the earthquake come!' Dionysus cries to his followers, 'Shatter the floor of the world!'[14] Pentheus' fate is to be ripped limb from limb by the Bacchae, led by his own mother, Agave, who had been tricked by Dionysiac madness to join the Bacchae on Mount Cithaeron, and was still stung with madness, believing she has killed the cub of a mountain lion. It is the destruction of the royal house of Cadmus in Thebes, and the disruption of the world of the Greek gods by a religion from the east.

The *Bacchae* was first performed in Athens in 405 BCE, after the death of Euripides. A changing wind blows through the sculpture of the time, churning the folds of drapery over the gods Nike and Aphrodite, figures now less of conquest and victory than of agitated desire. A marble figure of an athletic man holding a child signals the change of mood. Carved, most probably, by Praxiteles, one of the great

Hermes and Dionysos, attributed to Praxiteles. c.340 BCE. Marble, h. 213.4 cm. Archaeological Museum, Olympia.

sculptors of the fourth century, it has all the vivid wholeness that can be traced back to the time of Polykleitos and Myron. Yet there is a difference: a new human warmth, a humour even. They are still images of gods – it is Hermes looking at the infant Dionysus, a smile playing on his face as he foresees the child's notorious future, the god of wine, leader of the Bacchae, the great disruptor from the east. And yet the gestures are human – the infant reaches out, perhaps to grasp a bunch of grapes that Hermes once teasingly dangled, broken off instead by the frosts of time. The softness and sensuality of the forms are a long way from the noble, warlike ideals of Periclean Athens and the archaic attitudes of the *kouroi*.

It was not simply a matter of how sculpture was made, but also of how it was seen. In a fragrant grove of myrtle trees on a hillside overlooking the sea on the island of Knidos stood a small round temple. Inside, barely concealed by the ring of columns and a low interior wall, was the figure of a naked woman. She has just taken off her clothes to bathe. Her body is both muscular and fleshy, caught in a moment of subtle agitation – she leans forward in a gesture of protection, taking up a robe to cover herself, aware that she may be being spied on. She is part of an unfolding story, a scene spreading out into the world, rather than a self-contained character. The story is of those who have come to marvel at her, the first image of a naked female, carved by the great Praxiteles. The remote island sanctuary only adds to the frisson of excitement, a secluded orchard in which devotees of Aphrodite, like the Bacchae of Euripides, might linger to assuage their desires. The Aphrodite of Praxiteles would have stuck out like a sore thumb among the many sculptures on the Acropolis, such was the power of vision she implied – a woman to be looked at, desired. Visitors to the sanctuary were said to have been driven mad with erotic passion. The Greek writer Lucian, in his *Affairs of the Heart*, recounts a visit to the temple on Knidos, where amid the 'breezes fraught with love' a woman serving the shrine tells the story of a young man who had suffered from a mad obsession with the marble Aphrodite and was said to have hurled himself into the sea for shame at having spent the night in the temple, leaving a tell-tale stain on Aphrodite's smooth marble form.[15] Aphrodite was an emblem of the erotic imagination, of desire dangerously unleashed.

Such unleashing was part of a move away from the idealised, often narrowly intellectual, achievements of Polykleitos and Myron. Writers began for the first time to reflect on the history of image-making, and individuals began to collect painting and sculpture.[16] The Greek sculptor Xenokrates of Sicyon wrote the first recorded work of art history, which appeared around 280 BCE. Xenokrates' book was later lost (as were all of his sculptures), but his ideas were preserved in the great encyclopaedia of knowledge from the ancient world, the *Natural History*, written by Pliny the Elder in the first century CE. Pliny's description of the gradual improvement of image-making, culminating in the fourth-century BCE sculpture of Lysippus and the painting of Apelles, was partly derived from the lost art history of Xenokrates.

Images plunged deeper into life. Artists created the first representations of sleeping figures, of figures in pain and portraits that deviated from noble ideals – fat, ill-formed, ugly people, at least by the conventions of the day. Animals returned in their herds, as did the animal nature of man, in the figure of Dionysus. Imagination was reliant no longer on mathematics, or the lost canon of Polykleitos, but on the visible world, and real bodies. It was a return to nature after the elevated

perfection of Periclean Athens, and came as a breath of relief. Perfection itself now seemed limited – the great works of Polykleitos and Myron seemed to lack a human element compared with the Aphrodite of Knidos, and the Hermes and Dionysus. It was a new human measure that looked back to the archaic awakening of sculpture, the beguiling smiles and curiosity of the *kouroi*, and to the craft and cunning of the mythical Daedalus and his ever-inventive mind.

The Greek world of Periclean Athens never entirely recovered after the defeat by Sparta and the Persians at the end of the fifth century BCE – wars followed wars between the rival cities of Corinth, Sparta, Thebes and Argos. Power shifted to the north, to the small kingdom of Macedon, after the defeat of an alliance of Greek city-states by the Macedonian king Philip II.

It was Philip's eighteen-year-old son Alexander, after joining his father in the decisive Battle of Chaeronea in 338 BCE, who was to shape the new post-Athenian Greek world. In ten astonishing years, until his death in Babylon in 323 BCE, Alexander subjugated Egypt, defeated the Persian empire and expanded Greek and Macedonian influence throughout western Asia. It was no wonder that he was later known as Alexander the Great. It was a time of interconnection between states and kingdoms, and a realisation among Greeks that there were other cultures as interesting as their own – not all foreigners were barbarians. The Greek philosopher Diogenes was probably the first to use the word *Kosmopolites*, or cosmopolitan, in reply to the question of where he came from – 'I am a citizen of the world'.[17] As the Greek historian Polybius wrote, history had become an 'organic whole, and the affairs in Italy and Libya have been interlinked with those of Asia and Greece, all leading up to one end'.[18] The imagery of the Hellenistic world, as it was known, reflected these new interwoven lands not just in its reach but also in its variety.

Alexander's image was forged by those artists who were the culmination of the Greek story – at least, according to Xenokrates. Only the sculptor Lysippus and the painter Apelles, it is said, were permitted to create images of the great Macedonian leader in their respective media. When it came to carving his image in precious stones, the famed gem-carver Pyrgoteles was the only one for the task.

None of the portraits Apelles made of Alexander was to survive. They are known only through literary descriptions, recording the lengths to which Apelles went to convey Alexander's mighty reputation, combining all the tricks of Greek illusionistic painting with outlandish subject matter. In one painted panel, hung prominently in the Temple of Artemis at Ephesus, he showed the great leader as Zeus, holding a thunderbolt. It was a masterly piece of painting, with the thunderbolt appearing to be projecting right out, as Pliny wrote.[19]

Lysippus was not quite so fawning, and stopped short of creating images emulating Pheidias' gigantic Zeus at Olympus (which Apelles surely had in mind). His bronze busts of Alexander, again none of which was to survive, were noted by the Greek writer Plutarch for their restraint, their 'manly and leonine' qualities. It was through poetry rather than bombast that Lysippus captured Alexander's grandeur, by 'the poise of the neck turned slightly to the left and the melting glance of the eyes', as Plutarch wrote.[20] The distant gazes of the *kouroi*

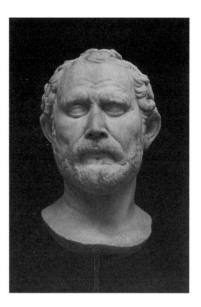

come once again to mind. Numerous later marble copies preserve this poetic composition, not a portrait but a symbol of grand, visionary ambition.

Just as with Egyptian Old Kingdom portraits of priests and high officials, which have shaken off some of the stiffness of the royal sculptor's chisel, so with Hellenistic portraiture it is as though we turn from the noble but generalised characters on the stage to the people in the audience. Portraiture becomes psychological and dramatic, telling stories of real lives rather than of fantastical thunderbolts. In the furrowed brow of a portrait bust of the great fourth-century orator Demosthenes we see the troubled story of the subject's life, as related by Plutarch – overcoming childhood tragedy and infirmity, including a speech impediment, to become one of Athens's greatest orators. He opposed the rise of Macedonia and led an Athenian uprising against Alexander the Great – enough to cause anyone significant stress. Despite outliving Alexander, he never relented in his patriotic struggle, ending his own life on the island of Poros by drinking poison rather than be taken alive by the Macedonians.

In the three centuries after Alexander's death Greek sculptors were still called upon to make images of glory, although the backdrop was now the growing power of Rome, rather than the Athenian Acropolis. A gently twisting statue of Aphrodite, her legs protected by thick drapery, was later named after the island on which she was discovered, Milos. She went down in history as Venus, the Roman version of Aphrodite. Her muscular, heroic pose seems a far cry from the naked figure in the sanctuary at Knidos. The Venus of Milo seems to be carved not of real flesh, but with a finely fitting suit of body armour. She was carved around 100 BCE, just two hundred years after Praxiteles' lost Aphrodite. We cannot directly compare the two sculptures, but might guess that, seen together, they would show innocence transforming into experience, desire maturing into resilient love.

In a city on the Mediterranean, founded by one of Alexander's successors in Asia Minor, the old Athenian spirit of sculpture found a new lease of life. The citadel of Pergamum was built as a treasury for the wealth of the Hellenistic Attalid dynasty but became famous for its library and workshop. The Attalids were no philistines when it came to commissioning works of art and furthering the old Greek spirit of intellectual curiosity – they saw themselves as the Athenians of the east, in contrast to the barbarians to the west, their enemies the *galati*, or Celtic Gauls, who had migrated down through the Balkans. The Attalids displayed more respect for their enemies than the Athenians had ever shown in their sculpture, setting up in a sanctuary on the Pergamene Acropolis three statues, two showing a Gaul and his wife, whom he has killed, before turning the sword on himself, to avoid them both being captured. The other statue, known as the *Dying*

THE HUMAN MEASURE

Gaul, depicts a warrior in the last stages of life, his moustache and golden torc (a thick metal ring worn around the neck) indicating his northern tribal origin, his pose, however, a noble composition, stage-managed to indicate his heroic demise, like a hero of the Trojan Wars.

Dying Gaul. Original c.230–220 BCE. Marble copy, Roman, h. 93 cm. Capitoline Museums, Rome.

The *Dying Gaul* shows a self-conscious fascination with suffering and death unique to the Greek world. It was not entirely new in the fourth century BCE: his pose is prefigured in earlier Greek art by the figure of a fallen warrior on the pediment of a temple on the island of Aegina. The Aegina warrior is shown naked, staring towards the ground in pain, refusing to submit to defeat, hanging on to

his shield as if still believing he might haul himself up to fight some more. Human emotion beyond mere victory in battle was there in Greek sculpture from the very beginning – the Aegina warrior was carved around 500 BCE, before the golden age of Athenian sculpture. Hellenistic sculptors brought out this emotion with their less wooden, more sensual style, an image of death as something to be overcome not with wealth and promises of the afterlife but by redemption through suffering.

The Romans of Latium in the west were never to be so interested in images of suffering – with one exception. They admired with ardour one of the last sculptures to emerge from the workshops at Pergamum, an image of struggle and suffering that seems to signal the end of the Greek world, neatly enough by showing a scene from its very beginning, in the Trojan Wars.

At first it seems a tangled mass of bodies, a muscled and bearded man and two slighter youths, around which coil the thick bodies of two serpents. The energy of the Parthenon frieze seems to have turned in on itself. It is the Trojan priest Laocoön, who, with his sons, was killed by a serpent sent from the gods for having attempted to expose the trick used by the Greeks to enter Troy by hiding themselves in a large wooden horse (probably the most transparent and ridiculous siege tactic in history). They are captured at the moment of dawning panic, as they recognise that their struggles are in vain, that the serpents are too strong and will overpower them. The pathetic gesture of the youth on the right, bending down to free his leg from the serpent, as it coils around his shoulder, is echoed in the anguished cry of his father at the centre, his head thrown back in futile appeal to the gods for mercy. The Roman poet Virgil gave the most famous account of the two 'giant arching sea snakes [...] with blazing and bloodshot eyes', which raced through the sea to the beach where Laocoön and his sons were caught unawares.

First each serpent enfolds in its embrace the small bodies of his two sons and with its fangs feeds upon the hapless limbs. Then himself too, as he comes to their aid, weapons in hand, they seize and bind in mighty folds; and now, twice circling around his waist, twice winding their scale backs around his throat, they tower above [...] he lifts to heaven hideous cries, like the bellowings of a wounded bull that has fled from the altar and shaken from its neck the ill-aimed axe.[21]

The Romans knew the sculpture of Laocoön through a copy in marble, made by three Greek sculptors from the island of Rhodes, named Hagesandros,

Athenodoros and Polydoros. Pliny admired the copy for being carved from a single block, showing 'the wonderful clasping coils of the serpent'.[22] By the first century CE the sculpture was admired more for its theatricality than as part of the founding myth of ancient Greece. For the Romans it was a symbol of Greek demise, after their cities were conquered and subsumed into the Roman world. And yet the Laocoön sculpture preserves in memory the violence and heroism of the Mycenaean world, kept alive in the images and rhythms of Homer's epic poetry, in the imagination of Athenian Greek sculptors and painters in the age of Pericles, and in the Pergamene sculptors' empathy

with the figure of defeat, with their sense of the meaningfulness of pain and suffering. After all, Troy, that great symbol of noble defeat, was only a short way up the Aegean coast from the citadel of the Attalids.

The achievement of artists in Periclean Athens was unique in the ancient world, and yet the cosmopolitanism of the age after the conquests of Alexander the Great spread their ideas far and wide. The forms of Greek sculpture travelled east and west – to the Roman world, and to the Persians and kingdoms of Asia Minor – and south to Egypt. Swept up on the horses and chariots of Alexander's army, the clear style of Greek sculpture also began its long journey across central Asia, being transformed on the way as it encountered different worlds of image and belief. The cast terracotta figures created in China for the tomb of the Qin emperor, as we have seen, are the closest artists came elsewhere to Greek sculptors of the fifth century BCE. And yet the baked clay army was made for

Laocoön and his sons, attributed to Hagesandros, Athenodoros and Polydoros. 1st century CE. Marble, h. 208 cm. Vatican Museums, Vatican City.

THE HUMAN MEASURE

an entirely different purpose – to be buried in earth rather than displayed high on an acropolis, and by a process of mass casting quite different from the time-consuming chiselling and abrading of making a figure in marble.

One of the most striking of encounters between the Greek and non-Greek worlds took place around the Black Sea, where Greek colonies appeared from the eighth century BCE. The Greeks came to know something of the nomadic tribes who lived on the grassland plains to the north, herders and warriors, part of a sprawling landscape of wandering tribes that occupied the plains stretching from the River Danube in the west, across central Asia to Mongolia and northern China and up into the snowy wastes of Siberia. 'They have neither cities nor fortifications,' the Greek historian Herodotus wrote of these tribes, known as Scythians, 'but carry their houses with them.'[23] Marble statues or stone temples were out of the question for the Scythians, who carried their lives with them on horseback. Instead they made ornamental objects in precious metals, usually decorations for horse trappings, weapons or ceremonial trinkets. The design of these ornaments, interweaving animal forms and bringing to mind both the *taotie* of ancient China and Celtic metalwork, was also used in the images they made on their own bodies in the form of tattoos.

On their nomadic routes the Scythians encountered the four settled cultures that surrounded them – China, Persia, Assyria and Greece – and yet they kept true to the ancient traditions of animal imagery common to the tribes of the northern steppes. Animals, fantastical and real, are shown fighting, or magically transforming into one another: a ram's horns are composed of hares; an antler's stags transform into birds; the paws of a panther and his tail are made from tiny beasts. The antlers of a stag billow down his back as if he were running, or swimming. He is made from a sheet of gold, pressed into shape, and was probably originally placed at the centre of a warrior chieftain's shield.[24] We can draw a direct line back from this powerful Scythian stag to the Stone Age carving of a swimming reindeer, made thousands of years previously. But there is one very important difference. Where the reindeer is carved from a mammoth's tusk, the image of an animal made from another animal, the Scythian stag is a worldly object forged from gold.

Shield plaque in the form of a stag. End of 7th century BCE. Gold, 19 cm by 31.7 cm. The State Hermitage Museum, St Petersburg.

THE HUMAN MEASURE

6

Roads to Empire

Where the Greeks saw their first stirrings in a vanished world of gods and heroes, the Romans looked to the living model of Greece itself, and the brilliance of Athens, as the source for their civilisation. The Greeks, wrote the Roman poet Virgil, were unrivalled as artists, able to 'hammer out bronzes that breathe in more lifelike and gentler ways' and to 'create truer expressions of life out of marble' that the Romans could only admire.[1] The Romans had a different craft, Virgil wrote, one devoted not to beauty but to power: the craft of dominion, of imposing peaceful Roman rule over the world. Virgil's story of the founding of the first dynasty of ancient Rome, the *Aeneid*, tells of the Trojan prince Aeneas, who escaped Troy as it was falling to the Greeks and set off on a journey that ended in Italy, and the first claim of Roman dominion. The *Aeneid* was for Rome what Homer's *Iliad* and *Odyssey* were for ancient Greece – a story of origins in the aftermath of war.

It was through the pursuit of dominion through war that Greek sculpture first entered the Roman world, at least in any great quantity. The Roman conquest of the Mediterranean was sealed by the defeat of the North African city of Carthage in 146 BCE, and the conquest of the wealthy Greek city-state of Corinth later that year. Lucius Mummius, the Roman general who led the army against Corinth, returned on ships crammed with sculptures, furniture and other precious objects. Such booty took its place in Rome alongside the Greek sculptures looted in previous campaigns, displayed in temples, villas and public places, after being carried as war loot amid the clamour of triumphal parades. Trundling along on wagons and chariots in one triumph held in 187 BCE, that of Fulvius Nobilior's victory over the Aetolians in the city of Ambracia, were some 785 bronze statues and 230 marble ones: great works of Greek sculpture, although it seems that they were appreciated not for their quality so much as for their quantity.[2]

It was long thought that the Romans had no innate talent for image-making, and took everything they knew from the Greeks. Although it is true that they depended on the Greek model, they also adapted it, evolving a distinctively Roman type of image and a Roman way of dealing with such a heritage of images. They became collectors and connoisseurs of Greek painting and sculpture, often paying enormous sums for them. Famous works were on show in *pinacothecae*, or picture galleries, the first of their kind. Collections of sculpture and painting were displayed in private villas throughout the Roman world, the largest becoming like museums of Greek art. Roman writers, most notably Pliny in his *Natural History*, produced the earliest surviving historical account of Greek image-making and its afterlife in ancient Rome. The Romans may not have invented the history of art

(Xenokrates got there first), but they wrote the first major books on the subject. Wealthy Romans commissioned versions of Greek masterpieces, for the most part from Greek sculptors, thus preserving their works, most of which were later lost. Such was the demand for these versions that the artisans turned out endless versions of famous originals, some better than others. The Romans may not have minded so much – it was the imagery of ancient Greece they wanted, the allure and glamour of Athens.

The Romans plundered the Greek world but also the towns and settlements that had existed on the Italian peninsula before their arrival. These towns and villages in the hills stretching north of Rome formed the civilisation of Etruria, the land of the Etruscans, who flourished from the ninth century BCE. They were, in the eyes of history at least, a mysterious people who left very few written texts revealing their lives and beliefs, but who filled their tombs with rich burial goods, often imported from the east, and marked their graves with terracotta statues of the deceased, often in a 'banqueting pose', in the Greek manner. Terracotta burial urns were designed so that the lid became a human head, a sculptural memorial to the person whose ashes were interred within. For the Etruscans, like so many ancient civilisations, the idea of death was the greatest spur to the imagination, and certainly the occasion, in the form of burials, for the survival of many of their images.

The Greeks had occupied trading posts in the southern part of Italy since the eighth century BCE – Magna Graecia, the Romans called it – bringing new ideas, which soon spread northwards to Etruria. The bronze figure of a snarling Chimera, made around 400 BCE, shows the Etruscan debt to Greek bronze-working but also their ability to rival it, at least in the realm of fantastical animal sculpture. An inscription on the Chimera's front leg, '*tinscvil*', suggests that it was an offering to the Etruscan god Tinia, an incarnation of the Greek chief god Zeus, and was probably part of a sculptural group including Bellerophon, the Greek hero who is said to have killed the creature – 'of divine stock, not of men, in front a lion, in back a serpent, and in the middle a goat, breathing out terribly the force of blazing fire', as Homer described it.[3]

The bronze Chimera, arching its back in defensive rage, echoes the sort of creatures animated by a violent energy imagined in ancient Mesopotamia and Iran – we might think of the fierce aurochs and snake-headed dragons on the Ishtar Gate leading to the city of Babylon. In Greek myth the Chimera had ravaged the land of Lycia in Asia Minor, a story that may have helped the Etruscan artist imagine its fantastical form in terms of the exotic world of western Asia and the Levant, which they knew through Greek and Phoenician traders.

Not all Etruscan images were so indebted to the east. One of the

Chimera of Arezzo. c.400 BCE. Bronze, l. 129 cm. Museo Archeologico Nazionale, Florence.

only Etruscan artists whose name has survived, Vulca, from the city of Veii, just north of Rome, is said to have created a terracotta statue of Jupiter, painted with red cinnabar, for the temple of Jupiter Optimus Maximus in Rome. It was commissioned by the last king of old Rome (the centre of the Roman kingdom before the inauguration, in 509 BCE, of the Roman Republic), Lucius Tarquinius Superbus, himself an Etruscan.[4] Vulca of Veii also created a statue of Hercules, and a quadriga, or four-horse chariot, to stand on the pediment of the temple.

When the first truly Roman sculpture emerged, in the late years of the republic, it bore traces of these earlier Etruscan forms, as well as of Greek ideas that were radiating throughout the Hellenistic world. It was identifiably Roman for the simple reason that the subjects were Romans themselves, shown according to the ideals of the republic.

Images of patricians and nobles were engraved on gems, shown in relief on coins but also, most impressively, carved in marble. The carved head of a wealthy Roman shows a face marked by the stresses and cares of life. Deep asymmetrical creases in the cheeks, beneath the eyes and across the brow, are signs of experience and age, kept in check by the ethos of personal virtue and the severity of spirit so prized by the Romans.[5] The contrast with the smooth, idealised surfaces of Greek sculpture could not be greater.

The apparent lifelikeness of these portraits is misleading. There is no evidence that they resemble the person they portray, and they were more probably valued as caricatures emphasising the Roman look, one of rugged power.

They are also faces marked by death. The old Etruscan obsession with mortality was never entirely erased by the Greek obsession with the living, thriving body. One of the models for republican portraiture was the tradition of making death masks, cast directly from the recently deceased, or modelled in wax, known as *imagines*. The *imagines* were carried in funeral processions, worn by mourners, and placed in household shrines, preserving the memory of illustrious ancestors at a time when family origins were a major claim to political power. The sunken, drawn features of the dead human face, imprinted on the funeral masks, seem

often to linger on the carved marble heads, leaving a disturbing impression of death in the image of a living person.

Greek painting was also admired and emulated in Rome, although virtually all of the works and many of the names of those who made them were subsequently lost and mostly forgotten. Pliny devoted an entire chapter of his *Natural History* to preserving the names of Greek artists and their Roman successors, adding brief anecdotal descriptions of the reasons for their fame. Painting had been brought to perfection early in the history of Rome, Pliny writes, although artists were for the most part accorded a low status. Turpilius, a knight from Venice, was an exception, known for his

Head of a Roman patrician.
75–50 BCE. Marble, h. 35 cm.
Fondazione Torlonia, Rome.

works at Verona (depicting what, Pliny does not say), and is also notable as the first left-handed artist on record.[6] Whether an artist was Greek or Roman was for Pliny, in fact, not a matter of great importance – what counted was where you came from, and what your contribution was to the evolving art of painting. At an early date, perhaps around the time of Homer, Eumerus of Athens was the first to distinguish male from female figures, and Cimon of Cleonae was the first to show figures from an angle, a rudimentary form of foreshortening. Or perhaps it was very advanced – without seeing his works we will never know. At this time painting was done in monochrome, Pliny writes, and so was probably more like drawing, or tonal sketches, done on prepared wooden panels. By the time of Polygnotus of Thasos, who painted in the years around 480 to 450 BCE, paintings in colour were being made with a great deal of detail and skill. Polygnotus gave subtle expressions to his figures, and took his place with the towering figures of Zeuxis of Hereclea and Parrhasius, great rivals in painting, bent, as we have seen, on trying to outdo each other with greater tricks of realism.

At the end of his lengthy chronicle, taking in the great Apelles of Cos, who forged the image of Alexander of Macedon, and lesser figures such as Piraeicus, known for his paintings of barbers' shops and cobblers' stalls, Pliny adds a short list of women painters. He begins with Timarete, the daughter of Micon, known for her 'extremely archaic' panel painting of Artemis displayed at Ephesus. Greatest of all women painters was Iaia, from the town of Cyzicus, on the southern shore of the Sea of Marmara (in modern Turkey), who lived during the second century BCE and 'painted pictures with the brush at Rome', as well as engraving images on ivory. Her subjects were mainly women, Pliny writes, and she was celebrated for the quickness of her hand and her skill in portraiture. On a wooden panel she painted the portrait of an elderly woman from Naples – the wife, perhaps, of a city official or merchant. She is also recorded as having painted herself, using a looking-glass – the first self-portrait by a woman on record. So impressive were her portraits that her prices far outdid those of other portrait painters of the time, those of Sopolis and Dionysius, Pliny reports, 'whose pictures fill the galleries'.

No painting by Iaia of Cyzicus was to survive, nor any by Sopolis or Dionysius, for that matter. Their style can only be guessed at, by piecing together the story told by Pliny. It was a story of the growing lifelikeness and illusion of the painted image, and of the ever-expanding idea of what painting might show: not only scenes from ancient literature, from Homer to the plays of Euripides, and images of the deities worshipped by various cults, but also images of the world itself, of landscapes and portraits of real people. The latest developments were shown on the walls of the *pinacothecae* and in private villas, and reflected the growing power of the Roman world and the cosmopolitanism of the Hellenistic Greek world alike. It may not have seemed so remarkable, in this worldly climate, that a woman from Asia Minor could take Rome by storm with her portraits.

Paintings that were to survive from the ancient world were mostly painted on walls, onto wet plaster. Among them are the earliest known landscape paintings, made in a house in the fashionable quarter of Rome some years after Iaia lived and worked in the city.[7] Any educated Roman would have recognised them as scenes from Homer's *Odyssey*, which had been translated into Latin the previous century by the poet and dramatist Livius Andronicus. The surviving eight panels

begin with the episode of Odysseus and his crew arriving on an island of man-eating giants, the Laestrygonians. Strange unnatural rock formations peppered with wild plants make it seem an alien and dangerous place. Soft mauves and blues in the background give a sense of atmospheric depth, showing the hand of an artist who had looked hard at the world and remembered the colour of distance. It is the earliest known depiction of a sea horizon.[8] Figures are painted with long strokes of the brush, like stick-men, those in the distance as silhouettes. Their shadows are not convincing but at least indicate a consistent source of light, a trick used by painters for centuries to come. Odysseus and his men meet the tall and powerful daughter of the king, engaged in fetching water from a spring at which a goat drinks, his form reflected in the water. She directs them to her father's palace, where they encounter her even taller mother – 'mountain-high', as Homer put it. Her husband's only thought is to kill Odysseus and destroy his fleet, and he launches his attack, giants hurling rocks at the Greek ships in the harbour. Only Odysseus manages to get away, sailing to the island of the sorceress Circe, where his adventures continue – although the murals from this point are damaged and the painted story fizzles out.

The Odysseus landscape paintings, with their atmospheric depth, are quite unlike the Assyrian palace reliefs made a few hundred years earlier. They are among the first painted depictions of human figures surrounded by and within a believable world: not just alongside nature, but truly part of it.[9]

By the time they were painted in the second century BCE Roman painting, like portrait sculpture, was in full swing. What survives gives only a taste of the best painting of the time: wall painting was a decorative form never quite as impressive as the painted panels of Zeuxis or Iaia, Pliny wrote. It was often done by lesser artists, for the simple and practical reason that it could not be rescued from fire. Ironically enough, it was for precisely this reason that the largest group of paintings from the Roman world was to survive, those on the walls of the southern towns of Pompeii and Herculaneum. These were protected from destruction by being buried in the ash of Vesuvius following the eruption of 79 CE, which otherwise destroyed the town and incinerated many of its inhabitants, and was the cause, indirectly, of Pliny's death.

Among the paintings preserved in volcanic ash are those painted in a villa on the outskirts of Pompeii, overlooking the sea, which show just how adept artists had become at telling stories with often bizarre scenarios and details. The

Ulysses's companions meet the daughter of the King of the Laestrygonian, from the Odyssey Landscapes. 1st century BCE. Fresco, both scenes with painted frame, 142 cm by 292 cm. Vatican Museums, Vatican City.

Dionysiac rites. c.60 BCE. Wall painting, h. 162 cm. Villa of the Mysteries, Pompeii.

images, covering the walls of one chamber entirely, show a mysterious initiation ritual, a mystical marriage to the god Dionysus. The initiates appear as rounded, solid, life-size figures, like characters acting out a play on a shallow stage. A veiled woman moves through the scene making preparations while a drunken satyr leans nonchalantly against a column, strumming a lyre, and a devotee of the god Pan feeds a kid goat from his breast. Sudden panic grips the veiled woman as she lifts her billowing mantle, or himation, and beholds Dionysus himself, lounging in a dishevelled state in the arms of his earthly consort, Ariadne. The mood darkens as she enters the heart of the ritual, bearing her back to a tall winged woman wielding a whip. It is a moment of ecstasy and transformation embellished by a woman clashing small cymbals, her cloak framing her naked form like a sail in the wind. Finally the initiated woman sits on her throne, attended by a handmaid, gathering herself, binding her hair, preparing herself for her new life as a consort of Dionysus (we might think of Agave, the mother of Pentheus in *The Bacchae*), admiring her reflection in a mirror held in the hands of a plump Eros.[10]

The paintings in the Villa of Mysteries, as it became known, as well as the Odyssey landscape paintings, are fragmentary glimpses of the poetic power of Roman painting, steeped in the imagination of Homer and the allure of mystery cults from the east – particularly that of Dionysus and his pleasure-seeking followers. They showed the reach of empire but also the sheer variety of imagery that was brought into the Roman world, just as republican portraiture, and undoubtedly the portraits of Iaia of Cyzicus, emphasised the *gravitas*, or dignity, of the sitters – that virtuous Roman demeanour that arose during the time of the Mediterranean conquests.

In the century after the defeat of Carthage and Corinth, dominion itself became the subject for Roman art and literature. Julius Caesar's account of his wars

ROADS TO EMPIRE

from 58 to 50 BCE against the Gallic tribes of the north, present-day France and Belgium, including his pacification of the ancient Britons, the *Commentarii de bello gallico*, was itself a powerful work of literature, driven by the story of conquest. The new vision of Rome wrought by Caesar's successor and adoptive son, Octavian, better known as Augustus, was one in which images and power merged in a way recalling some of the earliest political imagery in ancient Mesopotamia, the stele carvings and statues of the Akkadians.

Augustus has gone down in history as the emperor who brought peace and stability to the Roman world after years of civil war. The spirit of the Augustan age, the *pax romana* ('Roman Peace'), radiated from the appearance of Rome itself, transformed by Augustus from a place of sun-dried bricks into a 'city of marble', as the Roman writer Suetonius records (in fact, the more practical marble cladding, rather than the solid blocks used on the Parthenon).[11] The Roman Senate commemorated the *pax romana* by the construction of an altar devoted to peace – the Ara Pacis, on the Campus Martius, an extensive area originally devoted to military training. Alongside carved reliefs showing the mythological founding of Rome, and a procession of the great and good of Augustus' time, the altar is decorated with an abundantly flowering acanthus plant, its vines coiling and spreading over the outer walls, strewn with leaves, berries, flowers and tendrils, culminating in miniature palm leaves and swans in flight. It is nature as metaphor, the steady rhythmic swirl of the vine a symbol of the power held by Augustus over all things.[12]

This subtle symbolism of conquest and dominion came to define the Augustan age and its long legacy. In his *Natural History*, Pliny wrote that

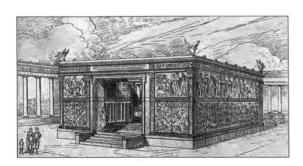

the wonders of Rome, the monuments built during that time, could encapsulate the long history of the 'conquest of the planet' – by which he meant the expansion of the Roman empire as far as it was possible to imagine in every direction. The very shapes of Roman architecture embody this drive to conquer: vaults soaring over great volumes of air; arches that bridge gaps much wider than ever before imagined; and splendid domes that seemed like man-made heavens, containing oceans of space beneath.

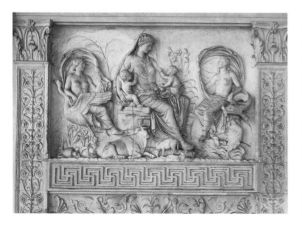

Although architecture had always been a way of claiming some

Illustration of Ara Pacis Augustae. 13–9 BCE.

Relief panel of the goddess Tellus, from the Ara Pacis Augustae. 9 BCE. Marble. Ara Pacis Museum, Rome.

sort of dominion, from the standing stones at Stonehenge to the ziggurat at Ur, Roman architecture transformed this from something heavy and immovable into a weightless, floating ideal. Where Roman architecture really differs is in being an expression not of mass but of space, and not the imaginary space of Greek architecture (the lines of the Parthenon columns meeting in the sky) but real, worldly space, captured and contained in stone.

Two technologies made this possible: the use of concrete as a building material, and the arched vault, enabling high, wide interior spaces and magnificent portals. Neither was a Roman invention, but, as with everything else they got hold of, the Romans brought the two ideas to a new perfection.

New building shapes emerged that were unmistakable symbols of Roman imperium. The great amphitheatre known as the Colosseum, built around 70–80 CE in the time of the emperor Vespasian, completed by his son Titus, was built almost entirely of arches, over three stories of cement and stone, clad in marble (all of which was later removed). The Colosseum is astonishing not only for its arched structure but also for its sheer size, over half a kilometre at its widest, so that some fifty thousand people or more might crowd on its terraced seats to witness gladiatorial combats or animal hunts. The deafening roar of the crowd was the sound of Roman imperial power. The roar from the Circus Maximus, the stadium that occupied an ancient site for chariot racing, was even greater, holding five times as many people.

Emperors looked back to the transformation of Rome under Augustus and tried to outdo each other with their own additions. Trajan built a great column, with carvings winding up from the base that depict his victory over the Dacians, the people who lived around the Carpathian mountains – they are largely illegible to ordinary eyes, particularly the ones near the top of the column, but the point was less to tell a story than to signal the power of victory.

Under Trajan's successor, Hadrian, a temple to all the gods – a 'Pantheon' – was built in the centre of Rome on the site of an earlier smaller structure from the time of Augustus. Hadrian retained an inscription included on the older building: M AGRIPPA L F COS TERTIUM FECIT ('Marcus Agrippa the son of Lucius, three times consul, built this').[13] Agrippa had been the right-hand man of Augustus, and retaining his inscription was a way of creating a link with the former age of glory. The entrance to Hadrian's Pantheon is supported by twelve columns carved from a single block of Egyptian granite, impressive not least for having been transported to Rome over 2,500 miles from the middle of the Egyptian desert. Through the portico, the temple interior is a dramatically simplified rotunda, topped by a hemispherical dome. The interior is faced with dazzling marble, hiding the rather less impressive but more structurally sound concrete, without which such a dome could not have been built. It has never been rivalled, at least not in concrete. At the centre of the dome an open *oculus*, or 'eye', beams in a shaft of sunlight, casting a roving disc of light on the interior. It might equally be a temple to the sun of a type that the Egyptians of the Amarna period would have admired. The Pantheon was a symbol of Rome's belief in itself as a divine empire, with the right to rule the entire world.

Hadrian filled his villa on the outskirts of Rome with hundreds of sculptures, most of them carved by Greek artists from originals, part of the considerable export market created by Roman demand. He also established a

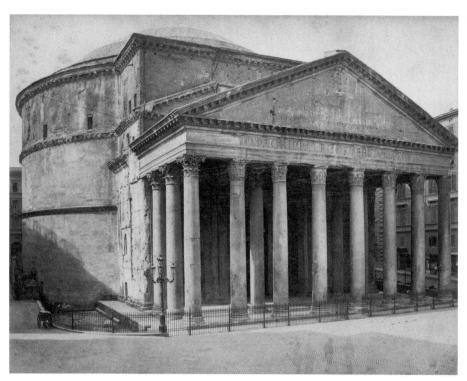

new type of image of the emperor – looking less like a warrior than like a Greek philosopher, with finely curled hair and a neatly trimmed beard. Hadrian's image was easily distinguished from his clean-shaven, sometimes even balding, predecessors, his piercing look intensified by the innovation in his time of carving the iris and pupil into the stone, rather than painting in the eye.

Like the image of Augustus, and of Alexander of Macedon before him, it was a 'look' taken up by later emperors, most strikingly by Marcus Aurelius. This was entirely appropriate for Aurelius, who had a reputation as a thinker thanks to his collection of self-improving aphorisms, published some time after his death as the *Meditations*.

He appears with his elaborate coiffure on horseback in a gilded bronze statue, once placed in the centre of Rome, perhaps in the Circus Maximus. Aurelius sits calmly, almost impassively, on his powerful steed, which is snorting, muscles bulging, quivering with vital energy. Its distinctive teeth suggest it may in fact be a portrait of a particular horse, a more lifelike portrait than the one of the sitter above. With his outstretched arm, the palm turned down, Aurelius commands his surroundings. At one time the limp body of a dying barbarian lay beneath the horse's hoofs. Marcus Aurelius may have shown himself

Head of Hadrian. *c.*125–150 CE. Bronze, h. 43 cm. Musée du Louvre, Paris.

as a philosopher, but he was also one of the most militaristic of Roman emperors.[14]

The Romans adapted their architecture to a great variety of buildings, and also to the planning and infrastructure – roads, aqueducts, sewers – of their towns and cities. Some of the grandest architecture was that of the imperial public baths, or *thermae*, with their great vaulted interiors. They also built the first apartment blocks, known as *insulae*, to house the ever-growing number of people moving to experience city life.

The most distinctive of Roman structures, however, was more like a sculpture than a useful building – or, more accurately, a cross between the two. Triumphal arches are free-standing arched structures decorated with reliefs and inscriptions commemorating a military triumph or honouring a great leader. Erected at the entrance to a city, or over a road within the city walls, the triumphal

arch is a pure piece of architectural symbolism – a portal to the idea of empire itself, echoing one of the earliest building forms, the prehistoric dolmen, three stones stacked to form a rudimentary arch.

One of the finest triumphal arches was built in Rome for Titus, the son of the emperor Vespasian. Titus had accompanied his father on campaign to the Roman province of Judea in 67 CE to put down a Jewish revolt against Roman rule, in the process destroying (and after Vespasian had returned to Rome to be crowned emperor) the Second Temple of Jerusalem (built to replace the first, Solomon's Temple, destroyed by the Babylonians). Titus' victory was celebrated by two arches, one erected in the Circus Maximus, devoted to the campaign (since destroyed), the other a large arch on the Via Sacra, the principal road in Rome, to commemorate Titus himself, who died the same year (the arch was put up by his brother and successor, Domitian).

The Arch of Titus on the Via Sacra is in fact a commemoration of a celebration. Carved panels on the inside walls show scenes from the triumphant procession staged in Rome ten years earlier, on Titus' return from Judea. On one side, soldiers hold aloft spoils from the second temple: a golden menorah, or candelabrum, and the golden trumpets of Jericho, brandished amid Roman military standards. On the other side, Titus is crowned by a winged figure of Victory, standing on a chariot pulled by four horses – hardly, however, the buoyant cavalry of the Parthenon frieze, more like a row of synchronised circus horses.

These were two details of a procession that must still have been fresh in the minds of those who had witnessed it. The spectacle and magnificence of Titus' triumph were described by one of them, the Roman-Jewish historian Josephus:

Equestrian statue of Marcus Aurelius. 161–180 CE. Bronze, h. 4.24 m. Piazza del Campidoglio, Rome (now in Capitoline Museum, Rome).

ROADS TO EMPIRE

Silver and gold and ivory in masses, wrought into all manner of forms, might be seen, not as if carried in procession, but flowing, so to speak, like a river; here were tapestries borne along, some of the rarest purple, others embroidered by Babylonian art with perfect portraiture; transparent gems, some set in golden crowns, some in other fashions, swept by in such profusion as to correct our erroneous supposition that any of them was rare. [15]

Carved panels from the Arch of Titus, Rome. 81 CE.

Most astonishing of all, Josephus writes, were the large movable stages, some several storeys high, on which scenes from the Roman–Jewish wars were depicted, including fortresses being overpowered, temples burned and general slaughter and mayhem, with captive Jewish generals forced to appear on the stages on their way to execution.

The Arch of Titus preserved the memory of this Roman triumph and of the deification of Titus himself, his body shown being carried upward by an eagle to dwell with the gods. Cut in marble at the top of the arch an inscription makes this purpose crystal clear: 'The Roman Senate and People dedicate this to the deified Titus, Vespasian Augustus, son of the Deified Vespasian.' Like the monumental chiselled letters on the front of Hadrian's Pantheon, Titus' inscription radiates power and purpose, with a clarity that surpasses even that of Egyptian inscriptions. The lettering style devised by the Romans, with its serifs (small lines at the end of each stroke), making each letter a statement of bold, unshakeable authority, was to influence carved and printed words for centuries to come.

Triumphal arches, with their brutal images of victory and upper-case inscriptions, seem far from the subtle forms of Greek architecture. By the end of the first century CE Athens itself had been long sacked and burned, and incorporated into the Roman empire, its buildings left standing. The once great city was now a deadened monument to itself.

The same, in a way, was happening in Rome itself, crammed full of monuments to the competing egos of successive emperors, weighed down with the burden of imperial pride.

Just a short way from the Arch of Titus, the most intriguing of all Roman arches was dedicated in 315 CE to the reigning emperor, Constantine. High up, above one of

Arch of Constantine, Rome. 313–315 CE.

its three arched openings, a carved frieze shows a line of squat figures listening as an equally squat Constantine gives an oration to the Roman people. The figures, with staring heads, wrapped in thick cloaks muffling the forms of their bodies, are more like symbols than real people. The point is driven home by the carved images above, roundels which for centuries have drawn attention away from Constantine's speech. They show elegant images filled with drama and vividness that bring to mind the carvings on the Ara Pacis, or even of Greek sculpture. They are in fact recycled, prised from a building put up during Hadrian's time two hundred years earlier, the heads recarved to resemble those of Constantine and his co-emperor Licinius. The Arch of Constantine is in fact covered with *spolia* – reused sculpture and building stones – including relief carvings of Trajan and stone panels from a lost arch dedicated to Marcus Aurelius. Brought together like pictures in an album, they show the historical emperors whom Constantine most wished to be seen with, no matter how much the styles jarred and how little the images made sense as a whole. Rather than a coherent triumph, Constantine's arch shows just how far the empire had distanced itself from its founding years, and from the inheritance of ancient Greece.

It was the last arch to be built in Rome, a bookend in stone to a period that had begun with the dramatic merging of Greek imagination and Roman power.

Relief panels from the Arch of Constantine, Rome. Roundels 117–138 CE, frieze early 4th century CE.

Although the Roman empire was defined by its expansion, much of this had happened in the earlier years of the republic. Following invasion and conquest, provinces and borders were created and diverse groups of people annexed, from the inhabitants of Bithynia on the Black Sea to the east, to the Britons on a small, cold island to the west, visited by Julius Caesar during his campaign in Gaul and finally conquered by Claudius in 44 CE. When Hadrian ascended the imperial

ROADS TO EMPIRE

throne just over seventy years later, the empire had reached its greatest extent. A vast network of paved roadways radiated from the imperial capital. Where roads proved impractical, the Romans built bridges, as well as aqueducts to bring water into their towns and cities. The impression of these structures in the countryside was as great as the glory-laden buildings in Rome itself, if not greater – they stood out as symbols of the endless will to expansion, the power of space, that Roman image-makers had realised.

Roman images found their way along these roads, changing as they encountered local traditions on their way to the far-flung corners of the empire, from Britain in the west to Tadmor (modern-day Palmyra) in the east.

Mosaics were one sign of Roman presence everywhere the imperial roads led, to Thysdrus in North Africa (present-day El Djem, in Tunisia), to Antioch in the Roman province of Syria, as well as Gaul, and as far afield as Roman Britain. Like so many other techniques, mosaic was not a Roman invention but, rather, as old as civilisation itself, appearing first in Sumeria, then in Egypt and ancient Greece and Asia Minor. In the Greek world coloured pebbles, and later tesserae, or cut stones, were used in some of the most inventive images of the time – an unswept floor, as if leftovers from a banquet and other sweepings had been thrown down, was shown on a mosaic floor at Pergamum, made by an artist named Sosus, as Pliny records.[16] Roman mosaics continue this inventiveness, although preferring less the banquet than images of the hunt on the floors of their dining rooms. Orpheus with his lyre taming wild beasts was another popular choice in the catalogue of mosaic decorators around the empire.

Provincial Roman governors might be more likely to choose an improving scene from Roman literature, such as Virgil's *Aeneid*. A floor mosaic in the *frigidarium*, or cold room, in the baths of a large country house in Roman Britain shows the scene of Aeneas arriving at Carthage and embarking on his love affair with Queen Dido. They go hunting together, their cloaks flying in the wind, before taking shelter from a storm in a cave, where their love blossoms. The mosaicist shows them entwined, flanked by swaying trees. The tragic end to their affair is signalled at the centre of the design, where Venus throws off her robe, symbolising Dido's suicide at Aeneas' departure, a cupid with his downward-pointing torch added as a conventional symbol of death.[17]

The story is strikingly told, although it lacks the refinement that such a scene would have if it had been made in a villa at Ostia, or even in Roman Gaul – it was probably copied by local artists from a book of designs, sent from a Roman workshop. The local artists added their own sense of the human form, as if scenes from the *Aeneid* were being played by local actors in their native tongue.

Not all provincial Roman images were of such mixed quality,

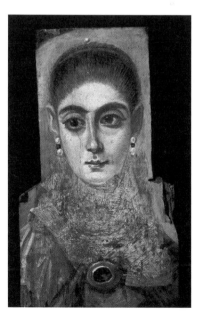

Portrait of a woman. c.100–150 CE. Encaustic and gold leaf on cedar panel, 42.5 cm by 24 cm. Musée du Louvre, Paris.

particularly where they met strong existing styles and high levels of craft. This was nowhere more true than in Roman Egypt, where for three hundred years after the fall of Ptolemaic Egypt to the Romans, striking portraits were painted on wood and linen and attached to mummy cases, preserving a living image into death. These 'Fayum portraits', so-called after the area of desert west of Cairo where many were later found, were painted with only a few colours and a straightforward style of hatched strokes, but remain among the most striking, lifelike images to survive from the Roman world.[18] A young woman with dark hair casts her gaze downwards, her face framed by large ear-rings echoing her large brown eyes with their catch of light, full of confidence and knowledge. The eyes are enormous, the ears more so, but this portrait radiates presence and life. With it we seem closer to the lost paintings of Iaia of Cyzicus, those psychologically compelling and glamorous portraits that summed up a much earlier time in the life of the Roman capital. The Fayum portraits show a rich meeting of traditions: of old Greek painting and its legacy in ancient Rome, combined with the afterlife itself of the Egyptian cult of the dead.

Where the Romans readily adapted to the Egyptian love of monumental luxury, they had far less in common with the people they conquered on the western frontiers – the Gauls, Britons, Iberians and Celts. The Celtic-speaking tribes, whom the Romans knew only vaguely, and saw simply as barbarians, occupied a large territory, with their heartland in modern-day Austria and Switzerland. They were migrants from central Asia and the Russian Steppes who, like any migrant people, could not claim such a historic connection with their landscape as the other great enemy of the Romans to the east, the Persians. The Celtic landscape was one of untouched nature, of modest wooden structures rather than large stone buildings. The large standing stones weathered by thousands of years in the northern climate were the only signs of enduring human habitation.

The Celts admired everything in nature that was to be admired, capturing the rhythms of natural growth and seasonal change in patterns and shapes. Geometric ornament, knots, interlace and images of animals abound in the first flourishing of Celtic art from around the fifth century BCE, in metalwork, jewellery and weapon ornaments in bronze and gold (in a style known as 'La Tène', after an archaeological site on a lake in Switzerland were many objects were discovered). The animal style of Scythian art was a close relation, as were the nomadic lives of the Scythians themselves. Rather than the abundant, dominating vines of the Ara Pacis, the patterns of the Celtic world signal a restless, movable energy. Of the symbols favoured by the Celts, the three-armed whirling wheel known as a *triskele* is the most common, and seems by a process of inertia to contain with it the dynamism first seen in the Minoan spirals over a thousand years earlier.

The Celtic tribes both on the continent and in Britain, after the Roman conquest, were either extinguished or absorbed into Roman society – at least in the urban and military settlements. Only the remote parts of Britain remained completely independent, such as the territory north of the wall built in the reign of Hadrian, occupied by the Picts – so-called from Caesar's name for them, the *Picti*,

or 'painted ones', referring to their tattoos. It was in Ireland that the spirit of the *triskele*, of flowing patterned imagery, painted, carved and forged, was to survive in local traditions and in folk memory, gathering in energy again after the conversion of Ireland to Christianity around the end of the fourth century CE, when it was summoned to symbolise a different sort of enthusiasm.

By this time, Rome itself was a Christian empire, a new source of authority and belief that had a profound effect on the creation of images. Just as the Romans had transformed the Greek world into one of worldly empire, so the new Christian world transformed Rome. At the beginning of the seventh century, Hadrian's Pantheon, standing amid the crumbling edifices of imperial glory, with the memory of the Augustan age inscribed on its front, a grand entrance in times gone by for the temple to the gods who had migrated from Athens to Rome with Aeneas on his ship, was converted into a Christian church.

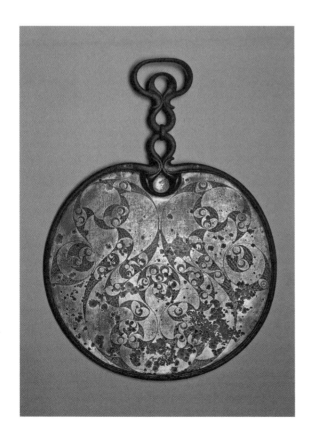

Bronze mirror, known as 'The Desborough Mirror'. c.50 BCE–50 CE. Bronze, 35 cm by 25.8 cm. British Museum, London.

7

Suffering
and Desire

As Rome was beginning its rise to power in the Mediterranean, around the fifth and fourth centuries BCE, far to the east, in the foothills of the Himalayas, the young prince of a small kingdom was having second thoughts about life. Turning away from the wealth and luxury of his royal upbringing, the prince, Siddhārtha Gautama, chose instead an austere path of poverty and meditation. One day, sitting beneath a sacred fig tree, he finally reached the state of enlightenment, or *nirvana*, and set out to preach of his discovery. He became known as the Buddha, or 'awakened one', and gathered many followers, monks and preachers who listened to his teachings, or *dharma*, and spread his word. The source of suffering is desire, Siddhārtha said, and by abandoning desire we bring ourselves ever closer to the perfected self-knowledge of enlightenment.

For the first hundred or so years after Siddhārtha's death all that was required to follow his teaching was a place to meditate and the robe and bowl of a life devoted to poverty. It was an austere doctrine that considered the physical world an illusion, so that early devotees of Buddhism closed their eyes to meditate. They had no need for images.

Around two hundred years after Siddhārtha's death, however, Buddhism had a second beginning, a reincarnation perhaps. The change came thanks to a king, Ashoka, who ruled over a vast territory, the Mauryan empire, covering most of modern-day India. Inscriptions on rocks and pillars spread wide over the Mauryan land told of Ashoka's conversion to Buddhism, following remorse at a massacre during a military campaign. It was this remorse, the memory of violence and the aspiration for self-improvement that set in train one of the greatest traditions of image-making in Asia.

One of the most prominent of Ashoka's pillars, which survives only in fragments, stood at Sarnath, in modern Uttar Pradesh, in the deer park where the Buddha preached his First Sermon. Without a base or pedestal, it emerges straight from the ground, as if growing like a tree. At the top four lions sit proudly, emitting a fearsome roar, while below each is a Buddhist wheel of law, a *dharmachakra*. Another large *dharmachakra* acts as a finial for the pillar, broadcasting the message of *dharma* and Buddhism to the

Ashoka Edict Pillar, Lauriya Nandnangarh, Bihar. 243 BCE. Photograph c.1860.

surrounding land.[1] Precious metals were inset into the capital, so that the Chinese traveller Fa-Hsien, on seeing a similar pillar several centuries later, described it as 'shining bright as lapis lazuli', as if beams were radiating from the eyes of the lions and the centre of the Wheel of Law.[2]

Buddhist teachings, or *dharma*, were inscribed on the side of the pillar, which also included one of the earliest statements in support of animal conservation. The Mauryan king renounced hunting and stated that certain animals should not be killed, a reversal of the human relation with animals that had held sway for tens of thousands of years. It is the earliest known written record of human care of other animals – one also recognised by adherents of Jainism, the other great belief system in India. In their sculpture, Jain artists showed figures in the yogic posture

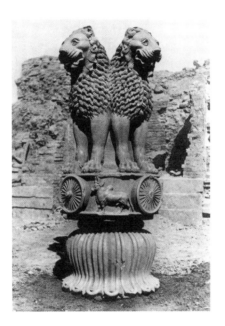

of *kayotsarga*, or 'body abandonment', an upright stance with hanging arms, immobilised so the body could fulfil the Jain edict of non-violence to all creatures – avoiding stepping on or accidentally swatting insects. Immobilised, the body becomes one with nature, abandoning all attempts to dominate or master, with forest vines growing around the limbs and birds nesting in the hair.

Ashoka's legacy comprised the first images of the Buddha, although these were at first symbols of his presence, rather than human forms. The Sanskrit word is *avyaktamurti*, meaning something like 'imageless' images. Alongside the *dharmachakra*, Siddhārtha appeared as a flaming pillar, an empty throne beneath the Bodhi tree (the name of the sacred fig tree beneath which Siddhārtha attained *nirvana*), a footprint (known as the *buddha-pada*) or simply an empty space. These often cryptic, mysterious symbols were continuations of older traditions of imageless representation, associated with Brahmanism and the ancient knowledge encoded in the Sanskrit-language scriptures known as the Vedas, the first of which was the *Rigveda*, which collected poems of praise to the gods. The Vedas record the use of sacrificial fire altars, piles of bricks in which might be buried an idol, and from which arose pillars that symbolised trees stretching into the firmament, precursors of Ashoka's columns. The symbolic world of the Vedic period arose from these scriptures and the rituals that accompanied them – the origins of the Hindu religion.

This symbolism was repeated on a far grander scale at the first Buddhist shrines, known as stupas – hemispheres of brick and stone whose forms descended from much older burial mounds, and which were topped by a parasol-like mast known as a *chatra*.[3] Pilgrims and travelling merchants would venerate the relics held within by walking around the stupa clockwise – they were not structures that could be entered. Ashoka ordered that the relics of the Buddha, already shared among eight stupas, be redistributed once again among a vast number of stupas built around the Mauryan empire – the relics must have soon

Lion capital from the Ashokan pillar at Sarnath. c.250 BCE. Sandstone, h. 215 cm. Sarnath Museum.

SUFFERING AND DESIRE

run out, but the building continued, as did the proliferation of carved images decorating the stupa.

The stories told by these carvings are known as the *Jātaka*, or tales from the life of the Buddha and of his former incarnations. They appear as 'imageless images' on one of the earliest stupas, at the hilltop site of Sanchi in

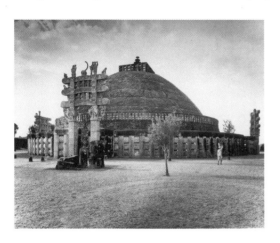

Madhya Pradesh. In the scene showing Siddhārtha leaving his palace at night on horseback, in search of enlightenment, the prince is shown by a riderless horse, and a parasol over an empty saddle. Around him luxuriate provocative female figures, which might seem out of place on a monastic shrine. They are the *yakshi*, ancient spirits that had traditionally been carved as standing stones along the paths in forests and in fields. They were roughly carved local gods, sources of solace as well as joy, upright sentinels like the daedalic figures being carved on islands in the Aegean. Yet none of these Western works was as given to the pleasures of nature and desire as the spirits of ancient India, who appear swaying and dancing on Buddhist shrines as a reminder of the worldly life that must be renounced.

The *Amarāvatī Mahācaitya*, or Great Shrine at Amaravati, on the banks of the River Krishna in south-east India, was one of the greatest of all Indian Buddhist stupas. At the peak of its glory it was covered with numerous carved sculptures and inscriptions.[4] Four cardinal gateways, guarded by lions, like those found on Ashoka's pillars, led through an outer railing to an inner walkway around the central domed drum, the whole surface animated with bright limestone carvings recounting the *Jātaka* tales. The Buddha is once again a ghostly presence,

his traces everywhere, his image absent. A giant pair of footprints, the *buddha-pada*, are carved with thousand-spoked wheels, like the *dharmachakra* on Ashoka's column radiating out divine law, as if inscribed on the feet of the Buddha and left imprinted in the earth wherever he went.

One of the most impressive surviving panels at Amaravati, a slab that was originally attached to the drum surrounding the lower stepped part of the stupa, shows four scenes of the birth of Prince Siddhārtha carved a few hundred years after the stupa was first built. Queen Māyā, languishing like a *yakshi*, or like a Roman goddess, dreams of the birth of her son – a dream that is interpreted at the court of her husband, King Śuddhodana, seated among courtiers in the panel

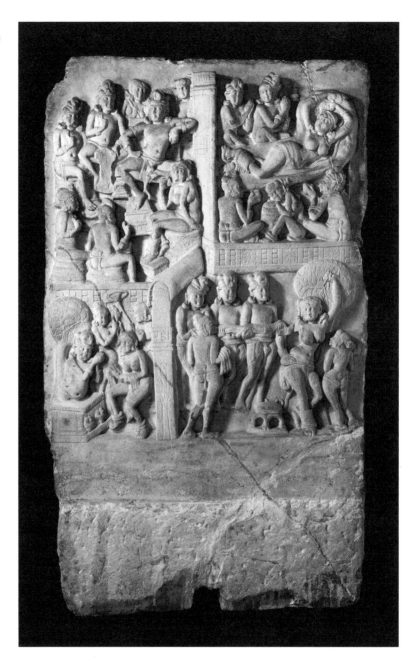

Drum slab from Amaravati showing four scenes relating to the birth of the Buddha. 1st century CE. Limestone, 157.5 cm by 96.2 cm. British Museum, London.

to the left. Māyā gives birth to Siddhārtha standing up, hanging from the branch of a tree – a customary pose both of fertility and of childbirth. Her son issues from her side and is represented by two small footprints on a cloth held by attendants. In the final panel Māyā presents her child, again shown by footprints on cloth, to a local seer who recognises his Buddhahood.[5] The scenes are separated by architectural details in a flattened perspective, guiding attention from scene to scene.

The craftsmen of Amaravati created a sculptural style that was admired throughout the region and appears as one of the three great schools of Buddhist sculpture in India. In the two other great centres, the northern region of Gandhara and the city of Mathura in the south, images of the Buddha himself began appearing around the first century CE (as they did on some of the later carvings at Amaravati). A new version of Buddhism emerged, known as *Mahāyāna*, meaning 'Great Vehicle of Salvation', which treated Siddhārtha not as a man but as a divine being. Quite why these images appeared at this moment is not known – perhaps it was simply the growing need for something to look at and worship.

The kingdom of Gandhara lay in the mountainous northern region straddling modern-day Pakistan and Afghanistan. Under the Kushan empire, with its capital at Puruṣapura (modern-day Peshawar), under King Kanishka (who reigned from 125 to 150 CE), the region and its sculpture workshops flourished.[6] At Puruṣapura, Kanishka built a vast stupa topped by a *chatra*, radiating the power of the relic kept within. But it was the new images of Buddha, bearing many of the characteristics of Greek sculpture, that were the most surprising inventions of the Kushans in Gandhara. Memories of the ancient Greek world are preserved in the regular classical features of the Ghandaran Buddha, his muscular, heroic body and the flowing toga-like drapery in which he is dressed. The Greek features were echoes of the Hellenistic sculptural style that had arrived in the region with Alexander the Great a few centuries earlier and had somehow clung on in the Hellenistic state of Bactria, in northern Afghanistan, preserved in Roman copies, perhaps.[7] The Gandharan Buddha preserves the regular features of classical statues – the small mouth, the straightened nose – as well as flowing, deeply incised drapery, animating

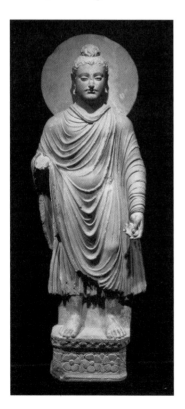

the forms of the body. Gandharan artists brought their own imagery to this prototype, working from a list of thirty-two features that described the Buddha, including the *ushnisha*, the protuberance on the head that demonstrated wisdom, and the *urna*, the whorl of hair between the eyebrows. The right hand was often raised in the gesture *abhaya mudrā*, reassuringly signalling 'have no fear'. His eyes are half-open, his gaze points downwards, signalling his lack of interest in the surrounding world – his only concern is his own salvation.

The Gandhara Buddhas are cosmopolitan types, a blend of fashions from far and wide. Their haloes, known as *hvareno*, meaning 'sun', are also borrowed – from the sun discs radiating from the head of the Persian god Mithras, whose cult was the greatest rival to Christianity in western Asia.[8] The halo is a celestial crown, indicating the divine right of gods and kings, but also a symbol that recalls the image-less origins of the Buddha – a thing, like the sun, that cannot be looked at directly.

Standing Buddha, from Gandhara. 1st–2nd century CE. Schist, h. 111.2 cm. National Museum, Tokyo.

Despite their apparent indifference to the world around them, the Buddhas of Gandhara looked far in both directions: west to the neighbouring region of Afghanistan, and further to central Asia and the Roman empire beyond; and east to China, then ruled by the Han dynasty.

They were part of a vast landscape of images and belief that was evolving across the Eurasian landmass, spreading along trade routes with merchants and pilgrims, such as Fa-Hsien of China, in search of the homeland of Buddhism.[9]

At the other great centre, in the city of Mathura, on the Yamuna River in the northern state of Uttar Pradesh, quite different images of the Buddha were being made. Stone-carvers created a bold new figure type in the distinctive red sandstone of the region: a human seated cross-legged, the soles of their feet upturned.[10] These novel images were derived from the meditating poses of *jinas*, or Jain sages, who were always shown either in the *kayotsarga* ('body abandonment') pose or in a seated, cross-legged meditating pose. For Jain and Buddhist sculptors carving such a pose must have involved direct observation, trial and error, as well as knowledge of the effect of yoga on the human body. The Mathura Buddhas have a broad chest, demonstrating their expanded yogic breathing, or *prahna*, the intake of life force, making them appear like broad-shouldered superheroes.

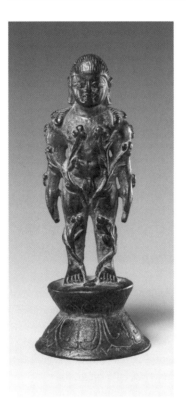

Jain Siddha Bahubali, entwined with forest vines. Late 6th–7th century CE. Copper alloy, h. 11.1 cm. Metropolitan Museum of Art, New York.

One of the greatest surviving Buddhas from Mathura is carved with the distinctive rounded features of the Mathura style, his appearance more fleshy and engaging than the cool Gandhara figures. He gazes straight ahead with a look of vivid, even mischievous, delight, his eyes wide open – it is our salvation that he anticipates. His outward-looking nature recalls the earlier example of Ashoka, broadcasting Buddhism as a force for good around his empire, taking the message of spiritual liberty out into the world.[11] Seated on a wide lion throne, in front of a large halo and the Bodhi tree, he is flanked by two lively attendants holding fly whisks, in the form of a trinity. Where the Gandharan Buddhas wear thick toga-like robes to suit the colder northern climate, the Mathura Buddha's *dhoti* is transparent, so that he appears almost as if naked. He was a popular deity and a clear step away from the austere and ascetic origins of Buddhist meditation, Siddhārtha's poverty and Ashoka's pillars.

The Buddhas of Gandhara and Mathura came together like different sides of a single character in the sculpture of the Gupta empire, the great period of Indian image-making, which dominated the Indian subcontinent from the mid-third century CE for some three hundred years. It was a time of great achievements

SUFFERING AND DESIRE

in literature – the poet Kālidāsa became famous for his poems and plays in Sanskrit, including the *Shakuntala*, a story taken from the Hindu epic the *Mahābhārata*.

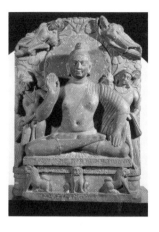
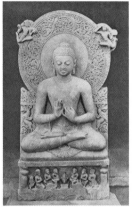
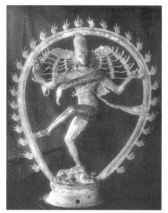

(Left) Seated Buddha from Katra, Mathura. 2nd century CE. Red mottled sandstone, h. 69.2 cm. Government Museum, Mathura.

(Middle) Teaching Buddha from Sarnath, Gupta. 5th century CE. Sandstone, h. 157.5 cm. Sarnath Museum, Varanasi.

(Right) Shiva as Nataraja, Chola. c.1100 CE. Bronze, h. 107 cm. Government Museum, Chennai.

Mathematicians and scientists made some startling innovations, postulating that the earth travelled around the sun, and including the discovery of zero as a mathematical quantity.[12] As so often, great advances in science were reflected in a high period of creativity. In sculpture, the austere, impassive faces of Gandhara appear on the warm, sensuous bodies of Mathura. The result is figures that seem to exist both in this world and somewhere beyond. Gupta representations of the Buddha reached a peak of refinement, with elaborate haloes, elegant bodies draped with transparent robes and eyes half-closed, turned downward in meditation. Hair is formed of tight curls, recalling the story of snails that crept up on Siddhārtha's head while he was meditating to protect him from the sun. A carved figure from Sarnath sits in meditation in front of extraordinary haloes radiating the inner experience of the Buddha. Two beautiful nymphs, known as *apsaras*, fly up the sides of the halo bearing flowers. It is with these images of Buddha made during the Gupta period that Buddhist sculpture itself seems to reach a form of enlightenment, to detach itself from all worldly connections and concerns, and to attain a state of weightless divinity, of perfect self-knowledge.[13]

Painted images of this superhuman Buddha, and of the earlier imageless images of footprints and empty saddles, were far less likely to survive.

As with the paintings of the ancient Mediterranean, it was only as wall paintings that they were preserved in any great number. At a Buddhist pilgrimage site in western India known as Ajanta, a series of shrines cut into volcanic rock in a remote gorge running around the Waghara River were filled with paintings

Cave 1, Ajanta, with wall painting of Bodhisattva Padmapani. 6th century CE.

and carvings as early as the last years of the Mauryan empire, around 200 BCE. Caves painted during the age of Gupta show the refined, worldly style of the age. One painting depicts the *bodhisattva* Avalokiteśvara, otherwise known as Padmapani, or in China as Guanyin (*bodhisattvas* are mystical beings who delayed their own enlightenment so that they might help other mortals in the quest for *nirvana*), wearing a necklace of pearls and a towering crown, studded with jewels. The lotus that Avalokiteśvara holds (from which derives the nickname Padmapani, or 'lotus-bearer') seems frail in comparison with the princely regalia – indeed, he might even be mistaken for Siddhārtha before his abandonment of worldly things. His unearthly nature, as with all *bodhisattvas*, is emphasised by the lack of a definite gender, suggesting a being both male and female. Yet still the richness of the painting of the *bodhisattva* Padmapani appears strange: what is such a worldly, luxurious image doing in a Buddhist monastery? It had less to do, perhaps, with the teachings of the Buddha than with the deep pockets of the merchants who passed by Ajanta on their travels and financed the decorations.

This worldliness posed a problem for those who held fast to an older interpretation of spiritual life, one closer to the original poverty of the Buddha, and the symbolism and mysticism of the ancient Vedic beliefs. It was in part as a response to the worldliness of Gupta imagery that the ancient traditions of Vedic Brahmanism, which had been such a strong shaping force on the earliest Buddhist and Jain images, rose to the fore. They took form in the religion – more a spiritualised culture, it might be said – later known as Hinduism, which became the dominant belief system in south Asia, virtually replacing Buddhism after the

Landscape with travellers, or parable of the illusory city from the Lotus Sutra, wall painting in cave 217, Mogao caves, Dunhuang. c.7th century CE.

last caves at Ajanta were decorated around the eighth century (although Buddhism continued to be practised in eastern India under the Pala dynasty). Hindu sculpture, which flourished in southern India from the middle of the ninth century to the thirteenth, recaptured the spirit and energy of some of the earliest Buddhist images, as well as their popular appeal.

Among these sculptures were bronze representations of the god Śiva, the creator and destroyer, dancing within a flaming wheel. They were made by artists working under the Chola dynasty, who for centuries ruled over the southern part of the Indian peninsula. In the guise of

SUFFERING AND DESIRE

Nataraja, Śiva was the great dancer (*nata* means 'dance' and *raja* 'king' in Sanskrit), whose primal energy and compulsive rhythmic action were part of the eternal cycle of the universe. The cosmos is Śiva's dance floor, on which he dances the Ananda Tandava, or 'dance of bliss in the hall of consciousness'.[14] In his four hands he holds a drum, banging the world into existence, and a flame, a symbol of destruction. He makes the *mudrās*, or gesture of 'no fear'. His scarves and hair braids stream with the rhythm of his dance, his left leg raised and poised, his right standing on a stunted figure, the dwarf Mushalaga, representing the dark cloud of worldly illusion. His multi-limbed pose expresses an abundance of graceful action. Surrounding him and framing his pose is a fiery arch, a symbol of nature and the cosmos: within it his dance measures the primal rhythms of existence, of being and nothingness.

They are the rhythms of creation that need not take on human form, and were most powerfully conveyed by Śiva's symbol, the linga, or phallic symbol, a smoothed upright rock placed in the shrines were Śiva was worshipped, such as the temple caves cut into the rocks on the island of Elephanta in the harbour of Mumbai. It was a symbol known to a much earlier culture, that of the of the Indus Valley, who in the second millennium BCE worshipped a god who appears to be Śiva's ancient predecessor, and who also appeared in the form of the imageless image of a stone phallus.

Angkor Wat. 12th century CE.

Buddhism, although diminished in its homeland, was like a great wave of image-making energy that surged east, rushing back down the trading routes along which merchants transported their silk and other valuable wares, and along which government officials, monks and nuns and other travellers criss-crossed from east to west. It was at stages along these routes, over deserts and mountains, that the second great site of Buddhist painting appeared, after Ajanta: a sizeable complex of rock-carved shrines, known as the Mogao caves, carved in the rocky escarpment along the Daquan River, near the oasis outpost town of Dunhuang, at the eastern extremity of the Chinese Han empire.

The Mogao shrines vary in size from small meditation chambers, like monastic cells, to assembly halls containing large wall paintings and clay sculptures of *bodhisattvas* and of the Buddha.[15] Although the origins of such painted rock shrines were the caves at Ajanta, and also at Ellora, in India, both were small in comparison with the sheer number of caves at Mogao, containing a tradition of Buddhist painting that continued for over a thousand years. Many different stories are told in these paintings – not just the Jātaka tales from the life of the Buddha but also tales of the *bodhisattva* Guanyin, who lost none of her appeal as she travelled east to China, becoming more and more feminised on the journey. In one painting at Mogao, Guanyin is shown in a landscape protecting a group of merchants against highwaymen – Buddhist monasteries had long offered protection for commercial travellers against robbery along trade routes (one of the reasons the travellers were so eager to donate large amounts of money for their decoration and upkeep).[16] Such paintings are also among the earliest evidence of landscape painting in China, highly stylised views that in their fantastical qualities echo the landscapes of classical antiquity, like those showing the adventures of Odysseus. Yet the delicate style of painting, with its affinity to calligraphic script, is definitely Chinese, rather than Western, in origin.

It is the sheer number of the images of the Buddha, the boundless energy to repeat the same formulas, like mantras chanted in endless cycles, that carried the beliefs of Siddhārtha, alongside devotees of the cults of Śiva and Vishnu, further to the Asian south. They arrived in the kingdom of Cambodia with traders settling along the Mekon Valley and were taken up by the powerful and wealthy rulers of the Khmer dynasty, who built vast temple complexes incorporating Buddhist and Hindu imagery. They created a new type of sculpture of the Buddha, based on the serene figures from the Gupta empire and the sculpture of the Pala dynasty, but with a distinctively long and expressive mouth. Their temples are steep-stepped shrines, stone mountains incorporating fantastical carvings, colossal heads that seem to come from a dream world where the bodies of giants and gods emerge from the forest into the stones. The greatest of these, Angkor Wat, is decorated with stories from the Hindu epics the *Mahābhārata* and the *Rāmāyaṇa*, and animated by flying *apsaras* and symbols of Śiva. Flanking the doorways and staircases of these great temples were often found large carved images of lions, guardian figures with bared teeth and bulging eyes. They are direct descendants of the lions from Sarnath, symbols of the Buddha and of the power of his message.

Lion from Preah Khan.
Late 12th–13th century CE.
Sandstone, h. 146 cm. Musée
national des Arts asiatiques
Guimet, Paris.

8

Golden Saints

Christianity, like Buddhism, was at first a religion without images. Hundreds of years were to pass after the death of Jesus of Nazareth before pictures showing him and his followers appeared. They were, at first, small coded paintings made on the walls of underground burial chambers and in clandestine meeting houses, emblems of a shared secret knowledge. A delicate painting of a shepherd with one of his wards across his shoulders, swaying gently, might well have been mistaken for an illustration of a passage from Virgil on a wall at Pompeii or a scene from Homer's *Odyssey* painted in a Roman villa. But in the Catacombs of Callixtus, outside Rome, where it appeared at the beginning of the third century, Christians would have recognised in it something quite different – Jesus Christ in the guise of the Good Shepherd, a story told in the Gospel of St John.[1]

Cryptic images began appearing far and wide, wherever Christians lived: around the Mediterranean, in North Africa, among the Coptic Christians and in the Roman province of Palestine, where the cult first appeared. In the Roman empire, where Christianity was outlawed, most of these early paintings were destroyed. Those made on the rough plaster walls of a private meeting house in the

Roman frontier town of Dura-Europos (in present-day Syria), including Christ as the Good Shepherd, as miracle worker, walking on water and healing a lame man, were an exception: they were preserved by being buried in sand after the destruction of the town by Sasanian Persians in the middle of the third century.

Stories from the Gospels were not the only images in town. Near the Christian meeting house in Dura-Europos stood a synagogue, its walls vividly painted with stories from the Old Testament.[2] A woman has disrobed to rescue Moses from the Nile, passing him to the women waiting on the banks of the river. They appear like actors on a stage, facing out to make the story clear for the viewer. The image of a naked woman might be surprising, not least considering the Old Testament interdiction on 'graven images' of anything in heaven above, on the earth beneath, or in the waters beneath the earth.[3] And yet from the end of the first century CE, synagogues everywhere contained paintings and mosaics telling the stories of the Jewish people. They were symbols of a shared faith that created a strong sense of a separate, sacred space, in the absence of recognisable religious architecture.[4] The

The Good Shepherd, Catacomb of Callixtus, Rome. 3rd century CE.

Dura-Europos paintings were far from anomalies, and were probably taken from images in a larger synagogue or shrine elsewhere, perhaps in the nearby caravan city of Tadmor or the thriving metropolis of Antioch.

Quietly, secretly, they were part of a gathering new era of religious images, of Judaism and Christianity and also of Buddhism. In the first centuries of the new millennium images became the currency of salvation.

The three religions were linked in another way. Early Christian and Jewish artists encountered the same problem that the Buddhist sculptors of

Gandhara and Mathura had faced: how do you make a convincing image of someone you have never seen? At the time Christian images began appearing in the catacombs and church houses, nobody had the slightest clue what Jesus and his disciples had looked like. There were no physical descriptions in the Bible, a remarkably unvisual book, let alone any sense of how the abstract, spiritual nature of Christianity might be imagined. Greek gods were real people – the Christian god, despite being born a man, was a disembodied idea.

For early Christian artists the solution was very practical: they borrowed images from the Roman empire surrounding them. It was in many ways a perfect fit – was not Christ like an emperor of the spiritual realm? Well then, he could be shown seated on a throne surrounded by his supporters and subjects.[5] On the marble sarcophagus of a Roman official, Junius Bassus, who died in 359, this is exactly how he appears – a youthful Christ, enthroned between his followers Peter and Paul, handing Paul a scroll, thought to be his new covenant, just as

GOLDEN SAINTS

a Roman emperor, or indeed Junius Bassus himself, might be shown handing rolled-up orders to a courtier or general. An inscription records that Bassus was a prefect, a high position in Roman society, and died at the age of fifty-two, but the imagery on his stone coffin reveals that the most important event in his life was not his promotion but his conversion to Christianity. Bassus was a Christian, but he remained a Roman, and on both ends of his sarcophagus happy pagan cherubs tread grapes to make fine Roman wine.

Not all Christian stories could be dressed up Roman-style, and especially not the central story of Christ's martyrdom and death. The Romans were little interested in showing images of crucifixion or any other of their gruesome methods of public execution. Power and victory were their subjects, rather than pain, suffering and martyrdom (except in those pathos-filled sculptures of Hellenistic times, the *Laocoön* and the *Dying Gaul*). When the first images of the crucified Christ appeared in the fourth and fifth centuries, it was an entirely new way of showing the human body, one that combined suffering with power in a form unknown in the world of antiquity.

By the time these images began appearing, Roman officials like Junius Bassus would have had no reason to fear reprisals for adopting the Christian faith. Around 312 the Roman emperor Constantine had converted to Christianity and put an end to persecution on religious grounds. Christianity had won the battle of faiths, and became (some decades later) the official religion of the empire. A new imperial capital, Constantinople ('City of Constantine', modern-day Istanbul), was established on the site of an old Greek town called Byzantium, which gave its name in later times to the golden age of image-making that followed, the Byzantine era. The citizens of Constantinople saw themselves as the inheritors of the old Roman empire, but crucially also as Christian Romans – although they spoke Greek rather than Latin, living as they did in the territory of ancient Greece and Asia Minor.

Constantine trumpeted the triumph of the Christian faith throughout the Roman Empire by a series of grand architectural commissions. He built the Church of the Holy Sepulchre in Jerusalem, at the place where Jesus was said to have been crucified and buried, and the Church of the Nativity in Bethlehem, where he was born. At Antioch he constructed a golden church, the Domus Aurea, octagonal in plan, famous in its day but later destroyed. It survives only in the description given by the Christian historian Eusebius of Caesarea, who wrote of a building 'unique for its size and beauty', great precincts surrounding a hall of worship raised to an 'enormous height' and decorated with 'abundant gold and bronze and all kinds of precious stuff'.[6] In the city of Rome, Constantine ordered the building of a vast basilica which he decorated with Roman silver and hanging golden crowns, and which was later known as the church of San Giovanni in Laterano (St John Lateran). Basilicas were originally Roman audience halls – large, simple spaces, long, light-filled halls ending in an apse where an image of the emperor might be displayed, or his throne placed. Constantine built one, the Aula Palatina, alongside the imperial palace at Trier (in modern Germany), where he resided in the early years of his reign.[7] As the customs of Christianity became part of imperial life, so the purpose of the basilica was transformed – less an old-fashioned Roman audience hall for the emperor, more a sacred space where the bishop might encounter his congregation.

Of all transformations of Roman to Christian architecture, the mausoleum Constantine built in Rome for his daughter Constantina is the most moving.[8] A central dome is illuminated by natural light, filtering into the surrounding walkway, above which runs a curved ceiling decorated with mosaic panels. The imagery is pastoral, evoking country settings through which the wine god Dionysus might have passed, spreading a lightness of spirit around the thick columns and stones of the mausoleum. Cherubs play in vines and harvest grapes; flowers and fruit-laden branches are intertwined with birds, vases and cooking pots, allegorical figures and portraits of children encouraging the continuation of

the imperial line. In an apse at one end of the mausoleum stands an enormous deep red porphyry sarcophagus, decorated with jolly cherubs among grapes and vines, with a simple portrait of Constantina at the top. It feels less a mausoleum than a temple to the pagan world, and to an emperor's daughter for whom such a world must still have been a source of delight.

The Christian decorations of Santa Costanza, as it is known, are likely to have been added some time after the building was consecrated – it was at first entirely pagan in spirit. And yet the very materials of the original building, the glass mosaics in the curved ceiling, shine with the new spirit of belief. Where most Roman mosaics were made from thick coloured stones embedded in the floor, Christian artists used

Santa Costanza, Rome. *c.*350 CE.

GOLDEN SAINTS

coloured glass, combined with gold and silver leaf, placed over or embedded in a glass tile, to create an overwhelming, space-filling radiance.

Glittering glass mosaics were the most powerful medium for Christian imagery in the centuries after Constantine's conversion. On walls, arches, columns and ceilings, visions of splendour symbolised the power and glamour of Christian salvation, through scenes of natural abundance and earthly paradise. Flowers grow in the grass beneath Christ's feet, where lambs and sheep graze, peacocks drink at wells, vines and foliage twist around chancel screens, decorated capitals, carved ivory panels.

The artists who made these images were trained in the workshops of Constantinople, speaking Greek, but would have felt themselves part of a greater Roman world, itself the inheritor of the glory of Periclean Athens and the cosmopolitanism of the Hellenistic world. And yet they were also aware of another source of imagery, the delight in nature and decorative impulse in the imagery of the Persian and Arab worlds to the east. The Sasanian empire was the last breath of ancient Persia, ruling for four centuries as the great rival to the Roman Byzantine empire to the west. The Sasanian kings saw themselves as heirs to an ancient Iranian culture stretching back to the Achaemenids and the days of Persepolis. At the Sasanid capital of Ctesiphon, just south of Baghdad, the wealth of the Persian empire was expressed in the royal palace built in the sixth century for Khusrau I, the envy of rulers for centuries to come. Beneath a vast brickwork arch, known as the Taq Kasra, the throne room of Khusrau at Ctesiphon was decorated with coloured marbles and mosaics as opulent as any Byzantine palace or church.

From the reign of Shapur II in the fourth century the royal hunt became the standard image engraved on Sasanian silver vessels, showing the king in the aspect of a warrior. The Sasanians had every reason to be proud, having defeated the Romans at the Battle of Edessa in 260 (a few years after having destroyed Dura-Europos) and taken the emperor, Valerian, captive. The images on their silver plates show their debt to the Roman metal workshops, dancing nymphs and young warriors who might be traced back to antique prototypes; and yet the valiant king firing an arrow on horseback, and the noble features of the lions he has felled, look back to the images of ancient Iran and Mesopotamia, and the relief carvings of the lion hunt at the Assyrian royal palace of Ashurbanipal over a thousand years earlier.

Silversmiths in Constantinople also drew on older Roman imagery to decorate their most expensive wares. A set of nine silver dishes, made in the early

seventh century, is engraved with scenes from the life of the Hebrew king David, from passages in the Old Testament book of Samuel. In his combat with Goliath, David is shown with flowing robes, recalling the dramatic and poetic style of Hellenistic sculpture. His body is rounded and muscular, and yet drawn with the lightness and grace of the old pagan world.

Stamps on the plates show that they were made during the reign of the emperor Heraclius, and may commemorate his victory over the Sasanian Persians in 628–

Plate showing King Ardashir II (r.379–386) hunting lions. c.380 CE. Silver, 28 cm in diameter. National Museum of Iran, Tehran.

9, during which he retook Jerusalem and occupied Ctesiphon, at that time one of the largest cities in the world. Although luxurious silver plates were often made in the late Roman world, these may well have been designed to rival the famous silverware of the Sasanian kings, by then veritable antiquities, and to show the victory of Christianity over the Persian religion of Zoroastrianism. The biblical King David was a model for the Byzantine emperors, a judicious and just ruler, a giant-slayer, a musician and a poet, and also a figure, at least as he appears on this silver plate, who could provide a link between Christianity and the old Roman world of pagan heroes.

Constantine's conversion to Christianity in the fourth century was a revolution for the faith but not necessarily for Christian art. Only two hundred years later, in the reign of the emperor Justinian and the empress Theodora in the sixth century, did Constantinople become the glittering citadel of a Christian empire for which it passed into legend. In the realm of politics Justinian's achievement was to regain western Roman territories, conquering the Vandals in Africa, the Visigoths in Spain and the Ostrogoths on the Italian peninsula. Orthodox Christian faith was reasserted over the heresies, quibbles in the meaning of Christian doctrine that had arisen in the Germanic people to the west.

 Now more than ever Constantinople was at the heart of a great network of creativity and ideas, one of the first truly great capitals of the world, rivalled only by the great city of Chang'an (the capital of T'ang dynasty China) to the east. Christianity was spreading deep into Asia, with Christian populations thriving in key cities such as Samarkand and archbishoprics established as far east as Kashgar, the oasis town and gateway to and from China on the Silk Road.

Plate with the battle of David and Goliath (detail), 629–630 CE. Silver, 49.4 cm in diameter. Metropolitan Museum of Art, New York.

It was along the Silk Road, in the caravans of traders, the pockets of merchants and the minds of pilgrims, that images and ornaments from the east made the journey to Constantinople and mingled with the legacy of ancient Greece and Rome. This great cosmopolitan whirlpool, with Constantinople at the centre, set the standard for images and architecture far and wide.

 During Justinian's reign two churches were built that came to symbolise the double glory of the Byzantine empire, east and west, beacons blasting out the light of Christian truth: in Ravenna, on the Italian coast, the modestly sized but richly decorated church of San Vitale;

and in Constantinople itself the immodestly vast domed structure of Hagia Sophia, dedicated on Christmas Day 537.

The first church of Hagia Sophia had been built by Constantine, in the form of a basilica, and it was on the ruins of this structure, destroyed in a fire, that Justinian raised his new church. This time the dedication to Holy Wisdom (Hagia Sophia) could truly be justified – it was designed by two mathematicians, Isidore of Miletus and Anthemios of Tralles, who drew on Roman scientific and engineering knowledge. This wisdom they transformed into a vision of grandeur that was never to be surpassed – 'a spectacle of marvellous beauty', wrote the Greek scholar and historian Procopius in his account of Justinian's buildings, 'overwhelming to those who see it, but to those who know it by hearsay altogether incredible'.[9]

To enter Hagia Sophia is certainly to be overwhelmed by a sense of encompassing space and other-worldly illumination. 'Indeed one might say that its interior is not illuminated from without by the sun,' Procopius went on, 'but that

the radiance comes into being within it, such an abundance of light bathes this shrine.' Above the enormous space of the nave hangs the central dome, supported on four great arches, themselves supported by great two-storey arcades, yet with such a feeling of weightlessness that it seems to be suspended from above – from heaven itself, as Procopius put it. Such a prominently visible dome was entirely new. The Pantheon in Rome was just as impressive from the inside but not designed to be seen from afar. Hagia Sophia dominated the city and surrounding water and land, symbolic of a presence both human and divine.

On seeing his church completed, Justinian is said to have remarked that it was greater even than the Temple of Solomon. He may also have been thinking of something much closer. The church of St Polyeuktos, built in Constantinople by the phenomenally wealthy Princess Juliana Anicia, had been

Hagia Sophia, Constantinople (modern Istanbul). 532–535 CE.

dedicated exactly a decade before Hagia Sophia, in 527.[10] Surviving fragments of the church, destroyed around the eleventh century, reveal an enormous building of great opulence – the largest in Constantinople before Hagia Sophia, and perhaps the first to combine a basilica with a dome. The ceiling was covered in gold (a safe place at least to store one's wealth), and the stonework carved with elaborate grapevines and inscribed with the lines of a poem that ran around the walls inside the church. Coloured marbles, the purples and violets of porphyry, sparkling amethysts and mother-of-pearl created a treasure-like setting for sculptures including elaborate column capitals and carved peacocks. It was an enveloping, transporting space of sanctity that directly influenced the mood and appearance of Hagia Sophia. At least some of the sculptors and workmen would have worked on both.[11] In the vaults of the churches they created glittering mosaics dissolving the massive architectural forms in reflections and light, so that, as one group of envoys from Russia in the tenth century, visiting on behalf of Prince Vladimir of Kiev, wrote (so it is said) of Hagia Sophia, 'we knew not whether we were in heaven or earth. For on earth there is no such splendour or such beauty, and we are at a loss how to describe it.'[12] The inscription in Juliana's church bravely boasts of her surpassing the wisdom (presumably architectural) of Solomon in constructing her church – although it was Hagia Sophia that was to survive for later generations, thanks to the wisdom of Justinian's mathematician–architects.

The basilica of San Vitale at Ravenna, the other great church built during Justinian's reign, and dedicated ten years after Hagia Sophia, was more modest in proportions but not in its decoration. Justinian built larger churches

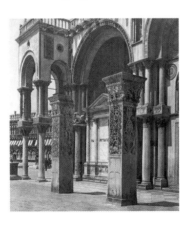

elsewhere, including the basilica of St John at Ephesus, in Turkey, and the New Church of the Theotokos, known as 'The Nea', on Mount Zion in Jerusalem. Neither church was to survive, yet an idea of their splendour is preserved in the interior of San Vitale. In the apse at the eastern end, glass and gold mosaics show Christ surrounded by saints, including St Vitalis, posed in a paradise setting, among lilies and peacocks strutting on the green grass. To either side altogether more earthly visions in mosaic are ranged – imperial processions. The emperor Justinian stands alongside the bishop of Ravenna, Maximianus, his right-hand man in the western empire, who was closely involved in the building of San Vitale. Soldiers crowd menacingly to the left, to make clear that if Justinian could not assert his power and belief in Orthodox Christianity by spiritual persuasion, embodied in his own elongated figure, seemingly floating in space, then force would swiftly follow.

Justinian holds a golden basket, to hold bread for the Christian ritual of the eucharist, while the empress Theodora holds a golden chalice for the wine. They appear willing to assist in church ritual, but the reality is that neither of them ever visited Ravenna. Images project imperial power in their absence. Theodora wears a gold-trimmed robe and a jewel-bespangled diadem. A servant lifts a curtain to reveal an ornate fountain. One of her retinue raises her arm solely to show off

the costly bracelet and ring she wears. It is a cosmopolitan spectacle, designed to impress the provincial town of Ravenna, and to remind any survivors from the years when the city was the capital of the Ostrogothic kingdom, which had fallen seven years before the dedication of San Vitale, in 540 CE, that their time was truly up.

The apse mosaic of Christ at San Vitale shows him as an emperor dressed in purple robes, sitting on a large blue globe, handing an imperial crown to San Vitalis. Like earlier portrayals at the time of Junius Bassus, he is a beardless, wide-eyed, dark-haired Roman, at Ravenna insouciantly holding his jewel-encrusted crown and covenant scroll – nothing like images of Christ made in centuries to come. Although by Justinian's time Christian images had largely been detached from Roman origins, the distinctive look for Jesus, and for the Virgin Mary for that matter, had yet to be forged. In an ivory carving made in Constantinople in the middle of the sixth century, Christ is bearded, with a broad flat nose, cauliflower ears and the melancholy face of a Greek river god. The Virgin is plump and self-satisfied, a Roman matron holding a little Roman boy with curly locks. From the perspective of later generations they may well have appeared like poorly cast actors in a play.

During the next century all this changed. Mosaics and painted images of Christ and the Virgin Mary began appearing that radiated a new, and decidedly non-Roman, sense of spiritual purpose. The earliest of these paintings, or icons (from the Greek word for 'image', *eikon*), to survive were kept at the monastery of St Catherine, in red desert sands at the foot of Mount Sinai in Egypt. One small painted panel shows a huddled group of figures, a Virgin and Child guarded by two saints, St Theodore and, probably, St George, while behind two white-robed angels

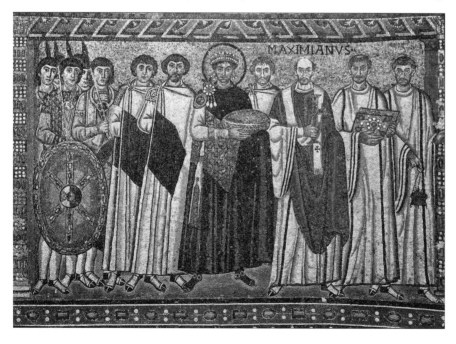

Justinian I and his retinue, mosaic, St Vitale, Ravenna. c.547 CE.

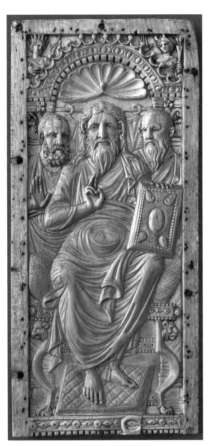
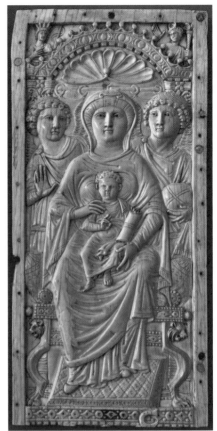

peer up with awed expressions to a divine hand flooding the scene with light. The saints stare straight out, barely smiling. The gazes of Mary and her baby drift thoughtfully away, their faces alive with secret knowledge. The Sinai icon looks both backwards and forwards. The inquisitive angels have all the vigour and life of Greek dancers, but the Virgin and saints are filled with a different sort of life, that of the knowledge of Christianity and its earnest pledge of salvation.

These new images were a powerful revelation of the Christian faith and its message. Believed to be charged with magical energy, painted images were held aloft in processions, like imperial Roman standards, or placed on the city ramparts to ward off enemies. They were worshipped in the belief that they could cure sickness, bring good luck or be a source of divine protection. Some were considered quite literally to have magical origins. Known as *acheiropoieta*, literally 'untouched by human hand', they were thought to have simply appeared, and were charged with the same magical power as the relics of a saint – a bone, a hair, a whole desiccated arm, perhaps, worshipped as physical tokens of a spiritual presence.

The most famous of these magical images was the Mandylion (the word refers to a type of cloth in Byzantium), or Image of Edessa, a portrait of Jesus of Nazareth. The legend went that it was sent to King Abgar, ruler of Edessa (in modern-day Turkey), after he wrote to Jesus asking him to come and cure him of an illness. The disciple Thaddeus made the journey instead, carrying a letter

from Jesus and the miraculous portrait. It was instrumental in protecting Edessa, it is said, against Persian attack – not as a famous image, but rather as a relic of Christ (it was later lost, after being taken by Crusaders to Paris, only adding to its legend).[13] Other such images were reported to have survived from the lifetime of Christ, such as the image created after St Veronica wiped the sweat from Christ's brow on his way to Calvary, known as the Veil of Veronica, the name derived from the Latin *vera icona*, or 'true image'.

Such magical images, protecting cities and healing kings, were fuel for the popular appeal of Christianity, the stuff of stories and legends. And yet this soon led to a reaction: was not this fascination with images, ascribing them supernatural powers, detracting from authentic worship and belief? Were the purveyors of such images not then heretics from the true faith, as laid out in the Bible, itself, as we have seen, a highly unvisual book? Arguments simmered on, became increasingly heated, and then violent, so that during the eighth and ninth centuries many paintings and sculptures were smashed, defaced and destroyed. It was the first wave of Christian Iconoclasm.

For the defenders of Iconoclasm (which became the official policy of the Byzantine empire in 726), all images were false idols, distortions of Christian doctrine. To make a painting of Christ was to deny his true, divine unpaintability. Iconoclasm was, in effect, a revival of the ban on 'graven images' of the Old Testament, justified by God's jealousy of the worship of 'other' idols. It was also shaped by another religion's mistrust of images – the Islamic interdiction on figurative images in a religious setting.

Islam was the great power rising to the south in Arabia, and by the mid-seventh century had conquered Egypt and Syria. In 717, just a decade before the first pulse of Iconoclasm, the Arab armies unsuccessfully laid siege to Constantinople itself. The Byzantine capital survived, but the power of Islam was impossible to ignore.[14] At church councils passions ran deep. Even in Hagia Sophia itself, mosaic images of Christ and his followers were violently hacked from the walls by workmen under orders and replaced with simple crosses or other 'imageless' symbols.

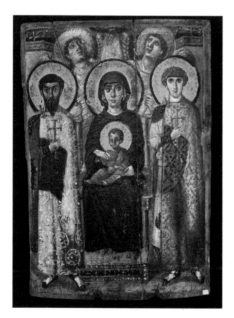

The defendants of Christian images, the iconodules (from the Greek *eikonodoulos*, 'one who venerates images'), saw images simply as windows onto the divine message, rather than actual embodiments of Christ. Their defence was led by a Christian Arab from Syria, John of Damascus, who wrote his manifesto, *Apologies against Those Who Attack the Divine Images*, from a monastic cell overlooking the Dead Sea. As Christ himself was the image of God, John of Damascus argued, then Christian images should be permitted as 'brief reminders' of the nature of God and

The Virgin and Child enthroned between St Theodore and St George. 6th or early 7th century CE. Encaustic on wood, 68.6 cm by 47.9 cm. St Catherine's Monastery, Sinai.

GOLDEN SAINTS

Christian stories. An image may be like its subject, yet there is always a difference between them – an image of a man does not 'live or think or speak or feel or move a limb'. Created images and visible beauty were necessary vehicles to arrive at the appreciation of the invisible truth of the divine.[15] The argument that a sacred image could derive not from a divine or magical source but from the ingenuity of human hands was a step in the evolution of an idea of 'art' that held sway in the Western world for centuries to come. Both the power and the limitations of images might be considered to derive from this handmade, rather than God-given, creation.

Just over thirty years after Iconoclasm was adopted as the official policy of the Orthodox Church, and after many waves of vandalism and persecution, in 787 the policy was renounced, thanks to Irene of Athens, at that time regent and later sole ruler of the Byzantine empire.[16] Although Irene fought for the presence of icons in the monasteries and churches, she was unable to stop a second period of Iconoclasm, some thirty years later, which was itself later revoked, this time under the empress Theodora, wife of the Iconoclast-friendly emperor Theophilus. Theodora waited until her husband's death, in 843, to reverse his crude and destructive policy, once and for all curbing the destructive anger of the Iconoclasts. Thus, at a pivotal moment, the defence of images, founded on an understanding of their power and its limits, was made by two powerful women. Legend has it that the first act of Iconoclasm, the removal of a portrait of Christ from the main entrance to the city of Constantinople, known as the Chalke Gate, was denounced by a large crowd of angry women.[17]

The centuries following Theodora's restoration of icons and image-making, from the middle of the ninth century until the middle of the thirteenth (known as 'Middle Byzantium'), were a golden age for the workshops of Constantinople. A renewed enthusiasm for old Roman images was carried by ever more refined techniques of creating luxurious objects for the Church and for the empire. The glittering glass mosaics of early Christian artists found their echo in the small exquisite objects, jewellery and boxes to contain relics, made with cloisonné enamel, a technique of fusing molten droplets of glass onto metal,

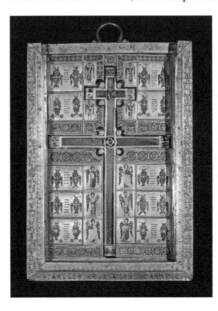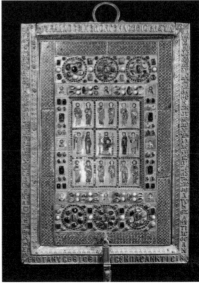

Staurotheke, known as the 'Limburg Staurotheke', interior with True Cross reliquary (left) and lid (right). 968–985 CE. Wood, gold, silver, enamel, gems, pearls, 48 cm by 35 cm. Cathedral, Limburg an der Lahn.

divided into patches of colour by metal filaments. One of the most spectacular of these, a Staurotheke (a relic box said to contain fragments of the wooden cross on which Christ was crucified, from the Greek *stauros*, 'cross', and *theke*, 'box or container') made in Constantinople, is covered with painstakingly crafted enamel images of Christ, the Virgin Mary, saints and angels. The labour and expense of creation emphasised the power of the relics within, including fragments of the cloth in which the infant Jesus was swaddled and of the sheet in which he was wrapped in his tomb. Precious jewels, gold and fine workmanship were in the Byzantine imagination fitting equivalents for these great spiritual objects, and part of the direct connection forged between the splendour of the imperial court and the glory of the Christian Church.

The defeat of Iconoclasm also led to a new enthusiasm for lavishly illuminated manuscripts. One of the most striking of these created in Byzantine Constantinople was a Psalter (a book of Psalms) made in the late tenth century, probably for the reigning emperor Constantine VII Porphyrogenitus.[18] The pages of the Paris Psalter (named after its modern location) are painted with scenes from the life of King David, the poet–king so loved by Byzantine emperors. The brightly coloured image of David composing the Psalms, dressed as Orpheus charming the animals – sheep, goats and a dog – with his lyre, while a personification of Melody stands close by, is a joyful riposte to all those who sought to destroy images. The setting, with atmospherically blue mountains in the distance, evokes a classical landscape of the type that could be found on the wall of a Roman villa in the time of Hadrian. Just as with the silver plates made for the emperor Heraclius four centuries earlier, so it was natural that the Paris Psalter, an aristocratic work made for an emperor, should include scenes from the life of the king who was the model ruler, a poet–king who could subdue nature with the power of creativity.[19] The Paris Psalter was a hymn of praise to the Byzantine emperor.

It was a golden age not only for the workshops of Constantinople but also for the political fortunes of the empire, a time of expansion and consolidation when territories lost during the struggles of Iconoclasm were regained. The glories of Byzantium at the height of its power were radiated to surrounding lands. Christianity and its images spread north to the Slavic people of the Balkan states, including Bulgaria and Serbia,

David composing the Psalms, accompanied by a personification of Melody, miniature from the Paris Psalter. 10th century CE. Tempera and gold leaf on vellum, 20.3 cm by 18 cm (image size). Bibliothéque Nationale, Paris.

to the eastern Slavs in Kievan Rus' (covering parts of modern Russia, Belarus and Ukraine) and west to the Norman kingdoms of Sicily and southern Italy.[20]

The most original response to the Constantinople style occurred to the north, after the conversion of the Eastern Slavic people at the end of the tenth century. Christianity was established as the religion of Kievan Rus' by Prince Vladimir (who had so marvelled at the sight of Hagia Sophia), who consolidated the bond with Constantinople by marrying Anna, a sister of the Byzantine emperor Basil.

The most celebrated image to arrive in Kievan Rus' was a small twelfth-century panel of the Virgin and Child in an attitude of tenderness, a painting kept in the city of Vladimir, and thus known as the 'Theotokos of Vladimir' ('Theotokos' means 'god-bearer', referring to the Virgin Mary). For artists in Vladimir it was an entirely new way of showing the mother of God, with her head bent in a gesture both sad and caring towards her son. It embodied a very un-Roman spirit of human compassion, a look of spiritual awareness that had appeared first in the icons of Sinai hundreds of years earlier, and was copied endlessly by painters.

Greek painters followed in the wake of this talismanic object, travelling slowly north, paying their way with commissions for large wall paintings in churches. One of these itinerant painters, Theophanes, was renowned for paintings looking like the glass mosaics in the churches of Constantinople. The glitter of mosaics was replaced by the effect made by rapid brushstrokes – it was after all much easier to carry around painting equipment than a portable mosaic workshop. Theophanes was known for the image of Christ Pantocrator that he painted on the walls of the Church of the Transfiguration in the city of Novgorod, the other great city of Kievan Rus' alongside Kiev.

However, it was in the paintings of a pupil of Theophanes that the Byzantine style was to have its greatest interpretation. Andrey Rublev was a monk who spent most of his working life around Moscow and died in the Andronikov monastery there in 1430. He is said to have painted a copy of the Theotokos of Vladimir, used to replace the original when it was taken to Moscow, but the depth and breadth of human life, the sense of suffering and the promise of salvation that he conveys took him far beyond Byzantine convention. His paintings of the archangel Michael, St Paul and Christ that he painted for an iconostasis (the wall of paintings separating nave from sanctuary in an Orthodox church) were discovered in the Cathedral of the Dormition at Zvenigorod, and may well have been painted there. Rublev's Christ casts off the last vestiges of borrowed, Roman authority and confronts us directly with his human dignity and compassion. His frontal gaze echoes the earliest religious paintings, the wall paintings on the baptistery and synagogue of Dura-Europos, with their wide-eyed appeal to the faithful. It was an appeal that found a similar look in religious imagery everywhere. Rublev's portraits are closer to images of the Buddha than to official Roman portraiture and its Byzantine offspring.

As Rublev was changing the face of Christian painting in the Slavic north, Constantinople itself was in decline. It had been occupied by Crusaders two hundred years earlier, and many of the city's treasures had been looted, so that a century later one emperor could complain that there was nothing left in the treasury 'but dust and air and, as they say, the atoms of Epicurus'.[21] Added to this

was the ever-present threat from the Ottoman empire to the east. By 1453, when the Ottoman Turks finally overran Constantine's city, the Byzantine world was largely dispersed, carried by the spread of Orthodox Christianity to Bulgaria, Serbia and Kievan Rus'. With a few notable exceptions, notably the frescoes and mosaics at the church of the Chora monastery in Constantinople, the energy of Byzantium had been transplanted elsewhere.

From their earliest, modest appearance in the catacombs of Rome, and in secret houses in the Syrian desert, the images of Christianity had come a long way. Further still than the Slavic north, they were carried west, to the rugged coasts of Ireland and England and south, into Africa, through Egypt, over the Sahara to the Guinea Coast, and through Nubia to Ethiopia. They seemed now very far from their origins in old Rome; and yet one of the greatest transformations of Christian imagery, which took place in the towns and cities of the Italian peninsula, was founded precisely on a return to the Roman and Greek world – a 'rebirth' of antiquity, as it much later became known – and a new faith in nature and the visible world.

Christ the Redeemer, central panel of the Deësis Tier, by Andrey Rublev. Early 1400s. Tempera on panel, 158 cm by 103.5 cm. Tretyakov Gallery, Moscow.

9

The Name
of the Prophet

In 762 al-Mansur, a caliph of the Abbasid dynasty, laid the foundation for a new city on the west bank of the River Tigris. Called Madinat al-Mansur (later Baghdad), it was perfectly round and built with bricks each weighing nearly two hundred pounds. Four lofty iron gates at the cardinal points, leading to the far-flung cities of the empire, were of such great weight that they required a small army to open and close. Al-Mansur wished his capital to be greater than the Sasanian palace of Ctesiphon, with its vast brickwork arch, and the ancient city of Babylon, both in ruins near by. At the centre of al-Mansur's Baghdad was the Caliph's Palace, known as Qasr Bāb al-Dhahab ('Golden Door Palace'), a magnificent and ornate building containing a throne room in the shape of a perfect cube, surmounted by a green dome, the so-called 'crown of Baghdad', visible against blue skies over all the minarets and towers of the surrounding citadel, and on top of which was a figure on horseback holding a lance, who turned in the wind, it is said, to show the direction from which al-Mansur's enemies were approaching.

The Abbasids were the second great dynasty of Islamic rulers in the Arab lands. They followed in the footsteps of the Umayyads, who had begun building the new faith of Islam into a mighty empire to the south of the Roman and Persian empires. The exile of the Prophet Muhammad with his followers from the dry stony town of Mecca, in western Arabia, two hundred miles north to the oasis settlement of Yathrib, later known as Medina – the *hijra* (the Arabic word for 'emigration') – marks the beginning of the Islamic calendar, in 622 CE. The Arab conquests, under the banner of jihad, or 'holy war', following the death of the Prophet Muhammad, took cities from Byzantium in Syria and Palestine, including Jerusalem and Antioch, and overran the Persian empire shortly after, putting an end to Sasanian rule. The Islamic empire at its height was a grand sweep of cultures and languages, stretching from al-Andalus (the Iberian peninsula under Muslim rule) in the west, through the province of Ifriqiya (North Africa), to cover most of western Asia, as far as the Indus Valley in the east.

Just as the first Christians borrowed and adapted from the Roman empire, so too Islam looked to the Byzantine and Persian empires, adjusting their images to the needs of a new faith.

One of the earliest acts of borrowing was also the most spectacular. Some years after the conquest of the holy city of Jerusalem by the Muslim Arab armies, a domed mosque was built on the orders of 'Abd al-Malik, an Umayyad

caliph, marking the victory of Islam over Christianity and Judaism, both of which held Jerusalem as their most sacred city. 'Abd al-Malik's dome was built on a large stone terrace, a holy and mystical site, where once the Temple of Solomon had stood. All that remained of this earlier building, destroyed by the Babylonians, was the rock that had reputedly served as a cornerstone, and which had a number of mystical associations – as the birthplace of Adam, and also as the rock on which Abraham had taken his sons to be sacrificed. For Muslims it was the place from which the Prophet had departed on his night journey to heaven, and it was around this rock, a large flattened outcrop of stone, with a square chamber cut within, that 'Abd al-Malik's domed mosque was raised.[1]

With its domed, centralised structure, surrounded by an octagonal colonnade, like the Domus Aurea, the golden church that Constantine had built at Antioch, and also in the rich mosaic decorations of the interior, the Dome of the Rock borrows from Byzantine church-building. Inside, you might think of San Vitale in Ravenna, copiously decorated with mosaics, or a Roman-Christian mausoleum such as Santa Costanza in Rome. Yet unlike Byzantine churches, with their pictures of emperors, saints and martyrs, the Dome of the Rock contains not a single image of humans or other animals. Gold and blue mosaic tiles carry a long inscription from the Quran, and an abundance of lustrous mosaics, green against gold and mother-of-pearl, show acanthus leaves, palm trees, vines and tendrils, fruits such as pomegranates, cherries and grapes interwoven with vases and jewellery, crowns, pendants and tiaras.[2] The inscription around the inner wall of the Dome of the Rock proclaims the central beliefs of Islam: the oneness of God; the leading role of the Prophet Muhammad; the position of Jesus as an apostle of God, rather than a messiah; and Islam as a fulfilment of the Judaic and Christian traditions. 'In the name of God, the Compassionate, the Merciful, there is no God but God, one. Muhammad is the envoy of God.'[3]

Caliph 'Abd al-Malik's mosque established the look for Islamic images for centuries to come. Like Buddhism, they were given to symbols and 'imageless' images, not showing the human form but predicated above all on the pictorial use of words.

The Islamic aversion to images is usually traced not to the Quran, which merely warns against the worship of idols, but to the hadith, a collection of the Prophet Muhammad's sayings. It was far from a complete ban, or a call for widespread iconoclasm. Images continued to be used in the secular Arab Islamic world, in the decoration of palaces and on ordinary, non-sacred objects. One story goes that the Prophet Muhammad objected to figurative images on curtains in his house in Medina, but accepted them when the curtains were cut up to make cushions – something to sit on, and therefore less visible than curtains draped from a wall.

THE NAME OF THE PROPHET

The ban on figurative images was also a way of distinguishing Islam from Christianity and Buddhism – making sure Islam stood out as an entirely different faith. From the Islamic perspective, images of Christ and the Buddha were signs of a backward culture, an earlier stage of development. The full revelation of God through the Prophet Muhammad was in no need of such crude and obvious instruments as pictures of people. In Islam, God's will was expressed solely in the words of the Quran, creating a tradition founded for the most part on inscriptions and calligraphy.[4] The written language of these, Arabic, rose alongside Islam as the language of the new empire.

Quran manuscripts were not only books to be read but also, like illuminated manuscripts in Europe, objects of considerable prestige. Their value came from the type of parchment, binding and ink used, but above all from the quality of calligraphy. At first this was an irregular script, Hijazi, named after a region in Arabia, but there soon appeared a more stylised and regular script, Kufic, used for the Dome of the Rock inscription. Letters became stronger, definite shapes that follow the flow of the line, seeming to visualise the chanting intonation of sacred speech. As with the Jewish Torah, the only ornaments in Qurans were non-figurative marks to aid reading and the occasional decorative element to break the monotony of the text. A folio, or page, from one of the earliest Qurans to have survived, made around 800 and known as the Tashkent Quran (from where a section of the surviving manuscript was later kept), shows the highly stylised nature of Kufic, broadly brushed in ink on parchment, thick with the zeal of spiritual revelation.

Such a Quran would have been sent to one of the newly converted villages and towns of the Islamic empire, creating a link with the wider Arab Islamic world and its new capital of Madinat al-Mansur – Baghdad. The cosmopolitan nature of Islam had already been signalled in the earlier Umayyad period, particularly in the secular palace buildings constructed by Umayyad princes in Syria, Palestine and Jordan, agriculturally rich areas previously under Byzantine control. Paintings in the baths of Qasr Amra, in Jordan, show figures including kingly rulers, huntsmen and naked women

Quran folio, from the 'Tashkent Quran'. 8th century CE. Ink on parchment, 58.5 cm by 71.5 cm. Aga Khan Museum, Toronto.

Facade of the Umayyad palace at Mshatta, Jordan. c.743 CE. Limestone, h. 290 cm. Staatliche Museen, Berlin.

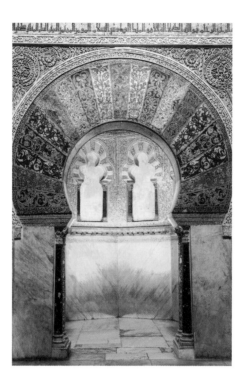

Mihrab in the Great Mosque, Cordoba. *c.*961–976 CE.

bathing – the atmosphere is more that of a Roman villa than a mosque or a church.[5] The ornamental forms on another of these desert palaces, Qasr al-Mshatta, built around the same time in the early ninth century, are more purely ornamental. Either side of the main gateway at Mshatta ran a thick band of ornamentation covering the entire lower part of the wall, a series of triangles filled with a mass of vines and animal motifs, including some representations of human figures. Where in Roman architectural decoration, such as the carvings on the Ara Pacis, plant motifs have spread to cover an entire surface, exuberant swirling foliage like a thick-growing vine, on Islamic façades the carved foliage has become severed from wild nature, transformed into something more geometric and symmetrical, like a formal garden, and one that might be expanded ad infinitum, adapting and transforming as it went. Where Roman buildings define borders and thresholds (think of the triumphal arch), Islamic architecture is given rather to the urge to infinite, borderless expansion.

This might happen over lands, or within the confines of a single building. One mosque, founded in the town of Córdoba in the southern part of al-Andalus, became known for its forest of columns, recycled from older buildings that had occupied the site, which give just such a feeling of borderless expanse, comparable with the vast size of Hagia Sophia or the Apadana at Persepolis.[6] The columns support double-horseshoe arches, animated by red and white striped voussoirs (the wedge-shaped bricks forming the arch), which create a labyrinthine interior predicated on the apparently endless repetition of the basic unit of column and arch. The caliphs of Córdoba were descended from the Umayyads, exiled from Syria, and their architecture is steeped in a sense of longing for their homeland. Repetition and expansion also shaped a new type of arch, in which the main curve is broken up into a series of smaller arches (known as 'poly-lobed') with the implication that such subdivision could go on for ever.

The same effect of endless repetition appears at Córdoba in the decoration of the mihrab, the niche-like opening showing the direction of the Kaaba at Mecca (in modern Saudi Arabia), the centre of Muslim prayer and pilgrimage. The inscription around the mihrab, designed as a separate, empty chamber viewed through an elaborate horseshoe arch, is taken directly from the long inscription around the walls of the Dome of the Rock in Jerusalem.

As well as the mihrab, showing the direction of *salah*, or prayer, mosques such as those built in Tunisia and Cairo to consolidate the Arab presence in North Africa were built around large open courts, open to the world in a way that

THE NAME OF THE PROPHET

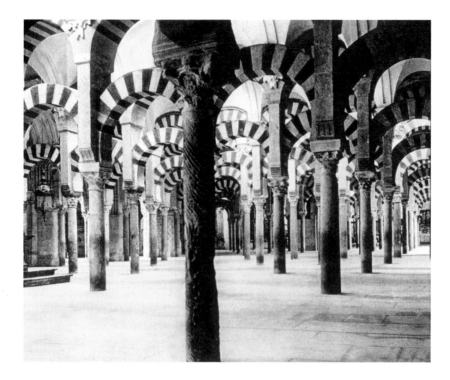

Great Mosque, Cordoba.
785−988 CE.

recalls Greek temple architecture; and, like many of the buildings of the ancient world, the alignment, pointing to the Kaaba, was determined by celestial objects, by the position of the rising sun at the winter solstice. The Kaaba itself was aligned with the heavens, with the summer solstice, and with the rising of Canopus, the second brightest star in the night sky, known in Arabic as Janūb, meaning 'south'.[7]

Mosques were also distinguished by the tall towers, or minarets, from which the muezzin summoned the faithful to prayer. At Samarra, a city north of Baghdad, the squat, spiral form of the minaret is circled by a narrow ramp, giving a precipitous ascent to the top. More than architecture, it seems rather a form of nature, geometrically contrived and evolving upward with the organic unity of a living thing – it might have been imagined by a Greek philosopher as much as by an Islamic architect.

One of the greatest of all mosques was constructed in the ancient Persian city of Isfahan. The Masjid-e Jameh, or Great Mosque (or Friday Mosque), was a revolutionary building for Islamic architecture, and a high moment for the Turkic Seljuks, who founded their dynasty shortly after 1000 CE, some years after converting to Islam, with its centre at Isfahan.[8] Where the Córdoba mosque is a forest of columns, Isfahan offers an empty space, shored up by great ornamental niches – four large iwans, or monumental arched alcoves, which surround a central court. The decorated iwans are like giant amplifiers of the message of the Prophet, and receptors for the supplications of the faithful. Their arching forms can be traced back to the great arch of the Palace at Ctesiphon, that symbol of ancient Persian grandeur that had inspired al-Mansur to rivalry in his perfectly round city of Baghdad, repeated by the Seljuks to signal their power in the region. The court is surrounded by a sequence of arches, on two levels, behind which are bays surmounted by domes. The Masjid-e Jameh was built, like the cathedrals of western

Europe, over a long period of time, so that it is difficult to ascribe a definite moment to its construction. Where the Christian church appears as a house for the divine presence, the mosque, particularly in the form of a large open court, with echo-chamber-like iwan-niches, is an architecture of openness and longing.

This spirit of openness was also an intellectual quantity, reflected in a curiosity that underlay a new era of science and scholarship. The capital of al-Andalus, Córdoba, was the scene of a flowering of culture under the Islamic rulers, following the arrival of the Arab armies on the Iberian peninsula in the early eighth century. Tolerant of the Christian and Jewish minorities, and zealous promoters of philosophy and learning, the Muslim rulers allowed western Europe, for so long dominated by Germanic tribes, to experience its first great moment of enlightenment, spurred on by the Islamic world. Like the cities of Damascus, Cairo, Baghdad and Chang'an, Córdoba, along with Seville and the old Visigoth capital of Toledo, became a centre of literature and science.

It was in Baghdad, however, from around the eighth century to the tenth, that the great age of Islamic scholarship and scientific discovery unfolded. Ancient wisdom was recovered, thanks to crumbling texts from India, Persia and Greece, translated into Arabic by scholars and scribes and thus preserved.[9] It was a scientific revolution, driven by a hunger for knowledge of geometry and mathematics, astronomy and medicine. There was also a practical side – the first paper mill was established in Samarkand, on the road to China, thanks to an Abbasid victory in battle over the Chinese in the mid-eighth century, which led to Chinese prisoners-of-war imparting their knowledge of the manufacture of paper.[10] Ideas could now be readily written down, and more easily kept and transferred.

One of the greatest of the Arabic scholars was born in Basra, Iraq, in the mid-tenth century. The most important discoveries of Ibn al-Haytham (known as Alhazen to European scholars) were in the field of optics, the study of vision and of the human eye.[11] Why does the moon look larger nearer the horizon? For centuries it was thought that it was due to the earth's atmosphere, but Ibn al-Haytham correctly saw it as a result of the psychology of seeing – up in the sky the moon is isolated and appears small. Next to the horizon there are mountains, trees and houses, all of which by comparison make the moon appear large.

Ibn al-Haytham's most stunning discovery was even more simple. How do we actually see things? How does an image of an object pass from that object to our eye? The Greeks got it largely wrong – they saw the eye as being like a torch, shining out beams of light that were reflected back from objects. Ibn al-Haytham, in his *Book of Optics*, the greatest treatise on vision since Ptolemy's *Optics* (*c.*160 CE), wrote that it was the opposite – rays of light emitting from objects fall on the eye. Although an understanding of the way images are formed within the eye and transmitted to the consciousness was to come some centuries later, Ibn al-Haytham's discovery was to have a profound influence on artists in the Western world.

It was to have less of an impact on Islamic artists, who were far less dependent on direct visions. It was rather the science of geometry and the ornamental impulse of calligraphic images that drew together images made over a wide sweep of Islamic Europe and Asia.

This love of geometry, however, was in time joined by a more pictorial storytelling impulse. The Fatimid dynasty (so-called as they claimed descent from Fatima, daughter of the Prophet Muhammad) ruled in North Africa, first

Mosque lamp made for Sultan Hasan. c.1361. Gilded and enamelled glass, h. 38 cm. Museo Calouste Gulbenkian, Lisbon.

in Ifriqiya (the coastal region around Tunisia), Sicily and Syria, and then from the middle of the tenth century in the heartland of Egypt. Fatimid Cairo became the centre of the Arab Islamic world, whose artisans' workshops soon came to rival those of Constantinople. The strict geometric forms of Umayyad and Abbasid decorative imagery slowly become populated with figures, animals and humans, appearing on the borders of textiles, in carved wooden panels and on rock-crystal ewers – all specialities of the Fatimid workshops and taken up by the Mamluks (former slaves of Turkic origin), who followed them in ruling Egypt and the Levant during the thirteenth century. The brightness and illumination of glassware, enamel decoration and glazed ceramic tiles easily match the opulence of Byzantine decoration. Mosque lamps with tall flared necks and squat bases, covered in inscriptions in blue and red against a golden ground, were made in the glass workshops of Mamluk Egypt and Syria. They often carried an inscription naming the sultan or emir who commissioned them, along with the Ayat al-Nur, or 'Verse of Light', from the Quran: 'God is the Light of the Heavens and of the Earth. His Light is like a niche in which is a lamp – the lamp encased in glass – the glass, as it were, a glistening star.'[12] Lamps produced for the Sultan Hasan in the middle of the fourteenth century are among the largest ever made, and were used to illuminate the vast mosque and madrasa (religious school) that he built in Cairo.

Glazed ceramic tiles were similarly brilliant in their visual effect. Often carrying inscriptions, these tiles form the connection between the written word

of Islam and its architecture. They also show some of the most delightful images of nature before the age of Islamic and Persian manuscript illumination, such as the seven gazelles galloping across the large lustrous star-shaped tile made in the old Persian town of Kashan, near Isfahan. Lines from the Quran are inscribed around the border, praising the Lord 'Who bringeth forth the pasture / And reduceth it to dusky stubble'.[13] The bright, lively gazelles might reflect a more worldly source, such as the folk tales collected in the *One Thousand and One Nights*. The lustrous surface of such tiles is the result of metallic substances used in the glazing, a process developed in Egypt in the period before Islamic rule and known as lustreware. These luxurious, reflective surfaces came to epitomise Islamic decoration, as spectacular as the stylised Kufic inscriptions or the complex geometric patterns of tiles and architectural forms.

Eight-pointed star tile from Kashan, with seven dappled gazelles. c.1260–1270. Lustred fritware, 30.1 cm by 31.2 cm. British Museum, London.

THE NAME OF THE PROPHET

Iskandar (Alexander) and the Talking Tree, from the Great Mongol Shahnama. c.1330. Ink, watercolour and gold on paper, 40.8 cm by 30.1 cm. Freer Gallery of Art, Washington.

Rustam sleeping while Rakhsh fights a lion, folio from a manuscript of a Shahnama, attributed to Sultan Muhammad. c.1515–1522. Paint on paper, 31.5 cm by 20.7 cm. British Museum, London.

THE NAME OF THE PROPHET

The Seduction of Yusef, by
Bizhad. 1488. Opaque pigment
on paper, 30.5 cm by 21.5 cm.
National Library, Cairo.

Elias and Prince Nur ad-Dahr,
from the Hamzanama. 1564–
1579. Opaque watercolour on
cloth, 81.4 cm by 61 cm. British
Museum, London.

In the early thirteenth century a new force swept through Persia and the Islamic world. A band of nomads from the east, known as the Mongols, were led by the great warrior Chinghis (or Genghis) Khan. At first they overran the cities of eastern Persia, Samarkand and Herat. Then, in 1258, led by Chingis's grandson Hulagu, they penetrated the defences of Baghdad, destroying the city and mercilessly slaughtering its inhabitants. It was the end of the Abbasid dynasty and signalled the demise of Arab dominance of western Asia.

The Mongol empire grew into a power across Asia. Kublai Khan, another of Chingis's grandsons, founded the Yuan dynasty in China, taking control of the entire country after defeating the Southern Song dynasty in 1279. In Kievan Rus' the Mongols ruled as the Golden Horde, and in central Asia as the Chaghadai Khanate. Those that ruled in Persia, after the fall of Baghdad, were known as the Ilkhanate.

Despite their reputation for brutality ('they came, they uprooted, they burned, they slaughtered, they plundered, and they left', wrote one contemporary)[14], the arrival of the Mongols in Persia was a moment of renewal for the painted image. Where the Arabs had drawn the ancient Persian traditions into the orbit of the old Mediterranean world, the Ilkhanid Mongols swung the influence back to central Asia, and to China, ruled by the Mongol Yuan dynasty. Trade routes were reopened, and along them artistic influences began to flow. Imagery arrived from China – dragons, phoenixes, lotus blossom, cloud bands – and became part of the Islamic imagination. In return went textiles and carpets, and also a blue cobalt ore from Persia used to create a coloured glaze, one of the most distinctive of Chinese ceramics, in the form of blue-and-white porcelain. Chinese artists travelled to western Asia, spreading the influence of one of the oldest traditions of painting. The sixteenth-century Persian historian and royal librarian Dust Muhammad wrote, in a preface for an album of calligraphy and painting, that a 'veil had been lifted' from Persian painting during the reign of Abu Sa'id, the ninth ruler of the Ilkhanate, in the early fourteenth century.[15]

Soon after their arrival in Persia the Ilkhanid rulers began commissioning illustrated works of classic Persian poetry, above all the *Shahnama*, or Book of Kings, the great Persian epic, written by the poet Firdausi around 1010.[16] A chronicle of the heroes of Persian history, legendary and real, it ends with the murder of the last Sasanian king and the arrival of Islam.

Of the early illustrated versions of the *Shahnama* that survive, the 'Great Mongol *Shahnama*' stands like a monument at the beginning of the classical period of Persian painting.[17] It was made in Tabriz (in modern Azerbaijan), the Ilkhanid capital. Surviving illustrations, now separated, show the great imagination of Ilkhanid artists. Many of them depict the story of Iskander, the Persian name for Alexander the Great. The Mongol rulers of Persia were seeking a past hero, a successful foreign invader, with whom they could identify – Alexander fitted the bill, as he had for so many other empire-builders. In the *Shahnama* his conquest of the known world is transformed into a great and marvel-filled journey. At the end of the earth he comes across a talking tree, of two twisted trunks – one male, which speaks by day, and one female, which speaks by night. The tree warns him of his impending death, and the futility of his projects of conquest. 'Death in an alien land / Will come ere long, crown, diadem, and throne / Grow tired of thee.' The fantastic rocks and landscape in which Iskander is shown are part of a

new vision of nature that was to become a classic feature of Persian manuscript painting. In a later manuscript painting, made in Tabriz at the beginning of the sixteenth century, the hero Rustam sleeps in a fantastical landscape while his horse, Rakhsh, kills a lion. Trees, rocks and plants seem to be alive.

Classical Persian painting reached a summit in the figure of Bihzad, who worked in the cosmopolitan studios of Herat in the decades around 1500, and died later in Tabriz. His miniatures illustrating poetic manuscripts create a world of vivid and fascinating perfection. Bihzad shows a different vision of Islam, that of the Sufis, a mystical sect that turned the outward, conquering spirit of the Prophet Muhammad into something more inwardly reflective. He often painted images of Sufis and Dervishes, and illustrated poems by Sufi writers, such as the *Bustan* ('The Orchard'), by the thirteenth-century Sufi poet Sa'di. One of these illustrations shows Sa'di's version of the story of Yusuf and Zulaykha, an equivalent of the biblical story of Joseph and Potiphar's wife. Zulaykha lusts after the beautiful Yusuf, and in order to seduce him builds a palace with seven locked chambers, the innermost decorated with images of her and Yusuf making love. Bihzad shows the moment where Yusuf realises the trap and escapes, losing his cloak which Zulaykha grabs as he runs away.

With Bihzad we have entered another epoch of Persian painting, under the Safavid rulers, where Herat had more in common with the city-states of the Italian peninsula than with the old world of al-Mansur's Baghdad. An even closer relationship with the West, as we shall see, was evident in the other great Islamic empire in western Asia, the Ottoman empire, with its heartland in Anatolia, which was at its height after the capture of Constantinople and conquest of the Mamluk empire.

Richer than both these Islamic dynastic families – the Safavids and the Ottomans – were the Mughals, a Muslim dynasty who came to power on the plains south of the Himalayas, in modern India. Mughal emperors were known for the wealth and splendour of their courts, and none more so than Akbar, who reigned for almost half a century from the 1550s. In politics he expanded and consolidated the empire, and through trade and conquest enriched it, but his most lasting achievement was the commissioning of an illustrated book known as the *Hamzanama*, the 'Adventures of Hamza'. It came to define an entire tradition of Mughal painting, and dominated the production of the royal painting studios for over two decades.

The *Hamzanama* was a fantastical undertaking. Like the *Shahnama*, it is a collection of stories handed down by oral tradition, concerning the exploits of the Persian hero Amir Hamza, who distinguished himself in fighting on behalf of his nephew the Prophet Muhammad.[18] The fourteen hundred paintings illustrating the *Hamzanama* were made in the Mughal royal painting studio by Indian painters under the direction of two Persian artists, first Mir Sayyid 'Ali, and then 'Abd al-Samad, both of whom had travelled to India to work for Akbar, bringing with them the richly ornamented style of Persian painting. One *Hamzanama* page shows the prophet Elias, or Elijah, rescuing a Mughal prince, Nur ad-Dahr, from drowning in the sea – the real subject, however, is the dense frieze of nature that surrounds them: the thick forest with its variety of trees and perched peacock; the flowers that grow on the rocks where wading birds strut;

and the choppy white wavelets of the water, in which aquatic creatures cavort around the action of the scene. It may well have been painted by the Indian artist Basawan, one of the greatest Indian painters of Akbar's court, who was famed for bringing an awareness of European oil painting to the products of Akbar's royal painting workshops.

The great achievement of the *Hamzanama* artists, and the close personal involvement of Akbar, was described by the historian Abu'l-Fazl ibn Mubarak:

> Such excellent artists have assembled here that a fine match has been created to the world-renowned art of Bihzad and the magic-making of the Europeans. Delicacy of work, clarity of line, and boldness of execution, as well as other fine qualities have reached perfection, and inanimate objects appear to have come alive.[19]

The magic-making of European painting would have been known to Mughal artists through the paintings and prints and illustrated books brought in by Dutch and English traders, as well as by Jesuit missionaries.[20]

It was in architecture, however, rather than painting that the supreme monument of Mughal inspiration was created – by Akbar's grandson the emperor Shah Jahan. On a large marble plinth in a formal garden on the banks of the River Yamuna, Shah Jahan elevated a monumental tomb for his wife, Mumtaz Mahal, who died just hours after giving birth to her fourteenth child. As the mist rolls off the river, and with the cool marble platform underfoot, the building rises like a pale apparition against the unbroken blue sky. To either side of the tomb are large alcove-arch *iwans*, the fine white marble carved with inscriptions from the Quran evoking the idea of a celestial paradise. The name of the monument, however, the Taj Mahal, or 'crown palace', suggests that this was also a monument to Shah Jahan himself, and his royal power.[21] And indeed it was in the Taj Mahal that Shah Jahan was buried, perhaps in accordance with his wishes, his cenotaph placed next to that of Mumtaz Mahal. 'Shah Jahan, the King Valiant', reads the inscription on his grave in the crypt of the tomb, 'May his grave ever flourish, and his abode be in the Gardens of Paradise!'[22]

The whirlpool of ideas that dominated the first epoch of Islam under the Umayyads and Abbasids, borrowing and adapting from the Byzantine and Persian artists they conquered, and looking further back still to the architecture of antiquity, had by the sixteenth century become a series of regional styles. In the three Islamic superpowers of western Asia – Mughal India, Safavid Persia and Ottoman Turkey – distinct types of image and shapes of architecture appeared, so that it is hard to trace any direct link between two of the greatest Islamic buildings, the Taj Mahal in the seventeenth century and the Dome of the Rock from almost a thousand years earlier, despite their apparent similarity – both centrally planned domed buildings adorned with Quranic inscriptions, raised on large plinths.

What, then, draws all buildings, objects and images together so that they can all be described as 'Islamic'? It is certainly not a matter of style, although geometry and calligraphy remain common factors. The real connection is less a

matter of appearances, more the sense of a shared purpose, and a knowledge in the mind of artists of something larger and more exciting than any local tradition. It is also a new vision of nature, transformed as endless design, and one that has remarkable parallels with the vision of nature arising from Celtic traditions in the far west of Europe, in illuminated manuscripts and on metalwork, although once again it is impossible to trace any direct link. There was a new feeling of being in the world, a renewed sense of human life as part of nature. Like the Hellenistic world forged by Alexander the Great, the Islamic world was illuminated and connected – but on a scale far larger than even Alexander could have imagined.

Taj Mahal, Agra. 1631–1648.

THE NAME OF THE PROPHET

10

Invaders and Inventors

Seen from the vast imperial domains of Byzantium and Islam, a small damp island in the western ocean might appear an unlikely place to look for art elsewhere. Yet in the centuries after the collapse of Roman rule there appeared in Britain a remarkable new vision of the natural world: geometric patterns, complicated interlace and animal motifs on elaborate metalwork, illuminated manuscripts and carved stone monuments.

Celtic traditions preserved in Ireland (which was never conquered by the Romans), where the style originated and flourished in monastic workshops, combined with those of the Germanic tribes, the Angles, Saxons and Jutes, who settled the west of Britain from the end of the fifth century. This heady mix of styles was fired by new spiritual beliefs. The first Christian mission from Rome, sent by Pope Gregory, arrived on the island in 597 CE, establishing a Roman Christian tradition with its centre at Canterbury. Roman Christianity provided a link to the Byzantine world, and with it to western Asia beyond. The mix of Celtic, Anglo-Saxon, Roman and Christian traditions created a unique decorative style that spread in its turn over the European mainland.

This new style was carried by the weighty manuscript volumes painted, or illuminated, in the scriptoriums, or writing rooms, of monasteries. They were for the most part Gospel books, the four biographies of Jesus of Nazareth, written by Matthew, Mark, Luke and John. They had a practical purpose, for use during church rituals, but were also expressions of wonder at a divinely created world. Many of the highly decorated Gospel books begin with an '*incipit*', marking the inception of the work, in which the opening words are transformed into spectacular

images of praise. The *incipit* of one Gospel book, made on the island of Lindisfarne, off the north-east coast of England, transforms the first letters of the books of St John – 'IN P' – into a microcosm of the world, a vortex of nature, filled with interlacing vines, animal forms, spinning three-legged wheels (the Celtic *triskele*), even a human head, whose voice we might imagine over the melodious lines spun all around, intoning the first words of John's book: *In principio erat verbum et verbum erat apud Deum*. 'In the beginning was the Word and the Word was with God, and the Word was God.'

The Lindisfarne Gospels, as they are known, were created by Eadfrith, the bishop of Lindisfarne. To design, paint and write the text of such a book

Lindisfarne Gospels, decorated initial introducing the Gospel of St John. *c.*700 CE. Parchment, approx. 36.5 cm by 27.5 cm. British Library, London.

was a colossal task, which would have taken years – large illuminated books such as the Lindisfarne Gospels were ordinarily the product of a small team of artisans. Perhaps it was the isolation of Lindisfarne that set Eadfrith to this task, the open vistas of the North Sea with its ever-changing light a spur to his imagination. Eadfrith was a great inventor. He had to be, as there were so few models on which to draw for his designs. The designs he traced on parchment using a graphite nib were the earliest recorded use of what was to become the lead pencil, and a black ink made from iron salts and oak apples (a type of growth on an oak tree caused by gall wasps). The pages were coloured with a multitude of pigments: red lead and indigo; verdigris green made from copper and vinegar; orpiment yellow from arsenic; a purple made from lichen or the dog whelk sea snail; white from crushed shells; and black from carbon, perhaps a piece of wood taken from a fire. These pigments Eadfrith mixed with beaten egg white (a medium known as glair) to spread, fix and dry the coloured substances.[1]

For the monks who first saw them, such elaborate, richly coloured pages might well have been shocking, too vivid for the solemnity of their daily rituals. Earlier painted books from the east, such as an illustrated version of the book of Genesis, made in Greece in the fifth century (known as the 'Cotton Genesis'), and another Genesis with pictures, made in Syria some decades later (the 'Vienna Genesis'), show how artists and scribes worked together to combine images and words. Yet Eadfrith's book, along with other illuminated books, including the Book of Kells, made in Ireland around a century later, show an altogether more complex and rich integration of images and words. Where the early Christian artists to the east solved the problem of the very unvisual quality of the Bible by drawing on the image world of the Roman empire, in Britain and Ireland the solution was to turn words themselves into images, held within a complex vision of the natural world.

Such a vision linked the monasteries with the warriors and royalty of the Anglo-Saxon kingdoms. When Raedwald, the king of East Anglia, died in 620, his body was placed in a wooden ship and surrounded by gold and garnet

Purse-lid, from Sutton Hoo. Early 7th century CE. Gold, garnet and glass, w. 8.3 cm. British Museum, London.

INVADERS AND INVENTORS

metalwork, Roman silver, a stone sceptre and ironmail coat, a decorated shield and great spiralling drinking horns, for the imbibing of ale and mead in the Anglo-Saxon feast hall, fashioned from the horns of an auroch. These burial treasures (now known as the Sutton Hoo hoard) show Raedwald's power, but also the trading networks across Europe, into the eastern Mediterranean, as far as India, the source of the red garnets used by the craftsman who created the astonishingly intricate metalwork buckles and clasps.

A gold clasp, originally from a leather coin pouch, shows a strange, eagle-like creature that appears to be holding a smaller bird, their shapes formed by rolling curves, geometrically plotted. On either side two warriors grapple with wolf-like beasts. It is the 'Master of Animals' motif that can be traced back through Scythian metalwork to the earliest images on Mesopotamian seals. Yet the craftsmanship of the clasp is far beyond anything these earlier cultures could have imagined. Mounts, buckles, clasps and weapons forged by the Anglo-Saxons and the Franks (the Germanic tribe who lived in the Rhine region on the edge of the western Roman Empire) were decorated with gold filigree, cloisonné garnets and millefiori (mosaic) glass, with complex interlaces of endless knots, stylised animals and humans, all made with an extraordinary skill and minute precision, such that their bearers must have considered them first as marvels of technology, made, like antique gems, with the naked eye and by daylight, before admiring the brilliance of their decoration.

Such brilliance shone all the brighter for the landscape in which the monasteries and royal palaces stood. In the Anglo-Saxon imagination, at least, it was less a glittering paradise than a sombre, threatening world, shot through with nostalgia for better days. This darkening atmosphere is evoked in *Beowulf*, the longest of the Old English epic poems, written around the time that the Lindisfarne Gospels were created. The story of Beowulf's struggle and defeat of the monster Grendel takes place in a world as labyrinthine as a decorated Gospel book or goldsmith's brooch – a world of shadows and gleams of gold and silver, in which fear and violence were the intimate counterparts of beauty and ornament:[2]

> In off the moors, down through the mist-bands
> God-cursed Grendel came greedily loping.
> The bane of the race of men roamed forth,
> hunting for a prey in the high hall.
> Under the cloud-murk he moved towards it
> until it shone above him, a sheer keep
> of fortified gold.[3]

And yet the landscape was changing. The old Roman buildings may have been falling into disrepair, but a new religious architecture was appearing wherever

Christianity spread, in monasteries and churches built of wood and stone. Public displays of Christian imagery became more common as the new beliefs took hold.

Carved stone crosses towered in the landscape, their presence matched only by the standing stones from very ancient times. One of these stone crosses, carved in the middle years of the eighth century and placed near a church on the northern coast of the Solway Firth, in Anglo-Saxon Northumbria (now Scotland), was carved with biblical scenes and covered with inscriptions. It was one of the many carved stone crosses that began to appear in the landscape of Britain, and in Ireland at Kells, Clonmacnoise and Monasterboice some time later.[4] High crosses were placed 'on the estates of the nobles and the good men of the Saxon race', the nun Huneberc wrote, and were 'held in great reverence, [each one] erected on some prominent spot for the convenience of those who wish to pray daily before it'.[5] They served not only for prayer but also as markers for a community, impressive objects that would exist in the memory, perhaps the first thing travellers would see when they returned from a long voyage, the stone darkened by rain and cold to the touch.

An inscription in runic script runs up either side of the Northumbrian cross (later known as the Ruthwell Cross). It is adapted from *The Dream of the Rood*, a visionary verse probably written by a monastic poet, and first recorded in a tenth-century manuscript, in which the tree used to make the Rood, the crucifix on which Jesus Christ died, speaks in the first person:

> They drove me through with dark nails:
> On me are the deep wounds manifest,
> Wide-mouthed hate-dents.
> I durst not harm any of them.
> How they mocked at us both!
> I was all moist with blood
> sprung from the Man's side
> After he sent forth his soul.[6]

For a tree to speak is for nature itself to have a voice, telling a tragic story of sacrifice and murder. The rood is a stand-in for Everyman, an equivalent to Simon of Cyrene, the bystander in the Gospel narratives who carried the cross for Christ on the way to Golgotha.[7]

In one of the carved panels Christ stands in majesty above two creatures whose features, worn by time, are difficult to discern. (They may well be otters, an allusion to the story that St Cuthbert's feet would be warmed and dried by kindly otters after praying by the sea at night.) Their paws are crossed in a sign of acclamation of Christ.[8] 'Beasts and dragons recognised in the desert the Saviour of the World' runs the runic inscription alongside, referring to the story of Christ during his period of fasting in the Judaean desert, the animals acknowledging his divinity.[9] Other carvings evoke the world of Christian asceticism and monasticism, with the hermits Paul and Anthony, the founders of the first monastery, and Mary Magdalene, who in Christian legend became a cave-dwelling recluse.[10] The form of the cross and the carved figures may have been Roman in origin, but the monastic imagination was closer to the Celtic Christianity that had arrived from

Ireland – the Ruthwell Cross combines the two traditions. The carving of Christ between two animals transforms the older 'Master of Animals' image, showing the confrontation between humans and other animals, into an image of accord and redemption.

The sense of the Roman past was still strong in Britain, embodied in the dilapidated monuments of a once powerful empire. The Old English poem *The Ruin*, by an unknown poet of the eighth or ninth century, and which survives only in fragments, records the impression made by these remains in the melancholy tones of a Sumerian city lament:

> There were splendid palaces,
> and many halls with water
> flowing through them; a
> wealth of gables towered
> aloft. Loud was the clamour
> of the troops; many were
> the banqueting halls, full of
> the joys of life – until all was
> shattered by a mighty fate.[11]

Ruthwell Cross. c.8th century CE. Sandstone, h. 550 cm. Shown here in the churchyard of Ruthwell Church, 1914; current location Ruthwell Church, Dumfriesshire.

If such splendid palaces might fall into decay, what of the monasteries with their luxurious manuscripts and ornamentation, the churches with their elaborated architecture and liturgy? Would these endure to prove the eternal glories of heaven? Or would they too become ruins?

It happened sooner than any Angle, Saxon or Jute might have wished. The first sight of the dragon-headed longships from Scandinavia off the shores of Britain was terrifying. The monks of Lindisfarne were taken by surprise by a Viking attack in the year 793. Their monasteries were plundered and the religious folk fled in mortal fear, taking with them what they could, including the greatest of all their treasures, Eadfrith's Gospel book.

As the elaborate carvings and wrought metal ornaments on their ships and swords warned, the Vikings rarely came in peace. Yet the ornamental style of the ships' prows and their swordheads and buckles would not have been completely unfamiliar to the inhabitants of Lindisfarne. The Anglo-Saxons, after all, were northern Germanic and Scandinavian people who had arrived just three centuries earlier, and whose minds were just as impressed with intricate designs and bold animal ornament. A bronze weathervane, incised with scrolling, bud-like shapes that form elaborate beasts, and topped by a crested creature similar to an ancient chimera, was one of the decorations attached to the prow of a fearsome

Viking longship. Streamers, tied to holes around the edge of the weathervane to give the speed and direction of the wind, are echoed in the billowing foliage surrounding the carved creatures. Gilded and painted animals decorated the sides and masts of the ships, so that each ship must have appeared a living thing – 'most like to a bird, it floated over the billowing waves, urged onward by the wind', as the *Beowulf* poet wrote. This bronze ornament came from the Scandinavian lands where *Beowulf* was set, but might well have been found in the burial hoard of an Anglo-Saxon king.

The illuminations of the Lindisfarne Gospel, the Sutton Hoo clasp and the high stone crosses of Britain and Ireland were all in their own way revivals of older styles. A half-hidden past was being rediscovered and seen anew.

With the high stone crosses it was the figure-carving of Roman sculpture that was being remembered. As for manuscript illumination and metalwork, Anglo-Saxon artists drew on the Germanic, Celtic and Mediterranean imagination. Older types of imagery had never quite disappeared from the landscape of the British Isles, or from the Mediterranean south, in Italy and Spain. But it was in northern Europe, in a region where Roman remains were least in evidence, that the most influential revival took place, in the court of Charlemagne, king of the Franks.[12]

Charlemagne, who was the first ruler to unite much of Western Europe, called his master plan the *renovatio imperii Romanorum*, the renewal of the Roman empire, culminating in his imperial coronation in Rome on Christmas Day 800. He was later called the first Holy Roman Emperor: the one-and-only ruler of a fully Christianised West, the Carolingian empire, following the end of the western Roman Empire. His grand scheme of *renovatio*, or renewal, was laid out in legislation and reforms aimed not only at Christianising the Franks, the people who had dominated Gaul since the Roman departure, but also at educating them, by the promotion of writing and the recovery of ancient texts – although Charlemagne himself, despite concerted attempts, never learned to read. He kept writing tablets and notebooks beneath his pillow, 'but, although he tried very hard, he had begun too late in life and made little progress', according to his biographer Einhard. He nevertheless spoke Latin fluently, and could read Greek. The classical world was open to him.

Renovatio was a carefully chosen word. It was a restoration of a Christian past that had been lost, since the end of the western Roman Empire in 476 (when Rome fell to Germanic rule), but more pressingly since the Arab Muslim invasion of the Mediterranean just over a century before Charlemagne's accession to power. When he decided to establish his court in the old Roman town of Aachen, in 794, just a few decades after al-Mansur founded the city of Baghdad, three thousand miles to the east, Charlemagne was also creating a new stronghold for the Christian faith in northern Europe, one that was to hold sway for over half a millennium. 'Nothing was ever nearer to his heart,' wrote Einhard, 'than that, by his own effort and exertion, the city of Rome should regain its former proud position.'[13]

The Palatine Chapel is the only part of his palace complex at Aachen to have survived, and shows a debt to what Charlemagne considered the most

impressive Roman Christian building, the church of San Vitale in Ravenna, that last great bastion of the Roman empire in western Europe, which he had seen on the way back from his coronation in Rome. In northern Europe such an edifice would have been a remarkable sight. For as long as anyone could remember, buildings had been made of wood – poor rivals to the stone ruins from Roman times. Wooden buildings didn't last long; they rotted, burned or simply fell down. Charlemagne's chapel of stone proclaimed stability and permanence, drawing a sturdy line from the Roman past to the Carolingian present. A central octagonal dome crowns a chapel rising up two storeys to a gallery on which stood Charlemagne's simple marble throne (the original was in fact made of wood). The interior may have been less radiant than that in Ravenna – the walls were thicker and the windows smaller – but the need for warmth was greater than the need to let in the scant northern light. Yet still the Palatine Chapel captured the spirit of the Roman south, as well as some of its actual materials. Stones and columns – *spolia* from Rome and Ravenna, it was said – were incorporated in the fabric of the building, and a gilt–bronze equestrian statue, imported from Ravenna, was placed outside (it was later destroyed).[14] Charlemagne would have felt the authority of this statue as he looked at it from the upper windows of his chapel, thinking of the similar equestrian statue outside the oldest and most important church in Rome, St John Lateran, which at the time was thought to show the first Christian emperor, Constantine – Charlemagne's greatest forerunner.[15] (In fact, the statue outside the Lateran was that of the Christian-persecuting emperor Marcus Aurelius, and the statue that Charlemagne gazed at in Aachen was probably of Theodoric of Ravenna, an Ostrogothic king.)

To drive his programme of *renovatio*, Charlemagne summoned scholars to his court from far and wide, from Spain, Lombardy and Britain. He took as his personal tutor an industrious scholar from York named Alcuin, who brought with him the classical learning preserved in monasteries in Britain and Ireland. Alcuin was, according to Einhard, 'the most learned man anywhere to be found', well versed in Latin writers such as Virgil and Ovid, but also steeped in the work of religious authors.[16] The result of Alcuin's learning, and of the Carolingian schools as a whole, was less a new philosophy or science than a reinvigoration of ancient knowledge. This spirit of preservation had been transmitted to mainland Europe by Irish missionaries, such as Columbanus, and also by missionaries from Anglo-Saxon Britain, notably Boniface, who established important Christian foundations

in the Frankish empire, and the Northumbrian monk Willibrord, who in the seventh century established the abbey of Echternach, in modern Luxembourg, which was to become famous for its scriptorium. The abbeys of Luxeuil, in France, and Bobbio and St Gall, in Switzerland, were also known for their industry in preserving and copying ancient manuscripts.

This spirit of preservation was taken up with fervour by Charlemagne, who drew his inspiration from the scholarship at Echternach. In a scriptorium at Aachen ancient texts in Latin and Greek were copied and preserved in a new script, known as Carolingian minuscule, designed, probably by Alcuin himself, for the greatest legibility. Roman works were studied, copied and illuminated, thus preserving ancient works of literature, just as the Romans had preserved Greek sculpture in their marble copies.

One of the most refined achievements of Charlemagne's court workshop is a carved ivory cover for a Gospel book known as the Lorsch Gospels (named after the abbey in modern south-west Germany where it was first recorded). A wide-eyed Virgin points with long fingers at her stern-looking son, who in turn points at the book he holds, while John the Baptist and the prophet Zechariah look on with elated expressions, their heavy braids falling down to corkscrew curls. Their robes are carved in deep relief and hang heavily, just as drapery was carved in much earlier Greek and Roman sculpture. The ivory book cover might have been made in this style by an artist working in Constantinople hundreds of years earlier. But the antique 'look' was precisely what made such a Gospel book cover so up-to-date, fully on-message with Charlemagne's programme of *renovatio*, and nowhere more so than in the carved, Roman-nosed angels, supporting a medallion with the image of a beardless Christ in the upper panel.

With such images Carolingian artists created the visual forms of Charlemagne's Christian *renovatio*, introducing into the old pagan world a new, restless spirit.

Front cover of the Lorsch Gospels. c.810 CE. Elephant ivory reliefs in wood frame, 37 cm by 26.3 cm. Victoria and Albert Museum, London.

It was a restlessness traced in the lines of Eadfrith's Gospel book, in the linear forms drawn with his metal stylus. Drawing appears often at those moments of rapid change, when new ideas need quick notation, as if a direct imprint of the imagination. The first true line drawings presented unadorned appear in a ninth-century Psalter made at a Benedictine abbey near Reims, a great centre of Carolingian manuscript illumination. It is one of the earliest books of linear drawing that survives. The images are built up from increasingly bold layers, using an ink made by dissolving the bark of a thorn bush in water and white wine (the text

uses the same ink with the addition of vitriol, sulphuric acid, to obtain a darker tone), and were made by a small group of artists who were undoubtedly looking at an earlier Roman manuscript. The Utrecht Psalter (as it was later named) is unique in its layout, lively drawings intertwining with the lines and verses, spilling over borders, illustrating in detail every idea and image in the Old Testament songs,

combined with pictures of daily life. It is as if we can see into the mind of an imaginative ninth-century reader, the mental images evoked by the words projected onto the page. Each image provides a precise equivalent for the text. For Psalm 103 we see God walking 'upon the wings of the wind', the 'fowls of heaven' singing among the branches, wild goats in the high hills, young lions roaring after their prey and a leviathan, or sea dragon, playing in the sea.

The style of the drawings is not uniform but shows, rather, the hand of at least five different artists. In their vigour and detail they are nothing like the formal classicism of the manuscripts or ivory carvings made at the Carolingian court, or the labyrinthine decorative initials of Eadfrith's illumination. They are a memory of Roman painting: the artists of the Utrecht Psalter injected this recollection with an urgent and vital spirit, creating a book of drawings that was a beacon for artists for centuries to come.

The rediscoveries of Carolingian artists in the manuscript workshops at Reims and Metz, as well as at Tours, where Alcuin was abbot, continued apace in the following century, when power had shifted to the Ottonian kings, the successors to Charlemagne's court, with their stronghold to the east in Saxony. The major Ottonian workshops of manuscript illumination were at Reichenau, an island monastery on Lake Constance, and also Trier and Lorsch. A new sense of spaciousness enters their images, increasingly emptied of the fulsome detail of earlier manuscripts such as the Lindisfarne Gospels, as if the void were no longer to be feared and filled.

One Ottonian painted page from Trier, part of a manuscript comprising a collection of the letters of St Gregory the Great, shows Gregory, as pope, seated by a lectern, dictating his commentary on the Book of Ezekiel to a secretary hidden behind a curtain. Gregory has fallen silent, prompting the secretary to peer through the curtain, to see a white dove, the animal spirit of Christian divinity in the form of the Holy Ghost, perched on the pope's shoulder, breathing the words into his mouth. To those reading the manuscript, more used to flattened figures and a profusion of ornament, the clear lines, subtle gradations of colour and Roman architectural forms would have been a revelation of clarity and space, making even the Lorsch Gospels appear a little backward.[17]

Utrecht Psalter, illustration to Psalm 103. c.820–845 CE. Ink on parchment, 33 cm by 25.5 cm. University Library, Utrecht.

Pope Gregory the
Great writing. *c*.983 CE.
Stadtbibliothek, Trier.

The artist, whose name was not to survive, would not have needed to travel south to appreciate Roman buildings but could have seen them in his native city. Trier boasted some of the most impressive Roman architecture in northern Europe – an amphitheatre, baths, an elaborate gateway and the basilica built by Constantine during his time of residence.[18] From these, as well as manuscripts in the abbey library, he would have taken the arches, and the classical columns with their acanthus-leaf capitals, seeing them all in the light of the new knowledge of Christian salvation.

Sculptors too began carving out space. After the intensity of the interlaced designs of Anglo-Saxon metalwork, it is a relief to come across the figures of Adam and Eve on the bronze doors forged for a church in Hildesheim, a major Ottonian city. They are surrounded by open air, acting out the scene of temptation in an emptiness punctuated only by oversized plants and sparse architectural details. The scene is reduced to the bare essentials, going beyond Roman relief-carving, so often made with the same space-cramming impulse as Anglo-Saxon illumination and metalwork. The bronze doors at Hildesheim were commissioned at the beginning of the eleventh century by the local bishop, Bernward, an enthusiastic collector and replicator of Roman sculpture, who wanted in particular to create something in his home town as grand as the doors of Santa Sabina in Rome, five hundred years before his time, which feature one of the earliest depictions of the Crucifixion. His unnamed sculptor goes far beyond the Santa Sabina crucifixion, which shows Christ between the two thieves up against a stone wall, creating a scene of the mocking of Christ on the cross, with the thinness of the figures emphasising the feeling of real space. Bernward's doors deepen the narrative by creating visual connections between Old Testament scenes on the left and New Testament scenes on the right-hand door. The tree from which Eve plucks the fatal fruit mirrors the upright form of the cross in the scene to the right, bringing to mind the speaking tree and its story in *The Dream of the Rood*.

The classical revival that had begun in the time of Charlemagne produced, over some two hundred years, images of a directness and clarity recalling the older Roman world – such as the inscription on the Arch of Titus or the chiselled lines of Roman portrait sculpture. The clear forms of the Carolingian *renovatio* are distinct from the intricate Celtic ornament of the Lindisfarne Gospels and the spell of mystery that seems cast over all the imagery of Anglo-Saxon England.

The Carolingian *renovatio*, having been inspired in part by the teachings of the English monk Alcuin, was to return to Britain, appropriately

INVADERS AND INVENTORS

enough, in the form of a striking manuscript. Around the year 1000 the famous Utrecht Psalter was carried to Canterbury, where it was part-copied in the creation of a book known as the Harley Psalter, a close version of the Utrecht original. Anglo-Saxon scribes were captivated by the simple line-drawings, which they tried their best to emulate, along with the idea of running images above or below the text of the Psalms. One manuscript that used this format was a book of Old English poetry based on the biblical stories of Genesis and Exodus, and of Daniel and Christ and Satan. It was illustrated with a series of drawings, some of which were taken directly from the Utrecht Psalter.[19] Noah's ark has been imagined as a Viking longboat, carrying a church constructed rather shakily in a classical style, complete with weathervanes.[20] A levitating Christ closes the door to the ship with a gesture of benediction. Noah's wife is reluctant to board, probably at the thought of sharing the journey with so many noisy animals, and is urged on by one of her sons. The illustrations bring vividly to life the scenes evoked in the poems, at one time believed to have been written by the Northumbrian Anglo-Saxon poet Caedmon. Not since ancient Egypt had word and image been combined in so direct a manner, as if writing and drawing were simply different sides of the same creative act.

'Embarkation of Noah's Ark', from The Caedmon Manuscript, MS. Junius 11, p. 66, approx. 32.4 cm by 20.3 cm. The Bodleian Libraries, University of Oxford.

11

Serpents, Skulls, Standing Stones

To the first humans arriving in America over ten thousand years ago, the landscapes through which they travelled would have seemed like a natural paradise. As they made their way from the cold northern land bridge down towards the tropical forests and mountains of the south, the spectacle would only have intensified. When they began evolving settlements and carving ornaments to give sense to their lives, the abundance and diversity of the natural world surrounding them were the first inspiration for the images they made.

Nature held many wonders, but none quite so spectacular as a forest-dwelling bird with impressively long emerald tail feathers. The quetzal is one of the rarest and most dazzling sights in the forests of Central and South America. For the earliest settlers it was a richly symbolic creature, associated with the wind that swept in from the ocean and the rain that came over the hills. These associations spurred the imaginations of the settlers, who combined the quetzal with the serpentine form of a snake to create a fearsome god known as Quetzalcoatl, or the Plumed Serpent. Quetzalcoatl ruled over the lands and stood at the origins of the world itself, a glittering light in dark water, enfolded in shining blue-green feathers, according to one of their creation myths.[1]

Quetzalcoatl, in one form or other, is a symbol of the great continuity that runs throughout the cultures that together form the civilisation of ancient America, known as Mesoamerica, from the earliest people, the Olmecs, to the last great efflorescence of the Aztecs over two thousand years later. It was a continuity founded on common gods, but also on a feeling for sculpted and painted images that remained largely unchanged, just as it had in the earlier civilisation of ancient Egypt.

Quetzalcoatl's first journey was from the depths of the tropical rainforest to the first great city in Mesoamerica, built on a mountain plateau north of the Olmec heartland. Teotihuacan, as it was later called, was one of the largest cities on Earth at its height around 450 CE with over 100,000 inhabitants.[2] There was no precedent for such a settlement in the Americas, and those who constructed it, with a mountainous flat-topped pyramid of stone at its centre, looked instead to the grandeur of nature as their model.[3]

The Pyramid of the Sun stands halfway along a broad central avenue that runs the entire length of the ancient city. Further down still a smaller pyramid, dedicated to the moon, overlooks a ritual plaza. From the summits of these pyramids the sprawling urban configuration of

Resplendent quetzal, from
*Charles Dessalines d'Orbigny,
Dictionnaire universel
d'histoire naturelle,* vol.1, Paris
1849, plate 5b.

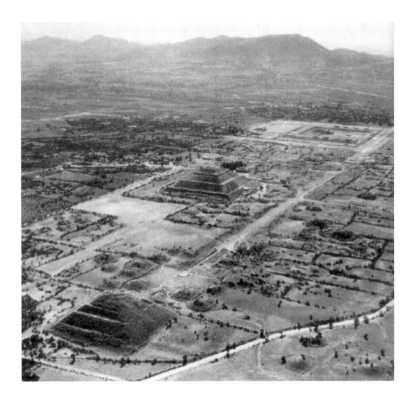

Teotihuacan could be seen through the heat haze of the day – streets and blocks of brightly coloured buildings and compounds stretching out into the distance, arranged by the straight lines of a grid down which it seemed that the city might never stop expanding, as if to infinity. It may have been inspired by natural grandeur, but it was a marvel of human ingenuity, all the more remarkable as the product of a culture still dependent on stone technology – metalworking had yet to be discovered. The wealth of Teotihuacan was largely derived from obsidian, a superhard black volcanic glass that was mined near by and used to make tools and objects for daily life – everything from axes to ear flares.

Obsidian was also used to decorate a third pyramid at Teotihuacan, built roughly at the same time as the Pyramid of the Sun. Carved reliefs and sculptures on its sides, snarling snake heads with feathered collars, show that it was dedicated to the Plumed Serpent, Quetzalcoatl. Strange block-like masks with hanging pendants, representing fangs, appear between the snake heads, most probably showing Xiuhcoatl, the Fire Serpent, engaged for combat, carrying the terrifying crocodile-like headdresses on its back.[4] With fearsome visages the snake-monsters appear hungry for the human sacrifices that were made on the platform above. Bodies of these sacrificial victims were buried within the pyramid and surrounding area, as if they had been consumed by Quetzalcoatl himself.

The drama of human sacrifice took place on a stage stretching out into the vastness of the cosmos. The Pyramid of the Sun and the city around it are aligned so that twice a year the sun rises directly over the distant mountain peak of Cerro Colorado, marking important dates in the Teotihuacano agricultural cycle, for the planting and harvesting of maize. Solar alignment was repeated in many Mesoamerican buildings, as it was throughout the ancient world –

immovable structures were the best markers of time, like calendars. As the sun rose in late March, illuminating the sloping sides of the pyramid, the grandeur of Teotihuacan was revealed once again to city dwellers, who felt themselves at the centre of their world. Their awed response seems reflected in the stone masks they made in abundance, open-eyed, open-mouthed, shining with obsidian and polished shells, devoid of any human emotion apart from a sense of blank wonder.

At the time of its destruction, in the middle of the sixth century CE, Teotihuacan was at the heart of a sprawling civilisation, a network of cities and peoples who may not have spoken the same language, but who worshipped the same gods and shared many common traits. South of Teotihuacan, in the valley of Oaxaca, the Zapotecs, who invented the earliest form of writing in Mesoamerica, flourished for over a thousand years, with the hilltop city of Monte Albán as their capital.

The Toltec capital of Tula, built in the valley of Mexico on a ridge overlooking the river from which it took its name, and known for its stout column-

figures, the 'Atlantes', was the greatest city in Mesoamerica after the fall of Teotihuacan. It was founded, according to traditional accounts, around the year 900 by a ruler who took his name from the feathered snake – Topiltzin Quetzalcoatl.

The stone cities of the Zapotecs and the Toltecs, like those of the Olmecs, were built as places of ritual rather than habitation, centred around flat-topped, stepped pyramids, square open plazas and ballcourts, where the rubber ball game was played. Buildings were aligned with cosmic exactitude according to complicated calculations produced by two calendars, one running for 260 days, which may have charted the period from conception to childbirth, the other measuring the solar year of 365 days. Carvings and paintings of their gods were made in a common style, and used similar materials. Jade, alongside obsidian, had been valued since the earliest times. These were the shapes and forms that gave a communal pattern to the lives of the people of Mesoamerica, a feeling of being part of something larger, both terrestrial belonging and a wider sense of cosmic awe.[5]

South of Mesoamerica on the American continent, civilisations flourished on the coast and in the river valleys of the Andes mountains, in modern-day Peru. Metalworking technology was known to the earliest Andean cultures, although it was used for decorative objects, jewellery and plaques, rather than tools: like the Mesoamerican cultures to the north, the Andean cultures depended largely on stone tools. In their textiles and ceramics they left a vivid record of their rich natural surroundings.

The long, coloured tail feathers of parrots and macaws were used in headdresses and on capes and other vestments, impressive to behold but also symbols of a creature that must have appeared magical – they could fly, and appear to speak. Hummingbirds, hovering and darting, sucking nectar with their long sword-like beaks, were associated with bloodletting ceremonies and were often depicted in battle scenes, where their beak was a metaphor for the archer's arrow.[6] Eagles were natural symbols of war and military might, and so, perhaps surprisingly, were owls.

Among the Moche, an Andean culture that flourished in the region of modern Peru around the same time as Teotihuacan, the owl was a supreme warrior, associated with human sacrifice, often shown killing captives and taking them back to the world of shadows in which they lived their nocturnal lives.[7] Owls were the most common animal represented on Moche pots, the stirrup-spout vessels designed to minimise evaporation in the arid desert climate – although the birds often seem more benign than warlike.[8] The Moche also included impressively lifelike portraits on their stirrup-spout vessels, commemorating the living and the dead. They had no written language to record their names, but instead set down what they saw around them with lifelike detail derived from close observation.

In the tropical rainforests of modern-day southern Mexico and Central America, in Guatemala, Belize and Honduras, there appeared in the first millennium BCE a civilisation that was to outlast Teotihuacan to the north by centuries. The ancient Maya worshipped a bird-god, not a quetzal or an owl, but rather a fantastical creature like a vulture, now known rather prosaically as 'Principal Bird Deity', often shown holding in its talons a serpent, a symbol of divine control over the restless forces of nature. It was a manifestation of Itzamná, the paramount deity of the Maya.

Like other Mesoamerican peoples, the Maya worshipped spirits of animals and nature but also looked with intelligence and curiosity at the world around them. They were scientists and inventors, artists and writers.[9] Their greatest creation was a written language, one of the most vivid and beautiful scripts ever invented, which took the form of squarish pictograms, or 'glyphs'. Some of these glyphs represent objects directly, transforming a thing into a recognisable symbol of itself, such as the glyph for 'jaguar'.

Other glyphs represented sounds and were used to spell out words phonetically.[10] Like the hieroglyphs of ancient Egypt, Mayan writing, or glyphs, showed pictures of things, often combined with phonetic symbols to make clear the sense of the inscription.

SERPENTS, SKULLS, STANDING STONES

These alluring glyphs – half-pictures, half-signs – were carved on large standing stones placed in the ritual areas of their villages and towns. Pictorial inscriptions tell the stories of the Mayan rulers and the cities in which they lived, of their wars and their alliances, of dynastic history and the godlike powers of rulers. The earliest were flattened upright reliefs, but in time they became carved in the round, broadcasting their message in all directions.

Alongside the stories of Mayan rulers were observations about the movements of the stars and the planets – calendrical symbols that placed their stories in measured, historical time. The Maya measured the solar year and the lunar month with startling accuracy, to the degree that they realised that the movements of the planets was not perfectly circular but elliptical. Their 'long count' calendar measured the number of days since the supposed creation of the current world, on 11 August 3114 BCE – just as good, really, as any other date as a point of reference.

The first of these fully carved monuments appeared at Copán (in modern-day Honduras), the largest of all Mayan cities, alongside Tikal and Calakmul. Mayan carving at Copán reached its height at the time of the king named Waxaklahun Ubah K'awil (later nicknamed 'Eighteen Rabbit', after a mistranslation of his name, which in fact means 'Eighteen are the bodies of K'awil', K'awil being a Mayan royal deity). From volcanic stone, craftsman carved stelae celebrating his rule. An inscription on one provides the exact date he came to power, on the second day of January in the year 695. The stelae were placed on the most important part of the city, the plaza next to the ballcourt, keeping watch as the players bounced the hard rubber ball from their hips and knees onto the sloping sides of the court, to the shouts and cheers of watching crowds.[11] Stone macaw heads were mounted on the side walls, marking the limits of play. Near by, a steep monumental staircase, constructed in the years following Waxaklahun Ubah K'awil's reign, carried a long inscription of glyphs telling the story of the kings of Copán from bottom to top as an unbroken series of victories (passing over the fact that Waxaklahun Ubah K'awil had been recently abducted and beheaded by a

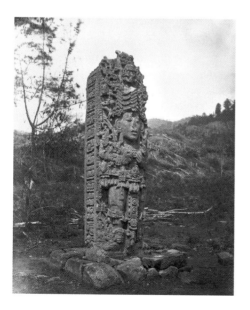

neighbouring city-state). Statues of six former kings sat on the steps, so that to ascend the stairs was also to walk back in time, through a gallery of royal ancestors.

Of all Mayan sculpture, the most striking forms are those of carved stone figures, which appear to twist as they raise themselves up, with some awkwardness, from a lying position. These figures, later termed *chacmool* figures (meaning 'jaguar paw'), were probably images of captives, and placed at the centre of the ritual of human sacrifice. The dish-like cavity in their stomachs would have held the sacrificial blood released by the priest's dark obsidian

Stela A, Copán. 731 CE.

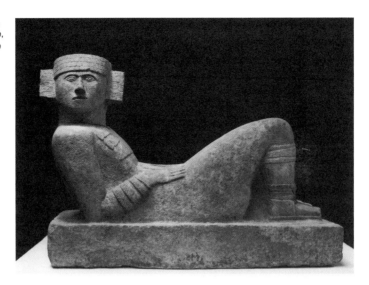

knife.[12] The first *chacmool* figures were made at the Maya site of Chichén Itzá, a city that arose late in the history of the Maya – it was also associated with the Toltecs, who inherited much of their culture from Teotihuacan. Quetzalcoatl was also at Chichén Itzá, in his Mayan guise, known as Kukulcan. His cult was honoured in a remarkable round building, modelled on a spiralling form like a conch shell. It was in a chamber at the heart of the nearby Pyramid of Kukulcan, down the stepped sides of which run a balustrade like the undulating back of a serpent, that the captive *chacmool* figure was placed, its eyes defined by pearl inlays, glinting in the dark.

Some seven hundred years after the fall of Teotihuacan, a tribe descended from the hot, arid region to the north, arriving on the mountain-bordered plateau where Teotihuacan lay in ruins. According to the myths of the Mexica people, also known as the Aztecs, it was the sight of an eagle perched on a nopal cactus on a muddy island in Lake Texcoco that showed them where to build their own great city, which they called Tenochtitlán ('place of the nopal cactus rock'), founded in the year 1325. Tenochtitlán was remarkable for being built on a lake that filled the highland basin of Mexico, a spectacular sight for visitors approaching along one of the narrow causeways that connected the island city to the shore. By the end of the fourteenth century it was a thriving city at the heart of a vast and efficient empire.

 The ruins of Teotihuacan were sacred for the Aztecs. At the heart of their lake-city was a precinct with a pyramid that echoed the Pyramid of the Sun, surmounted by two shrines, one devoted to Tlaloc, the storm and rain god, and the other to Huitzilopochtli, the god of the sun and of war, and the greatest of all Aztec deities.

 Standing a few steps away was one of the most audacious statues created in Mesoamerica, a towering stone figure of the god Coatlicue (her name

SERPENTS, SKULLS, STANDING STONES

means 'Serpent Skirts'), the mother of Huitzilopochtli, the supreme Aztec deity.[13] She had been impregnated by divine inception (a ball of feathers had landed on her breasts, it is said, while she worshipped on the Coatepec, or Serpent Mountain) and was decapitated by her vengeful children, who thought she had been dishonoured. Twinned coral snake heads rise from her neck, symbols of gushing blood, above a seething mass of sculptural life – a skirt of snakes, a necklace of hearts and hands, a belt from which hangs a human skull, and coiling snakes emerging from her arms, emblazoned with monstrous faces. Her feet are ferociously clawed appendages with staring eyes.

Coatlicue is a figure of terror, an inspiration for revenge, yet also a symbol of life and regeneration. This mass of life is repeated on her back, without the breasts, radiating a similar message of regeneration in both directions. Her symmetry suggests a mirroring, as though she were producing herself through a trick of doubling, an act of self-creation, ensuring the continuity of life, the rising of the sun, through the sacrifice both of decapitation and of motherhood. The self-sustaining civilisations of Mesoamerica, who allied their fates to the patterns of nature, the movements of the sun and the stars, seem condensed in her thickly carved forms. Her terrifying indifference to any worshipper is shown in an image of the rain god Tlaloc, carved crouching on the underside of the statue, concealed when Coatlicue was standing in the sacred precinct.[14]

It was said, in later historical accounts, that when the Spanish conquistador Hernán Cortés and his men arrived in Tenochtitlán in 1519, Cortés was received by the Aztec leader Motecuzoma as if he were a messiah, the 'natural lord' of the Aztec people, and even Quetzalcoatl himself. Such an identification was in truth highly unlikely, a justification invented by Cortés and subsequent Spanish historians for the violent conquest and theft of Aztec gold.[15]

And yet, such shape-shifting was not unusual for the Aztecs. When he donned a large headdress made from hundreds of feathers, including four hundred green iridescent plumes of the quetzal, imported from remote parts of the forest in the tropical south, Motecuzoma himself

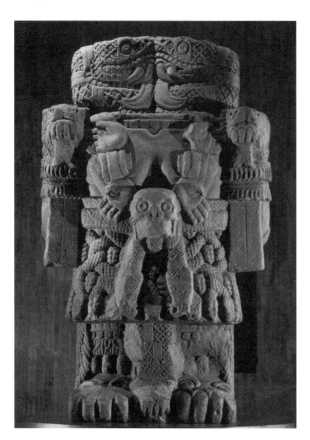

Coatlicue ('Serpent Skirt'). c.1500. Andesite, h. 257 cm. Museo Nacional de Anthropologia, Mexico City.

was also considered transformed into the serpent god. With its radiant form, the headdress, known as the Penacho, embodies the transfiguration of sacrifice, the creation of new life through death which stood at the heart of Aztec civilisation, as it had for the Mayans and Teotihuacanos before them.

The cycle was broken once and for all by the arrival of Cortés. In a short space of time his men killed Motecuzoma and destroyed the Aztec city of Tenochtitlán, barely two hundred years after it was founded, bringing in a new era of Spanish dominance.[16] Cortés sent Motecuzoma's spectacular headdress back to Charles V, the king of Spain and the Holy Roman Emperor, as war loot.

The fate of the ancient civilisations of Mesoamerica was to be returned to the nature from which they first appeared. Olmec and Mayan temples were submerged and obscured by jungle foliage, the Aztec city of Tenochtitlán destroyed, the lake drained and a great modern metropolis built directly over the ruins – Mexico City. With the decline of the ancient Maya, the meaning of their writing system was forgotten for over a millennium, and for those Mesoamerican people without written language the sounds of their names have been lost for ever.[17] Only Teotihuacan remains standing, preserved as a ruin, the Pyramid of the Sun still keeping calendrical time as the sun rises over distant mountains, an enduring monument to the grandeur of the civilisation of ancient America.

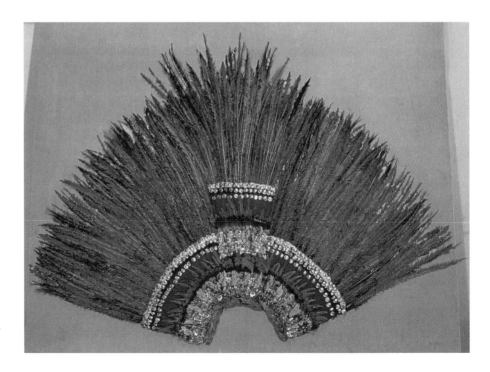

Feather headdress. Approx. h. 124 cm. Museum für Völkerkunde, Vienna.

SERPENTS, SKULLS, STANDING STONES

12

Sound
and Light

In the centuries following Roman rule the landscape of Europe was strewn with silent ruins: colossal amphitheatres, temples and bath houses, bridges, palaces and arches. For pilgrims travelling south to Santiago, or further east to the Holy Land, just as for the peasant tilling the land and gathering firewood, these ruins were a source of curiosity and wonder. They were remnants of a mighty and mysterious civilisation, described in awed tones by the early English poet of 'The Ruin', just as Homer had written of the palaces of Mycenaean Greece, ruins in his own time:

Bright were the buildings, halls where springs ran,
high, horngabled, much throng-noise;
these many meadhalls filled
with loud cheerfulness: Wierd changed that.

Came days of pestilence, on all sides men fell dead,
death fetched off the flower of the people;
where they stood to fight, waste places
and on the acropolis, ruins.[1]

Towards the end of the first millennium CE this landscape of ruins was slowly transformed by a new spirit of architecture. It was a spirit unleashed by the growing power of the Christian Church, and of monasticism, as well as by the political stability ensured by the new German emperors, rulers of the Holy Roman Empire. Where the buildings of the Carolingian and Ottonian kings were often no more than pastiches of antique grandeur, the new Christian architecture that came after them had an overall coherence and geometric clarity. It began appearing all over western and central Europe, in Lombardy, Catalonia and Burgundy, everywhere giving shape to a sense of spiritual authority spreading over the land, a power to rival that of ancient Rome (which is why it was later given the vague name 'Romanesque' – 'Roman-ish' architecture). Western Europe finally had something to rival the splendours of Byzantium, and of the Islamic empire closer to home in Spain and North Africa. Within a century the new Christian architecture could be found as far afield as Scandinavia in the north and Sicily in the south, and all the way from the Holy Land of Jerusalem to England and Ireland in the west.[2] Along the pilgrim ways, and at the heart of the cities of Europe, churches and monastic buildings were built with a feeling of solidity and harmony, so that their very stones echoed with a new voice of architecture, quite distinct from that of ancient Rome.

The solid walls and vast interior space of Speyer Cathedral, on the banks of the Rhine in southern Germany, is one of the earliest structures made in this new voice. It was rebuilt in the middle of the eleventh century under the

emperor Conrad, who designed it as the burial ground for his family dynasty (the Salian imperial house, who followed the Ottonians). Conrad enlarged the cathedral, giving it a new high roof, using a complicated structure known as 'groin vaulting', in which two semicircular barrel vaults cross one another.

This method of vaulting was known to the Romans, but at Speyer it was used for the first time to cover a high and wide space in a church building. Anyone entering the building when it was first constructed would have seen how it rivalled the great architecture of antiquity, the triumphal arches and bath houses that they had seen or heard about. They would have marvelled at the stone structure, hanging over a hundred feet above them, with mixed feelings of terror

that it might suddenly fall and relief that it was fireproof – in almost all other churches the ceiling was much lower and made of wood. But above all it was a roof that answered back. The voice of the priest intoning the Mass and the choir singing responses would have echoed up around the walls to the ceiling, as if the architecture itself was shaped by sound.

The voices they heard were singing a music now known as Gregorian chant, part of the ritual of the Church since much earlier times. The name derived from the music school established in Rome by Pope Gregory in the sixth century, the Schola Cantorum, where evolved a style of singing reflecting the slow-moving mystery of Catholic ritual.[3]

Built around the same time as Speyer, one of the largest churches of the time was the Benedictine abbey church of Cluny, in Burgundy. Little surprise that the architect, a monk named Gunzo, was also a musician. The idea for a new church on such a grand scale supposedly came to him in a divine dream, while lying paralysed in the infirmary – a convenient way of later excusing the vast expense the abbey church entailed.[4] Cluny was the monastery of the Benedictine order, founded in the early tenth century and soon became a great ecclesiastical powerhouse, the centre of an order of monks that stretched over a wide territory, and with close connections to the papacy in Rome.

The church that Gunzo built was the third and the largest at Cluny, surpassing even Speyer, as Abbot Hugh, who commissioned the building, doubtless desired. With St Peter's in Rome and Canterbury Cathedral in England, Cluny was one of the largest churches in Christendom. Abbot Hugh was intent on creating a fittingly grand setting for worship, requiring an enlarged space for the choir, but also lofty barrel vaulting, to create a mighty acoustic environment for the Gregorian chant. The cramped choir, about which the monks had long complained, was expanded into a wide open area with radiating chapels, allowing the relics to be housed behind the altar, far more convenient when the pilgrim crowds arrived

Nave of Speyer Cathedral. 1061. Engraving from: Jules Gailhabaud, *Monuments anciens et modernes: collection formant une histoire de l'architecture des différents peuples à toutes les époques*, Paris, 1853.

SOUND AND LIGHT

in summer.[5] Other new ideas included two transepts at the eastern arm of the church, as well as side-aisles along the nave, bounded by rows of columns, suggesting an endless unfolding of space.[6] The long melodious lines of Gregorian chant wound around these complicated architectural forms, bringing to mind the forest columns of the Great Mosque at Córdoba and the flowing recitation of the *adhan*, the muezzin's call to prayer.

Plan and elevation of the church of the abbey of Cluny III, Burgundy. *c*.1088–1130. Engraving, 1745.

It was at Cluny that the pointed arches which became so definitive of the era first appeared, an echo of the Islamic architecture that could be seen closest to hand in Muslim Spain and Sicily. Islam was a gathering influence in the west. The first Latin translation of the Quran in Europe was made at Cluny in the middle of the twelfth century, commissioned by Peter the Venerable, the abbot of Cluny, who travelled to Spain to study with Islamic scholars. Until this point, except in Córdoba, there was very little knowledge of Islam or the life of the Prophet Muhammad, only the sense of a large and threatening force to the east and south. It was after the first crusade, in the last years of the eleventh century, that real knowledge and experience filtered into Europe of the Muslim Arab world, through the stories brought back by the noblemen and warriors returning from the Holy Land. The translation of the Quran made to the orders of Peter the Venerable was the first real attempt to understand Islam, beyond the myth and legend, such as the supposition that the Prophet Muhammad's tomb could be found hovering in mid-air thanks to a giant magnet.

The decorative sculpture at Cluny was, however, quite unlike anything to be found in Islamic buildings. Gunzo, or another musically minded monk,

commissioned column capitals for the new abbey church, two of them carved with images of the eight modes, or tones, of Gregorian chant. The modes are shown as dancers and musicians, or *jongleurs* (travelling entertainers popular in the French and Burgundian courts), playing on various instruments, surrounded by inscriptions that identify the particular tone that they represent – the third mode is shown by a seated man playing a six-stringed instrument similar to a lyre. These were learned images, which drew on philosophical treatises, such as Boethius' *De institutione musica*, and *Consolatio philosophiae*, and a long tradition of allying music with

Capital showing the third Gregorian mode, from Cluny III. *c*.1100. Musée d'Art et d'Archéologie, Cluny.

cosmic harmony, but also on the more down-to-earth examples of the Tonaries, the manuscripts containing the antiphons, or melodies, of daily worship.[7] They were a reminder of these sources, but also fitting ornaments for a church where the singing and intoning of scripture played a central role in daily life.

New ideas of architecture and sculpture soon spread from Cluny to other churches in Burgundy. A carving of the *Last Judgement* above the portal at St-Lazare, the cathedral of Autun, was derived from a semicircular relief, known as a tympanum, over the central doorway to the church at Cluny, showing images of Christ as spiritual ruler over the earth. At Autun the tympanum shows startling representations of the Revelations of Saint John, the great vision of the end of the world and the victory of Christ over the Antichrist. It is also, more prosaically, one of the very few carvings from the time that is signed. The words 'Gislebertus hoc fecit' ('Gislebertus made this') appear along the lower edge.

Little is known about Gislebertus other than he probably worked at Cluny before moving to Autun, where he created most of the sculptural decoration for the new cathedral in the early years of the twelfth century. He was a sculptor with a rich imagination and prodigious capacity for invention. His *Last Judgement* is dominated by a large figure of Christ with outstretched arms, enclosed by an inscription: 'OMNIA DISPONO / SOLUS MERITOS CORONO / QUOS SCELUS EXERCET / ME JUDICE POENA COERCET' ('I alone dispose of all things and crown the just, those who follow crime I judge and punish'). Surrounding him, figures act out the words of his law. The chosen, waiting in the lintel below, are being lifted up into heaven in the tympanum, where St Peter stands by with an enormous key to the heavenly gates. On the other side souls are weighed, and the devil appears as a monstrous creature, half-human, half-reptile, dragging the damned down to hell. Gislebertus's style is unmistakable, from the elongated figures to the tight, expressive folds of their clothing and the dramatic contrast of tenderness and violence. Angels trumpet from either side through large oliphant horns (hunting horns carved from elephant ivory). The scene of Christ's final judgement is given an emphatic rhythm, on a surface that might itself be seen as taut and percussive: the word 'tympanum' refers both to a carved panel above a door and also to a drum.

Gislebertus was responsible for most of the sculpture in the interior and on a portal over the north door of St-Lazare, most of which was later destroyed. Biblical scenes range from the *Four Rivers of Paradise* to the *Suicide of Judas* and include fantastical creatures as well as lions, birds and fighting cocks. He also included a representation of *The Fourth Tone of Music*, symbolised by a musician ringing eight bells suspended from a pole on his shoulders, which he copied from a carving at Cluny (why he didn't copy the other seven tones, nobody knows). He also took his cue from the sculpture of antiquity. His figure of *Eve*, placed on the lintel of the North Portal, most of which was later destroyed, is one of the most beguiling figure sculptures of the day. Eve stretches naked among the branches of the tree of knowledge, seeming to whisper something into the ear of an unseen Adam. The devil leans in and bends a branch towards her. Eve reaches back lazily to grasp the fruit. She might be a river goddess, a reincarnation of an antique naiad, her wet hair flowing in the heavy current – but in Gislebertus's version it is a matter of seduction rather than anything more cleansing. Loose hair was a symbol of lust.

Gislebertus, Last Judgement (detail), west tympanum, St Lazare, now Autun Cathedral. c.1120–1140.

Gislebertus stood at the threshold of a new era of religious imagery in the eleventh and twelfth centuries.[8] Fantastic forms, colours and movement flooded carved and painted images. It was as if a block had been removed from the imagination, and artists allowed themselves for the first time to roam freely, projecting their imaginations. Although the purpose of image-making was to reveal the nature of God, and to transport the viewer beyond the material world, there was a strong appreciation and enjoyment of images for their own sake. It was a feeling of unbound sensuality that recalled the sculpture of ancient Greece, but had a much closer parallel in the forms of Islamic decoration and calligraphy. 'In the multicoloured paintings an admirable art ravished the heart by the alluring splendour of the colours and drew all eyes to the ceiling by the charm of its beauty', wrote William of Malmesbury, an English historian of the twelfth century, of the interior of Canterbury Cathedral, although he might well have been talking about the Great Mosque of Isfahan or Hagia Sophia itself.[9]

Such love of splendour and the visible world led, inevitably, to a reaction, just as the seductive images of Byzantium were attacked by the Iconoclasts. At the end of the eleventh century a group of monks formed a new community devoted to the ideals of austerity and simplicity. They became known as Cistercians, after Cîteaux, the region, south of Dijon, in which they first settled. Within fifty years hundreds of Cistercian monasteries appeared around Europe and in Britain, built in an architectural style quite different from that of Cluny and Autun.

The spare style of Cistercian building reflected the remote natural settings in which their monasteries were founded. Fontenay, one of the earliest, is surrounded by forests and hills, and entering the abbey church feels a little like entering a natural cavern. A high barrel vault rests on massive walls, no decoration interrupting the space, the doors and windows minimal and plain. It was not, however, simply a matter of rural retreat. The bare style was a conscious reaction to the ornamental excesses of the Cluniac order and to the buildings, such as Autun, that they had inspired.

This reaction was set down in a historic letter. The *Apologia ad Guillemuma*, a diatribe written in 1125 by the Cistercian abbot Bernard of Clairvaux,

the great critic and rival of Peter the Venerable, contains a damning description of the fantastical carvings typical of Cluniac architecture:

> In the cloisters, before the eyes of the brothers while they read – what is that ridiculous monstrosity doing, an amazing kind of deformed beauty and yet a beautiful deformity? What are the filthy apes doing there? The fierce lions? The monstrous centaurs? The creatures, part man and part beast? [...] Over there an animal has a horse for the front half and a goat for the back; here a creature which is horned in front is equine behind. In short, everywhere so plentiful and astonishing a variety of contradictory forms is seen that one would rather read in the marble than in books, and spend the whole day gawking at every single one of them than in meditating on the law of God. Good God! If one is not ashamed of the absurdity, why is one not at least troubled at the expense![10]

Bernard objected not only to the grand expense of Cluny but also to the distraction of such unnatural images. However much the noble, solid interiors of their churches were shaped by the invisible forms of music, they ultimately arose from minds too invested with material things – the corruption of worldly luxury. Before long a response to this materialism came in the form of architecture shaped by something even more ungraspable than sound. Buildings began appearing that seemed to defy nature, soaring upwards: weightless, transparent structures that were shaped not by sound but by light.

The origins of this new architecture of light can be traced to the enthusiasm of one individual, Suger, the abbot of St-Denis, Paris. He was an ambitious and capable man, trusted by the French kings, who played an important role in the political life of his time. In 1137 he began to extend the existing Carolingian church of St-Denis, one of the oldest and most revered abbeys in France, with strong connections to the French royal family.[11] It was sorely in need of repair, and changes were also needed to accommodate the ever-increasing streams of pilgrims venerating St Denis and the abbey's relics, including a nail reportedly from the crucifixion. Three great portals were constructed beneath two towers on the west end, which held great bronze doors, flanked by full-length stone carvings showing Old Testament kings and queens. The tympanum showed a *Last Judgement* similar to the one at Autun

Nave, Fontenay Abbey.
Dedicated 1147.

SOUND AND LIGHT

and, in the middle, a great wheel-shaped coloured window. The apparitions of richly coloured stained glass at Suger's St-Denis came to form the image of European church architecture. Coloured glass was known in Anglo-Saxon churches from the seventh century, and was used to great effect in Canterbury Cathedral when it was rebuilt after the Norman Conquest of England, in the early twelfth century. The bright blazes of colour high on stone walls recalled the mosaics of earlier Christian architecture. And yet it was at St-Denis that the whole interior of a church was for the first time steeped in coloured light.

The most stunning part of Suger's design, however, was the choir, a raised area housing the shrine of St Denis, around which ran an open space, known as an ambulatory, leading onto seven radiating chapels. Where in the old Roman basilica church, and in more recent abbey churches such as Cluny, the apse had simply been a rounded space at the eastern end, Suger transformed it into something far more spectacular. Stone arches open onto the arcade, from which chapels radiate, an intricate and absorbing interior of ever-changing vistas. Coloured glass windows are set at angles, giving an undulating feeling to the space flowing around the shrine. Deep chromatic hues illuminate the interior, as if the walls were encrusted with sapphires, emeralds and rubies, creating a magical spell of protection and transport. Suger wrote of the 'wonderful and uninterrupted light of most sacred windows, pervading the interior beauty', creating a perfect environment for the sacred relics that were kept in the choir and for the royal tombs in the crypt beneath. Suger filled his abbey church with treasures, so that it rivalled even Hagia Sophia as a repository of splendour and wealth.

Suger wanted to return to the glory of old Rome, but in so doing he created a style that was the first and most lasting departure from the ancient shapes of architecture. This style, known at the time simply as the 'French Style' (and centuries later as 'Gothic'), was an emblem of the intellectual light beaming from the great universities and schools founded around the beginning of the twelfth century. There was a revival of interest in classical authors – Pliny, Cicero and Plato – and a renewed confidence in rational argument, particularly from the mouth of Peter Abelard, who drew crowds with his philosophical and theological argumentation, and who famously fell in love with a scholar of ancient languages, Héloïse d'Argenteuil. Abelard and d'Argenteuil were part of a scholarly revival at least in part dependent on the preservation and translation of ancient texts by Arab

scholars, and on their transmission to Europe via Spain. 'Every creature, visible or invisible', Suger wrote, 'is a light brought into being by the Father of lights [...] This stone or that piece of wood is a light to me [...] As I perceive such and similar things in this stone they become lights to me, that is to say, they enlighten me.'[12] A fine thought, but a vaguer and more poetic formulation of the theory of the eye receiving, rather than emitting, light, at the heart of Alhazen's *Book of Optics*. Anyone wishing to observe and understand nature must know Alhazen's book for its knowledge of vision ranging from mirrors to rainbows, held one of the poets of the *Roman de la Rose*, the great poem of courtly love, written as great cathedrals began appearing in the landscape over the next hundred years.[13]

The architecture of light was first perceived as a shadowy darkness, a looming silhouette on the horizon as the pilgrim approached, unlike anything they had seen before. The two lofty towers of the cathedral at Chartres, rebuilt, with astonishing speed, after a fire around the year 1200, rise up from the main body of the church, a shimmering mass viewed over the fields. But even more astonishing sights awaited as the pilgrim and traveller arrived at the cathedral doors.

Carved figures, mounted on the pillars surrounding each of the three portals at the front of the cathedral, and on the north and south portals, were an unforgettable vision of lifelike figures in stone. On the west portal a woman with long braids seems inspired by classical sculpture, the long, thin, pleated robes of her dress echoing the fluting of a classical column. And yet she is filled with a feeling of life that comes from the world in which the sculptor lived, a noblewoman, perhaps viewed in an open carriage travelling through the dirty city streets. Another female figure on the darker south portal probably shows the biblical Judith and is one of the most beautiful images of the human figure carved since antiquity. Her delicate body turns as she holds a scroll protectively against her torso. She gazes with intensity, but also with an intelligence and love that are unprecedented – although hardly in keeping with her violent murder of the Assyrian king Holofernes.

Entering the cathedral was the sudden revelation of a different world, of soaring columns and gravity-defying walls, and an interior immersed in luminosity from the windows floating in the shadows above. Where Cistercian

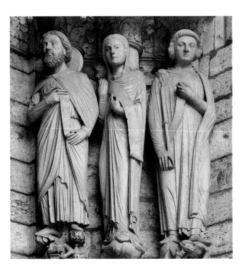

Figure of Judith (centre), north portal, Chartres Cathedral. Early 13th century.

churches had grisaille (uncoloured) windows, owing to the ban on coloured glass (it was too enjoyable, too Cluniac), those at Chartres were filled with the richest colours, particularly a type of deep blue, the colour of a cloudless summer sky. Beneath a vast rose window on the west front, three large windows were filled with stories of the life of Christ made from small panes of painted glass, each cut and mounted in the lead frame. To most, particularly those with poor eyesight, the stories would have been all but illegible from the vantage point

of the cathedral floor, but this was largely irrelevant – it was the overall effect that counted.

It was in the years after the building of Chartres that the architecture of light produced one of its greatest structures. The first impression on entering the cathedral at Amiens is of being swallowed by a vast corridor, a narrow elevated space leading straight down to a brightly illuminated choir.[14] The nave is divided into seven bays, designed on geometrical principles that can be feelingly discerned, even with no knowledge of the mathematical basis of the stone-cutting. Progressing down the nave, or down one of the side-aisles, the building opens up dramatically: first upwards, to the mid-level arcade gallery (known as a 'triforium'); then to the upper level (the 'clerestory'), glazed and translucent; then outwards into the lateral areas of the transepts, and finally to the hemicycle of the choir, and the surrounding aisles, space flowing freely around, just as at St-Denis. What at first appears a narrow passage unfolds into a spectacular light-filled environment. Columns shoot up the length of the inner walls like tall trees, bursting at their tops into elaborate patterns of tracery – *rayonnant*, or 'radiating', as such carved decoration came to be known.

For the thirteenth-century visitor, as for all those who followed, to enter the cathedral was to be transported to a place that appears to contravene the laws of nature and is shaped by a different idea of reality. The architect of Amiens, Robert de Luzarches, whose name is recorded on the labyrinth set into the pavement of the nave, followed the model established by Abbot Suger in designing his cathedral as a vision of the Celestial City of Jerusalem: in the splendour and harmony of its proportions, and the interlacing of the stories told in stone and glass inside and out, an analogy for the heavenly city described in the Bible.

The cathedrals that were elevated around the Île-de-France and Paris were witness to the increasing power of the French kings, particularly Louis IX, who reigned through the middle years of the thirteenth century. His mother, Blanche of Castile, was an avid supporter of artists and craftsmen alike – her heraldic emblem, a golden castle on a red background set into the north rose window at Chartres, testifies to her patronage of the cathedral building. Perhaps it was the memory of seeing Chartres as a young boy that led her son – St Louis, as he became known to history – to commission one of the greatest buildings in the *rayonnant* style: the Sainte-Chapelle in Paris, a magnificent chapel rising vertically and seemingly made entirely from coloured glass. It was intended to house precious relics collected by St Louis, outdoing the Crucifixion nails of St Denis with the Crown of Thorns said to have been placed on Christ's head on his way to Calvary, and appears not as much a chapel as a giant jewelled treasure box.[15]

The Sainte-Chapelle, in its size and fragility, reflects a confidence and optimism that were, however, not just the province of royalty. In the monasteries and courts, and in the city streets, sound and light were animating life, filling the dark void of the post-Roman world. A fresh sense of nature emerges, a glowing remnant from the Celtic sphere of pagan religion, of youthful, joyful regeneration. The poems collected together at the end of the thirteenth century

known as the *Carmina Burana* resound with unlimited joy in nature and youthful optimism at the possibility of human happiness, and the fulfilment of desire:

Ecce gratum
et optatum
Ver reducit gaudia.
Purpuratum
floret pratum,
Sol serenat omnia.
Iamiam cedant tristia!
Estas redit,
nunc recedit
Hyemis saevitia.[*]

It was a delight that pervaded religious images, with a delicacy of feeling largely unknown to Abbot Suger a hundred years earlier. An ivory carving of the Virgin and Child, once displayed in the paradise interior of the Sainte-Chapelle, reveals at first sight not the mystery of incarnation but an image of human happiness. Where the elegance of the eastern image of the Virgin, such as the Theotokos of Vladimir, was other-worldly, the Sainte-Chapelle figure, like the portal sculptures at Chartres, seems modelled on life, with a sensitivity to the bond between mother and child so strongly conveyed that it may well have come from personal experience. The Virgin sways gently back and to her right to counterbalance the weight of the infant, depicted as a lively young boy. Her eyes look out to the viewer with an expression of humility and pride. The drapery covering her body appears heavy, and yet there is a deep elegance in her gently swaying pose and delicate hands. The hands of mother and child do not quite touch, but are joined by a round object, an apple, perhaps, so that they enclose a space charged with confidence, charm and love.

The architecture of light radiated far and wide. French architects were much in demand. The choir of Canterbury Cathedral in England was rebuilt in the twelfth century by William of Sens, who had learned his trade working on the cathedral of Sens, in the Île-de-France. At León, in Spain, and Cologne, in Germany, cathedrals were built in a style directly modelled on the French, by architects trained in France. At Uppsala, in southern Sweden, a cathedral was built under the direction of the French master builder Étienne de Bonneuil. The *opus francigenum*, or 'French work', as contemporary writers termed it, swiftly became the only acceptable style of religious architecture.[16]

As is so often the case, the greatest achievements of the new style, at least in sculpture, appeared outside the centres of patronage in France. The name and identity of the sculptor of the twelve founders' statues, or *Stifterfiguren*, in Naumburg Cathedral (in modern Germany), made around the middle years of the thirteenth century, has been lost, but the spirit of vigorous realism they display suggests that he was a master of French origin.[17] He must have known

[*] 'Behold the spring, welcome and long awaited, which brings back the pleasures of life. The meadow with purple flowers is a-bloom, the sun brightens all things. Now put all sadness aside, for summer returns, and winter's cold withdraws.'

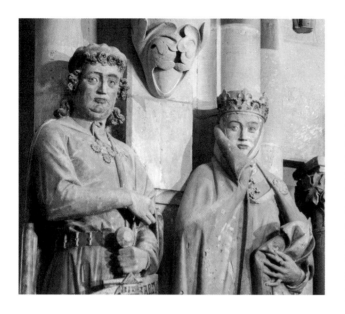

Stifterfiguren (founder figures) of Ekkehard II and Uta, sandstone, Naumburg Cathedral. c.1250–1260.

the sculptures at Chartres, Reims and Amiens, and may even have worked on them. In the German lands the style was intensified, achieving a level of realism unknown in France except in the unforgettable figure of Judith carved for the portal of Chartres. As with so much sculpture, stretching right back to ancient Greece and Rome, the physical presence would have been reinforced by the fact that the sculptures would have been painted – although it was just as much the fine detail of the carving, the sense of volume and proportions, that created the startlingly lifelike quality. At Bamberg and Magdeburg, just as at Naumburg, visitors would have been astonished by these seemingly living figures made of stone: not least the rich burghers of Naumburg who had paid for the cathedral, looking up in astonishment at these petrified versions of themselves set up on the cathedral wall.[18] These were images coming not from the past, from the model of the ancients, but brashly reflecting contemporary appearances, with all the shock of a mirror suddenly held up to life.

Artists and elegance radiated from Paris, and yet it was not the only centre of power. The duchy of Burgundy was becoming increasingly powerful, and under the house of Valois, from the middle of the fourteenth century, embarked

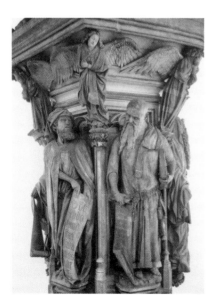

on a golden period of patronage. It was Philip the Bold, the first Valois duke, who commissioned leading artists to decorate the Carthusian monastery, or Charterhouse, known as the Chartreuse de Champmol, that he had built outside Dijon as a burial place for his family. Trained in Brussels, the Netherlandish sculptor Claus Sluter made his greatest work for the Burgundian duke in the years around 1400: a monumental well surrounded by figures of Old Testament prophets (after one of whom the 'Well of Moses' was later named), and on which stood painted and gilded figures of Christ on the Cross and Mary Magdalene.[19] Sluter's monumental figures, with their heavy woollen drapes, seem to turn their backs on the elegance

Daniel and Isaiah from the pedestal of the Well of Moses, Asnières stone, with traces of gilding and polychromy, by Claus Sluter and workshop, Chartreuse de Champmol, Dijon. 1395–1404.

epitomised by the Judith at Chartres, and on the graceful style of the sculptural schools at Paris and of Bourges to the south. Moses, Zechariah and the other prophets are carved instead with a strong, dramatic character, flavoured with foreknowledge of Christ's martyrdom.[20] Where the earlier carved figures at Chartres seemed to grow from their architectural surroundings, Sluter's are detached and independent witnesses. Shadows gather within and around Sluter's prophets, the thinly outstretched wings of the angels offering only temporary shelter from storms to come.

Impressive as his monument at Champmol was, Philip the Bold was outdone many times over as a patron of fine things by his brother Jean de France, the duke of Berry, a region with its capital at Bourges, south of Paris. Jean was obsessed by the refinements of art at the expense of the practical side of being a duke – he neglected his political duties, preferring to spend weeks in his magnificent château at Mehun-sur-Yèvre, planning improvements and schemes with his master of works, the sculptor André Beauneveu. His political advisers and aides must have been exasperated by his neglect of official duties, but not the artists and craftsmen he commissioned. Some of the discussions with Beauneveu may well have concerned the chapel in Bourges Cathedral, built by the duke for himself and Jeanne de Boulogne, his wife. From the Netherlandish sculptor Jean de Cambrai the duke commissioned life-size sculptures of himself and his wife, in painted alabaster, kneeling in prayer. The originals were later lost, but not before being sketched by a young German artist who had travelled up from Switzerland, Hans Holbein.

Holbein's drawing seems to be not of a sculpture but of the living duke himself, in an attitude less penitent than cheerful – happy, perhaps, that his chapel had been completed, and contemplating the marvels of the imagination that he had commissioned. Other statues of the duke and his family surrounded the walls of the magnificent dining hall of his palace at Poitiers, around an ornate triple fireplace. Alongside the many tapestries and paintings he commissioned, the duke also bought and commissioned illuminated manuscripts, amassing a considerable library.

One of these manuscripts, a book of hours known as the *Très Riches Heures*, was, as its name suggests, one of the most lavishly painted books of the era.[21] It is a testament to the largesse of the duke of Berry and the ambition of the artists, Pol de Limbourg and his brothers Jean and Herman. No previous manuscript had been made with such large paintings, each taking up an entire vellum sheet. Twelve pages at the beginning of the manuscript show scenes of everyday life through the seasons in the duchy, most in front of one of the duke's many castles (the great château of Mehun-sur-Yèvre appears later in the manuscript in an image of the *Temptation of Christ*). They are masterpieces of observation, showing the way snow settles on a thatched roof, or how sheep were sheared with giant clippers, or how bodies appear darker when in water, as harvesters take off their clothes to swim in the month of August, a falconry party passing in the foreground. Above each a hemispherical calendar shows zodiacal signs surrounding an image of Apollo as sun god.

Pol de Limbourg, the most talented of the brothers, probably painted the page for October. In the foreground, a sower casts seeds, leaving footprints in the soft earth, while a harrower on horseback, holding a whip, drags a square wooden

plough weighted with a rock. Magpies flutter down, hopping on the earth, pecking at the seeds and at the horse's droppings. Beyond, in a ploughed field, stands a scarecrow, holding a bow and arrow. White rags flap to startle the birds. A river – the Seine – separates the scene from the castellated walls and light grey turrets of the Palais du Louvre behind, and on a terrace minute figures are passing the time of day while two dogs fight and boatmen moor their craft. A group of three are reflected in the river while another casts a dark shadow on the palace wall behind.

A moment of life is suspended, as if a sudden equilibrium had been reached, the breath held and the scene captured. Then the seeds fall, the whip cracks, the plough moves on and the tiny figures on the terrace continue their daily lives. The world exhales. Nothing marks this sense of reality frozen for a second more than the shadows cast by each figure, not seen at the time in painting anywhere in the world – those in old Roman painting never gave such a sense of natural light and space, and shadows were unknown in Chinese painting. In this suspended moment, in the shadows caught, a new era of image-making, and human life, was born.

The *Très Riches Heures* was left unfinished when the three Limbourg brothers died, all in the same year, 1416. On 15 June that year the duke died as well. Only some seventy years later, after the manuscript had found its way into the library of Duke Charles I of Savoy, were the gaps filled in by the French illuminator Jean Colombe. Yet by this time, and indeed already when the Limbourgs were on their respective deathbeds, light as a metaphor of knowledge as well as spiritual

elevation was becoming part of a new world of painting emerging in the Netherlands. One of the great founding figures of this tradition, and one of the greatest painters of natural light, as we shall see, was the Flemish artist Jan van Eyck.

October, from the *Très Riches Heures du Duc de Berry*, by the Limbourg brothers. c.1416. Opaque paint and ink on vellum, 22.5 cm by 13.7 cm. Musée Condé, Chantilly.

13

Travellers
in the Mist

Like the painting of ancient Greece and Rome, virtually nothing remains from the first thousand years of art made in China. From the earliest recorded works made during the Han Dynasty, which rose to power around 200 BCE (the same time as Rome), artists painted dragons and Buddhas, demons and emperors, on silk and paper, and on the walls of temples and tombs. Of this long and rich tradition only the merest fragments remain.

From these fragments emerge the basest outlines of an idea of painting given more to isolated human figures than landscape scenes. A surviving handscroll, painted with ink and colour washes around the fourth and fifth century CE, is known as the *Admonitions Scroll*. It was a form of private instruction for women of the court, and shows scenes illustrating a poem from 292 CE by a court official, Zhang Hua, written to 'admonish' the women of the court and instruct them how to behave, in line with the rules of Confucian morality, the rule book for behaviour at court and in official life.[1] The figures are drawn with hair-thin lines and float in an imaginary space, separated by the lines of the poem. In one scene two women admire themselves in polished bronze mirrors, one having her hair arranged by a maid, with lacquered boxes of cosmetics strewn around: 'overcome your thoughts to make yourself holy', runs the admonishing inscription. Another scene shows the story of Lady Feng, who in 38 BCE bravely defended her consort, Emperor Yuan of Han, from attack by a bear, as the inscription explains: 'When a black bear climbed out of its cage, Lady Feng rushed forward [...] She knew she might be killed, yet she did not care' – clearly the height of Confucian court virtue.

Traditionally attributed to the fourth-century painter Gu Kaizhi, who himself may have been copying an earlier handscroll made around the time Zhang Hua wrote his poem, the admonitory scenes are pared down to the essentials. The essence of painting was the ink line, drawn with the brush on silk or paper, or an equally linear, flattened style of painting on the walls of tombs and temples. What counted was a sense of refinement and evocation, rather than description drawn

Admonitions Scroll (detail), after Gu Kaizhi. c.5th century. Ink and colour washes on paper and silk, 24.4 cm by 343.7 cm (entire scroll). British Museum, London.

from close observation. 'His ideas are like clouds floating in space, or a stream hurrying along – perfectly natural', a Chinese critic later wrote of Gu Kaizhi.[2]

It is a telling metaphor, and one that points to the ascendance of nature in Chinese painting in the century after Gu Kaizhi. Early Buddhist painting in China, most of which part was lost or destroyed during the persecution of Buddhists from the fifth century CE, was also a source of nature painting. Only the cave temples of Dunhuang preserve some sense of the heritage of this imagery and the first large images of landscapes, painted in a broad, decorative style. It was not religion, or at least not religious imagery, that came to define the long tradition of Chinese painting, but rather an experience of nature, away from the demands of temple and court.

Landscape painting in China was part of a new human sense of being within nature, of admiring the natural world for its own sake, a wilderness in

which to become lost, and to find shelter. The task of painters was to communicate this feeling. The eighth-century poet and artist Wang Wei was the archetypal figure of the official who found solace by retreating into the wild – in Wang's case it was to his famous country estate a day's journey south of the capital, Ch'ang an, known as the Wang-ch'uan Villa. He wrote a series of twenty poems describing places along the Wang River valley:

> Deer Park
> Hills empty, no one to be seen
> We only hear voices echoed –
> With light coming back into the deep wood
> The top of the green moss is lit again.[3]

Each of the poems Wang painted on a scroll, known as the *Wang River Scroll*, were lost, but not before the scroll became a model for artists wishing to combine the poetic word and the painted image.

Later generations of artists looked back to Wang Wei as a shadowy figure who founded a tradition of poetry and painting practised by gentlemen amateurs, scholar–painters who preferred to express the philosophical and

Wangchuan Villa, by Wang Yuanqui. 1711. Handscroll, ink and colour on paper, 35.6 cm by 545.5 cm (entire scroll). Metropolitan Museum of Art, New York.

TRAVELLERS IN THE MIST

religious beliefs in works of art, rather than reflect the opulence and power of court life (although Wang was often at court, and wrote poems for the emperor). They had an obsession with self-cultivation through poetry, painting and calligraphy, and a high-minded horror at having to earn a living through selling their creations. They preferred to give them to each other as gifts. These scholar–painters (later known as the 'literati') were most often found in rural retreats, wandering mountain paths, lost in the contemplation of art and nature and, on their return, making ink paintings in a simple, austere style, as enlightened amateurs.

The landscape painting that emerged in the tenth century, in the years of the Northern Song dynasty, had its origins in this view of nature, as something felt, and thought, rather than observed. One painter of this era tells the story of how, wandering in the mountains near his home, he stumbled across an ancient rock cave. 'Inside there was a moss-grown path dripping with water, and along it were strange stones enveloped in a mysterious vapour.' Further along, he marvelled at a grove of old pine trees, one of which 'looked as if it were a flying dragon riding the sky, or as if it were a coiling dragon aiming at reaching the Milky Way'. The painter, by the name of Ching Hao, returned to paint the scene many times, before meeting an old man who taught him the 'art of the brush'. Painting, Ching learned, was not a matter of outward appearances but a way of measuring the true reality of things. 'Lifelikeness means to achieve the form of the object but to leave out its spirit. Reality means that both spirit and subject are strong,' the old man tells him.[4]

Like Wang Wei, Ching Hao was a legendary figure, none of whose paintings was to survive in the original. Their spirit was preserved in the many copies and paintings influenced by his landscapes made on hanging scrolls, showing towering mountains, darkened gorges and precipitous ravines. Paths wind up through the glowering landscapes, a few tiny figures dotted about to give grandeur to the scene. The disappearance of most of the pioneering paintings of the Northern Song-dynasty landscape school only adds to their legend. The painter Li Cheng, who was born in the early tenth century, around the time that Ching Hao died, was known for his wintry scenes of rugged peaks and gnarled branches – a loner's pursuit, made by an artist who opted to be a recluse, wandering in the mountains. Most of Li Cheng's paintings were lost, or confused with copies, so it is not clear whether any of his works survived – he did not sign them.

One artist of the following generation, Fan Kuan, who continued the Northern Song style of lofty peaks, did sign his paintings – or, at least, one that was to survive, and which was to become the most famous early landscape of Chinese painting.

It is a portrait of nature, of the character of a mountain, with the tiny figures of travellers - two merchants with four mules - included only to emphasise the grand scale of the rocky mass rising above them, cut off from the foreground by a cloud of mist. Fan Kuan painted it with a particular type of brushstroke known as *yudian cun*, or 'raindrop texture stroke', conveying a sense of the rough, darkened surface of the rock. From the mountain heights a waterfall streams down a narrow cleft, shown by a strip of bare silk, mysteriously branching into two before disappearing into the mist behind gnarled trees and the roof of a hidden monastery. When it reappears in the middle distance, it has split into more streams gushing into a river flowing behind massive rocks in the foreground. In Fan Kuan's painting the mountain seems like a living being. As one of his near-

contemporaries, the celebrated painter Guo Xi, wrote, 'A mountain has water as blood, foliage as hair, haze and clouds as its spirit and character.'[5]

Guo Xi's own paintings preserve this living image of nature as an idea, an expression of thought. He was a painter at the court of the emperor Shenzong and was famed for painting all the murals, later destroyed, at the Northern Song-dynasty capital of Bianjing (present-day Kaifeng).[6] One surviving painting shows the idea of nature that permeated his work – a hanging scroll showing a barren landscape in early spring, originally displayed in one of the palace chambers for the emperor to enjoy.[7] It is a landscape of the imagination, where rocks, mountains and trees appear like apparitions in a floating field of mist. Guo's brushstrokes are loose, the ink applied in wet washes, thinned to indicate atmospheric depth, and using a type of hooked stroke called a 'crab's claw', to show the barren branches of the trees clinging to the mountainside. On one side a waterfall descends from a cluster of lonely monastery buildings; on the other a strange curving valley disappears into the mist. Tiny figures scurry about the landscape, reappearing on distant paths. What time of day it might be is unclear. The light is even, shadowless. Showing the effects of natural light, beyond misty recession, and using variations of tone were of little interest to Chinese painters. There are no cast shadows in Chinese painting.[8]

What counted was the idea of nature, of landscape mood, and painters were as eager to write treatises and descriptions of this mood as they were to capture it with ink on silk. The fourth-century painter and musician Zong Bing, in one of the earliest treatises on landscape painting, wrote that such painting should constitute a dream journey through mountains and water, so that the term *shan shui*, or 'mountain-water' pictures, became synonymous with landscape paintings. Although the origins of this

Travellers among Mountains and Streams, by Fan Kuan. Early 11th century. Hanging scroll, ink and colours on silk, 155.3 cm by 74.4 cm. National Palace Museum, Taipei.

TRAVELLERS IN THE MIST

dream journey might be religious thought, it is impossible to say exactly how. 'Landscapes display the beauty of the Tao through their forms', wrote Zong Bing with typical vagueness, referring to the principles of Daoism, an ancient system of mystical beliefs by which thought and nature were seen as part of a wider cosmological continuum.⁹ Unlike their Western counterparts, who were moving towards an ever closer observation of nature in their paintings in manuscripts and on wooden panels with oil, and in keeping with their status as scholars, Chinese painters did not feel compelled to paint from direct observation, rather relying on memory and their technical ability, their ink brushstroke bravura, to create their scene of mountains and water. As the tenth-century poet–painter Su Shi once observed, 'Anyone who talks about painting in terms of likeness deserves to be classed with the children.'¹⁰

Where Northern Song painting was grand and heroic, the paintings produced by artists of the Southern Song dynasty, after the imperial court was forced to move south to Hangzhou, are much quieter, more gently suggestive in their poetry. Southern Song painters excelled at images of emptiness and silence, of a fragility that seems to dissolve even as we look at them.¹¹ A small square painting on silk by Xia Gui, one of the most typical of Southern Song artists, shows the dark forms of trees overhanging a lake and the tiny sketch of a figure crossing a bridge to reach a moored boat. The barest wash of ink suggests

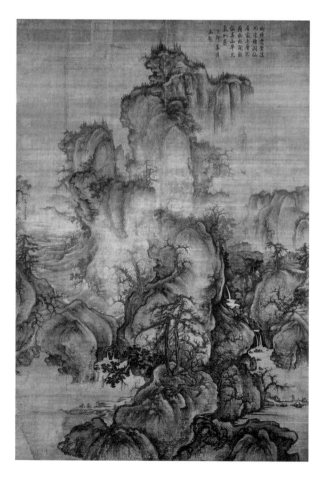

a mountain range in the background and a damp, washed-out atmosphere: ordinary weather on an ordinary day. In Xia's paintings, as in those of his contemporary Ma Yuan, the blank silk and paper become parts of the image, standing in for mist, vapour, fog or simply space. The Ma–Xia style, as it is known, conveys a contemplative response to nature that became the image of Chinese painting abroad: a moment of silent awe in front of the stillness of a lake or the simplicity of a winter landscape, forms covered in blankets of snow.

These were also precepts of a new type of Buddhism,

Early Spring, by Guo Xi. c.1072. Hanging scroll, ink and colours on silk, 158.3 cm by 108 cm. National Palace Museum, Taipei.

distinct from that expressed in the elaborate cave paintings of Dunhuang, known as Ch'an (it was to become Zen Buddhism in Japan). The ideals of emptiness and reflection in Ch'an Buddhism combined, in the work of Ch'an monk painters, with the nature painting inherited from the times of Wang Wei, by which the essential character of a thing, an animal, plant or scene, could be expressed in a simple series of brushstrokes, bringing image-making and writing as close as they had come since the earliest days of pictorial writing in China. Ch'an painters, who were really one type of 'literati' artist, worked in monasteries in the hills around Hangzhou, making spontaneous ink paintings, most of which were to disappear – only the works of the thirteenth-century monk–painter Muqi were to survive in any quantity, preserved in Japanese Buddhist temples. With his loosely brushed diluted-ink style, Muqi came much closer to nature than other Southern Song artists; in one of Muqi's best-known works, a female monkey and her child sprawl in the branches of a tree hanging with foliage, staring at the viewer with calm curiosity.

Such calm reflectiveness was not to last long – or at least not too long. In the 1270s Mongol invaders from the north put an end to the Song dynasty, taking Hangzhou in 1276, and began a period of foreign rule under the Yuan. Yuan-dynasty China was at the heart of one of the largest empires ever known, that of the Mongols, which stretched as far west as modern Hungary. At its centre stood Shangdu (now Dolon Nor, in Inner Mongolia), the famous palace built by Kublai Khan, grandson of the first Mongol conqueror, Chingis Khan. For those artists employed to decorate the rooms with 'figures of men and beasts and birds, and with a variety of trees and flowers', as the traveller Marco Polo later remembered of the palace of Xanadu, as he called it, the Mongols were an important source of commissions, just as they were in Persia. Yet others, particularly the 'literati' painters, faced the dilemma of whether to serve the new rulers or retreat from the city and court and take solace in the nature along the Yangtze River.

The renowned calligrapher and painter Zhao Mengfu, perhaps aware of his position as a descendant of the Song-dynasty imperial family, went to serve Kublai Khan as a civil servant at his court in Dadu. He had an illustrious career as an official, as well as being a poet, calligrapher and painter of landscapes, but was obliged to spend much of his time painting horses, the nomadic Mongols' favourite subject.

Others went into retreat, following a pattern established five hundred years earlier by Wang Wei, devoting themselves to evolving ever-more refined types of brushstroke to capture their heightened perception of nature. They cultivated small plots of land, played the Chinese lute, wrote poems, painted and practised calligraphy. The landscape was their solace, as well as their subject.

Of these none was more aristocratic in manner, or more refined in his painting

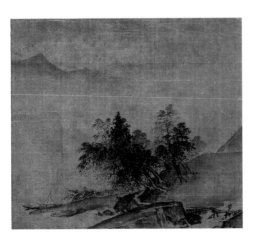

Landscape, by Xia Gui. 13th century. Ink and colours on silk, 22.5 cm by 25.4 cm. National Museum, Tokyo.

TRAVELLERS IN THE MIST

technique, than Ni Zan, a scholar–painter from southern China. He was obsessed by washing, and when the painter Qiu Ying made his portrait in the 1430s, showing him sitting in clean white robes on a dais, in the attitude of a connoisseur, he also included a servant bringing water and a towel to wash and another holding a large feather duster.

Civil unrest under Mongol rule, as well as insistent tax collectors, forced Ni Zan to leave his comfortable estate and spend his later years on a houseboat on Lake Tai and lodging at Buddhist monasteries. He whiled away the days painting similar scenes of a landscape with foreground trees and distant hills separated by a long stretch of empty water, as if getting ever closer to the essence of the subject. The composition came from a visit he had made one morning to a hermit in the mountains, which he had commemorated with a painting of the trees and lake in front of Mount Yu. Each subsequent painting was a recollection of the previous one, the scene becoming more and more detached from its source – just as memories themselves become memories of memories, smoothed and simplified by the habit of repetition.

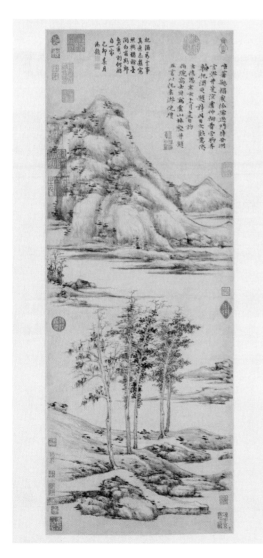

For Ni Zan, as for many Chinese painters before him, the image became a symbol: the clump of trees was a sign of steadfast friendship in a hostile world, the austere style and dry brushwork reflective of the hardened will of the exiled life. There are no interesting details or flourishes of style; the sense is rather of melancholy, purity and detachment – boredom, even.[12] Far from being seen as negative, this quality of blandness, even insipidity, was much admired, and Ni was one of the most sought-after artists of his time. The detachment and seclusion of his later life were considered a noble response to the occupation of China by a foreign power, the Mongols, and the turmoil and uprising against their dynasty, which was soon to come to an end when native rule was restored by the first emperor of the Ming dynasty, Hongwu, in 1368.

It was a time of renewal for Chinese culture,

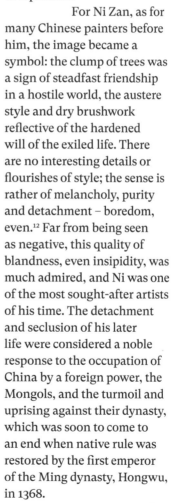

Woods and Valleys of Mount Yu, by Ni Zan. 1372. Hanging scroll, ink on paper, 94.6 cm by 35.9 cm. Metropolitan Museum of Art, New York.

and reverence for those spirits, such as Ni Zan, who had resisted foreign rule. A painting in Ni Zan's style, perhaps by one of his predecessors from the Southern Song school, is shown being admired by court officials in the Ming-dynasty handscroll *Elegant Gathering in an Apricot Garden*, painted just over sixty years after Ni's death. Held by a servant on a pole, only the corner of the Ni Zan-type painting can be seen as it is viewed in a Beijing garden. *Elegant Gathering in an Apricot Garden* records an actual gathering of connoisseurs, even giving the precise date – 6 April 1437 – some years after the collapse of Mongol rule and the beginning of ethnic Chinese rule of the Ming dynasty. The handscroll also records the name of the Ming court officials in attendance. Qian Xili sits in blue robes, holding the painting as if he were a prospective buyer. Beside him, Yang Pu looks on in amusement. The garden is that of the Ming statesman Yang Rong.[13] Viewing the painting is not the only diversion on offer. A chess game awaits, and tables are set up for calligraphy and painting – one of the guests has already availed himself of a brush and stares out of the picture, his brush raised, as though searching for inspiration. Perhaps it might come from the scroll painting being admired by Qian Xili – or the long tradition of exile painting, most recently in the austere paintings of Ni Zan. There is no better subject for works of art, after all, than troubles overcome. Ni's wintry trees, those symbols of steadfast friendship in adversity, have become real figures interacting as friends in a happier time, celebrating their friendship and success by looking at a fine work of the imagination.[14]

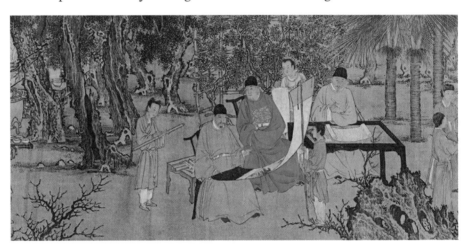

Elegant Gathering in the Apricot Garden, after Xie Huan. c.1437. Handscroll, ink and colour on silk, 37.1 cm by 243.2 cm. Copy of the original in Zhenjiang Municipal Museum; Metropolitan Museum of Art, New York.

These Ming officials might equally have been admiring fine ceramics, laid out on a table in another part of the garden. Ceramics are, in a distant sense, a landscape art – the quality of the pots and vessels made in Chinese kilns since time immemorial was dependent on the fine raw materials available in the landscape: pure types of clay such as kaolin and, above all, the porcelain stone found in southern China, Korea and Japan. Since the invention of the potter's wheel, around 2900 BCE, technological leaps in shaping, firing and glazing pots using these materials had evolved into one of the greatest ceramic traditions anywhere in the world.

The ceramics being admired by Yang Rong and his friends were probably those made during the T'ang and Song dynasties, from the seventh to the thirteenth centuries – by Yang's time, veritable antiquities. Among the greatest

TRAVELLERS IN THE MIST

of these were the white porcelain dishes and bowls produced in a northern kiln in Hebei province during the Song dynasty, in an area known as Dingzhou, from which the ceramics take their name. Ding ware was so thin that a new firing technique was invented, resting the bowls upside down – this led to a roughened rim, from which the glaze had been wiped to avoid it sticking to the resting surface, and requiring a silver or copper rim to be added after the firing had been completed.[15] Lotus flowers and peonies, ducks and dragons were often incised on the surface – later images were made by pressing the hardened clay dish over a shaped mould, carved with ornament. The decoration is barely visible, seen only by the subtlest of shadows over the glistening white surface of the dish.

It was the revelation of a coloured pigment from far away to the west that defined the look of pottery in China during the Ming era. Merchants brought cobalt ore from Persia, where it had been mined near Kashan and used for some time to decorate ceramics, mainly tiles.[16] Blue-and-white porcelain was at first made in China, at the beginning of the fourteenth century, for export to western Asia, for the Islamic market, but in time the fashion took hold in China itself. During the first decades of the fifteenth century production at the imperial kiln of Jingdezhen reached its height. On a porcelain flask made at the time of the Yongle emperor, in the early years of the fifteenth century, the sinuous form of a dragon is surrounded by scrolling shapes of lotus flowers. The look of blue-and-white porcelain is above all one of optimism, of blue skies, of freshness and lustre, an optimism that could inspire a new emperor and his subjects.

Yang Rong held his cultured gathering of officials in Beijing, the centre of the vast, ordered and ritualised world of the Ming dynasts. For artists and writers, however, there was only one place to be in fifteenth-century China: the glittering city of Suzhou on the Yangtze River, the unofficial art capital of the Ming empire.

A great walled city, criss-crossed by canals, and surrounded by a wide moat, Suzhou was one of the largest cities in China, its skyline dominated by the imposing form of the Great Pagoda, over two hundred and fifty metres in height. The great wealth of the city, derived from rice cultivation on the Yangtze delta, and also from weavers and artisans working in the textile industry, was a

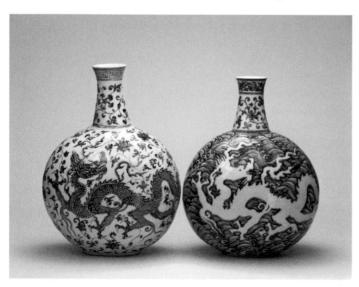

(left) Flask with blue and white dragons. Ming dynasty, 1403–1424. Porcelain, h. 47.8 cm. British Museum, London; (right) Flask with white dragons on blue waves. Ming Dynasty, 1403–1424. Porcelain, h. 44.6 cm. British Museum, London.

lure for artists from all over China to come and seek lucrative commissions and to enjoy living in a city that had itself been transformed into a work of art. Temples, government buildings and mansions had gardens for which Suzhou was famous, designed with streams and rockeries to imitate the world outside the city walls. The canals were crossed by numerous stone bridges, of which the most famous, the Maple Bridge, was the subject of a celebrated poem by the T'ang poet Zhang Ji:

> Moon set, a crow caws, frost fills the sky
> River, maple, fishing-fires cross my troubled sleep
> Beyond the walls of Su-chou from Cold Mountain temple
> The midnight bell sounds reach my boat.[17]

During the Yuan dynasty dissidents congregated in Suzhou, Ni Zan among them, to take advantage of its refined atmosphere, its pleasure boats and theatres, its temples and gardens.[18]

It was thanks to two artists, Shen Zhou and his pupil Wen Zhengming, that Suzhou was the setting for a revival of ink-wash painting in the middle years of the fifteenth century, an amateur style, derived from Ni Zan and his followers, that came to be known as the Wu School after the surrounding countryside, the area of Wuxian.

Shen Zhou was a scholar and painter who lived in comfortable seclusion on his estate near Suzhou. His desk was laden with volumes of ancient poetry, his study filled with paintings from which he copied and learned, absorbing the spirited brushwork of the Yuan masters such as Ni Zan and Huang Gongwang. He drew living creatures (although not necessarily from life) – a crab, a chicken, a cat – as well as painting more conventional subjects such as bamboo and plum blossom. But it was his landscape views that set him apart. Some showed scenery around Suzhou; others were entirely imaginary. All were done in the scholar's manner, spontaneous ink drawings unconcerned with fussy detail or glossy finish. To many he added poems and inscriptions. An ink drawing of a poet sketched with a few lines kneeling on a mountaintop, rising from the mist, shows the poem like an apparition in the sky:

> White clouds like a belt
> Encircle the mountain's waist
> A stone ledge flying in space
> And the far thin road,
> I lean on my bramble staff
> And gazing into space
> Make the note of my flute
> An answer to the sounding torrent.[19]

Shen's student Wen Zhengming went even further than his master in this journey into the spirit of nature. His image of *Wintry Trees* is a small painting

in drily brushed ink, displayed on a hanging scroll. The nod to Ni Zan is clear, and to the shadowy tenth-century figure of Li Cheng before him, yet Wen made the subject his own. A stream, cold and clear, meanders among rocks and trees, leading into the heart of the forest, its splashes and trickles breaking the wintry silence. An old tree at the heart of the grove is taller than the others; it leans slightly to the right, its crown a tangled mass of spiky leaves, perhaps mistletoe or some other parasite. The trees are like spirit presences, drawn not with lines but with dabs and touches of dry ink, brushmarks that by themselves barely exist, hanging in the atmosphere of the image, giving the presence and minute vibrations of nature. Small adjustments in brushmarks distinguish rocks, wood, water and leaves, each with its own distinct character.

In his calligraphic inscription Wen describes how he spent ten hours making the image, as a gift for a certain Mr Li Zicheng, who had walked from afar to visit Wen in Suzhou after the death of the artist's wife. Li Zicheng made condolence offerings, and according to custom was due something in return. The inscription implies that *Wintry Trees* was a gift, but also a way of getting rid of an unwanted guest.[20] Wen used the 'crab-claw' brushmarks associated with Li Cheng, a painter of the tenth century who made landscapes similar to those of Fan Kuan, and whom he had discussed with his visitor (so the inscription records), probably on account of the similarity of their names.

Nature is the animating personality in Wen's painting. Even when he included human figures, they are passive, standing, watching, listening to the world around them. Like the nature they stand within, their austerity has a moral dimension, one of nobleness, steadfastness, survival and sacrifice. Like Ni Zan's work, Wen's is an art of tacit dissent.[21]

In 1644 the Ming dynasty fell to Manchu warriors invading from the north, leading to the inauguration of a new dynasty, the last imperial family of China, that of the Q'ing. Just as under the Yuan dynasty, not all native Chinese artists fell into line with their new Manchu leaders, taking the traditional path of reclusive retreat. Gong Xian, an artist from Nanjing, was one such dissident,

Poet on a Mountaintop, by Shen Zhou. 1496. Album leaf mounted as a handscroll, ink on paper, 38.7 cm by 60.3 cm. Nelson-Atkins Museum of Art, Kansas City.

Wintry Trees After Li Cheng, by Wen Zhengming. 1542. Hanging scroll, ink and colour on paper, 60.5 cm by 25 cm. British Museum, London.

who spent the latter part of his life living as a recluse in his house and garden in Nanjing. The heavy dark forms of his landscapes, particularly *A Thousand Peaks and Myriad Ravines*, made in 1670, bring to mind the glowering mountains of Li Cheng and Fan Kuan, and also the more recent painting of Dong Qichang, an older, much revered painter and collector who in his theoretical writings had emphasised the importance of *qi*, or creative originality, rather than the copying of traditional models, the approach that Chinese artists had followed for close on two thousand years. Gong Xian was one such original: a visionary artist open to influences, quite free to take a step away from the traditions that had bound artists for centuries. He was one of the greatest painters of the Nanjing school at a time when the first European images were to be seen in China, brought by Jesuit missionaries. They were strange and shocking things that appeared far more rounded and real than the ink painting Chinese artists knew. Shading with light and dark, a technique known as *chiaroscuro*, gave solidity to objects, such as the mountains that Gong painted using the European method, although using a stippling that brought him back to a traditional Chinese idea of brushstrokes. Liberating image-making, however, does not always result in freedom for the image-maker. Despite a string of patrons, and some success, Gong Xian ended his years in poverty – when he died in 1689 he was destitute, and his funeral expenses were paid by his friend the famous playwright Kong Shangren.

Since the earliest days of the artform, painters in China had struggled with their lowly status, much as artists had in ancient Greece. The scholarly 'literati' painters disdained payment and official positions, opting rather for the independent life of amateurs. They held connoisseurship as a higher achievement than material gain, and were part of a culture in which looking, judging and appreciating were considered creative acts, on a par with the actual creation of works of art. Viewers were artists also. Despite the apparent continuity of painting traditions, however, based largely on monochrome ink applied with a brush, there was a large diversity of work created. The world's first tradition of landscape painting emerged, as did some of the first self-conscious images of art, paintings that show an awareness of being paintings. And these paintings often showed

a reverence for the past; the artists were open to the wider world, to a constant stream of migrant influences, from Mongolia to the north, and, from across mountains and deserts, from central Asia, and from Europe in the far west. None of these influences, however, was as important as the interaction with a people who lived on a set of islands curving off into the eastern ocean: the islands of Japan. [22]

14

Spellbound

On a wooded hill on the outskirts of a Japanese city stand a series of simple wooden gateways, upright posts crossed by a gently curving beam. Through them winds a path up between the trees to a clearing where stands an open-sided pavilion: a shrine. Plain in appearance, it is made from wood and bamboo, the roof thatched, decorated with strands of mulberry cloth, artfully torn to make streamers, fluttering in the wind. There are no images or statues of gods to worship or admire, only the spirits of nature: the spellbinding rustle of the wind in the trees; a crow's loud caw; the trickle of water in a fountain near by.

The shrine is devoted to Shinto, the oldest religion in Japan. The very earliest Shinto shrines were nothing more than a collection of rocks, or a tree where the spirits, or *kami*, which inhabited the place were worshipped. Like the wind forming dunes, this spirit of nature shaped the earliest objects made on the Japanese islands, the clay pots and vessels with their curious shell markings and rope patterns made by the Jōmon, a people who first appeared on the islands of Japan around 14,000 BCE.

For many thousands of years these hunter–gatherers made elaborate vessels, some with flame-like forms, others in human shape, with intricately decorated bodies humming with inner energy. The long passage of time is preserved in surviving clay pots, their forms slowly changing as if records of the slow shifts of geology and climate. They also record a more sudden change in the middle of the third century CE, when a new sort of clay image appears. Often associated with burial sites, these images signal a greater sense of stability and permanence, and are linked with a culture based around paddy fields and rice cultivation, which used bronze to forge farming tools but also weapons and ceremonial bells and mirrors. Cylindrical clay pots and vessels that often took the

shape of human figures and other animals, houses and boats were placed on tombs to say something about the person buried beneath – at this time there was no written language on the islands of Japan. These objects, known as *haniwa* figures, are hardly sombre but rather radiate optimism, like the Nok terracotta burial heads from ancient western Africa. An earthenware dog, made around the fifth century CE at the height of these *haniwa* figures, is a delightful image of canine optimism and alertness, free of any grand religious sentiment. It

Bowl. Jomon period, 4th–3rd BCE. Earthenware, National Museum, Tokyo.

Haniwa dog. Kofun
period, c.6th–7th century.
Earthenware, h. 57 cm.
Miho Museum, Shiga.

suggests an attitude to death unburdened by great pomp and emotion, accepting mortality rather as part of the greater pattern of nature.

Such a spirit of nature, emerging from the bare Shinto shrines, and the simple objects emerging for thousands of years from the potters' workshops, runs like a stream through images made on the Japanese islands.[1]

In the middle of the sixth century a larger, heavier, altogether more worldly type of image arrived. Gold and copper statues of the Buddha, along with banners, umbrellas and a selection of sutras, the sacred books of Buddhism, were a gift to the Japanese emperor Kinmei from a ruler on a neighbouring peninsula, the kingdom of Paekche (in modern south-west Korea). The initial reaction was, it seems, one of bewilderment. The appearance of the Buddha was one of 'severe dignity', Kinmei is recorded as saying, 'such as we have never at all seen before. Ought it to be worshipped or not?'[2]

Whatever objections there may have been (some accounts record the statue being thrown in the canal) were soon overcome. The new faith, with its powerful images, had arrived along the Silk Route connecting the Japanese islands with the towns and cities stretching west, through Chinese Xi'an to the cities of central Asia, then to the Indian homeland of the Buddha and beyond, all the way to Constantinople and the western Roman empire. Buddhism was a thoroughly cosmopolitan religion, the image of its gods having evolved as it travelled along merchant routes. By the time it reached Japan, the 'Great Vehicle' of Mahāyāna Buddhism had reached its final stop on the long journey across central Asia and China, loaded with statues and images of the Buddha and a pantheon of deities, ready to disembark and get to work in a fresh and propitious land.

To the native dwellers of Japan, used to the modest clay *haniwa* figures and their curious Jōmon predecessors, these bronze Buddhas were frighteningly realistic and alarmingly large. For a long time they were considered foreign imports with an other-worldly allure. Only slowly did a home-grown style of Buddhist image emerge in Japan: the second great image-making tradition on the island after thousands of years of nature worship and small clay figures.

One of the earliest Buddhist monasteries was established by a prince named Shōtoku, a nephew of the empress Suiko, the daughter of the emperor Kinmei and the first woman to rule Japan. Suiko was the first ruler to support Buddhism in Japan, although it was largely due to the industriousness of Shōtoku, who succeeded in creating the first centralised government for the country, founded on Buddhist principles, that it truly took hold. In the early years of the seventh century Shōtoku established a monastery known as the Hōryū-ji near his palace on the Yamato River.

Towering over the buildings at Hōryū-ji is the unmistakable stepped form of a pagoda. Like the Indian Buddhist stupa, the pagoda, first created in China, was designed not as an inhabitable building but rather as a place to store relics and radiate their sacred energy. Four carved images of the life of the Buddha

stand at the base of the Hōryū-ji pagoda, surrounding a reliquary holding, it is said, one of the Buddha's bones, from which point a pillar ascends through the centre of the structure to the finial at the top – the *axis mundi* – like the pillars erected by the first Indian Buddhist king, Ashoka, a mast broadcasting the Buddha's teachings.

The pagoda is in this way a symbolic structure and, like the Roman triumphal arch, more a sculpture than a building. With its upward lift and square-shaped stack of sloping roof eaves, the Japanese pagoda is a complete reversal of the form of the Indian Buddhist stupa, a downward, earth-clasping hemispherical form, as if the idea of a reliquary building had been quite literally turned on its head during the eastward journey of Buddhism. The pagoda at Hōryū-ji was certainly at odds with the modest appearance of Shinto shrines, which blended naturally into their surroundings.³

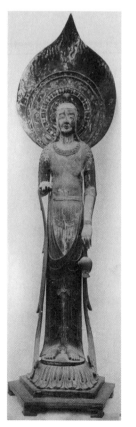

In the shadow of the pagoda at Hōryū-ji stands the Kondo, or 'Golden Hall', housing ancient Buddhist relics and sculptures – a treasury, rather like those found centuries later in European cathedrals. The frescoes on the walls were the most elaborate of early Buddhist painting, probably made by artists of Chinese or Korean descent, alongside the paintings at the Mogao caves at Dunhuang.⁴ Yet of all the Hōryū-ji treasures the most impressive is an elegant, willowy standing figure, with hanging sleeves and a flaming halo. It is the benign, comforting figure of Avalokiteśvara, or Padmapani, the *bodhisattva* of compassion, known in Japanese as 'Kannon'. Such an unnaturally elongated style was a Korean invention, giving the carving its name, the *Kudara Kannon* (Kudara was the Japanese name for the kingdom of Paekche in Korea). It was carved from a single block of camphor wood, painted in bright colours, the flowing sinuous forms surmounted by a flame-like mandorla behind the Kannon's head, adorned with a jewel-studded crown. Like the pagoda, it has a striking symbolic presence, standing between earthly cares and enlightenment, between male and female, between the reality of daily life along the Yamato River and the

Kudara Kannon. 7th century. Camphor wood, h. 209.4 cm. Hōryū-ji temple, Nara.

powerful, irresistible allure of a message from elsewhere: the promise of escape from hunger, pain and desire.

The *Kudara Kannon* appeared in the first era of Buddhist Japan, when the imperial capital was at Asuka (thus the 'Asuka period', from 538 to 710) and China and Korea were the models for sculpture and architecture. At the beginning of the eighth century the imperial capital was moved from Asuka to Heijō-kyō (present-day Nara), and a large Buddhist temple was built, known as the Tōdai-ji, symbolising the unity of the country under the sway of Buddhism. A giant bronze statue of the Buddha, measuring over sixteen metres high, was created to inhabit the Great Buddha Hall of the Tōdai-ji. Bigger was better when it came to the Buddha, particularly from a political point of view. The Great Buddha, or *Daibutsu*, was ordered by the emperor Shōmu (who reigned from 701 to 756) after a devastating plague and a period of civil unrest. It was created by Kuninaka no Muraji Kimimaro, a descendant of a Korean immigrant, and took some eight years to complete. The bronze used drained all the copper reserves in the country, so that wood-carving became popular for decades to come. In the spring of 752, anticipating the sculpture's completion three years later, an opulent eye-opening ceremony was performed, including a masked dance drama, where an Indian monk was hauled up the gleaming, as yet ungilded, body of the statue to paint in the eyes.[5]

Such a monster Buddha was a grand spectacle (at least until the Great Buddha Hall and the *Daibutsu* were destroyed by fire in 1140). Ordinary monks may have found it easier to identify with smaller, life-size images of the Buddha's disciples (ten in number, a sort of rival team to the disciples of Christ) made at Heijō-kyō around the same time. The robes of one disciple, Furuna, noted for his skills in preaching, cling to his emaciated ascetic's body. His expression is one of hesitancy, anxiety: a very human face. With furrowed brows and parted lips he gazes into the distance, as if trying to give voice to a difficult thought.

The figure was made with a technique imported from China known as dry lacquer, in which hemp cloth soaked in juice from the lacquer tree is layered over a wooden or clay core. Lighter and more manageable than bronze (reserves of which had in any case been exhausted by the oversized Buddha), lacquer allows the subtle surface texture and detail, the furrows and lines indicating the urgency of Furuna's message, and the extreme emotion of bodily denial. Dry-lacquer images of the ten disciples were arranged around a central figure of Buddha in temples and worshipped to the sonorous ring of bell chimes, like a scene frozen from a religious drama.

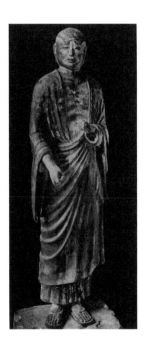

Furuna. c.734. Painted dry lacquer, h. 149 cm. Kōfuku-ji Temple, Nara.

Until this moment, in the early ninth century, there had been an obvious difference between sculptures made in local Japanese workshops and those ideas and objects that came from mainland China, then under the rule of the T'ang dynasty.[6] *Kara-e*, or 'T'ang things', had been the highest seal of quality in Japan: made in China. Now, with the advent of Furuna and other lifelike sculpture, Japanese artists recaptured a strength of response to their own

surroundings and landscape, a renewed feeling of their own powers of creation.

Like the confidence in ancient Greece after the adoption of the Phoenician alphabet and the setting down of oral traditions of poetry, Japanese artists were in part responding to the adoption of the Chinese script, fulfilling the need for written language on the islands. The first anthology of Japanese poetry, the *Manyōshū*, was compiled in the middle of the eighth century, a demonstration that the Japanese could rival the Chinese poetry that dominated literary circles, even if it was composed in the Chinese written language. The achievement of the *Manyōshū* was to crystallise a world view that stretched back to the origins of Shinto, and beyond to the earliest phases of Japanese thought and image-making. It appeared as *Beowulf* was being composed in Anglo-Saxon Britain, and yet the view of the natural world it proposes is quite different, closer to a true, observed experience of nature. During the sixth century, after climbing a hill in the Yamato plain (Yamato was the region around the imperial capital of Heijō-kyō, and became by extension a name for Japan as a whole), Suiko's successor, the emperor Jomei, had written a poem, included in the *Manyōshū*, that records such a moment of vision:

> Countless are the mountains in Yamato,
> But perfect is the heavenly hill of Kagu;
> When I climb it and survey my realm,
> Over the wide plain the smoke-wreaths rise and rise,
> Over the wide lake the gulls are on the wing;
> A beautiful land it is, the land of Yamato![7]

It was from the beautiful land of Yamato that the first native style of painting took its name. *Yamato-e* ('Japanese painting') was a renegade movement, a declaration of independence from Chinese painting, and a reaction to the ponderous repetition and alien forms of Buddhist sculpture and architecture.[8]

Yamato-e painting (distinct from *kara-e*, 'Chinese painting') was made on folding screens, in poetry booklets, on flat and folding fans, on the lids of lacquered boxes and also on long handscrolls, known as *emaki*. These were objects made for the imperial court, which in 749 had moved to Heian-kyō (modern Kyoto), in part as a way to escape the influence of Buddhism and the overbearing bronze *Daibutsu*. The refined arts of the Heian court were quite different in tone from the asceticism of Furuna. The happiness of the earthenware *haniwa* dog returns, transformed by the rituals of palace life. Poetry and literature, and tales of the imperial family and of court intrigue, appeared on painted screens alongside images of the rolling countryside around Heian-kyō, imagined in bright, delicate colours. It was an aristocratic art, devoted to peaceful pleasures ('Heian' means 'peace'), and could be applied equally to the sleeve of a robe or the scenes on an *emaki*, the long handscroll paintings designed to be slowly unrolled and pored over, section by section.

Of these *emaki* scrolls, few are more a prism of the intricate ritual of court life than those illustrating the great romantic epic of the Heian period known as the *Genji Monogatari*, or 'Tale of Genji', written around the year 1000 by Murasaki Shikibu, a woman working at the imperial court.

Muchaku, by Unkei. *c*.1208. Cypress wood, h. approx. 196 cm. Kōfuku-ji, Nara.

Murasaki tells the tale of a handsome young nobleman, Genji, his many love affairs and his attempts to regain his royal title, of which he had been stripped for political reasons by his father, the emperor. The long and complex story, with its twists and numerous subplots, mirrors the elaborate ritual and aesthetic passion of the Heian aristocracy. Women played a central role at the imperial court: the *Makura no soshi*, or *Pillow-Book* of Sei Shōnagon, a diary revealing the thoughts and obsessions of a noblewoman at the Heian court, was written at the same time as the *Genji Monogatari*.[9]

Women were also probably involved in the creation of the earliest known handscroll painting illustrating the *Genji Monogatari*, made in the first half of the twelfth century.[10] The *Genji* scroll, abridging Murasaki's epic tale, combines highly refined calligraphy, known as *kana*, on gold- and silver-flaked paper, with spellbinding paintings illustrating scenes from Genji's often complicated romances – the style is known as *onna-e*, or 'women's painting'.

Faces, in the *onna-e* style, were shown by a technique known as *hikime kagibana* ('line for an eye, hook for a nose'), shorthand for drawing a mask-like visage with little expression. Palace chambers are spied on from above, with a technique known as *fukinuki yatai*, or 'blown-off roof', removing the roof and walls to reveal an interior, making the viewer a voyeur.

The painted images of the earliest *Genji Monogatari* (which survives only in two fragments) are like intricate pictorial puzzles, done with deliberate understatement. It is a world of decoration and ritual, of captured beauty, where the moon is always full and the cherry tree always in blossom. Profound poetry, perhaps, but also a highly self-conscious world that keeps its distance. Stylised clouds part to reveal the habits of court intrigue, but then just as suddenly drift

Nezame Monogatari Emaki. Late 12th century. Handscroll, ink, silver and gold on paper, 26 cm by 533 cm (entire scroll). Museum Yamato Bunkakan, Nara.

back to restore privacy and obscure the scene. Like the Persian painter Bihzad, who worked some three hundred years earlier, Japanese painters delighted in opening up interior, emotional spaces as much as they enjoyed obscuring and hiding their subjects, only selectively revealing a closed, private world.

The *Genji Monogatari* handscroll was in fact the last breath of the Heian court and its delightful world of ritual and intrigue. In the late twelfth century power passed to the military class, the shōguns (an abbreviation of Sei'i Taishōgun, or 'barbarian-quelling general'), who built their stronghold of power at Kamakura, near modern Tokyo. Surrounded by their samurai protectors, the shōguns ruled in one form or another for the next seven hundred years.

It was a stark political change, and a strong resurgence for the workshops of Japanese sculptors devoted to Buddhist subjects. Sculptors evolved ever more refined techniques, a trajectory that reached its height with the sculptor Unkei, the greatest artist of the Kamakura period. He carved figures with a lifelikeness more rounded, confident and expressive than anything being produced in Europe in the years around 1200. His figure of Asanga, an Indian monk of the fourth century, made for the Kōfuku-ji temple at Nara, marks a new era for sculpture in Japan, building on the earlier dry lacquer images of Furuna.

There was no comparable high technique in painting, either on scrolls or on folding screens, which continued rather in the parallel traditions of Chinese-influenced Buddhist painting and *yamato-e* images of Japanese life. For the Kamakura shōguns and their samurai officials, however, the most exciting trend was a type of painting imported from China, an austere style of monochrome ink painting made by Ch'an Buddhists, known in Japan as Zen. Ch'an and Zen monks adhered to an aesthetic of renunciation, of simplicity, of melancholia and poverty even, expressed not only in ink splashes and improvisations but also in ritual tea-drinking, garden design and calligraphy. Zen obsessions set the Kamakura officials apart from the luxury of court life and allowed them to project a different, more austere, image of themselves as tough warriors with sparing tastes.

Unlike monastic painting in western Asia and Europe, where scribes and illuminators would labour over the fine, intricate illumination of parchment manuscripts, Zen monks made their monochrome ink paintings, known as *suibokuga*, swiftly and in a spirit of improvisation. They capture the Zen Buddhist preoccupation with spontaneity and emptiness. 'What is the sacred truth's first principle?' asked the emperor Wu of the founder of the sect, the Indian monk Bodhidharma, who introduced Buddhism into China in the sixth century. 'Vast emptiness, nothing sacred,' came the reply.[11] This charged emptiness was captured by the spare forms of Japanese poetry, suggesting an image suspended by wisps of experience:

> Trailing on the wind,
> The smoke from Mount Fuji
> Melts into the sky.
> So too my thoughts –
> Unknown their resting place.[12]

Haboku Sansui (Landscape in Haboku Style), by Sesshū Tōyō. 1495. Ink on paper, 147.3 cm by 35.6 cm. National Museum, Tokyo.

In their temples Japanese Zen monks made *giboku*, or 'ink-play', drawings inspired by those by Chinese Ch'an monk-artists. The simplest of brushstrokes might be transformed into the image of a dragonfly, bamboo leaves or a Zen priest experiencing enlightenment. Zen monks emulated the Chinese habit of combining ink-play drawings with poems, often inscribed in the empty space above the image. With only a few strokes of ink dissolved in water the fifteenth-century artist Sesshū Tōyō, one of the greatest of Zen painters, evoked mountain landscapes, seen as if through sudden clearings in the clouds.[13] With no outline or frame, everything is left hovering in the air – painter, viewer, image – for one crucial moment.

In 1467 Sesshū travelled to China to study with Chinese painters and see the landscape he had known only through painted and drawn images.[14] Thirty years later he recorded his memories of this trip on the inscription over the landscape he painted in the *haboku*, or 'splashed-ink', style. He painted it for a student, named Sōen, as a way of passing on the lessons he had learned in China, and crucially how those lessons might be applied to native Japanese scenery.[15]

These two concurrent traditions in Japan – of *yamato-e*, with its rich, colourful surfaces, and of monochrome Chinese-inspired ink painting – are like two parallel visions of the Japanese landscape: a split consciousness. One offered an austere, cosmopolitan vision, created by artists who had been to China, or who saw in *kara-e*, or Chinese things, the greatest allure and power; the other was an indigenous style that saw the quiet poetry in the landscapes and localities of Japan, with no sense of provincial deference or of being somehow secondary to Chinese painting.

Of all the images of everyday life in Japan the most vivid were recorded in map-like views of Kyoto, showing festivals and famous buildings, and the general hustle and bustle of daily life – a type of painting known as *Rakuchu rakugai zu*, or 'scenes in and out of Kyoto'. The earliest of these paintings (later

lost) was made by the painter Tosa Mitsunobo in 1506, and the tradition that he set in motion was known as the 'Tosa' school. The earliest surviving *Rakuchu rakugai zu* was painted in 1530 on two folding screens, each with six horizontal panels, crammed with myriad details of city life: shrines and temples, the shōguns' palace, carts drawn by oxen in busy streets, countless people going about their daily business. The spectacle of the city is revealed and obscured by the golden clouds that had drifted through Japanese painting since the days of the Heian court. It is a depthless image, figures in the most distant streets the same size as those in the foreground. Lines do not converge, as they would in perspective drawing, but run parallel, as though the scene might carry on for ever, always remaining at the same level of distance. Such drawing of space was derived from Chinese painting, combined with the decorative flatness of *yamato-e* – the sort of images on the *Genji Monogatari* scroll – a spellbinding type of flattened image unique to Japan.

This conversation between the quiet austerity of ink painting and the bold bedazzlement of *yamato-e* continued to shape the distinctive style of Japanese painting into later centuries. In the middle of the sixteenth century the *daimyo*, or warlord, Toyotomi Hideyoshi built a castle at Momoyama (which means 'Peach Hill') outside Kyoto. The new ornate style of Momoyama screen painting was designed to decorate Hideyoshi's castle, and others like it, equivalents of the tapestries in European castles, or the murals and frescoes that decorated the walls of palaces and churches.[16]

The leading spirits of Momoyama painting were two great rivals, Kanō Eitoku and Hasegawa Tōhaku. Kanō Eitoku and his followers, known as the Kanō school, painted bold images of lions and thick-trunked, sprawling cypress trees, bound to please their warlord patrons. The fiery beasts that stride together over Kanō Eitoku's *Chinese Lions*, their manes and tails spiralling in the wind, are shown against a background of golden clouds, parting to reveal a dark, stormy landscape beyond. Golden clouds had been seen before in Japanese painting, but from this moment they drift over nearly all painted screens, offering large reflective surfaces to glow in the darkness of the castle chambers, playing intricate games of concealment. This concealment was combined with an austere lack of expression, like the carved masks of the Nōh theatre that flourished during the Momoyama years, a memory of the blank faces of Heian court painting.

One pair of screens painted late in the Momoyama period shows the silhouettes of crows, in flight and perched, brilliantly capturing the movement and

Crows, one of a pair of screens. Early 17th century. Ink and gold on paper, 156.3 cm by 353.8 cm. Seattle Art Museum, Seattle.

Nō mask: woman (onna). Second half of sixteenth century. Polychromed wood, h. 20.6 cm. Suwa-asugi Shrine, Fukui Prefecture.

habits of the birds, as if seen against a golden sunset. The artist was of the Kanō school, but her or his name has not survived – one of the countless 'Anons', creators of the majority of images that have survived throughout human history. The Crow Screen is recognisably 'Kanō' by virtue of the gilded air against which the birds clamour, settle and huddle, a glimpse of nature transformed into a vivid design.

The Kanō school were a family firm of painters who held power in Kyoto for over three and a half centuries, and were known for such large painted screens – what Kanō Eitoku called *taiga*, or simply 'big paintings'. It was in part a reaction against the big, rich style of Kanō Eitoku that his great rival, the painter Hasegawa Tōhaku, who arrived in Kyoto in 1572, created his own variety of painted screens.[17]

Tōhaku's most famous painting, two six-panelled folding screens showing pine trees disappearing into the mist, might at first appear to be unfinished – most of the surface is blank. Tōhaku revered the Zen paintings of Sesshū Tōyō, whom he claimed as his painter ancestor in his book *Tōhaku gasetsu*, 'Tōhaku's comments on art'.[18] He took Sesshu's empty, floating style and transformed it into something far grander, reflecting the sizeable screens painted by Kanō Eitoku, but adding a level of subtlety that demonstrated his deep knowledge of historic painting styles. His painted screen *Tiger and Bamboo* was made in the style of the thirteenth-century Chinese Ch'an Buddhist painter Muqi Fachang. The tiger is caught in a crouching pose, looking up as if something was about to emerge from the bamboo grove: an encounter within nature caught on a flat surface, given depth only by the folding of the screen itself. Tōhaku's tigers are less threatening but more believable than Kanō Eitoku's strutting lions.

Remaining in the present moment, doing away with perspective and the effects of distance, was an idea that remained in the forefront of Japanese painting after the early years of the seventeenth century, with the beginning of the Tokugawa shōgunate, when the capital was moved to the city of Edo (modern Tokyo). Contact with foreigners was banned and trade restricted to Chinese and Dutch merchants through the closed port of Nagasaki, effectively isolating Japan from the rest of the world.

In their isolation Japanese artists became all the more fascinated with those images and objects that seeped through from China and Europe, as exotic and startling as the first bronze Buddhas, over a thousand years earlier. They also looked to their own past, to the glories of Heian culture, the age of *Genji Monogatari*. In the early years of the eighteenth century a new school of painting arose, devoted to the flattened and decorative effects of native art, and known as *rinpa*, after Ogata Kōrin, the founder of the school (from 'rin', the last part of his name, and 'pa', meaning 'school'). Kōrin's painting of purple-headed irises arranged across a golden screen was inspired by *The Tales of Ise*, a collection of poems from Heian times. It is a pure expression of the Japanese preference for flattened forms expanding rhythmically in lateral, rather than deep, space, and

which in the paintings of Kōrin perfectly crystallised a world view: an absorption, created at least in part by the fact of geographical isolation, in the present moment.

Other artists captured this feeling in a different way. The book illustrator Hishikawa Moronobu created a new genre of *ukiyo-e*, or 'floating world', images, poetic evocations of contemporary life that were to become famous in the Western world, as we shall see, and virtually synonymous with Japanese art itself.

Tigers and Bamboo, one of a pair of six-fold screens, by Hasegawa Tōhaku. Late 16th century. Ink on paper, 154.4 cm by 361.6 cm. Nezu Art Museum, Tokyo.

It was there also in the time before Japan was closed to the rest of the world, in the dying era of the samurais and *daimyos* who filled their forbidding castles with golden scenes on sliding doors, and built pavilions where they might hold refined rituals of tea drinking, bringing to mind the atmosphere of the earliest Shinto shrines.

A black-glazed stoneware tea bowl, made in the Mino kilns near the cities of Tajimi and Toki, embodies this spirit of absorption, promoted among warriors by the great Momoyama tea master Sen Rikyū, a friend of the painter Hasegawa Tōhaku. It was the spirit of *wabi*, of transience and impermanence, discernible in the form of a rock or tree, an ink-splash on paper, an arrangement of flowers or a modest tea house. In the hands of Sen Rikyū this tradition reached an austere extreme. His famous tea pavilion, built for the warlord Toyotomi Hideyoshi at Osaka castle, was less than two metres square, and made of the most basic materials.

No description or theory is ever truly adequate to our experience of things in the world, but if we pause, halfway through our long journey through the history of human images, for a moment, or indeed as long as we need to admire the Mino tea bowl, and imagine how it might be to drink some refreshing tea from it, and let our eyes wander over an image of the *Kudara Kannon*, or a scene from the *Genji Monogatari*, or a flight of crows against a golden sunset – we might reflect that, in its modesty and charm, such a simple tea bowl really can rival the grand visions of beauty unfolding elsewhere in the world.

Black Seto teabowl, known as 'Iron Mallet' (Tettsui). Late 16th century. Glazed stoneware, h. 9.3 cm. Metropolitan Museum of Art, New York.

15

The New Life

Early on the morning of 26 April 1336 the Italian poet Francesco Petrarca set off with his brother Gherardo and two servants to climb the rocky slopes of Mont Ventoux, near his home in southern France. It was a strange thing to do, as he confessed in a letter drafted later that evening. His purpose was nothing more than to admire the view.

At the summit Petrarch (as he is known in English) stood in wonderment, buffeted by the wind, dazed by the vista spread out before him. To the right he could see Lyon, and to the left the sea near Marseille, 'as well as the waves that break against Aigues-Mortes, although it takes several days to travel to that city', he wrote. The Rhone Valley lay below. He strained his eyes but could not see the Pyrenees, coming up against the limits of human vision.

To climb a mountain for the view was a novel undertaking in Petrarch's time. Such places were seen as inhospitable, fit only for wild animals and intrepid travellers. What he discovered at the summit of Mont Ventoux, however, was not only the stunning sweep of the landscape, as he related in a letter written to his former confessor, a priest from the town of Borgo San Sepolcro, but also something far more profound. Through the inspiration of a passage from a miniature copy of the *Confessions* of St Augustine that he had carried with him, he had experienced a revelation of the broad vista of the human mind and religious faith. Men may admire high mountains, wide seas and rivers, the 'circumference of the ocean and the revolution of the stars', Augustine had written, but neglect their own minds – the equally vast landscape within.[1]

Petrarch opened his eyes to the wide world, testing the limits of human vision: his faith revealed to him the equally vast capability of the human mind. The arduous ascent of a mountain was transformed into a symbolic quest for the self. Petrarch's story raises the curtain on a new of era of images in the early fourteenth century that unfolded in the land towards which Petrarch strained his eyes, yearning to breathe its air – his homeland, Italy.

The first stirrings of this new life came in the gloomy, narrow nave of a Tuscan church. In the late 1290s, in the basilica of Sant'Andrea in Pistoia, a small town just north of Florence, a stone-carver set to work carving images for a pulpit raised on six slender porphyry columns. The carved panels show scenes from the life of Christ, crammed with figures and details. Facing the entrance to the church, and dramatically lit from a round high window above, the focus of the pulpit is on the story of the Massacre of the Innocents, the horrific story of how King Herod of Judea ordered the massacre of all male children under two years old in Bethlehem.

At first it seems a violent tangle, a mass of figures locked in mortal struggle. But approach closer, and the drama, emerging from the shadows of the

dimly lit nave, becomes clear.[2] Three women are beset with grief over the lifeless bodies of their children – they shake and cry at their infants, as though urging them back to life. Soldiers wrest their small bodies away, plunging their swords into their flesh, terror on their faces as they commit the atrocious deed. One woman covers her eyes, unable to confront the horror of the scene, while those nearest Herod implore him to cease the massacre. He is anguished but remains unmoved, impassive, sitting over the gruesome carnage. No, he seems to say – it must be so.

The pulpit was the creation of a sculptor from Pisa, Giovanni Pisano, who had learned his trade working with his father, the celebrated sculptor Nicola Pisano. Together they had carved an elaborate pulpit for Siena Cathedral; but, like all ambitious sons, Giovanni was driven to create something even more impressive. Where Nicola Pisano in his sculptures at Pisa had captured the calm grandeur and noble spirit of Roman carvings, Giovanni's scenes are packed with a violent energy largely unknown to Roman sculpture. Despite their size, his figures seem tense with living energy. We feel in the presence not of an official account of a terrible event in the Roman province of Judaea, but rather of an eyewitness view from the ground, conveyed with uncensored emotion and compassion.

Petrarch would have admired Giovanni's story-telling, although there is no record of him visiting the town during his early life in Tuscany. One friend of the Pisano family, the poet Dante Alighieri, surely did. The carved figures at Pistoia, Pisa and Siena were part of his wider experience of a new life of images in Tuscany that shaped his imagination as he was composing his epic poem in the Tuscan language, the *Commedia* (known in English as *The Divine Comedy*). Dante's characters in the *Commedia*, like the figures in Giovanni's sculpture, are flesh-and-blood beings, who arouse our sympathies and our care, particularly the character of Dante himself as he undertakes his long journey through Purgatory and Hell to Paradise, a poetic, spiritual quest, just as Petrarch had undertaken on Mont Ventoux, and similarly inspired by St Augustine's *Confessions*. Dante was

THE NEW LIFE

accompanied first by the ghost of the Roman poet Virgil and then by the spirit of his departed lover, Beatrice.[3]

Dante mentions Nicola and Giovanni Pisano by name in his poem, and yet it was the famous painters of his day that he chose to ennoble in verse:

> In painting Cimabue thought he held
> The field, and now it's Giotto's acclaim –
> The former only keeps a shadowed fame.[4]

Perhaps Dante was right to reserve the accolade for painters. After all, they faced a greater challenge than sculptors, and both Giotto and Cimabue had recently completed works that proved their greatness beyond any doubt, at least to those receptive to their bold and brilliant innovations. Where sculptors could study the ancient carvings lying all around, there were far fewer models of lifelikeness for painters to study. Painters looked instead to the style of Greek artists working in Constantinople, the great centre of taste, which travelled to Italy in the form of mosaics and paintings in manuscripts, as well the occasional icon. The Greek style was powerful and yet ultimately formulaic, saints depicted rigidly against uniform backgrounds of gold – not stories but unambiguous statements of faith.[5] For painters these depictions were just too divorced from daily life in the towns and communes of central Italy where they lived. The odd Roman wall painting, such as those remaining on the Palatine hill, gave a glimpse of something more familiar, although none provided models for the scenes artists were required to paint – stories from the Bible, and from the lives of saints, recorded in a well-known book, *The Golden Legend*, compiled by the Italian chronicler Jacobus de Varagine.

Cimabue, Giotto and their contemporary Duccio knew that they had to rival sculpture in telling these stories, and also to create something more strongly connected with the images in ordinary people's minds when they heard and read

the stories from the Bible. Not a Byzantine art, given to luxurious surfaces and effects, images floating on a field of gold, but rather one more closely anchored in reality.

Their success was a second beginning for Christian image-making, and allied to a new beginning for the Christian faith itself, inspired by the life of St Francis of Assisi. Like Siddhārtha Gautama, St Francis was born into a rich family but exchanged his wealth for a life of spiritual devotion. The Franciscan friars who preached his message continued to spread their spiritual message in the mercantile, money-driven world in which Francis had been raised. They were in sympathy with the poverty in which most

Crucifixion, by Cimabue. 1277–1280. Fresco, 350 cm by 690 cm. Upper Church of San Francesco, Assisi.

people lived, and alive to their need for stories and tales to make sense of their lives – and to provide some sort of escape from them. His attitude may have been one of humility, talking to the birds, wedded to a life of poverty, but the legacy of St Francis was hardly unassuming. After his death in 1226 a great basilica was constructed at Assisi – two churches, in fact, one above the other – which became not only the headquarters of the Franciscan movement but also the great interior on the walls of which this astonishing new style of painting gradually appeared, telling stories in fictive space.

Cimabue and his assistants covered an entire wall in the transept of the upper church with a Crucifixion that sent shockwaves through rigid Byzantine conventions. Drapery folds seem caught in a sudden storm, gale-force winds sending angels circling rapidly around the figure of Christ, whose monumental body is brimming with static energy, somehow weightlessly rising and yet at the same time collapsing to the stony earth. St John grasps the hem of Christ's loincloth, as if to hold him down, while Mary flings her arms straight up in a gesture of rigid horror. Cimabue's painting is a masterpiece of style, but the technique he used meant that the painting was to suffer over time, whites oxidising to black, colours fading to leave only a light orange and a dusty blue. But those who saw it directly after it was painted, including the young Giotto, encountered a revelation of how powerful a painted image could be as a way of telling a story.

Giotto may well have assisted Cimabue – he would certainly have learned from watching the older artist at Assisi, gazing up at him at work on his painted walls. And yet the images Giotto went on to create at Assisi show how much further he was prepared to go, creating scenes of such illusionistic space that they seem extensions of the church itself, filled with figures so rounded and believable that it feels as if you could embrace them. As Giovanni Pisano had done in sculpture, so Giotto opened up a new field of possibilities in painting. It was no surprise that he was admired both by Dante and Petrarch, the two great poets of his day – Petrarch even owned a painting by Giotto, a panel showing the Virgin and Child. 'The ignorant do not understand the beauty of this panel but the masters of art are stunned by it', he wrote in his Testament.[6]

Giotto struck his first great monument on this path in the northern Italian city of Padua in 1305: a series of frescoes commissioned by the richest merchant in town, Enrico Scrovegni, a notorious moneylender, whose father had been cast by Dante, in the *Commedia*, into the seventh circle of hell for charging exorbitant rates of interest. Scrovegni commissioned a painted chapel in the hope that it would redeem him of his sins and bring glory to his name. He lies in stone effigy in the choir of the Arena Chapel (named after the ruins of a Roman arena in which the chapel was built), his eyes closed for eternity in front of Giotto's masterpiece.

The walls of the chapel are like pages from a giant picture book, framed scenes telling the stories of the life of Mary and the birth, childhood and death of Christ, while a cadre of fourteen allegorical figures representing the virtues and vices stands along the bottom of each wall. The story flows from scene to scene, treating the sources, the Gospels, the Golden Legend and other religious texts as sources of story-telling, not just as moral standards.[7] The voice of the story-teller – Giotto himself – is an unmistakable combination of reality and fiction: architecture is painted out of scale but illuminated by real-seeming light, giving it

a sense of solidity. Lighting within the fictional space of the painting corresponds to the natural light falling into the chapel, giving an extra dimension of reality to the scenes, blending natural and painted light. Giotto made his frescoes at Padua using a new technique of painting directly onto a freshly plastered wall, working section by section before the plaster dries. The paint mixes and bonds with the wall, becoming quite literally part of the building.

Each figure is drawn with the sharpness of life, and composed in shapes, often defined by coloured robes, with real weight. There is no mistaking the source of the emotion driving the story forwards – the faces of Christ and Judas, or of Joachim and Anna, or the resolute manner of Mary as she makes her way by donkey to Bethlehem. In the Lamentation, the most moving of all the paintings in the chapel, attention is entirely on the reaction of the onlookers, and the writhing forms of the grieving angels.

This combination of painting technique and illusionistic style gives the Arena Chapel frescoes Giotto's unforgettable voice – a voice with the quality of real humanity. But what is this humanity? Giotto's characters are ordinary folk – shepherds, workers, tired mothers, anxious fathers. We feel their moods and personalities – they are hardly heroic, but rather plain and unguarded in their reactions to situations. Bodies are made awkward by the robes that cover them – Judas' ungainly bulk as he grasps at Jesus, or the hunched form of Jesus as he carries the cross to Calvary, turning to look wearily at his mockers. In the Crucifixion, Christ's body is flattened and distorted, pinned up on two thin arms, the legs dangling useless, his face pale with death and disappearing into itself. Giotto sees humanity clearest in suffering, in the way that grief disturbs and distorts the body, making it pathetic, impoverished, unbeautiful. But amid all this he creates intense moments of recognition and communication: Christ's piercing look at Judas, foretelling both their fates, or the conjoined faces of Anna and Joachim as they kiss outside the Golden Gate, prophesying the birth of their daughter, the Virgin Mary.

Giotto was the first great painter of human nature. In his paintings we encounter ourselves as individuals, bound to each other and the world by joy and suffering. The story is not one of heroic overcoming, as it was in the classical world, but rather of the search for meaning in the real world, among real people: the story of salvation.

Despite his success at Padua, it was as a Florentine artist that Giotto was to be remembered, thanks to the painter and writer Giorgio Vasari, who two and a half centuries later, in his book *Le vite de' piu' eccellenti pittori, scultori, e architettori* (in English, *The Lives of the Artists*), both a great work of historical biography and also a clever promotion of the art of his adopted home, Florence, placed Giotto at the beginning of a great tradition of art created in the Tuscan town.[8]

Giotto's followers in Florence for the most part simply repeated his style without rivalling the emotional impact of his painted scenes. The vision of the world he had created was too startling, too emotionally powerful. The painter known as Altichiero, who worked in Padua in the later years of the fourteenth century, created frescoes the closest to a Giottesque style – monumental, spatial, story-telling images, including a 'Sala Virorum Illustrum', or 'Hall of Famous Men', in Padua, inspired by Petrarch's *De viris illustribus*, a collection of biographies of Roman statesmen; a portrait of Petrarch, sitting in his study, was

a memorial to the poet, who had died just a few years earlier, in 1374.[9] Giotto's voice had a more distant echo in the work of painters in towns such as Rimini and Bologna, but it was in Florence itself that it was heard the strongest, in the frescoes painted in the church of Santa Croce by one of Giotto's pupils, Taddeo Gaddi, and his son Agnolo Gaddi, which expand and enrich the world first opened up at Padua.

The same might be said of a third artist whose name might justifiably be added to those of Giotto and Cimabue, to complete the trio of great innovators in the early years of the fourteenth century. Duccio di Buoninsegna began his career modestly in the Tuscan *comune* of Siena, painting book covers for public officials working in the Palazzo Pubblico, the great town hall with its lofty campanile. His talents were such that soon he was receiving commissions for paintings of the Virgin and Child, leading to his first great work, an altarpiece known as the *Maestà*, or 'Majesty', created for Siena Cathedral and finished in 1311, just a few years after the dedication of Giotto's frescoes at Padua.

Duccio would have seen the Padua frescoes, and was undoubtedly impressed by their illusionism, particularly in the architectural details. And yet, like Giovanni Pisano looking at his father's work, he also saw how much further things might be taken. Everywhere in the *Maestà* there are signs of Duccio doing things differently, pushing the painted image deeper into life, rivalling the imagination of sculptors, but with an illusionism that could only be achieved in painting. Crowds accompanied the altarpiece in procession around Siena, on 9 June 1311, 'sounding all the bells in glory out of devotion for such a noble panel', as one contemporary chronicler recorded.[10] As they watched the massive work being placed on the cathedral high altar, and drew closer to admire it, the most miraculous passage of painting would have appeared the transparent purple cloth, flecked with gold stars, that lightly covers the body of Christ, sitting on his mother's lap on a marble throne, covered with gold brocade, surrounded by the celebrities of heaven, the saint and angels. Duccio painted it with a rippling elegance and lifelikeness without compare, at least for another one hundred years. It was not just for its beauty that Duccio's *Maestà* surpassed all previous paintings, but also for the compelling reality that Duccio gives to religious mystery.

Duccio placed his figures on a dazzling field of gold and yet hollowed out the panels of his altarpiece with illusionistic space, and painted his sacred figures as real people. It was a balancing act, between the older Byzantine and the newer Italian painting, and one that, like Giotto, was not easy to follow. It was in Siena, if anywhere, that Italian painting had its greatest moment during the fourteenth century and into the following century. Simone Martini may have worked as an apprentice for Duccio, and developed his master's illusionistic style while working in his home town of Siena, as well as at the Franciscan basilica at Assisi, and finally in Avignon in the mid-1390s, where he went with his wife and brother, seeking commissions from the pope and his court, who had resided in the city since being exiled from Rome in 1309. Here took place one of the great meetings of poetry and painting of the age: in Avignon, Simone met an old

acquaintance, Petrarch, who commissioned a painting from him, a portrait of his beloved muse, Laura, capturing all the agony of his unrequited love, as Petrarch elaborated in his long sequence of poems, known as the *Canzoniere*, two of which mention Simone's portrait (the painting was later lost; only the poems remain):[11]

Maestà, by Duccio di Buoninsegna. 1308–1311. Egg tempera on wood. Museo dell'Opera Metropolitana del Duomo, Siena.

If Polyclitus studied earnestly,
and all the others famous in his art,
a thousand years, they'd not see the least part
of this great beauty that has conquered me.

Simone must have been in Paradise
(this lady was originally there),
and studied well and copied what he saw,
as mortal proof of such a lovely face.

This work is one of those imaginable
in heaven indeed, but not with us down here,
where we have bodies to disguise the soul –

a work he could not manage any more
when he came down to feel the heat and chill
of mortal men, with sight no longer clear.[12]

Simone also created an image to illuminate Petrarch's prized possession, a manuscript of the works of Virgil commissioned by his father. He painted a luminescent landscape in which the great Roman poet sits among shepherds and farmers, his pen held aloft as another phrase arrives, the whole scene painted in a milky white that recalls the marble reliefs of antiquity, undoubtedly Simone's source of inspiration.[13] On the reverse of the cover Petrarch inscribed his poem lamenting the death of his beloved Laura.

By the time Simone painted his frontispiece for Petrarch, in 1342, the creation of an 'Italian' style of painting, distinct from Byzantine models, was fully under way – although 'Italy', it should be remembered, was a loose term referring

Frontispiece to Petrarch's copy of *Virgil* with a commentary by Servius, by Simone Martini. 1342. Tempera on vellum, 29.5 cm by 20 cm. Biblioteca Ambrosiana, Milan.

to a collection of city-states and republics rather than a single, bounded nation. The new self-governing *comuni* were at the heart of this sense of independence from imported models of painting and sculpture, nowhere more so than in the two great Tuscan rivals, Florence and Siena. Where Florentine artists may have thought in Giotto-esque terms of architecture and rounded figures, little scenes illustrating Christian stories, Sienese artists imagined their painted stories playing out in a wider world. When the golden backdrops, the gilded walls and brocaded cloths of honour began parting, what was revealed, naturally, was the real landscape.

At the Franciscan basilica of Assisi the Sienese artist Pietro Lorenzetti painted a *Deposition from the Cross*, where

THE NEW LIFE

the figure of Christ appears to slide off the wall into the real space of the church. Lorenzetti even painted an illusionistic bench below, somewhere to rest after such high drama. Where Giotto's figures disappear into the wall, as if seen through windows, Lorenzetti's frescoes seem to dissolve the wall itself, playing the parts in the real space of the church.

Pietro's brother Ambrogio painted the first true landscape, venturing into the countryside beyond the city walls. In a chamber of the town hall at Siena, a room reserved for a committee known as 'The Nine', citizens elected for a period of two months to determine the affairs of the republic, Ambrogio painted the walls with detailed panoramas of two imaginary cities. One side is ruled by Tyranny, a terrifying figure with horns and fangs presiding over a court of destruction where avarice, pride, vainglory and other symbols of injustice hold sway. The place is, unsurprisingly, going to rack and ruin, overrun by soldiers who terrorise the population and spill out into a landscape scarred by war and destruction, broken bridges, villages on fire and general desolation.

Opposite, by contrast, is an ideal city, guarded by the figure of Justice. The panorama records the hustle and bustle of daily life: a wedding procession on horseback, with the bride wearing red; a ring of women dancing to a tambourine and song; tradesmen, including a shoemaker and grain dealers; and a lecturer, whose sermon is interrupted by the loud city noise. Supplies arrive by mule and donkey from the surrounding landscape, where vines and villas are scattered around an ordered and peaceful landscape, reminiscent of the countryside around Siena. Hunters, travellers and farmers move freely, under the auspices of a naked winged woman, flying through the air holding an inscription beginning 'All men go freely' – thanks of course to the stability and wealth created by the republican

The Effects of Good Government on Town and Country, by Ambrogio Lorenzetti. 1338–1339. Fresco. Sala della Pace, Palazzo Pubblico, Siena.

government of Siena. The message would have been clear to the committee members sitting in the chamber below: through truth and justice, freedom and wealth will prevail.

Ambrogio completed his work in 1340. Less than a decade later Siena was looking much more like the city ruled by Tyranny. It had been ravaged by the Black Death, which was rumoured to have arrived in Europe with merchant ships docking in Venice. More than half the population of the Italian peninsula died, including Ambrogio and his brother Pietro and most of their assistants and pupils. An entire tradition of painting seemed to disappear with them. For painters of the second half of the fourteenth century, such as the Sienese painter Taddeo di Bartolo, the world of the Lorenzettis, of Simone Martini, of Duccio and Giotto and Cimabue before them, would have seemed like a glorious and yet now utterly lost past.

Few artists remained to bridge the time of Giotto and Duccio, and the years after the Black Death. The new life breathed into image-making seemed on the verge of extinction. The world was a more troubled, less confident place.

In the first years of the fifteenth century, the sound of hoofs and the rattle of a painter's tools in a saddle bag, coming down the road from the hills towards the city gates, would have filled the heart of any aspiring artist with hope. The figure on the horse was Gentile da Fabriano, a restless soul who travelled with the tools of his trade from town to town, working his way from the northern cities of Brescia and Venice down to Florence, where he arrived in 1420. As his reputation grew, Gentile became one of the most fashionable and sought-after painters of his

day, famed for the way his paintings captured natural light. Like Simone Martini before him, Gentile creates a delicate balance of luxurious surfaces and believable, eye-catching details of the story being told. Much of his panel showing Mary and the infant Jesus, painted for the church of San Niccolò sopr'Arno in Florence, is gilded and decorated with punched rings and incised lines (a technique later known as 'tooling').[14] The velvet red cloth of honour that hangs behind the Virgin and the brocade covering the throne hint less at riches than at comfort. One of the infant's feet is caught in the gold-fringed blanket that covers him, and with a hand he parts his mother's robe. The soft atmosphere is animated by incidental moments: a twist of the gilded hem interrupts the hanging shapes of Mary's sky-blue robe, like a path on a distant mountain. The infant is shown handing a daisy to an attendant angel, but in fact his fingers do not touch the flower's stem – he is dropping it, as toddlers do.

Madonna and Child with Angels, from the Quaratesi Polyptych, by Gentile da Fabriano. 1425. Tempera on wood, 139.9 cm by 83 cm. National Gallery, London

THE NEW LIFE

Such a tiny flourish on the part of Gentile, a small detail that makes the whole just a little more believable, would have been unthinkable a century earlier. It was a mark of how much the recreation of the world in paint, rather than the evocation of higher spiritual realms, had become the task of painting. And nowhere more so than Gentile's speciality: capturing the effect of natural light to create a space in which a story could unfold.[15]

Siena remained the setting for this imaginative story-telling well into the next century. In 1437 the Franciscan friars of a church in the small town of Borgo San Sepolcro commissioned a Sienese-trained artist to paint an altarpiece for their church. Seven years on, slightly later than the friars had hoped, the artist wheeled his finished work by cart to be installed on the high altar of the church.[16] The scene may have lacked the pomp of the arrival of Duccio's *Maestà* to Siena Cathedral over a hundred years earlier, but the artist, Stefano di Giovanni – later nicknamed Sassetta – easily rivalled his predecessor, and was part of a revival of Sienese painting following the low years after the Black Death.

It was not the front, showing an image of the Virgin, but rather the back of the Borgo altarpiece, the part facing the choir, that was truly astounding, certainly for the friars who gazed at it during their daily worship. Sassetta painted a giant figure of St Francis, levitating, his arms outstretched in imitation of the crucifixion, against low-lying hills surrounding a lake. His face, wide and gaunt, peers up at three winged women hovering on morning clouds, symbols of Chastity, Obedience and Poverty. In the waves of the lake below St Francis tramples an armoured man, symbol of Pride, while Lust admires herself in a red mirror and Avarice, with her pet wolf, screws her purse through a wooden press.

Surrounding the giant saint, eight large panels tell stories of his life, each in an arched window-like frame. Francis sets out on his spiritual journey, giving his clothes to a poor knight he encounters on the road. That night he dreams of a castle in the air marked with Christ's cross, which Sassetta paints hovering on a cloud, as the future saint sleeps in a comfortable bed. Perspective lines are not rigorously measured, nor are the proportions or scale of the figures very accurate; but like the strange light that bathes the scene, everything is both magical and believable. The story of Francis's life is compelling and alive. For Sassetta spiritual awakening could only be partly conveyed by recounting the facts of a story – where someone was, what they did – it was the echoes of that story in the surrounding world, in the slender elevated architectural forms as in the crystal-clear morning sky, that brought the meaning of the story home.[17]

Like Gentile's toddler dropping a daisy, or the tiny figures casting shadows on the wall in the *Très Riches Heures*, painted by Pol Limbourg two decades earlier, Sassetta's sparing use of incidental detail brings his scenes to life. At the dramatic moment when St

(left) *Saint Francis Renounces his earthly Father*, (right) *Saint Francis Gives his Cloak to a Poor Knight and Dreams of a Celestial Palace*, by Sassetta. 1437–1444. Egg tempera on poplar, both panels 87 cm by 52 cm. National Gallery, London.

Francis rejects his earthly father and, naked, is embraced by the bishop of Assisi, a character walks in the background, reading a book, comically oblivious to the drama unfolding near by.

Such real-life observation was one side of Sienese painting. Another painter working in Siena took a different path. In his paintings Giovanni di Paolo more often seems intent on breaking through the thin veneer of reality, entering into a world entirely dictated by his painterly imagination.

His illustrations for the third book of Dante's *Commedia*, the *Paradiso*, make no attempt at real-world accuracy, recalling rather the high mysticism of the Byzantine world. A step back from Giotto's legacy, perhaps, but also one mirrored in the Sienese sculpture of the time. Jacopo della Quercia was the most prominent sculptor working in the city then, and yet the style of his work seems to go backwards from the intense realism of Giovanni Pisano.[18]

It is as if, without this anchor in reality, or the model of lifelike sculpture, Giovanni di Paolo's imagination was free to create images such as the predella (the series of small paintings at the base) for an altarpiece in the Sienese church of San Domenico, showing the Creation and the Expulsion from Paradise. God spins wheels of colour and light, representing the elements, the planets (the ones that were known then) and the signs of the zodiac around a scene of mountains and rivers, recalling Dante's description of Paradise, a place beyond seven spheres that makes the earthly globe seem worthless by comparison. The figures of Adam and Eve, modelled on figures carved by Jacopo della Quercia on a public fountain in Siena, are pushed out of the garden by a naked angel.[19] Alongside on the predella was another scene showing the salvation of man and the return to Paradise, a tree-lined meadow strewn with flowers, in which rabbits peacefully nibble. The garden is full of happy reunions: siblings, lovers, parents and children, friends.

For artists working in Italy, Sassetta's *Life of St Francis* altarpiece, completed around the same time as Giovanni's charming predella, offered a surer sense of where the path opened up by Giotto and Duccio over a hundred years earlier might be leading.

It was certainly admired by younger painters, in particular a local artist by the name of Piero della Francesca. As a teenager Piero had worked on the altarpiece panels, then in the workshop of his master, Antonio d'Anghiari, before the commission passed to Sassetta. Piero would have looked on the finished panels with a measure of pride and admiration for his youthful part in their production, perhaps searching for remaining signs of his handiwork. The glowing clarity of

The Creation of the World and the Expulsion from Paradise, by Giovanni di Paolo. 1445. Tempera and gold on wood, 46.4 cm by 52.1 cm. Metropolitan Museum of Art, New York.

THE NEW LIFE

Sassetta's colour, the beautiful effect of morning light, the way in which religious feeling was expanded into a vision of the natural world, all these qualities would have made a deep impression on the young artist.[20]

Piero's own paintings were in time the fulfilment of the new life given to image-making by Giotto's frescoes at Padua, just over one hundred and fifty years earlier. His unforgettable fresco cycle at the church of San Francesco at Arezzo, the *Legend of the True Cross*, one of the greatest cycles of wall paintings ever made, stands at the summit of a tradition for which Giotto's Arena Chapel frescoes were the sure beginning.

Like Sassetta before him, Piero's painting was one of pure forms and colours, but rooted as much in mathematics as in mysticism. His small painted panel showing Christ's *Flagellation*, made in the late 1460s, is one of the most precisely composed yet mysterious paintings ever made. The scene of the *Flagellation* takes place at the back of a deep perspective vista, with Christ tethered to a Roman column on a black-and-white pavement shown with dazzling exactitude. Observing the scene is a seated figure in pink, evidently Pontius Pilate, the Roman ruler in Judaea who presided over the trial of Christ. In the foreground three figures stand close together. A man in a brocade cloak looks towards another man in a Turkish hat, gesturing as if speaking, while beside them a youth with an Arcadian air stares into the distance. The deep perspective suggests events happening not only in different spaces but at different times. The scene of martyrdom, illuminated by light coming from above, appears to emanate from the thoughts of the three figures in the foreground.[21] Painting in Piero's hands becomes a matter not of things seen but rather of things recreated in the human mind, measuring and imagining, projecting order and meaning into the visible world.

Piero owed much to the paintings of Sassetta which he saw in his home town. And yet his capacity to create such intellectually and technically intricate images was rooted more deeply in discoveries being made in Florence, where he travelled briefly to work on a commission in the late 1430s. Here he would have seen the paintings of Masaccio, the sculpture of Donatello, the architecture of Brunelleschi and the perspectival constructions of Paolo Uccello.[22] These artists, and others, took up the challenge of Giotto's realism and combined it with an enthusiasm for scientific observation, as well as a new understanding of the world of

antiquity, of the image world of ancient Rome. By so doing they created images of such visual power that it was seen as the rebirth of an ancient spirit of genius, a recreation of the lost paintings of antiquity. But above all they affirmed what the new life of painting had been about all along – the freedom to tell a story.

Flagellation of Christ, by Piero della Francesca. c.1455–1460. Oil and tempera on wood, 58.4 cm by 81.5 cm. Galleria Nazionale delle Marche, Urbino.

16

The Ordering
of Vision

It is a painting of a revelation, and a revelation for painting itself – the beginning of something. In the Christian story of the Annunciation, the archangel Gabriel descends from the sky to tell a young girl from Galilee, Mary, that she is to become pregnant, although not by her husband, Joseph. The conception would take place rather through the intervention of a dove, embodying the spirit of the Christian God, and her child was to be called Jesus. Mary reacts, quite naturally, with shock and fear. She doesn't return to the book she has come into the garden to read.

In the middle of the 1420s a Dominican monk, Fra Giovanni, otherwise known as Fra Angelico, made a painting of the Annunciation story for his church, that of San Domenico in Fiesole. Radiant colours – the light pink of Gabriel's flying attire, the ultramarine of Mary's robe – fill the painting with warm light. The slender columns and arches of the loggia where Mary had been absorbed in her book delicately frame the wonder of the moment. It is all so believable. The garden outside, where Adam and Eve are being expelled from Eden, like bad gardeners, seems one into which we might walk, just as Mary's bedroom in the background appears a real, measured space. The Holy Spirit descends in avian form on threads of golden light, so that we are witnessing the moment of revelation, but also of the conception itself, and Gabriel is announcing what has already begun. It is a dazzling, divine light, which casts no shadows anywhere in the painting. Just as for Chinese painters, for Angelico the shadowless image was one of timeless, essential truth.

Such timeless truth was mirrored in images that gave new order to the visible world, crystallised in the precise and illuminated forms of Angelico's painting – a second burst of creativity in the Italian towns and cities, like an aftershock from the time of of Giotto and Duccio a century earlier. Along with Angelico, four names stand out: the architect Filippo Brunelleschi; the sculptors Lorenzo Ghiberti and Donatello; and the painter Masaccio. They discovered new techniques of drawing, painting and building, based on principles of mathematics and geometry, combining this with ever-deepening knowledge of the literature of ancient

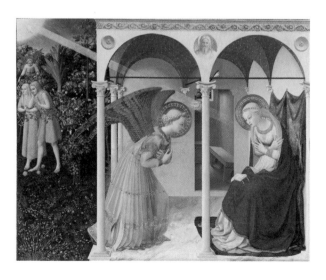

Annunciation, by Fra Angelico. 1425–1426. Tempera on poplar panel, 190.3 cm by 191.5 cm. Museo Nacional del Prado, Madrid.

Greece and Rome, following in the footsteps of Petrarch. The city of Florence, where they lived and worked, had grown into one of the wealthiest cities in the Italian lands – not as powerful as Venice but an undisputed leader in art.

There was no greater symbol of this surge of creativity than the cupola, or dome, designed by Filippo Brunelleschi for Santa Maria del Fiori, the cathedral church of Florence.[1] What the Parthenon was to ancient Athens, Brunelleschi's dome was to Florence and the Florentine republic: a sign of seemingly unlimited imagination and ambition. Many church officials thought that building such a structure without the traditional scaffolding, as Brunelleschi proposed, was impossible, and it was his triumph to prove them wrong.

One of Brunelleschi's many innovations was to build the dome as a hollow shell, allowing a staircase to run up the interior, through the network of ribs and horizontal stones, so that citizens might ascend and proudly survey the wide expanse of their city-state. Where Petrarch needed a mountain to see the world around him, now such access could be given by the work of human hands.

Brunelleschi's career had begun with an odd stroke of luck: he lost a competition to design a new set of doors for the baptistery of Florence Cathedral. The octagonal baptistery, set opposite the cathedral, was believed to have been built by the Romans (it dates in fact from the thirteenth century), so that designing its doors was a prestigious commission. It was ultimately to Brunelleschi's benefit that he lost: the winner, the twenty-year-old Lorenzo Ghiberti, went on to spend his entire career making two sets of doors for the baptistery.[2]

Brunelleschi consoled himself with a field trip to Rome in the company of his friend the sculptor Donato di Niccolò di Betto Bardi – better known as Donatello. They spent their time exploring, measuring and sketching, digging among the ruins and admiring antique sculpture.[3] Rome at this time was hardly the city it once had been, dilapidated and neglected since the papal court and the Church councils had taken up residence in Avignon. And yet Brunelleschi and Donatello must have felt a sense of change in the air. There was a new interest in the past, linked to the growing enthusiasm for works of ancient literature. Rome was once again coming to the fore as the capital of an empire that had once ruled the entire peninsula, and far beyond.

Sketching the buildings of Rome set Brunelleschi on the path of creating his own *all'antica* ('in the ancient style') language of architecture. Just as he had created his own machinery to build the cathedral dome, so he developed his own drawing system to render classical architecture accurately, a system that became known as perspective drawing. Based on the idea that light can be considered as straight lines (it does not go around corners), and that these lines can be mapped onto a flat surface, to suggest depth, it transformed painting and drawing into activities that could be rooted equally in mathematics and science as well as direct observation. Brunelleschi's system was almost certainly derived from existing knowledge, very probably from the Arab Islamic tradition of mathematics and philosophy that had been filtering through to the West for a few hundred years – although in the Islamic tradition, devoted primarily to decorative 'imageless' imagery, there were few opportunities to use this knowledge to construct pictures of the real world.[4]

In Florence, Brunelleschi set about giving form to these new technical discoveries. For the church of San Lorenzo he designed an elegant sacristy (where

the priests prepare for the ritual of Mass), focusing attention not on divine inspiration, but squarely on human reason – quite literally, as the central space of the sacristy is a perfect cube. To stand within it is to feel inside a projection of rational thought – an interior shaped entirely by mathematically conceived circles and squares.

Old Sacristy, by Filippo Brunelleschi. San Lorenzo, Florence. 1421–28.

The sacristy (or 'Old Sacristy', as it became known when a newer one was built) was decorated with sculpture by Donatello and so became a memory of the time the two artists had spent in Rome. Brunelleschi had some reservations about the round relief carvings Donatello made for the chapel: they were placed in the ceiling and frankly illegible when seen from below. The problem was that Donatello's new technique of relief carving was so subtle that it could not be seen at a distance. Where Giovanni Pisano, a century earlier, had carved figures jutting right out from his busy surfaces, Donatello created the impression of depth solely through the carved line and perspective – like Brunelleschi's arcs on the walls of the sacristy, Donatello was drawing with stone. This type of relief carving, known as *rilievo schiacciato*, or 'squashed' relief, was Donatello's great invention. His relief (made for a chapel elsewhere) of the *Ascension*, the moment when Christ rises into the sky to take his place in heaven, seems at a distance nothing more than a blank slab of marble, yet peering closer the subtle forms of Christ and his disciples appear, like ripples on the surface of

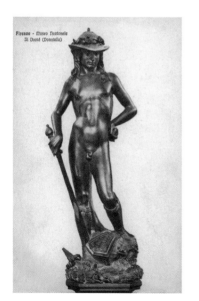

water, the soft drapes covering the figure, giving an impression of transparency as though the whole might simply be washed away.

With this beguiling technique Donatello captured images of great emotional intensity and bodily feeling, bringing to mind the sculpture of antiquity. Where the sculpted faces and bodies of the previous age, the portal figures at Chartres and Pisano's carved pulpit, are filled with emotion, it is with Donatello that the actual surface of the sculpture becomes charged with an ineffable power, a sort of haze.

Donatello could also create altogether more worldly images. In his beribboned hat and ankle-length boots, otherwise naked, Donatello's later bronze figure of *David*, slayer of the Philistine giant Goliath, seems hardly fitted for combat. It was

David, by Donatello. *c.*1440–1450. Bronze, h. 158 cm. Bargello Museum, Florence.

a bold and daring decision: not since the sculptures of ancient Greece, since the sensuous figures of Praxiteles, had a nude figure been cast or carved in the round. A broad-brimmed hat shades his young eyes against the midday heat, and he rests his weight languorously on one leg. The rock in his hand is smooth like a pebble, like the curves of his body, and his sword appears almost too heavy for his slim arms to lift. He has already killed Goliath, whose gory severed head lies at his feet. Yet is this really the brave young soldier, a king-in-waiting, who slew a giant with his sling? He appears, rather, as if he were ready to kill with his looks.[5]

Donatello spurred the imagination of a younger artist, Tommaso di Ser Giovanni di Simone, known as Masaccio, who in the twenty-seven years of his short life made paintings that combined the emotional story-telling of Donatello with the perspective discoveries of Brunelleschi. Masaccio created one of the great early essays in perspective painting, an image of the crucifixion in an architectural setting on the walls of the Florentine church of Santa Maria Novella. The image seems to pierce the wall, creating the illusion of another chapel beyond – one designed, perhaps, by Brunelleschi, and decorated with sculpture by Donatello.

Shortly afterwards Masaccio began work on a cycle of frescoes that was to become, with his tragic early death, the summation of his life and work. In the middle of the 1420s, in a chapel built by the Florentine merchant Pietro Brancacci – and so known as the Brancacci Chapel – Masaccio painted scenes from the life of St Peter, as well as two smaller paintings of Adam and Eve in the Garden of Eden. Masaccio worked with another painter, Masolino da Panicale, in completing the frescoes, but it is his contribution that stands out. The figures are full and rounded, sculpted even, standing in a space that is defined both geometrically – the perspective lines of the images converge in a vanishing point on Christ's forehead – and as a natural landscape, with barren trees and snow-covered mountains. The story of *The Tribute Money*, taken from the Gospel of Matthew, is a tale of the miraculous payment of tax – on arriving at Capernaum, a small town on the Sea of Galilee, Jesus and his disciples were met by a tax collector who asked for 'tribute money'. At the behest of Jesus, St Peter finds the money in the mouth of a fish he catches in the sea. Masaccio shows both these events, adding also the vignette of Jesus paying the money to the tax collector. The scene is set with great seriousness and economy, and yet the tone is not sombre – the light, buoyant colours provide a counter to the gravity of the scene, rather like those of Angelico in his *Annunciation*. Also like Angelico, Masaccio gives his figures their convincing, rounded look with the gentle medium of egg tempera, lending a light and earthy character to his fresco.

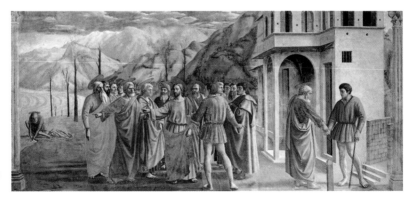

The Tribute Money, by Masaccio. *c.*1427. Fresco. Brancacci Chapel, S Maria del Carmine, Florence.

The Brancacci cycle was left incomplete on Masaccio's death in Rome in 1428, and finished only sixty years later by the painter Filippino Lippo. The style of Lippo's frescoes, a harder, more lifelike look, shows how much had changed in those few decades, how much a new enthusiasm for long, hard observation had risen to the fore.

It was, however, the achievements of this trio of Florentine artists, Brunelleschi, Donatello and Masaccio, earlier in the century that had broken new ground – making possible Angelico's unforgettable vision of the *Annunciation*. They saw the world with fresh intelligence, meeting it on their own terms, just as Duccio, Simone Martini and the Lorenzetti brothers had done a century earlier, but with a more solid sense of how to create believable images of the natural world. And crucially, unlike the three pioneers of the previous century – Giotto, Duccio and Pisano – Brunelleschi and his generation had one colossal advantage when it came to posterity: they had someone to write it all down.

The architect, writer, philosopher and general all-rounder Leon Battista Alberti arrived in Florence in the middle of the 1430s (his family had been sent into exile from the city years earlier), as a secretary in the retinue of the pope. The timing could not have been better. Florence was alive with invention and construction: Donatello was creating statues for public buildings filled with a sense of heroism and realism; Brunelleschi's mighty dome for Florence's cathedral was under construction, his striking cubic interior for the sacristy of San Lorenzo close to completion; Masaccio was already dead, but his Brancacci frescoes were there for all to admire, particularly Angelico, who was soon to begin a series of magnificent frescoes for the convent of San Marco; Lorenzo Ghiberti's bronze doors for the baptistery were model exercises in the new rational approach to spatial construction; and a young sculptor by the name of Luca della Robbia was giving the first intimations of his great skill in creating glazed terracotta reliefs.

Alberti saw all this and wrote it down, with the keen eye of someone who was also doing it all himself: painting and drawing, sculpting and building. Dante and Petrarch, it is true, had noted the achievements of the earlier generation, yet Alberti approached his task with a rigour thoroughly of his time. He spent his days in the workshops of the leading artists, discussing, arguing, discovering, so that in a remarkably short space of time he produced one of the most original books about painting ever written, *De pictura* – 'On Painting' – a more wide-ranging account of new ways of representing the world, which he dedicated to Brunelleschi.[6]

The new art, Alberti wrote, was simply the greatest ever made. Brunelleschi's cathedral dome, 'towering above the skies, vast enough to cover the entire Tuscan population with its shadow' was 'unimaginable' to the ancients.[7] When you compare the work of present-day artists, Alberti wrote, it was not so much a rebirth of antiquity, but rather a triumph over ancient art, and a resounding assertion of the greatness and confidence not only of Florentine artists but of human intelligence more widely in the face of nature. 'Man is the mean and measure of all things', Alberti wrote, quoting the ancient writer Protagoras.

The twin roots of this great talent in art were an understanding of geometry, so that bodies would be in the right proportion and correctly modelled, and an understanding, through poetry and oratory, of human emotion expressed through gesture. Above all, it was a matter of hard and relentless work. Alberti's was essentially a moral vision married to the triumph of human will, and honouring the human form as the greatest subject of art.[8]

Alberti's *impresa*, or personal emblem, was a winged, flaming eye: 'the eye is more powerful than anything, more swift than anything, more worthy than anything', he wrote. Observation was all. When it came to colour, Alberti abhorred the use of gold paint, and advised artists to squint to gain the true tone of objects, painting real colours in natural light.[9] In this, as in so much else, Alberti was decades, if not centuries, ahead of his time, and his book as influential on artists as any book might be (although the truth is that artists tend not to need manuals). From the pages of *De pictura* emanates a sense of confidence that, given the right application, one can quite simply do anything, be a 'universal man', as Alberti put it. There seemed no end to what could be achieved: *Quid tum* – what next? – reads the motto accompanying Alberti's emblem.

Not all artists fell so easily under the sway of the latest advances from Florence and Alberti's theories. In the northern Italian cities and courts, painters were inclined to carry on traditions passed down from the Burgundian court, strong echoes of which remain in Angelico's *Annunciation* – a decorative mood echoing tapestry designs and the illuminated pages of manuscripts, the most sought-after and fashionable images of the age.

This courtly mood was carried south by Gentile da Fabriano, whose painting of the *Adoration of the Magi* was commissioned by the wealthiest patron in Florence, the enlightened banker Palla Strozzi. The easeful elegance of Gentile's painting, with its remarkable combination of a beautiful surface design, reminiscent of the altarpiece paintings of Simone Martini, and an open landscape where Martini would have simply used a gold backdrop, would have impressed Strozzi, just as it inspired Florentine painters, in particular Angelico and his *Annunciation* panel, with its radiant open spaces.

Gentile bequeathed his paint box, it is said, to one of his students and collaborators, a younger artist from Verona by the name of Antonio Pisanello. In his haunting *Vision of St Eustace*, painted in egg tempera on panel around 1440, Pisanello uses the northern, courtly mood to record a visionary encounter. According to legend, a Roman huntsman named Placidus saw the vision of a crucifix between the antlers of a deer that he had been pursuing, and was converted to Christianity, baptised by the bishop of Rome and given the name Eustace. Pisanello painted the scene at night, the animals, swans, storks, dogs and rabbits set against the dark foliage with the decorative mind of a miniature painter – it might be compared with the Persian-influenced artists of the Mughal court who made the large paintings for the *Hamzanama*, just over a hundred years later.

Like Mughal painters, Pisanello was given to drawing from nature, rather than relying on pattern books for his imagery. When, in the late 1430s, the

Byzantine emperor John VIII Palaeologus visited Ferrara, Pisanello was on hand to sketch the emperor and his exotic retinue. These drawings he used to create a portrait medal in bronze, showing the emperor in profile, his hat, domed and peaked, like a piece of architecture, while on the medal's reverse the emperor is on horseback with attendants – he is out hunting, his favourite pursuit.[10]

Such a solid, round portrait, small enough to be held in the hand and having the allure both of images and of money, was Pisanello's invention, quite different in feel from his vision of St Eustace, with its echoes of woven tapestries. The Burgundian court had favoured large medals showing scenes and heroes from antiquity, but the idea of a cast medal showing the present was entirely original, and far more in keeping with the mercantile atmosphere of Florence.

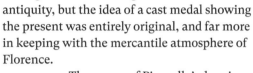

The power of Pisanello's drawing came from direct observation of nature rather than the scientific system of perspectival construction. Brunelleschian perspective was really an urban invention, so that the question of how it could be used to show the unruly world of nature, the spaces in between towns and cities, was one that few artists asked, and to which fewer still found any good answer.

This knotty problem ran through the career of one of the most single-minded artists of the era, the painter Paolo Uccello. Like other successful artists of the time, Uccello had trained in Lorenzo Ghiberti's Florentine workshop. It was here that he encountered the intoxicating and magical idea that would dominate the rest of his working life: mathematical perspective drawing.[11] He certainly read Alberti's treatises, and may have known him personally. His career was an epic and ultimately doomed struggle to impose Albertian theories of perspective and picture construction onto the world of nature. In his painting of a battle between Florentine and Sienese forces, known as *The Rout of San Romano*, an exceptional *condottiere* by the name of Niccolò Maurucci da Tolentino holds out against Sienese troops in the Arno valley, near the tower of San Romano, before reinforcements arrive to save the day. Nature and perspective are doing battle also: only the broken lances arranged so artificially on the floor are able to fit with a perspective grid. Brunelleschi's drawing system, designed to record works of architecture, and theoretically codified by Alberti, breaks down like the soldier's lances in the face of the profusion and variety of the natural world. Uccello's love of nature is evident in his painting of animals and landscapes, but his obsession with perspective drawing cost him dearly – he is said to have ended his life as an impoverished hermit.[12] His paintings have a contrived, artificial feeling, measuring and containing nature, ordering it on a flat surface. One of his last works, showing a hunt in a forest at dusk, reverts to an alternative mood, something more like Pisanello, as if Uccello had never penetrated the thicket of perspective construction and was thus unable to escape out the other side into the clear light of day.

Medal of John VIII Palaeologus, by Pisanello. 1438. Cast bronze and other metals, 10.3 cm in diameter. Musée des Monnaies et Medailles, Paris.

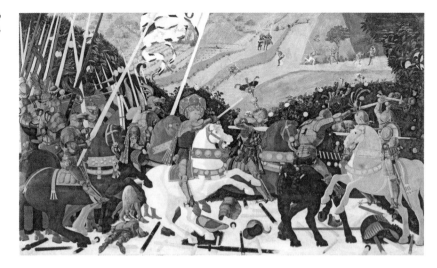

Niccolò Mauruzi da Tolentino at the Battle of San Romano, by Paolo Uccello. *c.*1438-40. Egg tempera on poplar, 182 cm by 320 cm. National Gallery, London.

Such clear light, it became apparent, could never truly be a natural light, or a direct recreation of the visible world. What painters saw around them could not be directly transposed onto the canvas by using some magical formula, like perspective construction, or by some mechanical device. For the ordering of vision, the light was rather that of human intellect. Few painters applied their intellect to this task more assiduously than Piero della Francesca, a one-time student of Alberti, but one, as we have seen, who plotted his own highly individual approach to picture-making, ordering the world with a vision as mathematical as that of Brunelleschi and Masaccio, and as sensual as the sculpted images made by Donatello.

Piero spent much of his life in the northern Tuscan towns, in his birthplace of San Sepolcro, in Arezzo, and then Urbino, where he was employed in the service of Federico da Montefeltro (it was here that he painted his *Flagellation*). In Florence itself the intellectual rigour of the early pioneers, of Brunelleschi, Masaccio and Donatello, became transformed into a style of painting that was for the most part lighter in spirit than Piero's mathematical images. Sandro Botticelli, Domenico Ghirlandaio and Filippino Lippi were the leading painters during the final decades of the fifteenth century, and each in his own way built on the earlier Florentine traditions: Botticelli with his complex mythological paintings, his *Primavera* and *Birth of Venus*, painted in the 1480s, with their figures like the marble statues of antiquity defrosted in the Tuscan sunshine, and his illustrations to Dante's *Commedia*, made in the same decade, showing the strongly literary side of his imagination; Ghirlandaio with his grand fresco cycles and astonishing portraits which capture all the elegance and pride of the Florentine world; and Lippi, with his sharp observational eye, Botticelli's only student, whose paintings completed the Brancacci Chapel decades after the death of Masaccio.

For all the achievements of Botticelli and his generation, by the middle years of the century Florence was being rivalled by cities elsewhere on the Italian

THE ORDERING OF VISION

peninsula. Old Roman sculpture and literature began to stir the imagination of scholars and artists, in particular in the city of Giotto's earlier triumph, Padua, where the university was the home of the growing intellectual movement, later referred to with the loose term 'humanism', meaning, very broadly, an understanding of human life through the critical study of ancient literature and culture.[13] Artists came to learn from this culture, bringing their own ideas from elsewhere. Uccello visited, Donatello also, creating a series of sculptures for the main church of Padua, the Santo. But it was in the imagination of a young artist who arrived in the town in the 1440s that this new critical awareness of the past found its most fertile lodging.

Judith with the Head of Holofernes, by Andrea Mantegna. c.1495–1500. Glue-size on canvas, 48.1 cm by 36.7 cm. The National Gallery of Ireland, Dublin.

Andrea Mantegna was the first great archaeological painter. He combined a deep knowledge of classical authors with surviving fragments of ancient sculpture and architecture to create images recalling the splendour of old Rome, giving a strong impression of historical accuracy. The truth is, of course, that nobody could really tell how things had looked centuries earlier, so that the image Mantegna created took on the appearance of actuality.[14] He used drawing to forge his ideas, and his paintings always retained a definite linear style, partly the result of the dry, even surface of the egg tempera that he used. He was fascinated by the illusions that could be obtained in painting, not necessarily of reality but of one technique mimicking another. His painting of *Judith with the Head of Holofernes*, a story of a beheading that suggests great violence and gore, is transformed by

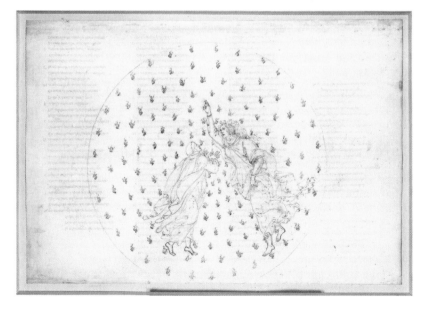

Dante and Beatrice in the second planetary sphere of Paradise, by Sandro Botticelli. c.1481–1495. Pen and ink on vellum, 32 cm by 47 cm. Kupferstichkabinett, Staatliche Museen, Berlin.

THE ORDERING OF VISION

Mantegna into something serene and noble (bringing to mind the innocent-looking figure of Judith on the facade of Chartres cathedral), by the use of a single colour – it looks more like a painting of a sculpture than of real people. Mantegna took his cue from Donatello, echoing the precision of Donatello's surfaces and Masaccio's rounded forms. Like Piero, Mantegna painted with his formidable intellect, rather than drawing images from the wellspring of the heart.

Mantegna looked south to Tuscany, to the inventions of the Florentines, but also closer east, to the most powerful of all European cities, and certainly the richest. The Venetian republic, with its vast trading network and connections to far distant cities, including Byzantium before its fall to the Ottoman Turks, was supremely wealthy, and proud of its tradition of painting. Where the Florentines frequently made images for export, the Venetians were happier to create for their own enjoyment.

That the Florentine spirit took hold in Venice in the middle years of the century was largely thanks to the pioneering efforts of one artist, Jacopo Bellini. Using a pointed stylus of soft metal, often lead, Bellini created a long series of drawings, gathered into albums, in which figures from Christian and pagan myth are posed in architectural settings, conscientiously drawn in perspective, measured with a ruler. Bellini often included fragments of ancient-looking architecture, although exactly which fragments he drew, or whether he in fact made them up, is hard to tell. And yet there is nothing amiss about the combination of the ancient world of myth and gods, and the modern world of scientific drawing – Bellini brokers the perfect compromise between the two. His drawings were made not as studies for paintings, it seems, but as works in their own right, and were mentioned in the will of his widow, Anna Rinversi, as 'quadros designatos', or 'drawn paintings'.

Jacopo and Anna had four children. Their daughter, Nicolosia, was to marry Andrea Mantegna. Two of their three sons, Giovanni and Gentile, were to become leading painters in Venice – Gentile the grand diplomat and creator of historic pageants and portraits, Giovanni the younger brother whose illuminated visions of nature established a tradition of Venetian painting that would become famous the world over. When the German painter Albrecht Dürer visited Venice in 1506, he visited the by then legendary Giovanni. 'He is very old, and yet he is still the best in painting', Dürer wrote, perhaps imagining himself as Giovanni's only rival.

Giovanni learned from his brother-in-law Mantegna's inventions, particularly his hard, linear style and precise forms, such as the rocks Mantegna so often showed in his paintings, cut and shaped as though quarried in the artist's mind.[15] Yet his love of colour and atmosphere led Giovanni to a painting determined not by cool precision but rather by the glow of a deeper spiritual feeling.

In the landscape settings of his paintings of Christian stories this feeling is clear and abundant. He was inspired to paint his *Agony in the Garden*

The Nativity, by Jacopo Bellini. 1440–1470. Metalpoint on paper with wash, 41.5 cm by 33.3 cm. British Museum, London.

after an earlier version by Mantegna, an image of bearing pain alone, through the night. Christ prays in the garden of Gethsemane, while three of his disciples sleep. Roman soldiers, led by Judas, the disciple who is to betray him, approach on a nearby path to arrest him. Christ appeals to an angel hovering in the morning air, a ghostly outline against the dense azure upper reaches of the sky, perched on the grey clouds whose undersides catch the first rays of the still invisible sun, illuminating the horizon. In Bellini's painting the search for release and redemption is magnified and scattered, like reflected and refracted light, into the hills and air of the surrounding world. The depth of feeling in Bellini's painting was a matter of disposition, but also technique. Like Mantegna, he painted at first with egg tempera, but the fine gradations and glowing quality of his morning sky appear more like the effect attainable with a new medium, that of oil paint. The translucent layers resulting from grinding dry pigment with a drying oil, such as linseed, gather and reflect light in a way that was to revolutionise painting in Europe, following in the footsteps of painters in the Burgundian Netherlands.

 Where in the Burgundian north oil paint enabled a precise, miniaturised rendition of natural light, Venetian artists operated at the other end of the scale. Grand processional images on vast canvases were created by Gentile Bellini, who handed down the tradition to the painter Vittore Carpaccio. From the studios of these artists came portraits both of the floating city and of the Venetian state itself. In the vast heavy chambers of the Doge's Palace artists and their workshops erected scaffolding to complete sprawling processional scenes, as though the very walls of the building were transparent, giving on to the waterborne pageants outside and the glorious history of the republic, victorious over its foes in war and trade. Such paintings were also commissioned by the *scuole*, or schools, charitable organisations housed in elaborate buildings. Yet beyond this spectacle there was something deeper and more important – a new sense of enjoyment of things seen, of the visible world, particularly the landscapes and countryside through which you had to travel to reach the Venetian lagoon.[16] It was in Giovanni Bellini's workshop – the real school of Venetian painting in the last decades of the fifteenth century – that a generation of painters learned to give expression to this feeling.

One artist above all others captured this, a mood that went beyond mere storytelling into the realms of poetry. In the paintings of Giorgio da Castelfranco, known as Giorgione, landscape becomes the true poetic subject of painting, bathed in the warmth of an atmosphere captured in the translucent layers of oil paint. Giorgione viewed nature through the image of the landscape, not in the spirit of scientific inquiry but rather as a means of lyrical escape. One of his most enigmatic paintings shows two figures in a landscape against a stormy sky, a *tempesta*, giving the painting its title. The woman, wearing nothing but a white cape and bonnet and suckling a baby, is watched by a figure resting on a staff, who might be a soldier. Lightning flashes as she suddenly raises her glance to meet the onlooker. Her forms glow in the evening sunlight, which illuminates the bridge and buildings in the background and catches the leaves of a few lonely birch trees so that they shimmer like silver against the inky dark sky.

Quite what it all means, if anything at all, nobody knows. Are the two figures a modern-day Adam and Eve? Or is it an allegory of parenthood, of the often stormy task of rearing children? Neither, probably – Giorgione seems uninterested in telling stories, or in making himself at all clear, so that we might remain with his images and keep wondering. Where Angelico lent new precision and illumination to sacred mystery, and Brunelleschi and his generation gave a new, intellectual order to images of the world and to the imagination of an antique past, Giorgione, infused with the glories of Venice, was devoted rather to an untethered idea of art, a poetic ideal enshrined in oil paint. It was a new ideal, but the medium itself had emerged almost a century earlier, far to the north in the Netherlands.

The Tempest, by Giorgione. c.1508. Oil on canvas, 83 cm by 73 cm. Gallerie dell'Accademia, Venice.

THE ORDERING OF VISION

17

Spectacular Small Things

By the early years of the fifteenth century oil paint had long been known as a bright, lustrous paint medium, first mentioned in a twelfth-century painting manual. Until this time, however, it was considered impractical, largely because of the length of time it took to dry. Some pigments could take weeks. In the hands of Flemish painters, and above all those of Jan van Eyck, however, the problem was solved by adding siccatives (drying agents), thinning it out to a transparent glaze, so that it might be applied to board or canvas with minute precision. The result was a crystalline vision of reality, mirroring the world in startling clarity and detail.[1]

Where the Venetians were to use ever larger brushes to capture a poetic mood, in the north the brushes could be minuscule – perhaps a matter of a few hairs from a squirrel's tail, bound in a ferrule and dabbed in coloured pigment. This miniaturised vision of the world evolved, at least in part, from the paintings in manuscripts that had been the mainstay of artists' workshops for centuries. Manuscripts illuminated by the workshops of northern Europe, and in Paris in particular, used egg tempera to create images of fine detail. The *Très Riches Heures*, made by the Limbourg brothers for the duke of Berry was, as we have seen, one of the most ambitious painted books made in France in the early fifteenth century. A few decades later Simon Marmion, working in Valenciennes, and Jean Fouquet working in Tours for the French king, were the leading names of their day, creating paintings in egg tempera.

Fouquet was apprenticed in Paris, where he learned to paint miniature scenes within intricate architectural settings; it was a trip to Florence and Rome, however, where he encountered the discoveries of Brunelleschi, Angelico and

Etienne Chevalier and his Patron, St. Stephen, Paying Homage to the Virgin and Child, by Jean Fouquet, from *The Hours of Etienne Chevalier. c.*1445. Vellum, each 20.1 cm by 14.8 cm. Musée Condé, Chantilly.

their generation, that opened his mind to the new world of image-making. The miniatures Fouquet painted in the *Hours of Etienne Chevalier* shortly after returning from Italy and settling in Tours combine Flemish realism, especially portraiture, with the painstaking accuracy of Florentine drawing.

Fouquet and Marmion, following the Limbourg brothers, took the tradition of miniature painting with egg tempera as far as they could. Only the new medium of oil paint could enable the next, decisive step into an infinitely more vivid world of natural light and scintillating detail – one that truly might deserve the epithet 'illuminated' – a step that Fouquet and Marmion were both to take. By the time Fouquet had returned from Italy in the late 1440s, the era of painting in oil was well under way in the Low Countries.

Where Giotto was the first great painter of human nature, Van Eyck was the first painter of natural light. His portrait of Chancellor Nicolas Rolin, the

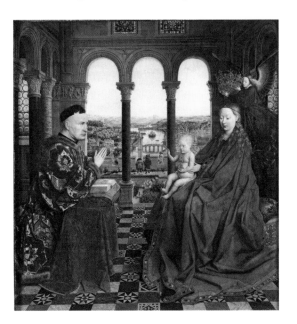

highest official of Philip the Good, the duke of Burgundy, praying and being rewarded by a vision of the Virgin Mary, shows the distant landscape with such power of observation and such an awesome technique that it seems we are looking at the sun glinting on the snowy caps of mountains themselves. It is one of the first landscapes painted in oil, and remains unsurpassed for its imaginative evocation of reality.

Oil paint shows how our impression of the world is built of reflected light, of gleaming metal, soft velvet, rough stone, glistening water and of airborne light, refracting the sun's rays differently throughout the day. Nicolas Rolin's vision of the Virgin and Child, as he lifts his eyes from his prayer book, happens at first light.[2] Through the loggia in which they sit, beyond a flower garden with lilies, roses and irises, in which magpies and peacocks hop, a river crossed by a bridge over which people go about their morning duties stretches into the far distance of blue hills and hazy mountains. On the Virgin's side of the river the townscape is dominated by church spires; on Rolin's side the buildings seem more worldly, grapevines growing on a hillside. Rolin was a well-known cultivator of fine Burgundy wine.[3]

Van Eyck was the first artist to capture the spectacularly rich density of the visible world and the softness of its atmosphere.[4] His paintings are crammed with details and such sudden leaps of scale that the surface becomes an intricate puzzle. Part of their seeming miracle is the coherence of the direction and intensity of lighting throughout his images, as though a moment of sudden illumination had somehow been captured for eternity, an effect that would have required detailed

Madonna of Chancellor Rolin, by Jan van Eyck. c.1435. Oil on panel, 66 cm by 62 cm. Musée du Louvre, Paris.

SPECTACULAR SMALL THINGS

calculation for each painted pearl, for each reflection in the complex concave and convex forms of a suit of armour and for the appearance of natural light over a minutely painted cityscape – endless laborious configuring and painstaking execution all geared to represent a single moment of intense illumination and vision. It was a feat of observation but also of knowledge, of the latest thinking about optical phenomena, probably derived from the Arab scholar Alhazen and those writers of the previous century in the West who had absorbed the lessons of his work on the refractive and reflective properties of light – a manuscript copy of Alhazen's *Book of Optics* was present in Bruges in Van Eyck's time.[5] It was the combination of this new scientific knowledge and a refined painting technique that enabled Van Eyck to create paintings that seem to be mirrors of reality – and themselves contained for the first time accurate depictions of mirrors and reflections.[6] They were also mirrors of belief, filled with complex and allusive symbols of the Christian faith.

This marriage of observation and vision, of knowledge and belief, inaugurated by Van Eyck, was to become part of what oil paint meant for artists and viewers for centuries to come. The impression of northern painting as small

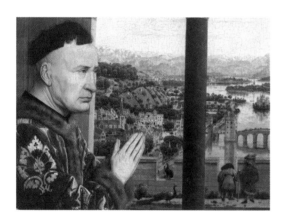

and gemlike is largely due to the accidents of survival – many paintings were of grand dimensions, and thus less likely to survive the ravages of war and iconoclasm.[7] And yet in the spectacular detail of their paintings the Netherlandish artists were unrivalled.

In 1425 Van Eyck travelled to Bruges to work for Philip the Good, duke of Burgundy. Where Paris had been the centre for artists for decades, now it was the turn of the towns further north – Ghent, Bruges and Lille, in particular – that attracted the leading artists of the day. Shortly after arriving, Van Eyck began work on his most ambitious marriage of reality and fiction, a large altarpiece commissioned by a wealthy businessman, Judocus Vijd, which he completed in the early 1430s. Van Eyck's brother Hubert had probably worked on it during the previous decade – little is known about Hubert, who is hailed by an inscription on the Ghent Altarpiece as a better painter than his brother. (Less still is known of their sister, Margaret, who was also recorded as being an accomplished painter.) Humble portraits of the donors, Judocus and his wife, Elisabeth Borluut, appear rich and weary on the closed panels, beneath a scene of the Annunciation and, either side, painted statues of the two Johns – the Baptist and the Evangelist.

Impressive enough: a vision both solid and airy, and also divine. And yet when opened, the twelve panels of the altarpiece show an even more astounding scene – Adam and Eve, painted in unerring detail, down to the split ends of Eve's hair, flanking a choir of angels and musicians either side of Christ sitting enthroned as heavenly king. Below, five panels show the Adoration of the Lamb, the great festival described in the book of Revelation when the blessed

Madonna of Chancellor Rolin, by Jan van Eyck (detail).

converge in a beautiful meadow, and where are found the mystical symbols of Christian salvation, the altar of the Lamb and the Fountain of Life. Crowds of saints and Christian pilgrims converge on the scene, a sweeping landscape painted with the most convincing effect of natural light ever achieved: the dark cumulus clouds are rendered with meteorological precision, like the cirrus clouds above the scenes on the wing panels.[8]

The vastness of mountains and clouds alongside the minuteness of a fingernail or the pupil of an eye – Van Eyck encompassed the grandeur and detail of creation. He set in train a great tradition of painting, combining the deep emotion of religious belief with precise observation of the natural world. This combination was crystallised in the image of a painted teardrop, which in the hands of the greatest Netherlandish artist, Rogier van der Weyden, glistens with the brilliance of a real teardrop resting on the surface of the painting.[9]

Rogier was the first artist to paint lifelike teardrops, signs both of grief and sanctity.[10] His large altarpiece of Christ being taken down from the cross – the *Deposition* – shows ten figures, their faces stained with tears, closely posed in a horizontal box-like picture, like a shallow niche, as if they were a carved relief. And yet their forms are modelled by colour and tone so that we seem to behold real presences, involved in some strange ritual dance of grief. Everything seems to be sinking under the weight of sorrow, marked by the stately repetition of the pose of Christ's dead body in that of his mother, held in her collapsed state by John the Evangelist and a holy woman. Her perfect blue robe and impossibly elongated leg leads back to the base of the cross, touching the site of her son's death.

It is a strange cross, stocky, with an impossibly short cross-arm, rather like a crossbow – no accident, as the painting was commissioned by the Guild of Crossbowmen around 1440. Their crossbows also appear as little emblems in the painted tracery at the corners. Joseph of Arimathea, richly clad in a golden robe, holds Christ's feet with an expression of blank resignation. On the other side a woman covers her tear-stained face, a conventional image of sorrow. Grief contorts the body of Mary Magdalene, on the right, in an entirely original pose – she clasps her hands, in a binding, consoling movement (also evoking the shape of a crossbow), lifting her arm as if to protect herself from the blows of grief. She seems to step forward and back at the same time, a paradoxical gesture of empathy and fear. This is true sorrow, a contorting energy that grips the body, but one that also transforms the world into an image of beauty, a coherent whole. The faces of all but three of the figures are wet with tears, even that of the dead Christ, although their tears, like the blood that runs from Christ's side, do not stain their garments, as if bodily fluids themselves contained great dignity and restraint. Energy courses through the figures, the energy of shock and grief affecting each figure slightly differently in their response to the terrible act of removing Christ's body from the wooden cross.[11]

Rogier's *Deposition* must have seemed the last word on the subject at the time – how could the emotion of the story be conveyed more directly? It emblazoned itself on the minds of artists for decades to come, who repeated the poses of figures, as if copying from life itself. Where Van Eyck dissects the appearance of things, Rogier, through the rhythms of his figures across the panel, brings to the surface what lies beneath – the passions and feelings driving human life in a situation of extreme emotion.

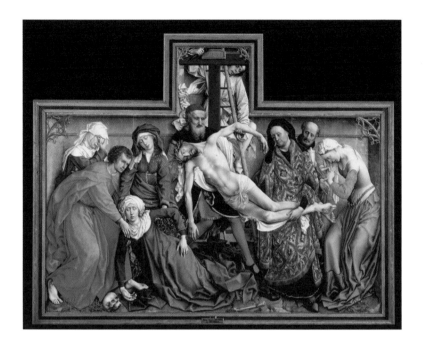

The monumentality of Rogier's paintings, the sense of a complete statement, eloquent and forceful, came not from Van Eyck but rather from another, more mysterious, painter by the name of Robert Campin, who worked in the town of Tournai, in modern Belgium. He is a mysterious figure, who may have studied with Van Eyck, and certainly met him during the 1420s, but who never signed his works, which have survived for the most part as copies by his many imitators and admirers, or transmitted in the style of his greatest pupil, Rogier van der Weyden.

Although the technique was identified with Burgundy, oil paintings were also made in France, notably by Jean Fouquet, who on his return from Italy turned with increasing ambition to the medium. One of his largest paintings, a *Lamentation* painted in a mix of oil and egg tempera, took inspiration from Rogier, just as it did from Italian painting. Christ's body is being lifted down from the cross, while the face of John the Baptist is streaked with tears and that of his mother is pale and drawn with grief. Fouquet captures the relationship between mother and son with great dramatic power, as if they were equals. (Mary was indeed only fourteen years older than her son, who died at the age of thirty-three.) The faces of the old men at the scene are painted at oblique angles, showing that Fouquet must have admired the paintings of Masaccio and Angelico on his trip to Florence and Rome, before bringing the new style back to the north, combining it with the realism of Flemish painting but also with the sculpture of Claus Sluter.

Fouquet influenced many artists in France, including those who worked at Fontainebleau and the court portraitist Jean Clouet. And yet it was the paintings of Van Eyck and Rogier that inspired a far broader tradition of painting in the Low Countries and France, one that soon freed itself from the older Burgundian ideal of manuscript painting and conventional decoration. Artists trained their observation on the surrounding world but used the seemingly magical properties of oil paint to transform it into something other-worldly, a higher reality filled with imagination and emotion. Oil paint could show anything – the differing

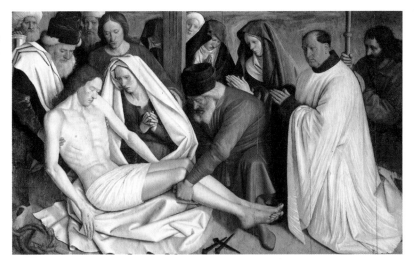

Deposition, by Jean Fouquet. c.1460–65. Oil on panel, 168 cm by 259 cm. Church of Saint Martin, Nouans-les-Fontaines.

effects of natural and reflected light, the different surfaces of fabrics, of gemstones, of water and human skin, and it was only natural that artists should fall in love with it.

Only natural too that they should turn their gaze on themselves and on the faces of those around them. Slow-drying linseed oil allowed for a long and hard look at the human face, so that all the peculiarities of individual character could

be brought out. People could be shown as part of a wider world, their personalities reflected in their surroundings. An image of a young man wearing a tall red cap is one of the earliest portraits to include a landscape view through a window.[12] His hands rest on the bottom edge of the painting, as if it were a ledge. A window shutter has been opened, framing the man's profile, and revealing a landscape in which a blue church spire punctuates the middle distance. His musing expression gives the impression of thinking, his thoughts drifting through the window into the luminous day. The matching clothes and hat the sitter wears may mean he was connected with the University of Leuven, the city where the artist, Dieric Bouts, made the painting.[13] As with Van Eyck's shifting between different scales, we find ourselves captivated both by the intimacy of such portraits, where we can closely examine every fold of skin, getting closer than we do to most people in reality, and by a sense of the wider landscape of their life.

Portrait of a Young Man, by Dirk Bouts. 1462. Oil with egg tempera on oak, 31.6 cm by 20.5 cm. National Gallery, London.

One of the most astonishing Flemish portraits was painted by an artist who arrived in Bruges around the time of Van Eyck's death. The sitter, a young woman, casts a sidelong gaze out, a little resentful perhaps at having been made to sit still for so long. Her high forehead, smooth features and thin body show her age.

Portrait of a Young Girl, by Petrus Christus. *c.*1465–1470. Oil on oak panel, 29 cm by 22.5 cm. Gemäldegalerie, Berlin.

She barely reaches over the wainscoting in the background. Light illuminates her face from the front, contrasting with the sober elegance of her costume, the height of fashion of the day, and the bare room in which she sits. The artist, Petrus Christus, focuses attention entirely on her face and on her curious, questioning gaze. Her identity was recorded by an inscription on the original frame, long since lost, which suggested that she might well have been the niece of John Talbot, an English earl who died in 1453, around the time the painting was made, but whose daughters, Anne and Margaret, could easily have travelled to Bruges.[14] Perhaps Petrus Christus made the painting on such a small panel, barely larger than a small book, so that it might be carried home by the sitter in her travel box.

For all this, neither Bouts nor Christus, nor even the great painter Hans Memling, who first painted a portrait against a landscape background and astonished painters everywhere with his realism, especially in Italy, ever exceeded Jan van Eyck or Rogier van der Weyden, or the mysterious Robert Campin, in evoking the living human presence in portraiture: their technique was the foundation of all that was to come.

The sophistication and psychological depth of Flemish portraits was imitated all over Europe – it was the most advanced 'look' of painting at this time, especially, as we have seen, in Florence. Portraits painted in the Italian cities had tended to show the sitter in profile, turning a face into a flattened shape, with little sense of believable depth. The three-quarter view of Flemish portraiture changed all this, giving subtle insight into the mind of the sitter, both hiding and revealing character, as people do in real life.

Painting from Bruges was in vogue, and the bigger the better. The Florentine banker Tommaso Portinari, the agent for the Medici bank in Bruges, was one of the most devoted patrons, commissioning for a Florentine church an enormous three-panelled *Adoration of the Shepherds* from the Flemish painter Hugo van der Goes. In the early summer of 1483 it was unloaded from the ship on which it had been transported and hauled by sixteen porters through the streets of Florence to the church of Sant'Egidio, in the Santa Maria Nuova hospital.[15] Hugo van der Goes had been dead for a year – he had painted the altarpiece during the previous decade in his monastery in the Forêt de Soignes, near Brussels, where he eventually succumbed to madness and died.

His *Adoration* altarpiece was studied and admired by Italian painters. It was the supreme manifestation of Netherlandish painting, surprising not least in its triptych structure, quite unlike the square panels common in Florence since Angelico's *Annunciation*, painted forty years earlier. Of all the captivating details – the angel's face, illuminated from below; the delicate tracery of branches in which jackdaws perch against a wintry sky; the believable rough-featured shepherds, still holding their long-handled trowels, used as walking sticks, who have just arrived to worship the child with guileless vigour, placed with startling vulnerability directly

on the ground, among stalks of hay; the beautiful dark velvet travelling dress of Maria Baroncelli, Portinari's wife, and the terrifying fang-toothed dragon, lurking behind her, the attribute of St Margaret above; or indeed the clawed demon hiding in the shadows of the barn – of all these, perhaps (although the only evidence is the striking appearance of the painting itself) the most stirring of all for Florentine painters was the three-quarter-view portrait of Portinari's daughter, Margherita. In her likeness to life, her tenderness, her childishness, she was quite unlike anything they had seen in a painting before.[16]

The fanged dragon and clawed monster in Hugo van der Goes's painting for Tommaso Portinari emerge from the dark forest of the northern imagination. Although Italian painters were no strangers to violence, they were too concerned with the active rendering of nature to be distracted by such dreamlike imagery – theirs was, by and large, an ordered imagination. And yet the spectacular effects of oil paint, as Van Eyck well knew, could be used to evoke visions and nightmares, and the bizarre imagery and logic of dreams.

 'Poor is the mind that always uses the inventions of others and invents nothing itself', one fifteenth-century painter inscribed at the top of a drawing

showing trees bearing ears and a field studded with open eyes.[17] The artist worked in the town of 's-Hertogenbosch, from which he took his professional name – Hieronymus Bosch (he was born Jeroen von Aken). His paintings were mostly of a religious nature, of hermits and saints, and stories from the life of Christ, as well as Old Testament subjects seen through the filter of a decidedly pagan imagination, shaped by the springs of folklore and popular morality tales. Bosch's true subject, it might be said, was human folly. His most ambitious painting, made in the closing years of the fifteenth century, shows the Garden of Eden, Paradise and Hell, and takes the form of a three-panelled altarpiece, created for a princely setting, the Brussels palace of Count Hendrick III of Nassau.

 Closed, the folding panels of *The Garden of Earthly Delights* show a murky monochrome scene of the world, held within a transparent globe, on the third day of creation. God sits quietly creating everything. Strange enough – but no preparation for the explosion of vivid and strange life, an extraordinary and unforgettable visual invention, that reveals itself when the hinged panels are swung wide open.[18]

 Bosch's Garden of Eden, on the left-hand panel, is a garden unlike any other. Adam and Eve stand with their creator in a landscape filled with animals, some recognisable – a giraffe, an elephant, a porcupine – others barely, or not at

all, as though from an earlier stage of evolution, still emerging from the primeval swamp. Glass cylinders and jewels litter the base of an ornate pink fountain, in the centre of which an owl perches. These lead to the baffling variety of pleasures being pursued in the large central panel, a paradise overrun by humans. In fact, it doesn't seem much of a paradise at all. Couples make love in a mussel shell and a translucent orb, or feed each other strange fruit. They climb and balance on brightly coloured organic structures, while others huddle in a group supporting a giant strawberry and emerge from a lake to enter a giant white shell. Where Van Eyck put the Lamb of God at the centre of his visionary meadow, Bosch places a circular pool full of naked women, attracting the attention of the men who ride around on horses, camels, leopards and stags, some performing acrobatics to attract the women's attention.[19] The architecture, fountains and follies, seems made from some brittle, smooth substance, synthetically coloured and mouldable into any form imaginable, with none of the classical structure of buildings made from brick and stone. Nature is flattened and distorted by human presence, made wholly artificial.

 The dubious delights of this paradise garden are slim preparation for the dark, hellish concatenation to which it leads. Here Bosch's imagination is turned to its highest, most horrible pitch. One man is tortured by the sound of bagpipes, sitting atop a hollow figure within whose body a woman pours drinks in an infernal tavern. Beneath them dark ice is cracking, and a strange bird sits on a throne wearing a cooking pot and devouring a naked human whole. A giant hurdy-gurdy leads a band playing music inscribed on the buttocks of one naked sinner;

their music accompanies the stabbing, crushing and burning of others. In the background cities burn and crowds of refugees are driven into dark water. It is an image full of auguries, devoid of 'real' nature, presenting a world entirely of human making, lost to the blindness of human desire.

 Bosch creates a fictional world, seemingly untethered from observable reality, from the laws of nature. And yet, despite the fever pitch of his imagination, Bosch also drew on the images of a new age of scientific inquiry, a time of growing knowledge about the extent and variety of the world. The elephants and giraffes he

Garden of Earthly Delights, by Hieronymus Bosch. *c.*1490–1500. Oil on oak panel, 185.8 by 325.5 cm. Museo del Prado, Madrid.

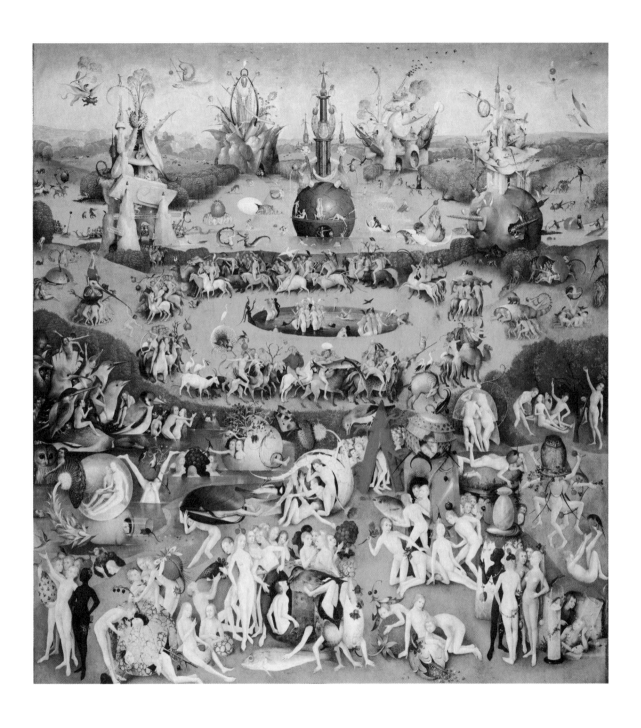

Garden of Earthly Delights, by
Hieronymus Bosch (central
panel).

shows in the 'Paradise' panel on the left were also represented in drawings made by the scholar Cyriacus of Ancona while travelling in Egypt a few years earlier, which Bosch may well have seen.[20] A few years earlier in Nuremberg a *Weltchronik*, or 'World Chronicle', purporting to chart all of history to the present, including a map of the world, such as it was known at that time, was compiled by Hartmann Schedel on the basis of older chronicles, and published by Anton Koberger, with woodcut illustrations by artists including Michael Wolgemut, Wilhelm Pleydenwurff and, perhaps, a young pupil of Wolgemut by the name of Albrecht Dürer. It was one of the first encyclopaedias of its kind.[21] Bosch used one of the illustrations to Schedel's *Weltchronik* for his image of creation on the outer panels, the earthly paradise that existed before the arrival of humans and animals on the third day of Creation.

In his love of spectacle and in his encyclopaedic, 'all-seeing' works, Bosch was heir to the ideas set in motion by Van Eyck. The seductions of oil paint were, however, only one way of showing the 'real' world – and perhaps, as both Van Eyck and Bosch had shown, in different ways, they were not that truthful after all.

When it came to creating convincing images with a semblance of 'truth' (whatever that might be), there was an alternative. Unlike oil painting, it was a recent invention, a way of imprinting onto paper images engraved on metal plates. At first used by goldsmiths as a way of recording designs, by the second half of the fifteenth century engraving had become an image-making technique in its own right. Lines gouged or scratched onto a metal plate are filled with ink made with thickened linseed oil, and are then printed by pressing the plate onto a sheet of paper. Replacing the expensive sheets of vellum used to make books since the days of antiquity, paper was itself a new arrival in Europe. The first paper mill was established at the Italian town of Fabriano in 1276.

Among the first engravings were those made by artists in towns along the Upper Rhine, Basel, Colmar and Strasbourg, in the middle years of the century. These were small pictures of Christian stories, intended to be sold to pilgrims. They were for the most part simple line drawings, although in many cases they show the mind of a more inventive artist, ready to explore the potential of the new engraving technique. Inspired by the great revolution in picture-making that was unfolding to the north, the first engravers saw that, combined with finely engraved lines, thick and lustrous ink made from linseed oil might be used to create images that rivalled the paintings of the Netherlandish artists, and had the added economic advantage of being printable over and over again.

Martin Schongauer, an artist born in Colmar, in the Upper Rhine Valley (in modern-day France), was one of those who made the journey north to see for himself the great inventions and achievements of Flemish artists. His paintings show the time he spent looking at those of Jan van Eyck and Rogier van der Weyden, but it was in his engravings that he pioneered a new type of image-making.[22] With different types of engraved line – sometimes a dense lattice, other times short strokes like the marks of a pen, or dots and hatches defining the shape of an object – Schongauer showed different textures of objects and a control of light

and dark that almost rivalled that of Van Eyck in painting. His engraving *Christ Carrying the Cross* was inspired by a painting by Van Eyck (later lost), copying the Flemish artist's love of detail and the density of his images. Schongauer convincingly shows the grain of the wooden cross and the fur of two dogs, jumping in the foreground, as well as the distant landscape.

Schongauer was one of many artists who brought the visual density and emotional weight of Netherlandish images to the south. The sculptor Niclaus Gerhaert von Leiden animated Strasbourg Cathedral with his lifelike stone- and wood-carvings of saints and patrons. In Basel the painter Konrad Witz took inspiration from Jan van Eyck for his religious paintings, using an intuitive type of perspective that gives his paintings a hauntingly expressive power. Others followed Bosch in seeing images from the north through the eyes of a more nightmarish imagination: the painter known as Matthias Grünewald, also at work in the Rhine valley in the years around 1500, was famed during his lifetime for his unflinchingly grotesque religious images, notably in his seven versions of the Crucifixion. One of the earliest of these, painted on a small wooden panel, magnifies the emotion of the scene through the gestures of the grieving figures, the intense colours and the brutal depiction of the martyred body of Christ. Grünewald takes the northern tradition of painting the density of the visible world and reverses it, showing rather the intensity of extreme emotion. Light is turned into darkness, quite literally by the solar eclipse Grünewald paints to give cosmic echo to his scene.

Christ Carrying the Cross, by Martin Schongauer. c.1475–80. Engraving, 28.9 cm by 42.9 cm. Metropolitan Museum of Art, New York.

Like Schongauer's prints and Grünewald's paintings, the sculptures of the German Tilman Riemenschneider were inspired by the lifelikeness of Netherlandish painting. Riemenschneider began his career in the late fifteenth century and worked in the southern German region of Franconia, in the town of Würzburg. The emotion he pours – or rather carves – into his images is shot through with the mournful knowledge of sin and redemption. He heightened this effect of mournfulness by not painting his sculptures, as most other artists at the

SPECTACULAR SMALL THINGS

time did, so that they retained the effect of the wood or stone from which they were made. Like monochrome engravings, the absence of distracting colour focused the eye more keenly on the message – one of melancholy, but also of a deeper, more violent emotion. In its plainness and candour his sculpture looks forward to the spirit of protest that arose with such fury in German-speaking lands in the early years of the sixteenth century, at the hands of Martin Luther and the Protestant Reformers. Yet Riemenschneider also recalls an older world of religious imagery, his carvings often seeming like three-dimensional realisations of the figures in Rogier van der Weyden's painting of the *Deposition*, made seventy years earlier. A newer world was coming, shaped by the spirit of the Reformation but above all by the image worlds of Flanders and Florence.

Two Mourning Women, by Tilman Riemenschneider. *c.*1508. Limewood. Landesmuseum Württemberg, Stuttgart.

One man from the north strode into this new world with an ambition and talent outstripping all others. Albrecht Dürer was born in the German town of Nuremberg, a major European centre of the time. He was a thinker who wrote groundbreaking treatises, a painter who achieved the highest level of technical skill, a draughtsman with great observational abilities, one of the first of the time to draw male and female nudes, and a printmaker who astonished with his virtuosity. It is in Dürer that the two great image-creating techniques developed in Europe in the fifteenth century, oil painting and engraving, came together, buoyed

by a supreme self-confidence expressed nowhere more than in a painting in which he showed himself in the pose of Christ as *Salvator Mundi*, or 'saviour of the world'. In fact he drew pictures of himself all his life, beginning at the age of fourteen, and virtually invented the genre of self-portraiture (although, as we have seen, at least one Roman painter, Iaia of Cyzicus, had got there two thousand years earlier).

Dürer's observation of the world was obsessive and all-encompassing. His painted watercolour of a crab, which he must have made while visiting Venice in the middle of the 1490s, remains a masterpiece of close observation, capturing the very essence of the crab as a living being. It is a portrait of a crab rather than a dry scientific drawing. Dürer was one of the first artists to use watercolour to paint individual subjects, and did so incessantly during his travels in Italy.

Crab (Eriphia Spinifrons), by Albrecht Dürer. *c.*1494–1495. Brush and ink with washes, 26.3 cm by 36.5 cm. Museum Boijmans van Beuningen, Rotterdam.

As a printmaker, Dürer was inspired by the work of Martin Schongauer, and would have seen the older artist's prints in the workshop of his master, Michael Wolgemut – himself a master of the woodblock illustration, contributing to Schedel's *Weltchronik*. Dürer's first prints were woodblock illustrations for books. It was only after returning from Italy in 1495 and settling in Nuremberg that he took up engraving, alongside an increasingly refined approach to woodcut printmaking, culminating in a series of religious subjects, including the Apocalypse, a pressing subject for many in 1498, when many believed that the Last Judgement was only two years away, following the prediction of the world ending 'half-time after the time' in the Book of Revelation. Rather than an apocalypse, however, Dürer's print brought him international fame.

Just as Van Eyck had done with oil paint, Dürer consciously pushed the medium of engraving to its utmost limit. Large, detailed prints, one showing a knight on horseback and another St Jerome in his study, use engraved lines to represent seemingly infinite gradations of texture and light. Alongside these two 'master' prints, a third engraving made by Dürer counts among the most arresting images ever created.

It is full of riddles. Who is the female figure, in a voluminous skirt, sporting wings and a laurel wreath, her face in shadows, who sits with her head in her clenched hand? The keys around the woman's waist, the compasses that she holds, the carpenter's tools at her feet – what do they signify? And what of the plinth-like structure behind her, with scales, hourglass and magic square, or the rhomboid, a mathematical shape, resting above the sleeping figure of a dog? A cupid sits on a grindstone, holding a tablet and an implement – in fact, a burin, the tool used by an engraver. He frowns and struggles, too childishly clumsy to get very far. The whole image seems to dwell on the struggles and darkness of creative achievement. One key to Dürer's riddle is given by the title of the image, written on a banner held by a flying bat against the explosive rays of moonlight over a sea: *Melencolia I*. The number in the title suggests that Dürer conceived of his image as the first in a series, although it was such a complete expression of the idea of the obscure, shadowy state of melancholy as the source of creative genius that he went no further.

Dürer's *Melencolia I* was a sceptical, northern European view of human nature by contrast with the heroism of the Mediterranean south. Where Florentine artists had placed their faith in measurement, in a scientific approach to visual representation, Dürer saw the other side of creativity, the gloomy, despairing character struggling to reach an unattainable perfection, breaking their rulers and staring into the void.

His figure of melancholy, with her mathematical and geometrical tools, her saw, compasses and grindstone, has realised the futility of scientific knowledge. And yet Dürer stopped short of abandoning a scientific, rational approach in favour of fantasy and imagination. Like Bosch's *Garden of Earthly Delights*, Dürer's *Melencolia I* is an intricate puzzle, designed to intrigue and provoke, and yet, unlike Bosch, Dürer constantly reins in his imagination by observation of nature and the 'real' world.[23] He was simply too interested in looking, discovering, measuring and knowing. 'I will take measure, number and weight as my aim', he wrote, summing up his approach to creativity. Not for him the descent into the world of dreams, or the summoning-up of fantastical creatures or forms of architecture.[24]

Shadows cast over the realm of creativity were a symbol of the age. Dürer's dissection of melancholy fitted a time in which the optimism of the previous two centuries in Europe, on the Italian peninsula and in the northern territories of France and the Netherlands, was in decline, a result of growing mistrust with the authority of the Catholic Church and accusations of papal abuse and corruption.

While he saw the benefit of images as a source of memory and instruction, Martin Luther, in his treatise *Against the Heavenly Prophets in the Matter of Images and Sacraments* (1525), condemned the magical and miraculous power of images claimed by the Catholic Church. Yet he also condemned the wholesale destruction of works of art advocated by the radical preacher Andreas Bodenstein von Karlstadt.[25] He wanted, rather, to neutralise images, if through a language that was itself filled with the violence of iconoclasm: 'I approached the task of destroying images by first tearing them out of the heart through God's word and making them worthless and despised [...] For when they are no longer in the heart, they can do no harm when seen with the eyes.'[26]

Karlstadt had whipped up enthusiasm for the destruction of all church decoration that had even the slightest hint of association with the corrupt papacy, smashing sculpture and stained glass, burning manuscripts and panels, whitewashing frescoes and wall paintings. Luther argued instead for a different type of image, one that reflected his central doctrine of justification by faith alone, and for the use of images as a means of instruction, and as a way of reminding the 'simple folk' of Christian stories, as in the woodcut images he included in his religious tracts and, above all, in his vernacular translations of the Bible, which he made throughout the 1520s and 1530s. These included woodcuts by his friend, and the greatest advocate of the Lutheran image, Lucas Cranach, together with those produced in Cranach's workshop by an anonymous artist who signed himself 'Master MS'.

Cranach's printing presses and paintings were the visual bedrock of the Lutheran cause. His association with Luther shows that Protestantism, as it came to be known, was far from being averse to images and beautiful things, creating

Melancholia I, by Albrecht Dürer. 1513. Engraving, 31 cm by 26 cm. British Museum, London.

its own visual world from the inspiration of Italian and Netherlandish painting. As court artist in Wittenberg in Saxony, Cranach had a workshop that produced not just religious paintings but also mythological subjects, including female nudes whose idealised forms Cranach clearly enjoyed painting, repeating the same subject frequently, so that his painting of Lucretia, the Roman noblewoman who killed herself after being raped, and whose beauty and pose seem like that of a queen of fashion, can be seen in some sixty versions, in various states of undress. Such repetition answered the spirit of the times, so dominated by the printing press, the engine of the Protestant Reformation, as well as a form of bare spirituality not without its sensual, image-conscious side.

The legacy of Netherlandish painting for the Protestant Reformation was divided. On the one hand rich, light-filled surfaces of oil were symbols of the materialism that the Reformers despised. Yet the direct expression of emotion in Rogier's painting and the highly personal and intimate portraiture of Bouts, Petrus Christus and others answered Luther's call for a personal and honest faith. Perhaps it would have found its greatest exponent in Albrecht Dürer, had he not been born too early – by the time of his death in Nuremberg at the age of fifty-six, in 1528, it was still far from clear what 'reformed' images might be. Dürer remained a harbinger, and also one who lacked the satirical or humorous impulse that effective reform so often needs.

For such an impulse we must return north, to the work of a painter born shortly after the death of Hieronymus Bosch, and whose work dominated the sixteenth century, as that of Jan van Eyck and Rogier van der Weyden had the fifteenth. Pieter Bruegel the Elder stood at the head of a family dynasty of painters, none of whom ever quite rivalled his imaginative landscapes and panoramas of human life, bringing the fantastical visions of Hieronymus Bosch into a more humanised realm.

Lucretia, by Lucas Cranach. 1533. Oil on wood, 36 cm by 22.5 cm. Gemäldegalerie, Berlin.

Bruegel explored this realm in large paintings containing hundreds of figures, known as *Wimmelbild*, or 'busy paintings', such as his vision of a Flemish town overrun by children playing every game imaginable, showing the harshness and violence lurking beneath the innocence of their childish pursuits. The great sweep of nature and human life is presented in a series of six paintings, a commission from the merchant Nicolaas Jonghelinck, to hang in his Antwerp dining room, representing the seasons (the number six was reached by the optimistic tradition of having two paintings each for spring and summer).[27] In creating such landscapes Bruegel had existing

paintings to look at for inspiration, but none quite as large: the closest such cycles of seasonal paintings were to be found in books of hours, such as the *Très Riches Heures* by the Limbourg brothers, a fraction of the size of Bruegel's canvases.

Each large painting opens out onto scenes of peasant life with the changing seasons, from the darkness of the early year, through the haymaking and harvesting of the summer months, the practice of returning herds of cows from mountain pastures in the middle of October, to Bruegel's image of hunters trudging past dark-branched trees through winter snow, the first large painting of a wintry landscape made in Europe. Bruegel's landscapes seem to contain time itself, an open expanse of world stretching into the distance, while in the foreground peasants go about their seasonal activities.

The Gloomy Day, the first in the series, shows a glowering day in late winter, with dark clouds scudding across the sky, against which the bare boughs of trees are silhouetted. It is early in the year, the battlements of a distant castle still topped with snow, and yet the warming air has brought with it floods and choppy seas that have claimed at least one boat, broken in two; the crew are rowing valiantly to shore. Ignorant of the drama, countryfolk in the village and on a wooded slope near by are going about their business, repairing the roof of a cottage, gathering firewood but also, in the right foreground, frolicking about: one figure is joyfully eating waffles, while another, a child, is wrapped in a bedspread, wearing a paper crown and a cowbell, ready for the carnival.[28]

What we see is not simply a landscape but a view of human nature, one that for Bruegel was marked by the vulnerability of human life and a penetrating sense of human isolation from the natural world, and from each other. His peasants often seem indifferent to each other, and he does not hesitate to show them in cruel pursuits, such as throwing sticks at a bird tied to a block of wood, in the background of *Harvesting* – just like the undertones of violence in *Children's Games*,

The Gloomy Day, by Pieter Bruegel the Elder. 1565. Oil on wood, 118 cm by 163 cm. Kunsthistorisches Museum, Vienna.

a painting that could not have been made without the provoking imagery of Bosch.

And yet it was neither scepticism nor satire but rather the spirit of observation, of looking directly at the world without religious intervention, that proved the most lasting legacy of Netherlandish painting of the fifteenth century. Portraiture, the combination of intense observation of appearance, combined with sensitivity to the vicissitudes of character, was the mainstream of this legacy, and practised by most of the artists of this period, with the notable exception of Bruegel, who seemed more inclined to show his figures turning away. His was an image world of general, rather than direct, observation.

Some one hundred years after Van Eyck made his portrait of Chancellor Rolin, the technique of direct observation reached a summit of achievement that was rarely to be surpassed. A chalk drawing of a young woman made around 1540 is identified by an inscription (a later addition) as showing Grace, Lady Parker, who served at the court of Henry VIII. It was made by the German artist Hans Holbein, towards the end of his life, much of which had been spent working at the English court, after emigrating from Basel, where the Reformation, with all its antipathy to religious image-making, was raging, putting many artists out of business. Like Dürer before him, Holbein was ill fitted to become a propagandist, although his early print series *Pictures of Death*, showing a skeleton with his hourglass taking into his clutches people from all ages and estates, was sure to include a priest, an abbess and a pope among the victims. Holbein drew his miniature designs for the *Pictures of Death* (they are each smaller than a playing card) directly onto wooden blocks, which were then cut by a craftsman to create woodblock prints. Holbein had already designed a title-page for Luther's translation of the Old Testament. In his conversations with the great Erasmus, of whom he had painted two portraits, Holbein would have understood the connection between the purity of language and thought advocated by the Dutch humanist and the reforming idea of Christ as the true light and the Gospel as the source of truth, opposed to the shadowy world of the papacy and the corrupt sale of indulgences – payments to the clergy to gain time off from the punishments of hell. The *Pictures of Death* was also, however, a subject that allowed his imagination free rein to create scenes that can be highly entertaining, often comic, or sometimes tragic (as in the case of the child taken away by the skeletal figure of death).

Such allegories, however, belonged to an older time: Holbein was destined to work not for the church but for the secular world. He became a painter of portraits of the court and of city-dwellers, of merchants and philosophers, and as such was one of the first true painters of what might be termed 'modern life'.[29] One of Holbein's paintings stands out as unusual both in its subject matter and in its mood. It is a portrait of his wife, Elsbeth Binzenstock, and two of their children – most likely the oldest of their four, Philipp and Catharina. It was probably painted around 1528, when Holbein returned to Basel from his first stay in London, where he had been working at the English court, in the circle of Thomas More.[30]

Elsbeth casts her reddened eyes downward, her face pale and rigid with fatigue. Her tiredness is that of motherhood, of the endless physical and psychological demands, the relentlessness of bringing up four children. Her husband, Hans, had been away for two years working in England, leaving her to bring up the children alone. Their daughter, Catharina, seems to mimic her mother's

tiredness, pale and wan, her hand reaching into the empty darkness behind. Philipp looks up, worried at something outside the picture – perhaps there was originally a self-portrait of his father alongside, although it has long since vanished. Holbein himself vanished a few years later, travelling back to England and fame, and dying there eleven years later, never returning to see his wife or children.

Portrait of the Artist's Wife and oldest children, by Hans Holbein. c.1528–1529. Oil on paper, affixed to wooden panel, 79.4 cm by 64.7 cm. Kunstmuseum, Basel.

Holbein's portrait of his family goes to the heart of his vision of portraiture as a record of life. It was a desire for unencumbered truth, just as Erasmus promoted a purity in thought and expression, a clearness of mind, unencumbered by magic or superstition, a sense of the solidity and finality of the objects around us, living and dead, the finality of the evidence of the senses. It was an alliance of truth that determined the course of human life in the European world for some time to come, and seemed to fulfil the hard, bright promise embodied in oil painting since the time of Jan van Eyck.

And yet in many of Holbein's paintings, with the notable exception of the family portrait, given as they were to the glorification of their subjects, there is yet a sense of something amiss. Considering how directly drawing, in chalk, silverpoint (a thin metal stick, and a precursor of the lead pencil), with washes and coloured tints, expressed the new alliance of truth, the richly coloured and layered surfaces of painting seem in part a betrayal. The pith of Holbein, like Dürer before him, was not in colour but in line.

With an unerring hand, so restrained that often there appears to be a line or an area of shading where there is nothing at all, like a blush disappearing beneath youthful skin, Holbein shows Lady Parker as a thoroughly self-possessed young woman, looking directly at the artist, and at viewers of her portrait, with the self-assured directness that Van Eyck himself might well have directed towards the world, the very act of looking being one of knowing and possessing.

Grace, Lady Parker, by Hans Holbein. c.1540–1543. Black and coloured chalks on pale pink prepared paper, 29.8 cm by 20.8 cm. Royal Collection Trust.

18

Bronze Kings

Drawing, making marks on a surface to delineate a form, is as old as human image-making itself. The earliest drawings were made with marks or scratches on rock or shell by humans inhabiting the African continent. Virtually all of these have been lost. Human animals, *Homo sapiens*, first appeared in Africa at least one hundred thousand years ago, and set off wandering the world some twenty to forty thousand years later. Soon after followed the earliest surviving images, at Sulawesi, Chauvet and other sites, such as Altamira in northern Spain. Had the image instinct evolved before? Did human image-making begin in Africa?

The evidence suggests that it most probably did. Stones and shells incised with patterns have survived from the earliest period before humans left Africa – such a slim chance of survival over tens of thousands of years indicates a much greater wealth of images cast into oblivion. Transforming those marks into recognisable images would have taken place over a very long time, perhaps the first tentative images appearing and disappearing, not repeated for thousands of years.

Around twenty-five thousand years ago, in a rock shelter (later named 'Apollo 11') in the Huns mountains of modern southern Namibia, a human made a drawing of an animal with spindly legs and horns, like an antelope, on a flat stone slab, small enough to be held in the hand.[1] The smooth quartzite face was the perfect surface on which to draw. Perhaps the image, with a number of others, was propped up against the shelter wall or passed from hand to hand, the drawn lines activating the minds of the onlookers in a way that felt to them entirely new. It is the earliest surviving lifelike drawing found on the African continent. Although it was made later than those images found elsewhere in the world where humans had wandered, it probably belonged to a tradition that stretched much further back in time.

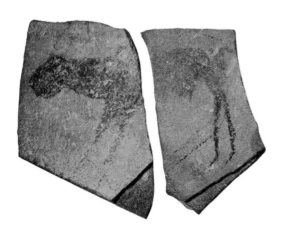

Rock drawings make up the vast majority of surviving ancient images in Africa: drawings and paintings of elephants, giraffes, antelopes, and other animals as well as human figures, made by hunter–gatherers who lived in the region of modern-day South Africa, Namibia, Botswana and Zimbabwe, and also in the rainforest of Mozambique. The people are collectively known as the San, and created one of

Depiction of an animal, from Apollo 11 Cave, Namibia. c.25,500–25,300 years ago. Charcoal on quartzite, two slabs, together w. approx. 10 cm. National Museum, Namibia.

the longest lasting image-making traditions anywhere on earth, stretching back at least ten thousand years, and enduring in some regions until very recent times.

One of the best-preserved paintings by the San can be found in the Drakensberg mountains of South Africa, on the walls of an open sandstone shelter in the foothills, known as the Game Pass Shelter. Along the sandstone surface appear images of the eland antelope, painted and shaded with subtle tones of brown and red and white pigments. Behind one of these eland, which is stumbling in his death throes, are three human figures in poses which suggest they are dancing. They are shown with antelope's hoofs, as though transforming into the dying eland, an animal of great spiritual significance for the San people of the region.[2] Although nobody knows for sure, the transformation of the humans into animals seems to show them in a state of hallucination, the dancer entering the spirit of the dying animal, as a way of overcoming, or seeing beyond, death.

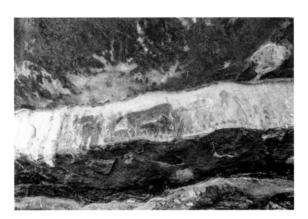

It is not known when the San artist painted the dying eland with his magician followers: it may have been two hundred, or two thousand years ago. Around the continent different traditions persisted over thousands of years: in the Aïr mountains of Niger upright symmetrical warrior figures were carved, with feather headdresses, brandishing throwing spears and holding a horse by reins; in eastern Africa, geometric markings on rocks relate in some cases to the branding marks on cattle and other animals, and markings on their own skin, made by pastoralist herders; at Kondoa, along the Great Rift Valley in Tanzania, slender human hunters with large ornate headdresses hold bows and arrows, alongside animals including elephants, giraffes, rhinoceroses and wildebeest. With the exception of West Africa, these paintings and engravings can be found all over the continent, from Morocco in the north to Somalia in the east, down to the cape of South Africa.[3] Although the origins of human images in Africa may not have survived, the continent is home to the greatest and most diverse range of rock images anywhere on earth, evidence of the lives and beliefs of hunter–gatherers and pastoralists, direct descendants of the earliest image-making humans.

In the centuries after the Roman conquest of Egypt, the emergence of new kingdoms and their capitals, joined by ever busier trade routes, was the setting for new built forms in the lands south of the Sahara. Monumental stone architecture appeared in the kingdom of Aksum (present-day Eritrea and Ethiopia), founded

Game Pass Shelter,
Drakensberg Mountains.

in the first century CE, palaces and tombs, as well as lofty granite stelae, some carved with architectural details as though they were tall, thin multi-storey buildings. The highest reached to over thirty metres – taller than any Egyptian obelisk. The kingdom was shaped by its position on trade routes between the Roman empire in the west and the Arabic and later the Islamic world to the east. With the arrival of Christianity in the fourth century, following the conversion of the Aksumite emperor Ezana (not long after Rome itself was Christianised, following the conversion of Constantine), new forms of church architecture appeared, large basilicas built on raised platforms, or hewn from the rock, and decorated with painted murals, like the Buddhist cave shrines being made far across the land to the east. Such buildings in the highland landscape were signs of a new cosmopolitanism in eastern Africa.

Islam also arrived in eastern Africa in the seventh century CE, but spread in the opposite direction, across the north coast of Africa and into the Maghreb and west African savannah, bringing in its energising wake new forms of architecture. Founded in the ninth century, Djenné, in present-day Mali, was to become the largest city in west Africa, and the capital of the later Malian empire. With the old Tuareg settlement of Timbuktu, which became absorbed into the Malian empire, Djenné became one of the greatest cities of Islamic buildings and images. In the thirteenth century, when the city was ruled by its first Muslim sultan, King Koi Konboro, a large walled mosque was constructed of earth and mud (a building material known as adobe) and renewed every year with a fresh ceremonial plastering of mud.

Dienné : la vieille mosquée reconstituée.

Shaped and renewed from the earth itself, the Great Mosque, like the Aksum stelae, was a great survivor and symbol of continuity, but also a localised response to a religion that came from afar. Just as with the varying response to Roman rule that appeared along the north coast of Africa, and from Syria in the east to Britain in the west, it was the strength of this localised response that gave a sense of permanence.

'The old Mosque restored', from Félix Dubois, *Timbuctoo the Mysterious*, London 1897, p.157.

The discovery of bronze- and brass-casting in the forest regions of west Africa, in the towns and villages on the Atlantic coast of modern Nigeria, created a different sense of permanence. Although iron-smelting and -forging had been known for over a thousand years, the discovery of bronze led to the creation of more complex and ingenious forms than had been known in metalwork before.

The earliest known bronze-casting appeared around the ninth century in a trading settlement in the tropical forest, known as Igbo-Ukwu (meaning 'Great Igbo'). It may well have been inspired by objects travelling along the Saharan trade routes that linked the Niger delta with East Africa and Arabia beyond, although the metals used to create the alloy – copper, tin and lead – could all be mined near by, and the casting technique was most probably built up locally over time.[4] The metal objects created by the people of Igbo-Ukwu used the lost-wax technique, one of the oldest forms of casting bronze, in which a wax model is encased in a ceramic shell, then melted away (lost) to leave a mould cavity into which molten metal is poured. Igbo-Ukwu sculptors relished the intricate surface decoration enabled by the technique, creating ever more elaborate vessels. A large water pot appears at first to be swathed in rope, but on closer inspection the rope can be seen to be made of bronze, a sculptural illusion that required great technical skill to realise. The bronze vessels, or at least those that survived, were placed in burial chambers, much like the bronze objects placed in the burial hoards of Celtic chieftains, or of Shang- and Qing-dynasty rulers in China.[5]

Further to the west, in the town of Ife, the centre of the Yoruba people, a second great metalworking tradition appeared a few hundred years later. Artists created terracotta and brass heads reminiscent of late-Dynasty Egyptian sculpture in their likeness to life. No such metal sculpture had been made in Europe since Roman times, and none would be for at least another hundred years. Striations on the faces of the Ife portrait heads appear like waves of life energy, giving the feeling of profound centredness and inner calm. They correspond with the Yoruba belief in the inner energy, or *ase*, which determines the character of all things, including humans, where it resides in the head and is expressed through the face.[6] As images of royal power they express a serene spiritual vitality, echoing the Yoruba's description of their culture as 'a river that is never at rest'.[7] As images of sacred power the Ife heads are close to Buddhist sculpture but go far deeper into individual exemplary characters. Looking at these heads, we feel we can read the story of their lives, even if we cannot be sure that they are individual portraits rather than portrait heads made in the same workshop from a single model – images of power, then, which could be adapted to changing times.

Many more sculptures were made by Ife artists, only to be lost or destroyed, perhaps melted down, as is so often the case, to make tools or weapons. And yet the technical know-how for metal-

Roped pot on a stand, from Igbo-Ukwu. 9th–10th century. Leaded bronze, h. 32.3 cm. National Museum, Lagos.

BRONZE KINGS

casting was never quite lost, and reappeared in a culture that arose some two hundred years later, further west, once again in the Niger delta, that of the kingdom of Benin.

Rulers of the Benin kingdom were traditionally said to have descended from the Yoruba, and to have inherited their talent for metalworking from Ife craftsmen. It was in the fifteenth century that the first great warrior king, or 'Oba', by the name of Ewuare, twelfth in the dynastic line, took the throne of Benin. He is said to have burned the existing Benin city to the ground, and rebuilt it as a magnificent stronghold. He established a new court bureaucracy and introduced royal ceremonies strengthening the power of the king, backing up the wars he embarked on to expand the Benin kingdom.

The city and royal palace that Ewuare created were adorned with some of the greatest cast sculpture ever to have been made on the African continent, rivalling that of Igbo-Ukwu and Ife.[8]

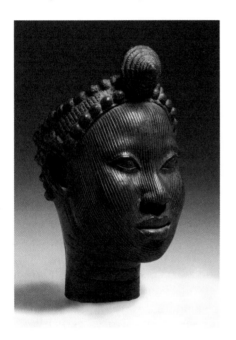

Brass leopards and pythons guarded Ewuare's palace, while inside statues in ivory, wood, terracotta and metal were placed on shrines created for the veneration of royal ancestors. One Dutch geographer, using reports from missionaries, and also from those involved in establishing Dutch trading posts for the Atlantic slave trade from the middle years of the seventeenth century, described the buildings of the king's court as being 'as large as the town of Haarlem', containing the numerous apartments for the prince's ministers and large impressive galleries, each supported by wooden pillars, covered with metal plaques showing images of the war exploits of the Benin kings. The roofs of the buildings were covered with palm leaves, and decorated 'with a small turret ending in a point, on which birds are standing, birds cast in copper with outspread wings, cleverly made after the living models'.[9]

These brass plaques show a variety of commercial scenes, including priests carrying ritual vessels, carved boxes containing kola nuts, while attendants blow trumpets carved from ivory. In one an Oba, wearing the distinctive *odigka*, or high collar made from coral beads, holds two leopards by their tails, swinging them into the air, a symbol of his domination over wild nature, and his prerogative as the only person allowed to sacrifice the leopard at the annual *Igue* ceremony, reinforcing royal might. Two mudfish – a creature admired by the Benin for its ability to deliver electric shocks – hang from his belt, or perhaps substitute as legs, symbols of the sea god Olokun, the provider of wealth from the bottom of the ocean. The Oba is shown as a tamer of nature, powerful enough to harness the wild forces of land and river, symbolised by those animals, both domesticated and hostile, that were the principal subject for Benin artists.[10] It was the innovation

Head with crown, Wunmonije Compound, Ife. 14th–early 15th century CE. Copper alloy, h. 24 cm. National Commission for Museums and Monuments, Nigeria.

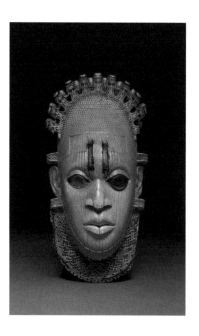

Pendant mask of the Benin Queen Mother. 16th century. Elephant ivory, iron and copper alloy, 24.5 cm by 12.5 cm. British Museum, London.

of Ewuare's grandson, the Oba Esigie, to commission a new type of image of Benin court life, showing the *iyoba* — the 'mother of the Oba', or queen mother. The first of these was Idia, who aided her son, the Oba Esigie, in his rise to power and the expansion of his realm over the next five decades during the early sixteenth century. She remains the most famous of the *iyoba*, revered for her role in expanding the Benin kingdom. Her headdress is made from images of bearded Europeans. Between her eyes, vertical incisions were originally inset with iron strips, giving an impression of resolution and power. The plaque is designed to be worn as a pendant around the waist of the Oba during an annual ceremony ridding the kingdom of evil.

The Benin people also made images of visitors from afar, of the Portuguese mercenaries, traders and diplomats who earlier in the fifteenth century had become part of the life of the Benin people, having worked their way down the African coast, establishing a fortress at São Jorge da Mina in the middle years of the century. They traded with the Benin, selling them coral beads, cloth for ceremonial attire and brass ingots, rings known as 'manillas', which were smelted down to create brass sculptures for the royal palace. From the Benin they took ivory objects, carved into intricate salt cellars and hunting horns, and spoons with handles in the form of birds.

The Portuguese also bought slaves from the Benin — the Benin king was himself a slave trader, capturing people from rival powers and selling them to the Portuguese, and then the Dutch, English and French. The Benin made bronze figures of these traders from afar, recognisable by their elongated European faces, beards and costume, as well as by their flintlock guns, the first of such weapons to arrive in Africa. They placed the figures, alongside images of past kings, carved tusks and other sculptures on their royal ancestral altars. The gun-wielding Portuguese they identified with the sea-monster Olokun, who had been tamed and captured by the Oba Ewuare.[11]

The Benin brass images of Portuguese mercenaries are untypical of images of the human form made in Africa. From the earliest rock engravings on the continent, images of humans were more stylised, more symbolic, derived not from appearance but rather the result of inventive imaginative reconstruction. They appeared in masks and sculptures made from wood, cloth, plant fibres and other perishable materials, and were used in ritual dances to harness the wild power of the bush, swamp and forest, of animals and of spirit beings, or to act in rituals of passage and transformation, of birth and death. The elaborate forms of the masks used

BRONZE KINGS

in these performances were repeated over the centuries by peoples inhabiting a broad swathe of western and central sub-Saharan Africa, from Mali in the north to Malawi and Mozambique in the south.

In western Africa, the farming communities of the Dogon people lived from the late fifteenth century in spectacular isolation on a cliffside, the Bandiagara Escarpment, a row of cliffs running alongside the River Niger. The whole sweep of the Dogon world is shown in their sculptures and masks, the animals and people, including neighbouring tribes, among the richest and most varied in west Africa. Masks made of natural fibres are decorated with

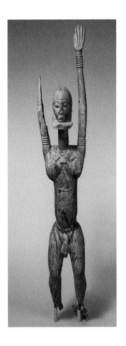

Male figure with raised arms, Dogon People, Mali. 14th–19th century. Wood, h. 210.5 cm. Metropolitan Museum of Art, New York.

cowrie shells, often showing eyes, or carved from wood, representing different animals – rabbits, antelopes, crocodiles, hyenas – and used in memorial rituals to accompany the dead safely from the village, through the fields and landscape, to the afterlife.

Dogon sculptures show human bodies as thin and elongated, formed of geometric shapes, with little correspondence to actual anatomy and yet filled with elastic power. These carved figures were placed on altars and in shrines, used in sacrificial rituals, praying on behalf of their owners, asking favours of Ama, the sky god, the creator of life through the provision of rain.[12] The figures are often in positions of prayer, such as the large wooden figure representing a village elder, arms upraised, imploring Ama to send rain clouds for the millet crop.

Sculptures and masks made across western and central Africa, mostly by Bantu-speaking people, were made to be effective in rituals, their forms designed to inspire both fear and delight. They may have been destroyed, or hidden, after being used, perhaps recovered years later. The Songye people live over a large region in the Democratic Republic of the Congo, in central Africa, and are known for their wooden *kifwebe* (the Songye word for 'mask'), marked with black and white striations. These stripes recall the crested mane on the plains zebra. Male *kifwebe* are distinguished by bands of colour; female masks are more soberly monochrome. Just as with the marks on the bronze Ife heads, the dynamic striations suggest lines of energy flowing from the body. The swollen, goggle eyes have a power of vision beyond the world of appearances. The puckered bird-like box mouth gives a sense of concentration while singing or speaking. Like all sub-Saharan masks, they were made to be used, rather than simply looked at, exercising an enchantment – one deliberately strange, parodic, fearsome even – connected with a moment of transformation.[13]

Female *Kifwebe* (mask), Songye, Democratic Republic of Congo. Wood, pigment, 30.5 cm by 18.1 cm by 15.6 cm. 19th–20th century. Musée des Civilisations Noires, Dakar.

The abstraction of the human image from natural appearances reaches an extreme in the sculptured figures made by the Kota people, who live in eastern Gabon and the Democratic Republic of Congo. The Kota create highly original reliquary sculptures, flattened images created from brass and copper sheets wrapped around a wooden armature, to place on top of wickerwork baskets holding relics and the bones of their ancestors. As with so many traditions of venerating relics, images are a way of speaking with the dead, and also of radiating the power of the relics, rather as the mast of the pagoda transmits the charge of the Buddhist relics to the outside world. Yellow brass and rose-coloured copper form the face on one example, with an elaborate hairstyle and a body defined by a single band of marked bronze, standing on two scissor-like legs.

As figures from the Songye, Kota and Dogon people show – among many more across the west and central African continent – wooden sculpture and masks were made across vast distances of land in west and central Africa. The idea of the masquerade would have spread with the early migration of people, such as the Dogon people, some of whom came from Djenné in Mali, or the Songye people, who originated from the Luba empire, in what is now the Democratic Republic of Congo. Their origins are lost in time, although we might think of them as remnants of the great royal courts of the kingdoms of Africa, of the Kongo, the Kuba and the empire of Mali, and of all the minor monarchies that dominated the continent before the arrival of traders and colonists, and the widespread destruction caused by the wars and disease they brought with them.

Of these ancient African monarchies, the Bantu-speaking people, ancestors of the Shona people, were to leave the greatest monument of sub-Saharan Africa.[14] From around the eleventh century they constructed a mighty and labyrinthine citadel, now known as Great Zimbabwe, in the south-eastern hills of the modern Republic of Zimbabwe. Thick, serpentine walls built from granite blocks without mortar reach in places over ten metres high, never quite running straight or creating angles. Often they incorporate the large smooth boulders that are scattered in the landscape, echoing their rounded shapes

Reliquary figure, Kota people, Gabon. 19th–20th century. Wood, copper, brass, 73.3 cm by 39.7 cm by 7.6 cm. Metropolitan Museum of Art, New York.

in doorways, towers and stairs, creating roofless enclosures in which smaller dwellings were constructed of *daga*, a clay also used to cover the walls, giving them a smooth appearance.

This unique set of structures, quite unlike anything elsewhere in Africa, protected a settlement that at its height stood at the centre of a thriving civilisation on the Zimbabwean plateau, and was the linchpin for trade in the region and with prosperous towns on the east coast, and for the traffic of goods over the Indian Ocean. Merchants dealt in the gold that was mined and panned in rivers in the region of Matabeleland, to the west, and traded by way of sea to Egypt, and in copper from the northern African kingdoms, as well as in cattle. Valuable objects came from afar: glass from Syria, faience from Persia, celadon from China.[15]

Thriving workshops in the citadel itself produced some of the most enigmatic objects later found at the site: long-necked birds carved from soft steatite stone, or soapstone, looking rather like eagles but with human-like legs and toes instead of talons. Their forms are smoothed and simplified to appear more as symbols of avian life rather than a particular species, heavy, flightless creatures who may have represented royal ancestors. They were perched on some of the many granite monoliths set up around the settlement, in a small sanctuary-like enclosure to the east of the main residence, and probably used in rituals associated with the ruling family, ancestor worship or intercession with the gods.[16] Carvings of birds perched on columns were made by the Benin, as well as by the ancient Egyptians, and the combination of human legs and animal body brings to mind the sphinx of ancient Greece. The Zimbabwean stone bird was one of those spirit creatures that had been painted and carved on rocks for millennia.

The massive granite walls and towers did not, it seems, serve any military purpose but were rather reflections of the great wealth and style of the rulers of Great Zimbabwe. Whatever the reasons for the decline of the citadel – a matter of changing patterns of trade or farming, perhaps – from around 1450, the stone ruins of this great African settlement began their journey to ruin, and rediscovery, as a great symbol of the African past.

Great Zimbabwe, outer wall of enclosure.

19

Some Kind of Genius

For an artist who attained great fame during his lifetime, Leonardo da Vinci finished remarkably few paintings, built no buildings and made few, if any, sculptures. Nor did he publish any of his voluminous writings or treatises, or express much interest in the humanist literature and philosophy of the Florence of his day. His renown arose, rather, from his inexhaustible curiosity about nature: his scientific drawings seemed to cover all things known to exist, and his paintings transformed this knowledge into mysterious images. Leonardo changed the very idea of what it meant to be an artist: no longer simply an illustrator of stories, a conjuror of pictures, however sophisticated, but rather a human capable of universal vision, creating perfected images of the world based on observation, analysis and imagination.

While still a teenager, in the 1460s, Leonardo trained in the workshop of the painter and sculptor Andrea del Verrocchio. Verrocchio's was the most exciting studio in Florence, where the leading ideas were discussed and put into practice – Brunelleschi's theories of perspective, Alberti's theories of painting and the compelling style pioneered over a century earlier by Giotto and Duccio.[1] It was the crucible of a new idea of painting, by which the world was seen through the lens of scientific knowledge, through mathematics, as well as optics: everything, it seemed, could be measured, represented, understood.

Leonardo took all he could from Verrocchio's teaching, and also from the other great workshops of Florence, that of Antonio del Pollaiuolo and his brother Piero, and also of the Ghirlandaio family firm. His earliest surviving drawing, a view from the hills of a Tuscan landscape, shows his agile, inventive mind awakening to how drawing could be a way of exploring the world. After ten years in Florence it became clear that to pursue his own interests Leonardo needed to be away from the worldly distractions and commerce of the Medici-run town.

At the age of thirty he travelled to Milan, in the hope of gaining commissions from the ruling duke, Ludovico Sforza. Here he set about a campaign of self-education, reading, discussing, questioning, observing and noting his questions and findings endlessly in notebooks and manuscripts. He studied anatomy, engineering and optics alongside poetry, music and gastronomy (Leonardo was reputedly an excellent cook), slowly gathering a body of personal learning that, although it was not always of the highest standard, was directed to the ambitious goal of understanding absolutely everything. It might seem strange that the ultimate proof of this understanding came in the form of painted pictures, until it is remembered that the basis for Leonardo's science was always the same – long, hard looking.

'L'occhio che si dice finestra dell'anima' – 'The eyes are said to be the window of the soul' – wrote Leonardo, a medieval saying he borrowed from Dante.[2]

One commission, in particular, allowed Leonardo to show the full force of his invention. Around the middle of the 1490s he was asked to paint a wall in the refectory of a Milanese convent. The subject was one on which he could pin all his boldness and imagination: a scene of the Last Supper, the meal Christ shared with his apostles before his Crucifixion, in which he foretells that one among them will betray him and one will deny knowledge of him. Leonardo shows the moment when Christ reveals Judas' betrayal, sending a shock of emotion through the gathered apostles, drawn together, as though one body, in a drama of gesture and facial expression.[3] It was shockingly real-looking, so that the friars on their benches below must have gazed up in open surprise when the painting was first unveiled, as if the refectory itself had been extended into an imaginary realm.[4] Plunging perspective lines throw the focus on Christ's head, the calm centre around which the drama unfolds. Leonardo was inventive both with the composition and with the technique – too inventive, perhaps. He developed a new method of painting, using oil paint directly on the wall (rather than the true fresco technique used by Masaccio and others), but this soon began to deteriorate, so that later generations would only have to guess at the appearance of the original through layers of restoration.

A clearer picture of his powers of observation remains in the portraits he painted in Milan. One shows a young woman by the name of Cecilia Gallerani, who happened, not entirely by coincidence, to be the mistress of his patron, the duke. Her hairnet tight around her skull, braids bound beneath her chin, black jet beads, velvet embroidered gown and barely perceptible golden veil lend Gallerani an air of confidence beyond her fifteen years. She looks quizzically to her left, out of the picture, as if hearing some faintly surprising news. Leonardo conveys her bright steady gaze and the grace and strength of her hand, holding the ermine as if it were a musical instrument. The ermine is at once formal, like a heraldic element (like the animals painted by Pisanello), and entirely natural, its smooth fur covering a warm, living body. Life and intelligence radiate from the affinity between human and creaturely animal, as had never been captured in a painted image before.[5]

Lady with an Ermine, by Leonardo da Vinci. 1489–90. Oil on wood panel, 54 cm by 39 cm. National Museum, Poland.

As a portrait of knowledge and beauty the image of Celia was also a prophecy. Having escaped the affections of the duke, she went on to become a successful poet and figure in Milanese life. It was a lucky escape, not least because, barely a decade later, Milan fell to the French and the duke and his court were driven into exile. Leonardo was obliged to leave alongside other court artists, including his friend the architect Donato Bramante. Had Leonardo been more interested in ancient Roman sculpture and architecture, he would surely

have accompanied Bramante to Rome (thus echoing the visit of Brunelleschi and Donatello a hundred years earlier). Both artists knew that it was the only place to study the classical past.

Bramante had earned a reputation in Milan for his architectural designs, inspired by grandiose Roman architecture. Like Alberti and Brunelleschi before him, he spent days, weeks and months studying, measuring and drawing Roman buildings, gathering information to use in his own designs. He even wrote a guide to the ruins of Rome, the *Antiquarie prospectiche romane*, which he dedicated to his '*cordial, caro ameno socio*' ('cordial, dear, and delightful colleague') Leonardo da Vinci.[6] The title-page shows a woodcut of an anatomical figure posed among the ruins, a perfect symbol of the spirit of measurement and fascination with the human body and ancient buildings that had captivated both artists in Milan.

Bramante's keen ability to understand and interpret the past was not lost on Pope Julius II, one of the greatest papal commissioners of art and architecture during his decade-long reign from 1503. He had already made his mark as a vociferous patron of the arts when a cardinal in the final decades of the fifteenth century, and was hailed in Rome as a great warrior pope.

Shortly after employing Bramante as papal architect Julius took the shockingly bold decision to knock down one of the principal churches of the Christian world, old St Peter's, and raise a much larger building in its place. Bramante's design for the new St Peter's created a vast interior space, based on ancient Roman baths, the only architectural model large enough for Julius's ambition.

Just as Leonardo's genius was always clearer on a smaller scale, so Bramante made one of his most memorable buildings at a comparatively modest size: a small circular temple, known as the Tempietto, built on the hill in Rome where St Peter had been crucified. It is a perfect expression of the form and proportion Bramante had learned from ancient buildings, and gives a

simple sense of rightness. No part is unnecessary; every part contributes to the effect of the whole, which is of something both satisfyingly compact but also open and expansive, giving a clear Roman sense of solidity and grandeur. Bramante's Tempietto is a memory of the temples of ancient Rome, particularly the temple of Vesta on the banks of the River Tiber, and also of Santa Costanza, the mausoleum built by the emperor Constantine. It also echoes the rounded tomb built in the time of Constantine on the site of the Christ's crucifixion, as part of the church of the Holy Sepulchre in Jerusalem.[7] The echo was the thing. Bramante's Tempietto, more than any other structure of the time, rivalled the architecture of ancient Rome

Woodcut title page of *Antiquarie prospectiche Romane*, by Donato Bramante. c.1499–1500.

while creating a building that epitomised the Christian spirit of contemporary Rome.

Bringing together ancient, often pagan, forms with Christian rituals and stories was the foundation for the work of a generation of artists born in the late fifteenth century, just as it had been for the earliest Christian artists. Leonardo was the bridge to the earlier age of Brunelleschi and Donatello, and to Giotto and his world before them.

Two of the new generation were especially close to Leonardo, so that they were in effect his spiritual progeny. The tempestuous figure of Michelangelo Buonarotti was born when Leonardo was in his twenties, and grew to be one of the greatest rule-breakers of all time. The far calmer Raffaello Sanzio (known as Raphael) was born nearly a decade later, and brought Leonardo's idealism to its furthest point. Raphael died a year after Leonardo, as if in grief. Michelangelo, the rebel of the 'family', outlived them both by almost half a century.

Raphael was indebted to the clear poetic atmosphere of Leonardo's painting, but also to the bold clarity of Bramante's architecture. Both can be seen in the paintings of the Virgin and Child that he made on his arrival in Rome in 1508, at the age of twenty-five, just as the city was entering its period of glory under Pope Julius II. Like Bramante's Tempietto, Raphael's paintings seem both entirely self-contained but also expansive, the forms solid and massive, bringing to mind the much earlier paintings of Masaccio, but with a luminosity of colour and gracefulness that Raphael owed as much to his teacher, the painter Perugino, as he did to Leonardo.[8]

On his arrival in Rome, the young Raphael was commissioned by Pope Julius to decorate his private apartments in the Vatican, known simply as *le stanze* – 'the rooms'. Julius was not noted for his love of books (he took his papal name from Julius Caesar, and much preferred the military camp to the reading room), but it was in a small room holding his modest private library that Raphael painted a series of frescoes that count among the greatest wall paintings of the age. Each of the frescoes covering the four walls embodies a branch of knowledge – law, theology, poetry and philosophy. It was the last that inspired Raphael's greatest image: a gathering of philosophers in a grand architectural setting that evokes the great tradition and variety of human reason, of inquiry into the origin of things. Above, the inscription *Causarum Cognitio* ('Knowledge of Causes') appears alongside a painted personification of knowledge.

SOME KIND OF GENIUS

Causarum Cognitio, (*Knowledge of Causes*) (also known as 'The School of Athens'), by Raphael. 1509–11. Fresco, 500 cm by 770 cm. Stanza della Segnatura, Vatican.

Plato holds centre-stage, pointing upwards and holding a copy of his book *Timaeus*, while Aristotle, holding his *Ethics*, points straight ahead. Surrounding them, figures are engaged in a variety of poses suggesting philosophical cogitation and discussion. Unlike the two protagonists, they are not all clearly identified but evoke figures such as Euclid, with his measuring compasses at the bottom right, and Pythagoras, writing in a bound manuscript as a youth holds up a diagram on a slate. The figure sprawled on the steps reading is Diogenes, with his beggar's bowl, noticeably unconcerned with what is going on around him.

Raphael's philosopher portraits were not, of course, taken from any real knowledge of how the philosophers appeared. What he created was an image of the activity of thought, and a demonstration that knowledge is founded on a tradition that builds over time, and can incorporate divergent views – of the Islamic scholar Averroes (who stands above Pythagoras) and the Persian Zoroaster (above Euclid), as well as the central dialogue between Aristotle, for centuries the foundation of philosophy, and Plato, whose theory of reality as a mere reflection of a divine ideal had been rediscovered in the West less than a hundred years earlier. Although this fresco is known as *The School of Athens*, the setting seems more like the Rome of Pope Julius, as designed by Bramante (a distant relation of Raphael, who had recommended him for service to the pope): a Roman bath adorned with statues not of saints but of the gods Apollo and Minerva.[9] Just as Leonardo placed the head of Christ at the mathematical centre of his *Last Supper*, so Raphael places the heroic figures of Plato (not unlike Leonardo in appearance) and Aristotle standing in front of a distant stone arch and blue sky through which clouds drift, with the lightness and changing shapes of thought itself.

Raphael's *Causarum Cognitio* was the most complex image of human life yet painted: some fifty-two figures gather on a grand stage, the clarity of their

placement and the mystery of their identity embodying a world of knowledge. It was fully planned and thought out in numerous drawings. And yet one of the philosophising figures was not in the original scheme: the moody figure in the foreground, resting his head on his fist, not looking at the paper on which he scrawls. Raphael painted him in later, after having glimpsed a great and secret work being made just a few corridors away in the Vatican, a painting on the ceiling of a chapel that had been built by Julius's uncle, Francesco della Rovere, Pope Sixtus IV. Raphael may have felt his frescoes were daring inventions, but when he saw the ceiling of the Sistine Chapel being painted by Michelangelo, he realised that here was something far greater: not just a scene on a wall but an entire stonework vault exploding into a vast complex of powerful imagery from the beginning of the book of Genesis, and the moment of the creation itself: the separation of light from darkness. The figure Raphael painted is Michelangelo himself. There was little he could do but pay homage.

The Sistine Chapel ceiling was dazzling but not totally unexpected. Michelangelo had already proved his ability to create breathtakingly ambitious images. He learned his trade in the workshop of Domenico Ghirlandaio in Florence, which he entered at the age of thirteen in 1487, but soon outdid his master – 'this boy knows more than I do' ('*costui ne sa più di me*'), Domenico is reported to have said. Before long Michelangelo had the perfect opportunity to prove it.[10] After a period in Rome in the first years of the sixteenth century, Michelangelo returned to Florence and began work on a colossal marble standing figure made to rival not only Donatello, whose bronze sculpture of *David* he admired, but also the Greek and Roman sculptures from antiquity that were being unearthed every day in Rome. Only a few years earlier a Roman statue of Apollo, stepping forward and holding a cloak majestically from an outstretched arm, had been unearthed in Rome and later placed by Pope Julius first in a courtyard of the Vatican, the Cortile del Belvedere, giving the statue its name, the *Apollo Belvedere*.

Michelangelo's towering sculpture, carved from a single block of marble, was originally intended to be placed remarkably high up on the exterior of Florence Cathedral. It was soon decided, however, after a meeting of cathedral officials and artists, that this was far too risky, and that the colossal sculpture should stand on the public square in front of the Palazzo della Signoria, next to the Loggia dei Lanzi. This was all the better for Michelangelo – his great work could truly be seen and its power appreciated, especially in relation to Donatello's bronze *David*, standing near by on the public square.

Michelangelo's *David* was the first monumental nude sculpture to be made since antiquity, and was often said to be more like Hercules than an image of the young boy who slayed Goliath with a stone from his sling. The nudity itself seems itself a form of violence, so directly sensual, so unabashed is the feeling of David's vanity at his strength and beauty. Here appears for the first time the sense of dangerous power, or *terribilità*, for which Michelangelo became famous.[11] For such a vast statue, with impressive musculature, oversized hands and head emanating both physical and mental strength, it is also surprisingly vulnerable. David turns his head, his attention caught by his foe, perhaps, leaving his body exposed to scrutiny, unguarded.[12] From the day of its unveiling, in the late summer of 1504, it became a symbol of the Florentine republic, an expression of the political freedom of the citizens from the rapacious Medici family, if only temporarily. It was also an image

David, by Michelangelo, c.1502–1504. Marble, h. 517 cm. Galleria dell'Accademia, Florence (shown here *c.*1853-1854, in the Piazza della Signoria).

of the human body as an expression of deep feelings and desires. The naked figure, almost always male, was Michelangelo's first and most important subject.

The human body was also the basis for Michelangelo's designs for architecture, which appear more like designs for sculptures than schemes for structures built for practical purposes. For his patron, Lorenzo the Magnificent, Michelangelo built a library, known as the Laurentian Library, the vestibule to which is designed with such unexpected and daring forms that it is as much sculpture as architecture. The idea came to Michelangelo, he claimed, in a dream. The tall, narrow space of the vestibule, or entrance way, is ornamented with blind (blocked-in) windows, or tabernacles, and columns are set into the walls like statues, although they serve an important load-bearing function.[13] The steps seem

to flow generously down from the reading room into the complicated, compressed space of the vestibule, with an intensity of purpose, like the thoughts in the mind of a reader about to ascend in the other direction and tackle the great works of philosophy, science and theology chained to the sloping desks in the far calmer, quieter architecture of the reading room above. It is as if Michelangelo is laying down a challenge to the scholar, proposing a life of action rather than one of contemplation. All of the elements, as with Brunelleschi's architecture, relate to the proportions of the human body, either mirroring them or giving the sense of a

giant, heroic being – such as the great marble *David* just a few minutes' walk away.

The human body seen as an object of knowledge, contemplation and admiration is the idea that draws together the work of these three great artists – geniuses, if you like: Leonardo, Raphael and Michelangelo. They worked in an age when overcoming technical difficulties was the greatest creative challenge: vaulting a high, wide space, for instance, and then covering it with powerful paintings of the human body, drawn with anatomical correctness. It was an age of technique, rather than style (their works can look rather similar), but above all one of the discovery of the human body, outside and in: Raphael was one of the first artists to draw from naked female models, and Leonardo had found beauty inside the human body, in the astonishing subject of the foetus growing in the womb. Not since antiquity had the female body been represented with such care and exactitude, and never before on the basis of such close and dispassionate observation.

Missing, however, were images made by women, not just of women's bodies but of any subject at all. For a woman it was hardly possible to become an artist – an account of forgotten women artists from the fifteenth and sixteenth centuries would be nothing like Pliny's extensive list of the lost works by women

SOME KIND OF GENIUS

from antiquity. One of the few exceptions was the sculptor Properzia de' Rossi, who worked in Bologna, away from the uniformly male creative environments of the cities and courts to the south, of Florence, Milan, Urbino, Naples and Rome. Her relief carving of the story of Joseph and Potiphar's wife shows quite a different view of the story from images made by male artists. The Egyptian official's wife (unnamed in the Bible, but known as Zulaykha in the Islamic tradition, as we have seen in the painting of the scene by the thirteenth-century Persian painter Bihzad) appears not to be attempting to seduce Joseph but rather to be pushing him summarily out of the bedroom.

Few works survive by de' Rossi, and those that do show her tenacity in pursuing her career as a sculptor, as her epitaph records:

> If Propertia had had the benefit as much of good fortune and the appointments of men, as of nature and skill, she who now lies overwhelmed with inglorious shadows, would, praiseworthily, have equalled the celebrated artificers in marble. Even so, with vivid talent and skill, what a woman can do is shown in the marbles sculpted by her hand.[14]

Rome in the early sixteenth century was impressively grand, reassuringly ancient and being ambitiously rebuilt. Yet it still lagged behind the largest and most spectacular cities on earth: Beijing, the capital of late Ming-dynasty China, and Constantinople, now named Istanbul, having fallen to the Ottoman Turks barely a hundred years earlier. Under the long reign of Sultan Süleyman in the middle years of the century the decorative images and architecture of the Ottoman empire reached a peak of achievement. The magnificent buildings designed by Süleyman's chief architect, Mimar Sinan, echoed the glory of his empire and his conquests, from Baghdad to Cairo, along the west coast of the Arabian peninsula and the north coast of Africa, as far west as Hungary.[15] The work of court calligraphers and painters, as well as the brilliant ceramics produced in Iznik, an important trading town to the south of Istanbul (in Byzantine times it had been known as Nicaea), with their distinctive coloured glazes, all reflected the luxury

Qibla wall, Süleymaniye mosque, by Mimar Sinan. 16th century. Photo c.1900.

and decorative splendour of the age. When Süleyman rode out to battle, it was said, he wore a diamond-studded turban.[16]

Mimar Sinan's mosque for the sultan Süleyman, begun in 1550 on a raised site overlooking the Golden Horn, was intended to rival Hagia Sophia, the church built by Justinian seven hundred years previously.[17] Süleyman's mosque housed the tomb of the sultan and his wife, Hürrem (known in the West as Roxelana). The vast surrounding complex of mosques, hospitals and colleges was completed in a remarkably short period of seven years. At the same time in Rome the building of the new church of St Peter's was dragging on, and the architect who had taken over from Bramante, Michelangelo, was complaining that he did not have the resources to complete the work.[18]

It was for Sinan's great mosque in Istanbul, as well as for a great mosque in Damascus and, in Jerusalem, the redecoration of the Dome of the Rock, that artisans in Iznik began producing square ceramic tiles, underglazed with brilliant colours. Earlier ceramics from the Iznik kilns had been inspired

Detail of a wall panel with ceramic tiles from Iznik. c.1560–90. From the tomb of Hurrem Sultan, known as Roxelana, in the complex of the Süleymaniye Mosque, Istanbul.

by the delicate blue-and-white forms of Chinese porcelain, decorating pots with plant forms, ingeniously following the shape of the vessel. The new flat tiles combined the freshness of Chinese ceramics with the tradition of glazed tiles from Persia. Their distinctive colours – a dark, cobalt blue, a bright red, an emerald green – as well as their floral designs, seen on a panel decorating Roxelana's tomb in the Süleymaniye complex, have a lightness and freshness otherwise unknown in ceramic decoration. The interior of another of Mimar Sinan's mosques, this one built for Rüstem Pasha, the grand vizier to Süleyman, is covered in tiles made in the Iznik kilns, precisely designed to cover the interior of the *mihrab* niche, the arches and the central

dome. At Edirne, to the west of Istanbul, the use of coloured Iznik tiles was brought to perfection in Mimar Sinan's Selimiye mosque. These buildings and their decorations came to define a look of Ottoman imagery that spread far and wide – an empire of colour.

Colour was life, but also wealth and ambition. For western Europe, especially the papal states of the Catholic Habsburgs, the Ottoman empire was a constant threat. Others sought alliances with this mighty power, when they were not obliged to wage war, for the purpose of trade – the Ottomans controlled the Levant, the only route east, and so a trading centre such as Venice had no choice but to co-operate with the sultan and his armies.[19] Where it had once appeared as the westernmost outpost of the Byzantine empire, after the fall of Constantinople Venice established a new relationship with the world of Islam – largely a matter of Venetian traders making the precarious journey to cities such as Alexandria, Cairo, Aleppo and Damascus, as well as Istanbul, and returning with exotic goods to sell in the Venetian markets. Trade brought exotic objects to the West, but also images – the image of the sultan himself, the great Süleyman, could be seen in prints and paintings. One Venetian artist showed the wily sultan with an enormous billowing turban, as if he were himself a work of architecture.

The artist who made this portrait (later lost and known only from a copy) painted a number of images of Süleyman, despite never having seen him (he used the image he found on the backs of coins). Tiziano Vecellio, or Titian, was the great Venetian painter of his age, working in a strong Venetian tradition: his early paintings are virtually indistinguishable from those of Giorgione, a sort of afterlife for his former rival. To this legacy Titian brought a feeling of fresh, boundless joy and colour that signals a new epoch in painting.[20] Unlike artists to the south, in Florence and Rome, Titian had no interest in being a 'universal man'. It probably never entered his head that he might design a building or carve a sculpture from marble or write a treatise on his work. Only one medium interested him, oil paint, and he spent his life proving that it was greater than sculpture, and that by contrast architecture was not even worth consideration.

Titian painted one of his most striking imaginings of ancient myths for Alfonso d'Este, the duke of Ferrara. Alfonso had set about commissioning paintings from leading artists to adorn a room in his palace known as the *camerino*, where he could escape from official duties – read, entertain visitors, look at pictures, sleep. The subject of the paintings, chosen by a scholar named Mario Equicola (the duke borrowed Mario from his more enlightened sister, Isabella d'Este, in Mantua, where he was a courtier), were the mythological

Sultan Süleyman II, attributed to Titian. *c.*1530. Oil on canvas, 99 cm by 85 cm. Kunsthistorisches Museum, Vienna.

pair of Bacchus and Venus, symbols of the more earthly quantities of wine and love.

Giovanni Bellini's *Feast of the Gods* was the first painting to be commissioned. Raphael was invited to contribute and submitted a drawing of the *Triumph of Bacchus*, but he died before he could complete the painting. The Florentine painter Fra Bartolomeo submitted a drawing of *The Worship of Venus*, but he too died shortly after. In some desperation the duke turned to Titian, who was not known for such subjects, to complete Fra Bartolomeo's painting. Completely disregarding Bartolomeo's rather polite drawing of Venus standing on an altar being worshipped by a handful of admirers, Titian instead filled his canvas with a throng of hyperactive *putti*, male and female infants, gathering apples according to the classical source used for the paintings, the book *Imagines*, by the Greek author Philostratus, describing a lost series of paintings that had decorated a villa near Naples in the first century CE.[21]

Evidently pleased with Titian's painting, the duke commissioned two more. The third, showing the story of *Bacchus and Ariadne*, was the most impressive, exceeding even Bellini's *Feast of the Gods* (which Titian had repainted, a little, to make it fit in with the overall mood of the room). The duke must have realised that he had been fortunate enough to commission one of the greatest paintings of his time.

It is an image of fearful abandonment and forced abduction. Ariadne has been abandoned on the strange island of Naxos by her lover Theseus, after sailing from Crete, where Theseus had slain the Minotaur and escaped from the labyrinth thanks to Ariadne's ingenuity. Titian drew his story from the descriptions in Greek and Roman literature. In Ovid's *Ars amatoria* Ariadne awakes after wandering distractedly on the shore, 'clad in ungirt tunic, barefoot, with yellow hair unbound', defenceless against Bacchus, who pursues her from his chariot,

Bacchus and Ariadne, by Titian. 1520–1523. Oil on canvas, 176.5 cm by 191 cm. National Gallery, London.

SOME KIND OF GENIUS

pulled by tigers (Titian turns them into cheetahs), and with his noisy drunken retinue, leaping from his chariot 'and clasping her to his bosom (for she had no strength to fight), he bore her away, easy is it for a god to be all-powerful'.[22] In another description, by the poet Catullus, one of Bacchus' retinue is described as girded, by choice, with 'writhing serpents', while others 'beat timbrels with uplifted hands, or raised clear clashings with cymbals of rounded bronze: many blew horns with harsh-sounding drone, and the barbarian pipe shrilled with dreadful din'.[23] Titian transforms the noise into a whirl of coloured fabrics: the blue of Ariadne's robe, girdled with a red sash, a lure to Bacchus leaping from the chariot, the swag of wine-red silken sheet billowing around him a splash of colour against the radiant evening sky. On a pile of yellow silk beneath Ariadne's feet a bronze vase is inscribed with the artist's name. Titian has awarded himself first prize for painting.

The energy of Titian's painting, like an ecstatic dance, comes from the transformation of poetry into colour. Painting, as Philostratus had written, was a matter of 'imitation by the use of colours', and with colour more could be achieved than with any other technique.[24] His early paintings, such as the *Bacchus and Ariadne*, were made with a strength and clarity of colour that recall the decorative brilliance of Venetian glass, the production of which reached a peak of splendour in the sixteenth century, and also, more distantly, the images of the Islamic world, from the Persian paintings of Bihzad to the mosque tiles of Iznik. Titian's paintings took their place in this new Venetian empire of trade and colour, part of a much wider world, reflected in the forms of Islamic architecture that appeared on the palaces that lined the Grand Canal.[25]

Paolo Caliari, known as Veronese (thanks to being born and raised in Verona), was the second of the great Venetian colourists of the sixteenth century.

Like those Florentine artists who were united by common technical challenges, rather than being distinguished by style, Veronese's paintings appear similar to those of Titian – they were created in a resolutely Venetian manner. Christ springs from the tomb with joyful spontaneity in Veronese's image of the Resurrection. The Roman soldiers are so surprised that one begins to draw his sword, the other lifts up his shield to protect himself from this sudden apparition of colour. Like Titian's *Bacchus*, painted fifty years earlier, Christ wears a wine-red robe attached across his neck that gathers around his lower body as he ascends, arms outspread. Bacchus leaping

The Resurrection of Christ, by Paolo Veronese. c.1570. Oil on canvas, 136 cm by 104 cm. Gemäldegalerie, Dresden.

from his chariot becomes Christ leaping from his tomb. The Roman soldier in the foreground of Veronese's scene echoes the figure of Ariadne painted by Titian, wrapped in ultramarine as a counterpart to Christ's red. In the background, the Virgin and Mary Magdalene look disconsolately at the empty tomb – Veronese has combined two moments in time. An angel kneels on the tomb above the two Marys, explaining what has happened, his wings like the forlorn distant sails of Theseus' ship in Titian's painting. The similarity need not mean that Veronese took his composition from Titian; rather, this was Venetian-type painting, largely unchanged for half a century.

Titian and Veronese were renowned for their great technique, not relying on preparatory drawings but rather attacking the canvas directly with coloured pigment, creating a sense of depth and atmosphere. Jacopo Robusti, known as Tintoretto (the name means 'little dyer' and refers to his father's occupation as a clothes dyer in Venice), the third of the great Venetian colourists of the sixteenth century, was different; he was known more for his personal style than his brilliant technique. He painted with swiftness and extravagance, and often seemed to leave his paintings unfinished. Such a state of affairs was too much for many patrons, and Tintoretto never achieved the same level of success in his lifetime as Titian or Veronese, despite the spontaneity and strange poetry of his canvases. They often seem closer to Michelangelo's *terribilità*, or emotional intensity, approaching the realms of dreamlike vision, where colour is no longer that of nature, or of decoration, but rather that of the images we see when we screw our eyes tightly shut and let the visions come from within.

Titian, Veronese, Tintoretto: this was the great trio of sixteenth-century Venetian colourists, the equivalent of Leonardo, Raphael and Michelangelo, exercising their trade further to the south. Just like those in Florence, the Venetian workshops were large, with many assistants working on paintings simultaneously. Veronese employed his brother Benedetto, among others, and Tintoretto trained his daughter Marietta to become a painter. The technique of oil painting was firmly established and changed little over the decades, reflecting also the stability of the Venetian republic during the middle years of the century, growing ever richer from trade with the east. Venice itself had become an object of intense admiration, endlessly described by writers and painted by artists as a city floating in the rippling and sparkling sea, an apparition bringing to mind the heavenly city of Jerusalem. For the Muslim traders who arrived on

St Mark's body brought to Venice, by Jacopo Tintoretto. 1562–1566. Oil on canvas, 398 cm by 315 cm. Gallerie dell'Accademia, Venice.

ships full of fragrant spices, silk and velvet and precious objects, it was an earthly paradise quite unlike anything they had seen before.

The image of Venice had been shaped over the centuries by generations of architects and builders. Jacopo Sansovino was the leading architect (and also a sculptor of great talent) in the early years of the sixteenth century, and through his design for the Biblioteca Marciana (Library of St Mark) introduced a new type of building to Venice, restrained and rectilinear, contrasting with the Byzantine and Islamic arches, curves and elaborately ornate façades that dominated the grand palaces lining the canals.

The greatest shaper of all, however, was Sansovino's successor, Andrea Palladio. He was born Andrea di Pietro della Gondola, but given the classical-sounding name Palladio in his thirties by one of his patrons, a count who lived on the outskirts of Vicenza. It was a fortunate name-change. Gondola would have been too ridiculous for an architect who redefined the look of Venice, a city that he described in his great treatise on architecture, *I quattro libri dell'architettura*, published in 1570, as the 'sole remaining exemplar of the grandeur and magnificence of the Romans' – not entirely accurate, but at the time the highest praise that one could bestow.[26]

Palladio modelled his designs for villas on Alberti's writings on architecture and on Vitruvius before him, both of whom drew on a Greek ideal of perfectly balanced architectural forms set in close relation to the natural surroundings. To these ideas Palladio added his own sense of elegance and delight in the variety of shapes and configurations that could be used to create a building, so that architecture became in part like sculpture. This was true of the villas he built in the countryside to the north, such as the one he designed for the Barbaro brothers at Maser, in the countryside north of Venice – a bright, open building, decorated on the upper level with frescoes by Veronese, showing scenes of mythology and easeful country life to reflect the aristocratic habits of the gentlemen–farmer owners.[27]

It was true also of his designs in Venice, which for the most part were for religious buildings. One of his grandest commissions was the church of

Il Redentore, by Andrea Palladio, Isola della Giudecca, Venice. 1577–1592.

Il Redentore, built by the Venetian state after the departure of the plague from the city. Palladio's most visible innovations in his religious architecture were the façades he invented, that of Il Redentore being the most spectacular. The shape of the classic temple front, with columns and pediments, is repeated as a flattened relief, the various parts sandwiched to an imaginary flatness, as if cross-sections of the architectural spaces inside the church had been combined to provide an overall picture of the building, a picture that shows the difference in height and shape between the lofty central nave and lower side aisles.

Palladio was inspired for the double pediment (the shallow triangular shapes above the main door) by the Pantheon in Rome, where one pediment rests over the portico and another projects from the rotunda of the main building.[28] He takes this repetition much further, creating a series of shapes both memorable and peculiar. The effect is of a complex sequence of forms that can still be understood in a single glance. Ornament is reduced to a minimum, leaving only a configuration of shapes and lines rising up from the water's edge, solid and resolute, yet also as transparent and luminescent as the surrounding light and water. Palladio's façades could not be further from the colour and drama of Venetian painting, forming instead the perfect counterpart: they show a pure, uncoloured style of architecture, using the basic elements of the medium, just as the work of Titian, Veronese and Tintoretto is reduced to the basic elements of painting.

Palladio was at least in part indebted to Michelangelo, to the expressive, fantastical sculptural forms used to great effect in the Laurentian Library. Michelangelo's imagination soars over the age as an unwavering source of energy and inspiration, and also of rivalry. In 1554 one of the great technical achievements in bronze-casting of the age (and indeed of any age) was unveiled just a few steps away from Michelangelo's marble *David*, on the Loggia de Lanzi, a raised arched platform next to Florence's Palazzo Vecchio.

A bronze figure of Perseus holds up the head of the gorgon Medusa, her lifeless body slumped at his feet, a scene from legend recorded by the Roman poet Ovid in his *Metamorphoses*. The creator, Benvenuto Cellini, knew that he could not outdo Michelangelo in marble or Donatello in bronze, but he thought he might rival them through the sheer technical audacity of casting such a bronze figure in one piece. Above all, he knew that whatever he did would be better than the work of Baccio Bandinelli, the sculptor most favoured by his patron, Cosimo I, for the proudly stated reason that he, Benvenuto, drew directly from life, whereas Baccio borrowed his forms from antique statues.

Cellini's account of the creation of the *Perseus and Medusa* in his autobiography is one of the most exciting descriptions of creativity and creation ever written by an artist. The mould for the figure of Perseus holding Medusa's head having been made, Benvenuto and his assistants got to work

Perseus with the head of Medusa, by Benvenuto Cellini. 1545–1554. Bronze. Loggia dei Lanzi, Florence.

SOME KIND OF GENIUS

melting the pieces (known as 'pigs') of copper and bronze to pour in. Outside a gale was blowing, 'chill gusts' coming into the workshop and threatening to cool the furnace. The effort in keeping the first burning was such that Benvenuto took ill, convinced that he was going to die. Yet when an assistant came to tell him that the bronze was failing, he leaped from his bed and rushed back to the workshop, taking control of the fire and ordering an ingot of pewter – tin – to be thrown in, helping the bronze to liquefy, but not before, in 'a brilliant flash of fire, just as if a thunderbolt had rushed into being in our very midst', the top of the furnace was blown open and the bronze began to run over. Benvenuto ordered some of his men to open the stops to the mould, so that the metal ran into it, and others to run out to fetch 'every pewter dish and porringer and plate' in his house to throw into the molten metal, tin helping the flow of the bronze into the complicated mould. 'In an instant my mould filled up; and I knelt down and thanked God with all my heart; then turned to a plate of salad lying on a bench there, and with splendid appetite ate and drank, and all my gang of men with me.'[29] When the cast was uncovered, Benvenuto found that every part of the mould had been filled by the molten metal, save the ends of Perseus' toes.

The statue, when it was finally installed, was universally admired – even Baccio Bandinelli conceded its greatness. In the tale told by Ovid, Perseus slays the gorgon Medusa, using the reflection in his shield to avoid her petrifying stare, before rescuing the Ethiopian princess Andromeda from a sea monster. In Cellini's statue shreds of life still shiver through the body of Medusa, her gaze dropping as she sighs her last breath. Her headless body is coiled around Perseus' feet, one hand still holding her foot, as if in desperate self-protection, the other dangling lifelessly down. Cellini used Dorotea di Giovanni, his young mistress and later the mother of his son, as a model. But the hero's head is idealised, inspired more by the sculpted heads of Michelangelo, as is the fantastical helmet he wears.[30]

Cellini, as he wrote in his autobiography, astonished everyone with the technical success of casting such a large, complex work in bronze, especially Cosimo I, the duke of Florence, who had commissioned it. The statue stood in the Loggia as an assertion of the duke's power. At the other end of the stage-like setting was Donatello's bronze group of *Judith* beheading Holofernes, the first sculpture to appear on the Loggia, positioned there in 1495, almost three decades after Donatello's death, as a symbol of the spirited citizens of the Florentine republic. Cellini's *Perseus*, however, was a symbol of changed times, and of the autocratic and supposedly heroic rule of the duke.[31] Soon after, Donatello's bronze Judith was replaced by

Abduction of the Sabine Women, by Giambologna. 1581–1582. Marble, h. approx. 410 cm. Loggia dei Lanzi, Florence.

another sculpture and moved to the back of the Loggia. Later on it was removed entirely.

The sculpture that replaced it shows three naked figures in a violent struggle. A young muscular man lifts a woman, gesturing in surprise, high from the ground, while an older male, strangely positioned between the other man's legs, looks up pathetically in defence. It was carved as an exercise in formal composition without any one subject in mind, so claimed the artist, the Flemish sculptor Jean de Boulogne, known as Giambologna.[32] Like Cellini's *Perseus*, Giambologna's three figures were a technical feat: they are carved from a single block of marble, although smaller than the one Michelangelo used for his *David* near by. Giambologna shows three figures twisting upwards, flamelike, as if to defy gravity and the sheer weight of the material from which the sculpture is carved. The subject was suggested only when the work was nearing completion: the story of Romulus and the founders of Rome seeking wives from surrounding tribes. When the Sabines refused to give up their women, the Romans staged a festival, at which they suddenly seized the women and carried them off back to Rome. On the Loggia dei Lanzi it stood as a complement, rather than a counter, to Cellini's brutal *Perseus*, and a symbol of male autocratic rule – in Giambologna's time that of Francesco I, the successor to Cosimo as grand duke of Tuscany.

The Loggia dei Lanzi was a public stage, and the works of art placed on it showed the very latest discoveries in dramatic, energetic sculpture. By Giambologna's time, however, the great period of technical discovery, reaching back through Leonardo, to Brunelleschi, and Giotto before him, was coming to an end. The world, it seemed, had been conquered, and the image of human life taken as far as it could go.

And yet a new world was already rising. Different voices were becoming heard, even if only as faint prophecies. As the sculpture of Properzia de' Rossi shows, it was increasingly possible for women to become artists, many of them the daughters of painters. Lavinia Fontana was a Bolognese painter – trained by her father, Prospero – who became celebrated for her portraits, and was to move to Rome where she worked on a public commission, creating a large altarpiece for the church of San Paolo fuori le Mura, a *Martyrdom of St Stephen* (it was later destroyed by fire). Fede Galizia, a painter from Milan, was also known for her portraits and public commissions from churches in her home town, but is best known for tackling the relatively new genre of still-life painting, spotlit images of peaches, grapes and cherries posed dramatically against darkened backgrounds. Barbara Longhi, a painter from Ravenna, assisted her father in his workshop, alongside her brother, and made religious paintings, including a self-portrait as St Catherine, in which she poses with the spiked wheel of the saint's martyrdom, looking out with a penetrating gaze.

Sofonisba Anguissola was one of six sisters born into a noble family in Cremona in the middle years of the sixteenth century, all of whom attained distinction as painters.[33] Anguissola's portraits, and the images she made of herself, show glimpses of a way of seeing the world that contrasts with the dominant male vision. There is no record of her visiting Florence, but she surely would have registered such a vision in the sculptures proudly displayed on the Loggia dei Lanzi: male swagger, rape and femicide. She spent time in Rome and was praised, and possibly tutored by Michelangelo, but had none of the

Sketchbook leaf, including a drawing of Sofonisba Anguissola, by Anthony van Dyck. 1624. Ink on paper, 19.9 cm by 15.8 cm. British Museum, London.

opportunities of a male artist in working directly from life, or producing large figure compositions outside the family circle. Yet this restriction allowed a greater concentration on the representation of psychological states, so that Anguissola's paintings have a depth of humanity often lacking from those of male artists. She painted three of her sisters – Lucia, Minerva and Europa – playing chess: Europa is laughing with delight at Minerva's reaction to the move Lucia has just made.

Anguissola was successful as a painter in the court of Phillip II, in Madrid, before moving as a result of marriage first to Sicily and finally to Genoa. In the summer of 1624 she was visited by a young artist from the north, who drew a portrait of her in his sketchbook.

Anthony van Dyck noted that, when he met her, Anguissola was ninety-six years old, but still talking with enthusiasm about painting. Perhaps she talked about her earlier self-portraits, and her boldness and delight in painting such images, which must have inspired other women to paint, not least her five sisters. The porcelain delicacy of her skin in one of these portraits, made in her early thirties while she was at the Spanish court, and the fineness of her costume recall Leonardo's portrait of Cecilia Gallerani, painted seventy years before, but the intentness of the open look Anguissola casts upon herself as an artist, and on those who look at her portrait, would hardly have been possible a hundred years earlier.

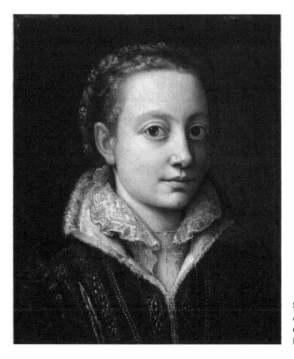

Self-portrait, by Sofonisba Anguissola. c.1561. Oil on canvas, 36 cm by 29 cm. Pinacoteca di Brera, Milan.

20

Shadows and Power

As Sofonisba Anguissola was living out her long life in Genoa, in the years around 1620, another painter was beginning her career further south, in Rome. She was making works that Anguissola could have only looked at with astonishment. One of these ranks among the most bloody and violent images ever painted. The scene is horrific: a bearded man wakes from a drunken stupor to find himself pinned down to his bed, the cold, sharp blade of a sword sawing through his bare neck. His pale arms raised in a pathetic gesture of defence, he struggles in agony as dark blood spurts from his wound, soaking the white sheets.

His assailants, a Jewish widow named Judith and her servant Abra, set about their task with grim determination. Their victim is the Assyrian general Holofernes, who was laying siege to their city of Bethulia, a story told in the book of Judith in the Hebrew Bible. Judith had gained access to his tent having been invited by the general, who wanted to seduce her: instead, she murdered him.

The artist, Artemisia Gentileschi, went far beyond other versions of the story, certainly further than Donatello, whose version in bronze stood in the Loggia dei Lanzi in Florence. Compared with Gentileschi's version, Donatello's Judith looks more as though she is cutting the sleeping general's hair. Rarely had such violence, such visceral gore, been seen in painting.

Gentileschi had been trained by her father, Orazio, also a painter. Her earliest works naturally show the imprint of her father's style, although his own version of the Judith and Holofernes tale was also genteel by comparison, with not a trace of blood. Hovering over all painting in Rome was the heroic, bloodless ideal that Michelangelo had woven like a spell over painting, sculpture and architecture, and which still set the tone over fifty years after his death.

Michelangelo's influence was soon eclipsed by an entirely different mood, one that appears for the first time in Gentileschi's painting of Judith. The source of this mood was the work produced by a painter from the north, from Lombardy, who had arrived in Rome in the 1590s, shortly before Artemisia was born, and who worked occasionally with her father.[1] Gentileschi would have marvelled at the two paintings by the Lombard artist in her local church, Santa Maria del Popolo, showing the conversion of St Paul and the crucifixion of St Peter. How such violence and drama, such stark contrasts of light and dark, and such lifelike portrayals of the human body, strained and suffering, differed from the high, heroic ideals of Michelangelo. Here were real people.[2]

In later life Gentileschi may have remembered the artist, her father's colleague, as a dramatic and dangerous figure who fled Rome when she was thirteen years old. She would have been impressed by his habit of painting directly from posed models, an approach he shared with the older, Bolognese artist Annibale Carracci, who arrived in Rome in 1595. Carracci, along with his brother Agostino and cousin Ludovico, had pioneered painting directly from life, and

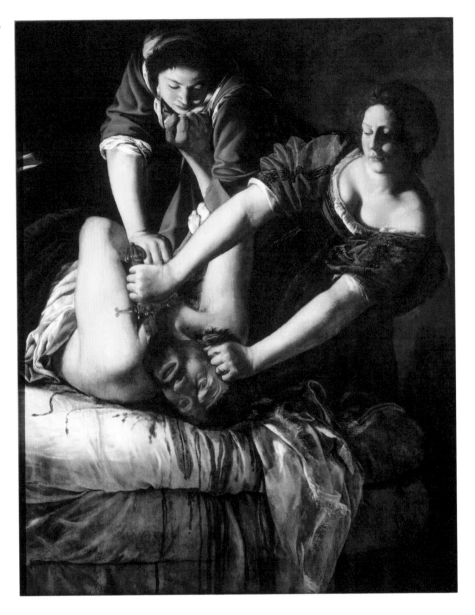

Judith Beheading Holofernes, by Artemisia Gentileschi. c.1613–14. Oil on canvas, 158.5 cm by 125.5 cm. Museo di Capodimonte, Naples.

was the most sought-after artist of the moment. And yet although Carracci chose subjects that seem to some shockingly ordinary, vulgar even, such as Annibale's painting of a butcher's shop, made a few years before he travelled to Rome, they were soon upstaged by an artist whose name became synonymous with a style, a mood of painting, shadowy and dangerous, dramatic and brilliant: Michelangelo Merisi da Caravaggio.

Caravaggio created the look of his paintings not with the soft *sfumato* of Leonardo's painting (the 'smokiness' of his later paintings, such as the second version of his painting known as the *Virgin of the Rocks*, painted with a soft, warm blur of forms), or the luminous lines of Michelangelo but with a dramatic clash of dark and light. It was a style that came to define the age. From the shadows welling in his backgrounds emerged the new power of the Catholic Church, after the

policies formulated at Trent in the middle years of the sixteenth century. The power of images was reasserted as part of Christian worship after the iconoclasm of the Protestant Reformation. The Counter-Reformation, as it became known, was a return to an older idea of religious authority in society, a direct and often violent assertion of power (the tortures of the Inquisition) and an approach to images based on emotional persuasion and an appeal directly to the heart, rather than on intellectual inquiry.[3] Gone was the spirit of knowledge and experiment of the age of Leonardo. The role of images was now to persuade, cajole, seduce and overpower. The light of knowledge was obscured by the shadows of Church ritual, of mystery and magic.

For Caravaggio the shadows were also those of a darkened corner of a cold chapel, or an alleyway around the Piazza San Luigi in Rome, where he lived and worked. He took his models, and the atmosphere of his paintings, directly from the streets: the nature he paints is devoid of the classical ideals that had held sway for so long, now replaced by dirt, sweat, furrowed brows, faces in shadow, fear and violence. Huddled in a corner are a group of figures – two men are pushed together by armed soldiers, while another, open-mouthed in fear, flees the scene to the left. It might be a fight at a tavern, soldiers called in to disperse and arrest the rowdy revellers, if it weren't for the intense emotion on the faces of the three men to the left. Caravaggio captures the moment when Christ is arrested in a garden in Jerusalem after Judas betrays him with a kiss – it is St John who flees to the left, shouting, his head strangely, disturbingly conjoined with that of Christ.[4] We are witnessing a moral collision: an act of betrayal, shored up by the power of an empire, Rome, yet countered by a far greater power, human dignity, expressed by the downcast features and interlaced hands of Christ, accepting his fate with equanimity.

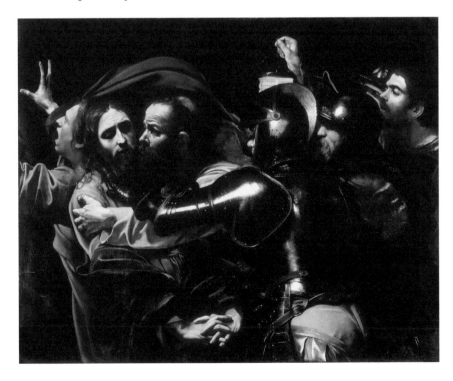

The *Taking of Christ*, by Caravaggio. 1602. Oil on canvas, 133.5 cm by 169.5 cm. National Gallery of Ireland.

In paintings such as *The Taking of Christ*, Caravaggio took Titian's bravura brushwork and Leonardo's famous *chiaroscuro* technique and transformed them into dramas shot through with the renewed power of the Catholic Church and the stories of the lives of the saints that it trumpeted; even if Caravaggio's sunburned figures with dirty feet did not always go down well with Church people. Where Michelangelo had observed a strict hierarchy of subject matter, for Caravaggio a flower could be as fascinating as the life of a saint, especially if it was dying. He looked at the world with the intensity and scepticism of a scientist, rather than as a painter seeking an ideal.

He was not out of keeping with his time. A generation of scientists was intent on dissolving older superstitions, particularly those about the make-up of the cosmos. Astronomers from Copernicus to Galileo Galilei (whom Artemisia Gentileschi knew) had come to the extraordinary conclusion that humans were no longer at the centre of the universe. Those ancients that had worshipped the sun, the Aztecs, the Mithraists, the Egyptians of the Amarna period, were intuitively right, it turned out. The solar disc does indeed stand at the centre of human life with godlike power.

This revolution in thought was accompanied by a new confidence in the power of direct observation. In 1611 Galileo gave the first demonstration of a new device, called a telescope, with which he attempted to prove Copernicus's theory that the sun, rather than the earth, is the centre of our solar system, a view he was later forced to recant. Those ancient texts that had placed man at the centre of everything were no longer the prime source of knowledge. Pliny's *Natural History* had for centuries been taken as the greatest authority on most things. Not any more. Many magical beliefs about the world fell away in science as they did in painting. For all the resurgent might of the Catholic Church, it was clear that the power of images derived not from some magical energy, or secret, lodged in the work, like the toenail of a saint energising a reliquary. It came, rather, from the individual style of an artist, and their ability to create convincing equivalents for the visual world in oil paint.

By the middle years of the seventeenth century oil paint was established in Europe and further afield, reaching as far as Peru, after the Spanish conquest in 1532 by Francisco Pizarro and the subsequent destruction of the ancient Inka culture. Spanish and Italian missionary painters voyaged to the Spanish colony, notably the Jesuit painter Bernardo Bitti, who died in Lima in 1610, bringing their oil paints and influential manuals such as Francisco Pacheco's *Arte de la pintura*, with a practical section on oil painting, published in Seville in 1649.

The ancient Inka capital of Cuzco was the home of a Peruvian school of painting, devoted largely to religious subjects painted by Spanish, Creole and Peruvian painters. Like other artists, the Peruvian painter Diego Quispe Tito, a Quechua descended from a noble Inkan family, often took his composition from Flemish engravings, adding a sense of colour influenced by Bernardo Bitti, so that it seems as if Bruegelian compositions are rendered with a mood closer to that of Caravaggio. With this individualistic style Quispe Tito was the leading light of the

Cuzco school, which flourished for some two hundred years, sealing his renown with twelve paintings showing the signs of the zodiac, each telling a Christian parable, hung in Cuzco Cathedral.

The career of Diego Quispe Tito in the Peruvian Andes proved that it was possible to achieve fame and long-lasting influence on the basis of style alone – rather than needing to be a great inventor of technique. The same was true for artists in Europe. From his workshop in the Flemish town of Antwerp, Peter Paul Rubens created a style of painting that seems to transform oil paint into real flesh and blood. It was a style forged during his journey south during his twenties, to Italy, where he lived and worked at the Gonzaga court in Mantua. Titian's *Bacchus and Ariadne* is one of the many paintings that he studied there. Like Quispe Tito, but with far greater resources at his disposal, he copied older art obsessively, from old Flemish paintings to the work of Michelangelo.

The paintings he made on his return to Antwerp were a crucible of the painting he had encountered in the south: the Venetian love of luxury and excess; the luminous classicism of Raphael; the gritty, closely observed realism of Annibale Carracci; and the dramatic lights and darks of Caravaggio. His mind was also full of the sculptures he had seen, the heavy sensual marble bodies from antiquity.

It was a heady combination, and the recipe for a grand style. Rubens created vast canvases that filled the galleries and chambers of the courts of Europe, of Philip IV in Madrid and Charles I in London. On the altars of the resurgent Catholic Church his paintings symbolised the ambition and reach of the post-Reformation papacy. For the ceiling of the Jesuit church in Antwerp he painted forty large panels showing scenes from the Old and New Testaments which, although in format they might have been seen to rival Michelangelo's Sistine ceiling, were far closer in style to the vigour and colour of Titian, Tintoretto and Veronese. The ceiling was later destroyed by fire, but it led to commissions that were to survive, such as the cycle of twenty-four paintings commissioned by Marie de' Medici, the queen of France, to be hung in the Palais du Luxembourg in Paris, relating the events of her life and justifying her reign, after the death of her husband, Henry IV, and a period of exile.

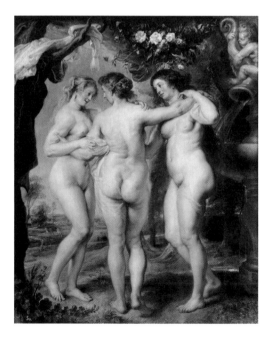

Rubens's style of painting spread across Europe, uncontained by any sense of being tied to any one kingdom or state. It was a borderless style, a pan-European 'look' of painting.

Beyond these images of power were images of the body. Looking through the vast corpus of Rubens's work – paintings, oil

The Three Graces, by Peter Paul Rubens. c.1630–35. Oil on oak panel, 220.5 cm by 182 cm. Museo del Prado, Madrid.

sketches, drawings – it is clear that the subject closest to his heart was the joyful abundance of the unclothed female body.[5] In his naked bodies, just as in his landscape paintings, Rubens captures a poetic spirit that leads back through Titian to the elegiac mode of Giorgione. Where Caravaggio and his followers were attempting to capture the world through direct observation, Rubens's paintings are more a matter of artifice, creating an atmosphere that is at once grand and diffuse.[6] Human bodies are defined not by detailed understanding of anatomy or measurement, as they were in the painting of Leonardo and Michelangelo, but by a deep feeling of what it is to have a body, to be heavy, solid and rounded, and to experience bodily pain and desire.

Rubens turned these bodies over, admiring them from different angles, measuring and weighing their flesh in the scales of his palette. His *Three Graces* stand in a closed ring, their bodies echoing antique statues, their faces and gestures distinguishing them as individuals, enjoying and exploring each other with the sense of touch, holding, pinching, caressing. Their hands, as so often in Rubens's paintings, are symbols of the tactile sense, and of expressive gesture.[7] They have hung their robes in a nearby tree, keeping them off the ground, and conveniently close at hand, for this is a believable landscape, one that Rubens modelled on his native Flanders, and they are naked, apart from the pearls in their elaborately dressed hair and a transparent diaphanous length of material that has no other role than to wind around their bodies, high between the legs of the woman at the centre.

Rubens painted his *Three Graces* at the beginning of the 1630s, by which time he was in his fifties, rich and famous, and had begun a family with his second wife, Hélène Fourment. Rubens painted Fourment in numerous guises, for the most part wearing no clothes – she posed self-consciously for the figure on the left in *The Three Graces*, her youthful head (she was sixteen when she married Peter Paul) attached, rather awkwardly, to a seemingly more mature body. The golden glow of her skin, the softness of the meadow grass on which she and her companions pose, the bower heavy with roses, the bold gushing fountain and the distant prospect, with all the manicured perfection of a private estate, complete with stags grazing peacefully by a babbling brook, are images of full-blooded plenty, of abundance and ease, of effortless dominion warmed by the breath of summer air.

From Rubens's Antwerp workshop emerged not only large amounts of paintings but also artists schooled in the Rubens style. One of the ablest of these was Anthony van Dyck, also a native of Flanders, who worked under Rubens for a few years before embarking on his own career, largely as a painter of portraits, exercising his trade in London as court painter to Charles I and his wife, Henrietta Maria, the daughter of Marie de' Medici and Henry IV of France. He learned his trade in Rubens's studio but was less concerned with naked flesh than with grandeur, with the spiritual and poetic force of Titian's painting and, above all, with portraiture and capturing a living likeness.[8]

Such skill was not just impressive; it was also very useful as a source of practical knowledge. One of Van Dyck's most striking commissions was to paint a bust-length portrait of Charles I, showing the king from three different angles, each view wearing a lace collar and the shiny blue ribbon of the order of the garter. The painting was sent to the sculptor Gianlorenzo Bernini in Rome, to serve as a model for the great sculptor to carve a portrait of the king in marble. Van Dyck

drew his curious composition, including all three views of Charles on the same canvas, from a painting in the royal collection, thought to be by Titian (in fact it was probably by the Venetian painter Lorenzo Lotto), *Portrait of a Goldsmith in Three Positions*. A few years after the portrait arrived in Rome, Bernini's bust arrived in London, testament to the skill of both sculptor and painter. It was destroyed in a fire at Whitehall some years later, leaving only the painting, as an indication of how the sculpture may have appeared.

Some years before Van Dyck's commission, Rubens travelled to London to negotiate a peace treaty between England and Spain, commemorating his visit in a painting on the subject of *Peace and War*. During his stay he was commissioned by Charles I to make paintings for the ceiling of a new building

attached to Whitehall Palace, the Banqueting House, designed by Inigo Jones in a Palladian style, and the setting for the king's execution just over a decade after the paintings were installed. Rubens's paintings were a celebration of Charles's father, King James I, who had shown very little interest in painting during his reign.[9]

Charles I, by contrast, was one of the great collectors of the time. He amassed a huge number of paintings to be hung at his palace in Whitehall. He acquired his taste for pictures while travelling to Madrid in his early twenties to negotiate a marriage to the sister of the king of Spain. Instead of a wife, Charles came back with canvases by Veronese, Titian and others, and sculptures by the likes of Giambologna. He also learned about commissioning, having his portrait done by the court painter Diego Velázquez. Many of his paintings, as well as antique sculptures, came from the collection created by the duke of Gonzaga in Mantua, most famously Andrea Mantegna's nine-part painting of the *Triumphs of Caesar* – sold off to pay the duchy's debts. In 1649 the nine paintings were up for sale again, part of the auction of the collection of Charles I following his trial and execution by the English Parliamentarians, led by Oliver Cromwell.

Collecting was not just a matter of exercising wealth and power – or at least not always. It could also be a means to knowledge, a way of recording, analysing and understanding the natural world and human history. In his *Museo Cartaceo*, or 'Paper Museum', the Italian scholar Cassiano dal Pozzo did just that. Aside from his official duties as secretary to a cardinal, Francesco Barberini, Cassiano was devoted to the study of ancient Greece and Rome, and to understanding the

Charles I (1600–1649) in three positions, by Anthony Van Dyck. c.1635. Oil on canvas, 84.4 cm by 99.4 cm. Royal Collection Trust.

Specimens of coral, figured stones, minerals and fossils, attributed to Vincenzo Leonardi. c.1630–40. Watercolour and bodycolour over chalk on paper, 39.4 cm by 25.5 cm. Royal Collection Trust.

ancient literature and archaeology that were still being rediscovered all around.[10] He was obsessed by the idea that knowledge could be encapsulated best in the form of an image, and so, with his brother Carlo Antonio, set about commissioning well-known and minor artists alike to make drawings of Greek and Roman antiquities as well as diverse images of the natural world.[11] Such an encyclopaedic scope made his 'museum' the visual equivalent to Pliny's *Natural History*, with the added value of being the world viewed through the eyes of artists.

One artist to make drawings and watercolours for this vast project was a young painter from France by the name of Nicolas Poussin. He met Cassiano shortly after arriving in Rome in 1624: it was in Cassiano's house, Poussin said, that he received his real training.[12] Rather than Rubens-size altarpieces produced in a busy workshop, Poussin made small paintings, alone, inspired by the conversations around Greek and Roman mythology and the stories that were being recovered, translated and discussed in circles such as those of Cassiano dal Pozzo. For Cassiano he painted a series of the *Seven Sacraments*, recording the gravity and mystery of Catholic ritual, from baptism to extreme unction; the paintings were hung in Cassiano's palazzo in Rome, along with some fifty other paintings by Poussin.

It was when he was wandering around in the countryside around Rome, the landscape strewn with ruins, or otherwise untouched since the earliest days of the Roman republic, that the tales of antiquity came alive in Poussin's mind. With his brother-in-law, Gaspard Dughet, and the painter Claude Lorrain he wandered around the Campagna, sketchbook in hand. He saw the landscape through the lens of literature – everywhere was a setting for a story, a place of myth.

Poussin's paintings were not, however, direct records of nature. He pondered his compositions endlessly, placing small wax models in boxes with stage scenery as a way of getting a coherent sense of light. Although the result may appear artificial, it is never, or at least very seldom, stilted and lifeless, but rather a perfect balance of poetic subject matter and pictorial composition.

In one such composition four figures dance in a ring to music played by an old man on a lyre. They are led by the figure of Bacchus, shown in shadowy profile, his head circled with a dry wreath, representing autumn, the time of harvest.[13] His right hand holds that of Winter, her shoulders and breasts coolly bared, her head wrapped in a light yellow cloth. Summer wears a white dress and golden sandals that seem to levitate on the ground, while Spring wears a garland of roses, and looks out of the painting with a disarming glance, seeming to ask a question of the onlooker – will you join the dance? The question seems coyly rhetorical, for she knows that we are already part of it – nobody can escape the

A Dance to the Music of Time, by Nicolas Poussin. *c*.1634–6. Oil on canvas, 82.5 cm by 104 cm. Wallace Collection, London.

rhythms played by the naked winged figure of Saturn on his lyre, measuring out time itself. He sits beneath an empty plinth, while two little boys, *putti*, or angels, blow bubbles and hold a draining hourglass, echoing Saturn's melody. Bacchus appears again as a double-faced herm, old and young, with flower garlands. In the sky above, the god Apollo stands magnificently on a golden chariot, led by Aurora, distributing sparkling gold, a symbol of the breaking of dawn light, while around him are the Hours, the goddesses of the seasons. Thus are evoked the timeless cycles of nature and the benevolence of the gods, sending Bacchus and his endless supply of wine to alleviate the emptiness of human life.

 Poussin made his painting, later given the title *A Dance to the Music of Time*, for a cardinal, Giulio Rospigliosi, who proudly hung it in his palazzo. As Poussin was working, Rome itself was being reshaped, fountains, churches, palaces appearing in a bold architectural style, in which forms seem pushed to the extreme and the classical constructions of the previous century inflated, rearranged and broken apart in an atmosphere of increasingly extreme theatricality. The work had begun decades earlier, under Pope Sixtus V, in the latter years of the sixteenth century. The urban landscape was being transformed from one dominated by pagan monuments of antiquity towards a new Rome, a splendid and festive centre of the resurgent Catholic Church.[14] Broad avenues culminated in large squares, at the centre of which stood ancient obelisks and dramatic fountains. This reshaping, restoring and decorating became ever more exuberant and daring, reaching new heights during the papacies of Urban VIII and Alexander VII in the middle of the seventeenth century. Many new churches were built, often small in size but always grand in ambition, and requiring frescoes and large wall paintings, as well as sculpture to embellish their interiors.

The whole city seemed up in the air, levitating, radiating power over the world. One artist above all others was responsible for this illusion of weightlessness.

Just as Rubens seemingly turned paint into flesh, so Gianlorenzo Bernini transformed marble into real, breathing bodies. His greatest work (which he described as his 'least bad') was commissioned in the late 1640s by a Venetian cardinal, Federico Cornaro, to decorate a small chapel in the recently built Roman church of Santa Maria della Vittoria. The chapel was to honour St Teresa, a Spanish mystic who with a combination of practical wisdom and mystical experience had reformed the Carmelite religious order. She was one of the great mystics of the previous century who had been canonised as a saint by the Catholic Church, along with Ignatius Loyola, Philip Neri and Francis Xavier.

As a newly minted official hero, it was not unusual that Teresa should have been represented by Bernini. Yet the image he created was unlike any other portrait of a saint. Teresa appears floating on a cloud, an angel standing before her, in a shallow, framed aperture above the altar in the chapel. She is surrounded by coloured marbles and carved decoration, to emphasise the purity of her form. In her autobiography Teresa wrote of the ecstasies and raptures that she experienced as the climax of her mystical experiences. It is the most famous of these that Bernini shows:

> It pleased the Lord that I should sometimes see the following vision. I would see beside me, on my left hand, an angel in bodily form – a type of vision which I am not in the habit of seeing, except very rarely [...] He was not tall, but short, and very beautiful, his face so aflame that he appeared to be one of the highest types of angel who seem to be all afire [...] In his hands I saw a long golden spear and at the end of the iron tip I seemed to see a point of fire. With this he seemed to pierce my heart several times so that it penetrated my entrails. When he drew it out, I thought he was drawing them out with it and he left me completely afire with a great love of God. The pain was so sharp that it made me utter several moans; and so excessive was the sweetness caused me by this intense pain that one can never wish to lose it, nor will one's soul be content with anything less than god.' [15]

Teresa is at the summit of her mystical experience, her head thrown back and eyes rolled upward, emitting one of the moans she describes as the angel, who also appears to be enjoying himself, withdraws his fiery arrow. The crackling energy of Teresa's ecstasy, 'completely afire' with love, spreads through her massive billowing robe, blending with the cloud on which she is lodged, one bare foot dangling down, limp and spent. Daylight streams in from a hidden window above, suggesting divine illumination. Everything floats on light and air.[16]

Bernini desired his sculptures to form what he called '*un bel composto*' – a 'beautiful whole'.[17] Rather than lifelike detail, he was concerned with overall effect: how sculpture worked in a specific space, together with architecture, painting, colour, light and atmosphere. The settings in which he worked were the grandest available. One of his earliest works was made for the recently completed

basilica of St Peter's in Rome: a gilt–bronze and marble baldachin – a tall canopy formed by four spiral columns, once believed to have come from the Temple of Solomon, topped by colossal angels standing on a heavily ornate roof. It was erected at the crossing of the nave, beneath Michelangelo's dome, and above the grave of St Peter himself. Bernini went on to create the greatest response to the architecture of Bramante, Michelangelo and others who had designed the massive forms of the basilica itself. His design for the piazza in front of the church incorporates two colossal colonnades arching around the circular space like encircling arms.

His sculptural and architectural spectacles were created not just as entertainment but also as an expression of deeply held religious beliefs.[18] He was well versed in Teresa's writing on her life, and many other theological texts of the time, such as the teachings of Ignatius Loyola. Talking to him was like defending a thesis, one of his contemporaries observed, with a touch of weariness. As with Michelangelo, there was no question of the seriousness of his loyalty to the Church: they were both known for their terrific energy, never stopping from project to project, coming up with ever more audacious schemes, deploying paint and marble as if divinely inspired. But where Michelangelo wrote profound sonnets about love, Bernini preferred to write plays in the tradition of the commedia dell'arte, which he staged in his house using friends and servants as players. He was known

The Ecstasy of St Teresa of Avila, by Gian Lorenzo Bernini. 1647–52. Marble. Santa Maria della Vittoria, Rome.

as a scenographer who arranged spectacles for the papal court, including operas, terrifying the artist with floods and fire, using ingenious machinery to create his stage effects.[19] Bernini's genius was dosed with irony, self-reflection and humour. He saw that being popular did not necessarily come at the expense of being profound.

The heirs to the great stylistic tradition of Rubens, Titian and Caravaggio were the painters who rose to the fore in the middle years of the seventeenth century in Spain and the Netherlands. Great style, rather than technical invention, was their goal, a fluid approach to brushwork and a genius for showing different textures and light, so that in the work of the two towering figures of the time painting became a metaphor for life itself.

Diego Velázquez distinguished himself while still young, learning as an apprentice in the studio of Francisco Pacheco in Seville. By the age of twenty he was making paintings that show supreme confidence in technique and composition. He was soon snapped up by one of the greatest patrons of the time, the Spanish king Philip IV, and in 1623 he went to Madrid to work in the royal court.

From his very first portrait Velázquez forged the king's image for posterity; his long, thin face, passive, intelligent mien and swollen Habsburg chin. Velázquez painted him in various guises, serenely in control of a rearing horse, kitted out in ostentatiously modest hunting attire or dressed in elegant black silk (a fashion legacy of the Burgundian court), holding an important-looking piece of folded paper, giving the impression that from time to time Philip might have actually done some work.

In fact, Philip did take work seriously: not that of stabilising the kingdom's finances, or that of consolidating Habsburg power, however, but rather the job of extending and decorating the royal palaces and commissioning paintings from the greatest artists of his day. His great-grandfather, Charles V, had been painted by Titian as the great warrior and Holy Roman Emperor, the universal monarch who fought for his vast empire against the Protestants, the Turks and the French. Philip's grandfather too was painted in martial guise by Titian, and shown in tough, no-nonsense bronzes by the Italian sculptor Leone Leoni and his son Pompeo.

Philip, by contrast, was an aesthete. He sent Velázquez to Italy to buy paintings and sculptures, and to take casts of antique sculptures, filling his palaces with these beautiful images and objects. It is a room in one of these palaces, the Alcázar in Madrid, that Velázquez used as the setting for one of his most striking portraits of Philip. The king, paradoxically, appears as nothing more than a blur of light in the background, next to a similar blur representing his second wife, Mariana of Austria, whom he had married in 1649, following the death of his first wife, Queen Elizabeth of France. Mariana was supposed to have married Philip's son and heir, Baltasar Carlos, whom Velázquez had painted on a delightfully rotund rearing horse, the size of a donkey to make the rider seem more grand, but the boy had died young, breaking his father's heart. Mariana, for dynastic reasons, had to settle for the mournful father and spent most of the first years of their marriage, or so it seems from Velázquez's portraits, wearing elaborate court dresses, with beribboned hair, pouting with childish disdain. The trace of the pout is still there in the mirror of Velázquez's great portrait. In truth it is a portrait rather of their daughter, the Infanta Margarita, and two of the queen's maids of honour – *Las Meninas*.

Margarita stands centre-stage wearing a white silk dress, her blonde hair hanging wispily, her open, childish gaze caught between girlish innocence and self-consciousness, the first stirrings of the vanity of power. Her airy self-regard contrasts with the blunt stares of the two court dwarfs, Mari Bárbola and Nicolasito Pertusato, the latter of whom places his foot gingerly on a mastiff, the dog closing his eyes with a look of forbearance.

One of the meninas, Mariá Augustina Sarmiento, offers Margarita a little red jug of water to drink, while the other, Isabel de Velasco, noticeably taller, leans forward in deference and curiosity. Gravity is added to her questioning look by the coincidence of her head in the composition with the figure of a man standing in a doorway at the back of the room (the chamberlain José Nieto), who turns to look before ascending a set of stairs. Isabel looks at us with an air of knowledge, but without the slightest trace of judgement. Like all the figures in the painting, she greets us with warmth and interest, suggesting the courtly manners of royalty and their retainers. All, that is, apart from one: Velázquez himself, who stands back from the canvas on which he is working, the back edge of which occupies the left-most strip of the painting. He tilts his head, holds his brush to his chest and thinks. How to create an image of power, yet one that can still seduce and

Las Meninas, by Diego Velázquez. *c.*1656. Oil on canvas, 316 cm by 276 cm. Museo Nacional del Prado, Madrid.

engage, speak to the heart, rather than demand respect through the assertion of rank? How to use the seductive medium of oil paint to show these austere beings, whose lives were bound up with the fate of kingdoms and empires? How to make a painting that reflects these subjects of power, their daily lives, and yet to be more than that, a painting about looking itself, about the spectacular nature of vision and the most extraordinary thing in creation, the human eye? How, in a word, to be interesting, and remain a court painter?

The answer Velázquez proposes is to show not the king and queen, who remain distant and inaccessible, reflected in a mirror in the background (implying that they are posing at roughly the place that we stand when looking at the painting), nor even their daughter, Philip's heir apparent when the painting was made (Philip's only surviving daughter by his first marriage, Maria Teresa, was betrothed to Louis XIV and had renounced her claim to the Spanish throne), but to place the focus of the painting on two peripheral figures – on Isabel de Velasco, the taller of the meninas, whose open, questioning gaze holds our attention more than any other figure in the scene and who, by a piece of subtle mirroring, the most infinitesimal echo of an inclined head, is linked with Velázquez himself. The painting was only later called *Las Meninas*. The original title is unknown, as it was hardly referred to at all when it was made, and only mentioned as a 'cuadro de la familia', or 'painting of a household', in an inventory made in 1662, after the death of Philip IV. Above all else, though, it is a self-portrait of an artist at work.

Where in paintings such as Rubens's *Three Graces* or Caravaggio's *Taking of Christ*, we can lose ourselves, our minds becoming part of the painted image, *Las Meninas*, quite uniquely, places us physically outside the work. We ourselves become the subjects, held in place by the gaze of the artist, of the Infanta Margarita and her attendants. Even the dog's closed eyes seem pointedly to acknowledge our presence by refusing it. We are not so much drawn in as firmly positioned in front of the painting, as though we must eventually ask permission to leave, or wait until Velázquez has finished his moment of critical reflection, or the dog turns and barks at the boy who is using him as a footstool, or the Infanta takes the jug she is being offered and drinks the cool, fresh water. It is one of the greatest instances of the way in which a picture can become a world.

Velázquez took the tradition of illusionistic brushwork to a magical extreme. And yet it remained within the bounds of reason: the world he paints is always fully believable. In the work of another painter, born in the middle of the sixteenth century on the Greek island of Crete, the transformation of paint into world went far beyond what might customarily be called reality, or nature.

The ecstatic, visionary type of painting for which El Greco ('The Greek'; his real name was the less catchy Doménikos Theotokópoulos) became famous was made largely in the town of Toledo, the religious capital of Spain. He was trained to paint in the Byzantine manner – rigid, flat forms, with conventional zigzagging white highlights on robes – but soon abandoned the old formulas, stretching back at least to the time of Andrey Rublev, and adopted a style akin to that of the Italian painters he saw when he first left Crete and travelled to Venice.

Most of his paintings were of religious subjects, commissioned by the Church and religious orders in Italy, and then in Toledo after his move to Spain. His *Laocoön* is his only painting of a subject taken from ancient mythology – Laocoön, we remember, was the Trojan priest, described by Virgil, whose death along with those of his two sons was depicted in the famous Graeco-Roman statue that had been uncovered in Rome at the beginning of the century. Laocoön looks in terror at the snake he holds, seeming to fall and float in a darkened space, while one of his sons wrestles another serpent, whose circling form frames the city in the background – supposedly Troy, but modelled in fact on Toledo, the city El Greco knew best. The pallid form of Laocoön's other son lies inverted to his side, while two elegant naked figures stand to the edge of the scene, as if observing. They might be gods, standing in judgement, or onlookers painted by El Greco to provide a sense of distance to the visionary scene.

Rather than visionary experience (painting while in an ecstasy like that of St Teresa must be quite difficult), or any other physical condition (such as a visual impairment), it was the wax and clay models that El Greco worked from, like Poussin and Tintoretto before him, that led to the artificiality of his style, as well as its purity, showing a world defined entirely by the basic elements of painting: colour, brushmarks, painted shapes. El Greco's figures often seem to float, and indeed there is no ground in his paintings apart from the ground of the canvas itself. When El Greco's paintings are seen together, their peculiar logic emerges: one founded, like those of Velázquez, Poussin, Rubens, Caravaggio and Gentileschi, on the true subject of all great painting – the act of painting itself.

Laocoön, by El Greco. 1610–14. Oil on canvas, 137.5 cm by 172.5 cm. National Gallery of Art, Washington DC.

21

An Open
Window

Over a Dutch landscape hazy clouds drift. It is late summer, and farm labourers are resting from reaping corn, their stacked sheaves drying, punctuating a field sloping down to the river. Clouds cast moving shadows over the summer harvest while sunlight breaks over a distant river, which runs alongside a church, a town hall, a windmill.

It is an ordinary day, painted in ordinary tones. The artist, Jan van Goyen, thinned his paint and worked quickly in muted grey and brown tones. Such monochrome landscapes, devoid of any bright patches of colour, were his trademark style. Transparent layers of oil drift across the canvas surface like slow-changing atmospheric effects. Objects dissolve in the atmosphere, so that the drama of the painting floats upwards into the vast panorama of the sky, beyond human reach.[1]

Jan van Goyen created a new type of landscape painting in the Netherlands at the beginning of the seventeenth century. Horizons were low, colours were muted, the mood undramatic. His paintings bring to mind the misty landscapes of a Southern Song dynasty Chinese painter such as Xia Gui. No heroics, no figures from myth or history, just everyday scenes of ordinary life, painted from drawings made out in the world. After centuries of story-telling, where painting was essentially a form of book illustration, artists suddenly took up their paints and sketchbooks and walked down to the town square, recording what they saw. It was advice given in one of the great books on painting of the age. The Flemish painter and historian Karel van Mander, in his *Schilderboeck* ('Book on Painting') of 1604, exhorted artists to leave their studios and draw '*naer het leven*' – 'after life'.[2] Let the world itself make the image.

This spirit of direct observation was also emerging in contemporary science. In his book *Paralipomena*, published the same year as Van Mander's *Schilderboek*, the German astronomer Johannes Kepler wrote of his discovery that images are projected, inverted and reversed by the lens of the human eye on the retina: 'the retina is painted with the coloured rays of visible things', he wrote.[3] Kepler's theory of retinal images built directly on Alhazen's pioneering work in his *Book of Optics*, written six hundred years earlier. His description of seeing as 'painting' suggests just how important painting, and drawing, had become for understanding the way we see the world.

Dutch seventeenth-century painting stands as one of the great traditions of art in Europe: the most prolific, the most inventive, the most amusing and the most profound. It announced a new era in European politics, and also in economic life. The Dutch Republic was formed when the northern provinces

View of Arnhem, by Jan van Goyen. *c.*1644. Oil on panel, 26 cm by 41.5 cm. Rijksmuseum, Amsterdam.

of the Low Countries declared independence from Spanish Habsburg rule in the 1580s. During a long and violent struggle the Protestant north separated from the Catholic south, and from around 1600 the newly formed northern Dutch state began to assert its independent identity, as a wealthy urban culture, governed by its citizens, given its image by a type of painting devoted to worldly observation, and made for money rather than for the glorification of God.

The wealth of the republic came from the Dutch East India Company, originally founded to trade with Mughal India, but which was to send its ships as far as Japan and Indonesia, battling with rival nations, the Portuguese and English, for control of lucrative trade. Traders as well as Jesuit missionaries brought back marvels from afar.[4] The first porcelain from Jingdezhen, the great city of ceramic production in China, arrived on captured Portuguese trading ships in the Dutch port of Middelburg in 1602. The Dutch called the porcelain *kraakporselein*, perhaps after the Portuguese ships, carracks, that had transported them – and also because they were liable to break (*kraken*). Ceramics and lacquerware cabinets from Japan, silverware from Batavia (modern-day Jakarta), the Dutch colony in Indonesia, carved ivory from Ceylon and textiles from southern India were among the luxurious objects, mixed with often large quantities of spices and exotic shells from the Indian and Pacific oceans, brought back in crates on traders' ships.[5]

These imported wonders were grist for the imagination of artists, and appear in their paintings – a carpet on a table, a vase for flowers, a shell in a still life. The variations seemed endless, as was the production of paintings itself – artists could not work hard enough to meet the burgeoning demand from a newly wealthy class of merchants, who crammed the walls of their homes with paintings

in what amounted to a craze for buying art. Artists, naturally, were only too happy to oblige, meeting the demand with ever more imaginative subjects and genres.[6]

Pleasure itself became a subject for painting. Judith Leyster's self-portrait, made in her early twenties, at her easel painting a radiantly happy musician, captures this light-heartedness, a genuine cheer that suffuses the scene. She leans back on her chair and greets us with confidence, inviting us, with no trace of arrogance, to admire her work in progress, the wild freedom of

AN OPEN WINDOW

the fiddler she paints, a symbol, perhaps, of her own sense of the pleasures of the artist's life, her brush an echo of the musician's bow.[7] She signed her paintings with the monogram 'JL' and a shooting star, punning on her name (the Dutch *leidstar* means 'leading star', or pole star).

The look of Leyster's paintings suggests she may have trained in her home town of Haarlem under the painter Frans Hals. There is little doubt that she admired his loose, energetic brushwork, which was also emulated by Hals's brother Dirck and by Jan Miense Molenaer, Leyster's husband. Also his optimism: nowhere before Frans Hals are there such unselfconscious laughing smiles in painting. Where Rogier van der Weyden had painted the first truly believable teardrop, Hals painted the first great laughing smile two hundred years later. For earlier Netherlandish painters the teardrop was a symbol of sanctity. For Leyster, Hals and their colleagues in Haarlem, smiling and laughing faces were symbols of a different, more material world, one of freedom and plenty.

Yet it would be wrong to assume that painters working in Haarlem or Amsterdam, or any other Dutch town, were morally indifferent. The Church was not entirely forgotten. The painter Jan Steen (Jan van Goyen's son-in-law, as it happens), from the town of Leiden, was a great purveyor of moral scenes, often with a rather compromising backstory. One of Steen's favourite subjects was a woman suffering from a mysterious illness, being visited by a suspiciously over-dressed doctor. In one version the doctor takes her pulse and prepares his quack medication (the cuckoo clock on the wall behind hints at his qualifications), but the smile on the woman's face and glint in her eye suggest that her malady may well have another cause. A swelling lute hangs on the wall above her head – she is pregnant with her lover's child.

In their accumulation of anecdotal detail and their love of peasant life, of disorderly tavern scenes, drunken couples and scheming lovers, Steen's paintings remind us of the paintings of Pieter Bruegel from a century earlier. Just as with Bruegel, Steen's morality was mostly for show – the purpose was not to instruct but rather to entertain. The only moral in Steen's painting, it seems, is that too much pleasure is a good thing.

Steen was known for earthy pleasures, Leyster and Hals for their bravura laughter, Van Goyen for his misty monochrome landscapes. Every Dutch painter was known for something. It was an age of freedom but also of specialisation, of the need to corner some kind of market to make your living – the market for tavern scenes, or exotic flowers in bloom, or skaters on ice, night scenes, bird's-eye views or group portraits in a certain kind of light. Artists dreamed of rivalling the

The Sick Woman, by Jan Steen. c.1663–66. Oil on canvas, 76 cm by 63.5 cm. Rijksmuseum, Amsterdam.

wealth of their richest clients, of living with all the luxury and respectability that such wealth could offer in the new era of capitalism.

Creating new genres was especially lucrative. The Antwerp-born painter Ambrosius Bosschaert virtually invented the genre of flower painting, after moving to the town of Middelburg in the 1590s, one of many Protestant refugees who moved north to escape persecution. His painstakingly composed, symmetrical bouquets of flowers, often arranged in Chinese porcelain vases, appear against dark backgrounds or a simple stone arch. The flowers are painted with such scientific exactitude that they might be botanical illustrations. Bosschaert trained his sons and brother-in-law, the painter Balthasar van der Ast, so that flower painting of the highest quality (and price) was synonymous with the Bosschaert name.

One painter, however, raised himself above market-driven specialisation, making works of all types and subjects, even bringing into prominence a new genre, that of the self-portrait (although it was not known as such at the time – the phrase came into use a few hundred years later). He created images of human life that went beyond any others in showing the depths of feeling and emotion that mark our lives, especially as we grow older. Like Albrecht Dürer before him, he combined a deep interrogation of human life in paint with a fascination for printmaking. What Dürer had done for engraving and woodcut, he did for etching, making prints that seem more like sketches in the landscape.

Rembrandt Harmenszoon van Rijn was supremely talented, and knew it. From early in his career he signed his paintings using only his first name, emulating a great painter of the previous century: Titian never signed with 'Vecellio'. Rembrandt also sought to rival Titian's rough brilliance of style, and succeeded, even surpassing the great Venetian painter in the range of effects of light and atmosphere he could emulate in paint. He worked voraciously, persistently and with the detachment of a painter who could see the world afresh every time he looked, a detachment such that he could master any subject, historical, contemporary, heroic or mundane, bringing everything into his painted realm.

One subject became strongly associated with his name, that of the natural effects of ageing. He was not the first to paint old people – in 1610, when Rembrandt was four years old, Sofonisba Anguissola had painted herself in her late seventies, capturing in an uncompromising manner the condition of old age. But not even Anguissola had anatomised the effects of ageing with such prolonged and profound scrutiny as Rembrandt. In the last few years of his life he created one of his most moving works, a self-portrait. Rembrandt shows himself still at work, holding a palette, mahlstick (a stick used to avoid touching wet paint on canvas) and brushes.[8] He looks out with a resigned expression, his features seeming to crumble into the dabs of paint, scratched into with the brush end, the palette he holds no more than a few strokes of earth-coloured pigment. His costume is a dark fur-lined robe, rising from darkness at the lower edge of the canvas up to the dramatic highlight of his white painter's hat. While close to it is nothing more than a few strokes of white paint and warm lemon shadows, a few paces back it is transformed into a noble headpiece, keeping an old painter warm as he works.

Everywhere there is this sense of economy, great effect being wrought from just a few marks of paint. Two broad curves on the wall behind might be the beginnings of a new painting, or simply shapes drawn on the wall. Perhaps they are the bare outline of a map, showing two hemispheres, although they are not regular circles, drawn rather by hand.[9] Their bare forms, extending beyond the canvas edge, are reassuring in their rough geometry. But still what we are left with is an image of doubt, of the fracturing of confidence that comes with age, especially for those who have known such success as Rembrandt, before bankruptcy forced him to sell his house and his great collection of paintings, leaving him in the last years of his life in depressing poverty.

The novelty of painting old age was remarked by Rembrandt's first biographer, Joachim von Sandrart, writing a few years after the painter's death in 1669. 'He gave proof of great industry, patience and experience in his depiction of old people,' Von Sandrart wrote, 'their skin and hair, so that he approached the representation of ordinary life very closely.'[10]

What Rembrandt saw in this 'ordinary life', however, was a world that was already transformed in his eyes into the mysteries of oil paint – that magical substance that can capture such lifelike appearances, such effects of natural light, that it seems itself '*naer het leven*', 'after life'. Rembrandt showed the world as though it were already made of paint. Flesh, fabric, windows and tables, weapons and armour, the pages of a book, the very atmosphere of a room or a landscape seem forged from the same substance, one that can capture the sharp glint on the edge of a sword, the sparkle of jewels, the wrinkled flesh of old age, the illumination of a landscape in a storm or simply an impression of poverty, pain and nothingness – a dull, airless void.

Rembrandt's search for truth of appearances led him to the truth about images themselves. What seems like close observation of the world, recorded in a masterfully lifelike technique, turns out again and again in his painting, and in Dutch painting of the seventeenth century as a whole, to have been not 'after life' after all, but rather a brilliant invention. And, like the waters on which the Dutch traders' ships sailed, criss-crossing the world in pursuit of wealth, so the paintings of the Dutch Republic

Self-Portrait, by Rembrandt van Rijn. c.1665. Oil on canvas, 114.3 cm by 94 cm. Kenwood House, London.

River landscape with cows,
Aelbert Cuyp. 1645–50. Oil
on panel, 43 cm by 72.5 cm.
Rijksmuseum, Amsterdam.

were as much a matter of glinting surfaces as of dark, welling depths. Rembrandt's portraits often hang alongside those of his contemporary Frans Hals, who gives vivid life to his sitters with deft brushwork, capturing the structure of a ruff, or the wrinkles of a smile, with just a few lightning jots of paint. Where Rembrandt plumbs the depths of human life, his emotions the glint of jewels in deepest darkness, Hals shows the clatter of the surface, revelling in dazzling light and the sound of brash laughter.

Hals and Rembrandt, like other Dutch painters of the seventeenth century, mastered the trick of appearances so well that their capacity to invent is often difficult to see. We may think we are looking at a precise transcript of reality, painstakingly transferred to canvas thanks to the steady vision and errorless hand of the painter, but the truth is more often a case of artful invention. Jan van Goyen may have sketched out of doors, as had Jan Brueghel and the Flemish artist Roelandt Savery, setting down what they saw with a precise line, like Dürer, but his paintings were made back in the studio.

The model was often not 'life' but other works of art. The landscape painter Aelbert Cuyp painted cattle from his native Dordrecht as though they were monuments in an Italianate landscape, and yet he never made the journey to Italy. His paintings were made in the studio, inspired by the glowing landscapes of the French artist Claude Lorrain and a feeling for classical literature, for the pastoral themes of Virgil's *Eclogues*. (Claude is said to have painted outside, although it is not known where, or which canvases he completed outside the comfort of the studio.)

The same holds true for still-life painting. Willem Kalf, a painter from Rotterdam who spent his early years in Paris and became one of the most celebrated still-life painters of his age after moving to Amsterdam in 1653, created little scenes of luxurious objects with such meticulous detail that he could not have consistently worked from life. How long could you tolerate a lobster on the studio table? Particularly in the summer months, when the light was best. His lobster and hunting horn are painted with a realism of light animated by tiny specks of white paint, like glints in the eye of a lens, a trick of technique that gives a strong flavour of observed reality.[11]

Still Life with Drinking Horn,
by Willem Kalf. c.1653. Oil on
canvas, 86.4 cm by 102.2 cm.
National Gallery, London.

Paintings of the Dutch countryside by the greatest landscape artist of the time, Jacob van Ruisdael, were similarly artful inventions, based on drawings, memory and a technique that could summon in their absence

AN OPEN WINDOW

the effects of natural light, atmospheric distance and changing weather. Tall, airy stacks of clouds surmount his views of the town of Haarlem, in which the landscape seems to open up and radiate, buildings and spires minute in the distance, marking an ineffable horizon, curving slightly with the shape of the earth itself.

Even the most apparently believable images, those paintings of flowers invented by Bosschaert which were to become a pinnacle of Dutch painting – the rich spectacle of a costly floral bouquet presented with an intensity of illusion and a saturation of colour, with meticulous care given to the arrangement of colours and shapes in space – were for the most part imaginative inventions, like a florist's costly fantasy.

A Still Life of Flowers in a Wan-Li Vase, by Ambrosius Bosschaert the Elder. 1609–1610. Oil on copper, 68.6 cm by 50.7 cm. National Gallery, London.

It is a paradox: paintings obsessed with appearances, with measuring and mapping, and yet largely invented rather than observed. The window may have been thrown open, but the real view is back into the vital space of the artist's *schildercamer*, or painting room: what was later termed the artist's studio.

These painting rooms were on the whole simple spaces with white walls and a high, north-facing window for consistent light. In the corner was a stone slab on which pigments were ground with oil, before being stored in pig's bladders. Apprentices would stretch canvases on wooden frames, ready for painting. The room might otherwise be filled with props, odd pieces of armour, costumes, textiles, statuettes, musical instruments, books on the shelf (including Karel van Mander's indispensable *Schilderboek*, and maybe even a copy of Kepler's *Paralipomena*), and studies and prints attached to the wall. Painters often took their own painting rooms as subjects, at times including themselves in the scene – one way of showing that business was going well.

One of these studio scenes bears none of the usual signs of an artist's workplace: bare floorboards and shelves cluttered with the accoutrements of their art. Like Vélazquez's *Las Meninas*, Johannes Vermeer's *The Art of Painting* is quite unlike any other image of an artist's studio – and quite unlike any other painting, for that matter. In its scale and design, but also in its very essence, it emanates a uniqueness that goes beyond painting, as if, instead of being an image of the world, it was rather a world in itself, possessed of its own gravity and light.

View of Haarlem with Bleaching Fields, by Jacob van Ruisdael. *c.*1670–75. Oil on canvas, 62.2 cm by 55.2 cm. Kunsthaus, Zürich.

The Art of Painting, by Johannes Vermeer. *c.*1666–68. Oil on canvas, 120 cm by 100 cm. Kunsthistorisches Museum, Vienna.

An artist sits on a stool at his easel, his back to us. He wears a black-and-white slashed doublet and bright red stockings. On the canvas his brush, resting on his mahlstick, is poised to paint the blue wreath of his model, posed in the guise of Clio, the muse of history. She holds a yellow book and trumpet, and looks coyly down, self-consciously acting out her fame. A thick tapestry curtain is pulled aside to reveal the room, where studio props are scattered on a table: a plaster cast of a mask, an open book, perhaps a volume of prints, and some expensive fabrics, perhaps silk. Hanging on the back wall, partly obscured by artist and model and by a gilded chandelier bearing the double-headed Habsburg eagle, is a map showing the entire Netherlands, the Protestant north and the Catholic south, which remained under the rule of the Spanish Habsburgs following the Treaty of Westphalia in 1648, barely two decades before Vermeer created his painting of an ideal artist's studio, to which he gave the title *The Art of Painting*.

AN OPEN WINDOW

Vermeer painted in such a meticulous style that he completed only a small number of paintings during his lifetime. Some thirty-six remain today. Most are interiors with figures engaged in pursuits around which it is almost impossible not to weave some story or other – a woman reads a letter, undoubtedly from her lover; an aristocratic lady absent-mindedly plays the guitar, staring out of the window; a milkmaid pours milk from an earthenware jug, lost in thought.

The real story, however, is of painting itself. Vermeer showed the world as though he were encountering it for the first time, as though he did not know the names and uses of objects, painting them as mere concatenations of colours, forms and shapes.[12] The closer you look at individual parts of *The Art of Painting* – the red stockings (so artfully placed to set off the blues and browns that otherwise dominate), Clio's blue robe or the weave of the heavy curtain in the foreground – the more the picture surface becomes an interlocking field of coloured shapes, detached from solid, knowable reality.

A ribbon in the hair, a letter held in the hand, a line of light running down a door frame, an unidentifiable object on a table – they exist in Vermeer's paintings like acts of pure observation, untainted by knowledge or by a sense of having been drawn, delineated, before being captured in light.

This detachment was in part a matter of technique. Vermeer was undoubtedly familiar with the camera obscura, a device for capturing an image of the world in a darkened chamber, using a lens or small hole that projects an inverted image onto an opposite wall. It was by no means a new discovery – Leon Battista Alberti was using one in Rome in the 1430s, and it seems likely that it was in origin an invention of Arab science, inspired by the writings of Aristotle.

Although by the evidence of his paintings he surely knew of the device, nothing Vermeer made was ever dependent on the camera obscura. Judging the tonality of colours, or even finding where your paintbrush was, would have been impossible in a darkened room, making the long and laborious task of creating such precise paintings maddeningly difficult. Instead Vermeer created a style that mimics the detachment of the camera obscura, and the tiny blurred points of light that are a characteristic of the image it produces, as if his own eye were such a device, according to the descriptions of Kepler, and Alhazen before him. It was by pure dint of concentration and long, hard looking that Vermeer achieved an effect that seems as instantaneous as an image produced by nature.

In the final count this is the true subject of *The Art of Painting*: the fame and glory of the painter's life, and the sacred aura that gathers around that sanctum of colour and light, the painter's room.[13] Vermeer realised the greatness of his image and, unusually, signed it 'I Ver. Meer', on the lower edge of the map in the background. He kept it with him at his house in Delft until his death in 1675 at the age of forty-three.

Rembrandt went beyond painting, creating canvases that appear uniquely alive. Vermeer also transcended all known techniques, but in a different way, submitting entirely to the visual impression of the world, unconsciously illustrating Kepler's theory of vision – the provocative discovery that the human eye is a passive receptor of light. Artists and scientists alike were encountering the visual world with a deeper understanding of the structure of light and the workings of the human eye. In 1666 Isaac Newton proved that colour is in fact a wavelength of light, rather than a separate property, using a glass prism that

The Sick Child, by Gabriel Metsu. *c.*1664–66. Oil on canvas, 32.2 cm by 27.2 cm. Rijksmuseum, Amsterdam.

scattered rainbow colours on the wall of a darkened room, hit by a beam of light coming through a shuttered window. It was a new way of describing the visual world, one that Vermeer achieved in the medium of paint, underlined by the words 'NOVA... DESCRIPTIO', legible on the map on the back wall of *The Art of Painting*.

Vermeer's followers were aware of his achievement. He could at best be equalled, but never surpassed. The painting of a child slumped in a woman's lap by the Leiden-born painter Gabriel Metsu is a tale of childhood illness and parental care, painted with Vermeer in mind: the map hanging on the blank white wall, or the way colour is used to divide the surface of the painting and show light coming from a high window. A simple story is being told: the earthenware bowl may just have been emptied of porridge, the slouching child is enjoying the presence and care of the woman, who may be a servant or the mother. Childhood illness was a common subject in Dutch painting, a distillation of a wider sense of anxiety about the Dutch Republic itself, at a time of growth and change.[14] Could all this wealth and expansionism last? When would the bubble burst? The same anxieties seem woven into the fabric of Metsu's painting *The Sick Child* – the technique is generalised, so that much of the detail is left out, with flat areas of paint showing surfaces, red, yellow and blue.[15]

Rather than Vermeerian objectivity, something else is happening. Pushed into such realms of artificiality and invention, painting itself seems to have developed a malaise, taking a step back from the encounter with natural light. Such brilliance as was seen in the artists' studios of the Dutch Republic in the century after its foundation could not be sustained for much longer after Vermeer and his

Shah Jahan, by Rembrandt van Rijn. *c.*1656–61. Ink and wash, 22.5 cm by 17.1 cm. The Cleveland Museum of Art, Cleveland. Leonard C. Hanna, Jr. Fund.

summation of an entire era of painting. By the time of the disastrous French invasion and brief occupation of the Netherlands in 1672 the glory days were over. Despite the riches of the Dutch Republic, the wealth acquired through trade and speculation, many artists died in poverty – a sure sign of the growing wealth divide in the new era of capitalism. Rembrandt went bankrupt and spent the last decade of his life in reduced circumstances, although continuing to paint. Vermeer spent his last years in financial hardship, and after his death left his wife, Catharina, with eleven children and considerable debt.

The Dutch Republic was the wealthiest European state during the seventeenth century, and yet it was far surpassed in riches by two of its trading partners, Ming-dynasty China and Mughal India. There was no equivalent in the Netherlands for the great royal palaces of the Muslim Mughal emperors, and yet in their paintings Mughal and Dutch painters created similar feats of miniaturism, as we have seen in the case of the *Hamzanama*, commissioned by the third Mughal emperor, Akbar. The elegance and intensity of the products of the Mughal painting workshops were not lost on European artists, who admired them as they arrived on ships carrying porcelain and other luxury goods from the East. Rembrandt himself collected Mughal paintings, and copied them in drawings, turning their dazzling colours and golden inscriptions into the sombre tones of brown ink wash.[16]

A chameleon, by Ustad Mansur. 1612. Brush and ink with bodycolour on paper, 11 cm by 13.8 cm. Royal Collection Trust.

Akbar's son, Jahangir, took court artists with him when he travelled to record the beauties of nature he encountered on journeys and campaigns. He ordered Mansur, his most favoured painter, to whom he gave the nickname Nadir al-Asr, or 'Wonder of the Age', to depict the flowers of Kashmir, a bird he had seen in a stream and also his favourite falcon, which had died on a march from Mathura to Delhi. Mansur's coloured drawing of a chameleon perched elegantly on a branch, eyeing a butterfly about to settle on a leaf behind, is sure to have delighted Jahangir and satisfied his love of exotic creatures. The chameleon, native to east Africa, was probably carried to the imperial Mughal court by way of the trading port of Goa, by Portuguese traders.

Mansur's chameleon is a world in microcosm, bringing to mind the fantastical dragons shown on Chinese porcelain, as well as the plants and animals drawn by European artists since the time of Dürer, whose prints were studied and copied in Jahangir's court workshops.

Jahangir also saw the degradation of the human body and death as worthy subjects for image-making. He ordered the court painter Bālchand to record the last days of Inayat Khan, the Mughal paymaster-general, whose addition to opium had emaciated his body.[17] Jahangir wrote: 'Whereas painters employ great exaggeration when they depict skinny people, nothing remotely resembling him had ever been seen [...] It was so strange that I ordered the artists to draw his likeness

[...] He died the second day.'[18] Bālchand's painting is almost anatomical, so clearly can the skeleton and muscles be seen beneath the haggard limp skin. Intense orange trousers, and the blue and yellow pillows and bolsters propping up his meagre frame, only emphasise the pale, wasting emptiness of the rest of the scene, bringing to mind the composition of Metsu's *The Sick Child*. A narrow dark aperture in the wall behind Inayat shows that death is very near.

The Death of Ināyat Khān, by Balachand. 1618. 12.5 cm by 15.3 cm. From MS. Ouseley Add. 171, folio 4v., The Bodleian Libraries, University of Oxford.

22

Choosing to be Human

A Chinese emperor sits on a wide wooden couch, surrounded by antiquities: bronze pots, ring-shaped *bi* discs, painted porcelain, ancient scrolls and codices. A bonsai tree perches on an ornamental stand, and a fire burns in a charcoal brazier. The emperor, Qianlong, who ruled for sixty years during the eighteenth century, holds a blank scroll of paper in one hand and a loaded brush in the other.[1] Behind, on a standing screen showing an ink-painted landscape, another portrait of Qianlong shows him wearing the same loose robes and black horsehair hat as in the 'real' image. It is a picture on a picture within a picture. A game is being played. As if in explanation, a poem inscribed on the real painting begins with the words: one or two?[2] Are we looking at one or two emperors? Or two portraits of the same emperor? Unexpectedly, it is the portrait hanging on the screen that appears the more living image.

One or Two? (there are in fact four known versions) was painted in the workshops of the imperial Qing court. The Qing dynasty was established in the middle of the seventeenth century when the Manchu, a nomadic people from the north, conquered China and established a realm that was to last for almost three hundred years. Although the name of the artist who made the image of Qianlong

is not known for sure, it may well have been Giuseppe Castiglione, a painter from Italy who adopted a Chinese style and worked to great acclaim, under the pseudonym 'Lang Shining', at the emperor's court. He had travelled to China from Milan as a Jesuit, intending to paint Christian stories, but spent most of his time, after working for the Kangxi and Yongzheng emperors, painting portraits of his final employer, the Qianlong emperor, and members of his court. He made himself popular by painting Qianlong's beloved horses, most famously in a handscroll titled *A Hundred Horses in a Landscape*, painted in 1728, tactfully mixing European and Chinese styles.[3]

One or Two? is a painting that does just this: it combines the traditional Chinese form of ink painting on paper with the European obsession with perspective and tonal shading, quite unlike the flattened, linear images that had

One or Two? 'Eternal Spring' version, anonymous. c.1745–50. Affixed hanging for standing screen, ink on paper, 61.2 cm by 118 cm.

defined Chinese painting for centuries. It was impressive, but admired at arm's length by Chinese artists. The lifelike appearance of European painting and the bright, glossy colours of oil paint appeared heavy and vulgar compared with the refined styles of Chinese painting, calligraphy and poetry.

European techniques nevertheless had their uses. With perspective drawing you could gauge the precise extent of cities and landscapes, showing not only accurate-seeming rows of buildings but also imperial subjects, so that an image could become a census, a form of control.[4] The long handscroll known as *Prosperous Suzhou*, created in 1759 for the Qianlong emperor by the painter Xu Yang, does precisely this, showing the detailed comings and goings in the city of Suzhou, and also providing a topographical record of the city's streets and houses, in a way quite different from the flattened city views, the *Rakuchu rakugai zu*, painted by Japanese artists from the traditions of Chinese painting, which evoked atmosphere and mood rather than material extent. European perspective drawing was a way of showing things as they appeared in relation to one another, of measuring and in so doing establishing dominion and control.

Where China was open to European pictorial inventions such as perspective drawing, the same was not really true of Europeans looking at images made in eastern Asia. The Chinese view of nature was too distant, a matter of evocation rather than description, and their paintings were, after all, not paintings at all but drawings done with ink, at least in the European mind. Instead it was in the form of garden design that the Chinese view of nature left its mark in Europe.

The architect William Chambers was renowned in his day for bringing the classical building style to England, seen in his design for Somerset House, the great palace surrounding a courtyard on the bank of the Thames in London, completed in 1776. Chambers was also an enthusiast of Chinese architecture and garden design, referring back throughout his life to the sketchbooks he had kept while wandering around Canton as a young man.[5] His books and treatises on Chinese painting were part of a growing awareness in faraway Europe that a civilisation existed in the East with its own antiquity, quite different from that of ancient Greece and Rome. That the Chinese were civilised was obvious from the delicate and refined porcelain vessels that were so highly valued (and copied) in Europe, the blue-and-white ware that became known simply as 'china'.

For Chambers the design of Chinese gardens revealed a deeper view of nature than the arid geometry and symmetry of European gardens, one shaped by variety and surprise, and on a sense of unfolding poetry. He wrote as much in his book *Designs of Chinese Buildings, Furniture, Dresses, Machines and Utensils* (1757), which included a chapter on the 'Art of Laying out Gardens among the Chinese'. His view of Chinese gardens was not always accurate, frequently overdoing the fantastical and grotesque. In his *Dissertation on Oriental Gardening*, written years later, Chambers describes gardens with subterranean vaults containing effigies of ancient kings, filled with the music of water-driven organs. And yet the atmosphere of wildness and variety came all the same as a relief from the relentless straight lines and geometry of European gardens, designed as if to be represented by the ordering principle of perspective drawings.

Nature seen as a form of uncontrolled wildness, an escape from convention, appeared increasingly in Europe at the beginning of the eighteenth century. The French artist Antoine Watteau made several paintings that claimed to be in the Chinese manner, including a portrait of a Chinese emperor (later lost). The style spilled out into his paintings of the aristocracy disporting themselves in idyllic landscapes, over which hung a mood quite unique in European painting, an ephemeral atmosphere of pleasure and melancholy, a wistfulness even, as if past joys were being recalled through the golden filter of memory. These were recollections summed up in the name for the genre, or type of picture, that Watteau was said to have invented: the *fête galante*, a sort of picnic of love.

One of these wistful picnics proposes a scene that had been a commonplace of Chinese painting for centuries: the sorrow of departure. Watteau shows a well-dressed party of pleasure-seekers departing from the beautiful island of Cythera. The Greek traveller Pausanias described Cythera as the most ancient and holy of sanctuaries dedicated to the love goddess Aphrodite – even more so than Knidos, with its famous *Aphrodite* by Praxiteles. The image of Aphrodite on Cythera was less refined, but closer to nature and prepared for love – an 'armed image of wood', Pausanias wrote.[6] Cythera cast a spell of love over all who visited,

a place of freedom and desire. Watteau's love pilgrims are leaving in stages – some are already on their way to the golden boat with a red canopy that awaits them, while others need help getting up, reluctant to depart, having garlanded the statue of Aphrodite with roses, a quiver and a pelt. One cupid tugs at a woman's robe, sitting on his quiver, bidding the lovers to stay; others tumble upwards, carrying a torch into the air to help dispel the mists. The characters of the pilgrims are indistinct, as if they were members of a chorus acting out their airy dream of departure.

Watteau may have admired Chinese painting, but he was more directly inspired by northern European styles. Born in the town of Valenciennes, only recently ceded to the French from the Spanish Netherlands, the world of Flemish painting was entrenched in his upbringing. As a young artist he made copies after Rubens, as well as the Venetian masters, in the collection of his patron, the rich banker Pierre Crozat. These (very un-Chinese) traditions he saw in the light of scenic and dramatic painting, after assisting the theatrical painter Claude Gillot, known for his canvases inspired by the *commedia dell'arte*, the comic troupes originating in Italy and who toured all around Europe.[7]

Watteau's *Cythera* was an exam piece, known as a *morceau de réception*: a picture painted so that Watteau might achieve full membership of the Académie Royale de Peinture et de Sculpture (Royal Academy of Painting and Sculpture), formed the previous century under Louis XIV, a necessity for any painter wishing

The Embarkation from Cythera, by Jean-Antoine Watteau. Oil on canvas, 129 cm by 194 cm. Musée du Louvre, Paris.

to get the right kind of commissions. It was Watteau's genius to mark his happy arrival at the academy with an image of sad departure.

With his *fêtes galantes* Watteau set the tone for much painting to come: a mood of elegance, sweetness, melancholy and love, as well as a poetic vagueness that seemed necessary for the erotic reveries of a painter such as François Boucher, the most enthusiastic, if not the most lifelike painter of human flesh of the time. Boucher's own enthusiasm for China was expressed in 'chinoiserie' designs for tapestries, as well as engravings such as his series *Scènes de la vie Chinoise*, of 1738–45, based on Chinese woodblock prints.[8]

The new freedoms given to painting were elaborated with the greatest candour in the work of one of Boucher's pupils. Where Watteau floated the seriousness and melancholy of love, Jean-Honoré Fragonard was steeped in its erotic abandon. He painted in a way that seems as free and spontaneous as nature itself, just as plants grow and the wind blows and spreads the seeds. Showing aristocratic figures enjoying themselves in nature, his canvases might well be a detail of a *fête galante* by Watteau. And yet the mood has turned resolutely towards pleasure – unmistakably so in a painting he made for an unnamed nobleman who enjoyed looking at his mistress being pushed on a swing. The airborne mistress emerges from shadowy foliage hiding the man pulling her strings, as though she were a puppet – the nobleman himself has fallen into a rose thicket, whisking off his hat as his desire for a glimpse of undergarment is satisfied. His mistress's skirt is billowing, one slipper flies from her foot, twisting in the air as it goes. A moment of supreme fantasy, perhaps, but one that cannot last. Beneath the swing a stone cupid looks up with an expression of fear – he has seen that the rope holding the swing is fraying.

Fragonard's *The Swing* might at first seem frivolous, and yet the virtuosity of its creation makes it far from trivial. When it was shown at the Salon, the free public exhibition of painting organised by the Académie Royale held from 1725, at first annually and then biannually, at the Palais du Louvre (which was to become in part a museum at the end of the eighteenth century), it appeared as a joyful rejection of the idea that the proper task of painting, enshrined in the rules of the academy, was to represent noble scenes from history, from classical mythology and the Bible.

From the middle of the 1750s the Salon exhibition was organised by an artist, Jean-Siméon Chardin, whose own still-life paintings took an equally startling place on the walls. Chardin transformed the genre of still-life painting from mere representations of objects on a table-top to great dramatic scenes, so that the wine glass, preserved fruit, coffee cups

The Swing, by Jean-Honoré Fragonard. c.1767–68. Oil on canvas, 81 cm by 64.2 cm. Wallace Collection, London.

and wrapped parcels in his painting of a jar of apricots seemed to be gathered for the dramatic finale of an opera, rather like Watteau's pilgrims leaving Cythera. Chardin guarded the secrets of his painting technique resolutely: how he created the blurred, atmospheric effects or attained such lifelike qualities, such as the coffee cups in his painting of a jar of apricots, which bring to mind the optical effects achieved by Vermeer. The 'blur' around the loaves and the oranges, or the thick white line marking the top of one of the cups, suggests the use of some optical device, or perhaps just a very refined squint: so much so that Chardin left some of the squinting, lingering look within the painting.[9] Chardin was the 'greatest magician we've ever had', wrote the great critic Denis Diderot in 1767, adding that his early paintings were sought after as though he were already dead.

Alongside Fragonard and Watteau, Chardin was one of those figures who made France the origin of a new dimension of critical understanding in art, a new feeling of life, one in which individual intelligence and wit were

pitted against money and power. The often brash cheerfulness that had emerged in Dutch painting in the previous century, in the work of Frans Hals and Judith Leyster, was transformed into something more profound, the smile that can shed light on the falseness of an argument, that can bring forward new knowledge and act as a symbol of human understanding. Such enlightenment was captured by the great sculptor Jean-Antoine Houdon's portrait bust of Voltaire, placing the French writer and philosopher squarely in the centre of the age as Roman portraiture had done for emperors and officials in days long past.

Jar of Apricots, by Jean-Baptiste-Siméon Chardin. 1758. Oil on canvas, 57.2 cm by 50.8 cm. Art Gallery of Ontario, Toronto.

The Royal Academy of Arts was formed in London in 1768 and mounted its first 'Salon' exhibition at Somerset House, designed (but not in the Chinese style) by William Chambers, twelve years later. It was in part inspired by the French royal academy but was also a reaction to the dominance of French artists. English artists were having a hard time in the face of their more cultured, more talented continental counterparts. French artists remained the model for the latest and best styles. When they came to London, everyone took notice.[10]

One of the founding members of the Royal Academy of Arts was an artist who fought tirelessly for the recognition of English painting, inventing a new genre of painting, just as Watteau had created the *fête galante*. William Hogarth's 'modern moral subjects' were scenes showing characters in dramatic

Voltaire, by Jean Antoine Houdon. 1778. Marble, h. 47.9 cm. Metropolitan Museum of Art, New York.

situations, told through sequences of paintings, like illustrations in a book. They were popularised by being turned into engravings, and their success reflected the English liking for pictures that tell stories, preferably those carrying finger-wagging moral messages.

Hogarth's sequence of paintings *Marriage A-la-Mode* tells of the wreck of a poorly planned alliance. A nobleman arranges the betrothal of his feckless and dissolute son, Viscount Squanderfield, to the daughter of a city merchant. They show little interest in one another and pursue their own pleasures, leading to the murder of the husband by the wife's lover, the lawyer Silvertongue, and ending with the suicide of the wife, Countess Squanderfield, on hearing of her lover's death by hanging.[11] The second of Hogarth's scenes, *The Tête à Tête*, shows the young couple at breakfast, although it is one o'clock in the afternoon, neither having had much sleep. Hogarth brilliantly characterises the dissolute, depressive nobleman, slouched in his chair after a night of debauchery, and the stretching, tired figure of his wife, who has been spending her time playing cards and having music lessons, an excuse for a tryst with her lover, as the upturned chair and abandoned violin still in its case suggest. The young husband signals his illicit nocturnal activity with the woman's cap stuffed in his pocket – probably belonging to the street girl who appears later in the series.[12] Exasperated, a steward marches out with a clutch of unpaid bills in his hand and a book of sermons stuffed in his pocket.

Hogarth's scene is a satire on aristocratic dissolution but also an attack on artificiality, as opposed to naturalness: the corrupting influence of French style and manners. And yet even Hogarth had to admit that the greatest artists and craftsmen lived in France. He travelled to Paris, his first trip abroad, to engage the best engravers to create prints of the six *Marriage A-la-Mode* paintings.[13]

French pre-eminence, however much English artists grumbled about it, was undeniable. Thomas Gainsborough, a young painter from Suffolk, trained in London with a French émigré, the engraver Hubert-François Gravelot, a devotee of Watteau. From his earliest works Gainsborough showed the first truly original and

Marriage A-la-mode: The Tête à Tête, by William Hogarth. c.1743. Oil on canvas, 69.9 cm by 90.8 cm. National Gallery, London.

Choosing to be Human

successful interpretation of French painting in England, absorbing the spontaneous brushstrokes, the sensuous optimism of Watteau, Boucher and Fragonard.[14] He mixed these influences with that of Dutch painting, increasingly popular in England among artists and collectors. Gainsborough made drawings of Jacob van Ruisdael's compositions, to gain insight into the great Dutch painter's work: their overall design, the patterning of light and dark, the use of figures and animals to create depth and the importance of clouds were all aspects that he sought to emulate.[15]

A Wooded Landscape with a River, Cattle and Figures, after Jacob van Ruisdael, attributed to Thomas Gainsborough. Whitworth Art Gallery, Manchester.

Gainsborough also took the idea of rural subjects from Dutch painting. *Peasants Returning from the Market* was painted for the owner of an English country house, and was intended to demonstrate the beginnings of a new school of British landscape painting. The country folk on horseback are not departing from Cythera but returning from the market, although they still have time for flirtation: a vision of the landscape, one of rural ease and natural abundance that Gainsborough knew well from the paintings of Rubens. Thick daubs of yellow and pink showing the morning sky glinting through branches and foliage have a richness of colour emulating the great Flemish artist.[16] And yet in his small flickering paint marks, spread across the surface of the canvas, as if building up the picture brushstroke by brushstroke, almost like a form of writing, Gainsborough recalls, at least at a distance, the surface created by Chinese painters with their repertoire of calligraphic painterly touches.

Gainsborough's landscapes, like those of Ruisdael or Rubens, or indeed of Chinese artists who had painted scenes of nature almost a thousand years earlier, were completed in the studio, based on drawings and recollection. He also brought chunks of the landscape itself back into his studio to contemplate and paint. A few months after his death, in August 1788, Joshua Reynolds, Gainsborough's great rival, and at that time president of the Royal Academy, gave a speech (one of his regular lectures, or 'discourses', at the Royal Academy) describing this method – how Gainsborough would collect up twigs and stumps and foliage and arrange them in small model 'landskips' in his studio and how he painted at night, by candlelight, recreating the effects of daylight by his skill and imagination.[17] Like many connoisseurs, Reynolds was uncomplimentary about

Gainsborough's lack of 'finish' – the messy, unresolved nature of the paintwork – but he still could not help admiring the spontaneity of it. The scratches and brushmarks on his paintings may look chaotic close up, but step back and by a 'kind of magick' everything falls into place.

Reynolds, as the leading portrait painter of the age, may well have thought

The Road from Market, by Thomas Gainsborough. 1767–8. Oil on canvas, 121.3 cm by 170.2 cm. Toledo Museum of Art, Ohio. Purchased with funds from the Libbey Endowment, Gift of Edward Drummond Libbey.

of developing such a spontaneous, and time-efficient, approach to painting. He remained bound, however, to a more conscientious technique, one devoted to capturing the often fashionable appearance of his sitters. Reynolds's portraits are the cast of the era – actors on a historical stage whose vivid personalities and peculiarities he set down on canvas. His style was formed during a tour of Italy in his thirties, where he absorbed, often through copying, the dramatic charge of Venetian colouring, particularly that of Tintoretto, and the 'Grand Manner' of Michelangelo, as well as admiring a host of other painters such as Raphael, Correggio, Masaccio and Mantegna.

The portraits Reynolds made on his return to England give a drama and grandeur to his subjects that can be compared to the paintings of Van Dyck, capturing the wealth and social status of his sitters, but also take a step away from the courtly images of his Flemish predecessor. Some of his most original and affecting paintings are of children, quite different from an older age of portraiture. One frequently copied painting, *The Age of Innocence*, shows a young girl barefoot in a white dress sitting in a grassy landscape. It was intended not as a portrait but rather as an evocation of childhood, a mood of unselfconscious innocence that Reynolds brought to his portraits of aristocratic children, such as his painting of *Collina* – a nickname of the future Lady Gertrude Fitzpatrick – painted over a number of sittings when Gertrude was five years old, or his portraits of Georgiana Spencer with her children after her marriage to the fifth Duke of Devonshire.

Before Reynolds, children were painted more as angels than as human beings, and were very rarely the subjects of portraits. Hugo van der Goes's startling painting of Portinari's daughter is one notable exception. It took an age in which childhood was taken more seriously, and connected with a belief in the purity of nature, for paintings to be made that showed the quality of openness to the world – what the philosopher John Locke called the '*tabula rasa*', or 'clean slate', of early life, ready to be filled with experience. Reynolds considered children to be natural in their poses, and that 'unnatural attitudes commence with the introduction of the dancing master'.[18]

The idea of children as symbols of the purity of nature was given its most influential expression by the French philosopher Jean-Jacques Rousseau. The education of Rousseau's imaginary pupil in his book *Émile, or, On Education* (1762) is shaped not by examinations or tests, but rather by his natural curiosity and experience of discovering the world. Where for centuries

Collina (Lady Gertrude Fitzpatrick), by Joshua Reynolds. 1779. Oil on canvas, 141 cm by 124.5 cm. Columbus Museum of Art, Columbus. Museum Purchase, Derby Fund (1962.002).

CHOOSING TO BE HUMAN

Julie Louise le Brun looking in a mirror, by Louise Élisabeth Vigée Le Brun. *c.*1786. Oil on wood, 73.7 cm by 61 cm. Private collection.

children had been shown by artists simply as small people, now they were shown distinctly as children, with their own childish psychological traits. Jean-Antoine Houdon's sculptures of his daughters, including those of his eldest daughter, Sabine, at different ages, are among the greatest carved images of children ever made. Gainsborough painted his two daughters throughout his life, documenting their growth from young girls to adulthood.

Equally impressive are the portraits made by the French painter Élisabeth Louise Vigée Le Brun of her daughter, Julie. She shows Julie wearing a white headscarf, captivated by her reflection in the mirror that she holds. Her profile portrait, with a neutral, open expression, gazes with unprejudiced curiosity at the reflection of her full face – we are caught between these two portraits, moving from the profile to the reflection as if caught in the revelation that Julie is experiencing of her newly formed features. In the mirror a smile seems to dawn on her face, as if in understanding of something.[19]

Vigée le Brun's portrait of Julie was hung on the walls of the Paris Salon in 1787, along with several other paintings of hers depicting mothers and daughters, including a self-portrait. This small display was one of the great exhibitions of the age, the culmination of a century during which the love between parents and children, and the sense of childhood as the most valuable and formative stage of life, had emerged as a subject for artists and writers. The pure mind of the child, like the wildness of nature, stood opposed to the corrupting influence of cities and the bustle of human civilisation.

For Rousseau, nature was not something that could be grasped or mastered with science, or understood with the measurements of perspective drawing, but rather something wild and separate from human life. Just as Petrarch had admired the view from Mont Ventoux, so Rousseau saw the beauty of the Alps (and so thus did many aristocratic travellers in his wake, from the comfort of their carriages) for their sublime vistas and inhospitable wildness. Sprawling ever larger, the urban world was one in which both nature and human relationships suffered. People everywhere began moving from the countryside to the city in search of work, and as factories appeared alongside other signs of industrialisation, the grim transfiguration of the urban environment that was to dominate the next century,

ever greater importance was given to unspoilt natural scenery, to animal wildness. But the growth of the city was inexorable, and revolutionised life in a way perhaps only comparable to the changes wrought by the first city-states over five thousand years earlier. At the time Rousseau wrote his great novel, *Julie, ou la nouvelle Héloïse*, in 1761, the largest city on earth was Peking (modern Beijing), with close to a million inhabitants.

A balance was being tipped, the human world was in the ascendant, and a bond between living things and the environment that had existed since time immemorial was being placed into profound question. It was a disturbance at the heart at the Romantic response to nature, a feeling of incipient crisis, a trouble caused by human ambition. As Robert Burns wrote in 1785, in his poem *To a Mouse, On Turning Her Up in her Nest With the Plough*:

> I'm truly sorry man's dominion
> Has broken nature's social union,
> An' justifies that ill opinion,
> Which makes thee startle
> At me, thy poor, earth-born companion,
> An' fellow mortal!

In the later years of the eighteenth century the pleasure island of Cythera was replaced in the imagination by the grand settings of the cities of antiquity. A new spirit of enlightened archaeology appeared in books such as *The Ruins of Balbec* and *The Ruins of Palmyra*, by the pioneering traveller and scholar Robert Wood, recording accurate measurements and plans of the ruins of these ancient cities, and including sweeping views and detailed measurements of buildings such as the Temple of Bel at Palmyra in modern Syria.

Discoveries of the ancient world came thick and fast, captured by artists working in a 'classical' style, but in media – printmaking and oil painting – unknown in ancient times. The Italian archaeologist and artist Giovanni Battista Piranesi created unforgettable poetic images of Roman architecture in etchings combining a fantasy of the Roman past with the reality of excavations. His knowledge of the engineering required to create complex structures such as aqueducts or the vaulted structures is shown in the *Vedute di Roma* ('Views of Rome'), which Piranesi worked on from 1747 until his death just over thirty years later.

The rediscovery of the ancient Roman cities of Herculaneum and Pompeii in southern Italy, destroyed by the eruption of Mount Vesuvius just over sixteen hundred years earlier, revealed intimate details of domestic life in ancient Italy and also a wealth of Roman wall painting. And yet it was the sculpture of the ancient world that provoked the greatest admiration and emulation among artists. The taste for ancient Greek sculpture was fuelled by a book written by a German historian, Johannes Winckelmann, *Gedanken über die Nachahmung der griechischen*

Detail of *A View of the Ruined City of Palmyra,* showing the Temple of Bel, from: Robert Wood, *The Ruins of Palmyra otherwise Tedmor in the Desart* [sic], London 1753.

Werke in der Malerei und Bildhauerkunst ('Reflections on the Painting and Sculpture of the Greeks'), in 1755. For Winckelmann antique sculptures were the last word in perfection and purity – not the purity of Rousseau, that of untouched nature, but rather as the summit of human achievement, the greatest product of civilisation. Never mind that it was a fantasy about Greek sculpture, which was originally painted gaudy bright colours (or that Winckelmann never in fact visited Greece). His ideas of noble grandeur, expressed in lyrical sentences, were enough to inspire a new taste for the sculpture of antiquity.

For artists this meant one thing – travelling to Rome to admire the sculpture and architecture, and painting the ruins. The French painter Hubert Robert founded his career on ruins (such that he was known as 'Robert des Ruines'), inspired by his experience of studying at the French Academy in Rome, and sketching in the Roman Campagna, just as Nicolas Poussin had done a century earlier. Winning the Academy's Prix de Rome was the golden ticket, and one that constantly eluded Watteau, who dearly wanted to make the journey south. Fragonard was one of the 'pensioners', as they were termed, at the French Academy in Rome. His paintings of the Villa D'Este and of the ruins of Hadrian's villa at Tivoli give a reality to the dream of antiquity evoked in Watteau's paintings.

It took an artist of a different ambition to elevate the experience of Roman ruins and old Roman painting into a new style of painting. When he finally made it to Rome in 1775 (like Watteau, he had failed to win the Prix de Rome twice already), Jacques-Louis David underwent a conversion among the ruins, admiring the antique scenery while reading the ancient histories of the Roman author Livy and the virtuous, stoical biographies of leading Romans recorded by Plutarch in his *Parallel Lives.* On returning to Paris he created a new vision of history painting: a large canvas showing three young Roman men from the Horatii family, armour-clad, raising their hands and swearing allegiance to their father, who holds their swords, before leaving to fight a neighbouring family. Compared with the gentle and lyrical world of Watteau, David's *Oath of the Horatii* has a clattering directness and piercing morality.

Oath of the Horatii (detail), by Jacques-Louis David. 1784. Oil on canvas, 265 cm by 375 cm. Musée du Louvre, Paris.

David refined the stoical spirit of his Horatii, ready to die for the greater good of Rome, in his painting *The Death of Socrates*, showing the Greek philosopher in prison, surrounded by his followers, about to commit suicide by drinking a cup of poison. Socrates' companions are thrown into despair and disarray as his hand hovers over the bowl of hemlock, delivering his final, stoical words. He, by contrast, is calm, resigned to his fate, happy even, for, as Plato recorded him saying, 'true philosophers make dying their profession'.[20] Death relieves the soul from the body, and the body, with all its desires, is always an impediment to knowledge. Socrates dies with perfect symmetry, and effortless nobility. The smooth forms and clear colours seem to echo his clarity of mind; the even illumination suggests an atmosphere in which anything can be analysed and understood.[21]

Although David may well have read Plato's account of the death of Socrates, in his *Phaedo*, and thought hard about what he had seen in Rome, the look of his painting is indebted to a more recent model, that of Poussin. There is less of the Greek and Roman world in David's paintings than of its revival in France in the paintings of Poussin and his followers during the previous century. David went on to record the tumultuous events of the French Revolution and the rise to power of Napoleon Bonaparte with paintings that continued this appeal to an older conservative style, a classicism that ignored and suppressed much of the human feeling of painting in the age of Watteau, Fragonard, Hogarth and Gainsborough.

With the French Revolution an old world was swept away: one of aristocratic privilege and social injustice, certainly, but also of a deep sensibility for human life, a sympathy and emotional understanding. Only in this older world could an artist like Vigée Le Brun have made such candid portraits of herself at work as an artist, and images of her daughter Julie as filled with parental attachment as they are devoid of overblown or false sentiment. Two years after her final great showing at the Salon, in 1787, Vigée Le Brun fled Paris as the revolutionary forces marched on Versailles.

It was Thomas Jefferson, at that time the American minister to France, who suggested that the sculptor Jean-Antoine Houdon might make a statue of George Washington for the Capitol in Richmond, Virginia (a building designed by Jefferson and the French architect Charles-Louis Clérisseau, and modelled on the Roman temple the Maison Carrée in Nîmes). Houdon, who had already made busts of the Founding Father Benjamin Franklin and the naval commander

John Paul Jones, travelled to America in 1785, nine years after the Declaration
of Independence from British rule. His full-length marble statue of Washington
shows him in his regimental dress, nobly posed with a cane, one hand resting on
a *fasces*, or bundle of wooden rods, the ancient Roman symbol of justice, and a
ploughshare, representing the virtues of agriculture: Washington is shown as a just
leader in peace and in war.

Houdon's sitters must have been taken aback by the uncannily lifelike
appearance of their portraits, capturing a lived moment. The effect of immediacy
is doubled in the Washington statue by the contemporary clothes he insisted on
wearing for the portrait, rather than being draped in a toga.

Washington's desire to be shown in modern dress (in other sculptures
Houdon had his way and showed him as a Roman general) was inspired in turn
by the American-born painter, Benjamin West, who worked in London as painter

to King George III and was one of the leading history
painters of the day.[22] Washington was thinking of
West's most famous work, completed over a decade
earlier, showing an imagined scene from a real battle:
the death of the British general James Wolfe in the
Battle of Quebec, where the British drove the French
from North America and established Canada as a
British colony. West shows Wolfe at the moment of his
death, in the thick of battle, surrounded by his officers,
and in the traditional pose of the dead Christ being
taken from the cross. Wolfe is shown as a martyr,
mourned even by the pensive Native American who
sits contemplating his demise. The sentiments are
noble, as in the best history painting, but West took
the bold step of dressing his figures in contemporary
costumes – what they actually wore at the battle –
rather than dressing them as noble Romans.

History painting had since the founding of the great academies of Europe been considered the pinnacle of academic practice. No greater endeavour could motivate artists than to show improving scenes of noble action from ancient history, such as Socrates, still philosophising as he breathed his last. West turned this sentiment on its head. This sense of lived history was a revolutionary gesture. The classical ideals of stoicism and liberty could truly be experienced in the present, not just read about in old books, or imagined on the stage of history painting.

This 'nowness' of West's paintings (at least following his *Death of General Wolfe*), as with Houdon's sculpture, was the shape of images to come. Fascination with the classical world had dominated image-making in Europe for some three hundred years, but added to this was a new obsession with the historical present and the future to which it would lead. In Rome itself a new, poetic response to the antique world was emerging, and nowhere more so than in the atelier of the leading Italian sculptor of the age, the counterpart to Houdon in France, Antonio Canova.

The nowness of Canova's sculpture is the immediacy and warmth of human flesh and the vision of touch, rendered in smooth marble: the nowness of bodily intimacy. Three women stand naked, gently embracing each other, revelling in each other's beauty. They are covered only by a tasselled length of fabric, and dressed only by elaborately coiffed hairstyles. Their poses are classical, undulating as their weight falls on one leg, yet the fine details of their hands, delicately touching one another in mutual admiration, and the sense of fullness and weight around their bodies, give them a sense not of archaism but rather of living in the

present moment. They are the daughters of Jupiter, willing helpers of the goddess Venus, the three Graces. Their charms were such that, on seeing Canova's original, a travelling English duke ordered a second version from Canova to install in his private sculpture gallery at his home in Bedfordshire.

Canova was celebrated as a reincarnation of an ancient Greek sculptor, a modern Phidias.[23] But it was not simply the classical subjects that he showed, such as his famous *Cupid and Psyche*, nor the way he could make his sitters look like the patricians and matrons of old Rome, but rather, like West, his utter contemporaneity. Everything he did was both ageless and entirely of the moment.

The Three Graces, by Antonio Canova. 1814–17. Marble, h. 173 cm. Victoria and Albert Museum, London.

Liberty, love, naturalness, happiness – great ideals. And yet so much harder to achieve in reality. The French Revolution was built on an idea of liberation from despotic royal rule but led to the even greater despotism of empire, under Napoleon Bonaparte, painted in all his vainglory by Jacques-Louis David on a rearing horse

CHOOSING TO BE HUMAN

The Death of General Wolfe, by Benjamin West. *c*.1771. Oil on panel. Private collection.

(he had in fact ridden a mule) along the St Bernard Pass while crossing the Alps on his way to conquer Italy. Canova also defined the image of Napoleon and his family in monumental sculptures that drew on the sculptural language of imperial Rome, a far cry from the happy pleasures of Watteau and Fragonard and – as David's painting showed, and just as West's before him – often a far cry from reality.

The reality was darker and harsher than most artists were willing to imagine. Where Watteau painted a dreamworld of pleasure, in his late paintings the Spanish artist Francisco de Goya created an entirely different vision of life, existence as a claustrophobic and nightmarish realm of suffering.

Early in life Goya had captured a spirit of charm and happiness, recalling the paintings of Giambattista Tiepolo, the greatest painter at work in eighteenth-century Italy, known for his blue skies, as much as Watteau – carefree picnics, kite-flying and dancing in temperate countryside settings in his designs for tapestries for the royal family. In 1788 Goya made one of his greatest painted designs for the royal palace of El Pardo, a painted sketch for one of a set of tapestries intended for the bedrooms of the daughters of the future king Carlos IV (the tapestries, however, were never woven). It shows a group of aristocrats playing the 'ladle game', dancing around a blindfolded youth, playing Blind Man's Buff

Blind Man's Buff, by Francisco de Goya y Lucientes. 1788. Oil on canvas, 269 cm by 350 cm. Museo Nacional del Prado, Madrid.

with a wooden spoon. Despite the lightness of the subject, Goya shows his mastery of composition, and the endless surprise of his painted surfaces, such as the snowy mass of white paint flecked with black and yellow on the head-dress of the woman at the front, sweet and brittle like spun sugar, an effect hardly to be seen elsewhere in painting and recalling the brilliance and bravura of Velázquez, Goya's great predecessor at the Spanish court.

The mountains and lake in the background are like a painted theatre backdrop, hinting at Goya's sense of the ephemerality of things, the vanity of pleasure and the darkness welling beneath the surface of even the most opulent lives. He was appointed painter to the Spanish king and portrayed the royal family in all their pomp, showing his sitters in a way that might well seem unflattering; so sure of their power were they, however, that flattery was irrelevant, even somewhat vulgar. It left Goya free to show the bare humanity of his sitters, and also to place himself within the painting, lurking in the shadows by his easel, just as Velázquez had done a hundred and fifty years earlier.

It was a bare humanity that became ever more brutal as Goya aged, especially after the illness that left him deaf at the age of fifty – not hard of hearing, as Joshua Reynolds was, but profoundly deaf (although of all the possible

afflictions for painters to suffer this might not be considered the worst). In his first great series of etchings, the *Caprichos*, Goya showed a topsy-turvy world of madness and desire, of witches and prostitutes: 'the sleep of reason produces monsters', one etching is famously captioned, showing a frock-coated man, perhaps an artist or writer, asleep at his desk, strange owl-bats flapping up into the darkness behind.

Goya's prints recall the satirical images of Hogarth, and also of his direct contemporaries the English printmakers Thomas Rowlandson and James Gillray, artists he admired. Yet in Goya's hands such satire becomes a much more generalised and profound comment on the human world. These fantastical images were hardly the result of direct observation, and neither were the *Disasters of War* etchings he made recording life during the Peninsular War. But it did

The Drowning Dog, by Francisco de Goya y Lucientes. *c.*1820–23. Mural transferred to canvas, 131 cm by 79cm. Museo Nacional del Prado, Madrid.

not matter – in some of the most disturbing images of human violence ever made, Goya showed the effects of the French invasion of Spain in 1808, its occupation under Joseph Bonaparte, Napoleon's brother, and the subsequent reign of terror of the Bourbon king Ferdinand VII and the restoration of the Spanish Inquisition.

CHOOSING TO BE HUMAN

Goya's darkest visions appeared on the walls of two rooms in a house outside Madrid which he bought late in life, known as the Quinta del Sordo ('Deaf Man's Country House' – named not after Goya but after a previous owner, a deaf farmer). Here he painted a series of frescoes on rough plaster, known as the 'black paintings' (they were later transferred to canvas). A long image of a witches' sabbath appeared opposite a terrifying image of desperate figures on a pilgrimage trail. Most startling were two smaller frescoes painted on the end wall: one showing Judith in the act of beheading Holofernes, the other a wild and terrifying image of the melancholy god Saturn eating one of his children. It is an image of madness and despair that might be taken to show society itself in a state of self-destructive collapse. Although it was hardly likely to have been deliberate (the painting was more a response to a similar subject painted by Rubens, which Goya would have seen in the royal collection in Madrid), the demonic figure of Saturn points to the ravages of time on Goya himself. The word 'Saturnine' relates to lead, and to poisoning by lead, and it was the ill effects from a pigment containing lead, or from cooking pots made using lead, that is often said to have been the cause for Goya's deafness and infirmity. It is an image of horror that seems to capture personal plight as well as a world view.

There is no indication, however, that Goya was melancholic. It takes a strong, even optimistic, personality to confront the horrors of the world and transform them into images. He shows a world that has come unstuck, detached from morality and reason, detached from anything familiar, symbolised by his fresco at the Quinta del Sordo of a defenceless dog lost in what appears to be dunes, or waves, or just a barren expanse of paint. The pathetic animal is painted with more fellow-feeling than most of Goya's images of humans.

These images were Goya's warning, even when reason prevailed, of how thin the surface of life might be, and of how the creative imagination might be a source of redemption. Goya was convinced, he would frequently say, of the '*magia*', or magic, of painting, as his son Francisco Javier recorded in a brief biography of his father.[24] It was a magic that in the final count made life worth living, as his great tapestry paintings show.

As Goya was making his tapestry designs for the Spanish court, the Qianlong emperor of China was coming to the end of his long reign. He died in 1799 after sixty years of glittering prosperity and territorial expansion. Qianlong's imperial academy, like the academy in France, and the one in Spain, of which Goya was a member, was intended to glorify the state and record the achievements of its rulers. Just as Goya's paintings came to show an individualism increasingly at odds with the creation of official images – the type at which Velázquez, and Rubens and Van Dyck before him, had excelled – so too in China there arose more individual and unorthodox styles, questioning the whole idea of 'official' image-making and the authority of tradition, so important in painting in east Asia.

The city of Yangzhou, at the centre of a great network of rivers and canals, linking the capital city of Beijing with the city of Suzhou to the south, was a centre of this 'eccentric' painting style, often rapid pen-and-ink sketches of popular

Fascination of Ghosts (detail), by Luo Ping. 1766. Pair of handscrolls, ink and colour on paper, h. 35.5 cm. Ressel Fok Family Collection.

subjects sold to the wealthy patrons of Yangzhou and inspired by the work of earlier painters who had survived the fall of the Ming dynasty in 1644.

In the early 1770s one of the last of these 'eccentrics', by the name of Luo Ping, set off from Yangzhou to Beijing to make his name. He carried with him a curious calling card – a set of eight ink paintings of ghosts that Luo claimed actually to have seen, mounted in a handscroll. The title of his scroll, *Guiqu Tu* or 'Ghost Amusement', also brought to mind Buddhist ideas of the supernatural, although Luo's ghouls and spectres are more of the nightmarish fantasy type. Luo worked with ink on wetted paper, creating the effect of a ghostly miasma. He made another scroll in 1797 in which his fantastical world is presented as a continuous frieze of strange and comic spirits.

Luo's ghosts are strange beings but not always terribly frightening. They are figures of the imagination, arising from Luo's own strange vision of the world. Whether or not he saw ghosts, he was certainly aware of other sources for his spirit shapes: the two skeletons that he drew at the end of his first scroll were derived from anatomical illustrations in a book from over two hundred years earlier, *De humani corporis fabrica*, by Andreas Vesalius, of 1543, which was well known in China through later editions, including one titled *Yuanxi renshen tushuo* ('Explanation of the Human Body According to the Distant West'). In his later scroll, with its masterful use of tonal painting, the characters have the fantastical and nightmarish look of Goya's 'black' paintings at the Quinta del Sordo. One of Luo Ping's eccentric figures is even swallowed up in waves, just like Goya's dog.

Swirling under the surface of the eighteenth century, erupting into the images of painting and sculpture, and the literature of the time, was a deep-seated scepticism about traditional truths: crucially, the idea that the world was divinely created and its rulers divinely appointed. This mounting scepticism was to break the surface of images in the next century in a dramatic and annihilating way.

And yet the ideals of liberty and self-determination were not completely dead. They were transformed in the face of new realities, of the vast changes to life, the result of great discoveries in the human world in the centuries to come. What we learn from the paintings, as from the literature of the eighteenth century (it should not be forgotten that this was the century in which the novel, that most private and intimate form of storytelling, first appeared, both in Europe and in China), is that to be human is to believe in the truth of individual feeling over abstract forces imposed on our lives from above, whether by gods or by men.

Fascination of Ghosts (detail) by Luo Ping. 1797. Handscroll, ink and colour on paper, 26.7 cm by 257.2 cm. Xubaizhai collection, Hong Kong Museum of Art.

23

The Poetic Impulse

The landscapes painted in Europe during the eighteenth century were, on the whole, light-filled, optimistic and often artificial in feeling. They were positive in spirit. Those made in the years after the French Revolution of 1789 were of a darker cast. In them storm clouds gathered, and the heroism of an earlier age was replaced by a sense of the empty, unconquerable expanse of nature and of the frailty of human life. Into the very weave of the painted canvas, and infecting every element of the painted image – the composition, the colours, the brushmarks – doubts began to creep. At first it seemed a minor niggle, a background worry, something that might almost disappear. But soon these destabilising doubts broke like a vast swelling wave, leading to images that could never have been imagined fifty years earlier, in the bright years of the eighteenth century.

In this new, darkening atmosphere a feeling of common spirit began to appear among artists and writers. It reached across borders and continents, spurred by political revolution, repulsed by the spectre of an increasingly industrialised world, and steeped in a newly awakened sense of nature and human life. It was a feeling that was condensed in a word that for the first time poets and artists used of themselves: Romanticism.

Romanticism, it might be said, was a projection of a new human sense of freedom and fate into the world. The curtains were raised on a new world of sound, crystallised in the figure of the German composer Ludwig van Beethoven. Throughout his music, from the dramatic chords opening his third symphony and the bright natural world of his sixth, to the apotheosis of the choral finale of the ninth, we are carried on a journey through darkness and light, as if whole dimensions of human life were being revealed in their cavernous complexity.

It was, however, a journey with no fixed goal in mind. The point was to keep moving. Romanticism, wrote the German philosopher Friedrich Schlegel in 1798, was a striving towards freedom that was never quite satisfied.[1] It was a matter of connecting and becoming, attained not through the creation of resolved and completed images, but rather in passing fragments, flashes of illumination opening onto a wider world of animals and nature. The awesome size and overwhelming power of mountains and rivers became subjects for painters in Europe, just as they had been for painters in China centuries earlier. The sublimity of nature, the grandness and nobleness of it all, echoed with human fears and desires.

Few artists gave themselves over to nature, to glowering storms of snow and rain as well as to radiant sunsets, with such determination as the English painter Joseph Mallord William Turner. With Turner we feel thrown into the thick of the action, cowering on a rocky outcrop as

Hannibal's army crosses an Alpine pass in an epic snowstorm or witnessing the decline of the ancient Carthaginian empire as the sun sinks below the horizon, casting elegiac, bloodied rays over the north African port. We also feel thrown into the midst of creativity itself, enveloped by canvases encrusted with pigment containing infinite refractions of light, as though the painting itself had been hit by a storm. Turner famously had himself tied to the mast of a ship to experience a storm – 'I was lashed for four hours, and I did not expect to escape, but I felt bound to record it if I did.'[2] The painting he made, *Snow Storm. Steamboat off a Harbour's Mouth*, first exhibited in 1842, shows a vortex of rain engulfing the dark form of a paddle-wheel ship. It was an act of imaginative reconstruction, bringing back the sensations and impressions that had lodged in his mind. Experience was one thing, recollection another. As the critic John Ruskin, his great supporter, pointed out, Turner's painting was a feat of memory.[3]

Turner's memories were often of the extremes of nature, and underlined by a mood of pessimism and emptiness. His seascapes, made during the last years of his life, were so detached from the solid appearance of things that many thought they were not paintings at all, criticising them for being mere scrapes and splashes of paint, 'cream, or chocolate, yolk of egg, or currant jelly', as one critic wrote, showing nothing. Turner countered his critics: 'indistinctness is my forte', he once quipped.

Turner was too absorbed in his own researches into the effects of nature in extreme conditions to care much what critics thought. He was fascinated by the radiance and interpenetration of light in the atmosphere, an effect that he conveyed in a vision of a world painted as though it were made of nothing but water and light. His *Seascape with Buoy*, painted in 1840, churns with dirty browns and greys, waves cresting and rolling into the distance, where the watery horizon blends with the sky in a veil of rain. Turner's sea, it should be remembered, is never blue. Without the smudge of darkish brown and ochre paint in the foreground, identified by the title of the painting as a buoy, there would be no clue as to the

THE POETIC IMPULSE

scale of the scene, or whether we are on the shore looking out to sea or, like Turner himself, in his imagination, in the middle of the ocean storm.

The Romantic imagination might skim the surface of the waves or, equally, ascend skywards and lose itself in the clouds above. 'By what hands', asked John Ruskin, about the shapes of clouds, 'is the incense of the sea built up into domes of marble?' John Constable might have pondered on this question as he sat with his drawing board on Hampstead Heath one morning in August 1822. Silvery clouds propelled by a gentle south-westerly breeze filled the sky, building over the expanse of meadows, grass, trees and sandy soil of the heath, sloping down towards the city, where in the distance might be glimpsed, on a fine day, before the air was darkened with the smoke of coal fires, the dome of St Paul's Cathedral. Constable looked to the sky and painted what he saw and remembered, like a scientist analysing form, creating a believable image of clouds in the morning sky made from grey and white scumbles of oil on paper.

Constable's paintings of clouds may seem as empty as Turner's seascapes, and yet they are charged with a sense of concentration, of close observation and empathy with the shapes of nature. For Ruskin, such accuracy and truth to nature were the very purpose of painting.

Romantic painting also showed that accuracy did not necessarily lead to reconciliation – more often the reverse. James Ward, in his painting of the

vast limestone ravine of Gordale Scar, in north Yorkshire, captures the terrifying indifference of the natural world to human life, the sense of being overwhelmed, crushed even, by the looming presence of a vast rocky mass – one that also brought with it the temptation to climb and conquer. Here more than in any other painting of the times we hear the powerful harmonies and shifting tones of Beethoven's orchestrations. This was the feeling for the sublime, a sense of nature going beyond mere beauty into darker, more obscure realms of terror and imaginative transport. Darkness and terror appeared in the wild, rugged places, populated by bandits and witches, in the painting of the seventeenth-century Italian artist Salvator Rosa and also in the supernatural scenes imagined by the Swiss painter Henry Fuseli, drawing on the works of Shakespeare and Milton. Yet it was the sheer size and romantic darkness of Ward's *Gordale Scar* that elevated nature to a fully different level of power and terror.

This feeling was elucidated in two great works of philosophy of the time, Edmund Burke's *A Philosophical Enquiry into the Origin of our Ideas into the Sublime and Beautiful*, of 1757, and the German philosopher Immanuel Kant's *Critique of Judgement*, of 1790. Neither, however, described the shaping forces of nature with the same directness as William Wordsworth. His long poem *The Prelude*, begun in 1798, draws on childhood encounters with nature lodged deep in his mind. He describes how, as a child, one night he had found a small boat

Gordale Scar (A View of Gordale, in the Manor of East Malham in Craven, Yorkshire, the Property of Lord Ribblesdale), by James Ward. 1812–14. Oil on canvas, 332.7 cm by 412.6 cm. Tate Gallery, London.

moored among rocks at the side of a lake, loosed it and pushed off into the water, heading for a 'craggy ridge' in the distance.[4] As he rowed further through the still waters, suddenly, behind the ridge, 'a huge cliff / As with voluntary power instinct, / Upreared its head'. The cliff's dark mass, not unlike Gordale Scar perhaps, caused Wordsworth to turn and row back to shore with trembling hands. He continues:

> [...] and after I had seen
> That spectacle, for many days, my brain
> Worked with a dim and undetermined sense
> Of unknown modes of being; in my thoughts
> There was a darkness, call it solitude
> Or blank desertion.

Wordsworth began *The Prelude* in 1798 while staying in the Harz mountains in Germany, just as Schlegel was formulating his view of what 'Romantic' poetry might be. It was an idea somehow separate from other parts of life, a source of belief apart from religion. And yet the question that both Wordsworth and Schlegel asked concerned the human relationship to nature – are we above it or within it? What does it mean for us, and what is this feeling we get gazing over a wide empty sea or at a distant mountain range? Is it for us that the world was made? Do we matter at all?

These questions echo around the remote and desolate places painted by the German artist Caspar David Friedrich, a contemporary of both Turner and Beethoven, showing inhospitable mountain passes, barren shores, wide empty seas and deathly wintry landscapes. In Friedrich's paintings we feel that we have arrived at the end of one world and are on the verge of another. His figures have their backs to us and gaze into the distance. And yet where we might expect to see some holy apparition, or at least a hint of another world, a dragon nestling in a mountain or ethereal figures passing through the sky, with Friedrich all we have is the emptiness and coldness of a bare world, leaving nothing but our own search for truth.

The work that made Friedrich's name, in Germany at least, was painted in 1810 and shown at the annual exhibition of the Prussian Academy of Arts in Berlin that year. The king bought it, and critics disputed it. Friedrich offered his own bare description of *The Monk by the Sea*:

> The work is a seascape; in the foreground a bleak, sandy beach, then, turbulent sea, and the air the same. A man is walking on the beach, lost in thought, in black clothing; seagulls crying fearfully fly around him, as though trying to warn him not to risk venturing out into the stormy sea.[5]

We struggle to find a foothold in the scene, the foreground disappearing into a void. There is nowhere for us physically to place ourselves, floating rather in a vertiginous expanse. Only the small figure of the monk gives

scale to the scene. Not even the weather is the subject, displaced instead by a bleak emptiness. It is the first great picture of nothing. Friedrich had originally included two sailing boats but changed his mind and painted them out, leaving only the blank expanse of sea.[6] Some decades later the poet Matthew Arnold wrote of standing on Dover beach and hearing the sea's 'long, withdrawing roar', and the 'breath / Of the night-wind, down the vast edges drear / And naked shingles of the world'.

Friedrich's painting, like that of Turner, was rooted in observations he recorded in countless sketchbooks, and yet, unlike Turner, Friedrich never ventured into the world of pure colour and light. Where Turner threw himself into the eye of the storm, Friedrich remained on the still shore looking out, the only movement the slow rising and setting of the sun and the passage of the moon and rotation of the celestial sphere across the night sky. Where Friedrich offers the vision of natural light as a religious remedy, Turner sees only light and colour, nothing beyond. Turner's pessimism was real, Friedrich's one that clung on to some sort of belief. The stillness and detachment of his world seem themselves a source of solace, as if in relief that the question of what it means to be, and not to be – what it means to die – had finally been broached. Friedrich painted winter as a time of death, where previously it had always been the backdrop for the continuity of life.[7] And yet in his wintry landscapes we seem to find again the sense of beauty and reassurance that had been lost in the dark shadows of Ward's *Gordale Scar*, and the churning froth of Turner's sea.

Not all Romantic painting was preoccupied with such deep questions, or beset with such melancholy. Wordsworth's great theme was happiness and joy, a feeling preserved from childhood, and one that marked the painting of the era

The Monk by the Sea, by Caspar David Friedrich. 1808–1810. Oil on canvas, 110 cm by 171.5 cm. Alte Nationalgalerie, Berlin.

just as much as did grown-up melancholy. It was in this happier key that another prominent German painter of the first decades of the nineteenth century, Philipp Otto Runge, spent much of his life planning and developing ideas for a series of paintings called *The Four Times of Day*, symbols of the organic cycles of nature and the stages of human life. They were part of a larger cycle of works, which he planned to display with music and architecture, a combination that for Runge showed the path to the future of image-making. The lofty symbolism of light, regeneration and divine harmony that marks his series echoes the writings of the German Romantic poet Novalis, especially his *Hymnen an die Nacht*, 'Hymns to the Night', published in 1800, and his novel *Heinrich von Ofterdingen*, with its ecstatic descriptions of fairy-like children enfolded in flowers singing sweet songs – far from the lifelike images of childhood of the previous century.[8]

Runge's death from tuberculosis at the age of thirty-three meant that *The Four Times of Day* series was never completed, remaining true to the period as a series of Romantic fragments: painted studies, drawings, prints, filled with flowers, ripe vegetation, often of giant fronds and leaves, and choreographed arrangements of angels showing Runge's obsession, almost to the point of madness, with hieroglyphic symbols of divinity and natural innocence. In a painted version of *Morning* a baby lies in a meadow, while angels strew roses all around, symbolic of morning light. Above rises the figure of Aurora, bearing a lily, symbolic of the coming of the day.

Runge's vision of childhood becomes clearer in the portraits he painted of his own children, Otto and Maria, who appear monumental, charged with significance for the future and the opening up of life in childhood. As Wordsworth wrote, and as Rousseau philosophised, childhood was a shaping time of freedom and creativity.

This youthful shaping was also the subject of two illustrated books of poems, the *Songs of Innocence* and the *Songs of Experience*, written and illustrated by the poet and artist William Blake in the closing years of the eighteenth century. They were small, handmade books that Blake printed, coloured and bound with his wife, Catherine, each unique in its ordering of poems and the colours used to print and tint the plates.[9] In the poem 'The Lamb', Blake asks of that most innocent of all creatures, 'who made thee?'

Five years after the *Songs of Innocence* Blake published, as if by way of response, the *Songs of Experience*. Creativity is once again the theme, although this time there is a difference – what divine being could create such a fearsome feline creature as a tiger?

Morning (Preparatory Drawing for the 'Der Kleine Morgen,' first version), by Philipp Otto Runge. 1808. Ink and pencil, 83.7 cm by 62.8 cm. Hamburger Kunsthalle, Kupferstichkabinett.

Tyger, tyger, burning bright,
In the forests of the night;
What immortal hand or eye,
Could frame thy fearful symmetry?

Was it the same creator who conceived of such an emblem of perfection as the lamb – 'Did he who made the lamb make thee?' In Blake's version the answer seems to be yes – his tiger looks like a stuffed toy who would play happily with the lamb, hardly the fearful creature he describes in his poem.

To create his little books Blake invented a new method of printing that he called 'relief etching', a way of combining images and words that could then be coloured by hand. From these seemingly modest beginnings Blake embarked on a great journey into imaginative realms, often deeply personal to the point of obscurity, and yet always predicated on a belief in the creative power of the imagination. His early illustrated poems were derived from the Bible and epic poetry, although they are quite unlike any other interpretations of these literary sources. Bearded patriarchs, angels and cloaked figures striding through his small watercolour and tempera paintings are drawn with a sinuous line, defining muscular bodies and sculpted faces with large eyes, all drawn with an engraver's precision. He had been trained and made his living as an engraver reproducing other images, for the most part paintings. Blake summoned a new vision of the Bible amid the fire of revolution for a godless industrial age, in which the only true source of liberation was the ever youthful imagination.

A few years after his *Songs of Experience* Blake made twelve large coloured prints using the novel monotype technique of painting on a board, printing the image on paper and finishing it with ink and other media. The effect is of a chalky, rough surface, rather like an old fresco painting, which

is exactly what Blake wanted. One of these twelve coloured prints, the only one not apparently of a biblical subject or derived from Blake's own obscure mythology, shows the scientist Isaac Newton in the guise of a muscle-bound superhero, seated on a rock, leaning over with a pair of compasses, measuring, thinking, creating.[10] Newton is shown less as a great scientist than a divine creator. An artist and poet, then, like Blake himself. The world was not to be measured and explained but experienced through the deeper wells of personal thought and feeling. As Blake wrote in one of his final works, the illustrated poem *Jerusalem*: 'I must create a system, or be enslav'd by another man's; / I will not reason and compare, my business is to create.'

'The Lamb', from *Songs of Innocence*, by William Blake. 1789. Fitzwilliam Museum, Cambridge.

Blake wrote his epic poem *Jerusalem* in the final two decades of his life, while living in poverty. An exhibition he had organised of his own work in 1809, in his mother's house in Soho, in London, had been a failure. By the 1820s he and his wife were living in two dingy rooms in a dark passage off the Strand near the Thames. It was at this time that he was 'rediscovered' by a group of young artists around the landscape painter John Linnell, who were inspired by his devotion to personal vision rather than giving in to financial gain. Blake's vision of personal freedom inspired them, but so did the deep poetry of his work. The nineteen-year-old painter Samuel Palmer visited Blake in 1824 and found him lying in bed like the 'dying Michelangelo', he wrote, working on illustrations of Dante's *Divine Comedy*. Palmer also admired a small set of woodcut prints Blake had made to illustrate a textbook devoted to the pastoral poems of Virgil, written by Robert John Thornton. They held for Palmer 'a mystic and dreamy glimmer as penetrates and kindles the inmost soul, and gives complete and unreserved delight, unlike the gaudy daylight of this world'.

Banding together in reverence for Blake, Palmer and a group of artists lived in the village of Shoreham in Kent, in the south-east of England, growing beards, wearing cloaks and referring to themselves as 'The Ancients'. Milton, Blake and nature were their gods. Palmer's drawings and paintings combine these sources to imagine the landscape of England as a rural idyll that seems a combination of all the golden ages of the past, bathed in the moonlight that came to obsess Palmer throughout his five years in Shoreham from 1825.

Among the first works Palmer made there was a small group of sepia ink drawings of rural themes, using heavy layered ink marks and strong tones that lend an air of mystery to the scenes. Palmer's technique is closer to Chinese ink painting than anything elsewhere in Europe at the time. *The Valley Thick with Corn* shows a figure reading in a late summer landscape, the corn growing high, some of it already harvested. Palmer added a quotation from the Bible alongside

Newton, by William Blake. c.1795–1805. Colour print, ink, and watercolour on paper, 46 cm by 60 cm. Tate Gallery, London.

THE POETIC IMPULSE

the drawing, ending: 'Thy folds shall be full of sheep; the valleys shall stand so thick with corn that they shall laugh and sing.'[11] The figure lying reading among the sheaves of corn wears archaic dress and might be an Elizabethan poet or an evocation of Virgil himself, reading pastoral poetry in his rural seclusion, the whole scene magically illuminated by the harvest moon above.

The Valley Thick with Corn, by Samuel Palmer. 1825. Ink and sepia mixed with gum arabic, 18.2 cm by 27.5 cm. Ashmolean Museum, Oxford.

It was the 'glimmering poetical light of eventide', a Virgilian atmosphere of simplicity and purity in which such visions might occur as those in John Bunyan's dream adventure of Christian virtue, *Pilgrim's Progress*.[12] Like Wordsworth, whom he read alongside Milton, Palmer encountered the natural world with a 'spirit of religious love'. Nature was never just nature, but was always illuminated by a feeling of something beyond: it was as God's creation that it not only gave a 'thrill to the optic nerve', as Palmer wrote, but also 'sometimes pours into the spiritual eye the radiance of Heaven'.[13]

As Philipp Otto Runge was to Friedrich, so Samuel Palmer was to Blake – a gentler, somewhat saner spirit who preferred to dwell on the happier portion of existence. Palmer sought to depict a world that might be an illustration of the warm feeling for nature that could be traced back to Virgil and to the Arcadian themes of Roman poetry, transposing that sensibility to the watery light of Britain. The darkness and terror found so often in Blake, in his nightmare visions that epitomise the Romantic imagination, are far from the familiar and reassuring world of Samuel Palmer.

The depth of Blake's poetic vision was matched by the impressive colour and design of his images. He was an accomplished engraver, who made his living from engraving images of paintings, and invented new techniques of printing in colour, from the early *Songs of Experience* to his final illuminated book, *Jerusalem*.

In Japan, colour-printing using woodblock prints was already in full swing by Blake's time. These elegantly designed prints with their luminous hues and elegant tonality, known as *ukiyo-e*, or 'floating world', came to define the image of Japan. Closed to the outside world (with the exception of a few Dutch merchants) from 1635 to 1868 by the shōguns of the Tokugawa family, Japan during the Edo period became itself a floating world of poetic isolation. The earliest *ukiyo-e* images were the large painted screens that decorated the castles of Japanese feudal lords during the seventeenth century, the so-called Momoyama period. *Ukiyo-e* came into its own, however, with prints and book illustrations showing courtesans of the Yoshiwara pleasure quarters of Edo, Kabuki actors on the stage and other inhabitants of the illuminated streets and

alleys. Some went far in showing explicit sexual acts, the so-called *shunga* prints. Others depicted more wholesome landscapes, birds and flowers.

The earliest *ukiyo-e* prints were black-and-white line images of samurais and courtesans made in the late seventeenth century by Hishikawa Moronobu – the term *ukiyo-e* was first used in 1681. Monochrome woodblock printing was over a thousand years old in Japan, having been first introduced from China by the fourth century. It was only in the eighteenth century that an artist, Suzuki Harunobu, invented a means of colour printing. Harunobu's technique was to use multiple blocks, each printing a different colour, a technique known as *nishiki-e* (meaning 'brocade').

Like Blake, he used this new technique as a springboard into realms of poetry. The mood is wistful; the air is perfumed, a woman gazes at cherry blossom by moonlight in one of Harunobu's prints. She wears a long patterned robe and has been smoking a pipe, the aroma from which mingles with plum flowers from the veranda below. A poem floats in a cloud above her head. It is Harunobu's homage to the ninth-century Japanese poet Ariwara no Narihira and his meditations on permanence and change: 'Can it be that the spring / Is not the spring of old times?', the poet asks.[14]

The women in Harunobu's prints, courtesans from the Yoshiwara pleasure district, recall the exquisite aristocratic women from the Heian court, shown in the *Genji Monogatari* scroll.[15] Their refinement and idealised beauty can hardly have reflected the reality of prostitution in the Yoshiwara. They show a world without shadows, but also a world without morality – everything is subservient to the beauty of a flat image. Where the coloured print for Blake was intended to be popular but also political, part of a wider campaign for human liberty, those of the *ukiyo-e* artists – of Moronobu, Harunobu and their followers – were given over entirely to a static world of pleasure and beauty.[16]

The woodcut print by Kitagawa Utamaro of Okita, a famously beautiful waitress from the Naniwa tea house in the Yoshiwara district, shows her admiring herself in a mirror, perhaps fixing her hair before a shift, scooping tea and luring in male customers. We see her only in reflection, as she sees herself. Utamaro covered the surface of the print with mica, a sparkling mineral dust, to create the effect of a reflective surface.[17] Mirrors were considered sacred in Buddhist and Shinto tradition, in part because of their rareness, but also for their magical protective power, as if the reflection could itself preserve the image of the human face. To look into a mirror is also to confront oneself, a moment of vanity but also of introspection, which in

Utamaro's print becomes a symbol of Edo-period Japan as a whole.

As the tradition of *ukiyo-e* woodcut prints evolved, the range of subjects expanded beyond images of actors and of courtesans to the landscape of Japan itself. In the hands of two of the greatest figures of woodcut printing of the time, Andō Hiroshige and Katsushika Hokusai, the Japanese landscape became itself a character famed for its beauty.

Hokusai is famed for creating the most popular print of the *ukiyo-e* school, and possibly of all time, showing the curling form of a large wave with finger-like tendrils and Mount Fuji in the distance, *Under the Wave off Kanagawa*, often simply called *The Great Wave*. Hokusai had shown Fuji from every different view imaginable in his series of prints *Thirty-Six Views of Mount Fuji*, which he made in his seventies. It was for him, as for Buddhist tradition, a sacred, protective mountain, the ascent of which would preserve life, as one popular interpretation of its name suggests: 'Fu-shi' – 'not-death'.

Hokusai saw life and poetry everywhere. His drawings, which he began later in life, were reproduced as woodcut prints and bound in books, stretching to fifteen volumes. The *manga* (simply meaning 'sketches'), cover a vast range of subjects, landscapes and seascapes, dragons, poets and deities, plants and natural scenes, all combined together on album pages in a seemingly haphazard way, as if deposited by the random forces of life itself.

Hokusai's *Great Wave* is also a portrait of Fuji, but as a speck in the distance, about to be engulfed in a great swell of water. It is far from the flattened, unreal world of earlier Japanese painting and printmaking, and shows what Hokusai had taken from European art, from prints brought into Japan by Dutch traders. Prints and drawings from early in his career show him attempting, rather awkwardly, to apply mathematical perspective drawing. By the time of *The Great Wave*, however, the sense of deep space was far more subtle. The rigid converging lines of European perspective drawing become the gently sloping sides of the sacred mountain.

Andō Hiroshige belonged to the samurai class and worked as a fireman, a job he inherited from his father, which gave him plenty of time to train as a *ukiyo-e* artist.[18] He began with prints of actors and of beautiful women, but from the 1830s he made landscapes that traced his journeys along the Tokaido, the highway between the Sanjo bridge in Kyoto and Nihonbashi bridge in Edo. At the age of sixty he began what was to become his most famous series, the *Meisho Edo hyakkei*, or *One Hundred Famous Views of Edo*, showing the sights of Edo and its surrounding country: shrines and temples, bridges in rain and snow, festivals of spring and autumn, gardens with plum and cherry blossom, moon-viewing pavilions, religious banners strung on bamboo poles, fluttering in the breeze, gushing waterfalls, busy shopping streets, maple trees and harvest moons, views of Edo Bay and along the Sumida River, with the ever-present silhouettes of Mount Fuji and Mount Tsukuba in the far distance.

The distinctive look of Hiroshige's prints comes in part from his use of Prussian blue (a chemical pigment first manufactured in Europe a few decades earlier), only available in Japan since the 1830s, lending his images a deep, unnatural luminosity. Rainbow-like gradations of colour are created using a technique termed *bokashi*, in which ink is applied by hand to the wet printing block, so that the Prussian blue of the sky in the print *Kanda Myojin Akebono-no Kei* (or *Dawn at Kanda Myojin Shrine*) dissolves into white and then the orange and red of the rising sun. The robes of the priest of the Edo shrine on the right are similarly gradated, matching the colours of the dawn sky. The three figures with their backs to us gaze into the distance, perhaps at the first slivers of the rising sun, hidden by the trunk of a cedar tree.

(Denshin kaishu) Hokusai manga (Transmitted from the Gods) Random drawings by Hokusai), vol. 9, by Katsushika Hokusai. 1819. Woodblock print on paper, bound, 23cm by 16 cm. Metropolitan Museum of Art, New York.

THE POETIC IMPULSE

Hiroshige's views of Edo are images of quiet elegance and true to the transience of the 'floating world' of *ukiyo-e*. By the time he had begun his series, foreign trading ships had already arrived to challenge the closure of Japan. One year after his death, in 1859, the port of Yokohama was opened, leading in a few years to the fall of the samurai class to which Hiroshige had belonged. The old Edo was soon gone, preserved only in the images of the *ukiyo*-e masters.

In Europe, it was not Runge's light-filled, rose-strewn meadows or Palmer's summer evenings but rather the cold and stormy seas of Friedrich and Turner that were the great symbols of the first half of the nineteenth century. The 'unplumb'd, salt, estranging sea', as the poet Matthew Arnold described it, became one of the great subjects and settings for painters of the era, as if the fate of humanity itself had been set adrift on the wide, cold ocean.

One painting came to symbolise this fate more than any other: a vast canvas showing shipwrecked figures on a raft, some alive, some dead. In July 1816 the French frigate the *Medusa* ran aground off the coast of north-west Africa (modern Mauritania). The captain, a hapless nobleman, and his officers took the seaworthy boats, consigning the rest of the crew and the passengers to a makeshift raft, which was cut loose by callous officers, anxious to reach shore. What followed was a nightmare of violence, starvation and cannibalism that lasted two weeks. When they were finally rescued, only ten out of some hundred and fifty remained alive. In his painting, shown at the Salon in 1819, the French artist Théodore Géricault show the cruellest moment, when the survivors sighted their eventual rescue ship, the *Argus*, only to see it disappear once again over the horizon.[19]

Géricault learned of the story from a book written by two of the survivors, Henri Savigny and Alexandre Corréard, who had sued the government for compensation. He transformed their grisly account into an image that showed a contemporary tragedy as deeply political. His painting was an outright attack on the indifference to ordinary lives of the aristocrats who had cut the raft loose. Géricault pioneered a type of painting that captured the fury and energy of revolution but turned it upside down, revealing rather the emptiness of idealism and the melancholy underside of human life, and yet showing how this tragedy might become part of a political struggle for change.

He worked up his painting from numerous sketches and studies, according to the usual academic method of creating such large painted scenes. Géricault made studies of body parts from the local morgue, to show the horrific scenes of cannibalism and dismemberment. One of these studies shows two severed legs and arms emerging from the shadows in a morbid pile.

Severed Limbs, by Théodore Gericault. 1818. Musée Fabre, Montpellier.

They are like the limbs of Caravaggio's saints, with the difference that Géricault's grimy feet with dirty soles have become detached from their bodies. Géricault kept the human remains, including severed heads, in his studio until the extremes of putrefaction obliged him to dispose of them.

The figures on the raft were painted from professional models, as well as wax figures. Géricault also asked his fellow students to pose – including a twenty-one-year-old painter named Eugène Delacroix. Eugène obliged by lying half-naked in Géricault's studio on a scale model of the raft, while his fellow artist sketched his form, imagining how it might be convincingly shown as dead, or nearly so (he is the figure in the middle foreground, face down with arm outstretched), with pallid skin tones, like those of the bodies he had painted in the hospital morgue.

Delacroix returned to Géricault's studio to see the large painting emerging on the canvas. Rather than having any misgivings about being shown as dead, he saw it as a new ideal of terror-ridden beauty, which made a deep impression. Delacroix was to spend the rest of his life exploring this strange idea of beauty, one that seemed drenched in its opposite, a violence and awkwardness of forms often bordering on the repulsive. Such an ideal was also found in the poetry and literature he read, in Shakespeare, Goethe, Byron and Walter Scott.[20] Against the clear forms and controlled colours of academic practice, above all that of Jacques-Louis David, Delacroix pitted the dark, violent heat of the Romantic imagination.

Such heat was generated by colour, particularly a gemlike, radiant red, recalling the deep, glowing hue of stained glass, as well as the red of Venetian painting, of Titian and Veronese. It is the one thing that remains in the mind from Delacroix's paintings, as if all the subjects might gradually dissolve, the stories fall away and leave only a glowing vermilion hue synonymous with the artist's name. Heat was also generated by violent energy, recalling the swirling compositions of Rubens, transposed by Delacroix into his images of lion hunts, in which the massive forms of beasts and men turn around in ecstasies of mortal, bloody combat. In his painting *The Death of Sardanapalus*, showing the last king of Assyria putting his harem to death before destroying everything else that he owned rather than surrender to the Persian siege, violence is mixed with eroticism, a disturbing combination of sex and death.

Liberty leading the People (28 July 1830) (detail) by Eugène Delacroix. 1830. Oil on canvas, 260 cm by 325 cm. Musée du Louvre, Paris.

THE POETIC IMPULSE

Heat arose also from the ferment of revolution. Delacroix's most famous image was painted in the wake of the revolution in France of July 1830, the overthrow of the Bourbon monarchy. Liberty, shown as a woman leading the armed populace over the barricade and fallen comrades, holds a musket and the tricolour, the flag of the French Revolution. For Delacroix, *Liberty Leading the People* was once again a memory of Géricault's raft, the flag a symbol of desperate hope, of the people against a corrupt established order. And yet, true to the indeterminate nature of Romanticism, it is hardly clear-cut propaganda. The top-hatted figure to the left of Liberty has stopped in his tracks, lost in worried thought, perhaps wondering if he really wants to die for an idea. Liberty herself seems to hesitate, not because her clothes are falling off but because of the contrast between her pure revolutionary ideals and the reality of black smoke and death all around. Heroism, like beauty, was complicated in the post-revolutionary Romantic age.

Despite such political subject matter, Romanticism was for Delacroix something highly personal. His paintings are all essentially portraits of his imagination. Unlike Géricault, he was unconcerned with historical reconstruction, with painting generated from endless notes and exhaustive research. The point was the image itself, in all its artifice. He had in truth never seen the wild beasts that he loved to paint – the lions and tigers that he showed in forest and wilderness or engaged in mortal combat with other animals, including humans – in their natural habitat; instead he sketched them at the Jardin des Plantes in Paris, sometimes with his friend the sculptor Antoine-Louis Barye. His tigers might be those described by Blake, with their 'fearful symmetry', although their fervour came not from dreadful encounters in the wild but rather from feeding time at the zoo.

However much artists wished to escape the past, history was still the greatest subject for painting, and large historical subjects were the goal for the most ambitious images, with Géricault's *The Raft of the Medusa* setting the standard for the era. Artists might earn their living painting or drawing portraits, like Jean-Auguste-Dominique Ingres, who was famed for his unerringly accurate pencil portraits, but they yearned to paint great heroic canvases – although in Ingres's case, not works like Géricault's *Raft of the Medusa*, the pain and horror of which he thought offensive, and which he thought should be removed from display at the Louvre.

The look of Ingres's paintings, disciplined and polished, put him at odds with the rough and wild spirit of Delacroix. They were rivals, although in truth their paintings were closer in their dependence on colour, surface and exotic subject matter than either would have admitted. Yet where Delacroix emphasised everywhere his brushmarks, Ingres did his best to create smooth surfaces, effacing all signs of his physical presence on the canvas. His image of a bathing woman (known as the *Valpinçon Bather* from the name of one its owners), shown from behind,

Tiger startled by a Snake, by Eugène Delacroix. 1854. Oil on paper on mahogany, 32.4 cm by 40.3 cm. Kunsthalle Hamburg.

The Bather, called the Bather of Valpinçon, by Jean-Auguste-Dominique Ingres. 1808. Oil on canvas, 146 cm by 97 cm. Musée du Louvre, Paris.

is a masterpiece of suggestion – we see nothing of her apart from her back, and the slightest detail of her nose and eyelash.[21] Light plays over her back and over the white sheets of the divan on which she sits with a startling realism, capturing forms with a stillness that brings to mind earlier Netherlandish painting. Ingres was the Van Eyck of his age. Light is the subject, conveyed by the different way materials are draped, or tightly wrapped, like the sheet strangely worn on the woman's arm. And yet for all the impression of intense naturalism, look closer and you see that it doesn't quite add up. The bather's right leg is a flattened form, included simply for the sake of pictorial balance, just as the spout of water behind the green curtain seems to belong to a different painting altogether. Ingres's figures are often like this: boneless, not in the Chinese sense of objects shown without volume, but in a literal sense of volumes of flesh painted to create a satisfying, balanced image, rather than to give a sense of the internal structure of the body.

Ingres, for all his spectacular technique, was really a painter of compromise, caught between the extremes of poetic Romanticism and academic exactitude. The fascination of his work depends on its minutely believable appearance as much as on the charm of his colours and smooth surfaces. Other painters, such as the leading history painter Paul Delaroche and Horace Vernet, known for his battle scenes, trod such a middle path with their anecdotal scenes, engaging but ultimately inoffensive story-telling drawing on popular stories of history and myth: qualities of what was known as '*le juste milieu*', or middle-of-the-road painting, illustrations of popular tales, preferably with an erotic or violent twist.[22]

Romanticism, in its formlessness, its appeal to sensation, individualism and freedom of imagination, was bound to win over such painting – it was, after all, simply a definition of what it meant to be young and of the moment. Poetry, rather than history, was the future. Where Turner and Delacroix were the beginning of a new world of painting, their classical rivals, from David to Ingres, seem more like the final statements of a tradition that can be traced back to Poussin and the work of the Italian painters of the sixteenth century. For their poetry, painters relied on personal memories, rather than historical sources. To evoke a sense of experience, of moments stored in the mind, as Wordsworth had described in *The Prelude*, became the great achievements of artists in the latter part of the century. Few painters evoked such a mood of recollection as Jean-Baptiste-Camille Corot, who began painting in his twenties and over the next sixty years, until his death in 1875, evoked a world of gentle poetic memory, as if seen through a dream. It was a timeless, unchanging world, on which the

symbols of the new, such as railways, never imposed, even though the tracks had already been laid.

Corot sketched and painted outdoors all his life. He mastered the technique of capturing subtle gradations of vision, the minute difference in light as it travels through air. In his later canvases he was concerned less with colour – his paintings rarely feature bright hues – than with silvery tonal values of light and dark. The paintings of the years from around the 1860s take on a soft, glowing poetic mood, a world of permanent twilight and reverie, in which suddenly a memory from the past might appear, like the stag that leaps past a clearing in some trees in the painting *The Clearing: Memory of Ville d'Avray*, momentarily glimpsed by a seated woman who turns, startled by the gentle thumping of galloping hoofs. Like Mary in scenes of the Annunciation, she has been disturbed in her reading. Solitary figures, often women, many of them reading, appear in Corot's late paintings, suggesting a world that has itself sprung from the pages of a book, a novel in which the words unfold images to which the mind can escape from the cares of daily life.

'Corot comes from the land of dreams where trees, brooks, horizons are nothing but serene visions, flowing souls that speak directly to our souls', the poet Théodore de Banville wrote in 1861.[23] 'Il étonne lentement', Baudelaire said: 'He astonishes slowly.'

When a young painter from England travelled to North America in 1820, the wilderness landscapes he encountered must have seemed like something from a dream. They were certainly unlike his native Lancashire. Thomas Cole arrived with his family in Ohio at the age of seventeen and began his steady ascent to become one of the leading landscape painters in America. He was as bad at painting figures as Turner was – his eye was always on the bigger picture, the epic sweep of landscape rather than the human life within it. He was fascinated by a looping bend in the Connecticut River at the foot of Mount Holyoke in Massachusetts, and took it as the subject for a landscape that captured the experience of pioneers in the wilderness. Meadows and farmland are shown in clear bright morning light, while the wilderness is darkened and pummelled by a rainstorm, a flash of lightning visible in the distance. The landscape is changing, and Cole places himself prosaically at the centre: a tiny figure perched on his vantage point, turning self-consciously to greet the viewer.

Cole stood at the beginning of a tradition of American painting that became known as the Hudson River School, of which Frederic Edwin Church, who studied with Cole in his studio in Catskill, New York, was to become a leading

The Clearing. Memory of Ville d'Avray, by Jean Baptiste Camille Corot. 1869–72. Oil on canvas, 99 cm by 135 cm. Musée d'Orsay, Paris.

Heart of the Andes, by Frederic Edwin Church. 1859. Oil on canvas, 168 cm by 302.9 cm. Metropolitan Museum of Art, New York.

light. He was a far better painter than Cole, and went much further afield to seek the wilderness that was their painterly ideal.

Church's large canvas *Heart of the Andes* shows thick vegetation, forests and a waterfall in front of snow-capped mountains, while close-to exotic creatures, including butterflies and a quetzal bird, as well as flowers, vines, moss and leaves, all come into view. The painting was based on two expeditions to Ecuador in the 1850s, themselves inspired by the German naturalist and philosopher Alexander von Humboldt. Church included Mount Chimborazo, which Humboldt had famously climbed, in the background of his painting.[24] Humboldt's view of nature and the natural world, which he encapsulated in his vast five-volume *Cosmos* (the final volume of which appeared in 1862, three years after the author's death), was one of dazzling diversity. Climbing the mountain in Ecuador, he saw that 'the depths of the earth and the vaults of heaven display all the richness of their forms and the variety of their phenomena'.

It was this variety that Church captured in drawings and oil sketches while travelling through Colombia and Ecuador, marvelling at the bird life and vegetation, and sketching views of Chimborazo and other snow-covered Andean peaks, drawings used in the creation of *The Heart of the Andes* back in his studio in New York. Like so many of the Romantic landscape painters before him – Friedrich, Turner and Ward, in particular – his vision drew on memory and imaginative recreation. The resplendent quetzal, to take one instance, could only be found further north, in Mexico and Panama, where it had been sketched by Church on an earlier trip.[25]

These visions of the American landscape were imaginative impositions in another, more fundamental way. They had their origins in a European tradition of oil painting, and were part of the colonial vision of the new world, just as the indigenous tradition of Cuzco painting in Peru was derived from Jesuit missionaries and Spanish colonialism. Although the American-born Church made his name with his extraordinary painting of the Niagara Falls in 1857, that work has more in common with the English landscapist Richard Wilson's painting of Niagara, made from a detailed drawing by a British soldier, Lieutenant William Perrie of the Royal Artillery, just under a century earlier, than with any older image of the landscape made in America.

An entirely different poetic response to the landscape was created by the indigenous peoples of North America who lived on the vast stretches of prairie –

THE POETIC IMPULSE

the rugged, open expanses of windblown grass of the Great Plains. They recorded the events of their lives, principally battles, on tanned buffalo hides, in a schematic, geometric style, and later on the sheets of ledger books they obtained from traders and officials.[26] Alongside Howling Wolf of the Southern Cheyenne and Black Hawk of the Sioux, the artist Wohaw, of the Kiowa people, was one of the leading Plains Indian artists. His drawing of a man receiving spiritual power from a bison and a spotted longhorn bull, to whom he offers pipes, is made with a powerfully direct drawing style.[27] We might think of the ancient 'Master of Animals' motif, a human taming two standing beasts, but Wohaw reverses the meaning, so that the human is drawing power from the animals, rather than subduing them.

Wohaw made his drawing while in prison at Fort Marion, Florida, having been sentenced for resisting American expansion onto the Great Plains. The drawings made here by Wohaw and other artists were an evocation of their experience and a response to the violent appropriation and colonisation of land by European settlers. They could not be further from the images of Thomas Cole, sitting primly on his hill looking over the valley, or Church, marvelling at the biodiversity of the tropical south. Wohaw's drawing, like many of the images made by indigenous Americans, bears witness rather to a changing, darkening world.

A Man Receiving Power from Two Spirit Animals, by Wohaw. 1877. Pencil and crayon, 22.2 cm by 28.6 cm. Missouri History Museum, St Louis.

24

Everyday Revolutions

As Delacroix was painting his great Romantic canvases and Hokusai was working in the twilight of Edo-period Japan, a novel means of creating images was invented in Europe that was to revolutionise the world. The middle years of the nineteenth century were the first great age of photography. It was in Paris in 1839 that the seemingly magical technique of fixing a projected image using light-sensitive chemicals was first unveiled, by the painter, stage designer and inventor Louis Daguerre. The images he created on silver-plated copper sheets he proudly christened 'daguerreotypes'.

As with many great leaps in human endeavour, it was not a single person, working alone, who created this new way of fixing images with light and chemicals. Just over a decade earlier the French inventor Nicéphore Niépce had discovered a process he termed 'heliography', or 'sun-writing', by which an image was fixed using light-sensitive bitumen coated on a plate. In England, around the same time that Daguerre announced his invention, William Henry Fox Talbot invented a method of printing multiple images on paper using a negative. 'Talbotypes', he called them, or 'calotypes' from the Greek word *kalos*, meaning 'beautiful'.

Another technique, invented in 1842 by the scientist John Herschel, a friend of Fox Talbot's, involved placing objects directly onto paper treated with photosensitive chemicals. One of the first artists to use this method, known as cyanotype (or 'blueprint'), was the botanist Anna Atkins, who recorded specimens from her collection of plants, including many seaweeds, in *Photographs of British Algae: Cyanotype Impressions* of 1843 – one of the first books to be illustrated with what soon came to be known as photographs.[1]

Word of this seemingly magical new technology spread rapidly. As early as 1840, a matter of months after Daguerre's announcement in Paris, it had reached as far as Brazil, where the entrepreneurial emperor Dom Pedro II was the first in the country to use a daguerreotype camera. In America, the first photographic studio opened in Boston the following year, after the technique had been demonstrated in New York by Samuel Morse, who had studied with Daguerre. Morse also taught Mathew B. Brady, who became one of the most celebrated photographers of his time. With the outbreak of the American Civil War in 1861 Brady became one of the first war photographers, although the laborious

Anna Atkins, Gelidium rostratum. c.1853. Cyanotype. Natural History Museum, London.

technique of fixing an image meant that images of action were rarely captured. His photographs were rather of generals posing, and of fields and ditches filled with the war dead.

It took an artist trained as a painter to transform photography into more than a mere record of appearances. Gustave Le Gray was a pupil of the French painter Paul Delaroche who had enjoyed some measure of success with his paintings, which had been accepted and hung at the Paris Salon. When he boldly submitted his photographs, however, they were roundly rejected. In the eyes of the Salon jury, photography was not on a par with painting.

Le Gray was hardly dissuaded, and persevered with all the zeal of a new convert. He established himself as a teacher of photography, wrote treatises, founded societies and explored new subjects and photographic techniques. The images he took of historic buildings around France were part of an official mission to record ancient buildings, and he followed in the footsteps of painters by taking photographs in the Forest of Fontainebleau. In Paris he established a fashionable photographic portrait studio, although any terror that he may have cast in the hearts of old-fashioned portrait painters was quelled when Le Gray's business failed. He fled for Egypt, where he spent his final years making some of the first photographic records of the ancient monuments along the Nile.

Le Gray's most sensational photographs were the seascapes he took at Sète, on the French Mediterranean coast, in the 1850s. From glass negatives he made a number of albumen prints (made using the albumen in egg whites and salts to bind the photographic chemicals to the paper), capturing the rushing of the water against dark, wet rocks, beneath a luminous sky. He used two glass negatives for his print – one of the sky, one of the sea, joined at the horizon, a way of avoiding overexposing the sky, reclaiming the brightness and brilliance of the clouds.

For painters, photography was an undoubted challenge. Why learn to draw like Holbein or paint like Ingres when the camera could do the job in a much shorter time? Portraiture, the commercial mainstay for many artists, now seemed to be entirely in the hands of photographers. The English photographer Julia Margaret Cameron, who was introduced by John Herschel to the technique 'in its Infant Life of Talbotype & Daguerreotype', as she later described it, was attracted to the idea of photographic portraits as aesthetic objects rather than mere records of appearance.[2]

Alfred Lord Tennyson, by Julia Margaret Cameron. 1866. Albumen silver print from glass negative, 35 cm by 27 cm. Metropolitan Museum of Art, New York.

As well as creating photographic illustrations to the poems of Alfred Tennyson (*Illustrations to Tennyson's 'Idylls of the King' and Other Poems*, 1874–5), she portrayed the poet himself as if painted by Rembrandt or Van Dyck, with a doleful expression, seemingly playing a part in a historical drama.

The success and convenience of photography were such that many young painters, trained in the best Parisian studios, decided to follow Daguerre and Le Gray rather than Delaroche who, on first setting eyes on a daguerreotype, famously declared that, 'from today, painting is dead'. And yet photography was also an inspiration to painters, not

only as a spur to rivalry but also to show how a painted canvas might offer an even closer impression of reality, recreating the physical impression of the natural world rather than, as with photography, mere appearances.

The fact that a camera could be set up anywhere – not just in the portrait studio but on the rocky coast, in the depths of a forest or in a city street – encouraged painters to turn their gaze away from the grand scenes of history and myth that had dominated painting for centuries and to take the shocking decision to show the everyday reality of the surrounding world and the people who dwelt within it. 'Almost never was man, in his common capacity as man, the direct subject of painting', wrote the critic Théophile Thoré.[3]

In 1849 the French artist Gustave Courbet painted a scene of two labourers, known as *The Stonebreakers*. Courbet painted the weight of the world, and the tiredness of the two workers' lives, their faces in shadow as they break rocks, clearing the way for a road. The older man lifts a hammer, not sufficiently robust for its task, bound to send a painful judder through his bones as he strikes the next boulder. His waistcoat is torn, like the shirt of the young boy lugging away a heavy basket of stones. Above them, a hill rises in darkness, blocking all view of the sky, save for a tiny patch of blue in the distance.

The Stonebreakers was later destroyed and was to survive, as it happens, only as a photograph. In Courbet's day it was a manifesto for a movement: his rural workers cleared the way for a new type of image, known at the time, and since, as realism. It was a very different kind of realism from that of photography; where the photographic print creates a distance between viewer and subject, like something seen through a small window, painting embodies reality on the very surface of the canvas, by the physical marks of the medium. We feel when looking at a painting that we might also be touching it, whereas the surface of a photograph is always invisible. We look rather through the paper to an imaginary image beyond.

Courbet's paintings of the sea, made, like Le Gray's photographs, at Sète, show up this contrast. His weighty, powerfully painted images of waves make Le Gray's images look distantly poetic, romanticised by comparison. Courbet's waves are physically present, cold water rushing and breaking on the shore close by, as if the water might run over our feet, while thick masses of clouds bear down over the expanse of sea. We can hear the waves and smell the salt air, feel its coldness on our cheeks. The effect of Le Gray's photographs, by contrast, is like looking through the lounge window of a comfortable hotel salon onto a silent seascape.

The reality that Courbet painted was earthy, heavy, self-effacing – ugly, even. It was a painted world intended to appeal not to connoisseurs (even if

these were the people who generally bought his paintings) but to the sensibilities of ordinary people. Where Delacroix drew illustrations for editions of Dante and Shakespeare, Courbet made illustrations of workmen to accompany a book of popular songs collected by his great supporter, the critic Champfleury, one of the first to promote his work.[4] He was, and liked to believe himself, a man of the people, whatever that might mean, and his aim was to make paintings that proclaimed his democratic vision.[5]

This defiant vision was launched with an image of a burial. Courbet used his own birthplace, the village of Ornans, near the Swiss border, as the setting for the painting that made his name when shown at the Salon in Paris in 1851. His depiction of a funeral at the village of Ornans shows the grave as a dark pit and the mourners as a continuous band of dark figures, the priests and choirboys simply a continuation of this heavy frieze. A crucifix is raised above their heads and appears almost to stand in the bare, craggy landscape beyond, but attention is attracted more by a dog in the foreground, looking the other way. For centuries, painters had represented death in terms either of salvation or tragedy. For Courbet death was nothing, cold zero, a body thrown into a gloomy hole in the ground.

This was one definition of realism: painting that was simply there, like life and death, without deferring to the hierarchies laid down by academic tradition and by the Church and court since time immemorial. None of the heroism of ancient myth, or transcendence of religion, but rather the drudgery and monotony of working lives.

Courbet was a quite different painter from Turner – he could paint figures, and rarely got lost in fantasy or myth – and yet the realism underlying their painting draws the two artists together, particularly in their depiction of the sea: neither of them painted it blue. The direct impression of nature also appeared, as we have seen in the paintings and oil sketches of John Constable, conveying the movement of light and the texture of water, the heaviness of trees, the billowing mass of clouds and the brightness of the sky. The painter Benjamin West, the president of the Royal Academy, gave the young Constable sound advice on this matter: 'In your skies [...] always aim at *brightness* [...] I do not mean that you are not to paint solemn or lowering skies, but even in the darkest effects there should be brightness. Your darks should look like the dark of silver, not of lead or of slate.'[6]

It was advice that Constable heeded closely: brightness shines from the wide skies above Constable's landscapes and rural scenes, while dramatic lights and darks, 'chiaroscuro', as he put it, made up from flecks and scuds of whitish paint, animate the world below. The 'dark of silver' might bring to mind silver-coated photographic plates, and yet in his painting Constable created the opposite of the invisible surface of a photograph, his canvases rather rippling with texture and encrusted detail.

In his painting of a young shepherd boy pausing to drink from a stream on a lane leading to a summer cornfield, we feel we have not so much a Romantic fragment, however poetic the scene may be, but rather a complete statement of reality, a world unto itself – that mark of all great painting. We see Constable's skill in composing a complex scene of light and dark, of patches of colour: the red of the boy's waistcoat, the sloping yellow band of the fulsome crop, painted with just a few masterly strokes, and the grand massing of trees against the silvery sky. The reality is the roughness of the detail, the fence hanging from its hinges, the random

The Cornfield, by John Constable. 1826. Oil on canvas, 143 cm by 122 cm. National Gallery, London.

dappling of sunlight all around, the slightly ragged heads of corn on a slope above the boy, his sheepdog, pausing, head raised and ears cocked, while the boy in a strange, ungainly pose lies face-down to the stream, not, like Narcissus, admiring his beautiful reflection but gulping the water thirstily down.

The rough reality of Constable's surfaces makes the completeness and balance of his compositions quite unlike the landscapes of Claude Lorrain, or of Richard Wilson, the Welsh painter who came closest to this type of classical landscape in the eighteenth century. Although Constable was careful to bring his canvases to a high level of finish to satisfy his buyers, he unleashed his sensuous love of oil pigment in his large-scale 'sketches' – preparatory paintings made in a remarkably loose manner, the paint dabbed and scraped to capture the tonality and flashes of colour in his subjects. Full-size sketches for *The Leaping Horse* and *The Hay-Wain*, as well as *The Cornfield*, were made with a boldness that suggests they are truer to Constable's own heart, to his love of painting, than the finished canvases, which were, however, more likely to sell. Both in their detail and in their overall impression they are splendid, free and chaotic.

Like Wordsworth, Constable walked in nature with a great feeling of spiritual reverence, filled with memories of childhood. He communicated this reverence in a language unaffected by the religious awe of Friedrich, but rather with a feeling for light, for its softness or hardness, its sparkling movement over meadows and through trees. His native village of East Bergholt and the surrounding Vale of Dedham and the Stour valley were Constable's inspiration. *The Cornfield* shows Fen Lane, the path leading to Dedham down which Constable walked to school every day. Childhood memories gave an intimacy to the nature that inspired him, rather than crashing waves or epic sweeps of landscape: 'the sound of water escaping from mill-dams, willows, old rotten planks, slimy posts, and brickwork, I love such things', he wrote.[7]

'Painting', Constable wrote, 'is with me but another word for feeling.'[8] His first biographer wrote that he had seen the artist admire a tree with the same ecstasy 'with which he would gather up a beautiful child in his arms'.

'Democracy is like a rising tide', wrote Alexis de Tocqueville in 1833, 'it only recoils to come back with greater force.'[9]

Some of the starkest images of sympathy with ordinary people made during the nineteenth century were by a Russian artist of Ukrainian birth, Ilya

Krestny Khod in Kursk Gubernia (A Religious Procession in the Province of Kursk), by Ilya Repin. 1880–83. Oil on canvas, 175 cm by 280 cm. Tretyakov Gallery, Moscow.

Repin. His early life painting religious icons in St Petersburg was put into question after visiting Paris in the 1870s, where he encountered a new style of painting that appeared untethered from weighty academic conventions, especially the works of the French artist Édouard Manet.

When he returned to Russia, Repin moved to Chuguyev (modern-day Chuhuiv, in Ukraine), the town of his birth, full of a sense of revival and enthusiasm to rediscover his roots. His painting of a religious procession in the Kursk province, to the north, could not have been painted without the revelation of the bright, airy images of French painting, but the subject is resolutely Russian, a history painting of contemporary social life, inspired by Repin's own sense of connection with his childhood world. A surging crowd, carrying icons, banners and a gilded shrine aloft, represents the broad sweep of society, from priests and officers to peasants. The focus of the scene is on a hunchbacked boy, limping, driven on by a figure who may he his father. Unlike Courbet's *Burial at Ornans*, which the Russian artist may well have known, and which transforms the mourners into silent monumental forms, Repin's painting shows ordinary people as dynamic and forceful, agents of a revolution to come, riven and yet undaunted by social inequality.

For all the portraits that he painted of artist and writers, as well as his later years working for the Russian state, Repin found the source of his images in the lives of ordinary people. He was to painting what his friend the writer Leo Tolstoy (of whom he made many portraits) was to Russian literature: a penetrating observer of the telling details of life, a writer who always lived within the present moment of those he wrote about.

Carried by the tide of democracy and workers' movements, and by the irresistible power of the photographic image, realism became a truly international style in the first years of the nineteenth century. Mexico gained its freedom from Spanish

EVERYDAY REVOLUTIONS

dominion in the 1820s after a long and bloody war for independence. Painters returned to indigenous Mexican subjects, rendering them in the realist style that accompanied the desire for social justice in the new liberal, democratic world.

Vicenta de la Rosa, by Hermenegildo Bustos. 1889. Oil on board, 17.3 cm by 13.5 cm. Museo Nacional de Arte, INBA, Mexico City.

One of the most unusual of these, and one far from the dramatic events of liberation, was an artist who lived and worked in La Purísima del Rincón, a remote locality in the state of Guanajuato. Hermenegildo Bustos liked to remind people that he was a self-taught painter, which can be seen in the lack of academic 'finish' on his portraits. Like John Constable, Bustos was obsessed by the weather, noting down in his calendar daily conditions, the occurrence of storms and heatwaves, as well as the often scandalous goings-on in his community. In the morning he conducted his duties in the parish church, one of the hundreds of such Catholic institutions in the Hispano-Mexican world, which included for Bustos making decorations and painting religious images.[10] He was clearly a proud man, who painted a self-portrait in 1891 wearing a tunic he had made himself, with his name 'H BUSTOS', embroidered on the stiff upright collar.

Bustos painted portraits of the locals of La Purísima, and of the neighbouring village of San Francisco del Rincón. The sittings in his small studio might be imagined, the sitter still with concentration, curious to see the image appearing on the canvas, probably the only image made of them during their lifetime. Bustos was not out to flatter, but rather to record the lives of his sitters, ranging from farmers to clerics, their individual humanity and also their physical presence. Their identity is in many cases unknown, attested only by a portrait and a name. All that remains of Vicenta de la Rosa, whom he painted in 1889, is the portrait made of her by Hermenegildo Bustos.

One of the greatest painters of working people in Europe during the nineteenth century was himself a peasant, born in 1814 in a small village in Normandy. Jean-François Millet turned to depicting peasants after leaving Paris in the wake of the 1848 revolution, which had inaugurated the short-lived Second Republic. Millet walked with his family to Barbizon, a small village in the Forest of Fontainebleau, and it was here that he spent the last thirty years of his life, painting the people of the land. Like Samuel Palmer before him, Millet drew and painted shepherds and shepherdesses, and others whose lives seemed to grow from the soil on which they worked, yet not as denizens of some glowing Arcadia but rather as tired and impoverished workers, carrying bundles of sticks, digging the soil or bent double, gleaning those stalks of wheat missed by the reapers' sheaves, an age-old right for the rural poor. Millet's *The Gleaners* shows

two such women bent double, signalling the endless repetition of their task.[11] Millet captures the monotony and emotional emptiness of labour, and yet an atmosphere of myth still seems to linger – not for Millet the awkward, often ugly reality that Courbet took as his subject. Millet saw the world through the filter of the Bible and classical literature, and was at pains to make clear that he was not a socialist – 'the human side is what touches me most', he explained.[12]

Millet was sympathetic to the drudgery of work, but also saw the moments of release and relief in everyday life. Two shepherdesses are at their noonday rest, knitting by a sheltered bank, when their attention is suddenly caught

by the honking of a flight of wild geese. One of the women has jumped up to view the sight, the other leans back, gazing upward, indifferent to the geese but transfixed by having been momentarily taken out of herself and released from the mundane labour of life.

Millet made his pastel drawing *Shepherdesses Watching a Flight of Wild Geese* in 1866 (it was in fact the third version of the subject he completed). Alongside the caricaturist Honoré Daumier, he was one of the greatest and most prescient draughtsmen of his time, and yet his shepherdesses belong to an earlier era. The landscape, especially in Germany and England, had already been transformed by new industrial processes, as had the nature of work itself. 'Who is the landscapist who will render the blast furnaces in the night, or the gigantic smokestacks crowned at their summits with pale fires?' the novelist and critic Joris-Karl Huysmans asked.[13]

Vicenta de la Rosa's tired but serious expression in Bustos's portrait suggest that her life was dominated by the routine of work, just as do the languid bodies of Millet's peasant women. In a world being transformed by industrialisation it was the subject that posed the greatest challenge. How to confront this new pattern of life, these new machines, these new tired human faces and weary bodies?

Shepherdesses Watching a flight of Wild Geese, by Jean-François Millet. 1866. Pastel and conté crayon on paper, 57.2 cm by 41.9 cm. Museum of Fine Arts, Boston.

Where Turner saw the epic in nature, the German painter Adolph Menzel saw a similar awesome quality in industrialised work. Whereas Caspar David Friedrich painted landscapes through a Romantic, religious lens, Menzel painted and drew just about everything else. He captured the world around with photographic intensity, as well as creating images of historical subjects, notably the life of Frederick the Great, the much-loved ruler of Prussia in the eighteenth century.

Menzel painted historical scenes with such accuracy that they seem like eyewitness records, and captured his own world with such precision that it remains alive more than a hundred and fifty years later. His painting of the Berlin–Potsdam railway, made in 1847, was one of the first depictions of this dramatic new subject. Turner's canvas of a train careering over Maidenhead bridge in England, *Rain, Steam and Speed, the Great Western Railway*, was painted just three years earlier.

Later in his career Menzel travelled to a large metalworking factory in Upper Silesia, his birthplace (in present-day Poland), to gather material for his most ambitious industrial painting. *The Iron Rolling Mill (Modern Cyclops)*, completed in 1875, shows the interior of a factory where white-hot iron is being manually rolled, or laminated, to produce railway tracks. Menzel spent weeks in the factory, drawing workers and machinery, trying to understand the complex and dangerous method of producing train tracks.[14]

It was an unusual subject. In France the painter François Bonhommé had painted factory interiors, and Courbet, as we have seen, had also painted workers, sensitive to the drudgery of their toil. And yet no other painter documented the intensity, clamour and danger of work in such exhaustive detail. It is as though Menzel himself was building the iron rolling mill, organising the production of the train tracks and setting the labour in process. On the left

workers wash themselves, while in the foreground two figures eat their meagre lunch, brought by a woman leaning precariously into the painting. Thick, dank smoke gathers in the skylit hall (not unlike a railway station), the white heat of the furnace frothing like a wave, the drab colours of the workers' uniforms, and their faces illuminated by the glow of the fire, all accurately recorded by Menzel. At the centre a single red-hot iron bar, rising through the composition, is being drawn out by a mill hand with giant tongs, ready to be taken off to be cooled and moulded with a steam hammer.[15]

Menzel's vision of working life, like Millet's images of peasants, drew on a long tradition of figure painting showing work as heroic. The reality of work in the newly industrialised world was one of repetition and boredom. The factory

Das Eisenwalzwerk (The Iron Rolling Mill), by Adolf Menzel. 1872–5. Oil on canvas, 158 cm by 254 cm. Alte Nationalgalerie, Berlin.

was not Vulcan's forge, and consolation in the form of a flight of wild geese, as Millet had shown, was in truth the province of poets rather than observers of the real world. With the division of labour into stages of production, there was not even the satisfaction of creativity, of seeing and taking pride in the product of one's own labour.

Such boredom and distraction spilled over into everyday life, into the new urban world of work and leisure. To capture this world was, for the French poet and critic Charles Baudelaire, the crucial task for painters. In his essay 'The Painter of Modern Life', written in the winter of 1859, Baudelaire set out his vision of paintings as 'eternal and immutable', yet also as a mirror to capture the fugitive, passing moment.[16] He saw the accomplished illustrator Constantin Guys as an artist who, in his sketches of everyday life as much as his drawings made as an eyewitness of the Crimean War, reproduced as engravings in the *Illustrated London News*, was attuned to the spirit of the moment, every image in some way the *dernier cri* – the latest thing.

Rather than Guys, however – a fascinating but ultimately secondary figure – it was another of Baudelaire's acquaintances, Édouard Manet, who became the great painter of modern life, both by what he depicted (although he also took in historical subjects) and by how he applied his paint to canvas.[17] Manet's loose brushwork recalls Diego Velázquez and Frans Hals, two artists whom he admired for their improvisatory style, and yet the figures on his canvases do not flash with bravado or engage laughingly with their viewers but seem rather to be lost in

Un bar aux Folies-Bergère
(*A Bar at the Folies-Bergère*),
by Edouard Manet. 1882. Oil
on canvas, 96 cm by 130 cm.
Courtauld Institute of Art,
London.

thought, detached even. A woman sits by the railings of the Gare St-Lazare, looking at us with a blank, resigned expression, while her young daughter turns her back and gazes at the railway, that great symbol of industry and progress. In an artist's studio a

young man poses by the breakfast table, wearing a straw boater, looking beyond the picture space with a look of haughty indifference. A woman lies naked on a divan, staring out with defiance. She appears to be a prostitute, greeting a client.

These looks are everywhere in Manet's painting. Where Hals was the first to paint a smiling laugh, Manet was the first great connoisseur of *ennui*, that sense of boredom spread out into time and space, so that the whole world seems suspended for want of something meaningful to do. It is the world of modern work, captured in Manet's painting of a barmaid at the *Folies Bergère* cabaret, staring at her gentleman customer, ready to serve yet another glass of champagne and listen to the same trite comments and insinuations. She doesn't appear to be enjoying her job. Behind her a large mirror reflects chandeliers and the crowd enjoying the show, tantalisingly hinted at by a pair of green boots on a trapeze at the top of the canvas. Nothing is natural or at ease. Even the reflection of the barmaids and bottles in the mirror is implausible, painted with an insouciance and humour that dispense with centuries of painters earnestly measuring and transcribing nature.

Manet painted swiftly, not, like Delacroix, to indicate the heat of passion but rather to show the disjunctures and distractions of urban life.[18] He also showed the strangeness of it. *Le Déjeuner sur l'herbe*, a painting of a picnic with two clothed men and two women, one naked and one almost so, appears at first as a deliberate attack on the tradition of the nude in the landscape, reaching back to Giorgione's naked woman reclining luxuriantly in nature. Manet, however, turns the tradition on its head, so that rather than being a voyeur, it is the viewer who feels examined and interrogated by the painting. What is a nude? How have women been painted through time? What it is acceptable to paint, and why? What, and how, should a painting mean? The questions that Manet asks broke the ground for a new era of painting. They were above all very modern questions.

Just as with Courbet and Constable, the surface of Manet's paintings carries much of their meaning, his bravura brushwork seeming to contradict the often photographic feeling of his subjects, snapshots from daily life. His colours too feel modern, not the burning ruby reds or strong hues of Delacroix but rather a pale, even quality, a delicate and tasteful balance of greens, pinks, yellows and dark tones. It was another way of signalling insouciant detachment, but also the result of a recent invention, one that changed the course of image-making as much as the invention of photography: the electric light bulb.

Gas lighting, glowering and suffocating, had been introduced in the early years of the nineteenth century; before that, long centuries of candles and millennia of fire. The carbon filament bulb, invented by Thomas Edison in 1879, cast a brighter and more even, unwavering light, and one that seemed closer to the natural light of day than the low fizzing glow of gas or the flickering and guttering of a candle flame. Electric light transformed life, the way humans moved and communicated and, above all, the way we experienced the world.[19]

It was this unwavering brightness that illuminated the *Folies Bergère*, among the first cabaret theatres to install electric lighting, making Manet's depiction of it the first great painting of the era of the light bulb: a momentous change. For centuries natural light had been the goal of painting, from the first renderings of crystalline daylight in the paintings of Jan van Eyck and his followers. Chinese painters cast an even illumination in their ink paintings, which may well have been completed by candlelight as the light receded in the winter

evenings, a restriction that artists had known for thousands of years, right back to the first images made by man, by torches dipped in resin or pitch to make them glow more brightly.

All these forms of artificial illumination were thrown into the shadows of history by the new invention. Now any place, at any time, could be flooded with light at the turn or flick of a switch. The consequences were still unravelling over a hundred years after the first artist made a drawing by the light of Edison's carbon-filament (originally made from a rare species of Japanese bamboo) long-lasting light bulb.

Manet never exhibited with the artists he most strongly influenced, those associated with the movement known as Impressionism. Unlike them, he rarely painted outdoors and was not interested in capturing the feeling of natural light and 'space with the transparence of air alone', as the poet Stéphane Mallarmé put it.[20] Artists had taken their sketchbooks out of doors for centuries, and in more recent times the Barbizon school artists in the Forest of Fontainebleau – such as Théodore Rousseau and Charles-François Daubigny, as well as Millet – created sketches and studies outside among the trees. John Constable, one of their great inspirations after his works were shown in the 1824 Paris Salon, had sat painting clouds on Hampstead Heath, as we have seen, while Turner experienced nature as directly as possible, storing up impressions in his retentive mind and hundreds of sketchbooks. In his later years Corot also worked out of doors, but used nature as the vehicle for his own poetic imagination, adding details here and there to build up a human story.

There were the practical difficulties. How to work on a large canvas out of doors, in the wind and rain, or in baking sunshine? How to mix and carry paints, or clean brushes? How to paint on a canvas large enough to be visible on the walls of the Salon? The invention in 1841 of squeezable metal tubes for paint by the American portrait painter John Goffe Rand, while he was living in London, led to the manufacture of artists' colours that could be easily transported and stored. Throughout the nineteenth century new pigments had been added to artists' palettes – blues, greens and yellows in the first decades of the century, and then brilliant pigments made with the metal cadmium – synthetic pigments that paradoxically enabled artists to create more nuanced impressions of natural scenery.

There was no such elegant solution to the problem of size. Although artists had sketched and painted in oils for over a hundred years, and from the 1820s the Barbizon painters had made the forest and lanes of Fontainebleau an extension of their studios, one of the first painters to create a large painting entirely in the open air, and one that seemed to breathe that air itself, was Claude Monet. In the 1860s he dug a trench in his garden so that a large canvas could be raised and lowered with pulleys, and with this rather clumsy device painted *Women in the Garden*, an image of four women (three of them were modelled by Camille, Monet's companion) wearing voluminous light summer dresses, enjoying the pleasures of the season. The painting was rejected from the Paris Salon in 1867 for departing too far from academic conventions of colour and composition. In capturing

the nuances of daylight, *Women in the Garden* was nevertheless, for Monet, the beginning of a lifetime spent exploring the effects of natural light translated into marks of pigment on canvas.

Monet was one of a group of friends who were inspired by the paintings of the Barbizon school, as much as by the independence of spirit shown by Courbet, Constable and Manet. The Batignolles artists, as they were first known, after the district of Paris that they frequented, were drawn together by the need not only to paint and draw outside but also to show their works away from the official Salon, and so escape the condemnation of academic judgement, to occupy a space in which they might answer the questions that Manet had asked so brazenly in his own paintings.

Above all, it was a matter of being there – outside, in front of the subject. 'Don't you think that directly in nature and alone one does better?' Monet wrote to the painter Frédéric Bazille, 'because it will simply be the expression of what I shall have felt, I myself, personally.'[21] Only by encountering nature directly, immersing oneself within it, could the mutability of vision and a changing emotional response to the landscape be set down: the way an emotional mood can alter completely as a cloud passes over, or the way snow alters the landscape or a garden is transformed when in full bloom. Where academic painting was built on eternal values and reverence for the past, Monet showed instead that nothing, in reality, remains the same. He set up his easel to capture his motif – grain stacks, or a cathedral façade – at different times of day, as if to prove this point. All things are subject to the infinite, ineluctable randomness of nature, beyond the predictability of sunrise, sunset and the fixed patterns of the stars. The sinuous forms of a snaking line of tall poplars on the bank of the River Seine seem to sway and judder in the wind, their silvery leaves caught in the eddies and flurries of air currents, branches waving, trunks leaning, this way and that. Monet creates the magical effect of

having painted the invisible force of nature. The electric light bulb might shed light in the darkness of night, but only the vision of an artist can perceive and represent the forces that bend and shape nature.

A couple of years after he painted *Women in the Garden*, Monet was working alongside Pierre-Auguste Renoir at the popular river resort of La Grenouillère, just outside Paris. They gazed at the ever-changing reflections of light on water, attempting to translate the visual impression into dabs of paint. For the first time the act of painting out of doors, a bold and unconventional thing to do, bound to attract the curiosity of passers-by, was paired with a style of painting, a form of 'broken' brushwork, that was to become the most basic element of the style later known as Impressionism.

Effet de vent, série des peupliers (Wind Effect, Sequence of Poplars), by Claude Monet. 1891. Oil on canvas, 100 cm by 73 cm. Musée d'Orsay, Paris.

The Batignolles group, as it was first known, assembled gradually during the 1850s in Paris. Camille Pissarro had been born in the Danish Virgin

Islands in 1830, and worked as an artist in Caracas for a couple of years before travelling to Paris in the middle of the 1850s. Monet arrived in the capital four years later and met Pissarro at the Académie Suisse, a private school for drawing from models, known for its informal atmosphere. Manet rented a studio in the Batignolles quarter in 1860, and met Edgar Degas at the Longchamp racecourse two years later. Paul Cézanne arrived from Provence a year later and enrolled at the Académie Suisse, where he befriended Pissarro. The same year Renoir arrived from Limoges, joining the studio of the painter Charles Gleyre, where he met Monet, Bazille and Alfred Sisley, the only British painter in the group, who had been born in Paris and spent nearly all of his life in France. The final member of the Batignolles group was Berthe Morisot, who had been living in Paris and showing at the Salon for a few years before she met Manet in 1868.

For Monet and his generation the challenge of the 1860s was to come to terms with the dominant figures in painting: with Ingres and his fine drawing, with Courbet's thick paint and stark subject matter, Delacroix's colour and energetic, exotic compositions and Corot's late, dreamlike visions of nature. It was also a time of reckoning with the dominance of the French Salon and the power of the jury in defining what was acceptable for hanging.

Some thirty artists took part in the first exhibition of the Batignolles group, held in Paris in April 1874, in rooms formerly used by the photographer and hot-air balloonist Gaspard-Félix Tournachon, known as Nadar, just off the Boulevard des Capucines. The dismissive critical and public reaction should have surprised nobody. Such a reaction was repeated countless times over the decades to come. Some came to laugh, seeing the paintings as nothing more than a joke or, even worse, a form of attack on their own taste. Others were not so sure of what they thought. The paintings were ugly, one critic wrote, but yet also 'fantastic, interesting, but, above all, alive'.[22] They may not have looked like nature, but they were still intensely lifelike, capturing a feeling of being in the world, of moving around and seeing. The painting Monet submitted shows a fizzing, illuminated street scene, *The Boulevard des Capucines*, the real version of which was visible just through the gallery's window.

Not all of the Batignolles artists immersed themselves so fully in the natural world. Edgar Degas was a keen observer, and a masterly draughtsman, but little interested in the nuances of natural light, digging trenches in his garden like Monet or enduring the heat or the rain, as artists had done since Barbizon days. He was not a nature-recorder in the sense that Monet, Sisley, Pissarro and Morisot might be considered, documenting the changing effects of natural light, but sought instead, as he put it, the 'vie factice' – artificial life.[23]

This artifice Degas found in the café-concerts and theatres of Paris. At the Paris Opéra he found the subject that was closest to his heart, the ballet. He drew and painted it from every angle, capturing every aspect of the life of a dancer: in the practice room, at rest, rehearsing on the stage and then, with none of the officials, the *maître de ballet*, the musicians or audience present, dancing alone on the stage. Ballet allowed seemingly endless views of the human body in movement and at rest, often graceful, sometimes ungainly or configured strangely by a pose, even truncated by scenery or by the scrolled head of a double bass in the orchestra pit. Degas drew the formal positions of ballet, as well as the costumes that the young dancers wore, the softness of their shoes and the habit of bending, stretching,

posing, practising their moves unconsciously even when they were at rest.

The results were hardly documentary, in the way that Menzel captured and ordered the facts of a scene. With Menzel we feel the ordinariness of things, the simple solidity of objects in the world. With Degas we have images formed and energised by a highly reflective mind.

Degas's paintings were also shaped by the 'look' of photography, the blurring of the subject, the truncations of the snapshot, all the accidents of vision suddenly caught by the shutter and the lens. The imprint was at times direct: he used a daguerreotype of the dance master Jules Perrot to paint the *maître de ballet*, wearing a bright red shirt, in the background of *The Rehearsal*, showing a dancing class at the Opéra. Perrot was a former dancer who had worked as ballet master in St Petersburg before returning to live out his retirement in Paris and give occasional master classes at the Opéra. The daguerreotype image was made for his *carte-de-visite*.[24] Contemporaries would have recognised Perrot, and also seen how 'photographic' Degas's painting was – two legs appear in the top left descending a spiral staircase, recalling the legs of the trapeze artist in a similar position in Manet's *A Bar at the Folies Bergère*. They are just the sort of detail that might be caught unintentionally in a photograph, but were deliberately included by Degas to suggest a real, rather than constructed, image and jolt the viewer with a little surprise.

'A painter of modern life has been born', wrote Huysmans of Degas, on seeing his paintings exhibited in Paris in 1880, 'and a painter who doesn't derive from anyone, who doesn't resemble anyone, who brings a wholly new flavour to art, wholly new techniques of execution.'[25]

It was Degas who invited the American painter Mary Cassatt to exhibit with the Batignolles group. Cassatt had trained as a painter at the Pennsylvania academy but, like countless other artists, knew that the only place where success really counted, and true inspiration was to be had, was Paris. She arrived in Europe

The Rehearsal, by Edgar Degas. c.1874. Oil on canvas, 58.4 cm by 83.3 cm. Burrell Collection, Glasgow.

EVERYDAY REVOLUTIONS

in 1866, and studied with the painters Jean-Léon Gérôme and Thomas Couture, developing a style sufficiently academic and conventional to gain her entry into the Paris Salon, the most important test for any young artist.

Her first encounter with Degas's paintings was a revelation, and determined her course away from officialdom and public honour at the Salon, towards independence. She showed her paintings for the first time in the fourth exhibition of the 'Intransigeants', as the Batignolles artists called themselves by 1879.

The women Cassatt painted are often not conventionally beautiful, which is to say that they appear not as the women depicted conventionally, beautiful or otherwise, by men throughout history. The revelation of this different view of women, and of real maternity as a subject for painting, after centuries of idealised images of the Virgin and Child, is one of the most profound shifts in image-making of the time, as striking as the painting of light on water or the dissolution of solid objects in pure atmosphere – a truth being told, simply and directly. Cassatt's images of mothers and children, which she began making around 1880, and to which she eventually devoted herself, are psychologically penetrating, showing the maternal bond of love but also the struggle and physical stress of parenthood, the ever-growing, ever heavier child who still needs picking up.

Like many other artists at the time, Cassatt was impressed with the idyllic view of Japan preserved in the woodblock prints of Hiroshige, Hokusai, Utamaro and others, which had begun to appear in Europe a few decades earlier. A large exhibition mounted at the École des Beaux-Arts in Paris in 1890 spurred

Cassatt into action. She bought her own printing press and developed her own colour-printing technique to recreate the delicate, linear surfaces of Japanese prints, 'the fine, flat delicate tone with no smudges and smears, adorable blues, fresh pinks [...] as fine as the Japanese', as Camille Pissarro wrote to his son.[26]

The print cycle Pissarro was describing tells the story (although in no particular order) of a modern mother's day: washing, dressing, writing letters, crossing the Seine by omnibus, visiting the dressmaker, taking tea, relaxing by evening lamplight. Pissarro was right to point out their charm and delicacy of colouring, and yet they are hardly idealised – the baby held by the young mother in *Maternal Caress* is heavy and vulnerable, the mother's eyes closed in thought but also parental weariness.

Maternal Caress, by Mary Cassatt. 1890–91. Drypoint, soft-ground etching and aquatint on paper, 36.8 by 26.8 cm. National Gallery of Art, Washington DC. Chester Dale Collection (1963.10.255).

As colour prints they rank with William Blake's great innovations in printmaking of around a century earlier, and further back with the pioneering colour prints of Suzuki Harunobu and the *ukiyo-e* school itself. The strange, artificial beauty of modern life is captured through the filter of the Japanese imagination: Cassatt's images are hardly works of realism, showing more an idyll, not untouched by nostalgia, reverberating in both Japanese and European art of the time.

As a living moment of creativity, Impressionism lasted barely twenty years, from the first sparkling paint surfaces created by Renoir and Monet at La Grenouillère in 1869 to the final group exhibition in 1886. By this time the Batignolles group artists had for some time been dispersed, and were largely at odds with one another. Intolerance, quarrelling and break-ups were incessant – 'It is all so human and so sad', wrote Pissarro, whose valiant attempts to keep the group together came to nothing.[27] Renoir's submission for the final exhibition, *Les Parapluies* ('The Umbrellas'), was begun in 1881, abandoned and then taken up again four years later. It shows the change in his style from the broken dabs of light of his painting with Monet at La Grenouillère to something more muted, classical in tonality, in which everything appears tastefully filtered through the blue umbrellas rather than illuminated by direct natural light.

And yet the perseverance and bloody-mindedness of the Batignolles group transformed what painting can be, and what it means to be an artist looking at the world. Of all the names they assumed, *Les Intransigeants* – the 'intransigents' – was the most revealing: a group of uncompromising radicals unwilling to fit in with the existing way of doing things. They constituted another wave of the democratic spirit pounding the century, receding only to come back with greater force, as de Tocqueville had put it, causing fear in the hearts of traditionalists, demanding that new voices be heard and that new ideas be aired.

Les Parapluies (*The Umbrellas*), by Pierre-Auguste Renoir. c.1881–1886. Oil on canvas, 180.3 cm by 114.9 cm. National Gallery, London.

The intransigent visions of Monet, Cassatt and their circle were for the most part recorded in flat images. The impulse of photography and the surge towards detailed realism in painting meant that sculpture was less in evidence as a way of capturing contemporary life and the spirit of change. In Europe, the leading lights were those sculptors working in Rome in the wake of Canova in the smooth classical style epitomised by his *Three Graces*. The appearance in the final years of the nineteenth century of the shocking bronze forms of the sculpture of Auguste Rodin was all the more marked for the lack of any warning. They seemed to come out of nowhere.

In his many sculpted studies of figure parts for *The Gates of Hell*, a portal encrusted with a profusion of figures, based on the first part of Dante's *Commedia*, as well as fragmented figures such as the *Walking Man* (composed from different studies of a torso and legs for a figure of St John the Baptist), modelled in plaster around 1900, and cast in bronze some years later, Rodin comes close to Degas's often bizarre compositions of the human body, recalling Géricault's sculptural paintings of severed limbs. But Rodin's *Walking Man* is striding forcefully onwards, powerfully, blindly.

The tilting headlong figure appears again in his monument to the novelist Honoré Balzac, as imposing seen from below as the limestone rocks of James Ward's *Gordale Scar*. And yet the onward drive of his figures was kept in check by his strong sense of the past. Although the texture of his bronze surfaces can seem close to the dappled effect of the paintings of Monet and Renoir, the comparison with the *Intransigeants* ends there. For all the breaking up of academic conventions and dependence on the past, and the emergence of new technology, the railway, the light bulb, the telegraph, disrupting the sense of space and time, tradition still held sway. Rodin revered Michelangelo above all others, seeing the Italian sculptor's *Slaves* as paragons of unfinished, expressive sculptural form. Degas, similarly, was uninterested in appearing as a radical. 'What I do is the result of reflection and study of the great masters', he is reported as saying: 'of inspiration, spontaneity [...] I know nothing.'[28]

L'Homme qui marche (Walking Man), by Auguste Rodin. c.1905. Bronze, h. 213.5 cm. Musée d'Orsay, Paris.

In an age of democratic realism, photography could at least claim to show up the lies of painting: the heroism and flattery and also the outright mistakes of the painter's art. The gait of a running horse, to take one famous case, had been wrongly shown for centuries until the stop-frame photographs made by Eadweard Muybridge in 1878 revealed the actual movement of legs, too fast for the human eye to perceive.

This revelation appeared most tellingly in images of human conflict. Photographs of war were among the most startling images of the age, recording for the first time the battlefield as it truly was. Where painters had shown war as a glorious pursuit, photography showed the reality. Roger Fenton's albumen prints of the Crimean War in 1855 were the first images to show the lives of enlisted soldiers in conflict, documenting their existence in the landscape around Sebastopol. Like his friend Gustave Le Gray, Fenton had studied painting at Paris in the studio of Paul Delaroche, and brought to photography a painter's eye for pose and composition. His *Valley of the Shadow of Death* shows a dirt road in a ravine, empty apart from cannonballs strewn around, mute witnesses of violent combat. The title (given by the art dealer Thomas Agnew, who had commissioned Fenton) is taken from the twenty-third Psalm, and from the poem by Tennyson commemorating the failed charge of the British Light Brigade cavalry into the face of the Russian artillery, a few months before Fenton took his photograph:

> Half a league, half a league,
> Half a league onward,
> All in the valley of Death
> Rode the six hundred.
> 'Forward, the Light Brigade!
> Charge for the guns!' he said.
> Into the valley of Death
> Rode the six hundred.

And yet, for all this, photography was hardly an indiscriminate record of reality, or one that could claim a deeper hold on truth. Adolph Menzel's drawings of the dead and wounded soldiers made in 1866 during the Austro-Prussian War carry a greater degree of realism than the war photographs of Fenton and Brady. And Tennyson's poem moves us and summons the clamour and horror of battle more profoundly than Fenton's photograph, which communicates only a sense of emptiness and desolation. War is a psychological reality that needs interpretation. In an age of modern, mass warfare, involving many more civilian casualties, this interpretation became ever more important. The great forerunners of modern images of war were Goya's etchings of war atrocities made in the 1810s, trenchant and terrifying human insights into the horrors of the Peninsular War between Napoleonic France and Spain.

The Valley of the Shadow of Death, by Roger Fenton. 1855. Photograph, 20.6 cm by 16.4 cm. Victoria and Albert Museum, London.

25

Mountains and Oceans

Where once mountains cast fear in the heart of man, wrote John Ruskin in 1856, in time they became sources of imagination and beauty, 'delighting and sanctifying' human life.[1] A handful of enterprising souls, including the Japanese emperor Jomei and the Italian poet Petrarch, had ascended them to admire the view. Artists had painted them for centuries. In tenth-century China, as we have seen, Li Cheng, Fan Kuan and their successors invented the genre of *shan shui*, or 'mountain-water' paintings, marvelling at the inaccessible height of mountains on hanging scrolls painted with brush and ink.

It was only in the nineteenth century, however, that portraits of individual mountains emerged, as if these vast forms of nature had drifted into the human domain, scrutinised for what they were and painted with greater truth to appearance, as Ruskin had urged. The American artist Frederic William Church's *The Heart of the Andes*, painted in 1859, as we have seen, shows Mount Chimborazo in Ecuador. In Europe, following Ruskin's advice, the British artist John Brett painted a meticulous view of the Val d'Aosta. Turner, Ruskin's great painter of mountains, first made watercolour studies of the St Gotthard Pass on visiting the Swiss Alps in 1802.

Two mountains, however, rise above all others in nineteenth-century art.[2] Mount Fuji was drawn endlessly by Hokusai, and appeared most famously in his *Under the Wave off Kanagawa*. Later in the century, in the south of France, a limestone ridge in the Provençal Alps called Mont Sainte-Victoire was immortalised in the paintings of Paul Cézanne.

Cézanne painted his mountain in the same way he painted his still-lifes and portraits, wishing to be true to nature but also to create images with a sense of permanence. 'I want to do Poussin again, after nature,' he said.[3] The ridge of his Mont Sainte-Victoire rises in dabs and patches of cool blue and ochre, giving a feeling of pure colour and a brilliant transparency of air. Each brushstroke records a deliberation of vision, a moment of looking documented in paint. The wooded plains seem flattened, raised up; in fact, from the vantage point chosen by Cézanne the landscape does have this peculiar upward-sloping quality. Cézanne completes the movement, bringing everything up to the surface, as if the image were floating on top of the canvas, illuminated by a clear light within. Some pinkish rooftops give foreground scale, otherwise the image beneath the horizon is a tessellation of pure colour, the 'vibration of light' as Cézanne put it, in which an opalescent field of greens and light ochres is punctuated by dark measuring marks as well as by lighter tones, giving the feeling of air, warmed yet not stilled, and the sensation, overall, of something constructed from a captured moment.

The impression of construction, of intellectual working out, of a perfect balance between mind and eye, between the observation of nature and the creation of an image, lies at the heart of Cézanne's achievement.

This might at first be a little hard to see. His paintings can appear shaky, as if made during a minor earth tremor, or as if Cézanne, with his flickering touch, was never quite sure where to place his lines and colours – 'the contours escape me', he would say. And yet, the more we gaze at the painted mountain, or the faces in his portraits, or the oranges and apples in his still-life compositions, the more this tremor reveals to us what makes Cézanne's paintings so distinctive. They show him actually looking, feeling his way around the subject, constructing his painting directly from his perception. Cézanne's approach was the slow study of nature: the 'spectacle that Pater Omnipotens Oeterne Deus ['God the Eternal Father Almighty'] spreads before our eyes', as he wrote to the young painter Émile Bernard.[4]

From this patient process Cézanne evolved images that are devoid of any trace of doubt, filled with a feeling of the authenticity of light and nature but also dependent on patient study of the images of the past. Cézanne's work was a summary of European painting, of Poussin's solid classicism, Delacroix's freedom with colour, El Greco's imaginative exaggerations. 'What I wanted', Cézanne said at the end of his life, 'was to make of Impressionism something solid and durable, like the art of the museums.'[5] Far from being indecisive, the effect of his paintings of Mont Sainte-Victoire is one of great solidity and grandeur, like the magnificent railway stations constructed and decorated with wrought iron that were appearing in cities around the world: monuments to human endeavour.

Such intelligent, poetic construction makes Cézanne a pivot around which the fate of painting turned – he was rooted in the world of Impressionism and French literary circles, yet his canvases look forward to some of the most startling images of the twentieth century.

Throughout his life Cézanne explored the possibilities of the nude figure in nature, usually bathing. The largest of his bathers, made in the last few years of his life, as he was painting Mont Sainte-Victoire, is one of these great, forward-looking images. For all its open airiness, its ease of life, the promise of pleasure and unabashed beauty, *Les Grandes Baigneuses* constantly reminds us that it is a painting, an artificial construction. The key is the figure to the left, the standing woman with large legs and a small head, whose straightened form seems awkwardly to be melding with that of the tree behind her. She might be the Daphne

Mont Sainte-Victoire, by Paul Cézanne. 1902–04. Oil on canvas, 73 cm by 91.9 cm. Philadelphia Museum of Art.

MOUNTAINS AND OCEANS

of myth, mutating into a tree as she is pursued by the hunter Apollo. But, looking at the bathers, we are Apollo, pursuing Daphne with our gaze. Her escape is to be transformed not only into a tree but into a new era of images, one detached from all traditional ideas of believable, lifelike representation.

One painter brought his own unique scientific approach to painterly composition, and through it produced canvases which are in turn great poetic statements. Georges Seurat died at the age of thirty-three but in his short working career created, alongside other, smaller works, five large paintings. Each was a major project involving numerous preparatory studies and sketches, completed with a deep scientific understanding of the effect of colour on the human eye. In dabbing down on canvas countless tiny dots or smudges of coloured paint, Seurat's aim was an 'optical mixing' of colour, placing two colours side by side so that the eye sees them as a blended tone – yellow and red dots creating orange; blue and yellow, green; and so on.

Seurat called his painting style 'chromo-luminist' to describe the effect of illuminated colour and light – they came more often to be known more simplistically as '*pointilliste*', referring to the tiny dabs, or 'points', that Seurat applied. Almost all were scenes of Parisians at leisure: workers bathing and reclining on the banks of the Seine in *Une Baignade, Asnières*, shown in 1844 in the first Salon des Indépendants (an open exhibition which set itself against the rule-bound Salon); or taking a Sunday stroll by the river in *Un Dimanche après-midi à l'Île de la Grande Jatte*, shown two years later at the eighth and final Impressionist exhibition. These large, intricately composed canvases have a feeling of solidity, a staged, choreographed quality, quite unlike Cézanne's 'captured moments'.

Painted a few years later, Seurat's *Parade de cirque*, or 'Circus Sideshow', appears at first a gloomier, more melancholy proposition, despite the light-hearted subject. Musicians and a moustachioed circus master with a baton beneath his arm are staging a sideshow entertainment to lure customers into their tent. The behatted heads of onlookers are silhouetted below, while a young girl steps up to the box office to buy a ticket. Above, gently fizzing gaslights, held by a pipe, run horizontal to the canvas edge. The bare branches of a tree show the seasonal coldness, the misty mauve haze of colours suggesting a

Parade de cirque (*Circus Sideshow*), by George Seurat. 1887–1888. Oil on canvas, 99.7 cm by 150 cm. Metropolitan Museum of Art, New York.

slight fog in the air, blending colours and creating the distinct mood of evening illuminations. From this haze rises the lithe figure of a trombonist, with a broad masculine face but slim, feminine legs, wearing a mysterious conical hat, like a Scythian headdress. Despite his intricate technique, painstakingly conceived and constructed, Seurat was little interested in the detail of the world. His forms are soft and generalised, as if seen through a mist. Too much detail would have distracted from what really gripped him: the way a supposedly unnaturalistic artificial style can bring us closer to reality, by capturing how we see the world through the mechanism of perception.

Cézanne and Seurat understood that looking is never an innocent activity. We always bring along our own perceptions, experience and memories, and can only ever see an object 'as' something. Artists of the past, such as Vermeer and Rembrandt, might have challenged this, giving the impression of recording pure vision, and yet their individual styles are always recognisable – they could not help but fill their canvases with themselves. A painting, wrote Cézanne's childhood friend the novelist Émile Zola, is a 'slice of nature viewed through a temperament'.[6]

For both Cézanne and Seurat it was a resolutely aesthetic temperament, one given to a poetic rather than a political feeling. As a forerunner of Cézanne's Mont Sainte-Victoire, Hokusai's Mount Fuji was part of a much wider admiration for Japanese art that shaped this aesthetic temperament in Europe, as we have seen with Mary Cassatt. Virtually every artist of note in France in the last forty years of the nineteenth century was an admirer, if not a collector, of Japanese things. They pored over albums of prints, changed into patterned kimonos behind Japanese painted screens and hung decorated fans on their studio walls. For European artists, Japan was to the nineteenth century what China had been in the eighteenth century for Watteau, Boucher and Fragonard: a realm of the imagination and of aesthetic inspiration that subtly yet decisively changed the course of image-making. They were emboldened by the strong colours of Japanese prints, and entranced by the 'floating world of sensory impressions and physical delight'.[7] However dissimilar Paris and Edo were in appearance, both cities were devoted in their own way to pleasure and nostalgia.

The Dutch painter Vincent Van Gogh owned over six hundred woodblock prints by Japanese artists, including Utagawa Hiroshige and Utagawa Kunisada, which he had bought shortly after moving to Paris in 1886. He pinned them around the walls of his apartment and studied their colours and compositions, even copying them in oils. When he turned to painting, around 1880, at the age of twenty-seven, Van Gogh's first inspiration was the paintings of Jean-François Millet and Jules Breton, images of peasant life that seemed to offer a form of personal salvation. He was recovering from the twin failures of his careers as an art dealer in London and Paris, and then as a lay preacher in Belgium. Just as for Millet, so too for Van Gogh peasants were a sign of authenticity and tradition, everything that seemed otherwise to be swept up and lost with the industrialisation of life. The peasant, at least as an idea, was a monument to the land and the soil from which they seemed to have been created.

Van Gogh soon realised that Millet, for all his classical appeal, was not the future. He first set eyes on Seurat's paintings on arriving in Paris in 1886, at the Salon des Indépendants, an experience that opened his mind to an entirely

different view of painting, one in which pure colour could have a powerful emotional and physical effect. He saw *Parade de cirque* in Seurat's studio in February 1888, a few hours before boarding the train to travel to the town of Arles, in Provence, where he was to live for two years.[8]

Rather than follow Seurat exactly or adopt his scientific approach to paint-mixing, Van Gogh created his own technique, using short strokes of unmixed paint, densely laid onto the canvas. His thick, coarse dabs, placed with a heavily loaded brush, make it seem as if the translucent, suggestive world of Cézanne, or the shimmering little dots of Seurat, have congealed into a more psychologically intense reality.

It was in Arles that Japanese prints began to weave their magic spell on Van Gogh, resulting in one of Van Gogh's most mysterious paintings.

A sower is scattering seeds into the earth, his form a dark silhouette against a large yellow sun. A thick tree trunk cuts across the scene, single strokes of dark paint indicating new shoots, laid over the greens and pinks of a hazy morning sky. Van Gogh was taking the idea of artificial colour to an extreme: 'could you paint the Sower in colour, with a simultaneous contrast of, for instance, yellow and violet? [...] yes or no? Why, yes', he wrote to his brother Theo, as if in relief at the discovery.[9] For Van Gogh colour itself was a creative force, containing the power and message of an image. Like Christ casting seeds on the earth, so the artist was like a sower, throwing down colours on the rough canvas surface.[10]

The dark form of the pollarded tree in Van Gogh's *Sower*, with its blossoming shoots, brings to mind Japanese woodblock prints, with their two-dimensional, pattern-like quality and delicate views of the natural world.

The Sower, by Vincent Van Gogh. 1888. Oil on canvas, 32.5 cm by 40.3 cm. Van Gogh Museum, Amsterdam

Utagawa Hiroshige's *The Residence with Plum Trees at Kameido*, which Van Gogh owned and copied, has a similar thick trunk with blossoming sprigs dividing the picture surface.[11]

Van Gogh may also have been thinking of another, quite different, painted tree. In the months before he travelled to Arles for their famously ill-fated period working alongside one another (which ended in Van Gogh's madness and self-mutilation), Paul Gauguin had sent Van Gogh a drawing of his painting *Vision after the Sermon*, knowing that it would appeal to Van Gogh's love of visionary religious subjects rooted in real world experience. Gauguin took the subject from the book of Genesis, the story of Jacob wrestling with an angel throughout the night on his way back from Canaan, a metaphor for spiritual struggle but also a reflection of Gauguin's material plight. He completed the painting in the Breton village of Pont-Aven, where he had gone to relieve his money troubles, following the loss of his job as a stockbroker (which had been a success) and the failure of a stint in Denmark with his wife and family, leading to the break-up of his marriage. He was to remain in straitened circumstances for the rest of his life, as the cheap canvas on which he painted and his sparing use of pigment (he claimed on a number of occasions that he hated thick, impasto paint) throughout his career as an artist suggest. It was an austerity that he transformed into a profound, almost sacred vision of the world.

Gauguin included a description of *Vision after the Sermon* along with the drawing he sent to Van Gogh:

> Breton women, grouped together, are praying: costumes very intense black [...] An apple tree goes across the canvas: dark purple, and the foliage drawn in masses like emerald green clouds, with yellow-green interstices of sunlight [...] I believe I've achieved a great rustic and *superstitious* simplicity in the figures [...] For me, the landscape and the wrestling exist only in the imagination of the people at prayer after the sermon.[12]

Gauguin's friend Émile Bernard saw the connection of his flattened forms and strong colour to Japanese printmaking, but also to Hokusai's *manga* drawings, one of which, Bernard recorded, was the basis for Gauguin's wrestling match between Jacob and the angel.[13]

For Gauguin such dreamlike images were symbols, images that existed independently of the visible world. Where Van Gogh, like Cézanne and the artists of the Batignolles group, needed reality in front of him – after all, what else was the point of going out into the open, into the '*plein air*'? – Gauguin summoned images more readily from his imagination. 'Art is an abstraction, derive it from nature by indulging in dreams in the presence of nature, and think more of creation than the result', he told his friend the painter Émile Schuffenecker.[14]

As Gauguin's painting evolved, it became clear that he needed to find a subject further away still than the peasants of Brittany, or the landscape of Arles, to match his vision of purity, untouched by the corrupting forces of civilisation. At the Paris Exposition Universelle of 1889, which took place in the Champs de Mars

around the newly built Eiffel Tower, Gauguin saw as part of the colonial section of the fair a recreation of a Tahitian village, as well as a replica of the Cambodian temple of Angkor Wat and dancers performing in a Javanese village.[15]

Two years later he set off for the South Seas in search of paradise. A banquet was held in his honour, presided over by the poet Stéphane Mallarmé, who recited his translation of *The Raven*, a poem by the American writer Edgar Allan Poe. The 'stately raven' of the poem arrives at the door of a man lamenting his lost love, Lenore, and, entering the room and settling on a 'sculptured bust above his chamber door', croaks 'Nevermore!' at the end of each lamenting verse.

'Nevermore' – the word must often have been on Gauguin's lips during his two visits to the islands of Polynesia, the second of which ended with his death. The paintings he began making on arriving in Tahiti, a French colony, in the summer of 1891 continued the flattened, coloured forms of the *Vision after the Sermon* (which was sold for a high price at an auction organised by Gauguin to support his voyage) but were steeped in the 'savage' atmosphere of the island landscape and Tahitian life.[16] It was not the paradise that he had sought. Tahitian culture, like many of the islands of Polynesia, was in deep decline, largely a result of European exploitation and disease and of the destruction wrought on traditional religions by Christian missionaries. A melancholy atmosphere of 'bitterness mixed with pleasure', as he wrote in *Noa Noa*, his account of his first visit to Polynesia, had settled over the people of the island, reflected in their features, which he captured in his paintings.[17] Later he made a painting of Pahura, his Tahitian wife, lying naked on a bed with a melancholy expression – behind her perches Poe's raven, more comical than stately, but identified by the title of the painting inscribed alongside: 'NEVERMORE'.

Gauguin returned to Paris in 1893, triumphantly Tahitian in his own eyes and yet still resoundingly poor. He wrote *Noa Noa* as a way of introducing his Tahitian paintings and their strange, exotic subject matter, though to little avail. Two years later he set sail again for Polynesia, this time for good. He was beset by illness and misfortune, his mental state summed up in the despairing title of a painting, made on cheap hessian sacking in 1897: *Where Do We Come From? What Are We? Where Are We Going?* He took an office job after a failed suicide attempt, after hearing of the death of his daughter, Aline, back in Europe, and finally sailed eight hundred miles north to the Marquesas Islands, arriving on Hiva Oa in

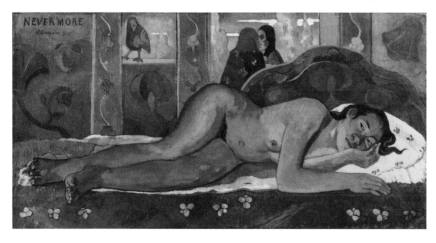

Nevermore, by Paul Gauguin. 1897. Oil on canvas, 50 cm by 116 cm. Courtauld Institute of Art, London.

1901. He built a house, known, balefully, as the 'Maison du jouir' ('House of Pleasure'), surrounding the doorway with carvings that echoed the elaborate tattoos of the Marquesans that he so admired. Here he came closest to creating a 'Polynesian' image, and it was here that he died just over eighteen months later.

The Marquesas Islands, in the middle of the South Pacific Ocean, have long been famed for their natural beauty as well as the decorative objects and tattoos created by their inhabitants, known as the Te 'Enana people. Tattooing for the Te 'Enana began early in life, and continued through adulthood until, in the case of high-ranking individuals (with time on their hands), every part of the body was covered, to the point of blackness. A needle made of human or bird bone was loaded with pigment, made from charcoal, and used to create the designs, based on a repertoire of patterns and shapes drawn symmetrically on the body.[18] These designs were part of remembered images, passed down generations, forming the image-world of the Te 'Enana, which was to become synonymous with Polynesian image-making itself.

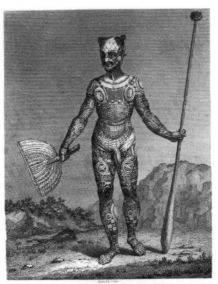

An Inhabitant of the Island of Nukahiwa, by Wilhelm Gottlieb Tilesius von Tilenau, engraved by J. Storer. 1813. Copperplate engraving, 26.4 cm by 20 cm. The New York Public Library, New York.

Decoration of the body with tattoos is one of the oldest traditions of image-making that could be found on many of the inhabitable islands of the South Pacific, across the regions of Polynesia, Micronesia and Melanesia, as they were termed by Europeans. The region is so vast that it is impossible to talk of any distinctive style of Pacific Island images, although some of the oldest representational images made by humans can be found in the region, on the island of Sulawesi in modern Indonesia, drawn on cave walls over forty thousand years ago.

Plants and animal life provided the materials from which images were made: canoes were carved from wood using a stone or shell-headed adze, their sails made from woven strips of pandanus leaves; figures of gods were carved from wood and painted with natural dyes; mats were woven from barkcloth, with striking geometric designs. Bodies were adorned not only with tattoos (the word comes from the Tahitian *tatau* – 'to strike') but also with whale's teeth, cowries, shells, mother-of-pearl and the bones of birds.

The Hawaiian islands are distantly related to Tahiti and the Marquesas by language, having been settled around 600 CE by eastern Polynesians. They

MOUNTAINS AND OCEANS

developed their own craft and image-making traditions, most remarkably in brightly coloured featherwork cloaks, known as *'ahu 'ula*, as well as featherwork helmets and standards, worn and carried by chiefs in ceremony and battle. The *'ahu 'ula* were made from many thousands of feathers: yellow and black feathers from the *'ō'ō* and *mamo* birds, and red from the *'i'iwi* bird tied to a backing of natural fibre. Markings on the *'ahu 'ula* were symbols of ancestry (although their meaning is now lost) but were above all simple, vivid forms that could be seen from afar and denote the origins of the wearer – whether they came in peace or war. The earliest known *'ahu 'ula* dates to around the fifteenth century, and is made with the same distinctive bright red and yellow plumage as the last to be made, during the nineteenth century.[19]

These were objects with a purpose, rather than simply to be admired. The same is true for the sculpture made on the Pacific islands, part of what is often referred to as Oceanic works of art. Largest of all are the elongated heads on buried truncated bodies carved from volcanic tufa, known as *mo'ai*, which rest in the landscape of Easter Island, the furthermost point from Asia, and which recall the carved stone heads of the Olmec people on the mainland of Central America, some three thousand miles over sea and land to the north. Set on stone altars around the island, these heads were the images of ancestors, faces recalled in order to ground families and communities in a changing world.

Prows and paddles for canoes, as well as decorations for meeting houses, are among the carvings made by the Māori of New Zealand, one of the few traditions that survived the arrival of the Europeans in the nineteenth century. The *whakapakoko*, or figure carving of a Virgin and Child, was made early in the nineteenth century by a converted Māori artist for display in a Catholic church, although the *moko*, the full facial tattoo, originally a pattern incised in the flesh, summons its power from the Pacific Ocean.

Alongside the Māori, the wood-carvers on the islands of Papua

New Guinea produced the most accomplished sculpture of the Pacific islands and also, in the case of the Inyai-Ewa people who lived along the upper Korewori River in the mountainous rainforest of Papua New Guinea, the oldest surviving wooden figures, the earliest dating to the sixteenth century. Hunters gave secret names to carved wooden figures, known as *aripa*, created to help them in their expeditions with bow and arrow and hunting dogs. They were placed in rock shelters and in men's ceremonial houses, alongside carvings of the mothers of the hunted animals. Flattened figures of women holding their hands in a protective gesture above their heads, or with flame-like halos suggesting ornamental

'Ahu 'ula (cloak). 18th century. Hawaiian islands. 149.9 cm by 274 cm. Bernice Pauahi Bishop Museum.

Female figure, Inyai-Ewa people, Papua New Guinea. 16th–19th century. Wood, h. 170.2 cm. Metropolitan Museum of Art, New York.

headdresses, were considered images of two mythical sisters, ancestors of one of the Inyai-Ewa clans, known as the hornbill, after the species of bird, and were left in caves, or protective rock shelters, as spiritual presences.[20]

Since the voyages of James Cook in the late eighteenth century, the Pacific islands have been known to the outside world but have also been transformed through the destructive process of settlement and control by foreign governments, especially by the British and French. Gauguin's time in Tahiti could have been experienced by countless other artists had they sought an island paradise annexed by their own nation. Destruction was wrought on native cultures, with the outlawing of the beliefs enshrined in images, following the conversion of Pacific islanders to Christianity in the eighteenth and nineteenth centuries, and also on the natural habitats that provided the materials for that belief. The birds that provided the feathers for the *'ahu 'ula* robes were, by the early twentieth century, largely extinct. During that century the great majority of all traditions of image-making that had existed on the islands of the Pacific Ocean, the largest and most various area of creativity on the planet, disappeared, along with many of the people, including the Inyai-Ewa people of Papua New Guinea.

Gauguin wanted to step out of time, crossing the barrier of the tree in his *Vision of the Sermon*, and enter into a magical world of belief and imagination. Instead he tripped into history, into a world darkened by colonialism and the ever-increasing exploitation of the natural world. For all their strong colours and debt to the pleasurable world of Japanese prints, Gauguin's paintings are beset by a sense of melancholy, bordering on despair. It is a feeling that hangs over many of the images of art of the time: symbols somehow detached from the world, charged with a feeling of loneliness. Van Gogh's sower scatters the last seeds of a tradition of oil painting that had lasted half a millennium; Gauguin's nude reclines unhappily, awkwardly. It was time for change.

The paintings of Cézanne, Gauguin, Seurat and Van Gogh, who hardly constituted a group although they were later referred to as the 'Post-Impressionists', came at the end of a century in which human life was transformed by the forces of industrialisation, crammed into ever-expanding cities, detached from traditional habits of life and finally divorced from the fundamental rhythm of night and day by the sudden blinding illumination of the incandescent light bulb. Their paintings, with their detached symbolism, bring with them the feeling that we have arrived at the end of a long tradition of image-making, one in which the encounter with nature produced more or less lifelike images – to this era the paintings of the Post-Impressionists are a sort of farewell.

In their closely painted surfaces and freely invented forms they also contain seeds for the future of image-making, one increasingly obsessed with

artificial symbols. It was hardly a new idea. Such symbols constitute most images made by human hand, from the earliest cave drawings to the richly symbolic allegory of Dürer's *Melencolia I*. In the closing years of the nineteenth century, however, the idea took on new life, as a way of linking the images of poetry with those of painting, however vaguely, and bringing both together with music. The movement was formally christened in the 1880s in France as Symbolism.[21] Edgar Allan Poe was a precursor, taking to an extreme many of the aspects of Romantic thought, particularly a form of elusiveness that was filled with spiritual feeling. One doesn't name a thing, the poet Stéphane Mallarmé wrote, 'to suggest it, to evoke it – that is what charms the imagination'.[22] Evoking the world through suggestion reflected a view of nature as ultimately unknowable. The illusion of reality was no longer the purpose of painting; instead artists now sought to evoke this strange, mystical, poetic unknowability: 'Nature is a temple from whose living pillars / Emerge sometimes indistinct words', wrote Charles Baudelaire, in his poem 'Correspondances'.[23]

For painters, as Gauguin showed, the 'indistinct words' were the colours on their palettes. In the paintings of Pierre Bonnard, colour itself became the poetic subject, tone and hue, and chromatic dissonances between hot and cold colours creating an often dazzling sense of visual rapture. Like Cézanne, Bonnard summoned images that seem somehow to reproduce the process of seeing itself, the roving gaze, suddenly captured by the shape of an object, a striking colour. The division of the canvas in *The Croquet Game*, made in 1892, one of Bonnard's first major paintings, is similar to Gauguin's *Vision after the Sermon*: in both paintings a vision is taking place in the top right-hand corner, separated from the 'reality' on the left.[24] Bonnard undoubtedly admired Gauguin's painting, and kept a reproduction of it in his studio until his death. He also kept *The Croquet Game*. Early in life Bonnard belonged to a group of painters, including Maurice Denis and Edouard Vuillard, known as the Nabis, the Hebrew word for 'prophets'. They might well have claimed to see into the future but, unlike Gauguin or Van Gogh, did not need to travel far to find their subjects: the dining-room table or the bathtub contained all the colours and mystery of light that they required.

The vagueness of painterly symbols could also be marshalled to evoke otherwise indescribable emotional and mental states. A well-known image by the Norwegian painter Edvard Munch (which achieved its greatest form in a lithograph of 1895, illustrating the less impressive painting made two years earlier) shows a figure standing on a bridge, letting out a wail that reverberates through the surrounding water and sky. The masts of distant boats form crosses that suggest Golgotha, the hill on which Christ was crucified. Suffering, for Munch, was always connected to tortured, or at least unresolved, feelings of love, rather than religious passion or self-mortification, an idea he elaborated in his great series of paintings made in the 1890s, including *The Scream*, which he later called *The Frieze of Life*. The life that Munch painted was one given to extreme feelings of melancholy and *angst*, of vampirical sexual lust and searing jealousy. Munch used Tulla Larsen, with whom he was having a tormenting and turbulent love affair, as the model for the women in his painting *The Dance of Life*, a symbol of innocence, lust and despair, dancing by the side of a lake into which the moon casts its long, thick, melancholy reflection.

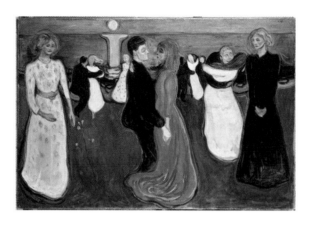

The Dance of Life, by Edvard Munch. 1899–1900. Oil on canvas, 125 cm by 191 cm. Nasjonalgalleriet, Norway.

It is as though the images made by Edvard Munch have themselves contracted some sort of illness, or show the world seen through eyes distorted by extreme psychological states. Munch was obsessed with madness and convinced that he would himself go mad in old age, although he lived well, and sanely, into the twentieth century.

Symbolism also caught the spirit of urban life, particularly that of *fin-de-siècle* Paris. As Gauguin was painting in Polynesia, and Van Gogh working in Arles, the painter and graphic artist Henri de Toulouse-Lautrec was forging a new image of the French capital, decadent, elegant, emanating from the drinking dens and cabarets of the hilltop quarter of Montmartre.

The medium that he employed, and one that he made his own, was lithography, a form of printing involving drawing with a greasy ink on a prepared flat stone surface (the 'litho' of the name), from which impressions can be pulled. It was a rapid means of creating an image, and well suited to commerce and publicity, taken up by artists as a way of creating prints directly, rather than having them engraved or etched by a professional artisan. Both Géricault and Delacroix had drawn on lithographic stones in the 1820s, but it was not until some decades later, when Manet took up the technique, that it came to be taken seriously as a medium.[25] Manet's use of lithography culminated in his illustrations of Mallarmé's translation of Poe's *The Raven* in 1875.

Colour lithography came into its own in the final decade of the century, used for posters and prints that captured the excitement of urban life in the new age of electricity. Toulouse-Lautrec used the fluid line and bright flat colours of lithography to create a series of around thirty posters that were the first great images in a new age of commercial advertising. In their flatness and in the strong

Miss Loïe Fuller, by Henri de Toulouse-Lautrec. 1893. Colour lithograph on woven paper, 37 cm by 26 cm. Brooklyn Museum of Art, New York.

quality of their line Toulouse-Lautrec's prints were often compared with Japanese prints. His lithograph of the Chicago-born dancer Loïe Fuller throwing up her voile skirts and tulle veils in her famous *danse du feu*, which she made famous in a routine at the *Folies Bergère*, was praised at the time, in February 1893, for reproducing the simple, dynamic shapes used to represent movement in Japanese woodblock prints.[26] Fuller pioneered a new type of dance in Paris, which had taken over from the ballet, now in decline (until the arrival of the Russian impresario Sergei Diaghilev in the early years of the twentieth century), so that Toulouse-Lautrec was filling the place left vacant when Degas stopped making

images of dancers around 1890. The brightly coloured veil, sprinkled with gold and silver dust, was illuminated by coloured electric spotlights especially installed for Loïe Fuller's act, echoing Manet's *Bar at the Folies Bergère* illuminated by electric lighting, made eleven years earlier. Fuller's swirling veil was a symbol of the times, a billowing emblem of the new electric age.

The Pacific is the widest and deepest of the earth's oceans. On the western edge are Japan, Taiwan and the Ryukyu Islands, with China beyond. To the north-west the cold extremities of Eurasia and Siberia lead to the Bering Strait, where the ancient land bridge of Beringia was the route by which humans first entered the Americas. In the southern Pacific are strewn the constellations of the South Sea Islands, populated by humans who had made the journey across Asia and slowly spread among the islands, large and small, of the great ocean. Traditions of image-making, as we have seen, were shaped by the isolation of these islands and their dependence on the sea, like the ancient seafaring cultures of the islands of ancient Greece and Crete. New Zealand and New Guinea are the largest islands on the western edge of the Pacific, before arriving at Australia and the islands of Indonesia.

Crossing to the other side of the Pacific, to the south, rise the Andes, the longest mountain range on earth, with its cloud forests and infinitely varied flora and fauna, recorded by Frederic Edwin Church in *The Heart of the Andes*. To the north, the rugged coastline of the Pacific coast of North America was the home to another image-making tradition, one with connections to Polynesia and yet related also to the wider world of Native American images, stretching over the northern American continent, from Alaska down to New Mexico.

The Pacific coast of Alaska and the island of Haida Gwaii are home to the Haida people, who, along with the Tlingit and Tsimshian people, make up the three indigenous groups populating the coast and islands stretching down the Pacific Rim. The Haida people carved the long straight trunks of cedar trees with depictions of animals and ancestors, recounting legends and marking social status. Looking out over the Pacific Ocean and the inland mountain ranges, these tall, smooth trunks – 'totem poles', as they became known – marked the presence of the Haida people and could be found in every village on the island by the end of the eighteenth century.[27] They grew in popularity during the next century so that carved columns of various heights could be found all over the towns and villages, in front of houses, some with an oval doorway in their base, carved in the belly of a seated creature, a bear, beaver or wolf.[28] Many proclaimed status; others were funerary posts, with a carved box at the top containing the bones of the deceased.[29] They were shaped with the metal tools that had arrived on the islands and coast with the first European traders and visitors, including, in 1778, James Cook. The inevitable tragic story of destruction followed: the Europeans also brought with them the smallpox that ravaged the population, leading to the decline of the Haida and other indigenous groups in the later years of the nineteenth century.

One large totem pole, reaching to a height of some twelve metres, was carved from a trunk, hollowed at the back and erected in front of a house in the small Haida village of Kayang. It tells two stories. One is the legend of a fisherman

whose catch was being stolen from them by the Raven, or Yetl, the creator deity of the Haida people. Using a different hook, the fisherman tricked the Raven but caught only his beak, which he retrieved by taking human shape and entering the fisherman's house. He later returned disguised as a chief, holding a hat and staff, as he is shown at the top of the Kayung Totem Pole, sitting above his image with a broken beak. Below them, acting out the second tale, are figures of a woman seer with magic rattles, leading a ritual to find a whale who had consumed her son-in-law, a ne'er-do-well who had lost his money gambling – he appears crouching in the sea creature's stomach below. Another sea monster appears underneath, on the head of a creature with large ears, probably a mouse.[30]

These great carved cedar poles with their hollowed backs might well have been made by the same craftsmen who fashioned ocean-going cedar canoes, another speciality of the people of the north-west Pacific coast. Like towering vertical images throughout human history, from the columns of Ashoka in early Buddhist India and the obelisks of ancient Egypt to the Anglo-Saxon crosses of England in the early days of Christianity and the stone columns of Rome and the Ethiopian kingdom of Aksum before them, the totem poles of the Haida people were symbols of a human sense of rootedness and dominion, and also of growing wealth through trade. Yet none of the earlier columns was created with such raw power as those of the Haida, where the very idea of the 'totem' (the word comes from the North American Ojibwa word *doodem*, meaning 'clan'), the image of an animal invested with spiritual powers, is given such an animated and powerful expression.

The Haida tradition of totem-pole carving reached its height in the middle years of the nineteenth century. Painting a mountain, going on a long journey, raising a building or carving an image to a great height – all were symbols of the human sense of dominion. Elsewhere on the American continent a quite different tradition of symbolic structures was reaching its apogee, in the first century of the skyscraper, in which symbolism was reduced to pure size and scale, the landscape transformed by human-made metal-framed structures that mimicked grand works of nature in their size, rivalled only in architectural history by the cathedrals of northern France and the pyramids of ancient Egypt and Mesoamerica. The very tall buildings that appeared first in Chicago and New York were made possible not only by the use of iron frames in construction, a technique first used in industrial architecture in England, but also by technological leaps: better fireproofing, ventilation and electric lighting, and also the invention of the elevator, making life and work possible without the sheer exhaustion of ascent. The skyscraper, like the swirl of the Chicago-born Loïe Fuller's dress in Toulouse-Lautrec's print, was the symbol of a new age of electrified and ever-expanding urban life.

MOUNTAINS AND OCEANS

The totem poles of the Haida Indians may have been symbols of dominion, but they were also ways of preserving memory. The enthusiasm for symbols in North America, as in Europe, was a journey into private experience, or into that of a closed community, a language of form that would always remain, to a degree, hermetic. The seeds for this hermetic language lay deep in the history of image-making, in every moment where the seduction of colour, pattern or surface took over from the subject: in the details of a dress painted by Velázquez, a wall by Vermeer or the darkness in the corner of a portrait by Rembrandt.

And yet it was only in the late years of the 1800s that these forms became like a new language of human emotion. At the time they were considered mystical, bizarre even. Pioneers such as the Swedish artist Hilma af Klint were not taken seriously: af Klint kept her own unnaturalistic paintings (she also made conventional landscapes) hidden, banning their display until twenty years after her death. Like other forerunners of such painting, which came to be known as 'abstraction', af Klint took inspiration from spiritualism and the occult, painting under spiritual guidance like a medium at a séance as much as from the example of Munch's symbolism, which she saw in a large exhibition in Stockholm in 1894.[31]

Although the images she used are difficult to decipher, such as the obscure symbols in her long series *The Paintings for the Temple*, which begin by evoking primordial chaos with squiggles and spirals, af Klint nevertheless made paintings which by their size alone show her ambition as a painter – these were not images to be sequestered away in albums, pored over only in private. In the autumn of 1907 she painted a series of ten paintings over three metres tall, showing 'four parts in the life of man', as she wrote, distantly recalling the symbolism of Philipp Otto Runge. Painted with tempera on paper, they contain strange objects, like natural forms recreated with artificial colours, symbolising the grand themes that preoccupied af Klint: evolution, progress, growth, the unity of the spirit and mind. There may have been no audience to appreciate and support such an ambitious undertaking, but these were subjects nevertheless that had appeared in images for at least a hundred years, and which seemed to carry with them the wish to ascend into the mountains, or soar over endless ocean. 'The sea wave, with all its beneficence, is yet devouring and terrible,' wrote John Ruskin, 'but the silent wave of the blue mountain is lifted towards heaven in a stillness of perpetual mercy.'[32]

They were symbols of a spirit of creative freedom in human life: the freedom to construct a new world.

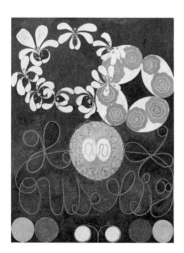

Group IV, The Ten Largest, No.1, Childhood, by Hilma af Klint. 1907. Tempera on paper, mounted on canvas, 322 cm by 239 cm. Hilma af Klint Foundation, Stockholm.

26

New Worlds

Great paintings are ends and beginnings wrapped in one. Alongside his images of Mont Sainte-Victoire, Paul Cézanne's *Large Bathers* is the culmination of some six centuries of painting in Europe devoted to recording the visible world. It is also the beginning of something quite different: an era in which images delved beneath the surface of nature, unpicking the atoms of life, burrowing into the workings of the human mind – how we see, how we think, how we dream – vigorously shaking off many of the assumptions and conventions attached to the creation of images for millennia.

It was a matter less of what was painted or sculpted, the subjects chosen, than of how they were shown. In 1910 the French artist Henri Matisse made a painting of five naked musicians, their skin glowing red, perched on a ridge. We seem to be witnessing a primal moment of human music-making, reduced to the barest elements. One stands primly playing a small violin, another blows into a flute, while the three others are open-mouthed, singing. Five naked figures whirl around an accompanying painting, as if witnessing the origins of dance. Singers and dancers were hardly novel subjects: what counted was the strength and simplicity of the colour, the thinness of the drawn line and the sureness of the placement of the figures, so that we might imagine hearing the rough, piercing sound of the music, the wavering harmonies, each colour a note in a chord, perhaps, and the eager need of these primitive players to communicate their melodies. The figures themselves are like notes on a musical stave, the violinist the clef symbol, the flautist and singers three notes rising then the fourth one falling to the tonic.[1]

Matisse tirelessly painted and repainted his canvases, changing and adjusting the composition, the placement of the lines, the exact hue and tone of his colours, until he reached what he described as the 'state of condensation of sensations which make a painting'.[2] Where painters of an earlier generation, from Monet to Cézanne, gazed at their subject and then translated their vision to canvas, Matisse created intuitively, generating images from drawings and from an almost bodily feeling for the overall design, the way a composition fits together. 'A work of art must carry within itself its complete significance', he wrote. It

Henri Matisse (1869–1954), *Music*, 1910. Oil on canvas, 260 × 389 cm. The State Hermitage Museum, St Petersburg. Inventory number: ГЭ-9674.

was a significance that should impress itself upon the beholder through colour and form before they even recognised the subject of the painting.[3]

Matisse was following his own sense of where painting might travel, freed from academic rules. He was also fired by a spirit of competition. A few years earlier, in the studio of a young Spanish painter living in Montmartre, he had seen a canvas so shocking and at first incomprehensible that it shook his sense of what might be accepted as a painting, not only by polite society but by artists themselves.

The painting, by the Spanish artist Pablo Picasso, shows five women, for the most part naked, standing among textile hangings, the lines and folds of which meld with the angular drawing of their bodies. The focus is squarely on the faces of the women, staring out at the viewer, with the suggestion that they – we – are visitors to a brothel, identified by the title of the painting, *Les Demoiselles d'Avignon*. It was a place Picasso knew well from his time in Barcelona, to be found on the Carrer d'Avinyo ('Avignon Street').

If such a stark representation of prostitutes were not enough, three of the women's faces are painted as if to make them deliberately ugly, at least according to European standards. Picasso is recalling the forms of African masks, which he collected and had seen at the Palais du Trocadéro in Paris, pushing their linear forms to an almost caricatured extreme. The faces of the women are caught between a comic expression and something more uneasy, more raw and brutal, an exchange of looks that triggers dangerous desire. A bowl of fruit in the foreground stages a crude visual pun on male genitalia, as if an extension of the viewer, unquestioningly assumed by Picasso to be another man, into the space of the painting.

Picasso rivals Cézanne's ugliness without transforming it, at least in *Les Demoiselles d'Avignon*, into a classically composed painting fit to rival the great works in the museums, as Cézanne had wished. Instead he remains within the harsh world he depicts, and stages a confrontation, a stand-off. It is as though the naked women in Cézanne's *Bathers*, which appeared in a large exhibition of Cézanne's paintings in Paris in 1907, a year after he had died (and the year Picasso painted the *Demoiselles*), had suddenly drawn together and been thrust to the front of the stage. Picasso's woman on the left seems taken directly from Cézanne's anchoring woman with her long dark hair. The painting fires a question at us, demanding a response. We cannot remain indifferent.

And yet there remains an awkwardness about the *Demoiselles*, an unresolved quality to the right-most quarter of the painting, giving it a rawness but denying us the satisfaction of a completed painting. Matisse may have felt this when he first saw the painting in Picasso's studio, seeing the risk Picasso had taken, and his success and failure. He had created a painting that seemed almost impossible to look at, or to enjoy as painting had always been enjoyed. But what counted in the end, as Matisse and others well knew, was the scale of the risk.

Picasso painted the *Demoiselles* three years after arriving in Paris from Barcelona. He established his studio in a building known as the Bateau-Lavoir in Montmartre, and swiftly went through a series of stylistic phases, from the poetic realism of his so-called blue- and rose-period images of melancholy circus performers, before arriving at this manifesto of painting, *Les Demoiselles d'Avignon*, which, even if he had died shortly after (rather than over sixty years

later), would have assured his fame as one of the great figures of twentieth-century art.

It was during the following year, after seeing the landscapes that Georges Braque had been painting in the south of France at L'Estaque, with their geometric, cubic look, that Picasso began solving the problem he had created with the *Demoiselles*: the problem of bringing your fist down so hard on an entire tradition of painting that everything shatters and must somehow be pieced back together again. Working closely with Braque was essential to this long process, so that at times over the next six or so years their paintings are indistinguishable. The style soon became known as 'Cubism', christened by the critic Louis Vauxcelles, who had described Braque's paintings as made up of geometric lines and cubes (although Matisse had been heard talking about 'cubisme' some months earlier).

The way Cubism pieced the image back together was on the face of it really quite simple: paintings were constructed roughly geometrically, with lines and planes, and the colour reduced to an almost monochrome palette of browns and greys. It was to be thoroughly impersonal, expressive not of the artist's mood or personality, but rather a workman-like painting. Impersonality meant also escaping from the trap of virtuosity: the idea that making a painting was a matter of technical refinement culminating in the greatest likeness to life. Picasso and Braque sought instead to show that painted images were always unnaturalistic, conventional, matters of pure style. They might exist in the world as a bottle or a newspaper, part of the world of things.

At the same time Cubism, in its purest form, was far from the world of outside nature. It was a style of painting entirely devoted to human life, to perception and intellect. One obvious sign of this de-naturing is the almost complete absence of the colour green. By 1910 Picasso's paintings were entirely composed of browns and greys, configurations of lines and areas of dabbed tone, as if a place, an object or a person – a guitarist, in the case of a painting made in the summer of that year – was being seen through smoky, shattered glass.

Such canvases feel like a new species of painted image, with a different internal structure from everything that had come before, a different consciousness of being in the world. Their surfaces are divided into complicated networks of lines and shapes, in among which objects hide, such as the T-square that cuts across the middle of Picasso's *The Architect's Table*. It is surrounded by what seem like architectural sketches, while the words 'MA JOLIE' float over the pages of an open book. They are taken from a popular song of the time, composed by an English music-hall singer:

> *O Manon*
> *Ma jolie*
> *Mon coeur te dit bonjour.*

The most lifelike detail is the calling card, bottom left, of Gertrude Stein, as if the American writer had visited but found the painter–architect not at home. Beneath Stein's card is the tiniest smudge of green paint, making nature all the more conspicuous by its general absence. These little details are hooks for our

attention, so that we don't feel entirely lost, for otherwise we seem to be looking at an incoherent projection of Picasso's ideas as he sits in his studio, thinking, imagining, creating. He is the architect and the painter rolled into one. Looking at Picasso's *Architect's Table* is like looking into the workings of the mind itself: an image about the act of vision, held within the mechanics of the human eye.

Together with Braque, Picasso opened up a fresh approach to painting, and yet he never relinquished the idea that painting was 'of' something in the real world. He was never to make an image composed entirely of symbolic lines, shapes and colours. Rather, he transformed the painted image into a sort of writing, where only the most significant attributes of a thing – a man playing a mandolin, a beautiful woman, the table of an architect – are included, the rest being pure atmosphere and imagination.

That a painting might show nature not through appearances, but rather by revealing the workings of the world, the invisible forces that create and destroy our surroundings, had been felt a generation earlier, by Cézanne and his contemporaries, and put into words by those few people who saw how revolutionary it was. The 'Post-Impressionists', as Roger Fry christened them – namely Gauguin, Van Gogh, Seurat and Cézanne – do not reproduce reality, but rather 'arouse the conviction of a new and definite reality'. Rather than imitate, they create, with the intention of finding an 'equivalent for life'.[4]

Showing the hidden forces of nature had been the task of painters for centuries, at least since Rembrandt had shown the effects of age on the human face. After Cézanne, however, the very composition of the work, its form and structure, might provide an 'equivalent for life', for the forces of nature, growth and death, but also for the experience of being in the world. We sense our environment moving around the city, being subject to constant changes and surprises, words, images, environments coming and going, very differently from that of being within nature, where we take our place as part of a coherent and continuous whole.

The second 'phase' of Cubism, from around 1912, was dominated by one technique that did just this. In place of painted words were 'real' words, or at least those printed in newspapers, bottle labels and musical scores, taken by Braque and Picasso and affixed to the surfaces of their paintings. The effect of such collaged elements in paintings such as Picasso's *Glass and Bottle of Suze*, from 1912, is that of a direct imprint of life onto the canvas, and also a feeling of almost jaunty comedy, something like the music-hall songs that both artists loved, and whose words so often found their way into their compositions.

These mysterious brown-toned paintings were the epitome of old and new rolled into one. From afar they might be mistaken for some heavily varnished darkened Old Master painting, whereas close to they were the most elegant, humorous and up-to-date images of the day. Cubism became a fashion, the very image of modern life that Baudelaire had demanded of artists some fifty years earlier.

Images themselves seemed to have gained velocity, rolling off the newspaper press, enlarged and pasted on the city walls, while tram cars and motor vehicles

whooshed past at frightening speeds. Life itself seemed to be accelerating, telegraph messages zipping across the Atlantic, the machines of industry being made ever more productive, such that the image of a modern factory in Menzel's *Iron Rolling Mill*, made some forty years earlier, was quite clearly the world of yesterday.

In February 1909 an article appeared on the front page of the French newspaper *Le Figaro*, 'The Manifesto of Futurism', signed by the young poet Filippo Tommaso Marinetti – it had first appeared in an Italian newspaper earlier that month. Marinetti recounted an ecstatic joy ride around the streets and lanes of Bologna, ending in a car crash in a ditch, for Marinetti a moment of revelation rather than of serious injury. 'We declare that the splendour of the world has been enriched by a new beauty: the beauty of speed', ran the manifesto, 'a roaring motor car which seems to run on machine-gun fire, is more beautiful than the Victory of Samothrace'.[5] Twenty years later the sentiments in the manifesto – burning down museums, glorifying war and patriotism, agitating against 'morality, feminism' and the intellectual currents of modern life – would have fitted perfectly with the cultural aspirations of Fascism, in Italy, Germany and elsewhere in Europe and in America.

The Futurist intoxication was encapsulated most memorably in the forms of a running figure, *Unique Forms of Continuity in Space*, made by Umberto Boccioni in 1913, three years before his death during the First World War (in a cavalry exercise). It is the closest sculpture came to mimicking the dynamism of a Cubist painting or the use of lines and planes that ultimately derived from Cézanne. The aerodynamic feeling of the figure, as though moulding the surrounding air through a striding movement, suggests more a work of engineering than a sculpture cast in metal. Bronze bathers and dancers made by Degas barely two decades earlier appear antiquities by comparison. Where Degas's figures bathe and dance in the twilight of the nineteenth century, Boccioni's bronze god is running headlong into a new world.

The trajectory away from the lifelike realism that had become so much of a stumbling block during the nineteenth century. Picasso, Braque and Matisse all followed Cézanne in turning away from natural appearances towards an ideal of self-sufficiency. Others took this journey further. How far could you depart from naturalism, from the look of reality, without becoming merely decorative or meaningless? For some artists abstraction was a means not of escaping the world but of intensifying it, crystallising the miraculous experience of human vision into images of colour and line, like those of the Russian painter Wassily Kandinsky. Although they might at first appear wholly abstract, the sense of light and movement in his paintings suggest that what we are seeing are believable depictions of an abstract world, one full of vigour and life, coloured shapes flying across an unrecognisable landscape, lines whiplashing and snaking across the surface. The whole of *Composition V*, painted in 1911, we might take as an invented landscape, and one that, like Picasso's Cubist compositions of the time, is largely devoid of the colour green. What counted was not that the painting showed the world, like a memory of something, a record of presence, but rather that it was itself a believable world, that it held together and lived under its own reality.

The Czech painter František Kupka was one of the first to produce paintings that abandoned all reference to nature, in canvases entirely composed of

colours and shapes, rather than images of things, exhibited at the Salon d'Automne in Paris in 1912. This was the self-sufficiency that Matisse had demanded, but now entirely cut free from the obligation to be in any way recognisable.

It was on the whole a balancing act, a matter of assessing just how much risk it was possible to take. Kandinsky had been earlier associated with a group of artists in Munich, notably the painter Franz Marc, who had attempted as far as possible to expand the repertoire of what might be accepted as 'art'. They exhibited together and produced a book documenting their enthusiasms, *Der Blaue Reiter Almanach* ('The Blue Rider Almanac'), of 1912 – drawings by untrained artists, by children, as well as those by the 'insane', alongside Japanese drawings, Russian folk images, objects from the Pacific islands and Egyptian puppets.

Marc in his own paintings often took the instinctive world of animals as his subject, creating an equivalent for their fears and awareness of the world in fleeting marks of coloured pigment. His death in the First World War was one of the great tragedies of early twentieth-century painting, particularly in a country, Germany, that had shown itself as the most open and supportive nation for artists who took on new forms of art. The Expressionist movement, as it became known, was primarily a literary movement, in which heightened emotion took on a philosophical dimension. In painting, the artists who came together in Dresden in 1905 and called themselves Die Brücke ('The Bridge'), including Ernst Ludwig Kirchner and Max Pechstein, returned to the landscape and childhood to create paintings in a rough, impressionistic style, that make of them more the last breath of nineteenth-century naturalism than a step into the new world of abstract painting – they stood at the foot of a bridge that others were to cross in the years after the group disbanded in 1913.

It was his experience painting the landscape of his native Netherlands that led Piet Mondrian to become obsessed by composition, the way marks and areas of paint fitted together on a canvas. From his earliest landscape paintings – compact, often gloomy images of rivers and mills – Mondrian evolved an ever more sparing, ascetic style. Just as Monet had used the trunks and branches of trees as a way of dividing a composition in painting poplars along the Seine, and both Van Gogh and Gauguin had used the forms of trees to structure their landscapes, so too Mondrian painted images of trees from around 1900 that became the armature for his increasingly reduced canvases.[6] His encounter with the Cubist paintings of Picasso and Braque in Paris during 1912–14 was the point of no return in this quest, one of the most committed and determined searches for a style of painting beyond natural appearances of the twentieth century, alongside that of Picasso.

The way seemed clear, and Mondrian was soon making paintings that existed entirely in a constructed, rather than observed, space, as if he were emerging into a clearer, lighter air, formed by vision and thought alone: a place in which the deep structures of the natural world could be recreated in the imaginative space of painting.

Paris itself became a subject. Fronts of buildings, perhaps around his studio at the rue de Départ in Montparnasse, become maze-like compositions of lines and muted tones, dominated by the muted browns of Cubism and Mondrian's own softer palette of pinks and greys. Their anonymity is that of the cityscape seen through the eyes of a newcomer, alive to both the spectacle and the melancholy of the modern world. Like the paintings of Picasso and Braque of modern Paris, they find their echo in the 'Unreal City' of *The Waste Land*, T. S. Eliot's great evocation of the shifting moods and atmosphere of London in 1922, in part a collage of quotations, from Dante to Baudelaire:

> Unreal City,
> Under the brown fog of a winter dawn,
> A crowd flowed over London Bridge, so many,
> I had not thought death had undone so many.

And yet it was away from the city that Mondrian discovered the path through to his own form of expression, beyond Cubism, beyond the modern city. In 1909 he had painted the sea at Domburg in the Netherlands. The open vision of ocean and sky was a space on which he could impose his own vision of ordered brushmarks and tones, expressing a sense of being spiritually attuned to nature.

He drew and painted the sea once again when he returned to the Netherlands in 1914, to visit his dying father; the outbreak of war meant that he was to remain there for five years. His final painted vision of the ocean from this moment, painted the following year, transforms the seascape into a field of horizontal and vertical lines, set within an oval, a form taken perhaps from Picasso in paintings such as *The Architect's Table*, but used by Mondrian in an entirely different way, to represent the encompassing field of human vision, giving a strong sense of physical presence in front of the ocean, standing on the wooden slats of the pier stretching out into a calm, glittering, silvery sea.

Mondrian's paintings soon became detached from all signs of nature and the natural world: pure creations, as he put it, of the human spirit.[7] Thick black lines imposed over white backgrounds, with rectangles of primary colours, generally blue, yellow or red, give a world formed, constructed, entirely on its own principles, and yet the feeling of a decorated façade, or of the airy spaces of ocean and shore, and the sense of a human presence within nature are never entirely effaced.

What counted was not the relationship of the things, the marks, the colours and shapes, in the painting with the outer world of nature but the way they related to each other, the internal relationships within a work. Universal beauty, as Mondrian

Piet Mondrian (1872–1944), *Composition 10 in black and white; Pier and Ocean*, 1915. Oil on canvas, 85 × 108 cm. Rijksmuseum Kröller-Müller, Otterlo.

described it, was a matter not of mimicking or reflecting but rather of constructing an image.[8] By achieving 'dynamic equilibrium', Mondrian wrote, painting could follow the 'fundamental law of equivalence', showing reality by reflecting the deep laws of nature rather than its superficial appearance – an equivalent for life.[9]

Such an idea had already surfaced elsewhere in painting, in Russia, among a group of artists and writers, including Kazimir Malevich and Vladimir Tatlin, who pitted themselves against the naturalism dominant for centuries. They saw the power of an image as derived entirely from its forms and structure, rather than from what it represented. The image was not a transparent screen onto a world but a world unto itself. Rather than repeat the familiar world, painting can awaken us to a new consciousness of things by making the familiar strange – just as the symbolism of Gauguin had shown a new way of looking at the world. As the Russian critic Viktor Shklovsky wrote, in 1917 in his essay 'Art as Device': 'what we call art exists in order to give back the sensation of life, in order to make us feel things, in order to make the stone stony. The goal of art is to create the sensation of seeing, and not merely recognising, things.'[10]

Merely copying nature was a 'false consciousness', Kazimir Malevich wrote in a booklet published in 1915 alongside an exhibition with the radical title *0.10* held in Petrograd (now St Petersburg). The true purpose of painting, Malevich proclaimed, was rather to 'create new form'.[11] This might not even mean painting or sculpting. If you put the same glass down on a table twenty times, he wrote, 'that's also creation'. The Futurists had blazed the trail with their glorification of speed, that invisible quantity, and of the machine age. But it was for Malevich (or so he thought) to complete the idea of 'painting as an end in itself, as spontaneous creation'. Everything extraneous to painting had to be abandoned, as if throwing ballast out of a boat to stop it sinking. All that was left were colours and forms, light, buoyant, intuitively wrested from nothingness by the self-proclaimed creative genius of the artist.

Hanging on the walls of the *0.10* exhibition were canvases covered with coloured shapes by Malevich and sculptures by the artist Vladimir Tatlin, sheets of iron and aluminium held by wires and floating high in the corner of the room, which he described as 'counter-reliefs' – sculptures of nothing, shaped only by the properties of the materials with which they were made: the solid squareness of wood, the reflective, transparent quality of glass, the bendable, weldable hardness of metal.

Counter to what? Counter to all past images, and the idea of having to copy nature. Counter to nature itself. And yet what made Tatlin's metal shapes and Malevich's *Black Square*, shown at the *0.10* exhibition, nothing more than a square of black paint on a small white canvas, so powerful, so beautiful even? Anyone could have made them, perhaps; but of course, nobody apart from Malevich and Tatlin did – and at the right moment, so that such a pure, radical image and object could become a symbol of a whole spirit of change in a society. Tatlin's counter-reliefs took the idea of Cubism, particularly reliefs being made by Picasso which he had seen in Paris in 1914, to a defiant extreme. Malevich's non-naturalist painting – 'Suprematism', as he called it, with ecstatic enthusiasm – was the conclusion of what Gauguin had set in train, the search for a type of painting that did not repeat the forms of nature but created a new visible world, answerable to nothing except itself.

What was at the end of this journey into new imaginary worlds? If the purpose of a painting or sculpture was not primarily to represent the appearance of things, then should it represent anything at all? Perhaps a work of art might be entirely about ideas, about thinking rather than seeing. Perhaps a work of art might not be a physical 'work' at all.

These were the questions circling around the mind of a French artist, Marcel Duchamp, during the year 1913. His paintings, which had arisen out of a style close to Cubism, were strange imaginations, even for his fellow painters. *Nude Descending a Staircase No. 2*, showing a barely recognisable woman walking down a stairway, like a very slow futurist painting or a very complicated piece of Cubism, and a highly intellectual elaboration of both, had been rejected from an exhibition organised by other Cubist enthusiasts in Paris, including his two older brothers, Jacques Villon and Raymond Duchamp-Villon, and the painters Albert Gleizes and Jean Metzinger.

Well, then – how to step beyond painting, to throw even colour and form out of the boat, but still create? Might the act of choosing be itself creative? Could any object might be transformed, or recycled, into a work of art by being chosen for contemplation? Difficult questions, which required long hours of mulling over.

Marcel Duchamp sat in his studio, thinking, smoking.

He got up and rested his hand on a bicycle wheel, mounted on a wooden stool, just for the sake of it. He gave it a spin, and sat down again to think, captivated by the glinting spokes whirring round and around.

There it was, the first 'ready-made': an ordinary object transformed only slightly, if at all, and presented as a work of art. Why not? The ready-made (Duchamp came up with the term a couple of years later, on arriving in America, where everything seemed ready-made) threw back the question onto the viewer – why *do* we look at images, painted and sculpted? What is it that we see in them that we cannot find elsewhere? It staged a confrontation much like Picasso's *Les Demoiselles d'Avignon*, although one created not by thoroughly daring technique but by an unexpected choice.

Duchamp's *Bicycle Wheel* was followed by other ready-mades: a wine bottle rack, a snow shovel, a coat hook and, most notoriously, a ceramic urinal, turned on its side and signed, mysteriously 'R. Mutt'. The urinal was sent to an exhibition, that of the American Society of Independent Artists, in April 1917, which was well known for having no jury or selection procedure – every work submitted was, according to a democratic ideal, automatically hung. Duchamp's urinal, given the elegant title *Fountain*, was nevertheless rejected.

South of the border, in Mexico, a more serious democratic contest was being waged. From the autumn of 1910 a series of revolutionary uprisings spread around the country, opposed to the dictatorship of Porfirio Diaz. Under Pancho Villa, in the state of Chihuahua, and Emilian Zapata, in the state of Morelos, guerrilla armies fought to restore land to the *campesinos*, or peasants, in the name of democracy and the rights of indigenous Mexicans Indians.

The ideals of this revolutionary period were set down in murals commissioned during the following decade, in the 1920s, most prominently from the Mexican artists Diego Rivera, David Alfaro Siqueiros, and José Clemente Orozco; all three admired Russia and were committed to communism as a political ideology.

Of them, Rivera was the greatest communicator of *Mexicanidad*, the folk spirit that fired the souls of dissenters. Rivera's murals appear like images of democracy itself, crowded, clamorous, inclusive, often difficult to read, 'setting down in passionate hieroglyphs every phase of the revolution', as the writer John Dos Passos put it.[12]

Painted at the top of an open stairway in the Palacio Nacional in Mexico City, Rivera's *History of Mexico*, is a chronicle of events from the earliest Mesoamerican civilisations to the present day. On one wall Rivera painted the *Aztec World*, a Mesoamerican panorama with the figure of Quetzalcoatl, the plumed serpent god, at its centre, marked out by his bright green headdress. The clamour continues on the main wall, showing the Spanish conquest, the time of the Emperor Maximilian – an Austrian archduke whose execution in 1867 ended European control of Mexico – as well as the dictatorship of Porfirio Diaz. Mexico's bright future under communism is shown on the third.

One of the figures in his *History of Mexico* murals is the painter Frida Kahlo, who Rivera had married in 1929. Although she shared his political views, and was an ardent supporter of communism, in her art Kahlo was his opposite. Rather than sprawling public murals, filled with a cast of thousands, she painted small canvases, revelations of her personal life, and her fortitude in the face of a long series of personal tragedies. A collision between a tram and the bus on which she was riding at the age of eighteen left her with multiple injuries such that, as one friend put it, 'she lived dying' for her remaining twenty-nine years.[13] Her pain and suffering were the source of knowledge that radiates her paintings; as she wrote a year after the accident to her then-lover, Alejandro Gómez Arias, who had been travelling on the bus with her:

> If you knew how terrible it is to know suddenly, as if a bolt of lightning elucidate the earth. Now I live in a painful planet, transparent as ice; but it is as if I had learned everything at once in seconds.[14]

The pain was also emotional, a result of her turbulent marriage to Rivera. The union was marked by numerous affairs on both sides and her own physical inability to bear children, despite many attempts, a personal disaster that she recorded in paint.

These accumulated traumas led to a sense of doubling of personality, a division in Kahlo's paintings between images of vitality and sickness, between devotion to Rivera and independence as an artist, between Mexico and Europe as a source for contemporary painting (she was claimed as a Surrealist by André Breton, but on visiting Paris turned against what she saw as the over-intellectualised milieu of Surrealism, making an exception only for the gentlemanly figure of Marcel Duchamp).

Frida Kahlo (1907–54), *Self Portrait with a Monkey*, 1938. Oil on masonite, 40.6 x 30.5 cm. Albright-Knox Art Gallery, Buffalo, New York, USA. Bequest of A. Conger Goodyear, 1966. Acc. No. 1966:9.10.

This split persona is strikingly set down in one of her greatest paintings, a double self-portrait — *The Two Fridas* — made in 1939, during a highly productive time when she was divorced from Rivera (they remarried shortly after). Seated on the left, the traditional Frida is dressed in Tehuana costume (long patterned dresses worn by Zapotec women which became symbols of *Mexicanidad* following the revolution), a white dress with a high lace collar and layered sleeves, while on the right the other Frida wears 'modern' dress for the time, a purple and yellow silk top with a long green skirt. Hearts and arteries are exposed, joined, and severed by surgical pincers held in the left Frida's hand, blood spurting down to mingle with the red flower embroidered in her dress. In the background a stormy sky casts a coldness over the scene. The hand of the right-Frida holds a miniature portrait of Diego, attached to a vein suggesting that the doubling here is also a replacement, a statement of sorrowful independence following the divorce. Isolated not only by lost love, but by the interminable reality of physical pain, Kahlo holds her own hand.

It is a mark of the power of Kahlo's paintings that despite their overwhelmingly personal subject matter — around a quarter of the two hundred or so paintings she completed are self-portraits — they are hardly documents of narcissism. Kahlo was in this sense more of a realist than Rivera, showing the reality of individual life, rather than the dream of an ideal society: she once criticised the whiteness of his painting of Zapata's horse as pure fantasy — Rivera recalled his earlier manifesto, saying he wanted to paint beautiful things for 'the people'.

In the end it was Kahlo who struck a deeper chord with 'the people', for her images that showed the reality of suffering and personal dignity. In time she emerged from the long shadow of her husband, although it was only after her death, at the age of forty-seven in 1954, that she achieved a celebrity rivalling that of Rivera, achieving the recognition for which she had fought, against the odds.

The Futurists had been supportive of the First World War, which had nevertheless claimed the life of one of their greatest artists, Umberto Boccioni. Elsewhere the energy of war was turned against itself, transformed into the fire of political protest. In Switzerland and Germany the Dadaists railed against

convention, doing all they could to sweep away the past and invent a wholly new idea of what it meant to be an artist.

The First World War was the first to result in the slaughter of millions through the use of mechanised weaponry. Artists had seen the horrors of war at first hand, and struggled to record them. In his print series *Der Krieg* ('The War') Otto Dix showed as directly as possible the horrible maiming and cruel deaths of trench warfare, and the collapse of morality in society at large. Only in 1924, six years after the war had ended, did he feel able to make such graphic images.

Quite what 'Dada' meant, nobody quite knew – it signalled the appeal to irrationality among the group, which was largely a matter of behaviour and comportment, particularly at one of the exhibitions they organised, the *Erste Internationale Dada Messe* ('First International Dada Fair'), staged in Berlin in 1920 at the gallery of Otto Burchard by George Grosz, Raoul Hausmann and John Heartfield. The walls were plastered with slogans ('Nehmen Sie DADA Ernst!' – 'Take Dada Seriously' – one of them ironically exhorted), surrounding paintings into which imagery cut from newspapers poured directly, literally stuck to the surface to reinforce the satirical caricature of contemporary life and the anti-war, anti-bourgeois message. 'When in the past colossal quantities of time, love, and effort were directed toward the painting of a body, a flower, a hat, a heavy shadow, and so forth, now we need merely to take scissors and cut out all that we require from paintings and photographic representations of these things', wrote the poet and Dadaist Wieland Herzfelde in the introduction to the catalogue.[15] It was a sales exhibition, yet only one work (subsequently lost) was sold, and the organisers were sued for slandering the military – although in Dada terms this was a good result.

Taking images from newspapers, or cutting and pasting photographs, John Heartfield, Raoul Hausmann and Hannah Höch produced photomontages that shouted out their message – in the case of John Heartfield, of the threat to democracy and to the working classes from Fascism and authoritarian politics. They were fired by the work of Russian artists, in particular Alexander Rodchenko, who had denounced traditional forms of art, taking Constructivism beyond the painting of Malevich and the sculpture of Tatlin and into the realm of photomontage, going far beyond the comparatively polite concoctions of Picasso and Braque. Heartfield's collages, like those of his Dadaist colleagues, drew on the flood of photographic images in contemporary society and showed how easy it was for these images to be manipulated for political reasons. Hannah Höch created a visual compendium of the politics of Germany following the end of the war and the workers' revolutions of 1919, in her collage *Cut with the Kitchen Knife Dada through the Last Era of the Weimar Beer-Belly Culture*, which was exhibited the following year at the *Erste Internationale Dada Messe*. The cutting of the title was across eras, and conventions: the New Woman, liberated and in motion, is shown alongside cut-out images of male politicians. At the centre is an image of the artist Käthe Kollwitz, cut from a newspaper article, who had just been appointed as the first female professor at the Academy of Arts in Berlin. Women were being given the right to vote in many countries, including Germany and Britain (Norway had come first some years earlier), and were now active participants in art circles.

Höch belonged to a generation of women who for the first time were able to participate in the arts on the level of equals, rather than as some sort of exception or concession, by invitation. The truth is that the story of human

image-making we have since the beginning of settled life, some twelve thousand years ago, is only half the story it might have been – or less, even, bearing in mind that the vast majority of human images made throughout time have been lost, and that what we are left with is largely the wreckage of time. From the scant traces that remain from the wilderness years of humanity, the hunting, gathering, cave-dwelling years, we might guess that women played a greater part in image-making. So too during the twentieth century women artists became not the exception – the talented daughter or sister of an established artist given permission to pursue her career – but increasingly the most important image-makers, for the alternative view they provided in a male-dominated world, as artists such as Mary Cassatt, Élisabeth Vigée Le Brun and Properzia de' Rossi had already shown. During the twentieth century this alternative view laid bare the prejudice lodged in our very vision of the world and the way that it is represented. Prejudice lingers in the language used to describe historical art, from 'Renaissance', a 're-birth' of art determined entirely by male artists, to the veneration of 'Old Masters'. Childbearing and child-rearing and the experience of childhood, central to our lives, have been subjects marginalised in the creation of works of art, so that, in Western art at least, the only image acceptable of a mother and child is that of a woman who has become pregnant while remaining a virgin. Perhaps we might call the *Virgin and Child* the first 'abstract' image, for its distance from biological and natural truth.

Among others it was these truths, and those of the horrors of war, that the Dadaists and others were determined to expose in the great waves of reform that swept over Germany in the 1920s. Risk-taking artists everywhere were creating images that answered the need for new voices in a new democratic age.

And yet this did not mean that 'ordinary' spectators saw much of them. Duchamp's *Bicycle Wheel* was lost in 1915, and *Fountain* was stored away after it was rejected for exhibition in 1917. Only in the 1950s did the ready-mades resurface and become widely known and influential. Picasso's *Demoiselles d'Avignon* itself was kept in his studio for almost two decades, and was exhibited just once before being sold to the couturier Jacques Doucet in 1924. Such works hardly existed in the popular, democratic imagination.

They were shocking not only in their shape and appearance but also in their content. And yet it was in literature that this shock was conveyed most keenly, and most presciently. No creation of those years, with the exception perhaps of Picasso's *Demoiselles d'Avignon*, was more shocking than *Ulysses*, the long novel written by James Joyce, following the character Leopold Bloom around Dublin on one day in 1904. We might imagine Bloom visiting the brothel in the Carrer d'Avinyo, shown in the *Demoiselles*. Joyce took the episodes of Homer's *Odyssey* as the model for his book, using them to recount the experiences of Bloom, of his wife, the singer Molly, who has an afternoon assignation with her tour manager Blazes Boylan, and of Stephen Dedalus, the autobiographical character known from Joyce's earlier novel, *Portrait of the Artist as a Young Man*.

Like Odysseus, Bloom is the hero, although it is a heroism cast in the everyday world of Dublin, and described in an often very obscure language with endless references and quotations so that *Ulysses* often feels like a history of the English language itself – indeed, one episode, the *Oxen of the Sun*, is made up from a long series of parodies of the English language as it developed from ancient

pagan forms, through Middle English and Arthurian legend right up to the critical writings of John Ruskin. The infamous final section of the novel – a long, scurrilous monologue by Molly, lying in bed unable to sleep – is the shocking climax to Joyce's relentless demolition of the conventions of writing, and of morality. And yet, just as with the violence of Picasso's *Demoiselles d'Avignon*, the purpose is to reach a deeper form of creation, one that emerges from our deepest memories, those of our own childhoods, but also of our collective memories, the long history that has formed us. This we read in the weave of Joyce's sentences, the natural flow of his words, epitomised by a long section in which Bloom reflects on the origins of water when turning on a tap. As Stephen Dedalus says earlier in the novel, 'The supreme question about a work of art is out of how deep a life does it spring.'

Such difficult new forms of art and literature were esoteric, hardly widely known and certainly not accepted. For most they were at worst evidence of insanity, and at best nothing more than jokes.

Jokes, however, can be serious things, as Sigmund Freud had written in 1905. They were a way of revealing the unconscious habits and workings of the human mind – deeply lodged memories that shape behaviour, but which only see the light of day in veiled, coded forms, as witticisms and puns, slips of the tongue or dreams. Freud saw painted images as another way of understanding the workings of the human mind, most famously in his study of the work of Leonardo da Vinci, in which he traced a hidden line between Leonardo's childhood experience and the paintings and drawings he made in later life. Creativity itself, in Freud's view, was somehow connected with deep unconscious urges that can be traced back to childhood experience: it is the continuation of childhood play, the fulfilment of wishes, often shaped by early life experiences, and feelings of want and lack.[16] It was thus that the writings of Freud and his followers appeared as the key to the symbolism that had been shaping the imagination of artists since the time of Gauguin.

Not all artists agreed with this interpretation, preferring to see images not simply as symptoms, as riddles to be solved. The American Georgia O'Keeffe filled canvases with the petals and reproductive interior of flowers, the stamen and pistil. Soft, sensuous forms envelop and cajole us, like an act of seduction. *Black Iris*, painted in 1926, is one of the most overwhelming, the crisply painted soft, diaphanous forms luring our gaze into the dark centre of the flower. The subject of the painting is less the flower than this act of visual penetration, easily seen in terms of sexual desire. O'Keeffe herself heartily resisted this interpretation – it said more about those who were looking at her paintings, she countered, than about what she herself was thinking, or might have intended.[17]

Others took the findings of psychoanalysis more literally. In the first manifesto of his new movement, written in 1924, the poet André Breton described Surrealism as 'psychic automatism', a stream-of-consciousness way of writing and making images that resulted from the 'absence of any control exercised by reason, exempt from any aesthetic or moral concern'.[18] For Breton and those artists he associated with Surrealism, freedom from control could mean either involuntary,

indecipherable 'automatic' drawings, like those by André Masson, or the dream-like images in paintings by Joan Miró, Max Ernst and Giorgio de Chirico. Of all the Surrealists, none was more enthusiastic about the writings of Freud than the Spanish painter Salvador Dalí, as a source for the most scandalous and taboo imagery.

Georgia O'Keeffe (1887–1986), *Black Iris*, 1926. Oil on canvas, 91.4 × 75.9 cm. Metropolitan Museum of Art, New York. Alfred Stieglitz Collection, 1969. Acc.n.:69.278.1.

In his paintings of the 1930s Dalí used a photographic, or at least precisely lifelike, technique to create paintings filled with dream imagery – or what appears to be dream imagery, disturbing, enthralling or just downright bizarre. It is in dreaming, Freud had written in 1900, that the things we desire and the desires we suppress in our mind return, often transformed into riddling images. Freud's *The Interpretation of Dreams* was a revelation for Dalí when he read it in Spanish in 1925, and was to form the basis for his best paintings, made over the following twenty years. The evocation of a weightless, luminous world in which strange figures enact often grotesque symbolic scenarios, painted in great detail, finds its historical equivalent only in the paintings of Hieronymus Bosch, which Dalí knew well from visiting the Prado Museum in Madrid.[19] Sexual desire combines with childhood memories, skewed through Dalí's invention of a 'paranoiac' method of painting, by which images double up, so that the form of a sleeping woman might also be read as that of a standing horse, or a crouching figure transforms into a hand holding an egg, in the painting *The Metamorphosis of Narcissus*, from 1937. The 'violence of the paranoiac thought' transforms one image into another, Dalí wrote in his essay 'The Rotting Donkey', of 1930.[20] It was also a comment on image-making itself – on our ability to see a configuration of lines as the image of a face, or the form of a horse, an ability that we take completely for granted.

Despite his bizarre imagery and juxtapositions, which reached a definitive statement in his *Aphrodisiac Telephone* of 1938, a telephone painted red, with a lobster instead of a receiver, Dalí's paintings and sculptures never feel arbitrary, or simply the expression of some elaborate joke. In part it was the authenticity of the experiences, of his childhood memories and desires, on which he was drawing, but also on his painstaking technique. Neither was he closed to the surrounding world, despite his obsession with his own madness (always a sign of sanity). Telephones appear in a group of paintings made later in the same year as *Aphrodisiac Telephone*, combined with images referring to Adolf Hitler and the British prime minister, Neville Chamberlain. In *Mountain Lake* the receiver of a telephone hangs on a crutch, its severed wire draped on another, slightly taller crutch, in front of a mountain lake, the form of which could also be read, paranoiacally, as a fish. Odd-shaped mountains in the background seem

themselves to be transforming into something else, although quite what is not clear. The black telephone receiver, with its severed cord, and thin crutches might be seen to refer to the failed diplomacy of Chamberlain in his attempt to appease Hitler and avoid war.

When Dalí met Freud, his hero, in London in 1938, he took with him *The Metamorphosis of Narcissus*. Freud was impressed with Dalí's technique, but doubted that his paintings were really the expression of unconscious desires. They were too knowing, too consciously unconscious. Psychoanalysis was there to unlock all images, not just those that presented themselves so obviously for decipherment.

Whatever might be said about them, Dalí's paintings were powerful symbols for the times. In the late 1930s the sky over Europe was darkening with the rise of Fascism. At its dark heart, in Germany, the brilliant cultural world that had gathered since 1919, during the Weimar Republic, was virtually extinguished overnight as artists were hounded out of public life and forced into exile. Paintings and sculptures were confiscated from museums, and held up as signs of the 'degeneracy' of modern life, and of the corruption of foreign influence and the twin evils of Judaism and Bolshevism.

No institution felt this crisis more than the Bauhaus, the design school founded by the architect Walter Gropius in Weimar in 1919. Unlike the academies that had dominated the education of artists for centuries, Gropius's Bauhaus combined the 'fine' techniques of drawing, painting and sculpting with 'applied' techniques, such as metalwork, weaving and furniture design. The idea was to break down the barrier between craftsmen and artists, producing students who might be great artists but might also make a contribution to everyday life. Creativity had to be part of wider society, not just for initiates, rich people and aesthetes.

The fame of the Bauhaus rested on the artists Gropius had convinced to come and teach at his school, including the weavers Anni Albers and Gunta Stölzl and the painters Paul Klee, Wassily Kandinsky and Oskar Schlemmer, all of whom brought different ideas of creativity to the school.

Mystical ideas dominated the first years of the school, but were replaced in time by more rational approaches. For Paul Klee, who joined as a teacher in 1921, the very purpose of making images and teaching techniques was to explore the mystery of creativity. It was a matter of penetrating beneath the surface to the essence of things, the invisible elements of nature that structure and shape our world – once again those 'equivalents for life'. Further still, for Klee, creating images was a re-enactment of the biblical Creation of the world, described in the book of Genesis: the creation of all things from nothing. Through an intuitive, inspired use of the basic elements of painting and drawing, line, tone and colour, the artist wrests form from the void and embarks on a mystical quest to the source of creativity itself, 'where the secret key to all lies guarded', Klee wrote.[21]

Like many other artists, Klee was dismissed from his teaching post by Nazi officials, and in 1933 he left Germany to spend the last years of his life

working in his childhood home in Bern, Switzerland. His work was included in the notorious exhibition of *Entartete Kunst*, or 'Degenerate Art', initially staged in Munich in 1937, ironically the first large exhibition to survey the new forms that had arisen since the turn of the century, and to show that of all countries Germany had been the most forward-looking in confronting these with a broad public.

The Bauhaus had been at the centre of cultural life during the politically volatile Weimar Republic. As a progressive, left-wing school it was twice forced to move by conservative local governments, first from Weimar itself in 1925 and then from Dessau in 1932, before opening for the last time in much reduced form in Berlin. The National Socialist Party forced its closure the following year, by which time it was clearly impossible for such an open-minded, liberal institution to exist in Germany at all.

In the middle years of the twentieth century the landscape was darkening, and the freedoms of the creative imagination, from the fractured worlds of Cubism to the dreamscapes of Surrealism, had by the outbreak of the Second World War in 1939 dwindled to nothing, at least in Europe. Rather than philosophical inquiries into how we perceive the world, or what might constitute creativity and image-making, the questions asked by artists had become grave ones of life, death and survival, and about the nature of existence itself.

The Swiss sculptor Alberto Giacometti described his austere wiry sculpture *The Palace at 4 a.m.*, made in 1932, as a representation of his mother (the figure on the left), his lover (the skeletal form on the right), and himself (the bean-like form in the centre) – thus a psychodrama, arising from highly personal experiences, obscure to anyone apart, perhaps, from Giacometti himself.[22] Impenetrable dream logic was a Surrealist speciality, one that Giacometti embraced.

And yet we might also see his miniature construct, like a model stage set for a tragedy, as the palace of European images in the 1930s – dark, muted, increasingly emptied of life throughout the decade. Giacometti, working from a life model, pared down his forms, thinning and reducing them, until there was almost nothing left, as if searching for the reality of the human figure perceived from afar. These sculptures and paintings, which occupied Giacometti until his death some thirty years later, were meditations on the mechanisms of vision and the feeling of human presence, and as such are closer to the paintings of Cézanne than to the work of any other sculptor of the twentieth century. Both artists were concerned with what happens in the distance between the artist and their subject: how the physical unattainability of a thing – a mountain or a person – affects the way that it is seen.

After the fall of Paris to the German army, Giacometti travelled south to Geneva. Only after the war, on his return to Paris, did he pick up the threads from the 1930s and create some of his most memorable sculptures, the slender standing figures that came to epitomise the austerity of the post-war years. Other artists remained in exile, adapting to their new environment wherever possible. Mondrian had fled Paris for London in 1938, before moving to New York in 1940 to

escape the Blitz. For those who had been watching his paintings develop over the years, the stylistic change in the last four years of his life (he died in New York in 1944) was momentous, even though it involved nothing more than changing black lines for coloured lines and disrupting the balance and repose of his compositions. This response to the energy of city life, and to the rhythms of jazz, was recorded in the title of the painting *Broadway Boogie Woogie*, a canvas he nevertheless considered a failure; what he sought in these final years was a sense of depth and illusion that contradicted the classical balance of his earlier paintings. He worked out his composition using lengths of coloured tape – red, yellow and blue – which he endlessly reordered on the canvas surface, creating a feeling of 'universal beauty', as he put it, shot through with his own vivid sense of a changing, unstable world. With its interlaced grid of lines, *New York City I* might be a street plan or an aerial view of a block of skyscrapers, life flowing around their monumental forms. Unlike his earlier images of the ocean expanse, it is an image of a regulated human world, contained and controlled – the opposite of natural abundance.

While Mondrian was refining his image of a perfectly ordered, purified city plan in his studio on 59th Street, the painter Jacob Lawrence was recording a different side of the city north of 125th Street, uptown in Harlem. Mondrian sought purity in the 'absolute' image, constructed of coloured lines; Lawrence, however, confronted the world directly, in his small watercolour and tempera paintings of black history and contemporary life. Lawrence had been born in New Jersey in 1917, and began painting after moving with his mother to Harlem when he was a teenager. Harlem was the setting for a great efflorescence of black life and culture in America, of music, painting, sculpture and literature – the 'Harlem Renaissance', as it became known. Lawrence grew up in this energetic milieu, with 'movement, color, gayety, singing, dancing, boisterous laughter and loud talk' animating 'the greatest Negro city in the world', as it was described.[23] Lawrence the young artist was encouraged and supported by an older generation who had already made their names, including the sculptor Augusta Savage, who had opened her own school on 143rd Street in 1932. The murals created by Aaron Douglas in 1934 for the New York Public Library on 135th Street, a series titled *Aspects of Negro Life*, showing the history of African Americans, reaching back to their ancestral home of Africa, were a precursor for Lawrence's own flattened, symbolising style of history painting.

NEW WORLDS

Piet Mondrian (1872–1944), *New York City*, 1942. Oil on canvas, 119.3 × 114.2 cm. Musée National d'Art Moderne, Centre Pompidou, Paris.

Lawrence's interest in Black history was roused by lectures he heard at the 135th Street public library, which led him to read more thoroughly into the political pioneers of African American life. During the 1930s he completed a series of paintings on the life of Toussaint L'Ouverture, the founder of Haiti as the first Black republic, as well as the freedom fighters Frederick Douglass and Harriet Tubman, leading voices in the nineteenth-century anti-slavery movement. Using direct, simplified imagery and extended captions, Lawrence's paintings tell the stories of these heroes and heroines from history, particularly in his 1941 series *The Migration of the Negro*, blending his family history with the wider experience of migration from the American south to the north, and to Harlem.

He also documented the Harlem of his own day in a series of thirty paintings made in his flattened, angular style. A photographer has set up his tripod on a street and captures an image of a well-to-do-couple, who are stopped in their tracks by the sudden glare of his flash bulb. Lawrence himself captures a snapshot of city life in a watercolour from 1942 – the businessman and construction worker, the delivery van and workers descending into a manhole and a horse-drawn cart carrying a bedstead. Moving and migration are an unending process in the modern city. They were scenes and figures with the 'laconic force

of abstract symbols', as James Amos Porter, a fellow painter, wrote of Lawrence at the time.[24]

Harlem was captured in the photographs of James Van Der Zee – perhaps he is the photographer in Lawrence's image. And yet Lawrence was working in a resolutely non-photographic way, making images that offer an alternative to photographic naturalism, the type of images that by the mid-1940s were saturating life. Mondrian too was implicitly repudiating photography. The word 'abstraction' is a weak description of his painting, which is otherwise non-naturalistic, non-photographic, self-sufficient in the way that Matisse had described and, above all, physically present, rather than referring to something else, or acting as a window onto the world.

For both artists it was a matter of inventing a technique to encode their vision. Lawrence's adeptness in using watercolour and also tempera – pigment mixed with egg white – gives a 'firmness and brilliance of surface', Porter writes, 'that one would look for in a Persian tile or an Italian fresco'.[25] Indeed his images tell stories in the same way that the fresco painting of Masaccio and other Italian painters of the fifteenth century related the Bible, rooting the stories in their own contemporary world. It was this, the artist's environment, rather than their theoretical constructs, that gave life to the forms of twentieth-century painting and sculpture. Even Mondrian, that most austere of painters, could not avoid the energy of the new world all around him in New York. For all their differences, both Lawrence and Mondrian sensed something of the greatest importance in the middle of the twentieth century: the feeling of ineluctable change, the rise of a new democratic world. Where Mondrian saw the new energy that might be given to geometric painting, an energy that came to the city itself, Lawrence saw a different kind of energy: the politics of popular life, as well as human struggle. In the early 1940s the world was at war with itself, and tragedies of human life, and of the natural world, were unfolding that would shape the images of art for the remainder of the century, and beyond.

Jacob Lawrence (1917–2000), *The Photographer*, 1942. Watercolour, gouache and graphite on paper, 56.2 × 77.5 cm. The Metropolitan Museum of Art, New York. Purchase, Lila Acheson Wallace Gift, 2001 (2001.205).

27

After the Trauma

A figure is wandering through the landscape, its clothes torn, hunger-racked limbs exposed to the cold air. Smoke drifts over charred fields, over the ruins of houses, of streets, of whole towns and cities, turned inside out by the destruction of war.

Over forty million people were killed during the Second World War, marked by the horrors of the Holocaust and the death camps, the atomic bombs over Hiroshima and Nagasaki, and the terrible bombardment of civilians from the air. In the face of such total destruction, human life itself seemed reduced to its barest ashen elements.

Where artists at the beginning of the twentieth century had examined the workings of the human mind – the way we see, the way we think, the way we dream – in the years after 1945 the human body itself became the object of interrogation, interpretation and reconstitution. At first it was a matter of registering the broken, defiled state of the body, the pain of countless deaths. The simple, stark symbol of a human mouth, screaming, was all that could be summoned: human life reduced to animal pain.

Le Métafisyx, painted by the French artist Jean Dubuffet in 1950, is the body of a woman disfigured in the ugliest, most brutal form possible, splayed flat, showing her internal organs, with a leering skull-like face. Her body has been exploded, as if in a real act of violence, not the intellectual unravelling of the object in space of Cubist painting but as if the consequence of an assault.

Dubuffet called his rough style of painting *art brut*, after the amateur, non-academic types of images that he collected, works created by the mentally ill, by children and untrained artists, interested only in setting down their highly personal visions. Like Paul Klee before the war, he saw the hidden value in these otherwise eccentric images as touching on a human authenticity often missing in the contrivances of professional, academic productions. It was a matter of creating equivalents for life as it was experienced, with the raw immediacy of graffiti, the image hastily scratched on a wall.

In the last moments of the German occupation of the city, at a psychiatric hospital on the outskirts, the artist Jean Fautrier created a series of paintings of hostage's heads, based on his knowledge of the Gestapo's torture and executions in the surrounding forest. Made with pigment and paint applied to a white crust of paint, they are veiled images which show more the impossibility of representing extreme human states, tipping over into elegant representations of decayed nature. Fautrier was also responding to the discovery of prehistoric drawings and paintings in the caves at

Georg Baselitz (b. 1938), *The Herder (Der Hirte)*, 1965. Etching, drypoint and aquatint, plate: 31.8 × 23.7cm; sheet: 44.2 x 31.8 cm. Ed.27/60. Publisher: Edition Heiner Friedrich, Munich, 1972. Museum of Modern Art (MoMA), New York. Gift of Galerie Daniel Blau (Acc. no.: 479.2006.).

Lascaux, France, in the 1940s – their rough elegance and urgent directness create an equivalent between human origins and the bare life of post-war Europe.

The testing search for an authentic image of the human body had begun for Alberto Giacometti before the war, as we have seen, as if a prophecy of what was to come. His finger-thin standing forms, rough and scarred in their making, anchored by oversized feet, their heads often dwindling to nothing, are humanity reduced to a single pronoun, 'I', and a single verb, 'am'. In *La Clairière* ('The Clearing') nine figures stand upright, their forms yet unclear, as if seen through a heat haze, or at a distance. They are the primal truth of the human body, the upright animal, making their presence felt in the landscape, like the earliest human settlers with their upright stones, although with Giacometti the signs of life seem to tremble with frailty, eaten away by the threat of imminent extinction.

Creative thought had been stripped bare in the hands of painters and sculptors, but also in those thinkers who were interrogating the very idea of art, just as the earliest images made by human hands were coming to light and being dated by the new scientific method of carbon dating.

In his essay 'The Origins of the Work of Art', first given as a lecture in 1935, the German philosopher Martin Heidegger advanced the complex, poetical idea that in making visible the invisible, the work of art was a way of revealing truth, of creating a clearing in which truth might happen, as he put it.[1] It was a way of dispensing with false categories and attempting to burrow down to the true reality of things, and the true purpose of the images of art, just as Dubuffet and others were getting rid of all vestiges of academicism and seeking out authentic images in the world at large. Existentialism became the rallying point for this search for authenticity, at least in Europe. Human life is given meaning by actions, Jean-Paul Sartre argued, rather than by any essential characteristic with which we are all born. The ability to choose, to create our own images and take responsibility for them is what defines us as human.[2] Marcel Duchamp had made a similar point fifty years earlier with his ready-mades. We can choose anything to be art, regardless of what anyone has said in the past, or what conventionally might be accepted as such.

Not everyone could grasp the creative act of living with such boldness and abandon. What did it mean to be human in an age of nuclear physics, jet propulsion, mass media and mass murder? And what, moreover, did it mean to be a colonial subject at a time of decolonisation, as the old empires were falling away, the whole system of unequal values on which they were based discredited by the disasters of war? The imposition of European colonies around the world had

Jean Dubuffet (1901–1985), *Le Métafisyx*, from the *Corps de Dame* series, 1950. Oil on canvas, 116 × 90 cm. Musée National d'Art Moderne, Centre Pompidou, Paris, France.

AFTER THE TRAUMA

rendered millions, the majority of the world's population, effectively invisible. It was only haltingly in the years after 1945 that this other search for authenticity – the authenticity of self-determination and liberation from colonial rule – became evident in images. This slow and difficult emergence appears in a series of paintings made by the Indian artist Francis Newton Souza after he moved from Bombay to London in the late 1940s. Black paint on a black background was his metaphor, including a series of heads painted with thick lines, looking like the inked-up block for a woodcut, hidden shapes made visible by reflected light.

 The rapid decline of European colonialism reshaped the world and Europe with it. The human body, unclothed, beautifully proportioned, an image of strength and desire, had been standing, sitting, lying at the heart of European art since the time of Praxiteles, through to Michelangelo and Ingres. It was an emblem of the assumption that European values were universal values, and its fracturing and reshaping throughout the twentieth century were the Reformation of the era. The claim that Europe was a beacon of civilisation could only be upheld if you were blind to the violent history of colonial exploitation, and the mass murder of the Second World War.

The human body was centre-stage not only as subject but also as the source of action. The swing of an arm, the twist of a torso, the flick of a wrist could create an image: a painting could be the trace of a gesture, rather than of an act of observation. It was hardly a new idea – Constable had made free with his brush on large canvases, and the surfaces of paintings by *Les Intransigeants*, by Monet and others, as well as their post-Impressionist successors, were full of vigour preserved from their making. During the 1940s, however, this gestural approach became highly political, bound up with ideas of democratic freedom in the Western world, and with the notion of painting as a physical action, an authentic encounter between a person – the artist – and a blank expanse of canvas, or the materials of sculpture.

 Different types of gesture were to become trademarks for artists working in New York from the middle of the 1940s. Barnett Newman was known for his 'zip', a single vertical stripe running across an otherwise monochrome canvas. From the first of these paintings, *Onement I*, made in 1948, the zip came to symbolise a new beginning, as if Newman was once again dividing light and dark. The surfaces of Newman's paintings are rough and churning, like some primal chaos, the 'zip' like a jet of fire cast into the void, or the painterly equivalent of Giacometti's tall standing figures, not itself as a figure but as the singular pronoun to which all of Giacometti's sculptures were reduced. They were symbols of human creativity, and for Newman closer to the truth of human origins than anything provided by the science of palaeontology, 'for it is the poet and the artist who are concerned with the function of original man and who are trying to arrive at his creative state', he wrote.[3] The first humans were image-makers, Newman held, before anything else, and the archaeological evidence being uncovered of the true antiquity of the earliest images – some tens of thousands of years earlier than had hitherto been thought – was proving him right.

The 'New York School', as they were sometimes known, counted Mark Rothko, Willem de Kooning and Clyfford Still among the older generation, alongside Newman, and Jackson Pollock, Franz Kline and Lee Krasner as a younger cohort. They each discovered their own gestural trademark on large canvases, using quantities of paint that most European artists could only dream of affording. Kline created thick armatures of black paint, dynamic structures fizzing with graphic energy. Pollock, cigarette clamped in mouth, danced over his canvases on the floor, flicking whirls and loops of gloss enamel to create a dense cloud of line and colour – he was also the first to venture into large, room-sized painting, with his *Mural*, made for the dealer Peggy Guggenheim in 1943 and inspired, Pollock claimed, by the vision of a stampede of animals. Willem de Kooning responded by attacking his canvases with ferocious energy, in his *Women* series of the early 1950s, creating canvases that went far beyond Dubuffet in their raw, violent images of the female form, taking the lessons he had learned from the Armenian painter and *emigré* Arshile Gorky to their conclusion. More than any other painter of the twentieth century, with the exception of Matisse, Mark Rothko used colour to create an emotional connection between painting and audience, one freighted with a sense of profundity that seems somehow, ineffably, religious. His floating, nebulous fields of colour bring to mind landscapes, but more of the moon than of any earthly scene, and indeed his final series of paintings, made shortly before his suicide in 1969, consisted of black-on-grey images made shortly after the first Apollo moon landing. Clyfford Still also took landscape for his inspiration, drawing on the paintings of Georgia O'Keeffe but also on memories of the American West, where he was raised. His canvases are like large craggy ravines, suddenly illuminated by flashes of coloured lightning, evoking a grandness of nature that brings to mind Turner's images of the Alps as well as the long tradition of mountain landscapes in Chinese painting. They were all in their way painting nature, mirroring the grand scale of the American landscape, part of a long tradition stretching back a century to the encompassing vistas of the Hudson River School.

Critical was the moment of physical encounter. As the critic Harold Rosenberg put it, what these artists placed on their canvases was 'not a picture but an event'.[4] The image was the result of the meeting between artist and canvas, a dramatic moment of spontaneous improvisation, often resulting in as much paint on the walls and floor as on the canvas itself.

Lee Krasner had come under the sway of the painter and teacher Hans Hofmann, who had opened a school of painting in New York in 1934 after emigrating from Germany two years earlier, and moved away from dream-like images of Surrealism to compositions of form and colour alone. Krasner's paintings from the late 1940s were constructed with broad, bold gestures, rather like those of Jackson Pollock, to whom she was married, but it was only after his death in a car crash in 1956 that she emerged from Pollock's shadow and began producing canvases that were her own version of 'encounter', or 'action' painting, in Rosenberg's formulation. Her *Assault on the Solar Plexus* is an answer to the male-dominated group, wielding their brushes with unassailable confidence. The paintings are also an answer to the depiction of women as passive, often violently distorted in the male imagination. Krasner presents us, rather, with the the body of a woman confidently enacting the ritual of creation on the canvas surface with paint that has the elemental appearance of dirt or mud.

Lee Krasner (1908–1984)
Assault on the Solar Plexus,
1961. Oil on cotton duck,
205.7 × 147.3 cm. Kasmin
Gallery, New York.

Such paintings came to be the sign of American images in the second half of the century – a broad, untethered sense of space and bodily freedom that brought with it a sense of liberation from all previous values, images of nature that were at once symbols of wide open landscapes and a spirit of pioneering discovery, but at the same time not images of nature at all, but traces of the human body.

Sculptors too played their part in the milieu of the New York School. David Smith welded together assemblages of metal shapes, often solid structures made from stainless steel, and then burnished them to create a shimmering, reflective surface. The freedom Smith espoused for sculpture was freedom from an organic notion that sculpture, derived from images of the human body, had a hidden, living interior (as was the case with the other prominent sculptor of the era, Henry Moore). With Smith's sculpture there is no inside or outside, just a selection of different viewpoints and surfaces.[5]

Like many artists in America, Smith was drawing on a European tradition as much as he was interrogating and detaching from it. In 1959 the Brazilian artist Lygia Clark wrote an emotional letter to the by then dead Piet Mondrian, questioning the artist on his rejection of the natural world, and the idealism of his painting. If creativity truly was an expression of freedom, she wrote, it should be resilient enough to throw itself into the currents of everyday life.[6] Shortly after writing her letter, Clark made a series of sculptures from cut-out shapes of metal, hinged, so that they could be endlessly reformed. Clark called them *Bichos* ('creatures'), the hinge their backbone, their shiny hardness bringing to mind some sort of shellfish or strange creature from the depths of the sea, or from outer space. Their restlessness contains a sense of frustration, both with the regulated nature of geometric painting and with the idea of sculpture as a solid, fixed thing. Non-naturalistic painting and sculpture had reached a dead end, it seemed – how many times can you paint a red square, a straight line, a grid? Was throwing paint on a canvas exercising freedom or expressing frustrations with the limitations of a five-hundred-year-old medium? Perhaps sculpture, creating objects and things, was the future, as Duchamp had intuited.

Since the time of Picasso's Cubist guitar and Tatlin's corner objects, sculpture had been used to create this feeling of framelessness. It had been taken off the plinth, but also out of the imaginary space within which it was framed, like a three-dimensional picture – Rodin's *Balzac* is deliberately tilted forward, as if crashing down on a new reality for sculpted and carved images.

As Picasso and Tatlin had intuited, only when sculpture became about the materials from which it was constructed could this process of reality-breaking become complete. But to engage with the world at large, and with the human body, sculptures needed to be made on a much larger scale, becoming their own immersive environments.

Anthony Caro made his first 'abstract' sculpture, *Twenty Four Hours*, in 1960, welding together scraps of salvaged metal with an oxyacetylene welding torch. A trip to America and an encounter with the paintings of Kenneth Noland and the sculpture of David Smith, artists working with simple shapes, textures and colours, set Caro on his course, getting rid of all sense of the sculpture being 'of' something else, rather than an assemblage of parts like notes in a piece of music, as he put it.[7] Two years later he made *Early One Morning*, an elongated structure, sitting on the ground like a piece of disused farm machinery, painted bright red. The forms reach into the space around so that there is no sense of a front or a back to the sculpture, or any sense of solidity or an 'inside', like a living body with a skin. Rather, we are the living body, obliged to keep circling around the work to make sense of it: where the New York School painters danced around and in front of their canvases, the physical encounter with Caro is between the sculpture and the viewer – us.

This idea of simple, irreducible presence was taken to an even greater extreme during the 1960s by the American sculptors Donald Judd and Robert Morris, whose sculptures, made of plywood, Plexiglas and other cheaply available materials, had an industrial, impersonal appearance, and went under the label Minimalism. They were simple objects that existed in and for themselves – you couldn't read meaning into them or interpret them as anything other than what they were. What mattered was the place in which they were shown, the real space surrounding them. Dan Flavin created sculptures from one simple object, electric lights, at first incandescent and then fluorescent, of a type that could be bought from any hardware shop, first manufactured and sold commercially in the late 1930s. It was the electrification of the ready-made. His medium was not so much the fluorescent tube as the light itself, cool white, or in many cases coloured. Standing in front of a sculpture such as *greens crossing greens (to Piet Mondrian who lacked green)*, we feel immersed in light, at least to the extent that we can enter the gallery, blocked off by two glowing fences of light. Flavin's work looks back over almost a century of electric lighting, and its appearance in works of art, from the time of Manet's *A Bar at the Folies Bergère*. He took the idea of light as a subject to its logical conclusion, making it literally so: dematerialised sculptures consisting of nothing but the waves of energy forming coloured artificial light. Mondrian's lack of green, an ostensible sign of his aversion to 'nature', much as Picasso had eradicated green from his Cubist palette, is the subject for a work that bathes the viewer in an artificial green light, seeming to question what nature might mean, and where it might begin and end in an age of permanent illumination.

The brightly coloured illumination of American life was a beacon for artists working in Europe in the grim years after the Second World War. In the late 1940s in Britain artists became fascinated by the strong, saturated colours and

photographic imagery of consumer magazines, the *Saturday Evening Post* and *The Ladies' Home Journal*, which had begun arriving from America during the war. In the grey, colourless world of post-war London, at least on the outside, such magazines offered the lure, if not the hope, of a brighter, better world. The artist Eduardo Paolozzi was the first to use them to make collages, but it was Richard Hamilton who in the early months of 1956 created a small collage that crystallised this moment, *Just what is it that*

Richard Hamilton (1922–2011), *"Just what is it that makes today's homes so different, so appealing?"*, 1956. Collage, 26 × 23.5 cm. Kunsthalle, Tubingen, Germany.

makes today's homes so different, so appealing? 'Today's home' is a small room crowded with the appurtenances of contemporary life: advertising, fast cars, cinema and, above all, the freedom of sexual desire, symbolised by a modern Hercules, a bodybuilder holding a giant lollipop with the word 'Pop', and a pin-up girl, inexplicably wearing a lampshade on her head.[8] Like the great paintings of Velázquez and Vermeer, *Las Meninas* and *The Art of Painting*, Hamilton's *Just what is it that makes today's homes so different, so appealing?* is a room that contains a world, in this case the New World, America.

'Pop', although nobody knew it in 1956, was to become the style of the era, when the 'look' of Hamilton's and Paolozzi's work was exported back to America and taken up by artists immersed in the consumer utopia of post-war life. It took an artist who began life as a commercial illustrator to become the great interpreter – and creator – of this new consumer world. His work designing book covers and window displays, was the background against which Andy Warhol first translated the images of commercial culture – soup cans, Coke bottles, newspaper photographs, and pictures of celebrities, notorious criminals and film stars alike – into silkscreened images on canvas that showed the world itself as an image: a world devoid of nature.

Fame, for Warhol, was a matter of repetition. His silkscreened paintings of Marilyn Monroe make this point unequivocally, repeating the same smiling image of the film star, like film posters plastered across a wall. It was a repetition, but one that contradicted Warhol's own statement that he liked things to be '*exactly* the same', over and over again, because 'the more you look at the same exact thing, the more the meaning goes away, and the better and emptier you feel'.[9] Everything he did bore the signs of being handmade, of varying slightly – the *Brillo Boxes* he made in 1964, copies of commercial packages for soap, cannot on close inspection be mistaken for the real thing. His images of Marilyn are hardly identical, ominously fading as the ink used in the silkscreening thins away. In his *Screen Tests*, three-minute black-and-white films, Warhol trained the camera on the face of a person, from film stars to ordinary people, asking them to remain still, looking into the camera. As the camera turns, the confidence of the sitter crumbles, smiles waver, doubts overtake persona. Coolness itself seems to melt.

In the case of Monroe, it is the tragedy of her death that is unmasked in the silk-screened images. Death in the final count was Warhol's great subject, the underside of life in the post-war era, driven by a relentless optimism and unwillingness to face up to the

Roy Lichtenstein (1923–1997), *Mirror # 1*, 1969. Oil and Magna on canvas, 152.4 × 121.92 cm. The Eli and Edythe L. Broad Collection.

reality of economic depression, the banality of the commercial world, car crashes and the race riots that were spreading in the wake of the civil rights movement.

Warhol's closest rival in the world of Pop was entirely of the opposite cast. Roy Lichtenstein created images that were as memorable as those of Warhol, and which arose from the same 'low' culture of advertising and comic books, but which had little to do with life and death, playing rather with the formal composition of paintings, with colour and line. He also drew on commercial printing techniques for his paintings, in his case the 'Ben-Day' dots used to create tonal and colour areas in cheaply printed publications such as comic books.

Lichtenstein enlarged the dots so that they became the real subject of his paintings, fizzing with a strange natural energy, although with nature nowhere in evidence. The energy of popular culture was its own kind of 'second' nature, expressed not only in images but also in the captions to comic book panels: *'Why, Brad darling, this painting is a masterpiece! My, soon you'll have all of New York clamoring for your work!'*, runs one, *'WHAAM!'* another, the sound of a missile launched from an American plane destroying an enemy fighter.

Even when Lichtenstein delved back into the history of painting, creating dotted images in the style of Cézanne or Mondrian, he cheerfully parodied the high seriousness attached to 'fine art'. The truth of life, Lichtenstein seems to say, always lies on the surface. His painted mirrors, reflecting nothing, are the purest expressions of this idea, simultaneously the blankest and most moving of his canvases. The dots forming the mirrors, with their bevelled edges and silvery sheen, are dematerialised: neither tone nor texture but rather a coded representation of light, the furthermost point of his dotted style.

In taking his imagery from comic books, as well as design objects, Lichtenstein escaped the dependence on photography that seemed to be overwhelming painting in an era when direct images of nature were no longer viable subjects for any artist of ambition. It was, in effect, an attempt to preserve the 'aura' of painting, as it was described by the German critic Walter Benjamin in the 1930s. Mechanical reproduction of images, in the form of photography and photo-lithography, Benjamin wrote, had destroyed the 'aura' of the work of art, as a somehow sacred, unique object.[10] This was not such a bad thing, he argued, as it meant that works of art could fulfil a political role and help change things for the better. It was a similar argument to those made by iconoclasts and reformers throughout history. Subsequent history, and Pop art in particular, was to prove Benjamin for the most part wrong: in the age of mass democracy, reproduction only increased the celebrity and aura, and commercial value, of the individual work of art.

Artists turned to photography in different ways, none of them doing much to dent the sacred aura of images – paintings by Warhol, as well as by the

Gerhard Richter (b. 1932), *Bombers*, 1963. Oil on canvas, 130 × 180 cm, Städtische Galerie Wolfsburg.

German artist Gerhard Richter, were still exhibited and sold with the same degree of reverence. For Richter this was in part due to his move from East Germany, where he had trained as a Socialist Realist, to the West, where he embraced the freedom given to artists, painting in divergent styles, from pure 'abstraction' to photographic realism.

This photographic realism was not simply a matter of copying the photograph but of evolving a technique, using a dry brush over wet pigment that mimicked the smoothness of the photograph, as well as the motion blur of a slow shutter speed, giving the feeling of amateur snapshots or reportage. The photographs Richter copied using this technique were never innocently chosen – they emphasised the hollowness of the consumer lifestyle in the West or cast an uncomfortable spotlight on repressed memories of Nazism and the Second World War. He was one of the first artists, alongside the painter Markus Lüpertz, to use Nazi imagery, still a shocking choice in the 1960s, especially when the images were taken from a family photograph album. Richter painted his uncle Rudi in German military uniform smiling, from a photograph taken shortly before he was killed in action. He also painted his aunt, Marianne Schönfelder, who was murdered by the Nazis. Both paintings are presented without commentary, as deadpan as the photographs on which they are based. As with his eerie paintings of warplanes dropping bombs, where it is not entirely clear who is bombing whom, the burden of interpretation is left to the viewer.

A photograph, Richter once said, is a perfect piece of nature. The century-long struggle between painting and photography finds a resolution, of sorts, in his work, where the two media are set alongside each other as being of entirely equal value. Many artists before Richter had used photographs as source material for paintings, but none had developed such a spectacular technique, which gave a smooth, photographic look to the surface of the painting (although it had been hinted at in Degas's painting). This look was one of Richter's many inventions in the medium of oil painting that made him as influential in the second half of the twentieth century as Picasso had been in the first.

Richter began his training as a Socialist Realist painter, making murals designed to reinforce the ideals of Soviet Socialism. The spirit of public engagement, of social concern, never left his work, even at his most abstract – his paintings never drift into a mystical or private realm. In its pure, apolitical sense, Socialist Realism is the style of all great art throughout history – art that attempts to show life as it is, rather than resorting to genre or fantasy.

The Socialist Realism that was the official style of painting in the Soviet Union from the 1920s was different – an attempt to show an image of life engineered for political reasons. The virtues of ordinary men or women might be placed centre-stage, although hardly with the subtlety or empathy of Courbet, more as an expression of the image of life endorsed by the state. The same held true wherever Socialist Realism was adopted as the official style: in Germany, China and North Korea, harking back to the realism that had dominated

painting in the latter half of the nineteenth century, but transformed into state propaganda.

From the establishment of the People's Republic of China in 1949 under Mao Zedong until the end of the Cultural Revolution in 1976, Socialist Realism dominated painting in China, communicating patriotic and enlightening messages to the Chinese people. Where in the Soviet Union such a style could draw on a long tradition, looking back to the paintings of Repin and his time, in China such realism was without precedent. Although oil paint had been used there for close to a century, the lifelike coloured detail required of Socialist Realism in China went directly against long centuries during which artists had obsessed over different types of brushstroke in monochrome ink.

Mao reversed many of the policies of the first years of his rule during the period of the Cultural Revolution, directing policies against the bourgeois supporters of culture and against anything reminiscent of 'high' art. Peasants and workers were encouraged not only to appreciate Socialist Realism but to create it. The artist Shen Jiawei was one painter who rose from the lower classes at this time. As a youth he was sent to work on a military farm in the province of Heilongjiang, partially bordering Soviet Russia. He was selected to join an amateur painting class, and in a very short space of time produced a canvas that was to become famous throughout China, a view of guards in a watchtower over the Wusuli River, protecting the Chinese–Soviet border, *Standing Guard for our Great Motherland*.[11] The spectacular scenery and vertiginous position of the defensive watchtower were one inspiration; the other was Socialist Realist painting, the principles of which were dictated by Chairman Mao. Like works of literature, painting should be 'loftier, more intense, more concentrated, more typical, and more ideal than ordinary actual life', so that it might appeal to the widest possible audience, at least within communist China.[12]

The story was often told: Socialist Realism in the communist East pitted against abstraction, the unofficial style of the capitalist West; a state-promoted and enforced style versus individual freedom. On the whole the story

was true, but the history of the period is told by the exceptions, of dissidents such as the East German painter Ralf Winkler, later known as A. R. Penck, who worked in East Germany, making paintings using signs and schematic figures, including a recurrent stick figure that was a direct challenge to the smooth finish of Socialist Realism. Like many dissident artists in East Germany, including Gerhard Richter, Penck eventually fled to the West.

In reality the conflict was less a matter of abstraction versus figuration than a more profound one between the idea of European image-making and that

Shen Jiawei (b. 1948), *Standing Guard for our Great Motherland (Wei women weida zuguo zhangang)*. Printed 1975. Ink and colour on paper. Image: 62.4 × 51.4 cm, sheet: 76.9 × 53.1 cm. Princeton University Art Museum, New Jersey. Gift of Jerome Silbergeld and Michelle DeKlyen. Inv.:2011-49.

of the countries and peoples colonised by European powers all over the world.[13] For many artists the defining condition was the end of colonial rule, being part of a newly independent nation, and the vital importance of returning to indigenous traditions, rather than relying on the model of European 'civilisation'. As the writer James Baldwin observed at the beginning of the 1960s, 'Europe' and 'civilisation' were by no means synonyms, as many people might have assumed, both in Europe and America.[14] Such a realisation might have dawned earlier on those subjected to European colonial rule, for whom memories of a violent past were overlaid with a sense of loss carried into the present.

The Congolese painter Tshibumba Kanda Matulu was a largely self-taught artist whose paintings, made in Lubumbashi, the largest city in the southern province of Katanga, during the 1970s in Zaire (now the Democratic Republic of Congo), were in a popular style using imagery taken directly from painted signboards and advertisements. His major series of paintings *History of Zaire*, made on canvas from flour sacks in the early 1970s, tells the story of the Congo from before the times of Belgian colonial rule to Tshibumba's present. He painted Patrice Lumumba, the first Congolese prime minister following independence, giving a speech in Kinshasa on Independence Day, 30 June 1960, a landmark in the struggle against colonial rule and in African nationalism. Behind him stands the grimacing figure of Baudouin, the last Belgian king to be colonial ruler of the Congo, whom Lumumba is gravely insulting in his speech.

Like Jacob Lawrence's historical series of paintings on African American history, Tshibumba's paintings of the history of the Congo deserve to be seen together. The captions that accompany them tell the story of the Congo to an outside audience: to the Europeans for whom colonialism also forms part of their history, but from the other side.

Tshibumba Kanda Matulu (b.1947–c.1981), *Lumumba Makes his Famous Speech*, 1973. Acrylic on canvas, 44 cm x 69 cm. Tropenmuseum, Amsterdam.

AFTER THE TRAUMA

Socialist Realist painting was supposed to be a mirror of the world, a realism that captured appearances with the directness of the photographic lens. With the end of the Cultural Revolution in China the dominance of such 'mirror painting' ebbed, and artists opened up to ideas from the outside, including works that provided a very different, more troubled view of the human body, contradicting the optimistic naturalism of Socialist Realism. The first video work in China, *30x30*, was made in 1988 by the artist Zhang Peili. He is filmed smashing a mirror and gluing it back together again, over a period of three hours, an act of repetition that seems both an expression of psychological disturbance and also an act of defiance against simple ideas of 'realism' in the creation of images, as well as the 'wholeness' of the human body. It is hardly a subtle metaphor, but the message is clear.

For all the excursions into new technologies in the post-war decades, the human body remained the most important means for reflecting the human encounter with nature. During the 1970s the Cuban-born artist Ana Mendieta staged performances, recorded in photographs, showing her body, or the trace of her bodily presence, placed back within nature: leaving its imprint in long grass, camouflaged with mud against a tree or strewn with flowers in a rocky ravine. Mendieta often used blood in her performances, smearing it on her body or down a wall. And yet, rather than being disturbing, the effect of these performances is restorative, a matter of creating an authentic connection between body and nature. (The will to restore arose from her personal sense of being in exile from her native Cuba, after she and her sister were sent to Iowa as children to avoid the political events of the Cuban revolution in 1961.) Her 'earth-body' works were also a means to restore the image of women's bodies to themselves, untangle them from dominion and abuse.[15] Male-dominated society emerged during the twentieth century as itself a form of colonialism: the world-colony of patriarchal society, met by the rise of the women's movement in the 1970s.

Mendieta was also reacting to the large sculptures and rearrangements of landscapes created by American artists at the time, most famously Robert Smithson's *Spiral Jetty*, an earthwork, constructed of mud and rock, stretching out into the Great Salt Lake in Utah, ending in a self-containing spiral. The spectacle of such sculptures comes from their size and their powerful rearrangement of the natural world using earth-shifting machines, the clear imposition of an unnatural human design.

Rather than rivalling nature in the spectacle of size and grandeur, trying to create an equivalent for a waterfall or a sunset, other artists confronting the problem of representing nature in an age dominated by the human world chose rather to rearrange, to create new symbols of nature. The stone circles of the artist Richard Long might be seen in a white room or in the landscape itself, where

Zhang Peili (b. 1957), *30×30*, (still), 1988. Medium: video, monitor, colour and sound (dual channel mono). Tate, London.

they are evidence of the most basic of human urges, to create patterns – making stone circles is one of the oldest forms of human creativity. It is a way of revealing nature, a sense of natural presence, where nature, as the ancient Greek philosopher Heraclitus said, delights in concealing itself.

Encountering nature in this symbolic, ritualistic way seems as far from the academic tradition of getting the lines and tones right, to create a lifelike scene, as you could get. Such was the power of the artist unchained from tradition that it seemed their mere touch might somehow channel the energy of life into otherwise dead materials. It was a form of symbolism founded not on imagery but rather on matter itself, the elemental substances that support life. For the German artist Joseph Beuys, fat was a symbolic store of energy, and felt was a form of protection, like an insulation layer of skin. He used these substances in sculpture and performances like a magician or a healer, weaving a restorative spell. Rock basalt he considered a naturally 'dead' substance, formed millions of years ago by cooling lava, taking the form of standing columns, like human bodies shrouded or entombed in stone. He placed quarried basalt columns next to seven thousand oak trees planted in the German town of Kassel, and elsewhere around the world, as symbols of the endurance of nature, and the beginning of a 'social-ecological' era, when humans would begin to rectify the destruction of nature by industrial production and technologies, and human dominion of the earth in the age of capitalism.[16]

The basalt columns also appear in an installation Beuys created in a museum gallery. From forty-four of these rocks stonemasons cut inverted cones at one end, which were wrapped in felt, and then placed back in their sockets, kept in place and raised slightly by a ball of clay. The circular shapes animate the dead stones, like faces or eyes, 'enlivened', as Beuys might put it, by his intervention. Arranged apparently haphazardly within a white-walled gallery, the forty-four

Joseph Beuys (1921–1986), *The End of the Twentieth Century*, 1983–5. Installation. Basalt, clay and felt. Dimensions: 900 × 7000 x 12000 mm. Tate, London. Purchased with assistance from Edwin C. Cohen and Echoing Green 1991 (T05855).

After the Trauma

stones occupy a space that we can walk into, but it is hardly the immersion that we feel with Dan Flavin, or the sense of openness of a Caro sculpture. The obdurate forms seem to exist in a space that we cannot fully enter, a space of ancient dead nature that brings to mind the slowing down of time we might feel before ancient dolmens, or the standing boulders of Stonehenge. Beuys titled the installation *The End of the Twentieth Century*: 'This is the end of the twentieth century. This is the old world, on which I press the stamp of the new world', he wrote. Looking at *The End of the Twentieth Century*, we might imagine this new world to be not that of American popular culture, nor the constructed utopias of the earlier twentieth century, but rather one defined by the terrible damage wrought by the human species on natural life and the urgent need for strategies of survival.

Beuys's poetic stones contain a sense of the human body caught between the deep time of nature, the millions of years in which the columns of basalt were formed, and the short duration of our own lives. They remind us of something, although we cannot be entirely sure of what: our own deaths, perhaps, or our fragile bodies, buffeted about in an often harsh world. Beuys was convinced of the importance of creativity within democratic society, and of the possibility that anybody might create images – they were not the domain of the privileged or the elite. And yet his own work is often highly difficult to read, allusive and poetic, demanding the attention and patience of viewers willing to enter into its mysteries.

Images themselves had become highly political by the time Beuys was making his valediction to the twentieth century. Underneath they always had been – after all, an image is always in some ways a point of view. In the 1980s these points of view were still polarised between a popular figurative style and more demanding 'conceptual', or ideas-based, ways of working. Politics pervaded much of the painting of the time in a way that recalled the realism of the nineteenth century. The German artist Jörg Immendorff made large paintings under the title *Café Deutschland*, bringing together figures from German history and from contemporary life, east and west, into an imaginary unified space – his German café – defying the real-world division of Germany, and the world at large, into two power blocs, the USSR and Western Europe/America.

Yet it was in the medium of photography, and the legacy of photomontage, that some of the most searchingly political images of the times appeared. A self-consciousness arose in image-making, coupled with a turn to highly reflective theorising, and appeal to ideas such as structuralism, which held (roughly put) that meaning arises not from some authentic and mystical place of origin but rather as a convention within a field of interrelating things. Meaning happens as a custom, or a conversation, rather than as a command, you might say.

Photographer artists were relentless in their exploration and unpicking of the conventions of representation, in the media, advertising and in film. In her series *Untitled Film Stills* the American artist Cindy Sherman photographed herself in the roles of film stars, creating stills from imaginary films according to all the conventions of the cinema of the 1950s and 1960s. In *Untitled Film Still #21* she is

pictured against high-rise city buildings, a young woman embarking on her career in a prim new outfit. She seems perturbed by something, momentarily unsure. Sherman captures these undramatic moments in women's lives, fictionalised as it were twice – once in her photographs and again in the films that she emulates. By this time, almost a hundred and fifty years after its invention, photography had its own history and past to reflect on. Sherman's *Untitled Film Stills* are, of course, not film stills but mock-ups, falsifying reality, just as the very first pictorial photographs, those of Gustav Le Gray, were elaborate fictions, his images of waves on the sea collaged from two negatives.

In her graphic montages using found photographs and short direct texts, the American artist Barbara Kruger created images that seem both to address us directly but also to pull back into a much wider meaning, asking us to reflect on society and the world at large.[17] The human body – and women's bodies in particular – appear in her montages not as given, natural things but as mental constructs, the product of often competing ideas and interests. 'We won't play nature to your culture', read the words across an image of a woman's face, her eyes masked by leaves as she lies in the sunlight – it might be Ana Mendieta, posing in a parody of one of Beuys's basalt columns. Where Warhol and Lichtenstein took images from advertising and popular culture and elevated them to high culture, Kruger remains within the realm of political advertising and slogans, making her point as directly and unambiguously as possible, reminding us that our place in the world is never 'natural' – it is always a convention, a construct, masking someone's vested interests.

That the photographic image is hardly a direct imprint of reality, and that it cannot claim any more 'realism' than a painted or drawn image, was clear by the time Kruger and Sherman were making their photographs and montages. In the age of the digital creation and editing of photographs, in which images are stored as disembodied computer files, it became possible to create photographic images that are as composed and manipulated as a painting, Socialist Realism being the closest, most recent comparison.

The photographs of Andreas Gursky have few rivals in human history for their intensity of detail, for their clarity and sheer scope of vision, as if rivalling the natural capability of the human eye itself. His subjects encapsulate the world in which the digital image is the prime source of representation: an age of world-cities, of spectacular sculptural architecture, of vast flows of deregulated capital around the world, of ever-increasing individual empowerment through affordable technology and of the epic struggle between democracy and social inequality. From 1990 his series of photographs of stock exchanges in New York, Tokyo, Hong Kong, Singapore and Kuwait shows the human form reduced to a mere tool in facilitating

AFTER THE TRAUMA

the flow of capital and the creation of financial wealth. His image of the New York stock exchange, made in 1991, rivals the history paintings of the nineteenth century and has a similar effect of capturing a sweep of time and human endeavour, and yet it presents a view of human life that is almost entirely abstracted, un-lifelike. Money abstracts human relations. The human body reduced to a coloured particle, floating in a field of darkness; the human body reduced to a piece of data, a single value.

Gursky's view of life is encyclopaedic. He is like a giant eye floating over the world, seeing in spectacular detail, dipping down from time to time to catch the crowd at a pop concert or a sports stadium before rising up to view entire landscapes. His subject is the contemporary world, a world shaped by the ideology of capitalism, by the spectacle and power of wealth, by the great concentration of objects and people in the so-called megacities. It is a world that finds its image in

Andreas Gursky (b. 1955), *Hong Kong Shanghai Bank*, 1994. C-Print, framed, 288 x 222.5 × 6.2 cm. Collection of the artist.

the endless windows of an office tower at night, or the millions of goods arrayed in the vast storage of an online retailer bent on discounting goods to the lowest price, regardless of the real cost of such an operation. A world in which nature seems totally absent, or totally consumed by human technology.

What, then, of individual lives and memories? What of the traces of real human bodies, imprinted into the real space of the world? Such traces are, after all, what it means to have a body, to think and feel, and to submit to the extraordinary fact of simply being alive, orienting ourselves in the world through the miracle of the human eye, the unfathomable complexity of vision and thought: what it is through the senses to know. Knowledge would be of little use, however, without the ordering power of memory and the deep wells of recollection, which can be drawn upon by the smallest stimulus – sunlight on a wall, the sudden commotion of a flight of birds or the long-buried memory of a smell from childhood. These triggers can be preserved in images, but so too can the complex process of triggering itself, so that even if we are not possessed of the original memory, we can still marvel at the structures of recollection and feel how they dwell deep within us, making us who we are.

On the edge of a park in the East End of London there appeared in the late months of 1993 a ghostly apparition, a cast of the complete interior of a terrace house. Concrete had been poured into an interior mould, and the walls, windows and whole outer structure then removed, so that fireplaces and window and door frames hung in the open air, making of them a strange public monument to a long history of private domestic life. The house was turned inside out, like those interiors revealed by aerial bombing or during demolition.[18] The artist who created it, Rachel Whiteread, had previously made casts of the interiors of smaller objects, and one of the interior of an entire room. *House* appeared more like a public monument than a sculpture, and provoked a hostility expressed by the famous graffito on the structure's side – 'Wot For [?]'. Three months later, *House* was demolished on the orders of the local council.

As a strange form on the outskirts of the city, preserved only in photographs following its demolition and the redevelopment of the surrounding area, *House* offers one answer to the question with which this book began – why do we make images of things? It was created for the same reason that images have been created throughout the human past: the earliest drawings of horses, bison and warty pigs on damp cave walls and the standing stone structures proclaiming human presence in the landscape; images of kings and queens preserved in burial chambers and the elaborate temples in which they were interred; stirring images of the human body and the portrait paintings of the dead in the ancient world; illustrations of the great epics of poetry and literature, as much as the paintings of the natural world that first appeared in China, and stood at the heart of image-making in Europe for almost half a millennium, from the time of Giotto until that of Cézanne; and the images of modern life, of the thinking, seeing mind and the suffering human body in the twentieth century, confronting nature with ever-mounting alarm at the effects of human actions on the planet that we inhabit,

circling in the darkness of space. These human images were created so that we might know, and so that we might remember.

Rachel Whiteread (b. 1963), *House*, London, 1993. Internal casting of 193 Grove Road, Bow, East London (destroyed).

Epilogue

A fuse is lit; sparks ascend, tracing the shape of a ladder in the night sky, up to the heavens. For a while the fire burns brightly, then over the ocean again falls darkness, and silence.

It is a drawing, a sculpture. Something to remember. Something made visible.

Around sweltering city streets a block of ice is being pushed. Along pavements, over crossings, until it melts to nothing. What to think? You find strange things in cities nowadays. Beneath a pavement grille on a busy square, a low chiming hum, as if the sound of time itself. Or an enormous puppy, the height of a building, made only from flowers. Or a giant spider cast in bronze, towering over an urban thoroughfare. Shall we go around it, or through it?

Somewhere else, in a museum room: an unmade bed, surrounded by the detritus of a decadent life. A painful exposure of a privacy, of the place where we are born, where we dwell in sleep, where we perhaps love and die. Our own beds, what do they say about us?

A film is projected on the floor of a grey rotunda. It shows an endoscopy. The camera probes a pulsing, glistening interior, showing the body like a living cave, a combination of fascination and disgust. Do we all look the same on the inside, like this?

In the museum a guard suddenly starts singing a plaintive song that echoes all around. Someone, somewhere else, is shouting, with an insistent barking tenor: 'Work! Work! Work!'

Films play in darkened rooms; we stumble in and adjust our eyes, groping to find the wall. Frame by frame a thriller is slowed right down, so that it takes a day and a night to watch. How long shall we stay? Another is a montage of clocks and watches, clips from other films, all telling the right time over twenty-four hours. Another shows long strings of numbers, data, gushing down a screen like a digital waterfall, or a man rolling an oil drum along city streets for as long as we are prepared to stay. Another shows ...

Can images change things? How can we change things? We see the devastation of an earthquake in China, and then the corruption that followed in its wake. Riots are re-enacted, battles between the police and angry disenfranchised workers. Placards and banners of a protest against state military intervention in foreign wars are gathered together, leaning against a gallery wall. A group of women dressed in bright outfits sing anti-government songs during a church service. What is a life worth? Is beauty a prejudice?

The images of art make the unseen visible: the unseen parts of our bodies and lives, and the assumptions lodged deep in our minds and social habits. The images of art are there to change the world, or to try and change the world, by showing a vision of something better, a greater freedom. The images of art make, or try to make, freedom visible.

Museums are built with rooms as high and wide as the basilica churches of olden times, or train stations and factories, calm expanses of white-walled galleries. How to fill them?

Photographs of everyday life are pinned to the walls, all different sizes and shapes. Other photographs show an open monochrome sea, or a blank cinema screen, a man standing, swaying, in a lonely urban street, or alongside a canal, papers flying and figures caught in a gust of wind.

Sprawling canvases show colours and shapes, or are left blank, bearing only the faintest shimmer of colour and light. Portraits are still painted; landscapes are still painted; even some still-lifes, just as they have been for countless years.

And yet canvases are also encrusted with anything that can be attached to a flat surface – dried flowers and barbed wire, butterfly wings and a mass of dead flies – or woven with bottle-tops, with tea bags or old clothes, or with organic matter that rots away, leaving an unpleasant smell behind.

Paintings can seem like riddles and puzzles, showing places where an artist has never been, people they have never seen or a memory of a moment long past. Or more like mirrors, mimicking with flawless technique older paintings, or the surfaceless imagery of photography. They show the unclothed human body in poses and shapes quite unlike the nudes of the past, or consist solely of large letters, spelling out simple words, or lines drawing commonplace objects, or show nothing at all, rectangles of monochrome grey.

Mirrors of the abundance, of the strangeness, of the fantastical variety of the world, but never more than mirrors, and never more than adequate as images of life, and unanswered by their subjects, like unrequited love. Paintings are more or less like life, but life is never like a painting.

A room is lit by a dull yellow light, draining our clothes and skin of all colour – we are monochromes too. Are we then works of art? How is it done? We wander along the corridors of a crumbling apartment, the walls plastered with propaganda posters and strange apparatus. It feels like being immersed in somebody's imagination. We watch while the entirety of a person's possessions are systematically destroyed on a conveyor belt, with no reason given for this extreme action. How did they feel after that? Why did they do it?

Sculptures are still made with bronze, wood and plaster, but transformed in essence: no longer monuments or memorials, but more obscure, perplexing things to encounter. Sound and light themselves become sculpture – if we can still call it that. A sculpture might be two people standing on a table singing a jaunty song, or a giant curved mirror-object at the heart of a great city. Great sheets of steel stand propped on their edges in galleries and city squares, creating vertiginous mazes that we cannot map in our heads as we navigate. A colossal female sphinx with African features, seemingly made entirely of sugar, sits expectantly in a disused refinery. A sculpture might be a famous person asleep in a glass box, or the artist herself, sitting silently, staring, or a giant collapsing spiral staircase. It might be a mystery inside a tin can, or the whole world, or just a crack in the floor, or nothing more than a light bulb turning on and off in an empty room.

And the past keeps coming back to haunt us, like windows opening on a long-forgotten world. Curtains fall, and the aeons of deep time before human life are revealed. Human creativity, we discover, reaches back into the earliest days of our species, revealed in magical and accomplished images of animals.

For millennia these earliest days were thought of as the realm of divine beings, of the giants and spirits who created all things. Yet we were there also, we learn, in some form or other, just as we are nowadays everywhere else, as far as our imaginations can travel.

We can recreate the birth of stars in laboratories, but also the micro-particles that destroy life, just as we can use giant telescopes and hurtling probes to record images of distant galaxies and nebulae of cosmic dust. We can hear the noise of the creation of the universe itself, through cosmic rays that are the remnants of the Big Bang, or so astrophysicists tell us. We step ever closer to discovering the uniqueness, or not, of terrestrial life. The blueprints of creativity are revealed to us, the origins of nature and life. And just at the same time – surely this cannot be a coincidence? – so are the catastrophic consequences of our own actions after millennia of human domination of the natural world.

Everywhere we encounter ourselves, and the products of our hands, in the all-too-human world we have created. Everywhere we encounter what we call, with a generous sweep 'contemporary art'. What is it? An abundance and a diversity, and yet also somehow instantly recognisable in spirit and tone. Something ever willing to test the limits of form, of freedom; images charged with the spirit of democracy and the relentless drive of capitalism, spreading with these gargantuan ideologies around the world. It is the great firmament of twenty-first-century art.

So much knowledge, so much remembrance, so much change. We are surely in danger of being overwhelmed. And yet, still, every day, millions of new artists are born. A dizzying thought – but true! Just look.

A child is drawing with a pencil on paper, or a stick in the earth, or a finger on a misted window. She is conjuring images: clouds, trees, flowers, a friend with spindly arms and legs, a rainbow, a house with doors, in each window a smiling face. Images alive with the same delight and wonder at seeing the world anew that is at the heart of all acts of creation.

Notes

Chapter 1: Signs of Life

1 The drawing of the warty pig at Leang Tedongnge has been scientifically dated to around forty-five thousand years ago: Maxime Aubert et al., 'Oldest cave art found in Sulawesi', *Science Advances*, vol. 7 (3), 2021. See also M. Aubert et al., 'Earliest hunting scene in prehistoric art', *Nature*, vol. 576, 11 December 2019, pp. 442–5.

2 Nicholas J. Conard, 'Palaeolithic ivory sculptures from southwestern Germany and the origins of figurative art', *Nature*, vol. 426, 18/25 December 2003, pp. 830–32.

3 Maxime Aubert, Adam Brumm and Paul S. C. Taçon, 'The timing and nature of human colonization of southeast Asia in the late Pleistocene: a rock art perspective', *Current Anthropology*, vol. 58, December 2017, pp. 553–6, here p. 562.

4 Jean Clottes, 'The identification of human and animal figures in European Palaeolithic art', in Howard Morphy, ed., *Animals into Art* (Oxford, 1989), pp. 21–56.

5 Jill Cook, *The Swimming Reindeer* (London, 2010)

6 Paul Pettitt et al., 'New view on old hands: the context of stencils in El Castillo and La Garma caves (Cantabria, Spain)', *Antiquity*, vol. 88, no. 339, March 2014, pp. 47–63.

7 Pamela B. Vandiver, Olga Soffer, Bohuslav Klíma and Jiří Svoboda, 'The origins of ceramic technology at Dolni Věstonice, Czechoslovakia', *Science*, vol. 246, 24 November 1989, pp. 1002–8.

8 Bohuslav Klíma, 'Recent discoveries of Upper Palaeolithic art in Moravia', *Antiquity*, vol. 32, no. 125, March 1958, pp. 8–14, here pp. 13–14.

9 Colin Renfrew and Iain Morley, eds, *Image and Imagination: A Global Prehistory of Figurative Representation* (Cambridge, 2007), p. xv.

10 The Old Stone Age, or Palaeolithic period, when most humans depended on stone tools, lasted from around 3.3 million years ago until around 12,000 years ago. The New Stone Age, or Neolithic period, is dated from around 12,000 to 5,000 years ago.

11 Whang Yong-Hoon, 'The general aspect of Megalithic culture of Korea', in Byung-mo Kim, ed., *Megalithic Cultures in Asia* (Seoul, 1982), pp. 41–64; Sarah Milledge Nelson, *The Archaeology of Korea* (Cambridge, 1993), p. 147.

12 Klaus Schmidt, 'Göbekli Tepe: a neolithic site in southwestern Anatolia', in Gregory McMahon and Sharon R. Steadman, eds, *The Oxford Handbook of Ancient Anatolia* (Oxford, 2011), pp. 917–33.

13 Mike Parker Pearson et al., 'The age of Stonehenge', *Antiquity*, vol. 81, no. 313, September 2007, pp. 617–39.

14 Yaroslav Kusmin, 'Chronology of the earliest pottery in East Asia: progress and pitfalls', *Antiquity*, vol. 80, no. 308, June 2006, pp. 362–71.

Chapter 2: Eyes Wide Open

1 Paul Collins, *Mountains and Lowlands: Ancient Iran and Mesopotamia* (Oxford, 2016), p. 32.

2 Henri Frankfort, *Cylinder Seals: A Documentary Essay on the Art and Religion of the Ancient Near East* (London, 1939).

3 R. W. Hamilton, 'A Sumerian cylinder seal with a handle in the Ashmolean Museum', *Iraq*, vol. 29, no. 1, Spring 1967, pp. 34–41.

4 Edith Porada, 'A leonine figure of the protoliterate period of Mesopotamia', *Journal of the American Oriental Society*, vol. 70, no. 4, October–December 1950, pp. 223–6.

5 Leonard Woolley, *Ur: The First Phases* (London, 1946).

6 Helene J. Kantor, 'Landscape in Akkadian art', *Journal of Near Eastern Studies*, vol. 25, no. 3, July 1966, pp. 145–52.

7 Irene J. Winter, 'Tree(s) on the mountain: landscape and territory on the Victory stele of Naram-Sîn of Agade', in L. Milano, S. de Martino, F. M. Fales and G. B. Lanfranchi, eds, *Landscapes: Territories, Frontiers and Horizons in the Ancient Near East* (Padua, 1999), pp. 63–72, here p. 70.

8 Sibylle Edzard and Dietz Otto Edzard, *Gudea and His Dynasty: The Royal Inscriptions of Mesopotamia*, *Early Periods*, vol. 3/1 (Toronto, 1997), pp. 30–38.

9 *The Epic of Gilgamesh: The Babylonian Epic Poem and Other Texts in Akkadian and Sumerian*, trans. Andrew George (London, 1999), p. 87.

10 Paul Collins, *Assyrian Palace Sculptures* (London, 2008).

11 Nahum 3, 7.

12 Psalm 137.

13 Exodus 25.

14 I Kings 6.

15 Genesis 11.

16 Josephus, *Jewish Antiquities*, X.I.

17 John Curtis, *The Cyrus Cylinder and Ancient Persia* (London, 2013); translation of the text by I. L. Finkel, pp. 42–3.

18 A. Shapur Shahbazi, *The Authoritative Guide to Persepolis* (Tehran, 2004), pp. 69–71.

Chapter 3: Ages of Elegance

1 Toby Wilkinson, *The Rise and Fall of Ancient Egypt* (London, 2010), p. 23.

2 Erik Iversen, *Canon and Proportions in Egyptian Art* (London, 1955); Gay Robins, *Proportion and Style in Ancient Egyptian Art* (Austin, TX, 1994).

3 Yvonne Harpur, 'The identity and positions of relief fragments in museums and private collections: the reliefs of Rʿ-htp and Nfrt from Meydum', *The Journal of Egyptian Archaeology*, vol. 72, 1986, pp. 23–40.

4 Rudolf Anthes, 'Affinity and difference between Egyptian and Greek sculpture and thought in the seventh and sixth centuries B.C.', *Proceedings of the American Philosophical Society*, vol. 107, no. 1, 1963, pp. 60–81, here p. 63.

5 Donald Spanel, *Through Ancient Eyes: Egyptian Portraiture*, exh. cat., Birmingham Museum of Art (Birmingham, AL, 1988).

6 Cyril Aldred, 'Some royal portraits of the Middle Kingdom in ancient Egypt', *Metropolitan Museum Journal*, vol. 3, 1970, pp. 27–50.

7 Ross E. Taggart, 'A quartzite head of Sesostris III', *The Nelson Gallery and Atkins Museum Bulletin*, vol. IV, no. 2, October 1962, pp. 8–15.

8 Arielle P. Kozloff and Betsy M. Bryan, *Egypt's Dazzling Sun: Amenhotep III and His World*, exh. cat., Cleveland Museum of Art (Cleveland, OH, 1992).

9 Wilkinson, *The Rise and Fall of Ancient Egypt*, p. 285

10 Herodotus, *The Persian Wars*, II.

11 Bernard Fagg, 'A preliminary note on a new series of pottery figures from northern Nigeria', *Africa*, vol. 15, no. 1, 1945, pp. 21–2.

12 Peter Garlake, *Early Art and Architecture in Africa* (Oxford, 2002), p. 111.

13 Frederick John Lamp, 'Ancient terracotta figures from northern Nigeria', *Yale University Art Gallery Bulletin*, 2011, pp. 48–57, here p. 52.

Chapter 4: Jade and Bronze

1 Ute Franke-Vogt, 'The glyptic art of the Harappa culture', in Michael Jansen, Máire Mulloy and Günter Urban, eds, *Forgotten Cities of the Indus: Early Civilization in Pakistan from the 8th to the 2nd Millennium BC* (Mainz, 1991), pp. 179–87, here p. 182.

2 Colin Renfrew and Bin Liu, 'The emergence of complex society in China: the case of Liangzhu', *Antiquity*, vol. 92, no. 364, August 2018, pp. 975–90.

3 Timothy Potts, 'The ancient Near East and Egypt', in David Ekserdjian, ed., *Bronze*, exh. cat., Royal Academy, London (London, 2012), pp. 32–41.

4 Chêng Tê-k'un, 'Metallurgy in Shang China', *T'oung Pao*, vol. 60, no. 4/5, 1974, pp. 209–29.

5 Jessica Rawson, *Chinese Bronzes: Art and Ritual* (London, 1987), p. 20; Jianun Mei and Thilo Rehren, *Metallurgy and Civilisation: Eurasia and Beyond* (London, 2009).

6 Chêng Tê-k'un, 'Metallurgy in Shang China', p. 224.

7 Rawson, *Chinese Bronzes*, p. 31.

8 Jenny F. So, 'The inlaid bronzes of the Warring States period', in Wen Fong, ed., *The Great Bronze Age of China: An Exhibition from the People's Republic of China*, exh. cat., Metropolitan Museum of Art, New York (New York, 1980), pp. 305–11, here pp. 309–10.

9 Robert Bagley, ed., *Ancient Sichuan: Treasures from a Lost Civilisation*, exh. cat., Seattle Art Museum (Seattle, WA, 2001).

10 Sima Qian, *The First Emperor: Selections from the Historical Records*, trans. with an intro. by Raymond Dawson and a preface by K. E. Brashier (Oxford, 2007).

11 Ibid., p. 83.

12 Maxwell K. Hearn, 'The terracotta army of the first emperor of Qin (221–206 B.C.)', in Wen Fong, ed., *The Great Bronze Age of China*, pp. 353–68; Jane Portal, ed., *The First Emperor: China's Terracotta Army*, exh. cat., British Museum London (London, 2007).

13 Lukas Nickel, 'The first emperor and sculpture in China', *Bulletin of SOAS*, vol. 76, no. 3, 2013, pp. 413–47.

14 Elizabeth P. Benson and Beatriz de la Fuente, *Olmec Art of Ancient Mexico*, exh. cat., National Gallery of Art, Washington (Washington, DC, 1996).

15 James C. S. Lin, 'Protection in the afterlife', in James C. S. Lin, ed., *The Search for Immortality: Tomb Treasures of Han China* (New Haven, CT, 2012), pp. 77–83; Wu Hung, *The Art of the Yellow Springs: Understanding Chinese Tombs* (Honolulu, HA, 2010).

16 Mary Ellen Miller, *The Art of Mesoamerica: From Olmec to Aztec* (London, 2001), p. 23; Susan Milbrath, 'A study of Olmec sculptural chronology', in *Studies in Pre-Columbian Art and Archaeology 23* (Washington, DC, 1979), pp. 1–75.

17 Stuart Fiedel, *Prehistory of the Americas* (Cambridge, 1987), pp. 179–84.

18 S. Kaner, ed., *The Power of Dogu: Ceramic Figures from Ancient Japan*, exh. cat., British Museum, London (London, 2009).

Chapter 5: The Human Measure

1 S. Hood, *The Minoans* (London, 1971).

2 A. J. B. Wace, *Mycenae: An Archaeological History and Guide* (Princeton, NJ, 1949).

3 The Pylos Warrior Seal was discovered in 2015. Sharon R. Stocker and Jack L. Davis, 'The combat agate from the grave of the Griffin Warrior at Pylos', *Hesperia: The Journal of the American School of Classical Studies at Athens*, vol. 86, no. 4, October–December 2017, pp. 583–605.

4 John Boardman, *The History of Greek Vases* (London, 2001).

5 P. E. Arias, *A History of Greek Vase Painting*, trans. B. B. Shefton (London, 1962), pp. 354–7.

6 Timothy J. McNiven, 'Odysseus on the Niobid Krater', *The Journal for Hellenic Studies*, vol. 109, 1989, pp. 191–8.

7 Pausanias, *Description of Greece*, X, 'Phocis, Ozolian Locri', XXV–XXXI.

8 Pliny the Elder, *Natural History*, vol. IX, books XXXIII–XXXV.

9 Lucretius refers to 'daedala rerum' – a 'cunning fashioner of things'. Lucretius, *De rerum natura*, Book 5, 234.

10 Rudolf Anthes, 'Affinity and difference between Egyptian and Greek sculpture and thought in the seventh and sixth centuries BC', *PAPS*, vol. 107, no. 11, 1963, pp. 60–81.

11 Nivel Spivey, *Understanding Greek Sculpture: Ancient Meanings, Modern Readings* (London, 1996), p. 71.

12 A. Furtwängler, *Masterpieces of Greek Sculpture: A Series of Essays on the History of Art*, trans. E. Sellers from German edition of 1893 (London, 1895).

13 Thucydides, *History of the Peloponnesian War*, II, XLIII.

14 Euripides, *The Bacchae*, trans. William Arrowsmith [1959], in David Grene, Richmond Lattimore, Mark Griffith and Glenn W. Most, eds, *Greek Tragedies* (Chicago, IL, 2013), pp. 202–66, here p. 225.

15 Lucian, *Amores*, 11–16.

16 J. J. Pollitt, *Art in the Hellenistic Age* (Cambridge, 1986).

17 Diogenes Laertius, 6.62. Cited in Pollitt, *Art in the Hellenistic Age*, p. 11.

18 Polybius, *The Histories*, 1.3.

19 Pliny, *Natural History*, IX. XXXVI.

20 Plutarch, *Lives*. 'Alexander', IV.

21 Virgil, *The Aeneid*, II, 213–24.

22 Pliny, *Natural History*, IX. XXXVI.

23 Herodotus, *The Persian Wars*, IV.46.

24 St John Simpson and Svetlana Pankova, eds., *Scythians: Warriors of Ancient Siberia*, exh. cat., British Museum, London (London, 2017), p. 209.

Chapter 6: Roads to Empire

1 Virgil, *Aeneid*, 6, 847–8.

2 Livy, *History of Rome*, 39, 5.

3 Homer, *Iliad*, VI. The tail with its serpent head was added to the bronze Chimera in the eighteenth century.

4 Pliny, *Natural History*, XXV. XLV.

5 Gisela M. A. Richter, 'The origin of verism in Roman portraits', *The Journal of Roman Studies*, vol. 45, 1955, pp. 39–46.

6 Pliny, *Natural History*, IX. XXXIII–XXXV.

7 Karl Schefold, 'Origins of Roman landscape painting', *Art Bulletin*, vol. 42, no. 2, June 1960, pp. 87–96.

8 W. J. T. Peters, *Landscape in Romano-Campanian Mural Painting* (Assen, 1963), p. 28.

9 Pollitt, *Art in the Hellenistic Age*, p. 185.

10 Jocelyn Toynbee, 'The villa item and a bride's ordeal', *The Journal of Roman Studies*, vol. 19, 1929, pp. 67–87; Victoria Hearnshaw, 'The Dionysiac cycle in the Villa of the Mysteries: a re-reading', *Mediterranean Archaeology*, vol. 12, 1999, pp. 43–50.

11 Suetonius, *Lives of the Caesars*, II. XXVIII.

12 D. Castriota, *The Ara Pacis Augustae and the Imagery of Abundance in Later Greek and Early Roman Imperial Art* (Princeton, NJ, 1995).

13 William L. MacDonald, *The Pantheon: Design, Meaning and Progeny* (London, 1976), p. 13.

14 Peter Stewart, 'The equestrian statue of Marcus Aurelius', in Marcel van Ackeren, *A Companion to Marcus Aurelius* (Oxford, 2012), pp. 264–77.

15 Josephus, *The Jewish War*, VII. 5.

16 Pliny, *Natural History*, XXXVI. LX.

17 J. M. C. Toynbee, *Art in Roman Britain* (London, 1962), p. 203; Stephen R. Cosh and David S. Neal, *Roman Mosaics of Britain*, vol. II, *South-West Britain* (London, 2005), pp. 253–6.

18 Susan Walker and Morris Bierbrier, *Ancient Faces: Mummy Portraits from Roman Egypt* (London, 1997).

Chapter 7: Suffering and Desire

1 John Irwin, '"Aśokan" pillars: a reassessment of the evidence', *The Burlington Magazine*, no. 848, November 1973, pp. 706–20.

2 James Legge, *The Travels of Fa-Hien* (Oxford, 1886), pp. 50–51.

3 Benjamin Rowland, *The Art and Architecture of India: Buddhist, Hindu, Jain* (Harmondsworth, 1967), p. 60.

4 Akira Shimada and Michael Willis, *Amaravati: The Art of an Early Buddhist Monument in Context* (London, 2016).

5 Robert Knox, *Amaravati: Buddhist Sculpture from the Great Stupa* (London, 1992).

6 John M. Rosenfield, *The Dynastic Art of the Kushans* (Berkeley and Los Angeles, CA, 1967).

7 Robert Bracey, 'Envisioning the Buddha' in *Imagining the Divine*, exh. cat., Ashmolean Museum, Oxford (Oxford, 2018), pp. 85–99, here pp. 97–8.

8 E. H. Ramsden, 'The halo: a further enquiry into its origin', *The Burlington Magazine*, no. 456, April 1941, pp. 123–7, 131.

9 Wannaporn Rienjang and Peter Stewart, eds, *The Global Connections of Gandharan Art* (Oxford, 2020).

10 Stanislaw Czuma, 'Mathura sculpture in the Cleveland Museum collection', *The Bulletin of the Cleveland Museum of Art*, no. 3, 1967, pp. 83–114.

11 William Empson, *The Face of the Buddha* (Oxford, 2016), p. 22.

12 Vidya Dehejia, *Indian Art* (London, 1997), pp. 96–7.

13 J. C. Harle, *Gupta Sculpture: Indian Sculpture of the Fourth to the Sixth Centuries A.D.* (New Delhi, 1996).

14 Stella Kramrisch, *The Presence of Śiva* (Princeton, NJ, 1981), p. 439.

15 Neville Agnew, Marcia Reed and Tevvy Ball, *Cave Temples of Dunhuang: Buddhist Art on China's Silk Road*, exh. cat., Getty Center, Los Angeles (Los Angeles, CA, 2016).

16 Sarah Whitfield, 'Dunhuang and its network of patronage and trade', in Agnew, Reed and Ball, *Cave Temples of Dunhuang*, pp. 59–75, here p. 62.

Chapter 8: Golden Saints

1 Oleg Grabar, *Christian Iconography: A Study of Its Origins* (London, 1969), p. 6.

2 Joseph Gutmann, 'The Dura Europos synagogue paintings: the state of research', in Lee I. Levine, ed., *The Synagogue in Late Antiquity* (Philadelphia, PA, 1987), pp. 61–72.

3 Deuteronomy 5.

4 Jas Elsner, 'Jewish art', in Jas Elsner et al., eds, *Imagining the Divine: Art and the Rise of World Religions*, exh. cat., Ashmolean Museum, Oxford (Oxford, 2018), pp. 69–72, here p. 69.

5 Grabar, *Christian Iconography*, p. 45.

6 Eusebius, *Life of Constantine*, intro., trans. and commentary by Averil Cameron and Stuart G. Hall (Oxford, 1999), p. 141.

7 Richard Krautheimer, 'The Constantinian basilica', *Dumbarton Oaks Papers*, vol. 21, 1967, pp. 115–40.

8 It has also been suggested that it was built as a mausoleum for Constantine's eldest daughter, Helena, commissioned by her husband, the emperor Julian.

9 Procopius, *Buildings*, I.i.

10 See Cyril Mango and Ihor Ševčenko, 'Remains of the church of St. Polyeuktos at Constantinople', *Dumbarton Oaks Papers*, vol. 15, 1961, pp. 243–7.

11 Martin Harrison, *A Temple for Byzantium: The Discovery and Excavation of Anicia Juliana's Palace-Church in Istanbul* (Austin, TX, 1989).

12 *The Russian Primary Chronicle: Laurentian Text*, trans. S. H. Cross and O. P. Sherbowitz-Wetzor (Cambridge MA, 1953), p. 111.

13 See Ernst Kitzinger, 'The cult of images in the age before Iconoclasm', *Dumbarton Oaks Papers*, 8, 1954, pp. 83–105; and Andrea Nicolotti, *From the Mandylion of Edessa to the Shroud of Turin: The Metamorphosis and Manipulation of a Legend* (Leiden, 2014).

14 G. R. D. King, 'Islam, Iconoclasm, and the declaration of doctrine', *Bulletin of the School of Oriental and African Studies, University of London*, vol. 48, no. 2, 1985, pp. 267–77.

15 Steven Runciman, *Byzantine Style and Civilisation* (Harmondsworth, 1975), pp. 83–4.

16 Steven Runciman, 'The empress Eirene the Athenian', in D. Baker, ed., *Medieval Woman* (Oxford, 1978), pp. 101–18.

17 Robin Cormack, 'Women and icons, and women in icons', in Liz James, ed., *Women, Men and Eunuchs: Gender in Byzantium* (London, 1997), pp. 24–51.

18 H. Buchthal, *The Miniatures of the Paris Psalter* (London, 1938). See also K. Weitzmann, 'Der Pariser Psalter MS. Gr. 139 und die mittelbyzantinische Renaissance', *Jahrbuch für Kunstwissenschaft*, 6, 1929, pp. 178–94.

19 Henry Maguire, 'Style and ideology in Byzantine imperial art', *Gesta*, vol. 28, no. 2, 1989, pp. 271–31, here p. 219.

20 Helen C. Evans, 'Christian neighbours', in Helen C. Evans and William D. Wixom, eds, *The Glory of Byzantium. Art and Culture of the Middle Byzantine Era A.D. 843–1261*, exh. cat., Metropolitan Museum of Art, New York (New York, 1997), pp. 273–8.

21 Gregoras, *Byzantina Historia*, vol. II (Bonn, 1829–55), p. 790, cited in Cecily J. Hilsdale, *Byzantine Art and Diplomacy in an Age of Decline* (Cambridge, 2014), p. 1.

Chapter 9: The Name of the Prophet

1 Oleg Grabar, *The Dome of the Rock* (Cambridge, MA, London, 2006).

2 Richard Ettinghausen, Oleg Grabar and Marilyn Jenkins-Madina, *Islamic Art and Architecture, 650–1250* (New Haven, CT, and London, 2001), p. 19.

3 C. Kessler, 'Abd al-Malik's inscription in the Dome of the Rock: a reconsideration', *Journal of The Royal Asiatic Society*, 1970, pp. 2–14.

4 Terry Allen, *Five Essays on Islamic Art* (Sebastopol, CA, 1988), p. 36.

5 Oleg Grabar, 'Islamic art and Byzantium', *Dumbarton Oaks Papers*, vol. 18, 1964, pp. 67–88, here p. 77.

6 R. Hillenbrand, 'The ornament of the world: medieval Córdoba as a cultural center', in S. K. Jayyusi, *The Legacy of Muslim Spain* (Leiden, 1992); Nuha Khoury, 'The meaning of the great mosque of Córdoba in the tenth century', *Muqarnas*, 13, 1996.

7 David A. King, 'Astronomical alignments in medieval Islamic architecture', in *Annals of the New York Academy of Sciences*, December 2006, pp. 303–12.

8 Oleg Grabar, *The Great Mosque of Isfahan* (New York, 1990).

9 Jim al-Khalili, *Pathfinders: The Golden Age of Arabic Science* (London, 2010).

10 J. M. Bloom, *Paper before Print: The History and Impact of Paper in the Islamic World* (New Haven, CT, and London, 2001).

11 D. C. Lindberg, *Theories of Vision from al-Kindi to Kepler* (Chicago, IL, 1976).

12 The Quran, sura 24, verse 35, *The Koran*, trans. J. M. Rodwell (London, 1994), p. 415.

13 The Quran, sura 87, verses 1–16, *The Koran*, trans. Rodwell, p. 415.

14 Cited by Zabhallah Safa, *Ta'rikh-i adabiyyat dar Iran* [History of Iranian Literature], vol. III ([1341] Tehran, 1959), p. 8; trans. in Eleanor Sims, Boris I. Marshak and Ernst J. Grube, *Peerless Images: Persian Painting and Its Sources* (New Haven, CT, and London, 2002), p. 41.

15 Dust Muhammad, 'Preface to the Bahram Mirza album', in *A Century of Princes: Sources on Timurid History and Art*, selected and trans. W. M. Thackston (Cambridge, MA, 1989), pp. 335–50.

16 Sims, Marshak and Grube, *Peerless Images*, p. 31.

17 Oleg Grabar and Sheila Blair, *Epic Images and Contemporary History: The Illustrations of the Great Mongol Shahnama* (Chicago, IL, 1980).

18 John Seyller, with contributions from Wheeler M. Thackston, Ebba Koch, Antoinette Owen and Rainald Franz, *The Adventures of Hamza: Painting and Storytelling in Mughal India*, exh. cat., Freer Gallery of Art, Washington (Washington, DC, 2002).

19 Trans. C. M. Naim, in Pramod Chandra, *The Cleveland Tuti-nama Manuscript and the Origins of Mughal Painting*, 2 vols, (Cleveland, OH, 1976), pp. 182–3.

20 Edward MacLagan, *The Jesuits and the Great Mogul* (London, 1932), pp. 242–67.

21 Wayne E. Begley, 'The myth of the Taj Mahal and a new theory of its symbolic meaning', *The Art Bulletin*, vol. 61, no. 1, March 1979, pp. 7–37.

22 Cited in Begley, 'The myth of the Taj Mahal', p. 33.

Chapter 10: Invaders and Inventors

1 R. Gameson, R. Beeby, A. Duckworth and C. Nicholson, 'Pigments of the earliest Northumbrian manuscripts', *Scriptorium*, 69, 2016, pp. 33–59.

2 Leslie Webster, *Anglo-Saxon Art* (London, 2006), p. 8.

3 *Beowulf*, trans. Seamus Heaney (London, 1999), p. 24.

4 Douglas MacLean, 'The date of the Ruthwell Cross', in Brendan Cassidy, ed., *The Ruthwell Cross* (Princeton, NJ, 1992), pp. 49–70.

5 'The Hodoeporican of St. Willibald, by Huneberc of Heidenheim', in C. H. Talbot, *The Anglo-Saxon Missionaries in Germany* (London and New York, 1954), pp. 154–5.

6 'The Dream of the Rood', in *The Earliest English Poems*, trans. M. Alexander ([1966] Harmondsworth, 1977), pp. 106–10.

7 Éamonn Ó Carragáin, *Ritual and the Rood: Liturgical Images and the Old English Poems of the 'Dream of the Rood' Tradition* (London and Toronto, 2005), p. 3.

8 Ibid.

9 Meyer Shapiro, 'The religious meaning of the Ruthwell Cross', *The Art Bulletin*, vol. 26, no. 4, December 1944, pp. 232–45, here p. 233.

10 Ibid.

11 N. Kershaw, ed. and trans., *Anglo-Saxon and Norse Poems* (Cambridge, 1922), p. 55.

12 Erwin Panofsky, 'Renaissance and renascences', *The Kenyon Review*, vol. 6, no. 2, Spring 1944, pp. 201–36.

13 Einhard and Notker the Stammerer, *Two Lives of Charlemagne* (Harmondsworth, 1969), p. 80.

14 Peter Lasko, *Ars sacra, 800–1200* (New Haven, CT, and London, 1994), p. 13.

15 See Richard Krautheimer, 'The Carolingian revival of early Christian architecture', *Art Bulletin*, vol. 24, no. 1, March 1942, pp. 1–38, here p. 35.

16 Einhard and Notker the Stammerer, *Two Lives of Charlemagne*, p. 79.

17 C. R. Dodwell, *Painting in Europe, 800–1200* (Harmondsworth, 1971), p. 141.

18 Henry Mayr-Harting, *Ottonian Book Illumination: An Historical Study* (London, 1991), vol. 2, p. 63.

19 Known as Junius 11, after Francis Junius, who published it for the first time, in Amsterdam in 1655. H. R. Broderick, 'Observations on the method of illustration in MS Junius 11 and the relationship of the drawings to the text', *Scriptorium*, 37, 1983, pp. 161–77.

20 See Catherine E. Karkov, *Text and Picture in Anglo-Saxon England: Narrative Strategies in the Junius 11 Manuscript* (Cambridge, 2001), p. 90.

Chapter 11: Serpents, Skulls, Standing Stones

1 *Popol Vuh: The Mayan Book of the Dawn of Life*, trans. Dennis Tedlock (New York, 1996), p. 64.

2 Kathleen Berrin and Esther Pasztory, eds, *Teotihuacan: Art from the City of the Gods*, exh. cat., Fine Arts Museum, San Francisco (San Francisco, CA, 1993).

3 Esther Pasztory, 'Teotihuacan unmasked: a view through art', in Berrin and Pasztory, eds, *Teotihuacan*, p. 46.

4 Saburo Sugiyama, 'The Feathered Serpent Pyramid at Teotihuacan: monumentality and sacrificial burials', in Matthew H. Robb, *Teotihuacan: City of Water, City of Fire*, exh. cat., de Young Museum, San Francisco (San Francisco, CA, 2017), pp. 56–61.

5 Winifred Creamer, 'Mesoamerica as a concept: an archaeological view from Central America', *Latin American Research Review*, vol. 22, no. 1, 1987, pp. 35–62. The Spanish word 'Mesoamerica' was coined in 1943 by Paul Kirchoff, in 'Mesoamérica, sus límites geográficos, composición étnica y caracteres culturales', *Acta Americana*, 1, 1943, pp. 92–107.

6 Elizabeth P. Benson, *Birds and Beasts of Ancient Latin America* (Gainesville, FL, 1997), p. 78.

7 Christopher B. Donnan, *Moche Art of Peru*, exh. cat., Museum of Cultural History, Los Angeles (Los Angeles, CA, 1978).

8 Elizabeth P. Benson, 'The owl as a symbol in the mortuary iconography of the Moche', in Beatrice de la Fuente and Louise Noelle, eds, *Arte funerario: coloquio internacional de historia del arte* (Mexico City, 1987), vol. 1, pp. 75–82.

9 Mary Ellen Miller and Megan O'Neil, *Maya Art and Architecture* (London, 2014).

10 Michael Coe, *Breaking the Maya Code* (London, 1999).

11 William L. Fash, *Scribes, Warriors and Kings: The City of Copán and the Ancient Maya* (London, 1991), p. 85.

12 Mary Ellen Miller, 'A re-examination of the Mesoamerican Chacmool', *The Art Bulletin*, vol. 67, no. 1, March 1985, pp. 7–17.

13 Esther Pasztory, *Aztec Art* (New York, 1983), p. 160.

14 David Summers, *Real Spaces* (London, 2003), pp. 45–50.

15 Herman Cortes, *Letters from Mexico*, trans. and ed. by Anthony Pagden, New Haven and London 1986, pp. 86 and 467-9

16 Richard F. Townsend, *The Aztecs* (London, 2000), p. 18.

17 Maricela Ayala Falcón, 'Maya writing', in Peter Schmidt, Mercedes de la Garza and Enrique Nalda, *Maya Civilization* (London, 1998), pp. 179–91.

Chapter 12: Sound and Light

1 'The Ruin', in *The Earliest English Poems*, trans. Alexander, pp. 30–31.

2 Kenneth Conant, *Romanesque Architecture, 800–1200* (London 1966); Eric Fernie, *Romanesque Architecture: The First Style of the European Age* (New Haven, CT, and London, 2014).

3 Giulio Cattin, *Music of the Middle Ages*, trans. Steven Botterill (Cambridge, 1984), p. 48.

4 Carolyn M. Carty, 'The role of Gunzo's dream in the rebuilding of Cluny III', *Gesta*, vol. 27, *Current Studies on Cluny*, 1988, pp. 113–23.

5 George Zarnecki, *Romanesque Art* (London, 1971), p. 14.

6 Andreas Petzold, *Romanesque Art* (London, 1995), p. 104.

7 Kathi Meyer, 'The eight Gregorian modes on the Cluny capitals', *The Art Bulletin*, vol. 34, no. 2, June 1952, pp. 75–94.

8 Meyer Shapiro, 'On the aesthetic attitude in Romanesque art', in Meyer Shapiro, *Romanesque Art* (New York, 1977), pp. 1–27.

9 N. E. S. A. Hamilton, ed., *Wilhelmi Malmesbiriensis, monachi gesta pontificum anglorum* (London, 1870), pp. 69–70; quoted in K. Collins, P. Kidd and N. K. Turner, *The St Albans Psalter: Painting and Prayer in Medieval England*, exh. cat., Getty Museum (Los Angeles, CA, 2013), p. 73.

10 Conrad Rudolph, *The 'Things of Greater Importance': Bernard of Clairvaux's 'Apologia' and the Medieval Attitude toward Art* (Philadelphia, PA, 1990), p. 106; Conrad Rudolph, 'Bernard of Clairvaux's Apologia as a description of Cluny, and the controversy over monastic art', *Gesta*, vol. 27, *Current Studies on Cluny*, 1988, pp. 125–32.

11 Lindy Grant, *Abbot Suger of St-Denis: Church and State in Early Twelfth-Century France* (London and New York, 1998).

12 E. Panofsky, *Abbot Suger on the Abbey Church of St Denis and its Art Treasures* (Princeton, NJ, 1979), p. 19.

13 Guillaume de Lorris and Jean de Meung, *Le roman de la rose*, ed. and trans. Armand Strubel (Paris, 1992), line 18,038, pp. 938–41.

14 Stephen Murray, *Notre-Dame, Cathedral of Amiens: The Power of Change in Gothic* (Cambridge, 1996), pp. 28–43.

15 Andrew Martindale, *Gothic Art from the Twelfth to Fifteenth Centuries* (London, 1967), p. 89.

16 Jean Bony, *Gothic Architecture of the 12th and 13th Centuries* (Berkeley, CA, 1983).

17 K. Brusch, 'The Naumberg Master: a chapter in the development of medieval art history', *Gazette des Beaux-Arts*, n. s. 6, vol. 122, October 1993, pp. 109–22.

18 Paul Williamson, *Gothic Sculpture, 1140–1300* (New Haven, CT, and London, 1995), p. 177.

19 Susie Nash, 'Claus Sluter's "Well of Moses" for the Chartreuse de Champmol reconsidered', part I, *The Burlington Magazine* no. 1233, December 2005, pp. 798–809; part II, *The Burlington Magazine* no. 1240, July 2006, pp. 456–67; part III, *The Burlington Magazine*, no. 1268, November 2008, pp. 724–41.

20 S. K. Scher, 'André Beauneveu and Claus Sluter', *Gesta*, vol. 7, 1968, pp. 3–14, here p. 5.

21 Millard Meiss, *French Painting in the Time of Jean de Berry: The Limbourgs and Their Contemporaries*, 2 vols (New York, 1974).

Chapter 13: Travellers in the Mist

1 See J. Stuart, *The Admonitions Scroll*, British Museum Objects in Focus (London, 2014).

2 Cited in L. Binyon, 'A Chinese painting of the fourth century', *The Burlington Magazine*, no. 10, January 1904, pp. 39–45, 48–9.

3 'Deer Park', from the Wang River sequence, trans. G. W. Robinson in *Wang Wei: Poems* (Harmondsworth, 1973).

4 Ching Hao, 'Pi-fa chi' ('A note on the art of the brush'), excerpt from Susan Bush and Hsio-yen Shih, *Early Chinese Texts on Painting* (Hong Kong, 2012), pp. 145–8.

5 Guo Xi, 'Advice on landscape painting', excerpt in Bush and Shih, *Early Chinese Texts on Painting*, pp. 165–7.

6 Craig Clunas, *Chinese Painting and Its Audiences* (Princeton, NJ, 2017), p. 85.

7 Ibid.

8 See Michael Sullivan, *Symbols of Eternity: The Art of Landscape Painting in China* (Oxford, 1979), p. 8.

9 Zong Bing, 'The significance of landscape', fourth-century text cited in Bush and Shih, *Early Chinese Texts on Painting*, p. 36.

10 Cited in James Cahill, *Chinese Painting* ([1960] New York, 1985), p. 91.

11 Sullivan, *Symbols of Eternity*, p. 77.

12 James Cahill, *Hills beyond a River: Chinese Painting of the Yüan Dynasty, 1279–1368* (New York and Tokyo, 1976), p. 118.

13 See Clunas, *Chinese Painting and Its Audiences*, pp. 51–7.

14 Ibid., p. 55

15 Margaret Medley, *The Chinese Potter: A Practical History of Chinese Ceramics* (Oxford, 1976), pp. 106–14.

16 Ibid., p. 177

17 Zhang Ji, 'Night-mooring at the Maple Bridge', from the *Ku Shih Hsüan*, compiled by Yüan Ting in the twelfth century.

18 See F. W. Mote, 'A millennium of Chinese urban history: form, time, and space concepts in Soochow', Rice Institute Pamphlet – Rice University Studies, 59, no. 4 (1973).

19 Translation in Richard Edwards, *The Field of Stones: A Study of the Art of Shen Zhou (1427–1509)* (Washington, DC, 1962), p. 40.

20 Translation in Craig Clunas, *Elegant Debts: The Social Art of Wen Zhengming, 1470–1559* (London, 2004), p. 31.

21 Sullivan, *Symbols of Eternity,* p. 124.

22 Jerome Silbergeld, 'Kung Hsien: a professional Chinese artist and his patronage', *The Burlington Magazine*, vol. 123, no. 940, July 1981, pp. 400–410.

Chapter 14: Spellbound

1 See V. Harris, ed., *Shinto: The Ancient Art of Japan*, exh. cat., British Museum, London (London, 2000).

2 Recorded in the eighth-century chronicle of Japanese history, the Nihon-Shoki. W. G. Aston, trans. 'Nihongi', *Transactions and Proceedings of the Japan Society* (London, 1896), vol. ii, pp. 65–7, here p. 66.

3 Alexander Coburn Soper, *The Evolution of Buddhist Architecture in Japan* (Princeton, NJ, 1942), p. 89.

4 They were destroyed in a fire in 1949. Joan Stanley-Baker, *Japanese Art* (London, 1984), p. 44.

5 Nishikawa Kyōtarō and Emily J. Sano, *The Great Age of Japanese Buddhist Sculpture AD 600–1300*, exh. cat., Kimbell Art Museum, Fort Worth (Fort Worth, TX, 1982), p. 24.

6 Clunas, *Chinese Painting and Its Audiences*, p. 9.

7 *The Man'yōshū: The Nippon Gakujtusu Shinkōkai Translation of One Thousand Poems*, with a foreword by Donald Keene (New York and London, 1969), p. 3.

8 Alexander C. Soper, 'The rise of *yamato-e*', *The Art Bulletin,* vol. 24, no. 4, December 1942, pp. 351–79.

9 *The Pillow-Book of Sei Shōnagon*, trans. Arthur Waley (London, 1928).

10 See Akiyama Terukazu, 'Insei ki ni okeru nyōbō no kaiga seisaku: tosa no tsubone to kii no tsubone', in *Kodai, chūsei no shakai to shisō* (Tokyo, 1979); trans. and abridged by Maribeth Graybill as 'Women painters at the Heian court', in Marsha Weidner, ed., *Flowering in the Shadows: Women in the History of Chinese and Japanese Painting* (Honolulu, HA, 1990), pp. 159–84.

11 Cited by Yukio Lippit, Japanese Zen Buddhism and the Impossible Painting (Los Angeles, CA, 2017), p. 3.

12 Saigyō Hōshi, 'Trailing on the wind', trans. Geoffrey Bownas and Anthony Thwaite, in Bownas and Thwaite, *The Penguin Book of Japanese Poetry* (Harmondsworth, 1998 [1964]), p. 93.

13 Yukio Lippit, 'Of modes and manners in Japanese ink painting: Seshhu's "splashed ink landscape" of 1495', *The Art Bulletin*, vol. 94, no. 1, March 2012, pp. 50–77, here p. 55.

14 W. Akiyoshi, K. Hiroshi and P. Varley, *Of Water and Ink: Muromachi-Period Paintings from Japan, 1392–1568*, exh. cat., Detroit Institute of Arts (Detroit, MI, 1986), p. 98.

15 Ibid., pp. 146–7

16 Julia Meech-Pekarik, *Momoyama: Japanese Art in the Age of Grandeur*, exh. cat., Metropolitan Museum of Art, New York (New York, 1975), p. 2.

17 Carolyn Wheelwright, 'Tōhaku's black and gold', *Ars Orientalis,* vol. 16, 1986, pp. 1–31.

18 Ibid., p. 4.

Chapter 15: The New Life

1 Petrarch, 'Ascent of Mont Ventoux', in Ernst Cassirer et al., eds, *The Renaissance Philosophy of Man* (Chicago, IL, 1948), pp. 36–46, here p. 41.

2 Jules Lubbock, *Storytelling in Christian Art from Giotto to Donatello* (New Haven, CT, and London, 2006), p. 86.

3 E. H. Gombrich, 'Giotto's portrait of Dante?', *The Burlington Magazine*, no. 917, August 1979, pp. 471–83, here p. 471.

4 Dante Alighieri, 'Purgatorio XI', *The Divine Comedy*, trans. Allen Mandelbaum (London, 1995), p. 266.

5 Ernst Kitzinger, 'The Byzantine contribution to western art of the twelfth and thirteenth centuries', *Dumbarton Oaks Papers*, vol. 20, 1966, pp. 25–47.

6 T. E. Mommsen, *Petrarch's Testament* (Ithaca, NY, 1957), pp. 78–81.

7 Hans Belting, 'The new role of narrative in public painting of the Trecento: *Historia* and allegory', *Studies in the History of Art*, vol. 16 (Washington, DC, 1985), pp. 151–68.

8 Giorgio Vasari, *The Lives of the Painters, Sculptors and Architects* (London, 1965), pp. 75–81.

9 Theodor E. Mommsen, 'Petrarch and the decoration of the Sala Virorum Illustrium in Padua', *The Art Bulletin*, vol. 34, no. 2, June 1952, pp. 95–116.

10 L.A. Muratori, *Rerum Italicarum Scriptores*, vol 15. part 6 (Bologna, 1932), p. 90.

11 J. B. Trapp, 'Petrarch's Laura: the portraiture of an imaginary beloved', *Journal of the Warburg and Courtauld Institutes*, vol. 64, 2001, pp. 55–192.

12 Petrarch, 'Per mirar Policleto a prova fiso', Sonnet 77; in Petrarch, *Canzoniere*, trans. J. G. Nichols (London, 2000), p. 77.

13 Timothy Hyman, *Sienese Painting: The Art of a City-Republic (1278–1477)* (London, 2003).

14 Keith Christiansen, *Gentile da Fabriano* (London, 1982) p. 45.

15 Paul Hills, *The Light of Early Italian Painting* (New Haven, CT, and London, 1987), p. 126.

16 James R. Banker, 'The program for the Sassetta altarpiece in the church of S. Francesco in Borgo S. Sepolcro', *I Tatti Studies in the Italian Renaissance*, vol. 4, 1991, pp. 11–58, here p. 12.

17 Hyman, *Sienese Painting*, p. 159.

18 Keith Christiansen, 'Painting in Renaissance Siena', in K. Christiansen, L. B. Kanter and C. B. Strehlke, *Painting in Renaissance Siena, 1420–1500*, exh. cat., Metropolitan Museum of Art, New York (New York, 1989), pp. 3–32, here p. 15.

19 Hyman, *Sienese Painting*, p. 167.

20 See Kenneth Clark, *Piero della Francesca* (London, 1951), p. 8.

21 Carlo Ginzburg, *The Enigma of Piero* (London, 1985), p. 126.

22 Jeryldene M. Wood, ed., *The Cambridge Companion to Piero della Francesca* (Cambridge, 2002), p. 3.

Chapter 16: The Ordering of Vision

1 Giorgio Vasari, *Lives of the Artists*, vol. 1, trans. George Bull (London, 1965), pp. 141–60.

2 Richard Krautheimer, *Lorenzo Ghiberti* (Princeton, NJ, 1970), pp. 31–43.

3 Antonio di Tuccio Manetti, *The Life of Brunelleschi*, trans. C. Engass (London, 1970), pp. 50–54.

4 Hans Belting, *Florence and Baghdad, Renaissance Art and Arab Science*, trans. Deborah Lucas Schneider (Cambridge, MA, and London, 2011), pp. 26–35.

5 Francis Ames-Lewis, 'Donatello's bronze *David* and the Palazzo Medici courtyard', *Renaissance Studies*, no. 3, September 1989, pp. 235–51.

6 Anthony Blunt, *Artistic Theory in Italy, 1450–1600* (Oxford, 1962), p. 22.

7 Leon Battista Alberti, *On Painting*, trans. C. Grayson (London, 1991), p. 35.

8 Kenneth Clark, 'Leon Battista Alberti on Painting', Annual Italian lecture of the British Academy (1944), in *Proceedings of the British Academy*, vol. XXX (London, 1945), pp. 185–200.

9 Alberti, *On Painting*, p. 155.

10 See Michael Vickers, 'Some preparatory drawings for Pisanello's medallion of John VIII Palaeologus', *The Art Bulletin*, vol. 60, no. 3, September 1978, pp. 417–24.

11 See John Pope-Hennessy, *Paolo Uccello* (London and New York, 1950).

12 Vasari, *Lives of the Artists*, vol. 1, trans. Bull, p. 95.

13 R. Weiss, *The Spread of Italian Humanism* (London, 1964).

14 See Kenneth Clark, 'Andrea Mantegna', *Journal of the Royal Society of Arts*, no. 5025, August 1958, pp. 663–80, here p. 666.

15 Caroline Campbell et al., *Mantegna and Bellini*, exh. cat., National Gallery, London (London, 2018).

16 Bernard Berenson, *Italian Painters of the Renaissance* (New York, 1952), p. 8.

Chapter 17: Spectacular Small Things

1 Ashok Roy, 'Van Eyck's technique: the myth and the reality, I', in Susan Foister, Sue Jones and Delphine Cool, eds, *Investigating Jan Van Eyck* (Brepols, 2000), pp. 97–100.

2 Philippe Lorentz, '*The Virgin and Chancellor Rolin* and the office of Matins', in Foister, Jones and Cool, eds, *Investigating Jan Van Eyck*, pp. 49–58.

3 James Snyder, 'Jan van Eyck and the Madonna of Chancellor Nicolas Rolin', *Oud Holland*, vol. 82, no. 4, 1967, pp. 163–71.

4 E. Panofsky, *Early Netherlandish Painting: Its Origins and Character*, vol. 1 (Cambridge, MA, 1953), p. 180.

5 Jan Dumolyn and Frederik Buylaert, 'Van Eyck's world: court culture, luxury production, elite patronage and social distinction within an urban network', in Maximiliaan Martens, Till-Holger Borchert, Jan Dumolyn, Johan De Smet and Frederica Van Dam, eds, *Van Eyck: An Optical Revolution*, exh. cat., Museum voor Schone Kunsten, Ghent (Ghent, 2020), pp. 85–121, here p. 93.

6 Maximiliaan Martens, 'Jan van Eyck's optical revolution', in Martens, Borchert, Dumolyn, De Smet and Van Dam, eds, *Van Eyck: An Optical Revolution*, pp. 141–80, here p. 176.

7 Catherine Reynolds, 'The early Renaissance in the north', in D. Hooker, ed., *Art of the Western World* (London, 1989), pp. 146–73, here p. 148.

8 Matthias Depoorter, 'Jan van Eyck's discovery of nature', in Martens, Borchert, Dumolyn, De Smet and Van Dam, eds, *Van Eyck: An Optical Revolution*, pp. 205–35, here p. 230.

9 Panofsky, *Early Netherlandish Painting*, vol. 1, p. 258; Jan van der Stock, 'De Rugerio pictore: of Rogier the painter', in Lorne Campbell and Jan Van der Stock, eds, *Rogier van der Weyden, 1400–1464: Master of Passions*, exh. cat., Museum Leuven (Leuven, 2009), pp. 14–23, here p. 17.

10 Moshe Barasch, 'The crying face', *Artibus et Historiae*, vol. 8, no. 15, 1987, pp. 21–36.

11 See Lorne Campbell, 'The new pictorial language of Rogier van der Weyden', in Campbell and Van der Storck, eds, *Rogier van der Weyden*, pp. 32–61.

12 Panofsky, *Early Netherlandish Painting* vol. 1, p. 316.

13 Lorne Campbell, *The Fifteenth Century Netherlandish Schools*, National Gallery Catalogues (London, 1998), pp. 46–51, here p. 50.

14 See J. M. Upton, *Petrus Christus: His Place in Fifteenth-Century Flemish Painting* (University Park, PA, 1990), pp. 29–30.

15 Paula Nuttall, *From Flanders to Florence: The Impact of Netherlandish Painting, 1400–1500* (New Haven, CT, and London, 2004), p. 61.

16 Panofsky, *Early Netherlandish Painting*, vol. 1, pp. 331–6; Robert M. Walker, 'The demon of the Portinari altarpiece', *Art Bulletin*, XLII, 1960, pp. 218–19.

17 'Miserrimi quippe est ingenij semper uti inventis et numquam inveniendis', in Matthijs Ilsink et al., *Hieronymus Bosch: Painter and Draughtsman* (New Haven, CT, and London, 2016), p. 498.

18 Joseph Leo Koerner, *Bosch & Bruegel: From Enemy Painting to Everyday Life* (Princeton, NJ, and Oxford, 2016), p. 185.

19 Ilsink et al., *Hieronymus Bosch: Painter and Draughtsman*, p. 369.

20 Phylis W. Lehmann, *Cyriacus of Ancona's Egyptian Visit and its Reflections in Gentile Bellini and Hieronymus Bosch* (New York, 1977), p. 17.

21 D. Landau and P. Parshall, *The Renaissance Print, 1470–1550* (New Haven, CT, and London, 1994).

22 Giulia Bartrum, *German Renaissance Prints, 1490–1550* (London, 1995), p. 20.

23 The comparison is made in W. S. Gibson, 'The *Garden of Earthly Delights* by Hieronymus Bosch: the iconography of the central panel', *Netherlands Yearbook for History of Art*, vol. 24, 1973, pp. 1–26, here p. 20.

24 'Und will aus Maß, Zahl und Gewicht mein Fürnehmen anfohen', in K. Lange and F. Fuhse, *Dürers Schriftlicher Nachlass* (Halle, 1893), p. 316.

25 Bridget Heal, *A Magnificent Faith: Art and Identity in Lutheran Germany* (Oxford, 2017), pp. 19–20.

26 Translation from ibid., p. 20.

27 Alice Hoppe-Harnoncourt, Elke Oberthaler and Sabine Pénot, eds, *Bruegel: The Master*, exh. cat., Kunsthistorisches Museum, Vienna (Vienna, 2018), pp. 214–41.

28 Iain Buchanan, 'The collection of Niclaes Jongelinck: II, *The Months* by Pieter Bruegel the Elder', *The Burlington Magazine*, vol. 132, no. 1049, August 1990, pp. 541–50, here p. 545.

29 Ford Madox Hueffer, *Hans Holbein the Younger* (London, 1905), p. 11.

30 Jeanne Neuchterlein, *Translating Nature into Art: Holbein, the Reformation, and Renaissance Rhetoric* (Philadelphia, PA, 2011), pp. 199–202.

Chapter 18: Bronze Kings

1 Tom Phillips, ed., *Africa: The Art of a Continent*, exh. cat., Royal Academy, London (London, 1996), pp. 181–2.

2 Patricia Vinnicombe, *People of the Eland* (Pietermaritzburg, 1976).

3 Mette Bovin, *Nomads Who Cultivate Beauty* (Uppsala, 2001); T. Russell, 'Through the skin: exploring pastoralist marks and their meanings to understand parts of East African rock art', *Journal of Social Archaeology*, vol. 13, no. 1, 2012, pp. 3–30.

4 Thurston Shaw, *Unearthing Igbo-Ukwu: Archaeological Discoveries in Eastern Nigeria* (Ibadan, 1977).

5 Peter Garlake, *Early Art and Architecture of Africa* (Oxford, 2002), pp. 117–20.

6 Rowland Abiodun, 'Understanding Yoruba art and aesthetics: the concept of *ase*', *African Arts*, vol. 27, no. 3, 1994, pp. 68–78.

7 Ulli Beier, *Yoruba Poetry: An Anthology of Traditional Poems* (Cambridge, 1970), p. 39.

8 The city and palace were destroyed, and the brass sculptures looted by the British, in 1897, in a 'punitive expedition' in response to the killing of several British officials by Benin warriors. Brass plaques and sculptures were brought back to Europe, many of which are now kept at the British Museum. David Olusoga, *First Contact: The Cult of Progress* (London, 2018).

9 Olfert Dapper, *Description de l'Afrique* (Amsterdam, 1686), pp. 308–13. This section is translated and cited in Paula Ben-Amos, *The Art of Benin* (London, 1995), p. 32.

10 Paula Ben-Amos, 'Men and animals in Benin art', *Man*, vol. 11, no. 2, June 1976, pp. 243–52.

11 Ben-Amos, *The Art of Benin*, p. 23.

12 Walter E. A. van Beek, 'Functions of sculpture in Dogon religion', *African Arts*, vol. 21, no. 4, August 1988, pp. 58–65, here pp. 59–60.

13 Dunja Hersak, 'On the concept of prototype in Songye masquerades', *African Arts*, vol. 45, no. 2, Summer 2012, pp. 12–23, here p. 14.

14 P. S. Garlake, *Great Zimbabwe* (London, 1973).

15 Webber Ndoro, 'Great Zimbabwe', *Scientific American*, vol. 277, no. 5, November 1997, pp. 94–9.

16 Thomas N. Huffman, 'The soapstone birds of Great Zimbabwe', *African Arts*, vol. 18, no. 3, May 1985, pp. 68–100.

Chapter 19: Some Kind of Genius

1 Martin Kemp, *Leonardo da Vinci: The Marvellous Works of Nature and Man* (London, 1981), p. 42.

2 Jean Paul Richter, ed., *The Literary Works of Leonardo da Vinci*, 2 vols (London, 1970), vol. 1, p. 367, no. 653 from the drafts for a 'Treatise on Painting' (MS c.1492).

3 Kenneth Clark, *Leonardo da Vinci* (London, 1939), p. 152.

4 J. W. Goethe, *Observations on Leonardo da Vinci's celebrated picture of the Last Supper*, trans. G. H. Noehden (London, 1821), pp. 7–8.

5 See Kemp, *Leonardo da Vinci*, p. 201.

6 Carlo Pedretti, 'Newly discovered evidence of Leonardo's association with Bramante', *Journal of the Society of Architectural Historians*, vol. 32, no. 3, October 1973, pp. 223–7, here p. 224.

7 Jack Freiberg, *Bramante's Tempietto, the Roman Renaissance, and the Spanish Crown* (Cambridge, 2014), pp. 92–101.

8 John-Pope Hennessy, *Raphael* (London, 1970), p. 184.

9 E. H. Gombrich, 'Raphael's *Stanza della Segnatura* and the nature of its symbolism', in *Symbolic Images: Studies in the Art of the Renaissance* (London, 1972), pp. 85–101. See also Roger Jones and Nicholas Penny, *Raphael* (New Haven, CT, and London, 1983), pp. 48–80.

10 Vasari, *The Lives of the Painters, Sculptors and Architects*, vol. 4, p. 110.

11 John Addington Symonds, *The Life of Michelangelo Buonarroti* (London, 1899), p. 98.

12 James Hall, *Michelangelo and the Reinvention of the Human Body* (London, 2005), pp. 37–62.

13 James S. Ackerman, *The Architecture of Michelangelo* (London, 1961), pp. 97–122.

14 Catherine King, 'Looking a sight: sixteenth-century portraits of women artists', *Zeitschrift für Kunstgeschichte*, 58, 1995, pp. 381–406, here p. 406.

15 Esin Atil, *The Age of Sultan Süleyman the Magnificent*, exh. cat., National Gallery, Washington, DC (Washington, DC, 1987).

16 Michael Levey, *The World of Ottoman Art* (London, 1975), p. 67.

17 Gülru Necipoğlu, *The Age of Sinan: Architectural Culture in the Ottoman Empire* (London, 2005), pp. 207–22.

18 Levey, *The World of Ottoman Art*, p. 80.

19 Suraiya Faroqhi, 'Cultural exchanges between the Ottoman world and Latinate Europe', in R. Born, M. Dziewulski and G. Messling, *The Sultan's World: The Ottoman Orient in Renaissance Art*, exh. cat., Centre for Fine Arts, Brussels (Ostfildern, 2015), pp. 29–35, here p. 29.

20 Bernhard Berenson, *The Italian Painters of the Renaissance* (Oxford and London, 1932). Also Peter Humfrey, *Titian: The Complete Paintings* (Ghent, 2007).

21 Philostratus the Elder, *Imagines*, I, 6; Humfrey, *Titian*, p. 102.

22 Ovid, *Ars amatoria*, I.

23 Catullus, *Poems*, LXIV.

24 Philostratus the Elder, Imagines, I. See also Paul Hills, *Venetian Colour: Marble, Mosaic, Painting and Glass, 1250–1550* (New Haven, CT, and London, 1999).

25 Deborah Howard, *Venice and the East: The Impact of the Islamic World on Venetian Architecture, 1100–1500* (New Haven, CT, and London, 2000).

26 Andrea Palladio, *The Four Books on Architecture*, trans. R. Tavernor and R. Schofield (Cambridge, MA, and London, 1997), p. 5.

27 James S. Ackerman, *Palladio* (London, 1966), p. 39.

28 Rudolf Wittkower, *Architectural Principles in the Age of Humanism* (New York, 1962), p. 93. See also Howard Burns, Lynda Fairbairn and Bruce Boucher, *Andrea Palladio 1508: The Portico and the Farmyard* (London, 1975).

29 *The Autobiography of Benvenuto Cellini*, trans. Anne MacDonnell (London, 2010), pp. 355–62.

30 John Pope-Hennessy, *Cellini* (London, 1985), p. 185.

31 Yael Even, 'The Loggia dei Lanzi: a showcase of female subjugation', *Women's Art Journal*, vol. 12, no. 1, Spring–Summer 1991, pp. 10–14.

32 Charles Avery, *Giambologna: The Complete Sculpture* (Oxford, 1987), p. 109.

33 Ilya Sandra Perlingieri, *Sofonisba Anguissola: The First Great Woman Artist of the Renaissance* (New York, 1992).

Chapter 20: Shadows and Power

1 Judith W. Mann, 'Artemisia and Orazio Gentileschi', in K. Christiansen and Judith W. Mann, *Orazio and Artemisia Gentileschi*, exh. cat., Metropolitan Museum of Art, New York (New York, 2001), pp. 248–61, here pp. 255–6.

2 Keith Christiansen, 'Becoming Gentileschi: afterthoughts on the Gentileschi exhibition', *Metropolitan Museum Journal*, vol. 39, 2004, pp. 10, 101–26, here pp. 106–7.

3 Anthony Blunt, *Artistic Theory in Italy, 1450–1600* (Oxford, 1956).

4 Letizia Treves, *Beyond Caravaggio*, exh. cat., National Gallery, London (London, 2016), pp. 66–9.

5 Kenneth Clark, *The Nude: A Study in Ideal Form* (New York, 1956), p. 148.

6 Heinrich Wölfflin, *Renaissance and Baroque*, trans. Kathrin Simon (New York 1961), p. 85.

7 Jacob Burckhardt, *Recollections of Rubens* (London, 1950), pp. 42–4.

8 See Per Rumberg, 'Van Dyck, Titian and Charles I', in *Charles I: King and Collector*, exh. cat., Royal Academy, London (London, 2018), pp. 150–55.

9 Gregory Martin, *Corpus Rubenianum Ludwig Burchard: XV: The Ceiling Decoration of the Banqueting Hall*, 2 vols (London and Turnhout, 2005).

10 Anthony Blunt, *Nicolas Poussin*, The A. W. Mellon Lecture in the Fine Arts 1958 (New York, 1967), vol. 1, p. 102.

11 Francis Haskell and Jennifer Montagu, eds, *The Paper Museum of Cassiano dal Pozzo: Catalogue Raisonné of Drawings and Prints in the Royal Library at Windsor Castle, the British Museum, Institut de France and Other Collections* (London, 1994– [ongoing]).

12 Elizabeth Cropper and Charles Dempsey, *Nicolas Poussin: Friendship and the Love of Painting* (Princeton, NJ, 1996), p. 110.

13 See Malcolm Bull, *The Mirror of the Gods* (Oxford, 2005), pp. 258–61.

14 Walter Friedlander, *Caravaggio Studies* (New York, 1969), p. 60.

15 E. A. Peers, trans. and ed., *Saint Teresa of Jesus: The Complete Works*, 3 vols (London and New York, 1963), vol. 1, p. 192.

16 Irving Lavin, *Bernini and the Unity of the Visual Arts*, 2 vols (London and New York, 1980), here vol. 1, p. 106.

17 Ibid.

18 Anthony Blunt, 'Lorenzo Bernini: illusionism and mysticism', *Art History*, vol. 1, no. 1, March 1978, pp. 67–89.

19 Lavin, *Bernini and the Unity of the Visual Arts*, vol. 1, pp. 146–57.

Chapter 21: An Open Window

1 Max Friedländer, *Landscape-Portrait-Still-Life* (New York, 1963), p. 92.

2 Karel van Mander and Hessel Miedema, eds, *The Lives of the Illustrious Netherlandish and German Painters, from the First Edition of the Schilder-boeck (1603–04)* (Doornspijk, 1994–9), vol. 1, p. 190.

3 Cited in Svetlana Alpers, *The Art of Describing: Dutch Art in the Seventeenth Century* (London, 1983), p. 38. Alpers cites Alistair C. Crombie, 'Kepler: De modo visionis: a translation from the Latin of Ad Vitellionem Paralipomena, V, 2, and related passages on the formation of the retinal image', *Mélanges Alexander Koyré*, vol. 1 (Paris, 1964), pp. 135–72.

4 Thijs Weststeijn, 'The Middle Kingdom in the Low Countries: Sinology in the seventeenth-century Netherlands', in Rens Bod, Jaap Maat and Thijs Weststeijn, eds, *The Making of the Humanities*, vol. II, *From Early Modern to Modern Disciplines* (Amsterdam, 2012).

5 Karina H. Corrigan, Jan Van Campen and Femke Diercks, eds, *Asia in Amsterdam: The Culture of Luxury in the Golden Age*, exh. cat., Peabody Essex Museum, Salem (New Haven, CT, and London, 2016), p. 16.

6 Michael North, *Art and Commerce in the Dutch Golden Age*, trans. Catherine Hill (New Haven, CT, and London, 1997).

7 James A. Welu and Pieter Biesboer, *Judith Leyster: A Dutch Master and Her World,* exh. cat., Worcester Art Museum (New Haven, CT, 1993), p. 162.

8 Christopher White and Quentin Buvelot, *Rembrandt by Himself*, exh. cat., National Gallery, London (London, 1999), pp. 220–22.

9 H. Perry Chapman, *Rembrandt's Self-Portraits: A Study in Seventeenth-Century Identity* (Princeton, NJ, 1990), p. 100.

10 Joachim von Sandrart, *Lives of Rembrandt, Baldinucci and Houbraken* (London, 2007).

11 Sam Segal, A *Prosperous Past: The Sumptuous Still Life in the Netherlands, 1600–1700* (The Hague, 1988), p. 180.

12 Lawrence Gowing, *Vermeer* (London, 1952), p. 22.

13 E. L. Sluijter, 'Vermeer, fame and female beauty: *The Art of Painting*', in *Vermeer Studies: Studies in the History of Art*, vol. 33 (Washington DC, 1998), pp. 264–83.

14 Simon Schama, *The Embarrassment of Riches: An Interpretation of Dutch Culture in the Golden Age* (New York, 1987), p. 522.

15 Adriaan E. Waiboer, *Gabriel Metsu: Life and Work. A Catalogue Raisonné* (New Haven, CT, and London, 2012), pp. 129–31.

16 Stephanie Schrader, ed., *Rembrandt and the Inspiration of India*, exh. cat., J. Paul Getty Museum, Los Angeles (Los Angeles, CA, 2018).

17 Ellen Smart, 'The death of Ināyat Khān by the Mughal artist Bālchand', *Artibus Asiae*, vol. 58, no. 3/4, 1999, pp. 273–9.

18 Wheeler M. Thackston, ed., *The Jahangirnama: Memoirs of Jahangir, Emperor of India* (Washington, DC, 1999), pp. 279–81.

Chapter 22: Choosing to be Human

1 Ju-his Chou and Claudia Brown, *The Elegant Brush: Chinese Painting under the Qianlong Emperor, 1735–1795*, exh. cat., Phoenix Art Museum (Phoenix, AZ, 1985), p. 2.

2 'One or two? / My two faces never come together yet are never separate. / One can be Confucian, one can be Mohist. / Why should I worry or even think?' Translation by Wu Hung, cited by Kristina Kleutghen in 'One or two, repictured', *Archives of Asian Art*, vol. 62, 2012, pp. 25–46, here p. 33.

3 Michael Sullivan, *The Meeting of Eastern and Western Art from the Sixteenth Century to the Present Day* (London, 1973), p. 68.

4 Cheng-hua Wang, 'A global perspective on eighteenth-century Chinese art and visual culture', *The Art Bulletin*, vol. 96, no. 4, December 2014, pp. 379–94.

5 R. C. Bald, 'Sir William Chambers and the Chinese garden', *Journal of the History of Ideas*, vol. 11, no. 3, June 1950, pp. 287–320; David Jacques, 'On the supposed Chineseness of the English landscape garden', *Garden History*, vol. 18, no. 2, Autumn 1990, pp. 180–91.

6 Pausanias, *Description of Greece*, 3, XXIII.

7 Thomas Crow, *Painters and Public Life in Eighteenth-Century Paris* (New Haven, CT, and London, 1985), p. 56.

8 Perrin Stein, 'Boucher's chinoiseries: some new sources', *The Burlington Magazine*, vol. 138, no. 1122, September 1996, pp. 598–604; Nicolas Surlapierre, Yohan Rimaud, Alastair Laing and Lisa Mucciarelli, eds, *La Chine rêvée de François Boucher: une des provinces du rococo* (Paris, 2019).

9 Norman Bryson, *Looking at the Overlooked: Four Essays on Still Life Painting* (London, 1990), pp. 91–5.

10 Ellis K. Waterhouse, 'English painting and France in the eighteenth century', *Journal of the Warburg and Courtauld Institutes*, vol. 15, no. 3/4, 1952, pp. 122–35.

11 Judy Egerton, *Hogarth's Marriage A-la-Mode*, exh. cat., National Gallery, London (London, 1997).

12 Robert L. S. Cowley, *Marriage A-la-Mode: A Re-View of Hogarth's Narrative Art* (Manchester, 1989), p. 58.

13 Jenny Uglow, *Hogarth: A Life and a World* (London, 1997), pp. 387–8.

14 Waterhouse, 'English painting and France in the eighteenth century', p. 129.

15 John Hayes, *The Landscape Paintings of Thomas Gainsborough*, vol. 1 (London, 1982), p. 45.

16 John Hayes, *Gainsborough: Paintings and Drawings* (London, 1975), p. 213.

17 Joshua Reynolds, 'Discourse XIV', in *Discourses on Art*, ed. Robert R. Wark (New Haven and London, 1975), pp. 247–61, here p. 250.

18 Frederic G. Stephens, *English Children as Painted by Sir Joshua Reynolds* (London, 1867), p. 32.

19 Joseph Baillio and Xavier Salmon, *Élisabeth Louise Vigée Le Brun*, exh. cat., Grand Palais, Paris (Paris, 2016), p. 194.

20 Plato, Phaedo, 68, a. This translation from *The Last Days of Socrates*, trans. Hugh Tredennick (Harmondsworth, 1969), p. 113.

21 Anita Brookner, *Jacques-Louis David* (London, 1980), pp. 85–6.

22 H. H. Arnason, *The Sculptures of Houdon* (London, 1975), p. 76.

23 H. Honour and J. Fleming, *A World History of Art* (London, 1982), p. 477.

24 A. Canellas López., ed., *Francisco de Goya, diplomatario* (Zaragoza, 1981), pp. 516–19, here p. 518.

Chapter 23: The Poetic Impulse

1 Friedrich Schlegel, *Athenaeum Fragment*, no. 116, in Friedrich Schlegel, 'Lucinde' and the Fragments, trans. Peter Firchow (Minneapolis, MN, 1971), pp. 175–6.

2 Cited in Lawrence Gowing, *Turner: Imagination and Reality*, exh. cat., Museum of Modern Art, New York (New York, 1966), p. 48.

3 Ibid., p. 13.

4　William Wordsworth, *The Prelude: A Parallel Text*, ed. J. C. Maxwell (Harmondsworth, 1971), p. 56.

5　Translation in Johannes Grave, *Caspar David Friedrich*, trans. Fiona Elliott (Munich, 2017), p. 151.

6　Ibid., p. 157.

7　Hermann Beenken, 'Caspar David Friedrich', *The Burlington Magazine*, vol. 72, no. 421, April 1938, pp. 170–73, 175, here p. 172.

8　Novalis, *Heinrich von Ofterdingen* ([1800] Leipzig, 1876). Cited in Richard Littlejohns, 'Philipp Otto Runge's "Tageszeiten" and their relationship to romantic nature philosophy', *Studies in Romanticism*, vol. 42, no. 1, Spring 2003, pp. 55–74.

9　Peter Ackroyd, *Blake* (London, 1995), p. 119.

10　Martin Butlin, 'The physicality of William Blake: the large color prints of "1795"', *Huntington Library Quarterly*, vol. 52, no. 1, 1989, pp. 1–17.

11　William Vaughan, *Samuel Palmer: Shadows on the Wall* (New Haven, CT, and London, 2015), p. 110.

12　Geoffrey Grigson, *Samuel Palmer: The Visionary Years* (London, 1947), p. 33.

13　Samuel Palmer, letter to John Linnell, 21 December 1828. Cited in Grigson, *Samuel Palmer: The Visionary Years*, pp. 83–6, here p. 85.

14　'Can it be that the moon has changed? / Can it be that the spring / Is not the spring of old times? / Is it my body alone / That is just the same?' Ariwara Narihira, extract from 'Ise Monogatari'. From *The Penguin Book of Japanese Verse*, trans. Geoffrey Bownas and Anthony Thwaite (London, 1964), p. 67.

15　D. B. Waterhouse, *Harunobu and His Age: The Development of Colour Printing in Japan* (London, 1964), p. 23.

16　Minne Tanaka, 'Colour printing in the west and the east: William Blake and ukiyo-e', in Steve Clark and Masashi Suzuki, eds, *The Reception of Blake in the Orient* (London and New York, 2006), pp. 77–86.

17　Deborah A. Goldberg 'Reflections of the floating world', *The Print Collector's Newsletter*, vol. 21, no. 4, September–October 1990, pp. 132–5.

18　Amy G. Poster and Henry D. Smith, *Hiroshige: One Hundred Famous Views of Edo* (London 1986), p. 10.

19　Lorenz Eitner, *Géricault's 'Raft of the Medusa'* (London, 1972).

20　Entry for 5 March 1857. *The Journal of Eugène Delacroix*, trans. Walter Pach (New York, 1948), p. 575.

21　Georges Vigne, *Ingres*, trans. John Goodman (New York, 1995), pp. 68–70.

22　Charles Rosen and Henri Zerner, 'The *Juste Milieu* and Thomas Couture', in Charles Rosen and Henri Zerner, eds, *Romanticism and Realism: The Mythology of Nineteenth-Century Art* (London, 1984), pp. 117–18.

23　Cited in Willibald Sauerländer, 'The continual homecoming', *New York Review of Books*, vol. LIX, no. 19, 6 December 2012, pp. 37–8.

24　Kevin J. Avery, *Church's Great Picture 'The Heart of the Andes'*, exh. cat., Metropolitan Museum, New York (New York, 1993).

25　Ibid., p. 31.

26　Gloria A. Young, 'Aesthetic archives: the visual language of Plains ledger art', in Edwin L. Wade, ed., *The Arts of the North American Indian: Native Traditions in Evolution* (New York, 1986), pp. 45–62.

27　Gaylord Torrence, ed., *The Plains Indians: Artists of Earth and Sky*, exh. cat., Metropolitan Museum of Art, New York (New York, 2015), p. 83.

Chapter 24: Everyday Revolutions

1　Larry J. Schaaf, *Sun Gardens: Victorian Photograms by Anna Atkins* (New York, 1985).

2　Julian Cox, '"To ... startle the eye with wonder & delight": the photographs of Julia Margaret Cameron', in Julian Cox and Colin Ford, eds, *Julia Margaret Cameron: The Complete Photographs* (London, 2003), pp. 41–79, here p. 42.

3　Théophile Thoré, 'Nouvelles tendances de l'art', in *Salons der Th. Thoré, 1844–48* (Paris, 1868).

4　Meyer Schapiro, 'Courbet and popular imagery: an essay on realism and naïveté', in *Journal of the Warburg and Courtauld Institutes*, vol. 4, no. 3/4 (April 1941–July 1942), pp. 164–91, here p. 168.

5　T. J. Clark, *Image of the People: Gustave Courbet and the 1848 Revolution* (London, 1973).

6　C. R. Leslie, *Memoirs of the Life of John Constable: Composed Chiefly of His Letters* (London, 1845), p. 15.

7　Ibid., p. 93.

8　Ibid., p. 93.

9　Alexis de Tocqueville, *Journeys to England and Ireland*, trans. G. Lawrence and K. P. Mayer (London, 1958), p. 67.

10　Octavio Paz, 'I, a painter, an Indian from this village ...', in *Essays on Mexican Art*, trans. Helen Lane (New York, 1993), p. 85–110, here p. 89. See also Raquel Tibol, *Hermenegildo Bustos, pintor del pueblo* (Guanajuato, 1981).

11　Gabriel P. Weisberg, *The Realist Tradition: French Painting and Drawing, 1830–1900*, exh. cat., Cleveland, Museum of Art, 1980, pp. 82–6.

12　Cited in Kenneth Clark, *Drawings by Jean-François Millet*, exh. cat., Arts Council, London (London, 1956), p. 53.

13　J.-K. Huysmans, *Oeuvres complètes de J. K. Huysmans* (Paris, 1928), pp. 140–42. Cited in Weisberg, *The Realist Tradition*, p. 4.

14　Cited in W. Busch, *Adolph Menzel: Leben und Werk* (Munich, 2004); English translation in Carola Kleinstück-Schulman, *Adolf Menzel: The Quest for Reality* (Los Angeles, CA, 2017), p. 235.

15　From Menzel's own description of the painting, cited in Claude Keisch and Marie Ursula Riemann-Reyher, eds, *Adolph Menzel 1815–1905: Between Romanticism and Impressionism*, exh. cat., National Gallery, Washington, DC (Washington, DC, 1996), p. 385.

16　Ibid., p. 13.

17　Alan Bowness, *Poetry and Painting: Baudelaire, Mallarmé, Apollinaire and Their Painter Friends* (Oxford, 1994), p. 7.

18　Charles Baudelaire, 'The painter of modern life', in *The Painter of Modern Life and other Essays*, trans. Jonathan Mayne (London, 1964), p. 4.

19　Wolfgang Schivelbusch, *Disenchanted Night: The Industrialisation of Light in the Nineteenth Century*, trans. Angela Davies (Berkeley and Los Angeles, CA, 1988), p. 56.

20　Stéphane Mallarmé, 'The Impressionists and Édouard Manet', *The Art Monthly Review and Photographic Portfolio*, 30 September 1876.

21 Monet to Bazille, September 1868. Cited in John Rewald, *The History of Impressionism* (New York, 1946), p. 164.

22 Frederick Wedmore, 'Pictures in Paris – the exhibition of "Les Impressionistes"', *The Examiner*, 13 June 1874, pp. 633–4. Repr. in Ed Lilley, 'A rediscovered English review of the 1874 Impressionist exhibition', *The Burlington Magazine*, vol. 154, no. 1317, December 2012, pp. 843–5.

23 George Moore, *Impressions and Opinions* (London, 1891), p. 308.

24 Richard Kendall and Jill DeVonyar, *Degas and the Ballet: Picturing Movement*, exh. cat., Royal Academy, London (London, 2011), p. 22; Lillian Browse, *Degas Dancers* (London, 1949), p. 54.

25 J.-K. Huysmans, 'Exhibition of the Independents in 1880', trans. Brendan King, in J.-K. Huysmans, *Modern Art (L'Art moderne)* (Sawtry, 2019), pp. 99–132, here p. 123.

26 Cited in Kathleen Adler, *Mary Cassatt: Prints*, exh. cat., National Gallery, London (London, 2006), p. 9. For a description of her method see George Shackelford, 'Pas de deux: Mary Cassatt and Edgar Degas', in Judith A. Barter, *Mary Cassatt: Modern Woman*, exh. cat., The Art Institute of Chicago (Chicago, IL, 1998), pp. 109–43, here p. 132.

27 Rewald, *Impressionism*, pp. 401–2.

28 George Moore, *Impressions and Opinions* (London, 1891), p. 313.

Chapter 25: Mountains and Oceans

1 John Ruskin, *Modern Painters*, vol. IV, *Of Mountain Beauty* (London, 1856), p. 92. 'And thus those desolate and threatening ranges of dark mountain, which, in nearly all ages of the world, men have looked upon with aversion or with terror, and shrunk back from as if they were haunted by perpetual images of death, are, in reality, source of life and happiness far fuller and more beneficient than all the bright fruitfulnesses of the plain' (p. 100).

2 Hidemichi Tanaka, 'Cézanne and "Japonisme"', *Artibus et Historiae*, vol. 22, no. 44, 2001, pp. 201–20, here p. 209.

3 Theodore Reff, 'Cézanne and Poussin', *Journal of the Warburg and Courtauld Institutes*, vol. 23, no. 1/2, January–June 1960, pp. 150–74.

4 Alex Danchev, *The Letters of Paul Cézanne* (London, 2013), p. 334.

5 Cited in Maurice Denis and Roger Fry, 'Cézanne – I', *The Burlington Magazine*, vol. 16, no. 82, January 1910, pp. 207–19.

6 'Une oeuvre d'art est un coin de la création vu à travers un tempérament', in Émile Zola, *Mes haines: causeries littéraires et artistiques* (Paris, 1879), p. 307.

7 '[U]n toit qui fût hardiment rouge, une muraille qui fût blanche, un peuplier vert, une route jaune et de l'eau bleue. Avant le Japon, c'était impossible, le peintre mentait toujours.' Théodore Duret, *Histoire des peintres impressionnistes: Pissarro, Claude Monet, Sisley, Renoir, Berthe Morisot, Cézanne, Guillaumin* ([1874] Paris, 1922), p. 176.

8 Vincent Van Gogh to Paul Gauguin, 3 October 1888, in Leo Jansen, Hans Luijten and Nienke Bakker, *Vincent Van Gogh: The Letters; The Complete Illustrated and Annotated Edition* (London and New York, 2009), vol. 4, pp. 304–5.

9 Vincent Van Gogh to Theo Van Gogh, c.28 June 1888, in *Complete Letters of Vincent Van Gogh*, vol. 2 (London, 1978), p. 597.

10 Judy Sund, 'The sower and the sheaf: biblical metaphor in the art of Vincent van Gogh', *The Art Bulletin*, vol. 70, no. 4, December 1988, pp. 660–76, here p. 666.

11 Nienke Bakker and Louis van Tilborgh, *Van Gogh & Japan*, exh. cat., Van Gogh Museum, Amsterdam (New Haven, CT, 2018), pp. 26–7.

12 Paul Gauguin to Vincent Van Gogh, 26 September 1888.

13 Emile Bernard, *Souvenirs inédits sur l'artiste peintre Paul Gauguin et ses compagnons lors de leur séjour Pont-Aven et au Pouldu* (Paris, 1939), pp. 9–10; Mathew Herban III, 'The origin of Paul Gauguin's Vision after the Sermon: Jacob Wrestling with the Angel (1888)', *The Art Bulletin*, vol. 59, no. 3, September 1977, pp. 415–20.

14 Paul Gauguin to Émile Schuffenecker, August 1988. Cited in Rewald, *Impressionism*, p. 406.

15 Elizabeth C. Childs, *Vanishing Paradise: Art and Exoticism in Colonial Tahiti* (Berkeley, CA, 2013), p. 71.

16 Claire Frèches-Thory, 'The paintings of the first Polynesian sojourn', in George T. M. Shackleford and Claire Frèches-Thory, eds, *Gauguin Tahiti: The Studio of the South Seas*, exh. cat., Galeries Nationales du Grand Palais, Paris (Paris, 2004), pp. 17–45, here p. 24.

17 Alastair Wright, 'Paradise lost: Gauguin and the melancholy logic of reproduction', in Alastair Wright and Calvin Brown, *Paradise Remembered: The Noa Noa Prints*, exh. cat., Princeton University Art Museum (Princeton, NJ, 2010), pp. 49–99, here p. 56.

18 Eric Kjellgren and Carol S. Ivory, *Adorning the World: Art of the Marquesas Islands*, exh. cat., Metropolitan Museum of Art, New York (New Haven, CT, and London, 2005), p. 11.

19 Leah Caldeira, Christina Hellmich, Adrienne L. Kaeppler, Betty Lou Kam and Roger G. Rose, *Royal Hawaiian Featherwork: na hulu ali'i*, exh. cat., de Young Museum, San Francisco (Honolulu, HA, 2015), p. 26.

20 Christian Kaufmann, *Korewori: Magic Art from the Rainforest*, exh. cat., Museum der Kulturen, Basel (Honolulu, HA, 2003), p. 25.

21 Jean Moréas, 'Le symbolisme', *Le Figaro*, 18 September 1886.

22 Edmund Wilson, *Axel's Castle: A Study in the Imaginative Literature of 1870–1930* (New York, 1931), p. 17.

23 'La nature est un temple où de vivants piliers / Laissent parfois sortir de confuses paroles ...', in Charles Baudelaire, *Oeuvres complètes* (Paris, 1954), p. 87 [author's translation].

24 Sarah Whitfield, 'Fragments of an identical world', in Bonnard, exh. cat., Tate Gallery, London (London, 1998), pp. 9–31, here p. 11; also Nicholas Watkins, *Bonnard* (London, 1994), pp. 21–2.

25 Frances Carey and Anthony Griffiths, *From Manet to Toulouse-Lautrec: French Lithographs, 1860–1900*, exh. cat., British Museum, London (London, 1978), p. 13.

26 'Japonisme d'Art', *Le Figaro Illustré*, February 1893.

27 James Deans, 'Carved columns or totem poles of the Haidas', *The American Antiquarian*, vol. XIII, no. 5, September 1891, pp. 282–7, here p. 283.

28 James Deans, 'The moon symbol on the totem posts on the northwest coast', *The American Antiquarian*, vol. XIII, no. 6, November 1891, pp. 341–6, here p. 342.

29 David Attenborough, *The Tribal Eye* (London, 1976), p. 30.

30 T. A. Joyce, 'A totem pole in the British Museum', *The Journal of the Anthropological Institute of Great Britain and Ireland*, vol. 33, 1903, pp. 90–95.

31 Iris Müller-Westermann, *Hilma af Klint – A Pioneer of Abstraction*, exh. cat., Moderna Museet, Stockholm (Ostfildern, 2013), p. 37.

32 John Ruskin, *Modern Painters*, vol. IV, *Of Mountain Beauty*, p. 100.

Chapter 26: New World

1 Jack Flam, *Matisse: The Man and His Art, 1869–1914* (London, 1986), p. 283.

2 Henri Matisse, 'Notes of a painter, 1908', in Jack D. Flam, ed., *Matisse on Art* (New York, 1978), pp. 32–40, here p. 36.

3 Ibid., p. 38.

4 'Now, these artists do not seek to give what can, after all, be but a pale reflex of actual appearance, but to arouse the conviction of a new and definite reality. They do not seek to imitate form, but to create form, not to imitate life, but to find an equivalent for life.' Roger Fry, *Vision and Design London* (1923 [1920]), p. 239.

5 F. T. Marinetti, 'The founding and manifesto of futurism 1909', in Umbro Apollonio, ed., *Futurist Manifestos* (London, 1973), pp. 19–24.

6 John Milner, *Mondrian* (London, 1992), p. 67.

7 Piet Mondrian, 'The new plastic in painting (1917)', repr. in Harry Holtzman and Martin S. James, ed. and trans., *The New Art — The New Life: The Collected Writings of Piet Mondrian* (London, 1987), pp. 28–31.

8 Piet Mondrian, 'Plastic art and pure plastic art (1936)', repr. in Holtzman and James, ed. and trans., *The New Art — The New Life*, pp. 289–300.

9 Ibid., p. 292.

10 Viktor Shklovsky, 'Art as device, 1917', repr. in Alexandra Berlina, ed. and trans., *Viktor Shklovsky: A Reader* (London, 2017), pp. 73–96.

11 Kazimir Malevich, 'From Cubism and Futurism to Suprematism: the new painterly realism', in John E. Bowlt, *Russian Art of the Avant-Garde: Theory and Criticism, 1902–1934* (New York, 1976).

12 John Dos Passos, 'Paint the Revolution', in *New Masses*, March 1927, p.15.

13 Hayden Herrera, *Frida. A Biography of Frida Kahlo* (New York, 1983), p.62

14 Ibid., p.75

15 Wieland Herzfelde and Brigid Doherty, 'Introduction to the First International Dada Fair', *October*, Summer 2003, vol. 105, pp. 93–104, here p. 101.

16 Sigmund Freud, 'Creative writers and day-dreaming, 1908', in Freud, *Collected Papers*, vol. 4, ed. James Strachey (London, 1959), pp. 141–53.

17 Charles C. Eldredge, *Georgia O'Keeffe* (New York, 1991), pp. 82–3.

18 André Breton, 'Manifesto of Surrealism (1924)', in Breton, *Manifestoes of Surrealism*, trans. Richard Seaver and Helen R. Lane (Ann Arbor, MI, 1969), pp. 3–47, here p. 26.

19 Dawn Ades, *Dalí: The Centenary Retrospective*, exh. cat., Palazzo Grassi, Venice (London, 2005), p. 118.

20 Salvador Dalí, 'The Rotting Donkey', trans. in Dawn Ades, *Dalí: The Centenary Retrospective*, pp. 550–51; 'L'Âne pourri', in *La Femme visible* (Paris, 1930), pp. 11–20.

21 Paul Klee, *On Modern Art* (London, 1945), p. 51.

22 Reinhold Hohl, *Alberto Giacometti: Sculpture, Painting, Drawing* (London, 1972), p. 101.

23 James Weldon Johnson, 'Harlem: the culture capital', in Alain Locke, ed., *The New Negro: An Interpretation* (New York, 1925), pp. 301–11.

24 James A. Porter, *Modern Negro Art* (New York, 1943), p. 151.

25 Ibid., p. 151.

Chapter 27: After the Trauma

1 Martin Heidegger, 'The origin of the work of art', *Basic Writings: From "Being and Time" (1927) to "The Task of Thinking" (1964)*, rev. and ed. David Farrell Krell (London, 1993), pp. 143–65.

2 Jean-Paul Sartre, *Existentialism and Humanism*, trans. Philip Mairet (London, 1948), p. 49.

3 Barnett Newman, 'The first man was an artist', *The Tiger's Eye*, no. 1, October 1947; repr. in Barnett Newman, *Selected Writings and Interviews* (Berkeley, CA, 1990), pp. 156–60, here p. 160.

4 Harold Rosenberg, 'The American action painters', *ARTnews*, January 1952, pp. 22–3, 48–50.

5 Rosalind Krauss, *Terminal Iron Works: The Sculpture of David Smith* (Cambridge, MA, 1971).

6 Lygia Clark, 'The Bichos' (1960), trans. in Cornelia H. Butler and Luis Pérez-Oramas, eds, *Lygia Clark: The Abandonment of Art, 1948–88*, exh. cat., Museum of Modern Art, New York (New York, 2014), p. 160; 'Letter to Piet Mondrian, May 1959', trans. in Butler and Pérez-Oramas, eds, Lygia *Clark: The Abandonment of Art*, p. 59. See also Briony Fer, 'Lygia Clark and the problem of art', in Butler and Pérez-Oramas, eds, Lygia *Clark: The Abandonment of Art*, pp. 223–8.

7 Cited in Paul Moorhouse, *Interpreting Caro* (London, 2005), p. 12.

8 John-Paul Stonard, 'Pop in the age of boom: Richard Hamilton's *Just What Is It That Makes Today's Homes So Different, So Appealing?*', *The Burlington Magazine*, vol. CXLIX, no. 1254, September 2007, pp. 607–20.

9 Andy Warhol and Pat Hackett, *POPism: The Warhol Sixties* ([1980] London, 2007), p. 64.

10 Walter Benjamin, 'The work of art in the age of its technological reproducibility', in Benjamin, *The Work of Art in the Age of Its Technological Reproducibility and Other Writings on Media*, ed. Michael W. Jennings, Brigid Doherty and Thomas Y. Levin, trans. Edmund Jephcott, Rodney Livingstone, Howard Eiland et al. (Cambridge, MA, and London, 2008), pp. 19–55.

11 Julia F. Andrews, *Painters and Politics in the People's Republic of China, 1949–1979* (Berkeley, CA, 1994), p. 365.

12 Cited in ibid., p. 365.

13 Katy Siegel, 'Art, world, history', in Okwui Enwezor, Katy Siegel and Ulrich Wilmes, eds, *Postwar: Art between the Pacific and the Atlantic, 1945–1965*, exh. cat., Haus der Kunst, Munich (Munich, 2016), pp. 43–57, here p. 49.

14 James Baldwin, *The Fire Next Time* (London, 1963), p. 80.

15 'Extracts from a lecture by Ana Mendieta, delivered at Alfred State University, New York, September 1981', in Stephanie Rosenthal, ed., *Traces: Ana Mendieta*, exh. cat., Hayward Gallery, London (London, 2013), p. 208.

16 Armin Zweite, ed., *Beuys zu Ehren*, exh. cat., Städtische Galerie im Lehnbachhaus, Munich (Munich, 1986); Bruno Heimberg and Susanne Willisch, eds, *Joseph Beuys, Das Ende des 20. Jahrhunderts: Die Umsetzung vom Haus der Kunst in die Pinakothek der Moderne München / Joseph Beuys, The End of the 20th Century: The Move from the Haus der Kunst to the Pinakothek der Moderne Munich* (Munich, 2007).

17 Craig Owens, 'The Medusa effect or, the spectacular ruse', in Iwona Blazwick and Sandy Nairne, '*We Won't Play Nature to Your Culture': Barbara Kruger*, exh. cat., ICA, London (London, 1983), pp. 5–11, here p. 6.

18 Richard Shone, 'Rachel Whiteread's "House", London', *The Burlington Magazine*, no. 1089, December 1993, pp. 837–88.

Artists evoked here (in alphabetical order):

Marina Abramović, Francis Alÿs, El Anatsui, Frank Auerbach, Georg Baselitz, Louise Bourgeois, Glenn Brown, Cai Guo-Qiang, Patrick Caulfield, Vija Celmins, Jake and Dinos Chapman, George Condo, Michael Craig-Martin, Martin Creed, Dexter Dalwood, Jeremy Deller, Marlene Dumas, Olafur Eliasson, Tracey Emin, Gilbert & George, Douglas Gordon, David Hammons, Mona Hatoum, Damien Hirst, David Hockney, Howard Hodgkin, Ryoji Ikeda, Ilya Kabakov, Emma Kay, Anish Kapoor, Anselm Kiefer, Sirkka-Liisa Konttinen, Jeff Koons, Michael Landy, Sarah Lucas, Christian Marclay, Steve McQueen, Beatriz Milhazes, Bruce Nauman, Max Neuhaus, Otobong Nkanga, Cornelia Parker, Sigmar Polke, Bridget Riley, Pussy Riot, Dieter Roth, Doris Salcedo, Jenny Saville, Khadija Saye, Tino Sehgal, Richard Serra, Monika Sosnowska, Hiroshi Sugimoto, Wolfgang Tillmans, Lee Ufan, Kara Walker, Jeff Wall, Mark Wallinger, Gillian Wearing, Ai Weiwei, Christopher Wool.

Bibliography

1. Signs of Life

Ajoulat, Norbert, *The Splendours of Lascaux* (London, 2005)

Bahn, Paul G. and Jean Vertut, *Images of the Ice Age* (Leicester, 1988)

Chauvet, J. M., E. Brunel Deschamps and C. Hillaire, *Chauvet Cave: The Discovery of the World's Oldest Paintings* (London, 1996)

Cilia, D., ed., *Malta before History: The World's Oldest Freestanding Stone Architecture* (Malta, 2004)

Clottes, Jean, *Cave Art* (London, 2008)

Cook, Jill, *The Swimming Reindeer* (London, 2010)

—, *Ice Age Art: Arrival of the Modern Mind*, exh. cat., British Museum (London, 2013)

Grigson, Geoffrey, *Painted Caves* (London, 1957)

Hill, Rosemary, *Stonehenge* (London, 2008)

Kim, Byung-mo, ed., *Megalithic Cultures in Asia* (Seoul, 1982)

Lewis-Williams, David, *The Mind in the Cave: Consciousness and the Origins of Art* (London 2002)

McMahon, Gregory and Sharon R. Steadman, eds, *The Oxford Handbook of Ancient Anatolia* (Oxford, 2011)

Nelson, Sarah Milledge, *The Archaeology of Korea* (Cambridge, 1993)

Renfrew, Colin, *Prehistory: The Making of the Human Mind* (London, 2007)

— and Iain Morley, eds, *Image and Imagination: A Global Prehistory of Figurative Representation* (Cambridge, 2007)

Scarre, Chris, ed., *The Human Past: World Prehistory and the Development of Human Societies* (London, 2005)

Sieveking, Ann, *The Cave Artists* (London, 1979)

2. Eyes Wide Open

Aruz, Joan, ed., *Art of the First Cities: The Third Millennium B.C. from the Mediterranean to the Indus*, exh. cat., Metropolitan Museum of Art, New York (New York, 2003)

Collins, Paul, *Assyrian Palace Sculptures* (London, 2008)

—, *Mountains and Lowlands: Ancient Iran and Mesopotamia* (Oxford, 2016)

Curtis, John, *The Cyrus Cylinder and Ancient Persia* (London, 2013)

— and St John Simpson, eds, *The World of Achaemenid Persia: History, Art and Society in Iran and the Ancient Near East* (London, 2010)

Edzard, Sibylle and Dietz Otto Edzard, *Gudea and His Dynasty: The Royal Inscriptions of Mesopotamia, Early Periods* (Toronto, 1997)

The Epic of Gilgamesh: The Babylonian Epic Poem and Other Texts in Akkadian and Sumerian, trans. Andrew George (London, 1999)

Finkel, Irving and M. J. Seymour, eds, *Babylon: Myth and Reality*, exh. cat., British Museum (London, 2008)

Frankfort, Henri, *Cylinder Seals: A Documentary Essay on the Art and Religion of the Ancient Near East* (London, 1939)

—, *The Art and Architecture of the Ancient Orient* (Harmondsworth, 1954)

Milano, L., S. de Martino, F. M. Fales and G. B. Lanfranchi, eds, *Landscapes: Territories, Frontiers and Horizons in the Ancient Near East* (Padua, 1999)

Porada, Edith, *Ancient Iran: The Art of Pre-Islamic Times* (London, 1964)

Robinson, Andrew, *The Indus Lost Civilizations* (London, 2015)

Shapur Shahbazi, A., *The Authoritative Guide to Persepolis* (Tehran, 2004)

Wheeler, Mortimer, *Flames over Persepolis* (London, 1968)

Woolley, Leonard, *Ur: The First Phases* (London, 1946)

3. Ages of Elegance

Aldred, Cyril, *Egyptian Art in the Days of the Pharaohs* (London, 1980)

Davies, W. V., *Egyptian Hieroglyphics* (London, 1987)

Davis, Whitney, *The Canonical Tradition in Ancient Egyptian Art* (Cambridge, 1989)

Eyo, Ekpo and Frank Willett, *Treasures of Ancient Nigeria* (New York, 1980)

Fagg, Bernard, *Nok Terracottas* (Lagos, 1977)

Garlake, Peter, *Early Art and Architecture in Africa* (Oxford, 2002)

Glanville, S. R. K., *The Legacy of Egypt* (Oxford, 1942)

Harris, J. R., ed., *The Legacy of Egypt* (Oxford, 1971)

Iversen, Erik, *Canon and Proportions in Egyptian Art* (London, 1955)

Kozloff, Arielle P. and Betsy M. Bryan, *Egypt's Dazzling Sun: Amenhotep III and His World*, exh. cat., Cleveland Museum of Art (Cleveland, OH, 1992)

Oppenheim, Adela, Dorothea Arnold, Dieter Arnold and Kei Yamamoto, *Ancient Egypt Transformed: The Middle Kingdom*, exh. cat., Metropolitan Museum of Art, New York (New York, 2015)

Petrie, Flinders, *The Arts and Crafts of Ancient Egypt* (London, 1923)

Robins, Gay, *Proportion and Style in Ancient Egyptian Art* (Austin, TX, 1994)

—, *The Art of Ancient Egypt* (London, 1997)

Sandman, Maj, *Texts from the Time of Akhenaten* (Brussels, 1938)

Schäfter, Heinrich, *Von ägyptischer Kunst besonders der Zeichenkunst*, 2 vols (Leipzig, 1919); trans. J. Baines as *Principles of Egyptian Art* (Oxford, 1974)

Shaw, Ian, *Ancient Egypt: A Very Short Introduction* (Oxford, 2004)

Spanel, Donald, *Through Ancient Eyes: Egyptian Portraiture*, exh. cat., Birmingham Museum of Art (Birmingham, AL, 1988)

Wilkinson, Toby, *The Rise and Fall of Ancient Egypt* (London, 2010)

Wilson, P., *Sacred Signs: Hieroglyphs in Ancient Egypt* (Oxford, 2003)

4. Jade and Bronze

Bagley, Robert, ed., *Ancient Sichuan: Treasures from a Lost Civilisation*, exh. cat., Seattle Art Museum (Seattle, WA, 2001)

Benson, Elizabeth P. and Beatriz de la Fuente, *Olmec Art of Ancient Mexico*, exh. cat., National Gallery of Art, Washington, DC (Washington, DC, 1996)

Berrin, Kathleen and Virginia M. Fields, *Olmec: Colossal Masterworks of Ancient Mexico*, exh. cat., Fine Arts Museum of San Francisco (New Haven, CT, 2010)

Deydier, Christian, *Chinese Bronzes*, trans. Janet Seligman (New York, 1980)

Ekserdjian, David, ed., *Bronze*, exh. cat., Royal Academy, London (London, 2012)

Fiedel, Stuart, *Prehistory of the Americas* (Cambridge, 1987)

Fong, Wen, ed., *The Great Bronze Age of China: An Exhibition from the People's Republic of China*, exh. cat., Metropolitan Museum of Art, New York (New York, 1980)

Hawkes, Jacquetta, *The First Great Civilisations: Life in Mesopotamia, the Indus Valley, and Egypt* (London, 1973)

Hung, Wu, *The Art of the Yellow Springs: Understanding Chinese Tombs* (Honolulu, HA, 2010)

Jansen, Michael, Máire Mulloy and Günter Urban, eds, *Forgotten Cities of the Indus: Early Civilization in Pakistan from the 8th to the 2nd Millennium BC* (Mainz, 1991)

Kaner, S., ed., *The Power of Dogu: Ceramic Figures from Ancient Japan*, exh. cat., British Museum, London (London, 2009)

Keightley, David N., *Sources of Shang History: The Oracle-Bone Inscriptions of Bronze Age China* (Berkeley, CA, 1978)

Kubler, George, *The Art and Architecture of Ancient America: The Mexican Maya and Andean Peoples* (Harmondsworth, 1962)

Lin, James C. S., ed., *The Search for Immortality: Tomb Treasures of Han China* (New Haven, CT, 2012)

Mei, Jianun and Thilo Rehren, *Metallurgy and Civilisation: Eurasia and Beyond* (London, 2009)

Miller, Mary Ellen, *The Art of Mesoamerica: From Olmec to Aztec* (London, 2001)

Portal, Jane, ed., *The First Emperor: China's Terracotta Army*, exh. cat., British Museum, London (London, 2007)

Qian, Sima, *The First Emperor: Selections from the Historical Record*, trans. Raymond Dawson (Oxford, 2007)

Rawson, Jessica, *Ancient China: Art and Archaeology* (London, 1980)

—, *Chinese Bronzes: Art and Ritual* (London, 1987)

5. The Human Measure

Arias, P. E., *A History of Greek Vase Painting*, trans. B. B. Shefton (London, 1962)

Beard, Mary, *The Parthenon* (Cambridge, 2010)

Boardman, John, *The History of Greek Vases* (London, 2001)

Evans, A. J., *The Palace of Minos at Knossos*, 4 vols (London, 1921–36)

Fürtwangler, A., *Masterpieces of Greek Sculpture: A Series of Essays on the History of Art*, trans. E. Sellers from German edition of 1893 (London, 1895)

Getz-Gentle, P., *Early Cycladic Sculpture: An Introduction* (Malibu, CA, 1994)

Havelock, Christine Mitchell, *The Aphrodite of Knidos and Her Successors: A Historical Review of the Female Nude in Greek Art* (Ann Arbor, MI, 1995)

Haynes, Denys, *Greek Art and the Idea of Freedom* (London, 1981)

Higgins, R. A., *Minoan and Mycenaean Art* (London, 1967)

Hood, S., *The Minoans* (London, 1971)

—, *The Arts in Prehistoric Greece* (Harmondsworth, 1978)

Mylonas, G. E., *Ancient Mycenae: The Capital City of Agamemnon* (Princeton, NJ, 1957)

Neer, Richard T., *Art & Archaeology of the Greek World: A New History c.2500–150 BCE* (London, 2012)

Pausanias, *Guide to Greece, vol.1, Central Greece*, trans. Peter Levi (Harmondsworth, 1971)

Pliny the Elder, *Natural History*, vol. IX, books XXXIII–XXXV, with an English translation by H. Rackham (Cambridge, 1952)

Pollitt, J. J., *Art in the Hellenistic Age* (Cambridge, 1986)

Renfrew, C., *The Cycladic Spirit* (New York, 1991)

Richter, Gisela M.A., *A Handbook of Greek Art* (London, 1959)

Robertson, Martin, *A Shorter History of Greek Art* (Cambridge, 1981)

—, *The Art of Vase-Painting in Classical Athens* (Cambridge, 1992)

Simpson, St John and Svetlana Pankova, eds, *Scythians: Warriors of Ancient Siberia*, exh. cat., British Museum, London (London, 2017)

Spivey, Nigel, *Understanding Greek Sculpture: Ancient Meanings, Modern Readings* (London, 1996)

—, *Greek Sculpture* (Cambridge, 2013)

6. Roads to Empire

Beard, Mary, *Pompeii: The Life of a Roman Town* (London, 2008)

—, *SPQR: A History of Ancient Rome* (London, 2015)

— and John Henderson, *Classical Art from Greece to Rome* (Oxford, 2001)

Boardman, J., *The Greeks Overseas* (Harmondsworth, 1964)

Brendel, Otto J., *Prolegomena to the Study of Roman Art* (New Haven, CT, and London, 1979)

Castriota, D., *The Ara Pacis Augustae and the Imagery of Abundance in Later Greek and Early Roman Imperial Art* (Princeton, NJ, 1995)

Colledge, M. A. R., *The Art of Palmyra* (London, 1976)

Cosh, Stephen R. and David S. Neal, *Roman Mosaics of Britain, vol. II, South-West Britain* (London, 2005)

Crawford, M., *The Roman Republic*, 2nd edn (London, 1992)

Favro, D., *The Urban Image of Augustan Rome* (Cambridge, 1996)

Fierz-David, Linda, *Women's Dionysian Initiation: The Villa of Mysteries at Pompeii* (Dallas, TX, 1988); translation of

Psychologische Betrachtungen zu der Freskenfolge der Villa dei Misteri in Pompeii: Ein Versuch (Zurich, 1957)

Haynes, S., *Etruscan Civilization: A Cultural History* (London, 2000)

Kleiner, Diane E. E., *Roman Sculpture* (New Haven, CT, and London, 1992)

MacDonald, William L., *The Pantheon: Design, Meaning and Progeny* (London, 1976)

Östenberg, Ida, *Staging the World: Spoils, Captives, and Representations in the Roman Triumphal Procession* (Oxford, 2009)

Peters, W. J. T., *Landscapes in Romano-Campanian Mural Painting* (Assen, 1963)

Pollitt, J. J., *Art in the Hellenistic Age* (Cambridge, 1986)

Stewart, Peter, *Roman Art* (Oxford, 2004)

Toynbee, J. M. C., *Art in Roman Britain* (London, 1962)

—, *Art in Britain under the Romans* (Oxford, 1964)

Walker, Susan and Morris Bierbrier, *Ancient Faces: Mummy Portraits from Roman Egypt* (London, 1997)

7. Suffering and Desire

Agnew, Neville, Marcia Reed and Tevvy Ball, *Cave Temples of Dunhuang: Buddhist Art on China's Silk Road,* exh. cat., Getty Center, Los Angeles (Los Angeles, CA, 2016)

Béguin, Gilles, *Buddhist Art: An Historical and Cultural Journey* (Bangkok, 2009)

Coomaraswamy, Ananda K., *The Transformation of Nature in Art* (Cambridge, 1934)

—, *The Dance of Śiva: Fourteen Indian Essays* (New York and London, 1942)

Craven, Roy C., *Indian Art: A Concise History* (London, 1997)

Dehejia, Vidya, *Indian Art* (London, 1997)

Empson, William, *The Face of the Buddha* (Oxford, 2016)

Gupta, S. P., *The Roots of Indian Art* (Delhi, 1980)

Harle, J. C., *Gupta Sculpture: Indian Sculpture of the Fourth to the Sixth Centuries A.D.* (New Delhi, 1996)

Ibbitson Jessup, Helen, *Art & Architecture of Cambodia* (London 2004)

Imagining the Divine, exh. cat., Ashmolean Museum, Oxford (Oxford, 2018)

Knox, Robert, *Amaravati: Buddhist Sculpture from the Great Stupa* (London, 1992)

Kramrisch, Stella, *The Presence of Śiva* (Princeton, NJ, 1981)

Legge, James, *The Travels of Fa-Hien* (Oxford, 1886)

Rienjang, Wannaporn and Peter Stewart, eds, *The Global Connections of Gandharan Art* (Oxford, 2020)

Rosenfield, John M., *The Dynastic Art of the Kushans* (Berkeley and Los Angeles, CA, 1967)

Rowland, Benjamin, *The Art and Architecture of India: Buddhist, Hindu, Jain* (Harmondsworth, 1967)

Shimada, Akira and Michael Willis, *Amaravati: The Art of an Early Buddhist Monument in Context* (London, 2016)

8. Golden Saints

Baker, D., ed., *Medieval Woman* (Oxford, 1978)

Beckwith, John, *Early Christian and Byzantine Art* (Harmondsworth, 1970)

Buchthal, H., *The Miniatures of the Paris Psalter* (London, 1938)

Cormack, Robin and Maria Vassilaki, eds, *Byzantium 330–1453*, exh. cat., Royal Academy, London (London, 2008)

Dalrymple, William, *From the Holy Mountain: A Journey in the Shadow of Byzantium* (London, 1997)

Eastmond, Antony, *Byzantine and East Christian Art* (London, 2013)

Ettinghausen, Richard, *From Byzantine to Sasanian Iran and the Islamic World* (Leiden, 1972)

Eusebius, *Life of Constantine,* introduction, trans. and commentary by Averil Cameron and Stuart G. Hall (Oxford, 1999)

Evans, Helen C. and William D. Wixom, eds, *The Glory of Byzantium: Art and Culture of the Middle Byzantine Era A.D. 843–1261*, exh. cat., Metropolitan Museum of Art, New York (New York, 1997)

— and Brandie Ratliff, eds, *Byzantium and Islam: Age of Transition 7th–9th Century,* exh. cat., Metropolitan Museum of Art, New York (New York, 2012)

Finney, Paul Corby, *The Invisible God: The Earliest Christians on Art* (Oxford, 1994)

Grabar, Oleg, *Christian Iconography: A Study of Its Origins* (London, 1969)

Gutmann, Joseph, ed., *The Dura-Europos Synagogue: A Re-Evaluation (1932–1992)* (Atlanta, GA, 1992)

Harper, Prudence Oliver, *The Royal Hunter: Art of the Sasanian Empire,* exh. cat., The Asia Society, New York (New York, 1978)

Harrison, Martin, *A Temple for Byzantium: The Discovery and Excavation of Anicia Juliana's Palace-Church in Istanbul* (Austin, TX, 1989)

Hilsdale, C. J., *Byzantine Art and Diplomacy in an Age of Decline* (Cambridge, 2014)

James, Liz, ed., *Women, Men and Eunuchs: Gender in Byzantium* (London, 1997)

Krautheimer, Richard, *Early Christian and Byzantine Architecture* (Harmondsworth, 1965)

Levine, Lee I., ed., *The Synagogue in Late Antiquity* (Philadelphia, PA, 1987)

Mango, Cyril, *The Art of the Byzantine Empire, 312–1453: Sources and Documents* (Englewood Cliffs, NJ, 1972)

Nicolotti, Andrea, *From the Mandylion of Edessa to the Shroud of Turin: The Metamorphosis and Manipulation of a Legend* (Leiden, 2014)

Rodley, Lyn, *Byzantine Art and Architecture: An Introduction* (Cambridge, 1994)

Runciman, Steven, *Byzantine Style and Civilisation* (Harmondsworth, 1975)

The Russian Primary Chronicle: Laurentian Text, trans. S. H. Cross and O. P. Sherbowitz-Wetzor (Cambridge, MA, 1953))

9. The Name of the Prophet

Al-Khalili, Jim, *Pathfinders: The Golden Age of Arabic Science* (London, 2010)

Allen, Terry, *Five Essays on Islamic Art* (n.p., 1988)

Beach, Milo, *Mughal and Rajput Painting* (New York, 1992)

Behrens-Abousief, Doris, ed., *The Arts of the Mamluks in Egypt and Syria: Evolution and Impact* (Bonn, 2012)

Blair, Sheila S., *Islamic Calligraphy* (Edinburgh, 2006)

— and Jonathan M. Bloom, *The Art and Architecture of Islam 1250–1800* (New Haven, CT, and London, 1994)

Bloom, J. M., *Paper before Print: The History and Impact of Paper in the Islamic World* (New Haven, CT, and London, 2001)

Brend, Barbara and Charles Melville, *Epic of the Persian Kings: The Art of Ferdowsi's 'Shahnameh',* exh. cat., Fitzwilliam Museum (London and New York, 2010)

Canby, Sheila R., Deniz Beyazit, Martina Rugiadi and A. C. S. Peacock, *Court and Cosmos: The Great Age of the Seljuqs,* exh. cat., The Metropolitan Museum of Art, New York (New York, 2016)

Carboni, Stefano, *Glass from Islamic Lands* (London, 2001)

A Century of Princes: Sources on Timurid History and Art, selected and trans. W. M. Thackston (Cambridge, MA, 1989)

Chandra, Pramod, *The Cleveland Tuti-nama Manuscript and the Origins of Mughal Painting,* 2 vols (Cleveland, OH, 1976)

Creswell, K. A. C., *Early Muslim Architecture,* 2 vols. (Oxford, 1969)

Dodds, J. D., *Al-Andalus: The Art of Islamic Spain,* exh. cat., Metropolitan Museum of Art, New York (New York, 1992)

Ettinghausen, Richard, Oleg Grabar and Marilyn Jenkins-Madina, *Islamic Art and Architecture, 650–1250* (New Haven CT, and London, 2001)

Grabar, Oleg, *The Great Mosque of Isfahan* (London, 1990)

—, *The Dome of the Rock* (Cambridge MA, and London, 2006)

— and Sheila Blair, *Epic Images and Contemporary History: The Illustrations of the Great Mongol Shahnama* (Chicago, IL, 1980)

Jayyusi, S. K., *The Legacy of Muslim Spain* (Leiden, 1992)

The Koran, trans. J. M. Rodwell (London, 1994)

Lindberg, D. C., *Theories of Vision from al-Kindi to Kepler* (Chicago, IL, 1976)

Maclagan, Edward, *The Jesuits and the Great Mogul* (London, 1932)

Seyller, John, with contributions from Wheeler M. Thackston, Ebba Koch, Antoinette Owen and Rainald Franz, *The Adventures of Hamza: Painting and Storytelling in Mughal India,* exh. cat., Freer Gallery of Art, Washington, DC (Washington, DC, 2002)

Sims, Eleanor, Boris I. Marshak and Ernst J. Grube, *Peerless Images: Persian Painting and Its Sources* (New Haven, CT, and London, 2002)

10. Invaders and Inventors

Alexander, M., trans., *The Earliest English Poems* ([1966] Harmondsworth, 1977)

Anglo-Saxon Kingdoms: Art, Word, War, exh. cat., British Library, London (London, 2018)

Beowulf, trans. Seamus Heaney (London, 1999)

Brown, Michelle P., *The Lindisfarne Gospels and the Early Medieval World* (London, 2011)

Cassidy, Brendan, ed., *The Ruthwell Cross* (Princeton, NJ, 1992)

Dodwell, C. R., *Painting in Europe, 800–1200* (Harmondsworth, 1971)

Einhard and Notker the Stammerer, *Two Lives of Charlemagne,* trans. Lewis Thorpe (Harmondsworth, 1969)

Evans, A. C., *The Sutton Hoo Ship Burial* (London, 1986)

Horst, K. van der, W. Noel and W. C. M. Wüstefeld, *The Utrecht Psalter in Medieval Art: Picturing the Psalms of David* (Utrecht, 1996)

Karkov, Catherine E., *Text and Picture in Anglo-Saxon England: Narrative Strategies in the Junius 11 Manuscript* (Cambridge, 2001)

Kershaw, N., ed. and trans., *Anglo-Saxon and Norse Poems* (Cambridge, 1922)

Lasko, Peter, *Ars Sacra, 800–1200* (New Haven, CT, and London, 1994)

Mayr-Harting, Henry, *Ottonian Book Illumination*, 2 vols (London, 1991)

Nordenfalk, Carl, *Celtic and Anglo-Saxon Painting: Book Illumination in the British Isles, 600–800* (London, 1977)

Ó Carragáin, Éamonn, *Ritual and the Rood: Liturgical Images and the Old English Poems of the 'Dream of the Rood' Tradition* (London and Toronto, 2005)

Talbot, C. H., *The Anglo-Saxon Missionaries in Germany* (London and New York, 1954)

Webster, Leslie, *Anglo-Saxon Art* (London, 2006)

—, *Anglo-Saxon Art: A New History* (London, 2012)

Wilson, David, *Anglo-Saxon Art: From the Seventh Century to the Norman Conquest* (London, 1984)

11. Serpents, Skulls, Standing Stones

Benson, Elizabeth P., *Birds and Beasts of Ancient Latin America* (Gainesville, FL, 1997)

Berrin, Kathleen and Esther Pasztory, eds, *Teotihuacan: Art from the City of the Gods*, exh. cat., Fine Arts Museum of San Francisco (San Francisco, CA, and New York, 1993)

Coe, Michael, *Breaking the Maya Code* (London, 1999)

Donnan, Christopher B., *Moche Art of Peru*, exh. cat., Los Angeles Museum of Cultural History (Los Angeles, CA, 1978)

Fash, William L., *Scribes, Warriors and Kings: The City of Copán and the Ancient Maya* (London, 1991)

Kubler, George, *The Art and Architecture of Ancient America: The Mexican, Maya and Andean Peoples* (Harmondsworth, 1962)

Miller, Mary and Karl Taube, *The Gods and Symbols of Ancient Mexico and the Maya: An Illustrated Dictionary of Mesoamerican Religion* (London, 1993)

— and Megan O'Neil, *Maya Art and Architecture* (London, 2014)

Pasztory, Esther, *Aztec Art* (New York, 1983)

Popol Vuh: The Mayan Book of the Dawn of Life, trans. Dennis Tedlock (New York, 1996)

Quilter, Jeffrey, *The Moche of Ancient Peru: Media and Messages* (Cambridge, MA, 2010)

Robb, Matthew H., *Teotihuacan: City of Water, City of Fire*, exh. cat., de Young Museum, San Francisco (San Francisco, CA, 2017)

Schmidt, Peter, Mercedes de la Garza and Enrique Nalda, eds, *Maya Civilization* (London, 1998)

Summers, David, *Real Spaces* (London, 2003)

Townsend, Richard F., *The Aztecs* (London, 2000))

12. Sound and Light

Bony, Jean, *Gothic Architecture of the 12th and 13th Centuries* (Berkeley, CA, 1983)

Brown, Sarah, *Stained Glass: An Illustrated History* (London, 1992)

Cattin, Giulio, *Music of the Middle Ages*, trans. Steven Botterill (Cambridge, 1984)

Collins, K., P. Kidd and N. K. Turner, *The St Albans Psalter: Painting and Prayer in Medieval England*, exh. cat., Getty Museum, Los Angeles (Los Angeles, CA, 2013)

Conant, Kenneth, *Romanesque Architecture, 800–1200* (London, 1966)

Erlande-Brandenbourg, Alain, *The Cathedral Builders of the Middle Ages* (London, 1995)

Fernie, Eric, *Romanesque Architecture* (New Haven, CT, and London, 2014)

Grant, Lindy, *Abbot Suger of St-Denis: Church and State in Early Twelfth-Century France* (London and New York, 1998)

Grivot, Denis and George Zarnecki, *Gislebertus, Sculptor of Autun* (London, 1961)

Grodecki, Louis, *Gothic Architecture* (London, 1986)

Husband, Timothy B., *The Art of Illumination: The Limbourg Brothers and the Belles Heures of Jean de France, Duc de Berry*, exh. cat., Metropolitan Museum of Art, New York (New York, 2008)

Joinville and Villehardouin, *Chronicles of the Crusades*, trans. Caroline Smith (London, 2008)

Jolliffe, John, ed., *Froissart, Chronicles* (London, 1967)

Kuback, Hans Erich, *Romanesque Architecture* (New York, 1978)

Longon, Jean and Raymond Cazelles, *The Très Riches Heures of Jean, Duke of Berry* (New York, 1969)

Lorris, Guillaume de and Jean de Meung, *Le roman de la rose*, ed. and trans. Armand Strubel (Paris, 1992)

Martindale, Andrew, *Gothic Art from the Twelfth to Fifteenth Centuries* (London, 1967)

Meiss, Millard, French Painting in the Time of Jean de Berry: The Limbourgs and their Contemporaries, 2 vols (New York, 1974)

Murray, Stephen, *Notre-Dame, Cathedral of Amiens: The Power of Change in Gothic* (Cambridge, 1996)

Panofsky, E., *Abbot Suger on the Abbey Church of St Denis and its Art Treasures* (Princeton, NJ, 1979)

Petzold, Andreas, *Romanesque Art* (London, 1995)

Rudolph, Conrad, *The 'Things of Greater Importance': Bernard of Clairvaux's 'Apologia' and the Medieval Attitude toward Art* (Philadelphia, PA, 1990)

Sauerländer, Willibald, *Gothic Sculpture in France, 1140–1270* (London, 1972)

Schapiro, Meyer, *Romanesque Art* (New York, 1977)

Simson, Otto von, *The Gothic Cathedral* (London, 1956)

Stones, A. and P. Gerson, *The Pilgrim's Guide to Santiago de Compostela: A Critical Edition* (London, 1998)

Williamson, Paul, *Gothic Sculpture, 1140–1300* (New Haven, CT, and London, 1995)

Zarnecki, George, *Romanesque Art* (London, 1971)

13. Travellers in the Mist

Binyon, L., *Painting in the Far East* (London, 1934)

Bush, S., *Theories of the Arts in China* (Princeton, NJ, 1983)

Bush, S. and Hsio-yen Shih, *Early Chinese Texts on Painting* (Cambridge, MA, 1985, Hong Kong, 2012)

Cahill, James, *Hills beyond a River: Chinese Painting of the Yuan Dynasty, 1279–1368* (New York and Tokyo, 1976)

Cahill, James, *Chinese Painting* ([1960] New York, 1985)

Clunas, Craig, *Pictures and Visuality in Early Modern China* (Princeton, NJ, 1997)

—, *Art in China* (Oxford, 1997)

—, *Elegant Debts: The Social Art of Wen Zhengming, 1470–1559* (London, 2004)

—, *Chinese Painting and its Audiences* (Princeton, NJ, 2017)

Edwards, Richard, *The Field of Stones: A Study of the Art of Shen Zhou (1427–1509)* (Washington, DC, 1962)

Fong, Wen, *Beyond Representation: Chinese Painting and Calligraphy 8th– 14th Century* (New Haven, CT, and London, 1992)

— and J. Watt, *Possessing the Past: Treasures from the National Palace Museum, Taipei* (New York, 1996)

Loehr, M., *The Great Painters of China* (Oxford, 1980)

McCausland, S., ed., *Gu Kaizhi and the Admonitions Scroll* (London, 2003)

Medley, Margaret, *The Chinese Potter: A Practical History of Chinese Ceramics* (Oxford, 1976)

Rowley, G., *Principles of Chinese Painting* (Princeton, NJ, 1947)

Silbergeld, Jerome, *Chinese Painting Style: Media, Methods and Principles of Form* (Seattle, WA, and London, 1982)

Siren, Oswald, *The Chinese on the Art of Painting* (Beijing, 1936)

Stuart, J., *The Admonitions Scroll, British Museum Objects in Focus* (London, 2014)

Sullivan, M., *The Birth of Landscape Painting in China* (London, 1962)

—, *Symbols of Eternity: The Art of Landscape Painting in China* (Oxford, 1979)

—, *The Meeting of Eastern and Western Art* (Berkeley, CA, 1989)

Vainker, Shelagh, *Chinese Pottery and Porcelain* (London, 1991)

Wagner, Marsha L., *Wang Wei* (Boston, MA, 1981)

Waley, A., *An Introduction to the Study of Chinese Painting* (London, 1923)

Wang Wei: Poems (Harmondsworth, 1973)

Watt, James, *The World of Khubilai Khan: Chinese Art in the Yuan Dynasty*, exh. cat., Metropolitan Museum, New York (New York, 2010)

14. Spellbound

Akiyama, Aisaburo, *Shinto and its Architecture* (Kyoto, 1936)

Akiyoshi, W., K. Hiroshi and P. Varley, *Of Water and Ink: Muromachi-Period Paintings from Japan, 1392–1568*, exh. cat., Detroit Institute of Arts (Detroit, MI, 1986)

Awakawa, Yasuichi, *Zen Painting*, trans. John Bester (New York, 1970)

Bownas, Geoffrey and Anthony Thwaite, *The Penguin Book of Japanese Poetry* ([1964] Harmondsworth, 1998)

Harris, V., ed., *Shinto: The Ancient Art of Japan*, exh. cat., British Museum, London (London, 2000)

Kyōtarō, Nishikawa and Emily J. Sano, *The Great Age of Japanese Buddhist Sculpture AD 600–1300*, exh. cat., Kimbell Art Museum, Fort Worth (Fort Worth, TX, 1982)

Levine, Gregory and Yukio Lippit, *Awakenings: Zen Figure Painting in Medieval Japan* (New York, 2007)

Lippit, Yukio, *Japanese Zen Buddhism and the Impossible Painting* (Los Angeles, CA, 2017)

The Man'yōshū: The Nippon Gakujtusu Shinkōkai Translation of One Thousand Poems, with a foreword by Donald Keene (New York and London, 1969)

McCormick, Melissa, *The Tales of Genji: A Visual Companion* (Princeton, NJ, 2018)

Meech-Pekarik, Julia, *Momoyama: Japanese Art in the Age of Grandeur*, exh. cat., Metropolitan Museum of Art, New York (New York, 1975)

Soper, Alexander Coburn, *The Evolution of Buddhist Architecture in Japan* (Princeton, NJ, 1942)

Stanley-Baker, Joan, *Japanese Art* (London, 1984)

Waley, Arthur, trans., *The Pillow-Book of Sei Shōnagon* (London, 1928)

Weidner, Marsha, ed., *Flowering in the Shadows: Women in the History of Chinese and Japanese Painting* (Honolulu, HA, 1990)

Yashiro, Yukio, *Two Thousand Years of Japanese Art* (London, 1958)

15. The New Life

Berenson, Bernard, *The Central Italian Painters of the Renaissance* (London, 1909)

—, *A Sienese Painter of the Franciscan Legend* (London, 1910)

Cassirer, Ernst et al., eds, *The Renaissance Philosophy of Man* (Chicago, IL, 1948)

Christiansen, Keith, *Gentile da Fabriano* (London, 1982)

—, L. B. Kanter and C. B. Strehlke, *Painting in Renaissance Siena, 1420–1500*, exh. cat., Metropolitan Museum of Art, New York (New York, 1988)

Clark, Kenneth, *Piero della Francesca* (London, 1951)

Ginzburg, Carlo, *The Enigma of Piero* (London, 1985)

Hills, Paul, *The Light of Early Italian Painting* (New Haven, CT, and London, 1987)

Hyman, Timothy, *Sienese Painting: The Art of a City-Republic, 1278–1477* (London, 2003)

Israëls, Machtelt, ed., *Sassetta: The Borgo San Sepolcro Altarpiece* (Leiden, 2009)

Lavin, Marilyn Aronberg, *Piero della Francesca: The Flagellation* (London, 1972)

Lubbock, Jules, *Storytelling in Christian Art from Giotto to Donatello* (New Haven, CT, and London, 2006)

Maginnis, Hayden B. J., *Painting in the Age of Giotto* (University Park, PA, 1997)

Martindale, Andrew, *Simone Martini* (Oxford, 1987)

Mommsen, T. E., *Petrarch's Testament* (Ithaca, NY, 1957)

Moskowitz, Anita Fiderer, *Italian Gothic Sculpture c.1250–c.1400* (Cambridge, 2001)

Pope-Hennessy, John, *Italian Gothic Sculpture* (London, 1986)

—, *Paradiso: The Illuminations to Dante's 'Divine Comedy' by Giovanni di Paolo* (London, 1993)

Richards, J., *Altichiero: An Artist and His Patrons in the Italian Trecento* (Cambridge, 2000)

Seidel, Max, *Father and Son: Nicola and Giovanni Pisano* (Munich, 2012)

Wood, Jeryldene M., ed., *The Cambridge Companion to Piero della Francesca* (Cambridge, 2002)

16. The Ordering of Vision

Alberti, Leon Battista, *On Painting*, trans. C. Grayson, intro. by M. Kemp (London, 1991)

Belting, Hans, *Florence and Baghdad: Renaissance Art and Arab Science*, trans. Deborah Lucas Schneider (Cambridge, MA, 2011)

Berenson, Bernard, *Italian Painters of the Renaissance* (New York, 1952)

Blunt, Anthony, *Artistic Theory in Italy, 1450–1600* (Oxford, 1962)

Campbell, Caroline et al., *Mantegna & Bellini*, exh. cat., National Gallery, London (London, 2018)

Dunkerton, Jill et al., eds, *Giotto to Dürer: Early Renaissance Painting in the National Gallery* (London, 1991)

Krautheimer, Richard, *Lorenzo Ghiberti* (Princeton, NJ, 1970)

Kristeller, P. O., *Renaissance Thought and the Arts* (Princeton, NJ, 1980)

Manetti, Antonio di Tuccio, *The Life of Brunelleschi*, trans. C. Engass (London, 1970)

Martindale, Andrew, *The Triumphs of Caesar by Andrea Mantegna in the Collection of Her Majesty the Queen at Hampton Court* (London, 1979)

Martineau, J., ed., *Andrea Mantegna,* exh. cat., Royal Academy, London (London, 1992)

Paoletti, John T. and Gary M. Radke, *Art in Renaissance Italy* (London, 1997)

Pope-Hennessy, John, *Paolo Uccello* (London and New York, 1950)

Syson, L. and D. Gordon, *Pisanello: Painter to the Renaissance Court,* exh. cat. National Gallery, London (London, 2001)

Vasari, Giorgio, *Lives of the Artists*, 2 vols, trans. George Bull (London, 1965)

Weiss, R., *The Spread of Italian Humanism* (London, 1964)

17. Spectacular Small Things

Ainsworth, Maryan W., with contributions by Maximiliaan P. J. Martens, *Petrus Christus: Renaissance Master of Bruges*, exh. cat., Metropolitan Museum of Art, New York (New York, 1994)

Avril, François, ed., *Jean Fouquet: peintre et enlumineur du XVe siècle*, exh. cat., Bibliothèque Nationale, Paris (Paris, 2003)

Bartrum, Giulia, *German Renaissance Prints, 1490–1550* (London, 1995)

Baxandall, Michael, *The Limewood Sculptures of Renaissance Germany* (London, 1980)

Belting, Hans, *Hieronymus Bosch: Garden of Earthly Delights* (Munich and London, 2002)

Campbell, Lorne, *Van der Weyden* (London, 1979)

—, *The Fifteenth Century Netherlandish Schools, National Gallery Catalogues (London, 1998)*

— and Jan Van der Stock, eds, *Rogier van der Weyden, 1400–1464: Master of Passions*, exh. cat., Museum Leuven (Leuven, 2009)

Chapuis, Julian et al., *Tilman Riemenschneider: Master Sculptor of the Late Middle Ages* (New Haven, CT, and London, 1999)

Eastlake, Charles Lock, *Materials for a History of Oil Painting* (London, 1847)

Foister, Susan, Sue Jones and Delphine Cool, eds, *Investigating Jan Van Eyck* (Brepols, 2000)

Gibson, Walter S., *Pieter Bruegel and the Art of Laughter* (Berkeley, CA, 2006)

Heal, Bridget, *A Magnificent Faith: Art and Identity in Lutheran Germany* (Oxford, 2017)

Heard, Kate and Lucy Whitaker, *The Northern Renaissance: Dürer to Holbein* (London, 2011)

Hooker, D., ed., *Art of the Western World* (London, 1989)

Hoppe-Harnoncourt, Alice, Elke Oberthaler and Sabine Pénot, eds, *Bruegel: The Master,* exh. cat., Kunsthistorisches Museum, Vienna (Vienna, 2018)

Hueffer, Ford Madox, *Hans Holbein the Younger* (London, 1905)

Ilsink, Matthijs et al., *Hieronymus Bosch: Painter and Draughtsman* (New Haven, CT, and London, 2016)

Kemperdick, Stephan, *Martin Schongauer: eine Monographie* (Petersberg, 2004)

Koerner, Joseph Leo, *Bosch and Bruegel: From Enemy Painting to Everyday Life* (Princeton, NJ, and Oxford, 2016)

Landau, D. and P. Parshall, *The Renaissance Print, 1470–1550* (New Haven, CT, and London, 1994)

Lehmann, Phylis W., *Cyriacus of Ancona's Egyptian Visit and its Reflections in Gentile Bellini and Hieronymus Bosch* (New York, 1977)

Martens, Maximiliaan, Till-Holger Borchert, Jan Dumolyn, Johan De Smet and Frederica Van Dam, eds, *Van Eyck: An Optical Revolution*, exh. cat., Museum voor Schone Kunsten, Ghent (Ghent, 2020)

Mayr-Harting, Ursula, *Early Netherlandish Engraving c.1440–1540*, exh. cat., Ashmolean Museum, Oxford (Oxford, 1997)

Nuecherlein, Jeanne, *Translating Nature into Art: Holbein, the Reformation, and Renaissance Rhetoric* (Philadelphia, PA, 2011)

Nuttall, Paula, *From Flanders to Florence: The Impact of*

Netherlandish Painting, 1400–1500 (New Haven, CT, and London, 2004)

Pacht, O., *Early Netherlandish Painting: From Rogier van der Weyden to Gerard David* (London, 1997)

Panofsky E., *Early Netherlandish Painting: Its Origins and Character*, 2 vols (Cambridge, MA, 1953)

Parker, K. T., *The Drawings of Hans Holbein in the Collection of Her Majesty the Queen at Windsor Castle* (London, 1983)

Purtle, Carol J., *The Marian Paintings of Jan van Eyck* (Princeton, NJ, 1982)

Reynaud, N., *Jean Fouquet*, exh. cat., Musée du Louvre, Paris (Paris, 1981)

Shestack, A., *The Complete Engravings of Martin Schongauer* (New York, 1969)

Upton, J. M., *Petrus Christus: His Place in Fifteenth-Century Flemish Painting* (University Park, PA, 1990)

Weale, W. H. James, *Hubert and John Van Eyck: Their Life and Work* (London, 1908)

18. Bronze Kings

Beier, Ulli, *Yoruba Poetry: An Anthology of Traditional Poems* (Cambridge, 1970)

Ben-Amos, Paula, *The Art of Benin* (London, 1995)

— and A. Rubin, *The Art of Power: The Power of Art: Studies in Benin Iconography* (Los Angeles, CA, 1983)

Bovin, Mette, *Nomads Who Cultivate Beauty* (Uppsala, 2001)

Cole, H. M., ed., *I Am Not Myself: The Art of African Masquerade* (Los Angeles, CA, 1985)

Drewal, H. N. and E. Schildkrout, *Dynasty and Divinity: Ife Art in Ancient Nigeria*, exh. cat., Museum of African Art, New York (New York, 2009)

Ezra, Kate, *Art of the Dogon: Selections from the Lester Wundermann Collection*, exh. cat., Metropolitan Museum of Art, New York (New York, 1988)

—, *The Royal Art of Benin: The Perls Collection*, exh. cat., Metropolitan Museum of Art, New York (New York, 1992)

Garlake, P. S., *Great Zimbabwe* (London, 1973)

—, *The Hunter's Vision: The Prehistoric Art of Zimbabwe*

(London, 1995)

—, *Early Art and Architecture of Africa* (Oxford, 2002)

Gillon, Werner, *A Short History of African Art* (London, 1984)

Griaule, Marcel, *Masques Dogon* (Paris, 1938)

Hodgkin, Thomas, *Nigerian Perspectives: An Historical Anthology* (Oxford, 1960)

Olusoga, David, *First Contact: The Cult of Progress* (London, 2018)

Phillips, T., ed., *Africa: The Art of a Continent*, exh. cat., Royal Academy, London (London, 1995)

Phillipson, David W., *Aksum: Its Antecedents and Successors* (London, 1998)

Shaw, Thurston, *Unearthing Igbo-Ukwu: Archaeological Discoveries in Eastern Nigeria* (Ibadan, 1977)

Vinnicombe, Patricia, *People of the Eland* (Pietermaritzburg, 1976)

Visona, Monica Blackmun et al., *A History of Art in Africa* (London, 2000)

Willett, Frank, *African Art: An Introduction* (London, 1971)

19. Some Kind of Genius

Ackerman, James S., *The Architecture of Michelangelo* (London, 1961)

—, *Palladio* (London, 1966)

Atasoy, Nurhan and Julian Raby, *Iznik: The Pottery of Ottoman Turkey* (London, 1989)

Atil, Esin, *The Age of Sultan Süleyman the Magnificent,* exh. cat., National Gallery, Washington, DC (Washington, DC, 1987)

The Autobiography of Benvenuto Cellini, trans. Anne MacDonnell (London, 2010)

Avery, Charles, *Giambologna: The Complete Sculpture* (Oxford, 1987)

Bambach, Carmen, *Leonardo da Vinci Rediscovered* (New Haven, CT, and London, 2019)

Born, R., M. Dziewulski and G. Messling, *The Sultan's World: The Ottoman Orient in Renaissance Art*, exh. cat., Centre for Fine Arts, Brussels (Ostfildern, 2015)

Burns, Howard, Lynda Fairbairn and Bruce Boucher, *Andrea Palladio, 1508: The Portico and the Farmyard* (London, 1975)

Carswell, John, *Iznik Pottery* (London, 1998)

Clark, Kenneth, *Leonardo da Vinci* (London, 1939)

Dunkerton, Jill, Susan Foister and Nicholas Penny, *Dürer to Veronese: Sixteenth-Century Painting in the National Gallery* (New Haven, CT, and London, 1999)

Ekserdjian, David, ed., *Bronze*, exh. cat., Royal Academy, London (London, 2012)

Freiberg, Jack, *Bramante's Tempietto, the Roman Renaissance, and the Spanish Crown* (Cambridge, 2014)

Giambologna, Sculptor to the Medici, exh. cat., Arts Council of Great Britain (London, 1978)

Goethe, J. W., *Observations on Leonardo da Vinci's Celebrated Picture of the Last Supper,* trans. G. H. Noehden (London, 1821)

Gould, Cecil, *The Studio of Alfonso d'Este and Titian's 'Bacchus and Ariadne': A Re-Examination of the Chronology of the Bacchanals and of the Evolution of One of Them* (London, 1969)

Hall, James, *Michelangelo and the Reinvention of the Human Body* (London, 2005)

Hibbard, Howard, *Michelangelo* (New York, 1974)

Hills, Paul, *Venetian Colour: Marble, Mosaic, Painting and Glass, 1250–1550* (New Haven, CT, and London, 1999)

Howard, Deborah, *Venice and the East: The Impact of the Islamic World on Venetian Architecture, 1100–1500* (New Haven, CT, and London, 2000)

Humfrey, Peter, *Titian* (London, 2007)

Jones, Roger and Nicholas Penny, *Raphael* (New Haven, CT, and London, 1983)

Kemp, Martin, *Leonardo da Vinci: The Marvellous Works of Nature and Man* (London, 1981)

Levey, Michael, *The World of Ottoman Art* (London, 1975)

Necipoğlu, Gülru, *The Age of Sinan: Architectural Culture in the Ottoman Empire* (London, 2005)

Palladio, Andrea, *The Four Books on Architecture*, trans. R. Tavernor and R. Schofield (Cambridge, MA, and London, 1997)

Paoletti, John T., *Michelangelo's 'David': Florentine History and Civic Identity* (Cambridge, 2015)

Perlingieri, Ilya Sandra, *Sofonisba Anguissola: The First Great Woman Artist of the Renaissance* (New York, 1992)

Pope-Hennessy, John, *Raphael* (London, 1970)

—, Cellini (London, 1985)

Richter, Jean Paul, ed., *The Literary Works of Leonardo da Vinci*, 2 vols (London, 1970)

Salomon, Xavier F., *Veronese: Magnificence in Renaissance Venice*, exh. cat., National Gallery, London (London, 2014)

Summers, David, *Michelangelo and the Language of Art* (Princeton, NJ, 1981)

Symonds, John Addington, *The Life of Michelangelo Buonarroti* (London, 1899)

Syson, Luke, *Leonardo da Vinci: Painter at the Court of Milan*, exh. cat., National Gallery, London (London, 2011)

Wackernagel, Martin, *The World of the Florentine Renaissance Artist: Projects and Patrons, Workshop and Art Market,* trans. Alison Luchs (Princeton, NJ, 1981)

Wittkower, Rudolf, *Architectural Principles in the Age of Humanism* (New York, 1962)

20. Shadows and Power

Alpers, Svetlana, *The Making of Rubens* (New Haven, CT, and London, 1995)

Barnes, Susan J., Nora de Poorter, Oliver Millar and Horst Vey, *Van Dyck: A Complete Catalogue of the Paintings* (New Haven, CT, and London, 2004)

Blunt, A., *Art and Architecture in France, 1500–1700* ([1953] New Haven, CT, and London, 1999)

—, Nicolas Poussin (London, 1958)

Brown, Beverley Louise, ed., *The Genius of Rome*, exh. cat., Royal Academy, London (London, 2001)

Bull, Malcolm, *The Mirror of the Gods* (Oxford, 2005)

Burckhardt, Jacob, *Recollections of Rubens* (London, 1950)

Christiansen, K. and Judith W. Mann, *Orazio and Artemisia Gentileschi*, exh. cat., Metropolitan Museum of Art, New York (New Haven, CT, 2001)

Clark, Kenneth, *The Nude: A Study in Ideal Form* (New York, 1956)

Cropper, Elizabeth and Charles Dempsey, *Nicolas Poussin: Friendship and the Love of Painting* (Princeton, NJ, 1996)

Duffy, S. and J. Hedley, *The Wallace Collection's Pictures: A Complete Catalogue* (London 2004)

Friedlaender, Walter, *Caravaggio Studies* (Princeton, NJ, 1955 and New York, 1969)

Haskell, Francis and Jennifer Montagu, eds, *The Paper Museum of Cassiano dal Pozzo: Catalogue Raisonné of Drawings and Prints in the Royal Library at Windsor Castle, the British Museum, Institut de France and Other Collections* (London, 1994– [ongoing]).

Hibbard, Howard, Bernini (Harmondsworth, 1965)

Krautheimer, R., *The Rome of Alexander VII, 1655–1667* (Princeton, NJ, 1985)

Lavin, Irving, *Bernini and the Unity of the Visual Arts,* 2 vols (New York and London, 1980)

Mahon, D., *Studies in Seicento Art and Theory* (Westport, CT, 1971)

Mormando, Franco, ed., *Saints and Sinners: Caravaggio and the Baroque Image*, exh. cat., Charles S. and Isabella V. McMullen Museum of Art, Boston (Boston, MA, 1999)

Peers, E. A., trans. and ed., *Saint Teresa of Jesus: The Complete Works*, 3 vols (London and New York, 1963)

Rosenberg, P. and K. Christiansen, eds, *Poussin and Nature: Arcadian Visions*, exh. cat., Metropolitan Museum of Art, New York (New York, 2007)

Rumberg, Per and Desmond Shawe-Taylor, *Charles I: King and Collector,* exh. cat., Royal Academy, London (London, 2018)

Treves, Letizia, *Beyond Caravaggio*, exh. cat., National Gallery, London (London, 2016)

Warwick, Genevieve, *Bernini: Art as Theatre* (New Haven, CT, and London, 2012)

Wittkower, Rudolf, *Bernini: The Sculptor of the Roman Baroque* (London, 1955)

—, Art and Architecture in Italy, 1600–1750 ([1973] New Haven, CT, and London, 1999)

Wölfflin, Heinrich, *Renaissance and Baroque*, trans. Kathrin Simon (New York, 1961)

Wright, Christopher, *Poussin: Paintings, a Catalogue Raisonné* (London, 1984))

21. An Open Window

Alpers, Svetlana, *The Art of Describing: Dutch Art in the Seventeenth Century* (London, 1983)

—, *Rembrandt's Enterprise: The Studio and the Marke*t (London, 1988)

Beck, Hans-Ulrich, *Jan van Goyen, 1596–1656,* 2 vols (Amsterdam, 1972–3)

Bevers, H., P. Schatborn and B. Welzel, eds, *Rembrandt: The Master & his Workshop, vol. II: Drawings and Etchings*, exh. cat., Altesmuseum, Berlin; Rijksmuseum, Amsterdam; National Gallery, London (New Haven, CT, and London, 1991–2)

Brown, Christopher, *Scenes of Everyday Life: Dutch Genre Painting of the Seventeenth Century* (London, 1984)

—, J. Kelch and P. J. J. van Thiel, eds, *Rembrandt: The Master & his Workshop*, vol. I: Paintings, exh. cat. Altesmuseum, Berlin; Rijksmuseum, Amsterdam; National Gallery, London (New Haven, CT, and London, 1991–2)

Chapman, H. Perry, *Rembrandt's Self-Portraits: A Study in Seventeenth-Century Identity* (Princeton, NJ, 1990)

Clark, Kenneth, *An Introduction to Rembrandt* (London, 1978)

Corrigan, Karina H., Jan Van Campen and Femke Diercks, eds, *Asia in Amsterdam: The Culture of Luxury in the Golden Age*, exh. cat., Peabody Essex Museum, Salem, MA (New Haven, CT, 2016)

Friedländer, Max, *Landscape, Portrait, Still-Life* (New York, 1963)

Gowing, Lawrence, *Vermeer* (London, 1952)

Griffith, Anthony, *The Print before Photography: An Introduction to European Printmaking 1550–1820* (London, 2016)

Haak, B., *The Golden Age: Dutch Painters of the Seventeenth Century* (New York, 1984)

Impey, Oliver, *The Early Porcelain Kilns of Japan: Arita in the First Half of the Seventeenth Century* (Oxford, 1996)

Jansen, Guido M. C., ed., *Jan Steen: Painter and Storyteller*, exh. cat., National Gallery of Art, Washington, DC (Washington, DC, 1996)

Leeflang, Huigen and Pieter Roelofs, eds, *Hercules Seghers:*

Painter–Etcher, exh. cat., Rijksmuseum, Amsterdam (Amsterdam, 2017)

Mander, Karel van and Hessel Miedema, eds, *The Lives of the Illustrious Netherlandish and German Painters, from the First Edition of the Schilder-boeck (1603–04)* (Doornspijk, 1994–9)

Montias, John Michael, *Vermeer and His Milieu: A Web of Social History* (Princeton, NJ, 1989)

North, Michael, *Art and Commerce in the Dutch Golden Age, trans. Catherine Hill* (New Haven, CT, and London, 1997)

Sandrart, Joachim von, *Lives of Rembrandt, Baldinucci and Houbraken* (London, 2007)

Schama, Simon, *The Embarrassment of Riches: An Interpretation of Dutch Culture in the Golden Age* (New York, 1987)

Schrader, Stephanie, ed., *Rembrandt and the Inspiration of India*, exh. cat., J. Paul Getty Museum, Los Angeles (Los Angeles, CA, 2018)

Segal, Sam, *A Prosperous Past: The Sumptuous Still Life in the Netherlands, 1600–1700* (The Hague, 1988)

Slive, Seymour, *Dutch Painting, 1600–1800* (New Haven, CT, and London, 1995)

—, *Frans Hals* (London, 2014)

Waiboer, Adriaan E., ed., *Gabriel Metsu: Rediscovered Master of the Dutch Golden Age*, exh. cat., National Gallery of Ireland, Dublin (Dublin, 2010)

—, *Gabriel Metsu: Life and Work: A Catalogue Raisonné* (New Haven, CT, and London, 2012)

Welu, James A. and Pieter Biesboer, *Judith Leyster: A Dutch Master and Her World*, exh. cat., Worcester Art Museum (New Haven, CT, 1993)

White, Christopher, *Rembrandt* (London, 1984)

— and Quentin Buvelot, *Rembrandt by Himself,* exh. cat., National Gallery, London (London, 1999)

Wright, Elaine, *Muraqqá: Imperial Mughal Albums from the Chester Beatty Library*, Dublin (Alexandria, 2008)

22. Choosing To Be Human

Arnason, H. H., *The Sculptures of Houdon* (London, 1975)

Baillio, Joseph and Xavier Salmon, *Élisabeth Louise Vigée Le Brun*, exh. cat., Grand Palais, Paris (Paris, 2016)

Banks, O. T., *Watteau and the North: Studies in the Dutch and Flemish Baroque Influence on French Rococo Painting* (New York and London, 1977)

Bindman, D., *Hogarth* (London, 1981)

Brookner, Anita, *Jacques-Louis David* (London, 1980)

Bryson, Norman, *Looking at the Overlooked: Four Essays on Still Life Painting* (London, 1990)

Chou, Ju-his and Claudia Brown, *The Elegant Brush: Chinese Painting under the Qianlong Emperor, 1735–1795*, exh. cat., Phoenix Art Museum (Phoenix, AZ, 1985)

Cowley, Robert L. S., *Marriage A-la-Mode: A Re-View of Hogarth's Narrative Art* (Manchester, 1989)

Crow, Thomas, *Painters and Public Life in Eighteenth-Century Paris* (New Haven, CT, and London, 1985)

Duffy, Stephen and Jo Hedley, *The Wallace Collection's Pictures: A Complete Catalogue* (London, 2004)

Egerton, Judy, *Hogarth's Marriage A-la-Mode,* exh. cat., National Gallery, London (London, 1997)

Hayes, John, *Gainsborough: Paintings and Drawings* (London, 1975)

—, *The Landscape Paintings of Thomas Gainsborough*, 2 vols (London, 1982)

Honour, H. and J. Fleming, *A World History of Art* (London, 1982)

Hsü, Ginger Cheng-Chi, *A Bushel of Pearls: Painting for Sale in*

Eighteenth-Century Yangchow (Stanford, CA, 2001)

Karlsson, Kim, *Luo Ping: The Life, Career and Art of an Eighteenth-Century Chinese Painter* (Bern, 2004)

—, Alfreda Murck and Michele Matteini, *Eccentric Visions: The Worlds of Luo Ping*, exh. cat., Museum Rietberg, Zurich (Zurich, 2009)

Postle, Martin, ed., *Joshua Reynolds: The Creation of Celebrity*, exh. cat., Tate Britain, London (London, 2005)

Richardson, Tim, *The Arcadian Friends: Inventing the English Landscape Garden* (London, 2007)

Rousseau, Jean-Jacques, *Discourse on the Origin and Foundations of Inequality among Men,* trans. and ed. Helena Rosenblatt (Boston, MA, and New York, 2011)

Stephens, Frederic G., *English Children as Painted by Sir Joshua Reynolds* (London, 1867)

Sullivan, Michael, *The Meeting of Eastern and Western Art from the Sixteenth Century to the Present Day* (London, 1973)

Surlapierre, Nicolas, Yohan Rimaud, Alastair Laing and Lisa Mucciarelli, eds, *La Chine rêvée de François Boucher: une des provinces du rococo* (Paris, 2019)

Tomlinson, Janis, *Goya: A Portrait of the Artist* (Princeton, NJ, 2020)

Uglow, Jenny, *Hogarth: A Life and a World* (London, 1997)

Wildenstein, G., *The Paintings of Fragonard: Complete Edition* (London, 1960)

23. The Poetic Impulse

Ackroyd, Peter, *Blake* (London, 1995)

Avery, Kevin J., *Church's Great Picture 'The Heart of the Andes'*, exh. cat., Metropolitan Museum, New York (New York, 1993)

Bindman, David, *Blake as an Artist* (Oxford, 1977)

Brookner, Anita, *Romanticism and Its Discontents* (London, 2000)

Clark, Steve and Masashi Suzuki, eds, *The Reception of Blake in the Orient* (London and New York, 2006)

Eitner, Lorenz, *Géricault's 'Raft of the Medusa'* (London, 1972)

Gowing, Lawrence, *Turner: Imagination and Reality*, exh. cat., Museum of Modern Art, New York (New York, 1966)

Grave, Johannes, *Caspar David Friedrich*, trans. Fiona Elliott (Munich, 2017)

Grigson, Geoffrey, *Samuel Palmer: The Visionary Years* (London, 1947)

Honour, Hugh, *Romanticism* (Harmondsworth, 1979)

Howat, John K., *Frederic Church* (New Haven, CT, 2005)

The Journal of Eugène Delacroix, trans. Walter Pach (New York, 1948)

Lane, Richard, *Images of the Floating World: The Japanese Print, Including an Illustrated Dictionary of Ukiyo-e* (Oxford, 1978)

Poster, Amy G. and Henry D. Smith, *Hiroshige: One Hundred Famous Views of Edo* (London, 1986)

Rosen, Charles and Henri Zerner, eds, *Romanticism and Realism: The Mythology of Nineteenth Century Art* (London, 1984)

Torrence, Gaylord, ed., *The Plains Indians: Artists of Earth and Sky*, exh. cat., Metropolitan Museum of Art, New York (New York, 2015)

Truettner, William H. and Alan Wallach, eds, *Thomas Cole: Landscape into History* (New Haven, CT, and London, 1994)

Vaughan, William, *Samuel Palmer: Shadows on the Wall* (New Haven, CT, and London, 2015)

Vigne, Georges, *Ingres*, trans. John Goodman (New York, 1995)

Wade, Edwin L., ed., *The Arts of the North American Indian: Native Traditions in Evolution* (New York, 1986)

Waterhouse, D. B., *Harunobu and His Age: The Development of Colour Printing in Japan* (London, 1964)

Wordsworth, William, *The Prelude: A Parallel Text,* ed. J. C. Maxwell (Harmondsworth, 1971)

24. Everyday Revolutions

Aceves Barajas, P., *Hermenegildo Bustos* ([1956] Guanjuato, 1996)

Adler, Kathleen, *Mary Cassatt: Prints*, exh. cat., National Gallery, London (London, 2006)

Atkins, Anna, *Sun Gardens: Victorian Photograms*, with text by Larry J. Schaaf (New York, 1985)

Aubenas, S. and G. Baldwin, eds, *Gustave Le Gray, 1820–1884,* exh. cat., Getty Museum, Los Angeles (Los Angeles, CA, 2002)

Barter, Judith A., *Mary Cassatt: Modern Woman*, exh. cat., The Art Institute of Chicago (New York, 1998)

Baudelaire, Charles, *The Painter of Modern Life and other Essays*, trans. Jonathan Mayne (London, 1964)

Bowness, Alan, *Poetry and Painting: Baudelaire, Mallarmé, Apollinaire and Their Painter Friends* (Oxford, 1994)

Browse, Lillian, *Degas Dancers* (London, 1949)

Busch, W., *Adolph Menzel: Leben und Werk* (Munich, 2004); English trans. by Carola Kleinstück-Schulman as *Adolf Menzel: The Quest for Reality* (Los Angeles, CA, 2017)

Clark, T. J., *The Absolute Bourgeois: Artists and Politics in France, 1848–1851* (London, 1973)

—, *Image of the People: Gustave Courbet and the 1848 Revolution* (London, 1973)

—, *The Painting of Modern Life: Paris in the Art of Manet and His Followers*, rev. edn (London, 1999)

Cooper, Douglas, *The Courtauld Collection* (London, 1954)

Cox, Julian and Colin Ford, eds, *Julia Margaret Cameron: The Complete Photographs* (London, 2003)

Danchev, Alex, *The Letters of Paul Cézanne* (London, 2013)

Eisenman, Stephen F., ed., *Nineteenth-Century Art: A Critical History* (London, 2011)

Fox Talbot, William Henry, *The Pencil of Nature* ([1844] Chicago, IL, and London, 2011)

Gordon, Sophie, *Shadows of War: Roger Fenton's Photographs of the Crimea, 1855* (London, 2017)

House, John, *Impressionism: Paint and Politics* (London, 2004)

Huysmans, J. K., *Modern Art (L'Art moderne)*, trans. Brendan King (Sawtry, 2019)

Jansen, Leo, Hans Luijten and Nienke Bakker, *Vincent Van Gogh: The Letters: The Complete Illustrated and Annotated Edition* (London and New York, 2009)

Keisch, Claude and Marie Ursula Riemann-Reyher, eds, *Adolph Menzel, 1815–1905: Between Romanticism and Impressionism*, exh. cat., National Gallery, Washington, DC (New Haven, CT, 1996)

Kendall, Richard, ed., *Degas by Himself* (London, 1987)

— and Jill Devonyar, *Degas and the Ballet: Picturing Movement*, exh. cat., Royal Academy, London (London, 2011)

Leslie, Charles Robert, *Memoirs of the Life of John Constable, Composed Chiefly of his Letters* (London, 1845)

Mathews, Nancy Mowll, *Mary Cassatt: A Life* (New Haven, CT, and London, 1994)

Moore, George, *Impressions and Opinions* (London, 1891)

Murphy, Alexandra R., Richard Rand, Brian T. Allen, James Ganz and Alexis Goodin, *Jean-François Millet: Drawn into the Light,* exh. cat., Sterling and Francine Clark Art Institute, Williamstown, MA (New Haven, CT, 1999)

Os, Henk van and Sjeng Scheijen, *Ilya Repin: Russia's Secre*t, exh. cat., Groninger Museum (Groningen, 2001)

Paz, Octavio, *Essays on Mexican Art* (New York, 1993)

Pollock, Griselda, *Mary Cassatt: Painter of Modern Women* (London, 1998)

Rewald, John, *The History of Impressionism* (New York, 1946)

Schivelbusch, Wolfgang, *Disenchanted Night: The Industrialisation of Light in the Nineteenth Century*, trans. Angela Davies (Berkeley and Los Angeles, CA, 1988)

Stevens, MaryAnne et al., *Manet: Portraying Life*, exh. cat., Royal Academy, London (London, 2013)

Thoré, Théophile, *Salons de Th. Thoré, 1844–48* (Paris, 1868)

Tibol, Raquel, *Hermenegildo Bustos, pintor del pueblo* (Guanajuato, 1981 and Mexico City, 1999)

Valkenier, Elizabeth, *Russian Realist Art: State and Society: The Peredvizhniki and Their Tradition* (New York, 1989)

Venturi, Lionel, *Les archives de l'impressionnisme*, 2 vols (Paris and New York, 1939)

Weisberg, Gabriel P., *The Realist Tradition: French Painting and Drawing 1830–1900* (Cleveland, OH, 1981)

Wilson-Bareau, Juliet, *Manet by Himself* (London, 1991)

Wue, Roberta, *Art Worlds: Artists, Images and Audiences in Late Nineteenth-Century Shanghai* (Honolulu, HA, 2014)

25. Mountains and Oceans

Adriani, Götz, *Toulouse-Lautrec: The Complete Graphic Work*, exh. cat., Royal Academy, London (London, 1988)

Attenborough, David, *The Tribal Eye* (London, 1976)

Bakker, Nienke and Louis van Tilborgh, *Van Gogh & Japan*, exh. cat., Van Gogh Museum, Amsterdam (New Haven, CT, and London, 2018)

Barbeau, Marius, *Totem Poles of the Gitksan, Upper Skeena River, British Columbi*a, Bulletin of the National Museum of Canada, no. 61 (1929)

Bashkoff, Tracey, *Hilma af Klint: Paintings for the Future*, exh. cat., Guggenheim Museum, New York (New York, 2019)

Brunt, Peter and Nicholas Thomas, eds, *Art in Oceania: A New History* (London, 2012)

Caldeira, Leah, Christina Hellmich, Adrienne L. Kaeppler, Betty Lou Kam and Roger G. Rose, *Royal Hawaiian Featherwork: Na Hulu Ali'i*, exh. cat., de Young Museum, San Francisco (Honolulu, HA, 2015)

Carey, Frances and Anthony Griffiths, *From Manet to Toulouse-Lautrec: French Lithographs 1860–1900*, exh. cat., British Museum, London (London, 1978)

Childs, Elizabeth C., *Vanishing Paradise: Art and Exoticism in Colonial Tahiti* (Berkeley, CA, 2013)

Conisbee, Philip and Denis Coutagne, *Cézanne in Provence*, exh. cat., National Gallery of Art, Washington, DC (New Haven, CT, 2006)

Danchev, Alex, *Cézanne: A Life* (London, 2012)

—, *The Letters of Paul Cézanne* (London, 2013)

Duret, Théodore, *Histoire des peintres impressionnistes: Pissarro, Claude*

Monet, Sisley, Renoir, Berthe Morisot, Cézanne, Guillaumin ([1874] Paris, 1922)

Gathercole, Peter, Adrienne L. Kaeppler and Douglas Newton, *The Art of the Pacific Islands*, exh. cat., National Gallery of Art, Washington, DC (Washington, DC, 1979)

Gell, Alfred, *Wrapping in Images: Tattooing in Polynesia* (Oxford, 1993)

Hooper, Steven, *Pacific Encounters: Art & Divinity in Polynesia, 1760–1860*, exh. cat., Sainsbury Centre for Visual Arts, Norwich (London, 2006)

Ireson, Nancy, ed., *Toulouse-Lautrec and Jane Avril: Beyond the Moulin Rouge*, exh. cat., Courtauld Institute, London (London, 2011)

Jansen, Leo, Hans Luijten and Nienke Bakker, *Vincent Van Gogh: The Letters: The Complete Illustrated and Annotated Edition* (London and New York, 2009)

Jonaitis, Aldona, *From the Land of the Totem Poles: The Northwest Coast Indian Art Collection at the American Museum of Natural History* (New York, 1988)

Kaufmann, Christian, *Korewori: Magic Art from the Rainforest*, exh. cat., Museum der Kulturen, Basel (Basel, 2003)

Kjellgren, Eric, *Oceania: Art of the Pacific Islands in the Metropolitan Museum of Art* (New York and London, 2007)

— and Carol S. Ivory, *Adorning the World: Art of the Marquesas Islands*, exh. cat., Metropolitan Museum of Art, New York (New York, 2005)

Müller-Westermann, Iris, *Hilma af Klint: A Pioneer of Abstraction*, exh. cat., Moderna Museet, Stockholm (Ostfildern, 2013)

Rewald, John, *The Paintings of Paul Cézanne: A Catalogue Raisonné*, 2 vols (London, 1996)

Rilke, Rainer Maria, *Letters on Cézanne*, ed. Clara Rilke, trans. Joel Agee (London, 1988)

Roskill, Mark, *Van Gogh, Gauguin and the Impressionist Circle* (Greenwich, CT, 1970)

Ruskin, John, *Modern Painters, vol. IV, Of Mountain Beauty* (London, 1856)

Shackleford, George T. M. and Claire Frèches-Thory, eds, *Gauguin Tahiti: The Studio of the South Seas*, exh. cat., Galeries Nationales du Grand Palais, Paris (Paris, 2004)

Teilhet-Fisk, Jehann, *Paradise Reviewed: An Interpretation of Gauguin's Polynesian Symbolism* (Ann Arbor, MI, 1983)

Thomas, Nicholas, *Oceanic Art* (London, 2018)

Townsend-Gault, Charlotte, Jennifer Kramer and Ki-ke-in, *Native Art of the*

Northwest Coast: A History of Changing Ideas* (Vancouver and Toronto, 2013)

Uhlenbeck, Chris, Louis Van Tilborgh and Shigeru Oikawa, *Japanese Prints: The Collection of Vincent Van Gogh* (London, 2018)

Watkins, Nicholas, *Bonnard* (London, 1994)

Weisberg, Gabriel P. et al., *Japonisme: Japanese Influence on French Art 1854–1910*, exh. cat., Cleveland Museum of Art (Cleveland, OH, 1975)

Whitfield, Sarah and John Elderfield, *Bonnard*, exh. cat., Tate Gallery, London (London, 1998)

Wright, Alastair and Calvin Brown, *Paradise Remembered: The Noa Noa Prints*, exh. cat., Princeton University Art Museum (Princeton, NJ, 2010)

26. New Worlds

Ades, Dawn, *Photomontage* (London, 1976)

—, *Dalí: The Centenary Retrospective*, exh. cat., Palazzo Grassi, Venice (London, 2005)

Apollonio, Umbro, ed., *Futurist Manifestos* (London, 1973)

Barr, Alfred Hamilton, *Matisse: His Art and His Public* (New York, 1951)

Bergdoll, Barry and Leah Dickerman, eds, *Bauhaus 1919–1933: Workshops for Modernity*, exh. cat., Museum of Modern Art, New York (New York, 2009)

Bowlt, John E., *Russian Art of the Avant-Garde: Theory and Criticism 1902–1934* (New York, 1976)

Breton, André, *Manifestoes of Surrealism*, trans. Richard Seaver and Helen R. Lane (Ann Arbor, MI, 1969)

Cooper, Harry, *Mondrian: The Transatlantic Paintings* (Cambridge, MA, 2001)

Cowling, Elizabeth, *Picasso: Style and Meaning* (London, 2002)

Dickerman, Leah and Brigid Doherty, eds, *Dada: Zurich, Berlin, Hannover, Cologne, New York, Paris*, exh. cat., National Gallery of Art, Washington, DC (Washington, DC, 2005)

Dickermann, Leah and Elsa Smithgall, *Jacob Lawrence: The Migration Series* (New York and Washington, DC, 2015)

Eldredge, Charles C., *Georgia O'Keeffe* (New York, 1991)

Flam, Jack D., ed., *Matisse on Art* (New York, 1978)

—, *Matisse: The Man and His Art, 1869–1914* (London, 1986)

Foster, Hal, Rosalind E. Krauss, Yve-Alain Bois, Benjamin Buchloh, David Joselit, *Art since 1900: Modernism, Antimodernism, Postmodernism* (London, 2004)

Freud, Sigmund, *The Interpretation of Dreams*, trans. James Strachey ([1900] London, 1954)

Fry, Roger, *Vision and Design* (London, 1920)

Gale, M., ed., *Paul Klee: Creative Confession and Other Writings* (London, 2013)

Golding, John, *Boccioni's Unique Forms of Continuity in Space* (London, 1985)

Gray, Camilla, *The Great Experiment: Russian Art 1863–1922* (London, 1962)

Green, Christopher, ed., *Picasso's 'Les Demoiselles d'Avignon'* (Cambridge, 2001)

Helfenstein, J. and C. Rümelin, eds, *Paul Klee: Catalogue Raisonné* (New York, 1998–2004)

Hills, Patricia, *Painting Harlem Modern: The Art of Jacob Lawrence* (Berkeley, CA, 2009)

Hohl, Reinhold, *Alberto Giacometti: Sculpture, Painting, Drawing* (London, 1972)

Holtzman, Harry and Martin S. James, ed. and trans., *The New Art – The New Life: The Collected Writings of Piet Mondrian* (London, 1987)

Klee, Paul, *On Modern Art* (London, 1945)

Krauss, Rosalind, *Passages in Modern Sculpture* (New York, 1977)

Leja, Michael, *Reframing Abstract Expressionism: Subjectivity and Painting in the 1940s* (New Haven, CT, and London, 1993)

Lodder, Christine, *Russian Constructivism* (New Haven, CT, and London, 1983)

Lynes, Barbara Buhler, *Georgia O'Keeffe: Catalogue Raisonné* (New Haven, CT, 1999)

Milner, John, *Mondrian* (London, 1992)

Nesbett, Peter T. and Michelle DuBois, eds, *Over the Line: The Art and Life of Jacob Lawrence* (Seattle, WA, and London, 2001)

Ottinger, Didier, ed., *Futurism*, exh. cat., Centre Pompidou, Paris (Paris, 2009)

Porter, James A., *Modern Negro Art* (New York, 1943)

Richardson, John, with the collaboration of Marilyn McCully, *A Life of Picasso, vol. II: 1907–1917* (London, 1996)

Schwarz, Arturo, *The Complete Works of Marcel Duchamp* (London, 1997)

Sylvester, David, *Looking at Giacometti* (London, 1994)

Tomkins, Calvin, *Duchamp: A Biography* (New York, 1996)

27. After the Trauma

Andrews, Julia F., *Painters and Politics in the People's Republic of China, 1949–1979* (Berkeley, CA, 1994)

Benjamin, Walter, *The Work of Art in the Age of Its Technological Reproducibility and Other Writings on Media*, ed. Michael W. Jennings, Brigid Doherty and Thomas Y. Levin, trans. Edmund Jephcott, Rodney Livingstone, Howard Eiland et al. (Cambridge, MA, and London, 2008)

Blazwick, Iwona and Sandy Nairne, *We Won't Play Nature to Your Culture: Barbara Kruger*, exh. cat., ICA, London (London, 1983)

Butler, Cornelia H. and Luis Pérez-Oramas, eds, *Lygia Clark: The Abandonment of Art, 1948–88*, exh. cat., Museum of Modern Art, New York (New York, 2014)

Enwezor, Okwui, ed., *The Short Century: Independence and Liberation Movements in Africa 1945–1994*, exh. cat., Museum Villa Stuck, Munich (Munich, 2001)

—, Katy Siegel and Ulrich Wilmes, eds, *Postwar: Art between the Pacific and the Atlantic, 1945–1965*, exh. cat., Haus der Kunst, Munich (Munich, 2016)

Fabian, Johannes, *Remembering the Present: Painting and Popular History in Zaire* (Berkeley, CA, 1996)

Fajardo-Hill, Cecilia and Andrea Giunta, *Radical Women: Latin American Art, 1960–1985*, exh. cat., Hammer Museum, Los Angeles (New York, 2017)

Feldman, Paula and Karsten Schubert, eds, *It Is What It Is: Writings on Dan Flavin since 1964* (London, 2004)

Foster, Hal and Mark Francis, *Pop Art* (London, 2005)

Godfrey, Mark, Paul Schimmel and Vicente Todolí, eds, *Richard Hamilton*, exh. cat., Tate Modern, London (London, 2014)

Govan, Michael and Tiffany Bell, eds, *Dan Flavin: A Retrospective*, exh. cat., National Gallery of Art, Washington, DC (New Haven, CT, 2005)

Greenberg, Clement, *Art and Culture* (New York, 1961)

Heidegger, Martin, *Basic Writings: From 'Being and Time' (1927) to 'The Task of Thinking'* (1964), rev. and ed. David Farrell Krell (London, 1993)

Heimberg, Bruno and Susanne Willisch, eds, *Joseph Beuys: Das Ende des 20. Jahrhunderts: Die Umsetzung vom Haus der Kunst in die Pinakothek der Moderne München / Joseph Beuys: The End of the 20th Century: The Move from the Haus der Kunst to the Pinakothek der Moderne München* (Munich, 2007)

Krauss, Rosalind, T*erminal Iron Works: The Sculpture of David Smith* (Cambridge, MA, 1971)

Lingwood, James, ed., *Rachel Whiteread: House* (London, 1995)

Moorhouse, Paul, *Interpreting Caro* (London, 2005)

Nairne, Eleanor, *Lee Krasner: Living Colour, exh. cat., Barbican Centre, London* (London, 2019)

Newman, Barnett, *Selected Writings and Interviews* (Berkeley, CA, 1990)

Nochlin, Linda, *Women, Art and Power: And Other Essays* (New York, 1988)

Rosenberg, Harold, *The Tradition of the New* (New York, 1959)

Rosenthal, Stephanie, ed., *Traces: Ana Mendieta*, exh. cat., Hayward Gallery, London (London, 2013)

Sartre, Jean-Paul, *Existentialism and Humanism*, trans. Philip Mairet (London, 1948)

Sherman, Cindy, *The Complete Untitled Film Stills* (New York, 2003)

Sontag, Susan, *On Photography* (New York, 1977)

Stonard, John-Paul, *Germany Divided: Baselitz and His Generation, from the Duerckheim Collection*, exh. cat., British Museum, London (London, 2014)

Storr, Robert, *Gerhard Richter: Doubt and Belief in Painting*, exh. cat., Museum of Modern Art, New York (New York, 2002)

Warhol, Andy, *Popism: the Warhol '60s* (New York, 1980)

— and Pat Hackett, *POPism: The Warhol Sixties* ([1980] London, 2007)

Acknowledgements

A great many thanks to those who encouraged and supported *Creation* from the outset: to Katherine Graham, Jacky Klein and Lara Feigel, to my editor at Bloomsbury Michael Fishwick, and my agent at Rogers Coleridge and Wright, Zoë Waldie. Thank you to all those at Bloomsbury: in particular to Sarah Ruddick and Lauren Whybrow, who so brilliantly managed the production of the book, to Amanda Waters, Hannah Paget and Jonny Coward. Thank you to Matthew Taylor for excellent copy-editing, to Catherine Best for proofreading, Evi O. and Kait Polkinghorne for the design, and to Jo Carlill, who researched the pictures for this book and dealt so adroitly with the minefield of copyright and reproduction fees.

I am deeply grateful to the support of Christian Duerckheim, without which the writing of this book would not have been remotely possible. Vital support was also received from the Daiwa Foundation, for a study trip to Japan, and at a crucial juncture from the Society of Authors Covid Emergency Fund.

I am very grateful to those who offered to read individual chapters on the basis of their own expertise. Their comments were invaluable in shaping the text, through often trenchant criticism: Dawn Ades, Mary Beard, Douglas Brine, Caroline Campbell, Paul Collins, Jill Cook, Kathleen Doyle, Antony Eastmond, David Ekserdjian, Eric Fernie, Robert Hewison, Paul Hills, Linda Goddard, Yuriko Jackall, Eleanor Jackson, Yujen Liu, Manuela Mena Marqués, Mary Ellen Miller, Tom Phillips, Imma Ramos, Jessica Rawson, Gay Robins, Norman Rosenthal, Richard Shone, Peter Stewart, Christopher White, Rachel Wood.

Thank you also to those who helped out during study visits: to Patrick Kingsley for his address book in Cairo; to Claudia Lega for unlocking the Vatican Museum; to James Fenton and Darryl Pinckney for their hospitality in Harlem; to Liliana Dominguez for her help in Mexico City; to Yujen Liu for expert guidance around the National Palace Museum in Taipei; to Birte Kleeman and to Zhou Tiehai for help and conversation in Shanghai; and to Annabel James for help in Tokyo.

Numerous librarians, curators, archivists, press officers and others provided help, and I thank all of those, particularly the staff of the London Library, and of the Rare Books and Music Reading Room at the British Library. *Creation* was written in transit around the world, and I am grateful to all those who helped along the way, many whose names I never learned, but whose kindness I will not forget.

Many others provided support and encouragement over the years during which the ideas for this book were emerging as well as during the writing. My thanks in particular to Alister Warman, who was sadly unable to see a copy of the finished book. His conversation and insight truly helped shaped the contents. Much gratitude also to: Nasser Azam, Carmen Bambach, Doris Behrens-Abousief, Chiara Barbieri, Shulamith Behr, Paul Benney, Sue Brunning, Glenn Brown,

Mimi Chu, Craig Clunas, Rob Cooper, Bart Cornelis, Dexter Dalwood, Renata Danobeitia, Andrew Davidson, Nicola Elvin, Donato Esposito, Flora McEverdy, Rupert Faulkner, Jonathan Hay, Damien Hirst, Howard Hodgkin, Sam Hodgkin, Yasuyoshi Ichihashi, Sachiko Idemitsu, Emily Jarvis, Emma Kay, Rose Kerr, Edgar Laguinia, Michelle Matteini, Steven Mithen, Vanessa Nicholson, Lukas Nickel, Hiroko Nishida, Stuart Proffitt, Steven Quirke, John Riley, Karsten Schubert, Michael Taylor, Alison Turnbull, and to Aurélie Verdier.

First, last, and most profound thanks are to Katherine Graham, who read many of the early drafts, and made so much of the writing of *Creation* possible.

Picture Credits

All reasonable efforts have been made by the author and publishers to trace the copyright owners of the material quoted in this book and of any images reproduced in this book. In the event that the author or publishers are notified of any mistakes or omissions by copyright owners after publication, the author and publishers will endeavour to rectify the position accordingly for any subsequent printing.

Key: t: top, b: below, m: middle, l: left, r: right

akg-images: 201l; 234; 235; 237t; 261; 264; 265; 290b; 339r; 345; 349; 368t; /Bible Land Pictures 27, /Zev Radovan 100t; /Nimatallah 41; /Pictures From History 42t; /De Agostini Picture Lib. 75l, /V. Pirozzi 99, /G. Dagli Orti 203; /Eric Vandeville 76; /Interfoto 80; / Erich Lessing 83, 109, 324, 342; /Jean-Louis Nou 93tl; /Hervé Champollion 161t; /Mondadori Portfolio / Remo Bardazzi 193; /Heritage Images /Fine Art Images /Rabatti & Domingie 207t, 208; / National Gallery, London 215, 291t, 353; /Heritage Images /Fine Art Images 224b, /Art Media 225; / Fratelli Alinari 255; /Gerard Degeorge 258b; /World History Archive 302; /Album 260, 311b, 319, /Prisma 312; /CDA /Guillemot 354; /© **2021 Mondrian/ Holtzman Trust** 379; /© Banco de México Diego Rivera Frida Kahlo Museums Trust, Mexico, D.F./ DACS 2021 383; **Alamy**: /Chronicle 9, 241; /Peter Svarc 34; /Prisma Archivo 57; /Beryl Peters Collection 61; /ephotocorp 93b; /Peter Horree 108l, 108r; /Adam Eastland 117b; /Artokoloro 152; /Ivan Vdovin 155; /John Kellerman 157; /Art Heritage 163; / Art Collection 2 170; /The History Collection 192; /The Picture Art Collection 197, 257t; /Archivart 224t; / Pictures Now 231b; /Suzuki Kaku 240; /robertharding 247; /Abbus Acastra 251; /MSE Stock 263; /Art Collection 3 303b; /Cecil O.Cecil 309b; /Heritage Image Partners 337; /© **Andreas Gursky**: Andreas Gursky /DACS, 2021, courtesy: Sprüth Magers 411; **Archive.org**: Courtesy of the Smithsonian Libraries and Archives /Licensed by CCO 1.0 /Robert Wood (1717-1771), *The ruins of Palmyra, otherwise Tedmor, in the desert*. pub. London 1753 307; **art-and-archaeology.com**: /Michael D. Gunther /Licensed by CC BY-SA 3 47; **Artimage**: Artwork © Rachel Whiteread. All Rights Reserved, DACS 2021. Photo: © John Davies *(House 3b)* 413; **Asia Art Archive**: /Hans van Dijk Archive. Courtesy of Zhang Peili 407; © **Asian Art Museum of San Francisco**: Gift of the Grabhorn Ukiyo-e Collection, 2005.100.32. Photograph 327b; **biodiversitylibrary.org**: / page/19538109 /Smithsonian libraries, from *Dictionnaire d'histoire naturelle* by Charles d'Orbigny (1806-1876) 141; © Bishop Museum, Bishop Museum Archives: photo by Hal Lum and Masayo Suzuki 365; **Bridgeman Images**: 88; 97; 103; 107; 113; 146; 147; 148; 161b; 196t; 211; 212; 220; 223; 227; 228; 250; 253; 259; 262; 281; 291b; 299; 321; 322; 329; 330; 331; 332; 341; /© Ashmolean Museum 14b, 325; /© Ali Meyer 17t; /© Zev Radovan 22; /© Museum of Fine Arts, Boston: / Harriet Otis Cruft Fund 17b, /Harvard University -Museum of Fine Arts Expedition 32, /Purchased of Edward P.Warren, Pierce Fund 37, /Gift of Quincy Adams Shaw through Quincy Adams Shaw, Jr., and Mrs. Marian Shaw Haughton 344; /Werner Forman Archive 39, 110l, 110r; /photo © **Fitzwilliam Museum,**

University of Cambridge 43, 323; /© British Library Board. All Rights Reserved 87, 129, 133; /Pictures from History 91, 123t, 326; /Luisa Ricciarini 100b; /United Archives/Carl Simon 119; /© photo Peter Willi 153b; / Seattle Art Museum/Eugene Fuller Memorial Collection 187; /© Veneranda Biblioteca Ambrosiana/ Gianni Cigolini/Mondadori Portfolio 198; /Alinari 199b, 256; /© Royal Collection Trust © Her Majesty Queen Elizabeth II, 2021 200, 237b, 275, 276, 295t; /© Look and Learn 207b; /Stefano Bianchetti 217; /© Musée Condé, Chantilly 219; /photo © Dirk Bakker 242; /Granger 258t, 361; /© Wallace Collection, London 277, 300; /© Art Gallery of Ontario 301t; / Phillips, Fine Art Auctioneers, New York 311t; /© Courtauld Gallery 346, 363; /© CSG CIC Glasgow Museums Collection 351; /© Philadelphia Museum of Art/The George W. Elkins Collection 358; /© Brooklyn Museum of Art/Museum Collection Fund 368b; /© photo Peter Willi /© **2021 Mondrian/Holtzman Trust 391**; /© **ADAGP, Paris and DACS, London 2021** 396; /© R. Hamilton. All Rights Reserved, DACS 2021 401; © **Calouste Gulbenkian Foundation, Lisbon**: / Calouste Gulbenkian Museum - Founder's Collection. Photo: Catarina Gomes Ferreira 121t; **ColBase** (https://colbase.nich.go.jp/): /Tokyo National Museum /CC BY 4.0 179, 186; **Columbus Museum of Art, Ohio**: Licensed by CC-PD-US 304; **Compania Mexicana Aerofoto**: from *The First Civilizations* by Glyn Daniel, publ. 1973 142; © **Dunhuang Academy**: / photo 94; **Freer Gallery of Art, Smithsonian Institution, Washington, D.C.**: Purchase -Charles Lang Freer Endowment, F1935.23 122t; **Getty Images**: /Jeff Pachoud/AFP 5; /De Agostini 30, 31b, 48, 55, 75r, 77b,308; /Corbis 36, 68, 116, 168, 169, 292; / The Print Collector 67, 79t, 252; /Fine Art Images/ Heritage Images 69, 199t, 271, 286t, 289; /ullstein bild 279; /The Royal Photographic Society Collection / Victoria and Albert Museum, London 81t; /Bettmann 81b, 127; /UIG 82; /Eliot Elisofon/The LIFE Picture Collection 89t, 95; /Universal History Archive 93tc; / Universal Images Group 106, 111, 156; /©Santiago Urquijo 118; /Apic 153t; **Gerhard Richter Images:** © Gerhard Richter 2021 (0062) 403; **Glenstone Museum, Potomac, Maryland**: /Courtesy Barbara Kruger and Sprüth Magers. Photo: Ron Amstutz 410; **Giulio Emanuele Rizzo**: From *Per la Ricostruzione dell Ara Pacis Augustae, in Capitolium, vol.2*, no.8 (Nov. 1926), pp. 457-473 82; **Griffith University**: / Maxime Aubert 3; **heliview.co.uk**: /© Dave White 11; **Herlinde Koelbl**: 42b; **Hilma af Klint Foundation**: / photo 371; **Hong Kong Museum of Art Collection**: / photo 315; **John-Paul Stonard**: /Nezu Art Museum, Tokyo 189t; **Kasmin Gallery**: /Image courtesy. © The Pollock-Krasner Foundation ARS, NY and DACS, London 2021 399; **Kolpinskij Ju. D.**: From *Skulptura*

Drevnej Ellady. Moscow, 1963. Ill. 59; **Leon Marotte**: from Rodin Ars Asiatica, 1921 93tr; **MIHO MUSEUM:** /photo courtesy 180; **Musée des Civilisations noires, Dakar, Senegal**: 245b; **Museo Nacional de Arte, Mexico, INBA**: 343; **Museum Rietberg** Zürich: /photo Rainer Wolfsberger 177;© **Museum Ulm, Ulm, Germany**: /photo Oleg Kuchar 4; **Nara National Museum, Kofuku-ji**: 182; photo from 1933 volume on Japanese sculpture 184t; © National Commission for Museums and Monuments, Nigeria: /Museum for African Art. Photo Karin L. Willis 243; **National Gallery of Art, Washington**: /Samuel H. Kress Collection (1946.18.1) 283; /Gift of Mr. and Mrs. Robert Woods Bliss (1949.6.1) 286b; /Chester Dale Collection (1963.10.255) 352; © **National Museum of Namibia**: /photo courtesy 239; **Oriental Institute of the University of Chicago:** /photo courtesy 24; **Palazzo Liviano, Universita di Padova**: 196b; **Petr Novák**: /Licensed by CC BY-SA 2.5 7; **Ressel Fok Family Collection**: 314; **Rijksmuseum, Amsterdam**: 285, 287, 290t, 294t; **Scala, Florence**: /photo Hervé Lewandowski. Paris, Louvre. © 2021. RMN-Grand Palais 56; /photo Les frères Chuzeville. Paris, Louvre. © 2021. RMN-Grand Palais 79b; /photo **© 2021** 102t; / photo Andrea Jemolo © 2021 102b; /photo Manel Cohen © 2021 158; /© **2021. Image copyright** Museo Nacional del Prado © **Photo MNP** 205; /photo Joerg P.Anders © 2021. /bpk, Bildagentur fuer Kunst, Kultur und Geschichte, Berlin 213b; /photo Gérard Blot. Paris, Louvre. © 2021. RMN-Grand Palais 221; /photo **© 2021** 226; /© 2021. Image copyright The Metropolitan Museum of Art/Art Resource, New York 245t; /© 2021. Image copyright The Metropolitan Museum of Art/Art Resource, New York 246; /© 2021 - courtesy of the Ministero Beni e Att. Culturali e del Turismo 267b; /photo © **2021** 270; /© **2021.** Image copyright Museo Nacional del Prado © Photo MNP 273; /photo Adrien Didierjean. © 2021. Nice, Musee des Beaux-Arts. RMN-Grand Palais 333; /© **Georgia O›Keeffe Museum / DACS 2021**. Image copyright The Metropolitan Museum of Art/Art Resource, New York 387; /© The Estate of Alberto Giacometti (Fondation Giacometti, Paris and ADAGP, Paris), licensed in the UK by ACS and DACS, London 2021. © **2021**. Digital image, The Museum of Modern Art, New York 390; /© The Jacob and Gwendolyn Knight Lawrence Foundation, Seattle / Artists Rights Society (ARS), New York and DACS, London 2021. © **2021. Image copyright The Metropolitan Museum of Art/ Art Resource, New York** 393; /© **Georg** Baselitz 2021. Digital Image © 2021 The Museum of Modern Art, New York 395; /© **Shen Jiawei. © 2021**. Princeton University Art Museum/Art Resource, New York 405; **Sebah &Joiallier, Constantinople**: 105; © Sebastian **Schutyser, www.sebastianschutyser.com**: Bugun-ri dolmen from *Goindol: dolmen in South-Korea* by Sebastian Schutyser, 2016 Chaeg 8; **Shaanxi History Museum**: /Qin Shihuang Terracotta Warriors and Horses Museum: 46; **Shimbi Shoin**: Kudara Kannon from *Japanese Temples and their Treasures, Vol 2*, 1910 181b; **Shutterstock.com**: /Granger 135, /schlyx 143t, /Gianni Dagli Orti 143b; **Sotheby's**: 15; **Stadtbibliothek, Stadtarchiv Trier**: 138; © **Tate:** /photo 2021 318; /photo 2021 © DACS 2021 408; © The Aga Khan Museum: 117t; © The Bodleian Libra**ries, University of Oxford:** /MS. Junius 11, p. 66 139, /MS. Ouseley Add. 171, folio 4v 295b; **The Cleveland Museum of Art, Ohio**: /Creative Commons (CC0 1.0) 294b; **The Eli and Edythe L. Broad Collection:** /©

Estate of Roy Lichtenstein/DACS 2021 402; **The Metropolitan Museum of Art, New York**: /Fletcher Fund, 1940 (40.156) 13; /Gift of The Institute of Archaeology, The University of London, 1951 (51.59.7) 14t; /Bequest of Alice K. Bache, 1977 (1977.187.33 49; / Gift of Timothy, Peter, and Jonathan Zorach, 1980 (1980.83.12) 51; /Samuel Eilenberg Collection, Gift of Samuel Eilenberg, 1987 (1987.142.339) 92; /Gift of J. Pierpont Morgan, 1917 (17.190.396) 104; /Ex coll.: C. C. Wang Family, Purchase, Douglas Dillon Gift, 1977 (1977.80) 166; /Ex coll.: C. C. Wang Family, Gift of The Dillon Fund, 1973 (1973.120.8) 171; /Purchase, The Dillon Fund Gift, 1989 (1989.141.3) 172; /photo from Julia Meech-Pekarik, Momoyama: Japanese Art in the Age of Grandeur, exh.cat., 1975, cat. No. 44, p.91 188; /Mary Griggs Burke Collection, Gift of the Mary and Jackson Burke Foundation, 2015 (2015.300.272) 189b; /Robert Lehman Collection, 1975 (1975.1.31) 202; /Purchase, The Sylmaris Collection, Gift of George Coe Graves, by exchange, 1935 (35.27) 230; / Purchase, Mr. and Mrs. Charles Wrightsman Gift, 1972 (1972.61) 301b; / Bequest of Mrs. Charles Wrightsman, 2019 (2019.141.23) 305t; /Catharine Lorillard Wolfe Collection, Wolfe Fund, 1931 (31.45) 309t; /Harris Brisbane Dick Fund, 1946 (JP3018) 327t; /The Howard Mansfield Collection, Gift of Howard Mansfield, 1936 (JIB111a–k) 328; /Bequest of Margaret E. Dows, 1909 (09.95) 334; /The Rubel Collection, Purchase, Lila Acheson Wallace, Michael and Jane Wilson, and Harry Kahn Gifts, 1997 (1997.382.36) 338; /Gift of John Goldsmith Phillips, 1976 (1976.646) 339l; /Bequest of Stephen C. Clark, 1960 (61.101.17) 359; /The Michael C. Rockefeller Memorial Collection, Purchase, Nelson A. Rockefeller Gift, 1965 (1978.412.857) 366; **The Missouri Historical Society, St. Louis**: /photo courtesy, ref: 1882-018-0016b 335; © The Museum Yamato **Bunkakan**: /All Rights Reserved 184b; **The National Gallery of Ireland, Dublin**: /Licensed under CC BY 4.0. 213t; **The Nelson-Atkins Museum of Art, Kansas City, Missouri**: /Purchase: William Rockhill Nelson Trust, 62-11 33, /Purchase: William Rockhill Nelson Trust, 46-51/2. Photo: John Lamberton 175; **The New York Public Library**: /Astor, Lenox and Tilden Foundation, cat no.21. Image from Eric Kjellgren and Carol S.Ivory, 'Adjorning the World. Art of the Marquesas Islands', exh cat., New York (Metropolitan Museum of Art), 2005, p.57 364; **The Penn Museum, The University of Pennsylvania:** 16; © The State Hermitage Museum, St Petersburg: / photo by Vladimir Terebenin Artwork © **Succession H. Matisse/ DACS 2021** 373; © The **Trustees of the British Museum**: 18; 23; 25; 31t; 44; 62; 85; 90; 121b; 122b; 123b; 130; 145; 165; 173; 176; 214; 233; 244; 267t; 370; **The Whitworth Art Gallery, The University of Manchester**: /photo courtesy 303t; **Topfoto**: 54; 72, 181t; **Tropenmuseum, Amsterdam**: /Aankoopfonds Volkenkundige Collectie/Mondriaan Stichting © Unknown Rightsholder 406; **University Library, Utrecht**: 137; © Victoria and Albert Museum, London: 136; 310; /© Royal Photographic Society Collection 355; **Vincent A Smith (1848–1920):** From *A History of Fine Art in India and Ceylon* 89b; **Yale University:** /Art Gallery, New Haven 66; /Press, New Haven and London, from Diana E Kleiner, *Roman Sculpture*, p.38, fig 16, photo © DAIR 1933 73.

Index

BLOOMSBURY CIRCUS
Bloomsbury Publishing Plc
50 Bedford Square, London, WC1B 3DP, UK
29 Earlsfort Terrace, Dublin 2, Ireland

BLOOMSBURY, BLOOMSBURY CIRCUS and the Bloomsbury Circus
logo are trademarks of Bloomsbury Publishing Plc

First published in Great Britain 2021

A catalogue record for this book is available from the British Library

Library of Congress Cataloguing-in-Publication data
has been applied for

ISBN: HB: 978-1-4088-7968-9; eBook: 978-1-4088-7966-5

2 4 6 8 10 9 7 5 3 1

Publisher: Michael Fishwick
Managing Editor: Lauren Whybrow
Assistant Editor: Amanda Waters
Production Manager: Laura Brodie
Designer: Evi O. Studio | Evi O. & Kait Polkinghorne
Picture researcher: Jo Carlill

Printed and bound in Italy by Graphicom

To find out more about our authors and books
visit www.bloomsbury.com and sign up for our newsletters

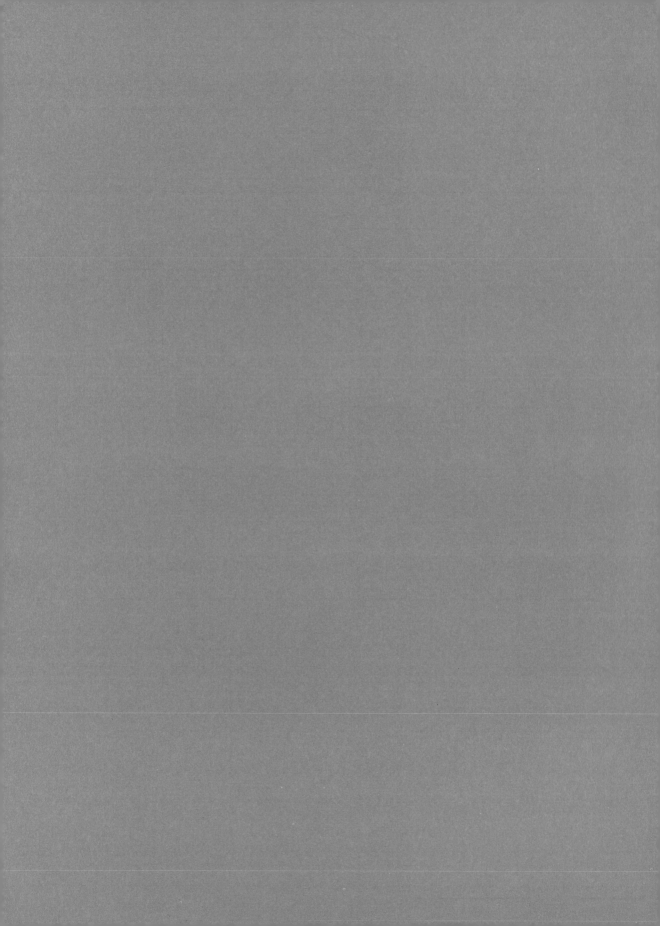